# Contents

List of Illustrations     viii

Acknowledgments     x

Introduction: Modernism and Diaspora—The School of Paris in an
Age of Immigration     1

1  Is there Jewish Art?     15

2  From Montmartre to Montparnasse: New Social and
Psychological Dimensions, 1900-1914     63

3  Masculinity and Patriotism: Artistic Responses to
World War I, 1914-1920     97

4  Cosmopolitan Montparnasse in *Les Années Folles*, 1920-1930     143

5  Jews in Jazz Age Paris: The Symbiosis of Music and Art     187

6  Marketing Art: Jewish Critics and Art Dealers     223

7  Nationalism, Internationalism, and Zionism in the 1930s     255

8  The End of Time: Artists in Exile, Hiding, and Deportation     301

Bibliography     341

Index     361

# Illustrations

1.1 Marc Chagall, *Paris through the Window*, 1913.  15

1.2 Mané-Katz, *Homage to Paris*, 1930.  17

1.3 Sonia Delaunay-Terk, *Bal Bullier*, 1913.  40

1.4 Marc Chagall, *Self-portrait with Clock*, 1947.  47

1.5 Chaim Soutine, *Carcass of Beef*, c. 1925.  49

1.6 Man Ray, *Object to be Destroyed*, 1932.  53

1.7 Man Ray, *Observatory Time—The Lovers*, 1932-6.  54

2.1 Marc Chagall, *Homage to Apollinaire*, 1913.  72

2.2 Sonia Delaunay-Terk, *Electric Prisms*, 1914.  73

2.3 Amedeo Modigliani, *Léon Bakst*, 1917.  84

3.1 Jean Cocteau, photograph: Amedeo Modigliani, André Salmon, and Pablo Picasso, August 12, 1916.  97

3.2 Jean Cocteau, photograph: Moïse Kisling, Pablo Picasso, and others, August 12, 1916.  98

3.3 Photograph of the Kisling-Gottlieb duel, June 12, 1914.  106

3.4 Chana Orloff, *The Kiss, or The Family*, 1916, bronze.  111

3.5 Simon Mondzain, *Pro Patria*, 1920.  116

3.6 Photograph: Léopold Gottlieb in uniform (undated).  117

3.7 Léopold Gottlieb, *Brigadier Josef Pilsudski*, 1914.  117

3.8 Léopold Gottlieb, *Dr. Edward Wertheim*, 1916.  118

3.9 Léopold Gottlieb, *Legionary next to sick woman*, 1915.  119

3.10 Jules Pascin, *Landscape*, 1917.  125

3.11 Amedeo Modigliani, *Head of a Woman*, 1910-11.  128

3.12 Amedeo Modigliani, *Jacques and Berthe Lipchitz*, 1916.  130

3.13 Amedeo Modigliani, *Nude on a Blue Cushion*, 1917.  132

4.1 Chana Orloff, *The dancers (sailor and sweetheart)*, 1923, cast 1929, bronze.  148

4.2 Chana Orloff, *Crouching woman*, 1925, bronze.  149

4.3 Jules Pascin, *Two nudes, one standing, one sitting*, 1913.  157

4.4 Jules Pascin, *Two standing nudes*, 1914.  158

4.5 Amedeo Modigliani, *Portrait of the painter Moïse Kisling*, 1915.  162

4.6 Chaim Soutine, *Portrait of Moïse Kisling*, c. 1919-20.  164

# Modernist Diaspora

# Modernist Diaspora

## Immigrant Jewish Artists in Paris, 1900–1945

Richard D. Sonn

BLOOMSBURY VISUAL ARTS
LONDON • NEW YORK • OXFORD • NEW DELHI • SYDNEY

BLOOMSBURY VISUAL ARTS
Bloomsbury Publishing Plc
50 Bedford Square, London, WC1B 3DP, UK
1385 Broadway, New York, NY 10018, USA
29 Earlsfort Terrace, Dublin 2, Ireland

BLOOMSBURY, BLOOMSBURY VISUAL ARTS and the Diana logo are trademarks
of Bloomsbury Publishing Plc

First published in Great Britain 2022
Paperback edition first published 2023

Copyright © Richard D. Sonn, 2022

Richard D. Sonn has asserted his right under the Copyright, Designs and Patents Act, 1988,
to be identified as Author of this work.

For legal purposes the Acknowledgments on p. x constitute an extension of this
copyright page.

Cover design: Toby Way
Cover image © ADAGP, Paris and DACS, London 2021. Marc Chagall,
*Time is a River without Banks*, 1936.

A catalogue record for this book is available from the British Library.

| ISBN: | HB: | 978-1-3501-8531-9 |
| | PB: | 978-1-3502-8661-0 |
| | ePDF: | 978-1-3501-8532-6 |
| | eBook: | 978-1-3501-8533-3 |

Typeset by RefineCatch Limited, Bungay, Suffolk

To find out more about our authors and books visit www.bloomsbury.com
and sign up for our newsletters.

*To Leah, Everett, and Eli, two generations on, and to other children of the twenty-first century, who one day may look back at their forebears a century ago with amazement, and see a time of boundless hope and creativity, mixed with unsurpassed violence and horror. Meanwhile, they can enjoy the pictures.*

4.7   Amedeo Modigliani, *Portrait of Chaim Soutine*, 1917.   165
4.8   Chaim Soutine, *Winding Road, near Gréolières*, 1920-1.   167
4.9   Chaim Soutine, *Pastry Chef*, 1919.   168
4.10  Chaim Soutine, *Grotesque (self portrait)*, before 1929.   171
4.11  Isaac Grünewald, *Land och stad* (Country and City), 1918.   178
5.1   Marc Chagall, *The Green Violinist*, 1923-4, oil on canvas.   190
5.2   Mané-Katz, *The Wedding*, c. 1935.   194
5.3   Daniel Baranoff-Rossiné, *Capriccio Musicale*, 1913.   197
5.4   Daniel Baranoff-Rossiné, *Symphony Number 1*, 1913.   198
5.5   Isaac Grünewald, *Dramats Fodelse* (Birth of Drama), 1933.   200
5.6   Henri Hayden, *The Three Musicians*, 1920.   208
5.7   Jacques Lipchitz, *Harlequin with Clarinet*, 1919.   211
5.8   Jacques Lipchitz, *Song of the Vowels*, 1931-32, executed 1969.   212
5.9   Ossip Zadkine, *Orpheus Walking*, 1930.   214
7.1   Man Ray, *Veiled Erotic*, 1933.   256
7.2   Sonia Delaunay-Terk, *Propeller*, 1937.   270
7.3   Marc Vaux, photograph: Jacques Lipchitz in his workshop with the fireplace, mantelpiece, and firedogs, n.d.   274
7.4   Marc Vaux, photograph: Jacques Lipchitz in front of his plaster model *Prometheus Strangling the Vulture*, 1936.   275
7.5   Jacques Lipchitz, *Rape of Europa II*, 1938, bronze.   276
7.6   Jacques Lipchitz, *Prometheus Strangling the Vulture*, begun 1943, cast 1952-3, bronze.   278
7.7   Paris World Fair, 1937, Eiffel tower, Trocadéro fountain, seen from Palais de Chaillot.   280
7.8   Jacques Lipchitz, *Theseus and the Minotaur*, 1942.   283
7.9   Grégoire Michonze, *We Play Red*, 1937.   286
7.10  Marc Chagall, *White Crucifixion*, 1938.   291
8.1   George Platt Lynes, *Artists in Exile* exhibition at the Matisse Gallery, New York City, March 3-28, 1942.   302
8.2   Marc Chagall, *Yellow Crucifixion*, 1943.   315
8.3   Abraham Rattner, *The Air Raid*, 1943.   318
8.4   Abraham Rattner, *Procession*, 1944.   319
8.5   Jacques Lipchitz, *The Prayer*, 1943.   321
8.6   Léon Weissberg, *Portrait of the merchant Léopold Zborowski*, 1926.   324
8.7   Léon Weissberg, *The Old Clown, Self-portrait as a clown*, 1942.   326
8.8   Boris Taslitzky, *The Little Camp at Buchenwald*, 1945.   328
8.9   Marc Chagall, *The Falling Angel*, 1947.   332

# Acknowledgments

Over the decade that I have been working on this book, I have incurred numerous debts. I would like to thank the helpful staffs of the Bibliothèque Nationale de France, the Bibliothèque Kandinsky, the Musée d'art et d'histoire du Judaïsme, the Barnes Foundation in Merion, Pennsylvania, and the Interlibrary Loan Department in Mullins Library at the University of Arkansas. I received useful feedback from the outside readers for Bloomsbury, and appreciate the help and advice of the visual arts editors Edward Thompson, April Peake, and Yvonne Thouroude, in bringing this book to completion. Chapters of the book were read by K. Steven Vincent, Patricia Leighten, and Mark Antliff. Vicki Caron provided encouragement early on about the viability of the project. Jacob Adler helped me with Yiddish texts. The staff of the Department of History at the University of Arkansas, Brenda Foster and Melinda Adams, were particularly helpful in dealing with my many requests for payment for the illustrations. Former department chair James Gigantino and current chair J. Laurence Hare have been supportive, and have nurtured a harmonious environment in difficult times. The University of Arkansas granted me two semesters off in the course of working on this book. I used the first leave to do research in Paris; the second fell during the pandemic, so instead of traveling I stayed home and contacted museums for the book's illustrations.

Portions of this book have appeared in three edited collections. An early version of Chapter 2 appeared as "Jewish Modernism: Immigrant Artists of Montparnasse, 1905-1914" in Karen L. Carter and Susan Waller (eds.), *Foreign Artists and Communities in Modern Paris, 1870-1914: Strangers in Paradise* (Farnham, Surrey: Ashgate, 2015). Portions of chapters 2 and 4 appear as "Jewish Expressionists in France, 1900-1940," in Isabel Wünsche (ed.), *The Routledge Companion to Expressionism in a Transnational Context* (New York and London: Routledge, 2019). I adapted part of Chapter 3 for "Jewish Artists and Masculinity in France in the Great War," in Sally Charnow (ed.), *Artistic Expression in the Great War, a Hundred Years On* (New York: Peter Lang, 2021). Most of my research has been presented at meetings of the Conference for French Historical Studies and the Western Society for French History. I presented the World War I material at the National Endowment for the Humanities summer seminar held

at the University of Cincinnati in 2014, on the arts during the First World War, and at the conference Sally Charnow organized at Hofstra University in November 2018, which led to the volume cited above.

Many museums have cooperated in providing illustrations for this book. Images were provided by museums in the United States, France, the Netherlands, Sweden, Switzerland, Poland, and Israel. Their names can be found in the captions to the illustrations. Thanks to Joyce Faust of Art Resources and Sara Moinian of the Artists Rights Society, who helped procure high-resolution images and copyright permissions. I am grateful to the Humanities Center of the Fulbright College of Arts and Sciences at the University of Arkansas for providing a stipend to offset the cost of the illustrations for the book. I appreciate the technical assistance that my wife Mary has provided throughout this project. I alone am responsible for any errors of fact or interpretation.

# Introduction: Modernism and Diaspora—The School of Paris in an Age of Immigration

*If a painter is Jewish and paints life, how can he help having Jewish elements in his work? But if he is a good painter, there will be more than that. The Jewish element will be there, but his art will tend to approach the universal.*

Marc Chagall[1]

The era of modernism in art coincides with the life of the Third French Republic, starting in the 1870s with the birth of impressionism and lasting until the cataclysm of World War II. These convenient dates are not ironclad; some might want to start with Courbet and the realists of the 1850s; others would include abstract expressionists of the postwar era and carry modernism until the rise of postmodernism around 1970. The more modestly dated seventy-year miracle of modernism, beginning with the Franco-Prussian War and the Paris Commune and ending with a third German war, coincides with the era of mass migration. In this period of global mobility, artists too left their homelands to seek opportunities elsewhere, in particular in artists' colonies where they could absorb the latest trends.

While there were a few Jewish artists active at the beginning of this period, their numbers increased exponentially after the turn of the twentieth century. Young Jews began to appear in significant numbers in Paris in the decade before World War I. During the war, most stayed in France while others repatriated to their countries of origin. Some, including Marc Chagall and Mané-Katz, returned to Paris from Russia after the era of war and revolution. During the boom years of the 1920s, their numbers surged, with hundreds of Jewish artists working in Paris, most of whom had studios in the left-bank artists' colony of Montparnasse. These same years saw increased Jewish emigration to France, but most Jewish immigrants resided on the right bank, in the fourth, eleventh and eighteenth arrondissements. In the 1920s, Jewish artists acquired a new visibility in Paris, and some achieved financial and artistic success, while incurring resentment among some French critics.

Two economists have tried to quantify artistic mobility. They examined artists' migration for four periods (based on their date of birth): Renaissance Italy, Europe in the first half of the nineteenth century, and the Western world for the periods 1850-99 and 1900-49. They found that artists clustered in all periods at remarkably high levels. As Florence and Rome dominated in Renaissance Italy, Paris especially attracted artists born in the late nineteenth century. Of 181 prominent artists born between 1850 and 1899, 102 moved within or to France, and almost seventy relocated to Paris. Of sixty-one artists who migrated outside their native country, almost half made a permanent long-term move to Paris. Nearly all of the major artists born in the late nineteenth century undertook long-term migrations. The authors concluded that "the more tacit knowledge associated with an activity, the more important is permanent or semi-permanent physical proximity; thus, artists tend to cluster ... artists cluster because they need to transfer tacit knowledge in the process of innovation."[2] Artists were extraordinarily mobile, and they congregated at key sites in order to share "tacit knowledge," that is to learn from each other. But why Paris?

The glib response might be to cite Gertrude Stein: "Paris was where the twentieth century was."[3] Quotable as Stein was, her quip conflates her own life spent in the Ville Lumière with that of modern art, whose journey began well before the arrival in Paris of Gertrude Stein and Pablo Picasso at the beginning of the twentieth century.

As artists were distancing themselves from the art academies and salons in order to develop their own vision and style, they were also separating themselves from an uncomprehending public and from bourgeois commercial values by establishing artistic enclaves. The rise of bohemian subcultures reinforced the growing recognition that being an artist entailed a distinctive lifestyle that was more disorderly and hedonistic than that lived by the general public. Particularly in nineteenth-century Paris, first the Latin Quarter and then Montmartre embodied the notion that artists should congregate in artists' colonies where they could share ideas while reinforcing unique forms of sociability. In this way, bohemia reinforced modernism by distinguishing how artists lived as well as how they defined their artistic practice, and by placing a premium on innovation and in-group solidarity over the claims of tradition and authority. Rejection of authority went by another name: the avant-garde.

For such out-groups as Jews, bohemia offered toleration of difference, as well as acceptance and even valorization of poverty for those immigrants who arrived in Paris with few resources. There is a further reason why Paris drew young Jewish artists, expressed evocatively by the phrase "to live like God in France."

This saying—in Yiddish, "leben vi Got in Frankraykh"—encouraged Ashkenazi Jews to emigrate to France, where many settled in the Marais district of the fourth arrondissement that became known as the Pletzl of Paris.[4] Despite the shock of the Dreyfus Affair, the Third French Republic had a reputation for toleration, and Jews remembered that the French revolutionaries of 1791 were the first to confer equal citizenship and civil rights on Jews in Europe.

While Jewish immigration to France was relatively slow, it picked up after further repression in Russia following the 1905 Revolution, including a savage pogrom in Odessa that year. This correlates with the arrival of increasing numbers of Jewish artists after 1905.

A key ingredient of modernism that formalist art critics tend to ignore is its cosmopolitanism. Always an international movement, modern art became increasingly so in the early twentieth century. French modernism in particular is impossible to understand without referring to foreign artists who came to Paris and transformed modernism in the process. This was truer of cubism in the era of Picasso and Gris than it was of impressionism, whose only major foreign contributors residing in France were the American Mary Cassatt and the Danish-Caribbean Jew Camille Pissarro. After 1910, the number of foreign artists in Paris included a growing proportion of Jews, mostly Ashkenazi Jews from Eastern Europe, along with a few Sephardic Jews (like Pissarro) such as Amedeo Modigliani and Jules Pascin. A second surge of Jews fleeing new waves of dislocation and oppression in Bolshevik Russia and Nazi Germany reinforced these numbers. Along with the values of independence and non-conformism already in place came a third value of cosmopolitan toleration, which by the 1930s acquired clear political overtones. With the rise of extreme forms of right-wing nationalism, modern art became assertively leftist and internationalist; in Paris, it was also increasingly Jewish.[5]

Around 1910, the center of Parisian avant-garde art shifted from the right-bank region of Montmartre to the left-bank neighborhood of Montparnasse. As this transition was occurring, modern art movements proliferated at a dizzying pace, with fauvism, cubism, futurism, and expressionism all issuing manifestos and seeking critical attention. Yet something else was happening in the decade preceding World War I, when modern art made its decisive move away from the painterly illusion of three-dimensional realism that had marked Western art since the Renaissance. The wider, non-art world witnessed vast amounts of immigration and the movement of peoples. Millions of migrants moved from East to West, most dramatically from Europe to the New World. This migration included large numbers of Jews fleeing oppression in the Habsburg and Russian empires. The era

of pogroms, that began in 1881 after the assassination of Tsar Alexander II in St. Petersburg, Russia, coincided with the rise of modernism, but it took a further generation before young Jews, most born between 1884 and 1894, responded to the push of oppression and the pull of opportunity and secularism to participate in the revolution of modernism. At first relatively unnoticed, many attended art schools in Vilna, Vitebsk, and Kraków before migrating to Paris. Their numbers increased from a trickle to a flow and then to a torrent, so that by the 1920s hundreds of young Jews arrived in Paris hoping to succeed as artists.[6]

While the Parisian Jewish population swelled in these same years, none of these immigrant Jewish artists chose to live in the right-bank neighborhoods where other Jews congregated. Rather, nearly all went to Montparnasse, where they found cheap studio space, artistic encouragement, and toleration. Immigrant Jewish artists saw in Montparnasse if not a utopia at least a heterotopia that was distinct from other locales. Their identities shifted from being poor immigrants to that of bohemian artists, a more free-floating category not available in the Pale of Settlement.

The poet and playwright Jean Cocteau photographed some of the artists of Montparnasse on August 12, 1916. These photos testify implicitly that wartime Montparnasse sheltered many foreigners, since most French-born artists were serving at the front. Cocteau himself served in the ambulance corps but moved freely between the front and Paris. In the summer of 1916, he photographed the Spanish painter Pablo Picasso, the critic André Salmon, and two immigrant Jewish artists, Amedeo Modigliani and Moïse Kisling. Also included in the photos were the native French Jewish poet and painter Max Jacob and the Chilean painter Manuel Ortiz de Zárate. Kisling had in fact served with the French Foreign Legion, but after being wounded in 1915 he had returned to Paris. Salmon had also returned from the trenches. Cocteau's memories of these years emphasize the international quality of life there:

> When I was young and we all lived in Montparnasse, we had no money and no political, social or national problems of any sort. So when people ask me who the great French artists were, I was able to reply: Picasso, forgetting he was Spanish, Stravinsky, forgetting he was Russian, and Modigliani, forgetting he was Italian. We formed a group, we fought a lot, we quarreled a lot, but there was a kind of international patriotism among us too. This patriotism is a privilege of Paris and often threatens to make the city incomprehensible to the outside.[7]

The oxymoronic term "international patriotism" that Cocteau used to describe artists who were intent on serving aesthetic rather than nationalistic ends nicely

highlights Montparnasse's transnational ambience. One cannot take Cocteau's reminiscences at face value; he did not live in Montparnasse and always possessed superior cultural connections. Yet even if he annexed Montparnasse into his own biography, this suggests the lure that the up-and-coming artists' colony had in these years. All these denizens of Montparnasse—Picasso, Kisling and Modigliani—painted or sketched Cocteau in the same year that he photographed them.[8] Cocteau was also involved with the painters in organizing the wartime Lyre and Palette evenings held in artists' studios, in which modern composers performed new compositions in rooms hung with paintings for sale. Cocteau brought his well-heeled friends to these music and art venues.

It was not unprecedented for Jews to become artists, despite the famous biblical prohibition against making graven images. In 1855, Camille Pissarro arrived in Paris from the Danish island of St. Thomas; Max Liebermann came there from Berlin in 1872, though he missed impressionism and only caught up with it in the 1890s. The handful of nineteenth-century Jewish artists who absorbed French modernism in no way threatened French artistic hegemony, and while Pissarro became an esteemed master and the only artist to show at all eight impressionist exhibitions from 1874 to 1886, it would be difficult to ascertain any Jewish elements in his art. Possibly his anarchist politics and respect for the downtrodden could be ascribed to his Jewish background; he certainly differed from Renoir and Degas politically, both of whom were anti-Dreyfusards in the 1890s.

This ethos of artistic assimilation contrasts with the visibility of Jewish artists in interwar Montparnasse. In 1925, the French critic André Warnod coined the term Ecole de Paris or School of Paris to refer to the international community of artists working on the left bank. Of the dozen artists whose names he listed in the January 1925 issue of *Comoedia*, seven were Jews. Of them, Jacques Lipchitz and Ossip Zadkine were sculptors; the rest—Jules Pascin, Marc Chagall, Modigliani (by then deceased), Louis Marcoussis, and Moïse Kisling—were painters. The non-Jews cited by Warnod included the Spaniards Pablo Picasso and Juan Gris, the Dutch Kees Van Dongen, the Japanese Tsuguharu Foujita, and the Greek Demetrios Galanis.[9]

That same year, French journals began publishing articles exploring the sudden appearance of Jews on the art scene, mostly disparagingly. In the *Mercure de France*, critics Fritz Vanderpyl and Pierre Jaccard bemoaned foreign Jewish incursion in an area of long native domination, their fears multiplied by the many Jewish art dealers and critics. These included Daniel Henry Kahnweiler, Léonce and Paul Rosenberg, Berthe Weill and Nathan Wildenstein (and later his

son and grandson Georges and Daniel) among dealers, and Florent Fels, Adolphe Basler, and Waldemar George among the critics. They believed that Jewish critics and dealers conspired to advance the careers of their co-religionists, and that the Ecole de Paris was really the Ecole Juive, the Jewish School.[10] There was indeed a booming art market in the 1920s that made impecunious immigrants such as Chaim Soutine and Moïse Kisling suddenly prosperous. Soutine, the most expressionist of any artist working in France, especially aroused the ire of many French critics. He manifestly refused to conform to French values of harmony and balance, and his rapid rise to prominence after the American collector Albert Barnes "discovered" him in 1923 did not reassure them. Dealers and collectors were at least as cosmopolitan as were the artists themselves. Well before New York displaced Paris as the center of modern art after 1945, many French feared that the large foreign presence ensconced in Montparnasse already threatened French artistic hegemony.

The School of Paris deviated from most of the key movements of modernism in not presenting a unitary artistic style. Unlike dada and surrealism, the contemporary movements shaking the interwar cultural scene, this "school" came with no manifestos and did not demand obedience to a common set of practices and beliefs, as André Breton required for his surrealist followers. Rather, inclusion and locale defined the School of Paris. Its artists were associated with Montparnasse, which its residents celebrated as the cosmopolitan art center of the world. Stylistic eclecticism has led art historians to neglect the School of Paris. While Chaim Soutine (whom Warnod omitted from his list, but is now probably the best-known Jewish artist of this era after Chagall and Modigliani) is identifiably an expressionist, Chagall is harder to pigeonhole; he refused to join with the surrealists despite their admiration for his work. Modigliani is equally hard to categorize, and many Jewish artists' styles evolved in the thirty years between arriving in Paris and fleeing the city with the arrival of the Germans in 1940. Cosmopolitanism was the crucial factor defining the art scene of 1920s Paris.

Prescriptive cosmopolitanism, the idea of the superiority of an international perspective, follows from the thought of eighteenth-century philosopher Immanuel Kant, who saw it as befitting the outlook of men of letters, whom we would call intellectuals. Kantians see a cosmopolitan attitude as respectful of difference and open to pluralism. The concept sanctions explicit universalism, and implicit moralism. Cosmopolitanism empowers marginal and non-national populations such as Jews and homosexuals. In the context of 1920s Paris, and especially in the heterogeneous artistic communities of Montmartre and

Montparnasse, this attitude of toleration benefited two diasporas: African Americans who brought the new sounds of jazz music to France in the aftermath of the war, and Jewish artists, mostly coming from the East.[11] Names like Aaron Copland and George Gershwin remind us that these categories were not as distinct as they might seem, while the Provençal Jewish composer Darius Milhaud integrated the sounds of Harlem and the chazan into his music.

Cosmopolitanism fitted comfortably with the culture of the Jewish Diaspora. The negative image of the wandering Jew expressed the cliché of eternal mobility, the perception of the Jew as permanent exile who lacked roots and was at the mercy of whichever host nation provided refuge. Marc Chagall, one of the leading Jewish artists of the Ecole de Paris, frequently portrayed the wandering Jew as an older, stooped, bearded figure carrying a knapsack over his shoulder. Chagall's wandering Jew was always fleeing persecution, in this case from the pogroms that shook the Pale of Settlement. Sometimes the figure floats over Chagall's hometown of Vitebsk, dominating the skyline. Another great modernist figure, the poet Guillaume Apollinaire, wrote a poem dedicated to Chagall called "A travers l'Europe," ("Across Europe") shortly before the war, which highlighted the peripatetic artist traveling the roads of the continent, as if Apollinaire conflated the Jew with rucksack with the Jewish artist with paintbrush.[12] To be Jewish in the Diaspora meant being an outsider, and despite the nostalgia inherent in Chagall's paintings of bearded rabbis and tipsy violinists, Jews signified rootless modern man. As the work of economists O'Hagan and Hellmanzik shows, Jewish artists were not exceptional in this regard, but their visibility in Montparnasse made them embodiments of transnational mobility.

As Apollinaire celebrated Chagall as modern exemplar of the wandering Jew, Chagall returned the favor. In 1913, he painted *Homage to Apollinaire*, one of the most unusual works in his entire oeuvre (see Figure 2.1). It shows a bifurcated, androgynous being, half man and half woman, posed in front of a cubist-inspired, fragmented background that resembles a clock. Along with the name Apollinaire, Chagall also inscribed other supporters of his work, including the Swiss-born poet Blaise Cendrars, the Italian-born journal editor Riccioto Canudo, who hosted a show of Chagall's paintings in 1913, and the German-Jewish gallery owner Herwarth Walden, who would put on Chagall's first solo exhibition in Berlin the following year.[13] These literary/artistic figures, as cosmopolitan as was Chagall himself, were men with whom he felt comfortable, as well as indebted to for their support.

The first chapter of this book raises a question that critics asked in the 1920s about the increasing prevalence of Jewish artists: is there Jewish art? They

answered the question negatively: there were Jewish artists but no distinctly Jewish art. I suggest instead that there was something unique about the Jewish contribution to modernism. This introduction has emphasized cosmopolitanism as part of that contribution. Chapter 1 suggests further that, in the era of Bergson and Einstein, Jews were especially sensitive to issues of temporality. Ashkenazi Jews had little access to space in the sense that they could not own land in the shtetls and urban areas of the Pale, but they had long historical and cultural memories and a wealth of traditions. Judaism is a peculiarly historical religion, many of whose holidays, including Purim, Passover, and Hanukkah, commemorate actual events. Marc Chagall in particular used the repeated image of the clock that had adorned his childhood home in Vitebsk in paintings spanning many decades. In 1936, he painted *Time is a River without Banks*, one of his many meditations on time. Other artists, from Soutine to Man Ray, also made temporally-conditioned art.

Chapter 2 focuses on the decade preceding World War I, when many young Jewish artists arrived in Paris and the center of Parisian artistic life shifted from Montmartre to Montparnasse. Montparnasse offered affordable studio space, none cheaper or more convivial than the beehive-shaped structure called La Ruche, on the southern edge of the fifteenth arrondissement. Pre-war Paris saw the vogue for primitivism—African art for some and Russian culture for others— which powerfully influenced modernism. Some French associated Jews with the Ballets Russes, which took avant-guerre Paris by storm and showed how the most modern art forms could express archaic longings.

Chapter 3 highlights the difficult choices immigrants faced in the Great War. Jews as foreign nationals had to decide whether to repatriate, to fight for France, or to remain outside the fray. Many Ashkenazi Jews had fled Russia to avoid serving in the tsar's army; few were eager to fight for tsarist autocracy. Though they faced less prejudice in the West, they had to contend with conceptions of Jewish masculinity that did not correspond to French ideals of manliness. Two Polish immigrant artists, Moïse Kisling and Leopold Gottlieb, fought a duel on the eve of the war; then Kisling joined the French Foreign Legion while Gottlieb served in the Polish Legion of the Austro-Hungarian Army. Their story foregrounds questions of nationalism, bellicosity, and masculinity. Of those who stayed in France, Amedeo Modigliani's career peaked during the war; Alice Halicka and Jacques Lipchitz were among those who embraced cubism and helped maintain an embattled avant-garde.

Chapter 4 shows how the cosmopolitan ambience of the pre-war Paris of Picasso and Apollinaire was exceeded by the Paris of *les années folles*, the crazy

years of the 1920s—the Paris of James Joyce, Tristan Tzara (born Samuel Rosenstock, a Jewish immigrant from Romania), and Sylvia Beach. The other great diaspora of the period, the Black diaspora, also included persecuted exiles who found a new home in Paris. In a world of persecution, racism, and antisemitism, Paris became a beacon for a new cosmopolitan toleration that appeared briefly to be part of the zeitgeist. Deviants from gender norms, especially lesbians, became a noticeable presence in modernist Montparnasse. Sometimes the categories overlapped, as with Gertrude Stein, Claude Cahun (Lucy Schwob), and other Jewish lesbians who frequented the Montparnasse club Le Monocle.

Nativist French critics reacted against a phenomenon becoming increasingly obvious in interwar France. There were fewer names like Léger and Matisse to compete with the legion of foreign-born artists. In Montparnasse, a host of expatriate writers from the U.S. and Britain joined the artists. Most Americans think of Roaring Twenties Montparnasse principally as the home of Gertrude Stein, Ernest Hemingway, F. Scott Fitzgerald, Man Ray, Djuna Barnes—Americans seeking an alternative to the U.S. of Prohibition (African Americans also fled the Ku Klux Klan). Stein and Man Ray remind us that American Jews also came to Paris. Born Emmanuel Radnitzky, Man Ray became a major figure in interwar surrealism. Marcel Duchamp, who had met Man Ray in New York during World War I, smoothed his entrée into the echelons of the French avant-garde. Duchamp was as international a figure as any foreign-born artist, whose *Nude Descending a Staircase* scandalized the 1913 Armory Show that introduced Americans to the new currents of European art. In 1934, Duchamp described the contemporary Parisian art scene in the following terms:

> Montparnasse was the first really international colony of artists we ever had. Because of its internationalism, it was superior to Montmartre, Greenwich Village or Chelsea [and] the colorful but non-productive characters of Montparnasse often contributed greatly to the success of the creative group.[14]

Contemporary political trends cast Duchamp's comments in greater relief. The greatest internal violence witnessed in Paris since the Paris Commune of 1871 occurred in February 1934, as right-wing rioters responded to the revelations over the Stavisky Affair, which concerned the murder or suicide of a Jewish embezzler from Ukraine named Alexandre Stavisky. Fifteen demonstrators were killed and hundreds wounded; the parties of the left responded by creating the Popular Front later that year. For Marcel Duchamp, Montparnasse was not merely a haven for artists, but represented a standing reproach to fascists and

nationalists. He explicitly included the "non-productive characters" who comprised bohemia, suggesting that artists' colonies derived their alterity from more than the practice of art.

Chapter 5, "Jews in Jazz Age Paris," argues that Jewish artists were prone to seek a "symbiosis of music and art." While immigrant Jewish artists drew upon minimal traditions in visual or plastic art, the same was not true of music. Representing instruments and musicians may have been a way for these artists to annex the familiar to the alien. The image of the klezmer musician in *The Green Violinist* by Chagall iconically represents pre-Holocaust Ashkenazi culture. Modernism was auditory as well as visual; 1920s Paris welcomed African-American jazz, whose syncopated sound filled the night along the Boulevard Montparnasse. Painting and sculpture are spatial arts, yet these artists' musicality suggests that, as Jews, they felt more at home immersed in art with a temporal dimension.

Chapter 6 focuses on the important role played by Jewish art dealers in France and Germany in promoting modern art. Art critics also included many Jews; together with dealers they made it possible for artists to live by their art. As mentioned earlier, some French critics responded negatively, suspecting Jewish critics and dealers of advancing the careers of their co-religionists. This was mostly not true; established dealers like Paul Rosenberg would rather show Picasso than Soutine, and some Jewish critics were hostile to Jewish artists.

Paris did not just turn left and right; it also turned more Jewish. France included fewer than 100,000 Jews at the time of the Dreyfus Affair,[15] and approximately 150,000 Jews in 1914; that population would more than double in the interwar period to over 300,000. Two-thirds of these Jews lived in the Paris basin, comprising 7 percent of the overall population by the late 1930s. Most of these immigrants were Jews fleeing persecution in Poland, Germany, and Austria. This large-scale immigration coincided with the Great Depression and created an atmosphere of increased antisemitism. The Popular Front government that took power in 1936 was led by Léon Blum, the first socialist prime minister of France and the first Jew in that position, which exacerbated currents of hatred.

Chapter 7 demonstrates how Jewish artists in particular responded to the rise of fascism and antisemitism in the 1930s. In the fraught political context of a world lurching toward war, France put on a world's fair in 1937. Called the International Exposition of Arts and Techniques in Modern Life, the fair welcomed pavilions from many nations, notably including Nazi Germany and the Soviet Union. Less visible was the Pavilion of Modern Jewish Culture, where on August 14 socialist Minister Leo Lagrange welcomed the participants, saying

"on our soil, you Jews are not foreigners."[16] Elsewhere at the fair was a small Palestine Pavilion. Two massive art exhibitions also accompanied the fair. The Popular Front government commissioned Jacques Lipchitz to produce an immense plaster sculpture called *Prometheus Strangling the Vulture*.[17] Wearing a Phrygian cap, Prometheus symbolized the ideals of the French Revolution; the vulture represented fascism. By the 1930s, Lipchitz had abandoned his earlier cubist style for an expressionist mode, which did not sit well with some French critics. Lipchitz's leftist politics furthered alienated these critics. In 1938, the newspaper *Le Matin* began a successful campaign to remove the statue. Lipchitz left France for exile in the U.S. after World War II broke out, and unlike most other Jewish artists in exile, he never lived in France again.

While the Parisian Exposition was demonstrating the virtues of inclusion, 840 kilometers to the east in Munich, Germany, the Nazis were displaying contrary values. They directed painter Adolph Ziegler to purge German museums of modern art, and to gather representative works in an exhibition of *Degenerate Art*. Ziegler took his cue from the Führer himself, since Hitler had failed at an artistic vocation in his native Austria before the war and bore a deep hatred for modern art. The Nazis also hated modern music and jazz in particular, which they identified as Black and Jewish. They thus repudiated the cultures that thrived in interwar Paris. Modernism for Hitler and Ziegler also signified cosmopolitanism, an art that was not rooted in blood and soil—an art that was Jewish. In this sense, Hitler was not wrong to see modernism as a threat to his own racial utopia. The cosmopolitan modernism of Montparnasse was a standing reproach to redemptive racist nationalism.[18]

One irony underlying the Nazi fear of degeneration as an inescapable symptom of the modern urban landscape is that a Jew made this critique part of the cultural lexicon. In 1892, Max Nordau (born Simcha Südfeld in 1849 in Pest, Hungary) published his book *Degeneration*, which attacked every variation of fin-de-siècle modern art from symbolism to naturalism and from Mallarmé to Wagner as neurotic and decadent. It is not coincidental that Nordau helped found modern Zionism a few years later, as second in command to Theodor Herzl, another Hungarian-born Jew. Nordau hoped to replace the decadent breed of "coffeehouse" Jews with robust "muscle" Jews who would work the land of Zion. Nordau intended Zionism to cure not only the Diaspora but also cultural cosmopolitanism, which had become synonymous with Jews.[19] Modernism had diverse enemies.

Notwithstanding such outbursts of identity politics as the Dreyfus Affair, the French republican mainstream favored universalism, which felt liberating to

Jewish immigrants fleeing the Pale. French *liberté* included the freedom to transcend ethnic/religious limitations. Jews came to Paris seeking freedom; their ideal could be termed humanist universalism. This aspiration still characterized Jewish artists in the moment of greatest crisis, when Jews were marked for destruction in the Holocaust. Chapter 8 shows how Jewish artists-in-exile during World War II turned to the figure of Jesus on the cross to express their anguish at the suffering of their people. Chagall, Abraham Rattner, Mané-Katz, Mark Rothko, and Emmanuel Levy in Britain all used the crucifixion to respond to the Holocaust.[20] They seized upon the most potent of Christian symbols of suffering to portray the plight of their martyred people with an inclusive rather than particularizing image.[21] Even when their identity as Jews was most fraught, and the very existence of their people was threatened, they chose to universalize their suffering. Many artists went into hiding in the south of France; the Germans deported many others, aided by the collaborationist government based in the town of Vichy. Exiles, those in hiding, and survivors had distinctive ways of representing war and Holocaust.

As a small population submerged in a large Gentile world, assimilation and the question of Jewish identity has been a central issue for Jews at least since the Haskalah or Jewish Enlightenment of the eighteenth century. The French republican tradition poses the issue of assimilation, and of Jewish particularism, in a different way from the United States, with its "melting pot" approach to minorities, as well as from other national traditions. Ever since the French Revolution, France has raised assimilation to a higher and more abstract level, arguing that ethnic and religious differences should not be recognized politically; that all French citizens exist only as individuals with equal rights under the law.

For the Jews especially, this meant a kind of civic and political equality that existed nowhere else when the French National Assembly granted it in 1791. The Jewish artists who arrived in the Third Republic accepted French universalistic values and conflated them with the promise of modernism. Modern art, like universalism, accepted the individual distinct from any group identity. When French publicists exaggerated Montparnasse's importance in the interwar period, calling it the center of the world, they were implicitly holding up the left bank artistic community as a model of universalism in an era when it was imperiled by the rising forces of racism and nationalism. This implicated Jewish artists particularly, since Jews had always been key to French thinking about republican universalism.[22] Immigrant artists certainly craved acceptance, and may have painted or sculpted nudes or still lives to become more like Matisse or Rodin, but they also believed that doing so let them reach a higher realm where

art was neither French nor Jewish but universal. In the minds of traditionalists and antisemites, modernism, cosmopolitanism, and universalism would all become code words for Jews.[23]

# Notes

1 Marc Chagall, quoted in Alfred Werner, *Chaim Soutine* (New York: Abrams, 1977), 34.

2 John O'Hagan and Christiane Hellmanzik, "Clustering and Migration of Important Visual Artists: Broad Historical Evidence," *Historical Methods* 41, no. 3 (Summer 2008): 123, 124, 133.

3 Gertrude Stein, *Paris, France* (New York: Liveright, 1940), 11.

4 Paula Hyman, *The Jews of Modern France* (Berkeley: University of California Press, 1998), 118.

5 This generalization appears to be truer for artists than for writers. It is easy to find examples of writers such as Ezra Pound and T. S. Eliot who were modernists but not leftists. It is harder to find such figures in France, and the dadaists and surrealists were far to the left.

6 Nadine Nieszawer, Deborah Princ et al., *Artistes juifs et l'Ecole de Paris, 1905–1939* (Paris: Somogy, 2016), provides 178 capsule biographies of Jewish painters and sculptors working in Paris, but estimates that over 500 immigrant Jewish artists were in Paris in these years.

7 Jean Cocteau, "Pablo Picasso," in Margaret Crosland, ed., *My Contemporaries* (London: Peter Owen, 1967), 75.

8 Picasso did the sketch; Kisling and Modigliani, who shared a studio, painted Cocteau's portrait.

9 André Warnod, "L'Ecole de Paris," *Comoedia*, January 21, 1925.

10 The articles by Vanderpyl and Jaccard appeared in the summer issues of the *Mercure de France*. In November, the journal gave space to the Jewish critic Adolph Basler, who repeated the title of Vanderpyl's article, "Existe-il un art juif?," "Does a Jewish art exist?" For more on this controversy, see Romy Golan, "The 'Ecole Française' vs. the 'Ecole de Paris': The debate about the status of Jewish artists in Paris between the wars," in Romy Golan and Kenneth Silver, eds., *The Circle of Montparnasse: Jewish Artists in Paris, 1905–1945* (New York: Jewish Museum, 1985).

11 There is a considerable literature on modernism and cosmopolitanism. See, for example, Janet Lyon, "Cosmopolitanism and Modernism," in Mark Wollaeger, ed., *The Oxford Handbook of Global Modernisms* (New York: Oxford University Press, 2012); and Peter Kalliney, *Modernism in a Global Context* (New York: Bloomsbury, 2016).

12 See Guillaume Apollinaire, *Calligrammes, Poems of War and Peace, 1913–1916* (Berkeley: University of California Press, 2004). Online, see poetica-fr/guillaume-apollinaire-à-travers-europe.

13 Jackie Wullschlager, *Chagall, A Biography* (New York: Knopf, 2008), 175–7.

14 Sophie Lévy, "Sympathetic Order," in Sophie Lévy, ed., *A Transatlantic Avant-Garde: American Artists in Paris, 1918–1939* (Berkeley: University of California Press, 2003), 15.

15 There are many books on the Dreyfus Affair. A revisionist study is Ruth Harris, *Dreyfus: Politics, Emotion and the Scandal of the Century* (New York: Metropolitan, 2010). An excellent account that places the affair in the context of rising antisemitism is Frederick Brown, *For the Soul of France: Culture Wars in the Age of Dreyfus* (New York: Knopf, 2010). A recent collection of essays is by Maya Katz, ed., *Revising Dreyfus* (Leiden: Brill, 2013). For visual imagery of the affair, see Norman Kleeblatt, ed., *The Dreyfus Affair: Art, Truth and Justice* (Berkeley: University of California Press, 1987).

16 Jacques Biélinky, "La culture Juive moderne à l'Exposition Internationale, Discours du Ministre Léo Lagrange," *Nouvelle Presse Juive*, Geneva, August 20, 1937.

17 See Bernadette Contensou, "Autour de l'Expo des Maîtres de l'Art Indépendants en 1937," in *Paris 1937, L'art indépendant* (Paris: Paris-Musées, 1987), 49, for the summary of artists by room. For the sculptors, see Cécile Goldscheider, "La Sculpture en 1937," in the same publication.

18 James Herbert briefly compares the two exhibitions of 1937 in *Paris 1937: Worlds on Exhibition* (Ithaca, NY: Cornell, 1998), 118–19. There are many books that discuss the *Degenerate Art* show; one good recent work is Olaf Peters, ed., *Degenerate Art: The Attack on Modern Art in Nazi Germany, 1937* (Munich, NY: Prestel, 2014).

19 Olaf Peters, "From Nordau to Hitler: 'Degeneration' and Anti-Modernism between the Fin-de-Siècle and the National Socialist Takeover of Power," in Olaf Peters, ed., *Degenerate Art: The Attack on Modern Art in Nazi Germany, 1937* (Munich, NY: Prestel, 2014), 16–18.

20 Susan Tumarkin Goodman, *Chagall: Love, War, and Exile* (New Haven, CT: Yale University Press, 2013), 54.

21 In *Facing the Abyss: American Literature and Culture in the 1940s* (New York: Columbia University Press, 2018), George Hutchinson argues that American Black, Jewish, and homosexual writers in the 1940s resisted identity politics and sought instead to connect the position of their group with that of humanity at large.

22 See Maurice Samuels, *The Right to Difference: French Universalism and the Jews* (Chicago: University of Chicago Press, 2016), for a stimulating discussion of these issues. Samuels does not discuss artists, but argues that "French universalism has evolved in the modern period largely as a discourse on Jews" (5).

23 Yuri Slezkine makes this argument in *The Jewish Century* (Princeton, NJ: Princeton University Press), 2004.

# Is there Jewish Art?

In 1913, Marc Chagall was a young painter living in the artists' colony known as La Ruche, the beehive-shaped structure at the south edge of Paris that provided cheap studio space for dozens of painters and sculptors. In that year (as it is conventionally dated), he painted *Paris through the Window*, which both

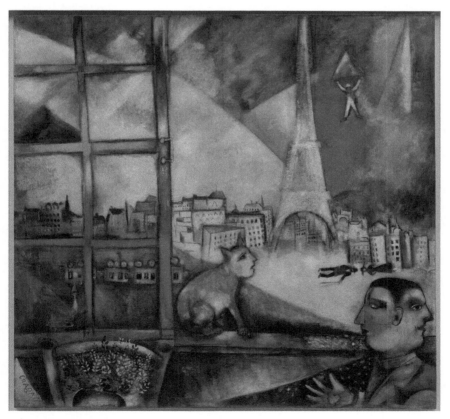

**Figure 1.1** Marc Chagall, *Paris through the Window*, 1913, oil on canvas. P. 37.438, Solomon R. Guggenheim Museum, New York. Solomon R. Guggenheim Founding Collection, By gift. 2021 Artists Rights Society (ARS), New York/ADAGP, Paris.

stylistically and thematically is one of his landmark early works. It features surreal features set against a fragmented background that reflects his knowledge of cubism and Orphism, the latter as practiced by his friends Sonia and Robert Delaunay. The man in the foreground with two different-colored faces is presumably facing east and west, towards Russia and France; the heart in his palm may signify his love for both places. A man is shown parachuting from the Eiffel Tower, while a train runs upside down and a man and woman seem about to collide in mid-air. The parachutist may refer to Franz Reicheit, an Austrian immigrant who jumped to his death from the Eiffel Tower on February 4, 1912, when the wearable parachute that he designed failed to deploy. The event was widely covered in the press, which makes me wonder whether Chagall may have painted it in 1912. Chagall would feature the Eiffel Tower in later works, including himself and his wife Bella in the foreground after she joined him in Paris in 1923. It is doubtful that he could actually see the Eiffel Tower through the window of his shabby studio, but that would be misplaced literalism for a work that the poet Guillaume Apollinaire dubbed *surnaturel* (supernatural). Unlike many of his early paintings, this paean to Paris contained no overt references either to Jews or to Russia.

In 1930, Mané-Katz, another immigrant from the former Russian Empire, painted his own *Homage to Paris*. Seven years younger than Chagall and from Ukraine rather than Belorussia, Mané-Katz also arrived in Paris before World War I. Mané-Katz too celebrated the presence of Jews in the French cityscape, as captured in the Yiddish saying that indicated a country that welcomed Jews: "happy as God in France." Mané-Katz showed a young Jew wearing long sidelocks and with phylacteries—leather straps and case holding sacred texts—wrapped around his forehead, arms raised, a bible in one hand, as if in ecstatic prayer, the Eiffel Tower rising from the background. Here, too, West met East, since such a figure would have been alien even to the assimilated Jews of France, much less to French Catholics. This is likely an autobiographical image, since the artist wore *peyas* or sidelocks when he arrived in Paris in 1913.[1] One can imagine that the Eiffel Tower represented for Jewish immigrants the promise of the French Revolution, since it was built in 1889 to commemorate the revolution's centenary. Jewish artists felt welcomed into republican France at a time (before World War I) when empires still dominated the continent and when discrimination, trials for blood libel, and pogroms remained realities faced by Jews in Eastern Europe.

The symbolism of the Eiffel Tower becomes more poignant when one considers that Chagall featured it prominently again in a work painted over a quarter-century later. In *Bridal Couple of the Eiffel Tower*, painted in 1938–9,

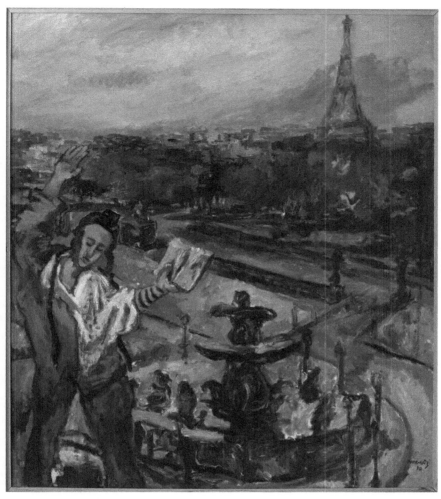

**Figure 1.2** Mané-Katz, *Homage to Paris*, 1930. Mané-Katz Museum, Haifa, Israel. 2021 Artists Rights Society (ARS), New York/ADAGP, Paris.

Chagall posed a joyful bride and groom accompanied by a rooster in front of the tower, now imagined as a site of love.[2] The city of light is also the city of love; Chagall painted *Bridal Couple* to express his love for his adopted city: France had conferred citizenship on Chagall in June 1937. The joy expressed in this painting would not last, as Marc and Bella Chagall would soon have to flee from their adopted homeland and become émigrés once again in 1941. Their fame enabled the Chagalls to escape, along with other prominent Jewish artists of Paris, including Jacques Lipchitz, Ossip Zadkine, Moïse Kisling, Mané-Katz, and Man

Ray. Others, including Chaim Soutine, Louis Marcoussis, and the poet-artist Max Jacob, would die in France during the war; over a hundred Jewish painters and sculptors would die in Nazi gas chambers.[3]

The third of a century between the arrival of young immigrant Jews between 1900 and 1913, and the end of the era in 1940 with the collapse of the Third French Republic in the maelstrom of World War II, would become in retrospect a golden age for Jewish art. French critics claimed that this sudden appearance of Jewish artists was unprecedented and that Jews had previously had no tradition in the plastic arts of painting and sculpture, but this was not true. Since Jewish emancipation had liberated many Jews from sequestration in ghettos and rigid adherence to orthodox religious practice in the late eighteenth and throughout the nineteenth century, there had been an increasing number of Jewish artists practicing their craft throughout Europe. A few had even become notable practitioners of modern painting styles, including Camille Pissarro (1830–1903) in France, Josef Israëls (1824–1911) in the Netherlands, and Max Liebermann (1847–1935) in Germany. Yet these remained relatively isolated examples, and all were notably from Western Europe (Pissarro came from St. Thomas, a Danish colony in the West Indies). A handful of Jews were able to make artistic careers in Eastern Europe, including the sculptor Mark Antokolsky (1840–1902) and Isaac Levitan (1860–1900); their success was truly extraordinary given the restrictions and prejudice they faced.[4] In 1907 in Berlin, an art show billed as the first exhibition of Jewish artists focused on nineteenth-century painters from Poland, Germany, and France. The artists represented were Maurycy Gottlieb, Artur Markowicz, Josef Oppenheimer, Camille Pissarro, and Lesser Ury.[5]

Another emerging Jewish movement at the turn of the twentieth century was Zionism. At the fifth Zionist Congress, held in Basel, Switzerland, in 1901, the young philosopher Martin Buber (1878–1965) lectured on Jewish art and exhibited some contemporary Jewish artists. He argued that art must play a role in Jewish as in other forms of nationalism. Three years later, he received his doctorate in art history and philosophy. In a letter to the Berlin-based artist Lesser Ury (1861–1931), written in 1901, Buber asked, "Is Jewish art possible today?" His rather surprising answer, considering he wrote to a Jewish artist, was no, since Jews had no homeland (later in the letter, he acknowledged that Jewish artists were possible).[6] In 1906, as if to answer Buber's call, Boris Schatz founded the Bezalel Academy of Arts and Design in Jerusalem, named after Bezalel ben Uri, the artist mentioned in Exodus and considered to be the first Jewish artist.[7] In 1908, the eminent Rabbi Abraham Kook helped inaugurate Bezalel,

proclaiming "the renaissance of art and of the Hebraic aesthetic in the land of Israel,"[8] which placed a religious stamp of approval on Jewish representation. Despite Buber's Zionist message, diasporic Jewish art blossomed in the next decade.

Though the phenomenon of Jews who painted and sculpted was not entirely novel, there had been nothing like the appearance, in Paris as well as in London, Vilna, Kraków, Munich, and Jerusalem, of numerous Jewish art students in the decade before World War I, and their emergence as modernists in the interwar era. These artists were mostly born between 1884 and 1894; a younger generation would be born between 1895 and 1911. A few outliers were born in the 1870s, including Otto Freundlich, Leopold Gottlieb, Mela Muter, and Louis Marcoussis. Nearly all the rest saw the light of day from 1884 on, with Amedeo Modigliani at the head of this generation, and Jules Pascin and Sonia Stern (Delaunay-Terk) born the next year in 1885. Chagall was born in 1887, Chana Orloff in 1888, Zadkine in 1890, Lipchitz and Kisling in 1891, and Soutine in 1893. Mané-Katz was the youngest of this cohort, born in 1894, and so only nineteen when he arrived in Paris in 1913.

Modigliani, Pascin, Chagall, Soutine, and Lipchitz are the best known of a very large group of Jews who made their way to Paris between 1905 (1901 in Muter's case, 1903 for Marcoussis) and the 1930s. The catalog of a French show on these Jewish artists lists a total of forty-three names: ten from the Austro-Hungarian Empire, four from the German Empire, twenty-seven from the Russian Empire, and one each from Bulgaria and Italy. One authority on the Ecole de Paris, as the French critic André Warnod designated these artists in 1925, provides short biographies of 178 Jewish painters and sculptors. She estimates that over 500 Jewish artists were working in Paris in the interwar years between 1918 and 1940.[9] With a few exceptions, they lived and worked in one neighborhood, the left-bank artists' colony called Montparnasse. A few, such as Freundlich and Modigliani, started out in the northern Parisian artist colony of Montmartre, and Marcoussis, Halicka, and Pascin maintained studios there throughout this era, but Modigliani was part of the cohort of artists who left Montmartre for Montparnasse around 1910. When Pablo Picasso (1881–1973) left his Montmartre studio in the Bateau Lavoir on the rue Ravignan for a more commodious space across from the Montparnasse Cemetery in 1911, that move signaled that Montmartre's days as the mecca of modernism were over. Many Jewish immigrants to Paris arrived knowing only one phrase in French, "rue des Rosiers," naming the street in the Marais that was the center of Jewish settlement on the right bank, in the fourth arrondissement. Other Jews settled further north

in the eleventh and eighteenth arrondissements, yet virtually all of the Jewish artists forsook the Jewish immigrant neighborhoods and crossed the Seine to the left bank. Montparnasse was located in the fourteenth arrondissement of Paris, to the southwest, hence on the opposite side of Paris from the Jewish quarters in the northeast. Young would-be artists distanced themselves from their co-religionists who settled in the "Pletzl" (little square) of Paris.

When these young artists arrived in Paris, they were not trying to produce an explicitly Jewish style of art out of the traditions of their childhood. Most left behind the limitations of their ethnic-religious origins, intending to absorb everything that Paris had to offer. Like art students who flocked to Paris from all points of the globe, they too wanted to become modern artists, which meant absorbing the lessons of impressionism, neoimpressionism, cubism, fauvism, and all the other schools of modern art that had arisen in Paris since the mid-nineteenth century.[10] They probably did not refer to these styles as "modern," and they certainly did not envision participating in a movement called modernism. The French were more likely to refer to such styles as independent, meaning free from the aegis of the Ecole des Beaux-Arts, the official art style and school sanctioned by the French government. Some immigrant artists studied at the Beaux-Arts, but most did not last long there and the majority headed instead to smaller art academies, many located in Montparnasse, such as the Academies Julian, Grande Chaumière, and Colarossi, or the school that Henri Matisse led from 1908 to 1911, designed especially to appeal to foreign-born art students. In 1884, the impressionists and others excluded from the juried official salon staffed by Beaux-Arts faculty set up the Salon des Indépendants, which remained a major venue for modern art in the 1920s. Independence would have appealed to these young Jews. In Paris, they felt liberated from the expectations and restrictions of family, village, repressive governments, and religious orthodoxy. In Montparnasse, they found a receptive, bohemian, tolerant environment as well as cheap studio space and art schools. They also found fellow Jewish *rapins* (art students) with whom they could converse in Yiddish, Russian, Lithuanian, or Polish.

## Bohemian Montparnasse

Immigrant Jewish artists chose to live in Montparnasse rather than Belleville or the Marais with other newly arrived Jews for several reasons. They aspired to become talented artists in the French style; none of them, not even Chagall,

wanted to be labeled as Jewish artists. They chose socialization within a cosmopolitan artistic community, not an ethnic enclave like the Marais, comprised of artists coming from all over the world to study in Paris. Montparnasse provided not only studio space and art schools but also cafés where for the price of a cup of coffee one could learn about what other artists were doing. All memoirs of the era prominently feature the cafés lining the boulevard Montparnasse: the Dôme, the Select, the Rotonde, and, nearer the Latin Quarter, the Closerie des Lilas. Socializing, what might now be calling "networking," played a vital role not only for young artists learning what others were doing but also in meeting critics and dealers who might help them market their work.

Though artists did not formally join a guild, as they might have in earlier centuries, Montparnasse functioned much like a guild, not in setting prices or determining quality but in establishing bonds of solidarity. When younger artists came upon a more established figure such as Pascin or Modigliani, they could learn and emulate, particularly if the artist was busy sketching on the café's terrace. As they assimilated into the new milieu, their status shifted from that of immigrant, leaving the Pale of Settlement of the Russian Empire with millions of other desperate people seeking a better life and freedom from persecution, to something more ambiguous.

Montparnasse between 1910 and 1940 became the most international artist's colony of all time. While the official Ecole Nationale des Beaux Arts remained 85 percent French, the academies that peppered Montparnasse were overwhelmingly foreign. At the Académie Russe, founded in 1910, those students who were not Russians were likely Germans and Scandinavians. Among the Russians were a large number of Jews: Soutine, Indenbaum, Lipchitz, Nadelman, Orloff, and Zadkine, in addition to Modigliani. The Julian attracted the most Americans, as well as Armenians, Norwegians, Scots, Canadians, Hungarians, Russians, and Japanese.[11] Foreign artists' associations also abounded in Montparnasse: the American Art Association, the Association des Artistes Scandinaves, the Union des Artistes Polonaise en France, and the Union des Artistes Russes.[12] Internationalism rather than a particular artistic style became the predominant characteristic of the interwar avant-garde. When the art critic Harold Rosenberg published an article in *Partisan Review* in 1940, lamenting that "the laboratory of the Twentieth Century has been shut down," he compared the intellectual pioneer spirit of Paris to the economic breakthroughs of the United States, and wrote, "Paris represented the international of culture."[13]

What does this cosmopolitan spirit imply for the self-identity of Jewish immigrants who aspired to become artists? A variety of related terms with

varying implications signifies a transnational identity: cosmopolitan, immigrant, émigré, exile, expatriate, and foreigner. Montparnasse also sheltered the American expatriates escaping from Prohibition-era America, yet they could readily repatriate, which they mostly did when the "Roaring Twenties" ended. Some Jewish art students returned to their home countries after studying in Paris, but the vast majority of those from Poland, Romania and Russia did not. Émigrés consider themselves temporary residents forced out by political upheaval, who hope to return to their homeland with the restoration of the status quo ante, like the 45,000 "white" (anti-communist) Russians who fled the Bolshevik Revolution and settled in Paris in the 1920s. The Jewish artists remained temporary residents or visitors, residing in France thanks to the toleration of the immigration officials and the police until they could attain naturalization papers. They learned French and many became French, at least until the collaborationist Vichy government redefined the boundaries between foreigner and French national in 1940–1. Aside from issues of legality, the status of artist in a country that valued creative production meant that the immigrant artist was already different from an immigrant hat-maker or furrier. If not quite an intellectual, the artist in the twentieth century was also not a laborer or worker. Artists belonged to the guild of symbol generators, heirs of clerics who were valued because they could elevate the human spirit.

There is another way in which Montparnasse detached immigrant Jews from both ethnic and class-based categories that would have been applied to most of the newcomers living on the right bank. Many of the young artists living in artistic warrens located at the Cité Falguière and La Ruche were poor, but bohemianism transformed indigence, if it did not entirely efface it. They were the heirs of the bohemians of the Latin Quarter described and sometimes romanticized in the nineteenth century by Henri Murger, in *Scenes of Bohemian Life* (1851), subsequently further idealized by Giacomo Puccini in the 1896 opera *La Bohème*. Bohemians may well be *déclassé*, implying they came from bourgeois backgrounds before "dropping out," and many of the Jewish artists did derive from middle-class families. Whether or not they were literally "starving artists," their choice of vocation placed them outside normal class-based status systems. Their incomes may have placed them below hatters, but artistry elevated them to a more ambiguous but aspirational status. This was particularly true when they were young; bohemians of the Latin Quarter had always associated with students, who shared a provisional status. Hatters would remain poor; artists, like actors working as waiters in restaurants, lived in a liminal world that tolerated and even encouraged unconventional behavior, including inebriation,

sexual freedom, and irregular hours, in the name of creativity. Montparnasse provided a subculture in which Jewish immigrants could transform themselves into something else—modern artists.

Mention of the nineteenth-century antecedents of the Jewish generation of the 1880s and 1890s underscores that this process of bohemian acculturation was not new. In 1889, the year that the Moulin Rouge opened and tourists flocked to Paris for the International Exposition of that year, a young Jewish art student named William Rothenstein (1872–1945) arrived in Paris from London to study at the Académie Julian. He soon moved to a studio in Montmartre, on the rue Ravignan (the same street to which Picasso would move fifteen years later), which he shared with an Australian painter named Charles Conder, who was a friend of Henri de Toulouse-Lautrec. Rothenstein also noted an international body of art students at Julian, which at that point was located in the Faubourg St. Denis, not far from Montmartre. It later opened a branch on the rue Dragon in Montparnasse. Rothenstein felt shy among the French students and his limited French kept him in an Anglo-American orbit. He noted, "Frenchmen are generous in the appreciation of any sign of promise in a foreigner, perhaps because they fear no rivals ... the promiscuity of the studios brought me into contact with several among the French students."[14] Despite the large number of foreign students, French artists reigned supreme, and nearly all the art instructors were French (he might have encountered the American James McNeill Whistler).

Rothenstein returned to England and an eventual knighthood for his contributions to British art, which sets him apart from his co-religionists of the next generation. The dynamic in which French artists confidently asserted their supremacy would also shift after the turn of the century. For every Matisse and Léger there would be a Picasso and Chagall, for Rodin and Maillol an Archipenko, Brancusi, and Lipchitz. Modernist experimentation increasingly came to, not from, France.

## An Age of Jewish Immigrants

When Rothenstein arrived in Paris in 1889, he may have noticed active and growing currents of French antisemitism. Three years before, in 1886, the journalist Edouard Drumont had published *La France juive*, Jewish France, which attacked Jewish financial and banking interests for undermining the nation, in particular the crash of the Union Générale Bank in 1882. The

remarkable success of this scurrilous work (it would go through 150 editions in its first year of publication) led Drumont to publish the newspaper *La Libre Parole* in 1892, which focused initially on the Panama Canal scandal, also involving Jewish financiers, before being handed the gift of the Dreyfus Affair at the end of 1894.[15] The affair concerned the army officer Captain Alfred Dreyfus (1859–1935), sole Jew on the French General Staff, convicted of espionage on trumped up evidence and sent to endure solitary confinement on Devil's Island, off the coast of French Guiana, in 1895. The vituperation hurled at Dreyfus shocked the highly assimilated correspondent for the Viennese newspaper the *Neue Freie Presse*, leading Theodor Herzl to write a pamphlet called *Der Judenstaat*, calling for a Jewish state. If modern Zionism did not begin in France in the 1890s, it accelerated there.[16] Assimilated Western European Jews had thought that republican France was nothing like Tsarist Russia. Antisemitic riots were even worse in French Algeria, which had a Jewish minority roughly the same size as on the French mainland, and which unlike the Muslim majority enjoyed French voting rights. President Loubet pardoned Dreyfus after a second military trial in 1899 failed to exonerate him, and the army reinstated Dreyfus in 1906.

Most Eastern Jews were not dismayed by the Dreyfus Affair. Accusations of blood libel they could understand; the furor over a Jewish army officer would have been unthinkable in the tsar's army, since no Jews attained that status. The period from 1906 to 1918 has been called a golden age for French Jewry,[17] when the assimilated and mostly middle-class French Jewish population, who called themselves *Israélites* rather than *juifs* (Israelites rather than Jews), were not yet threatened by large numbers of poor Jewish immigrants from the East. Over two million Jews fled from tsarist Russia in the three decades after 1881 and the assassination of Tsar Alexander II; only 30,000 came to France before 1914. Despite Drumont's exaggerated fears, there were only about 100,000 Jews in France at the start of World War I in a population of 38 million. This number would triple during the interwar years.

It is not difficult to explain why so many young Jews flocked to Paris in the early years of the twentieth century. The Third French Republic, heir to the Enlightenment and universalistic traditions of the French Revolution and still the only major republic in Europe before 1914, promised a kind of toleration not available in Eastern Europe. The Russian Empire still confined Jews to the Pale of Settlement, and Jews could only reside in Moscow or St. Petersburg with special dispensation. Paris was the home not only of the art displayed in the Louvre but also of all the newest aesthetic currents. Art teachers told their young

Jewish art students that they must go to Paris to become real artists. Young Jews who emigrated to America would blaze new ground in other cultural fields, creating Tin Pan Alley in New York, and Hollywood in Los Angeles. Marginality and the experience of liberation in the West predisposed Jews born in the last quarter of the nineteenth century to occupy new cultural spaces. The question to pose is not what drove young Jews liberated from the restrictions of the shtetls (villages) of Eastern Europe to become artists, but rather what distinguished their creations from those of the many other young artists from France and elsewhere. Was there anything distinctly Jewish about their art that reflected their religious or ethnic identity?

Answering this question requires understanding what it meant to be Jewish at the turn of the century. Judaism is one of the great monotheistic faiths of the Western world, along with Christianity and Islam, and though it predates the other faiths, numerically it is and was much smaller. While there are over a billion adherents each of the Catholic and Muslim faiths and several hundred million Protestant Christians, Jews have never even numbered twenty million. At the turn of the century there may have been nine million Jews in Europe, most still living in the East, and twelve million Jews overall. Unlike other faiths, Jews have refused to proselytize. With the possible exception of the medieval state of the Khazars on the Russian steppe, Jews in post-biblical times did not have their own polity until the creation of Israel in 1948. Since the destruction of the second temple by the Romans after the Jewish revolt of 70 CE in Roman Palestine, Jews have been dispersed around the world, in cities from Rome and Damascus to Baghdad and eventually to Moorish Spain and throughout Europe, with small pockets in such outlying places as Ethiopia, India, and China.

Diaspora, from the Greek word meaning scattering or dispersion, meant that for nearly two millennia the Jews lacked a homeland. The word diaspora was itself ancient, arising in the third century BCE to refer to the Jewish community of Alexandria.[18] The rise of Jewish artists in France occurred in the Diaspora but coincided with a Zionist movement that sought to reclaim a nation of their own. In a minority everywhere, Jews registered the largest percentage of the overall population in Poland at around 10 percent. The early modern rulers of the Polish-Lithuanian Commonwealth welcomed Jews expelled from Western and Central Europe. When Russia conquered Poland and Lithuania in the late eighteenth century, the Jews became subjects of the Russian tsars but remained in their traditional area of habitation, known as the Pale of Settlement. After the assassination of Tsar Alexander II in 1881 by members of the revolutionary group, *Narodnaya Volya* or People's Will, which included some disaffected young

Jews, attacks on Jews, called pogroms, became common. The tsarist government actively encouraged some pogroms. Jews dissatisfied with their deteriorating status developed three options in response: emigration, Zionism (which involved emigration to Palestine as opposed to the West), or further revolutionary activity designed to topple the repressive government.[19]

None of these options necessarily involved intense religiosity, and revolution-minded socialists and anarchists explicitly opposed religion. Whether or not Jewish immigrants or Zionists were religious, they possessed Jewish ethnic and cultural traits; the same was true of political radicals who repudiated religious belief. This underscores that Judaism is more than a religion. At the turn of the century under the pervasive influence of Social Darwinism, many considered Jews to be a race, but Jews are better understood as a distinct ethnicity marked by a shared culture. One of those commonalities is the Diaspora, which gave rise to the wandering Jew motif of the people without a homeland. Jewishness can be difficult to identify unless one perceives it as a cultural complex based on a variety of factors that include but transcend religion. The most notable features of Jewish culture were the high valuation placed on literacy and scholarship, and the economic role of Jews as middlemen and merchants existing in peasant cultures in which Jews were forbidden to own land. These roles enabled Jews to succeed in capitalist societies, where they acquired skills that allowed them to enter the middle class. This social transformation happened at the same time that a small minority of Jewish emigrants sought alternative opportunities in the arts. Ashkenazi Jews also maintained their cultural distinctiveness by speaking their own language, Yiddish (Sephardic Jews spoke Ladino), living in distinct neighborhoods, towns, and regions, obeying kosher dietary laws, and marrying endogenously. While most Jews preserved some sense of separateness in their new emigrant communities, Jewish artists did not, preferring to live among other artists. This also led many to marry outside their faith.

## Jewish Art and the Critics

Whether something Jewish inhered in the art created by Jewish immigrant artists in France depends on what one means by Jewishness. Most interwar critics and the artists themselves would have answered that there were Jewish artists but not Jewish art, because no unitary style predominated among the hundreds of Jews practicing art in Montparnasse. As late as 1944, the émigré Jewish art historian Richard Krautheimer (1897–1994), who had

been asked to direct the new Jewish Museum being established in New York City, wrote:

> The difficulty of such a scheme lies in the limited amount of material available. It lies even more in the fact that the quality of Jewish art is rarely so outstanding in itself as to make it an object of purely aesthetic interest ... Jewish art is to a large extent folk art and its position in the life of the Jewish community resembles very much the position of art in the life of colonial America: rarely outstanding and never on a pedestal, yet part of the community's religious and daily life.[20]

Professor Krautheimer may have been thinking primarily in terms of ritual objects; still, his dismissal of Jewish art at a time when New York was replete with émigré Jewish artists, not to mention such American Jewish artists as Ben Shahn and Raphael Soyer, suggests a serious gap in recognition.

The title of this chapter was borrowed from a tongue-in-cheek talk given by the art critic Harold Rosenberg at the Jewish Museum in New York and published in *Commentary* in 1966, titled "Is There a Jewish Art?" Here is what Rosenberg said (it would help to add a Jewish inflection):

> Is there a Jewish art? They build a Jewish museum, then ask, is there a Jewish art? Jews! As to the question itself, there is a Gentile answer and a Jewish answer. The Gentile answer is: Yes, there is a Jewish art, and No, there is no Jewish art. The Jewish answer is: What do you mean by Jewish art? Needless to say, the Gentile answer, either way, is anti-Semitic.[21]

Rosenberg pointed to the uncertainty of what Jewish art might mean, and implied that Jews favored ambiguity whereas Gentiles sought straightforward answers. He provided a range of possible answers to his question, from Jews who make art, to art that depicts Jews or contains Jewish subject matter, to Jewish handicrafts used for ritual purposes, such as menorahs or goblets, on to metaphysical art that has some sort of Jewish essence, such as the abstract art of Mark Rothko or Barnett Newman.

Rosenberg also addressed the second biblical commandment against graven images, which was frequently raised when French critics confronted the sudden upsurge in Jewish artists in their midst. Rosenberg's theory was that in a biblical world of miracles—his example was burning bushes—human fabrications were a distraction:

> If you inhabit a sacred world you find art rather than make it ... When the mind of the people is loaded with magical objects and events, which unfortunately cannot be assembled physically, what is there for artists to do but make cups for

ceremonial drinking and ornaments for the Torah? ... Jewish art, then, may exist in the negative sense of creating objects in the mind and banning physical works of art. In this sense, the Second Commandment was the manifesto of Jewish art.[22]

This clever rejoinder responded to the many critics who dismissed Jewish art as lacking any tradition due to the religious injunction against graven images, and who imagined that a conspiracy by Jewish dealers and critics was foisting unworthy art on a credulous public. Instead, Rosenberg saw mercurial Jewish artists as continually engaged in a search for identity in a rapidly changing world.

Rosenberg may have identified the dialectical quality of Jewish thought, in which one answers one question by raising another, but he did not resolve the issue of what, if anything, made Jewish art unique. This question perplexed observers in the 1920s when the phenomenal upsurge in the number of immigrant Jewish artists was undeniable. The fallback position—that Jewish art was simply that made by Jews, without any particular characteristics that bore on Jewish identity—could be maintained by philosemitic critics such as André Warnod, who coined the neutral term Ecole de Paris to include all the foreign-born artists of Montparnasse, and affirmed by Jacques Biélinky (1881–1943), the immigrant Jewish art critic for *L'Univers Israélite*. Biélinky had been in France since 1909 and represented the mainstream Alliance Israélite Universelle, created by assimilated French Jews in 1860. Fascinated by the phenomenon, Biélinky enumerated the Jewish artists, both domestic and foreign, showing at the various Parisian salons. A long article from September 1924 told of all the Jews from Russia, Romania, and Poland who faced increasing difficulty in finding affordable lodging and studio space as Montparnasse rents rose in response to the boom caused by the foreign invasion, in particular by affluent Americans and Canadians. Adding to their difficulties was the decline in German and Austrian dealers, who had visited Paris annually before the war but no longer did so. Some Jewish artists showed their art collectively at the café Parnasse; others even went up to such folkloric venues as the Foire aux Croûtes in Montmartre.[23] Seven years later, Biélinky counted 301 Jewish painters and sculptors showing at six salons in 1930, some of them French Jews but the majority foreign born. Since many Jewish artists did not show at the salons, this number was not comprehensive. He identified foreign artists as based in Montparnasse, unlike the native French Jewish artists. He summarized that "the diversity of origin and of teaching of most of the Jewish artists of today makes impossible the constitution of a Jewish school of modern art, but it is our duty to underline that

the specifically Jewish temperament carries to modern art a contribution of value, a contribution rich in dynamic forms indicative of a flourishing future."[24] Biélinky refused to separate French-born from foreign Jews, and wrote extensively about artists such as Léopold Lévy and Maxa Nordau (daughter of the Zionist leader Max Nordau). Since none of the French-born Jewish artists would achieve the level of fame of the best-known foreign Jews, this suggests that life in cosmopolitan and bohemian Montparnasse and the cultural adjustment needed for those living between two worlds fed the brilliance of immigrant artists.

Another commentator in *L'Univers Israélite* raised the question of whether Jewish art existed. Joseph Milbauer wrote specifically in response to the antisemitic diatribes of Camille Mauclair, art critic for *Le Figaro*, who published the first volume of *La Farce de l'art vivant* (The Farce of Living Art) in 1929. Milbauer wrote that everyone was discussing Mauclair, even those who had only a passing acquaintance with his writing acquired in the cafés of Montparnasse. Some affirmed the existence of Jewish art, citing a host of names of Jewish artists, whose ethnic qualities they vaunted; no said others, asking "what are the characteristics of a Jewish art, what society does it reflect? Others pretend that art internationalizes itself, that Jewish artists would be unpardonable for holding themselves apart from the movement in favor of particularism."[25] Milbauer defended Jewish artists from the accusation that there were no Jewish Titians or Van Eycks, at a time when most Jews lived in dank ghettos; the corollary was that Jewish artists were equivalent to nouveaux riches who lacked the taste that came with artistic tradition. Jewish artists had only existed since emancipation, and had not yet developed a Jewish style of painting in the brief century in which they had access to air, light, and freedom. The conflict between these artists and their critics was similar to the old conflict between the ancients and the moderns, and had become heated because issues extraneous to art had envenomed it. Responding to Mauclair, Milbauer said that Jews had brought to art only their temperament. They had had to make up five centuries of painting in a few short years, and one should "render homage to these sons of Israel who have proved to the world that Jews know, they too, how to create beauty."[26] This even-handed response to the many critics of Jewish art recognized that this was a new phenomenon worthy of praise, but that it was too soon to conclude that these artists had anything in common beyond the vague term "temperament."

When André Warnod introduced the term L'Ecole de Paris in the January 27, 1925 issue of *Comoedia*, an arts newspaper, he mentioned many artists by name but never singled out Jews. He did, however, compare Montparnasse to a ghetto

and said it was no wonder that so many foreigners saw Paris as the "promised land" of painters and sculptors. These code words may have alerted the reader that Chagall, Pascin, Modigliani, Marcoussis, Kisling, Lipchitz, and Zadkine, all of whom Warnod cited, were Jews. The only qualities Warnod positively asserted of this new school was its internationalism and its independence from academicism. He defined it as a school of liberty. A more ideological response was not long in coming that summer and fall in the literary journal *Mercure de France*. In July, Fritz Vanderpyl asked, "Does a Jewish Painting Exist?" He cited earlier Jewish artists such as Camille Pissarro, Lucien Lévy-Dhurmer, and Josef Israëls, and sneered that the "Lévys" were everywhere. The explanation seemed obvious: in an era of rampant speculation, including in art, Jews entered the art market with their typical enthusiasm. Since modern art no longer required patience, it was ideally suited for making a quick fortune. Further, since modern art encouraged deformation, Jews excelled since "they are the melancholy seekers of the truth, skeptical judge of the established order, pitiless hangmen."[27] He did cite some Jewish artists of talent, but said there was no trace of Jewishness in the art of Jules Pascin or Eugène Zak. He called Moïse Kisling the first artist who deserved the title "peintre juif," which is ironic in that Kisling himself saw neither Polish nor Jewish elements in his work, and believed he was formed wholly in Paris.[28]

The month following the publication of Vanderpyl's article a more thoughtful piece in the same journal attested to the interest aroused by the new phenomenon. Pierre Jaccard considered "Greek Art and Hebrew Spiritualism in relation to Jewish Painting." Jaccard claimed to enlarge the discussion by arguing that the Jewish "race" had always lacked a plastic sensibility: "Israel is the sole race in the world which has left no trace of artistic activity whatever in the plastic domain."[29] The ghettos of Venice and Amsterdam were teeming with Jews, yet the Louvre possessed no important work signed by a Jew. Jews may be masters of the art market but had never created anything. Jaccard cited the prohibition against images, and then argued that this was merely a legalized expression of a deeper psychological incapacity to represent forms and colors that characterized all Semites, not just Jews. That is why the Greeks mastered impersonal art while the Hebrews produced only music and poetry. The suffering of the Hebrew people reinforced a tendency toward individualism and subjectivity. For this contrast between Semites and Hellenes the author cited the nineteenth-century French thinker Ernest Renan. The Semitic temperament led to an absence of curiosity regarding material objects and an incapacity to represent them. We should be satisfied that the Jews gave us monotheism and universalism, he argued, and

should not expect them to excel in art. Christian art did not derive from the religion's Jewish origins, but was instead a pagan survival.

Adolphe Basler also contributed an article to *Mercure de France* with the title "Is there a Jewish Painting?",[30] but since Basler (1878–1949) was himself a Jewish immigrant from Kraków who had come to France in 1898, one would expect him to conduct a vigorous defense of the Jewish capacity for art.[31]

Unfortunately, Basler was poorly suited for this task, for though he knew some of the artists of Montparnasse personally, he was not sympathetic to their accomplishments. He downplayed Jewish ethnicity, and saw instead an admirable capacity for assimilation. Once emancipated from religious strictures, Jews had been able to make the same strides in art as they had in science. The Polish-born artists KIsling, Mondzain, Zak, Marcoussis, and Menkès showed no ethnic particularity; the epoch, not the race, counted.[32] He had mostly harsh words to say about the Jewish sculptors Lipchitz, Zadkine, and Orloff, none of whom were Poles. Basler agreed with the other critics of Jewish art that Jews had a penchant for ideas, and thus tended to approach art as problems to solve. He concluded his article with a striking proof that Jews approached art abstractly. He reported that Picasso once asked him if "you see something Jewish in my painting," to which Basler replied that "all your cubism is only the Talmud." Then he asked himself, "Is it due to distant Jewish origins or an Arab atavism that Picasso owes that too subjective art?"[33] Basler thus concluded that Picasso was the most Jewish, because the most abstract and speculative, of the artists of Montparnasse. Nor was he unique in concluding that Picasso exemplified Jewish art. At least two other critics, the psychoanalytically informed French critic Germain Bazin and the Polish Jewish immigrant critic Waldemar George, also made frequent references to Picasso's Jewish blood. Bazin cited Picasso's nomadic soul; George thought he typified modern anxiety.[34] Picasso's biographer John Richardson has suggested that Picasso's maternal grandmother may have been a *converso* or hidden Spanish Jew, but unless one takes racial theory seriously that hardly makes Picasso Jewish.[35]

## The Context of Jewish Thought

What does the fact that several contemporary critics assumed that a Spanish artist was Jewish, and that his work exemplified certain Jewish traits, imply? Picasso was the most important modernist of the era, and by the 1930s, when Bazin and George were writing, had also become politically involved with the

left (though he did not join the Communist Party until 1944).[36] Jews represented a minority of modern artists despite their growing numbers, and few of them were Sephardic Jews with roots in Spain, though the fame of Camille Pissarro may have obfuscated this reality. Modigliani and Pascin were Sephardic Jews, both long removed from their Spanish origins; Diego Rivera also claimed Jewish connections through his mother. However, these critics were not conflating Picasso with other Sepharads; instead, they were placing Picasso in a constellation of abstract Jewish thinkers who were closely associated with the latest trends in modernity. East of the Rhine one might have included Karl Marx as a harbinger of modernity, but more up-to-date names in the 1920s would have been those of the physicist Albert Einstein and the psychoanalyst Sigmund Freud. Winning the Nobel Prize in 1922 made Einstein the most famous scientist in the world, while the French were translating Freud's works in the 1920s. As many Jewish artists were assumed to be concerned with expressing the sort of interiority theorized by Freud (Jewish surrealists, including Man Ray, Marcel Janco, Meret Oppenheim, and Victor Brauner, openly acknowledged Freud's influence), so Picasso was perceived to be experimenting with space in ways analogous to Einstein's conception of relative space-time.[37] Numerous commentators have found it irresistible to relate Einstein's 1905 papers setting forth the special theory of relativity to Picasso's experiments with cubism two years later. They have expended much effort in revealing that among *la bande à Picasso* was a mathematician named Maurice Princet who explained non-Euclidean geometry to his artist friends, mostly as distilled from the French polymath Henri Poincaré.[38] Princet may have also influenced the Delaunays a little later, and wrote the catalog preface for Robert Delaunay's 1912 exhibition at the Galerie Barbazanges.[39] What this suggests is not that Picasso or Delaunay were crypto-Jews (though Delaunay married a Jew, Sonia Terk), but rather that some of the same intellectual tendencies that led some high-profile Jewish thinkers of the period to be identified with the most modern trends in thought also characterized Jewish artists.

Closer to home than Freud or Einstein, the Jewish-French philosopher Henri Bergson personalized time in a way that challenged the formerly fixed categories of space and time. Bergson aroused the ire of a defender of these categories, the essayist Julien Benda, who was also a French Jew.[40] The critics who assumed with little or no evidence that Picasso was Jewish were using him to signify that some of the most disturbing and challenging aspects of modern culture were perceived to be Jewish. Much as cubist canvases exposed different perspectives simultaneously, and destroyed the distinction of foreground and background by

employing positive negative space, so Freud and Einstein upset the distinction between past and present, as between space and time. A relativistic world deeply troubled many, who instead found comfort in timeless neoclassical truths and a "return to order" announced at the end of the Great War by the Parisian cultural arbiter Jean Cocteau.

Some critics resolved Jewish artistic identity by claiming that most Jews were expressionists, or "Express-Sionistes" (Express-Zionists) as Adolphe Basler punned in his 1926 book on the current art scene.[41] Few German expressionists were Jewish, but in France the movement was seen as alien and hence appropriate for Jews.[42] Among the artists of Paris, the arch-expressionist was Chaim Soutine, the very incarnation of the tormented *peintre maudit* (accursed painter). The Litvak (Jews from Lithuania) painters Pincus Krémègne and Michel Kikoïne were classified this way, as was the Polish painter Mela Muter. All used thick impasto reminiscent of Van Gogh, founding father of expressionism. Some critics called Chagall an expressionist, yet his style and paint handling was nothing like Soutine's, while other painters and sculptors aligned themselves with cubism. In 1945, the critic Bernard Dorival reduced the Ecole de Paris to Jewish expressionists marked by pessimism, spiritual disquietude, and intellectualism, none of which terms fit Chagall or Kisling.[43]

One approach that will not work in characterizing this generation of artists is to identify a Jewish spirituality that rejected the natural world and sought some higher transcendence. Some of the expressionists, such as the Swiss Paul Klee, the German Franz Marc, and Wassily Kandinsky, a Russian artist working in Germany, exemplified the use of art to achieve a spiritual dimension. Because Kandinsky correlated his search for aesthetic spirituality with abstraction, and painted some of the first non-representational works in 1910–11, the spiritual was equated with the abstract and immaterial.

German Jewish philosophers Martin Buber and Franz Rosenzweig influenced Kandinsky and Klee, but it is difficult to correlate Jewish philosophy and Jewish art.[44] After World War II, Jewish artists such as Mark Rothko (born Marcus Rotkovitch in Russia in 1903; his family came to the U.S. in 1913) who did engage in fully abstract art were seen as exemplifying Jewish aniconism, and Rothko was inclined to interpret his own work spiritually.[45] Yet neither aniconism nor transcendence are relevant categories in relation to the Ecole de Paris artists. If the prohibition against graven images meant anything, it should have proscribed sculpture in particular as approximating idols, yet there were dozens of Jewish sculptors working in Paris. Nor did many of these artists appear to be deeply religious. The fact that they emigrated to the secular West, represented by

hedonist and materialist France, suggests that religiosity was not high on their list of priorities. Hasidic Judaism influenced Chagall, but that heritage increased his distrust of intellectualism and grounded him in the joyful exuberance expressed in much of his iconology.[46]

If heterogeneity and cosmopolitanism are the principal markers of these artists, does that mean that after all there were only diverse Jewish artists developing their unique talents and pursuing their own artistic vision? Further, has the Ecole de Paris deservedly been marginalized by art historians and curators fixated on modernists and their manifestos? In order to appreciate the achievement of the artists born in the 1880s and 1890s, and to assess their contributions to modernism, one must situate them beyond the confines of art history. When they arrived in Paris, they picked up different approaches to art that mirrored the amazing profusion of styles. These differing versions of modernism distinguished the artists from each other, yet something about their Jewish immigrant experience remained to connect them. To understand those connections, one needs to place these artists in the context not of Jewish religious philosophy but rather in terms of Jewish secular thought. I have already referred briefly to Einstein, Freud, and Bergson, who revolutionized the fields of physics, psychology, and philosophy in the first third of the twentieth century. To a significant degree, modern thought did have a Jewish ambience, which is why anti-modernists like the Nazis condemned it as such, and why critics may have assumed that Picasso must have been Jewish. Jewish thinkers were enjoying the same air of emancipation that invigorated the artists, and yet remained marginalized from the mainstream of society and academic advancement, so that in order to achieve recognition they had to think in unconventional and even revolutionary ways. That explains why psychoanalysis in Vienna was almost entirely the domain of Jewish physicians, and why Freud did not receive a university chair until he was nearly fifty.

These Jewish *maîtres à penser* related to the artists of their own era in the way they redefined the relationship between space and time. Many of these artists were involved either consciously or unconsciously in rethinking these fundamental categories in the terms set forth by Einstein, Freud, and Bergson. For the Ashkenazi Jews, the contrast in their own lives between their experiences in the East and then in the West helped concretize differences in space and time. Jewish art was overdetermined by modern understanding of the psyche, the mind, and the universe. An internal history of art will not suffice to identify the sensibility shared by these artists, and referring to a "Jewish temperament" begs the question. By contextualizing their art in terms of the Jewish thought that

helped define modernity, we may have more success at identifying what Jewish artists may have shared, while acknowledging that non-Jewish artists were also translating these new modes of thought into art.

A remarkable array of Jewish thinkers was preoccupied with understanding the temporal dimension in new ways between 1889, when Henri Bergson published his dissertation, *Time and Free Will*, and 1933, when his disciple Eugène Minkowski adapted the ideas of Bergson and another Jewish philosopher, Edmund Husserl, to psychology in his book *Lived Time*. In the first decades of the twentieth century, two French Jewish social scientists, Emile Durkheim and his nephew, Marcel Mauss, analyzed time as a social construct in both modern and primitive societies. In the German-speaking world, in addition to Husserl, Sigmund Freud perceived the recovery of the buried individual past to be the key to one's present mental health. Probably the greatest of all intellectual transformations ensued from the four papers that Albert Einstein published in 1905, while working in the patent office in Bern, Switzerland, known as special relativity, and which culminated in the general relativity theory that appeared a decade later. The path-breaking ideas of these thinkers did not only affect Jews, nor is it likely that immigrant Jewish artists were reading Husserl or Einstein in their studios at La Ruche. What I am suggesting is that the remarkable range, from physics and philosophy to sociology and psychology, of ideas all grappling with new ways of understanding time suggests that something fundamental was occurring, and that it was not simply a coincidence that Jewish thinkers played a major role in reconceptualizing time. Unlike the intellectuals cited above, but quite similar to the Jewish artists, Minkowski (1885–1972) was born in St. Petersburg, Russia, to parents of Lithuanian origin, and migrated to Paris. He was born the same year as Sonia Stern, who became Sonia Delaunay-Terk and who was raised in St. Petersburg as well. Sonia and her French husband Robert Delaunay were the central figures in an artistic movement called simultaneism, whose very name suggested temporality. Whereas cubism was a name bequeathed to Picasso and company by a hostile critic, simultaneism was what the Delaunays chose to call their own art.

The other inescapable aspect that these figures (with the possible exception of Einstein) have in common is their concern for the subjective self. There were indeed early psychologists who were not Jews, and it has been argued that too much attention has been paid to Freud and Jung (the latter figure was famously not Jewish—Freud saw Jung as his entrée into the Gentile world), and not enough to Charcot, Janet, and James, and to Vienna rather than Paris.[47] Nevertheless, Freud above all the rest connected one's personal past with the psyche, and

idealized the artist as one who instead of repressing childhood memories could sublimate them into art. For Bergson, one's interior sense of time was synonymous with life itself, and was irrational, yet he distrusted Freud's method of bringing the unconscious self into consciousness. This Jewish focus on the interior self, on the past flowing into the present, and on the relationship between time and space has a number of interesting implications for the Jewish artists of Paris. While they participated in the modernism they found in Paris, these psychological and temporal orientations may have made them less likely to be preoccupied with the avant-garde adage (stated emphatically by Ezra Pound) to "make it new." Most had too much respect for the past on display in the Louvre, which even those deemed most radical, like Chaim Soutine, visited often for inspiration. It may be significant that the Jews who were involved in the avant-garde movements of dada and surrealism, such as Tristan Tzara and Man Ray, changed their names and suppressed their Jewish origins in an effort to escape or efface the past.

One other important Jewish modernist was obsessed by time, but she expressed this in writing rather than painting. Gertrude Stein patronized and befriended many artists in her Montparnasse home and salon, while creating fiction as modernist as the Picasso and Matisse paintings that adorned her home. Stein wrote in 1926, "So then I as a contemporary creating the composition in the beginning was groping toward a continuous present, a using everything a beginning again and again and then everything being alike then everything very simply everything was naturally simply different . . ."[48] The repetition that makes reading Stein's prose so challenging called attention to her compositional strategy, tending to obscure its content. Her insistent style rendered time palpable, as *the* theme of the modernist artist. Stein's significant presence in interwar Montparnasse made her influential beyond her own artwork. Both Jewish and Gentile artists came within her ambit; Jacques Lipchitz sculpted her head in 1920, long after Picasso painted her portrait. "Now there is still something else the time-sense in the composition. This is what is always a fear a doubt and a judgement and a conviction. The quality in the creation of expression the quality in a composition that makes it go dead just after it has been made is very troublesome."[49] One would not be overstating the case to say that Gertrude Stein was obsessed by time.

## The Visual and Other Senses

The dominance of the visual sense over the other senses has emerged as a hallmark of the modern era since the Renaissance. Ocularcentrism, or in its

philosophical guise Cartesian perspectivalism, is equated with the rise of print culture in the fifteenth century, which led to reading with the eyes rather than sounding out words with the mouth, and the dominance of vision over hearing. That in turn was one factor leading to the Protestant Reformation, which valued Bible reading over the intercession of priests and led to a wave of iconoclasm as whitewashed walls replaced sacred images and relics. At roughly the same time that Gutenberg discovered moveable type in northern Europe, Brunelleschi helped create three-dimensional rationalized space in Italian painting.[50] Later, in the seventeenth century, the French philosopher René Descartes reproduced a seemingly more accurate version of reality in two dimensions through an epistemological model based on visual representations of the outer world occupying the human mind. The seventeenth-century scientific revolution reinforced the sense of an objective natural world based on regular laws understood rationally. The visual sense both separated and connected humans to nature. Visuality emerged as dominant, at least in the West, in the early modern era, and contributed to European expansion to dominate the globe through commerce, capitalism, and technology. Perhaps the best shorthand way of understanding this achievement as based on the visual is to think of the rise to power and wealth of the Dutch in the seventeenth century. Their merchant marine brought them wealth, their Calvinist faith, piety and independence from Hapsburg Spain, and their art in the age of Rembrandt and Vermeer cultural supremacy based on the "art of describing."[51] Dutch art as well as Dutch capitalism mastered reality.

If the "crisis of the *ancien* scopic regime," that is, the questioning of this sensory hierarchy, can be dated to the late nineteenth and the twentieth centuries, the key figure who raised the alarm about its costs was Henri Bergson (1859–1941). We no longer remember Bergson's name like those of his contemporaries Freud and Einstein, but in the first decade of the twentieth century he was more famous than either of them. Bergson packed auditoriums in Paris and elsewhere with eager listeners. A professor with a chair at the elite Collège de France, an institution which provides a public profile to French intellectuals, who despite his Jewish background entered the Académie Française, Bergson went on to win the Nobel Prize in literature in 1927, and the highest category of the French Legion of Honor in 1930. His father was a Polish Jew and a pianist, which is significant given Bergson's "denigration of vision" and the Jewish penchant for music.[52] The best man at his wedding was Marcel Proust, a cousin of his wife (Katherine Levison, descended from Irish and British Jews), also significant in that Proust's multi-part novel *La Recherche du Temps Perdu* (In Search of Lost

Time, or Remembrance of Things Past), published between 1913 and 1927, is often seen as a literary offshoot of Bergson's philosophy. From the publication of his doctoral dissertation as *Time and Free Will* in 1889 to *Creative Evolution* in 1907 and for the next decade, Bergsonism was all the rage. The English intellectual and aesthete T. E. Hulme was a follower until Bergson spoke in London in 1910 and crowds of fashionably dressed women showed up; Hulme thought this popularity cheapened his idol and tainted him with feminism, then at its militant height in England. The right-wing leader Charles Maurras, who opposed Bergson's entry into the Académie Française because of his religion, called Bergson's philosophy "feminine romanticism," regarding it as the inverse of his own Latin classicism.[53] Though Bergson, with his awards and academic chair, was a mainstream figure, his ideas remained controversial and were attacked by Julien Benda in *Belphégor*, published just as Bergson entered the French Academy, and by Wyndham Lewis in *Time and Western Man* (1927).

## The Argument over Time

Bergson had one fundamental idea that he expressed in a variety of ways throughout his long life, and from which he never wavered. He argued that time was synonymous with life, and flowed within us as *durée* or duration. *Durée* was irrational and impervious to reason or externalization, and therefore had been suppressed by the dominant mechanical and visual culture. He argued that most people thought of time in terms of space, as being ticked off by the hands of a clock, but that was merely spatialized time, not the internal reality. Bergson inclined to dualistic thinking, dividing being from becoming, intellect from intuition, extensive matter from intensive mind, and seeing all such divisions as aspects of the opposition of space vs. time. By space, he meant the Cartesian universe of scientific objectivity; his praise of intuition, which women of the Belle Epoque eagerly accepted as a philosophical defense of a conventionally scorned feminine trait, matched perfectly with the *fin* and *aube de siècle* reaction against nineteenth-century positivism and materialism. The goal of the psyche was to "go back to the real and concrete self and get back into pure duration," as he wrote in *Time and Free Will*.[54] Doing so freed one from determinism and the distortions of consciousness, and allowed one to enter into a realm of freedom. In *Creative Evolution* he called this sense of interiority *élan vital*, vital force or drive, a term that captured perfectly the sense of an irrational force pushing against all the deadening constraints of convention. This had an irresistible

appeal to bohemian artists intent on bucking the status quo of the salons. *Elan vital* also appealed to French soldiers in 1914, and to intellectuals such as Charles Péguy who contrasted French *élan* with German mechanical efficiency.

The aesthetic implication of Bergson's ideas was the supremacy of temporal art forms such as music over static and visual forms such as painting and sculpture. Yet some modern artists inspired by Bergson's intoxicating philosophy attempted to translate *durée* into their work. Cubists and futurists tried to provoke an intuitive state in the viewer by following Bergson's advice in his 1903 "Introduction to Metaphysics." In their theoretical treatise *Du Cubisme* of 1912, Albert Gleizes and Jean Metzinger suggested that "in order that the spectator, ready to establish unity himself, may apprehend all the elements in the order assigned to them by creative intuition, the properties of each portion must be left independent, and the plastic continuity must be broken up into a thousand surprises of light and shade."[55] This was perhaps as clear as a Bergson-inspired artist could be in trying to adapt intensive intuition to the extensive and spatial world of art. The goal was to achieve some sort of dynamic and rhythmic form, attained through cubist fragmentation and futurist evocation of motion that implied change over time. Though Bergsonian irrationalism did not similarly inspire Picasso and Braque, in 1913, poet and critic Guillaume Apollinaire referred to cubists as pursuing "the fourth dimension" in their art, which presumably meant time.[56]

Another pre-war art movement that would seem indebted to Bergson was simultaneism, which Apollinaire called Orphism, and whose main practitioners were Robert and Sonia Delaunay. Robert Delaunay had shown with the cubists at the Salon des Indépendants in 1911 before breaking with them the following year. Delaunay's path toward abstraction in 1912–13 took him in a different direction, toward brightly colored circular forms, called *Simultaneous Disks*. Yet despite his suggestive terminology and close links to cubist theory (Apollinaire stayed with the Delaunays in their apartment at the end of 1912), Robert Delaunay disclaimed Bergsonian influence.[57] His "law of simultaneous contrasts" celebrated the immediacy of visual impressions as compared with temporality in other arts, and he professed to be "horrified by music and noise."[58] At the same time, Sonia Delaunay-Terk pursued her own version of simultaneous art by illustrating the poet Blaise Cendrar's *The Prose of the Transsiberian and of the Little Jeanne of France* on a 6-foot-long sheet of paper that folded into a book format. In this pre-war work as well as in her 4-meter-long *Bal Bullier*, one must view the work sequentially. For Sonia Delaunay, if not for Robert, an artwork could be sequential as well as simultaneous.[59] In the 1920s, when she mostly left

**Figure 1.3** Sonia Delaunay-Terk, *Bal Bullier*, 1913. MNAM Paris, AM 3507 Pracusa 20200824.

painting behind for clothing and textile design, she retained the term *simultaneous* to describe the bright patterns and circles that adorned her dresses and jackets. To emphasize the idea of speed, she even had an automobile painted to match a woman's costume. All of this underscores that there were other influences besides those of Bergson in suggesting to avant-garde artists like Sonia Delaunay new ways of interweaving space and time.

Historians have gone to great lengths to show that concepts like the fourth dimension and space-time were available in the years before World War I without having to demonstrate that artists in Paris knew of the highly theoretical work of Albert Einstein. The mathematician Maurice Princet explained non-Euclidean geometry and simultaneity to *la bande à Picasso* in terms taken from Henri Poincaré.[60] Poincaré was another figure like Bergson who was far better known than Einstein at the time, but who would likewise be overshadowed by him. Einstein was two years older than Picasso, and his breakthrough year, 1905, came just two years before Picasso painted the first cubist picture, *Les Demoiselles d'Avignon*. As Picasso had painted his women from multiple perspectives, showing all sides at once, so Einstein had destroyed conventional notions of objective reality by demonstrating that no observer had a privileged point of view, and that each perspective was relative to one's vantage point. As the fixed, universal categories of space and time established by Isaac Newton in the seventeenth century were shown to be relative to each other, with the speed of light fixed as the only absolute, space-time came to be accepted as the new worldview. Time dilation, the way in which time slowed down as one approached the speed of light, which suggested that events that seemed to occur simultaneously could actually be perceived as occurring in different time frames, was difficult to accept from the perspective of classical physics. The problem with these suggestive parallels is that none of the artists knew of Einstein's theories until 1920–1, when a number of books appeared in French and other languages explaining relativity theory in the aftermath of the experimental confirmation of General Relativity by the British Royal Society solar eclipse expedition of November 1919.[61] Words such as parallels and interplay are used instead of the older term *zeitgeist* to convey an atmosphere of experimentation that linked art and science and leads to the necessarily imprecise use of terms such as *fourth dimension* and *simultaneity*.

On April 6, 1922, on the eve of being awarded the Nobel Prize in physics, Albert Einstein spoke at the Société française de philosophie, having been invited to Paris by the French physicist Paul Langevin with the hope that Einstein's visit would improve Franco-German relations. Einstein gave his speech in imperfect

French, after which Bergson, prodded to respond by friends in the audience, got up and gave a half-hour response to Einstein, in which he maintained that time could not be fully understood scientifically, but instead must be comprehended epistemologically. Einstein's response took less than a minute, and one damning phrase stood out: "*il n'y a donc pas un temps de philosophie*," there is no philosophical time.[62] Einstein admitted only a psychological time sense that might differ from that of physics, thereby implicitly ascribing Bergson's claim to have understood what time meant in a new way to the limitations of the human psyche. Bergson's longer response was contained in a book, *Duration and Simultaneity*, in which he repeated his claim that duration could never be grasped quantitatively.

This foray into physics was not the philosopher's finest moment, and he was widely suspected of not fully comprehending relativity theory, but the event did return him to the limelight; the British artist/writer Wyndham Lewis commented that they had all thought Bergson was dead, but relativity resuscitated him.[63] Later in the decade, Lewis published a furious diatribe against both thinkers, in *Time and Western Man* (1927). On the opening page, Lewis wrote about "how the 'timelessness' of Einsteinian physics, and the time-obsessed flux of Bergson, merge in each other."[64] Lewis appeared unaware of the Einstein–Bergson debate, and revealed little knowledge of relativity theory, but announced that it was Bergson who "put the hyphen between space and time . . . His doctrine of *durée* is the hyphen."[65] Lewis also perceived that modernist literature, as exemplified by Proust, Joyce, and Gertrude Stein, represented "the school of Bergson-Einstein."[66] He did not comment that all of these figures except Joyce were Jewish, or that Joyce made the hero of *Ulysses* a Jew. Although Einstein had no use for quasi-mystical concepts like intuition and duration, in a curious way both thinkers helped dethrone a homogeneous sense of time as a single, universal, objective category. Both Bergson and Einstein thereby contributed to a modernist sense of time as private, heterogeneous, and fluid.[67] In an age of standardized time zones, speeded up assembly lines, and the concomitant capitalist injunction that time is money, subjectivist philosophy and modern physics fractured conventionally quantified, objectively conceived time. Both forced people to question the ubiquitous symbol of objective time: the ticking clock.

This is not the place to include every prominent Jewish thinker or writer of the early twentieth century, and among this pantheon Eugène Minkowski (1885–1972) is far from the most notable. Yet a brief discussion of his 1933 work, *Lived Time* (*Le Temps Vécu*), will be useful in highlighting the connections I have

been establishing between Jewish culture, introspection, and attitudes toward temporality. Minkowski was a Russian-born physician who studied medicine in Munich, took his medical exams in St. Petersburg in 1910, then returned to Germany so his wife could study medicine, while he pursued further studies in philosophy and wrote "The Essential Elements of Time-Quality." When war came in 1914, the couple moved to neutral Zurich, Switzerland, where Minkowski assisted the famous psychiatrist Eugen Bleuler at the Burgholzli Cinlic, much as Carl Jung had done a decade earlier. In 1915, Minkowski enlisted in the French army, where he was awarded the Croix de Guerre, and became a French citizen. In *Lived Time* he talked of facing the tedium of the trenches; when confronting the monotony of soldiering, men forgot the date and day of the week. Minkowski applied the phenomenological ideas of Edmund Husserl and Bergson's philosophy to psychiatric practice, and described schizophrenic patients with whom he worked at St. Anne's Hospital for the Insane in Paris as deficient in intuition and a sense of lived time. Like his master Bergson, Minkowski also complained that relativity theory had spatialized time and "only progresses from abstraction to abstraction by this method . . . our thought moves in a diametrically opposite direction; weary of abstractions, it attempts to go 'back' toward lived time, with all that is inherent in it."[68] Minkowski praised Freudian psychoanalysis for the access it gave to the unconscious, but also criticized it for substituting rational images "for the very source of our life and in doing so subordinat[ing] to them all values of life, great or small."[69] Minkowski proposed an alternative therapeutic approach to that of Freud based on phenomenology and Bergson's conception of time as intuitive and irrational. "Instead of looking for childhood traumas, Minkowski concentrated on understanding how his patient directly experienced time in the present moment."[70] If Minkowski could analyze how his patients experienced space and time, one might assume that such a phenomenological approach would also provide insight into what motivated artists to produce particular kinds of art.

Another Jewish savant who knew of the intellectual conflict that occurred in Paris in 1922 described himself as having "little claim to be named beside Bergson and Einstein as one of the intellectual sovereigns of his time,"[71] but Sigmund Freud was too modest, and like Einstein, his fame would eclipse that of Henri Bergson and his acolyte Eugène Minkowski. In the course of the 1920s, he would also replace Bergson as an intellectual influence on modernism, as philosophy retreated before the authority of medicine as well as of physics. Freud's main contribution lay in his enlarging the role that the unconscious played in the human mind, and the surrealists seized upon Freud as a prophet of

liberated desire. Yet Freud, like Bergson and Marcel Proust, who died the same year that Bergson faced off against Einstein in Paris, was also interested in placing humans in a temporal flow rooted in the past. For Freud, all traumas lay buried in our childhood, where they lay festering and repressed until brought to consciousness by the therapist. Health and fulfillment lay therefore in recapturing the past, whether through intuition, stream of consciousness literature (in 1922 James Joyce also published the novel *Ulysses* in Paris), or psychoanalysis.

## A Jewish Art of Temporality

These overly condensed summations of the thought of major intellectual figures indicate an important commonality in their thought concerning temporality. Why would consciousness of time have been particularly resonant for Jews? Ashkenazi Jews confined to the Pale of Settlement had long been forbidden to own land, hence were forced to occupy roles as artisans and traders, itinerant others in a landed society. Deprived of space, Jews instead dwelled in the traditions of their faith passed down over many centuries, studying not only the biblical texts but also the commentaries on those texts added to by generations of rabbis in the Talmud. For Jews, history replaced territory. Even the Jewish holidays were historical, commemorating for example the Jews' deliverance from Egypt (in Passover) or their triumph over the Hellenistic rulers of Palestine (Hanukkah). The Polish-born Jewish-American theologian Abraham J. Heschel argued that the Jews transformed ancient agricultural festivals linked with the seasons into commemorations of historical events. Passover, for example, changed from being a spring festival into a celebration of the exodus from Egypt; the Feast of Weeks (Shavuot), an old harvest festival, marked the day on which the Torah was given at Sinai. "To Israel the unique events of historic time were spiritually more significant than the repetitive processes in the cycle of nature … Judaism is a *religion of time* aiming at *the sanctification of time*."[72]

Jewish cosmopolitanism registered this lack of place, whose spiritual concomitant was an immaterial divine presence. Stephen Kern summarizes succinctly: "The Wandering Jew is at home only in time. The Jewish religion also eschewed all spatial representations of the deity whose reality and goodness became known through his action in history."[73] I mentioned above that contemporary Jewish philosophy did not greatly influence the young Jewish artists, but Jewish artists and thinkers alike had absorbed the pervasive Jewish religious focus on the centrality of historical memory at every Passover Seder.

*Zakhor*, remember, appears as a divine injunction to the Jewish people 169 times in the Bible.[74]

For artists living far from home, this sense of displacement must have been all too real. As Jews, they took advantage of a mobile identity to leave the past behind and, as artists, aspire to a more tactile and visual reality. Balanced between the old country and France, as between past and present, Jews faced an increasingly uncertain future as the 1930s wore on. The most famous of these artists, Marc Chagall, was the most emphatic in situating his art between two worlds. He openly admitted that he had been "born again"; that he was born in Vitebsk but also was born in Paris. Nostalgia suffused his art, not just for a remote place but also for a past time:

> At first glance, nostalgia is longing for a place, but actually it is a yearning for a different time—the time of our childhood, the slower rhythms of our dreams. In a broader sense, nostalgia is rebellion against the modern idea of time, the time of history and progress. The nostalgic desires to obliterate history and turn it into private or collective mythology, to revisit time like space, refusing to surrender to the irreversibility of time that plagues the human condition.[75]

If we turn again to the painting with which we began this chapter, Chagall's *Paris through the Window*, we do not see nostalgia but do experience a striking sensation of simultaneity. This painting features the Eiffel Tower in 1913, the year that radio signals began to be broadcast from the tower—a powerful symbol of international temporal coordination. Meanwhile at street level a train runs upside down, as if overturned by these new forces (or perhaps this is Chagall's metaphorical metro moving beneath the earth), and a man and woman fly at each other as the parachutist descends from the sky. The whole fragmented scene is a contemporaneous simultaneous drama, while a nostalgic work from the same period such as *I and the Village* juxtaposes images of the old country, also in a quasi-cubist way. Yet in this latter painting, with one small detail Chagall distances himself from this pastoral setting of peasants and animals, for the green-faced man is wearing a small cross. While the Russian peasant remains in Russia with his animals, Chagall is in Paris handling paint and memories rather than goats.

Chagall frequently made his nostalgia explicit by including clocks in his paintings; this clock image was itself nostalgic. He always depicted the same wall clock with pendulum, inscribed "Le Roi à Paris" that hung in his childhood home in Vitebsk.[76] He painted this clock in a painting by that name as early as 1911, and then painted it again (presumably because it was one of the paintings he had

left behind in Paris) on his return to Russia in 1914. The pendulum clock dwarfs a small figure looking out of a window. For the next twenty-three busy years, time was not a thematic focus, then in the 1930s he painted his best-known meditation on temporality, *Time is a River without Banks* (see front cover).[77] A brightly colored fish flies through the air above a town with a river (Chagall's native city of Vitebsk), an ornately carved wooden clock suspended beneath it. Even more bizarrely, a small arm protrudes from below the fish's lower jaw, playing a violin. The fish may represent the herring that Chagall's father hauled throughout his working life; the violin reinforced the nostalgia, as did the young lovers on one bank, the woman wearing a white bridal gown, as if Chagall was recalling his marriage to Bella in 1915. The title implies that the fish is swimming through time, which represents a Bergsonian conception of time as flux, while the violin-playing fish further signifies the inherent temporality of music. Nearly all of Chagall's time paintings also feature violins.

The same clock, as well as a violin, appears in a major painting on which Chagall worked intermittently for a quarter-century, *The Falling Angel* (also called *Fall of the Angel*), from 1923 when he returned to Paris from Russia until 1948, when he moved back to France from American exile (see Figure 8.9). The familiar wall clock reappears here, and it was already in place in studies done in 1934.[78] The clock is falling from the sky along with the red angel, past a crucified Christ and a bearded man holding a Torah. This work represents the chaos Chagall and the world were undergoing in these cataclysmic years. Since most of these elements were in place by 1934, they must represent the artist's distress at the Nazi seizure of power in Germany the preceding year, with the clock signaling that time was growing short for Jews.

After World War II, in 1947, the year he turned sixty, Chagall painted *Self-Portrait with Clock* to underscore his awareness of aging; he could not know that he would live for nearly forty more years. This self-portrait could hardly be less conventional: the artist's head emerges from an animal icon of himself, seemingly a red horse (or possibly a goat), standing in front of a painting of Christ being held by a bride in white, while the clock flies overhead. The hands of the clock face become real hands that protrude from the clock. A decade later, in 1957, he produced a lithograph called *Christ as a Clock*, in which a clock face replaces the human head, and a large fish is superimposed alongside Christ on the cross. The effect is parodic; perhaps Chagall was commenting on how people worship time. Another clock appears mysteriously in *The Black Glove*, which, like *Falling Angel*, he began in interwar France and completed on his return in the late 1940s. In this work, the artist merges with his bare-breasted wife Bella; on his easel appears a clock face.

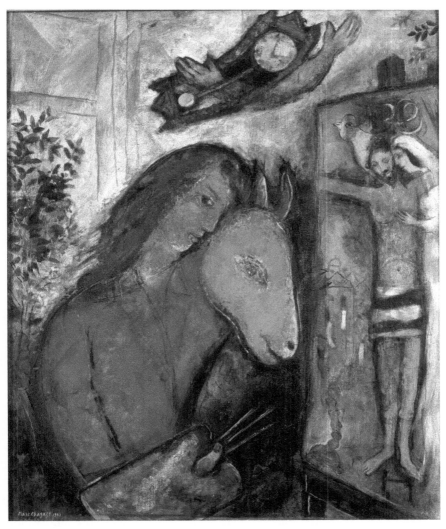

**Figure 1.4** Marc Chagall, *Self-portrait with Clock*, 1947. Photo: Banque d'Images, ADAGP/Art Resource, New York. 2021 Artists Rights Society (ARS), New York/ ADAGP, Paris.

This seems like an unambiguous reference to Bella's death in 1944 and the passage of time. I know of no other artist who referred to time as often as Chagall, and for whom clocks signified both memory and the crises of history through which he lived. Chagall exemplifies what the Italian Jewish architect Bruno Zevi meant when he wrote that "the artist ... does not exchange space for time, he temporalizes space. Seen from this angle, the artist is more Hebraic than the rabbi."[79]

Chagall's nostalgia was strongest in times of crisis and loss, as when he first arrived in Paris in 1911–14, and again in the 1930s. By contrast, Chaim Soutine banished the bad old days of extreme deprivation from his art, replacing the gray skies of Lithuania with bright French landscapes. The past evoked by Soutine was not that of his childhood but that of art, as he haunted the Louvre to see the paintings of Pierre Chardin, Gustave Courbet, and other artists he admired. He traveled repeatedly to Amsterdam to see the paintings of Rembrandt, who was undoubtedly the most admired master among the Jewish modernists for his warm humanity, handling of paint, and familiarity with the Jewish community of seventeenth-century Amsterdam. It is relatively easy for art historians to find examples of Soutine imitating paintings he had seen in museums, yet no one denies that his art was thoroughly modern and that he made it his own. His paintings vibrate with his interior vision. Whether inspired by Rembrandt or Chardin, they all inescapably say Soutine.

A still life would seem to be atemporal. The artist usually arrays a variety of living things, flowers or fruit, on a plate and preserves the fragile objects by painting them. Soutine had little patience for this genre, with one major exception. His beloved master Rembrandt, whose *Flayed Beef* Soutine saw hanging in the Louvre, inspired one of his most notorious series of paintings. Flush with new wealth after his discovery by Dr. Albert Barnes, Soutine hung a whole beef carcass in his studio and had his assistant occasionally freshen it with buckets of blood. As the carcass aged, it changed color, acquiring a patina of ripeness as well as flies and odor (causing his neighbors to protest to the police).

Soutine's beef paintings registered time not only in terms of its antique Dutch inspiration but also by registering the decomposition of once-living tissue. Some commentators have suggested that the kosher butchers of his youth influenced Soutine. Equally likely is his own fascination with the effect of time on flesh, allowing him to perceive beauty and changing color in a substance most would have found grotesque. Where Chagall resorted to clocks, Soutine signified the passage of time through rotting meat.

Egyptian and African sculpture inspired Jacques Lipchitz and Amedeo Modigliani, who became friends in wartime Montparnasse, so despite their openness to modernist experimentation, their appreciation of "primitive" art rooted them in the past. Modigliani, the Sephardic Jew from Italy, was also fond of reciting passages from Dante, yet was proud of his Jewish heritage and claimed descent from the seventeenth-century philosopher Spinoza. Modigliani also read Bergson as well as Nietzrsche, and since he was friends with many other Jewish artists, including Kisling, Soutine, and Lipchitz, they may have been

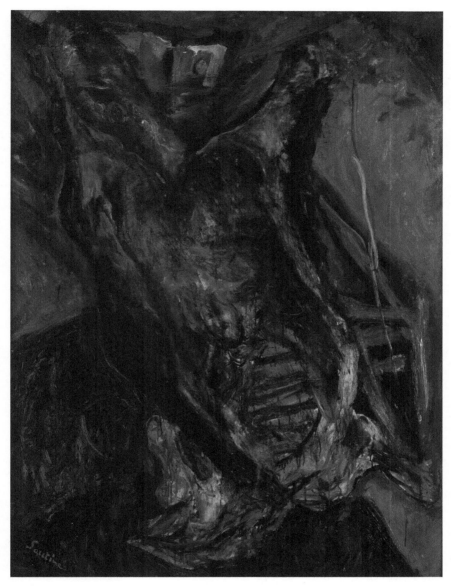

**Figure 1.5** Chaim Soutine, *Carcass of Beef, c.* 1925. Public domain: Albright-Knox Gallery, Buffalo, NY, RCA 1939: 13.2.

familiar with Bergson as well.[80] In the 1930s, Grégoire Michonze was inspired by Flemish primitive art, in particular by Pieter Breughel, which gave his art both a unique stamp and a timeless quality. Critics frequently compared Jules Pascin, painter of Parisian nightlife, to Watteau, Fragonard, and other eighteenth-

century artists whose delicate work expressed joie de vivre. Jewish artists sought a usable past.

Commentators saw in Jules Pascin the embodiment of the Wandering Jew, who had been taking off for parts unknown ever since he left his native Bulgaria for Munich while still in his teens. Pascin was restless, mercurial, cosmopolitan; he also refused to sacrifice a life lived intensely in the present to the demands of his future reputation, and was said to live "above conventional morality."[81] The Jewish critic Florent Fels reported in a memoir that he met Pascin on the terrace of the Montparnasse café La Rotonde one spring day in 1930. Pascin, in a philosophical mood, told Fels, "I would not be disagreeably surprised if the works were treated as perishable matters and disappeared at the death of the artist."[82] Fels wrote this remembrance in hindsight, knowing that Pascin committed suicide a short time later, yet assuming the words are accurate, they registered Pascin's own reflections on time and evanescence.

Fels commented more generally on the relationship of Jewish artists to their non-Jewish predecessors:

> The Ecole de Paris has permitted the original miracle: painters of Jewish origin understood that the human figure was necessary for the expression of human beauty, of human pathos ... Kisling rubbed shoulders with Ingres, Chagall rejuvenated the personages of Jean de La Fontaine, Modigliani, to represent the little girls of Paris rediscovered the blues of Botticelli, Soutine rejoined Georges Rouault, and Pascin the graces of Fragonard translated into the postwar [interwar] taste.[83]

Fels makes two important points in this passage: that all of these artists were driven to paint people; in some cases, nearly exclusively as with Modigliani and Pascin, and they were inspired by artists and writers from the past. Jewish artists felt obliged to register human subjectivity, and therefore favored representational rather than abstract art, and they found inspiration in past masters of their craft. Insofar as the artists cited by Fels were Western, and Kisling, Chagall, Soutine, and Pascin came from the East of Europe, this artistic heritage enacted another momentous displacement (Fels connected Modigliani the Italian Jew with another Italian artist of the Quattrocento). Fels assumed that these young men came to Paris to become artists, not specifically modern artists nor Jewish artists. If a Jewish quality inhered in their work, that was despite their intentions. One can say similarly that Bergson, Minkowski, Freud, and Einstein happened to be Jews who pursued excellence in their chosen fields; they did not produce Jewish physics or philosophy. Their ethnic origins betrayed something about these

pursuits, and situated them as members of a particular generation of Jews both liberated and constrained by their cultural backgrounds.

Two Russian Jewish artists explicitly cited space and time in a manifesto published in August 1920, but they did so in Moscow rather than Paris. Brothers Antoine Pevsner (1886–1962) and Naum Gabo (1890–1977, who changed his name so as not to be confused with his artist brother) were able to get their oddly titled *Realistic Manifesto* published to accompany a show they participated in that year. Legend has it that Trotsky's sister approved the text without having read it, since she judged by the title that it advocated realism in art.[84] That was hardly the case, as the Pevsner brothers along with Vladimir Tatlin and other avant-gardists were sculptors in pursuit of abstraction using modern materials. Pevsner had studied in Paris in 1911 and again in 1913, had befriended Alexander Archipenko and Modigliani, and learned about cubism, futurism, and the latest artistic trends.[85] The manifesto derided these movements as passé, particularly futurism, and in its revolutionary ardor certainly lacked the nostalgia characteristic of Chagall. Gabo and Pevsner announced that "time and space are reborn to us today ... Space and time are the only forms on which life is built and hence art must be constructed ... time is continuous in life's true duration ... We affirm in the arts a new element: kinetic rhythms as the basic form of our perception of real time."[86] Gabo produced a variety of kinetic constructions in the early 1920s, some with motors that provided motion. This art soon proved too radical for Soviet tastes, and the brothers held a joint exhibition called *Russian Constructivists* at the Galerie Percier in Paris in 1924.[87] Pevsner moved to Paris in 1923, becoming a French citizen in 1930. In 1926, he did *Portrait of Marcel Duchamp* in celluloid on zinc, which still borrowed from cubism, but later works were fully abstract, with names such as *Developable Surface* (1938) and *Projection into Space* (1938–9). Gabo taught at the Bauhaus in Germany, and then left first for France, then Britain, finally settling in America. Their work is at the furthest remove from the Ecole de Paris painters, and surpasses in abstraction anything produced by Lipchitz or Zadkine, yet remained true to their 1920 manifesto. It also bears comparison to the work of the Hungarian Jewish constructivist László Moholy-Nagy (born László Weisz, 1895–1946), who taught at the Bauhaus and whose *Light Space Modulator* (1930) was equally kinetic.

One was unlikely to find a ticking timepiece or even the sweeping hands of an electric clock in the constructivists' work. Gabo and Moholy-Nagy were not involved in the Ecole de Paris, Pevsner only tangentially, but they remind us of the range of the arts in which Jewish artists participated between 1910 and 1940. Their space-time is Einsteinian rather than Bergsonian, formal rather than

personal, mental rather than sensuous. It is also international, connecting Moscow, Dessau, Germany, Paris, and the U.S. where Gabo and Moholy-Nagy ended their careers. That westward momentum was also significant, as these modernist Jewish artists fled from Soviet Russia and Nazi Germany, to end up in (capitalist) France and America. Yet they retained the utopian ideals of their youth: as Pevsner put it, they foresaw the synthesis of painting, sculpture, and architecture in great collective works, hoping for "imposing constructions in vast public spaces."[88]

I do not claim that only Jews focused on these themes. The most famous painted image of time from this era is surely that of Salvador Dali, *The Persistence of Memory* (1931); another surrealist, the Belgian René Magritte, painted *Time Transformed* later in the decade, showing a locomotive coming through a fireplace as a clock rests on the mantle above. The proto-surrealist Giorgio de Chirico can be included in this temporal group. Chagall had in common with Dali, Magritte, and de Chirico a penchant for narrative painting. All of these modern artists produced art that told stories, a tendency that formalist art critics saw as retrograde to the idea of pure painting that referred only to itself, but which undoubtedly contributes to these artists' popularity among the public. Representational and narrative paintings imply time as well as space. One can easily imagine paintings such as Magritte's *Time Transformed* advancing a moment later as the locomotive continues its journey through the room; the parachutist and upside-down train in Chagall's *Paris through the Window* similarly are frozen in time. As I have shown, Chagall was more obsessed by time than Dali or de Chirico, for reasons that relate specifically to his Jewish heritage. Paintings such as *White Crucifixion* (1938), while certainly narrative, might also be thought of as representing spacetime, a distinctly Chagallian take on simultaneity that is more dynamic and certainly more historically cognizant than the paintings of Dali and Magritte (see Figure 7.10). For other Jewish artists as well, their art represents what Abraham Heschel, referring to Jewish ritual, called an "architecture of time."[89]

The Italian futurists also evoked time through motion, as in Umberto Boccioni's sculpture *Unique Forms of Continuity in Space* (1913). Many paintings showed stop action movement, most famously Duchamp's *Nude Descending a Staircase*. It is likely that Moholy-Nagy and Gabo would have made kinetic sculptures irrespective of their ethnic-religious origins. Nevertheless, it seems analytically useful to underscore temporality as a thematic element in Jewish culture that played an important role for many of these immigrant artists. Among the surrealists, for example, one could contrast the deformed clocks of

Dali's *Persistence of Memory* with a work by a Jewish surrealist, Man Ray's kinetic sculpture *Object to be Destroyed*, dated from 1923 to 1934. Man Ray took a metronome and attached a picture of a human eye on the arm with a paper clip, so that the eye moved back and forth. He wrote, "It is still my earnest desire, someday, while the eye is ticking away during a conversation, to lift my hammer, and with one well-aimed blow to completely demolish the metronome."[90] Whereas Dali and Magritte represented time externally, with clocks, Man Ray

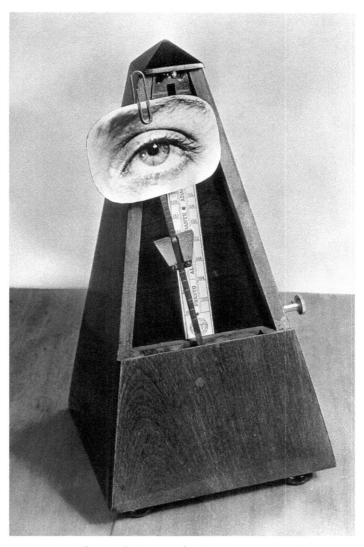

**Figure 1.6** Man Ray, *Object to be Destroyed*, 1932. Man Ray 2015 Trust/Artists Rights Society (ARS), NY/ADAGP, Paris 2021.

**Figure 1.7** Man Ray, *Observatory Time—The Lovers*, 1932–6. Man Ray 2015 Trust/Artists Rights Society (ARS), NY/ADAGP, Paris 2021.

created an image of human consciousness via the eye marking time with its life, until the artist might decide to play God and make time cease—abolishing ocularcentrism with a vengeance.

Man Ray also evoked time in his large dramatic painting *A l'heure de l'Observatoire—Les amoureux, Observatory Time—The Lovers*, painted between 1932 and 1936. The bright red lips floating in the sky were a memento of his student and lover, Lee Miller, painted on a canvas that was eight feet long. Aside from nostalgia for a lost love, the twin domes of the Paris Observatory mentioned in the painting's title can be glimpsed in the lower left corner of the canvas. The Paris Meridian time line passed through the observatory, and since 1919, the building had housed the headquarters of the International Time Bureau.[91] The disembodied lips are thus not simply floating in space; they are rooted in both space and time. Man Ray reimagined *Object to Be Destroyed* in 1932, affixing an image of Lee Miller's eye to the metronome's arm, making explicit his sense of loss. Though he did not rename his object, one could imagine it bearing Proust's title, *In Search of Lost Time*.

While it would be surprising if many modernists failed to respond to the focus on time made by so many leading early twentieth-century thinkers, Jewish artists were predisposed to temporalize space due to their cultural inheritance. Diasporic culture made Jews nomads; insecurity made it risky to invest in fixed assets; in the old country, they had been forbidden to do so. While Zionists dreamed of a Jewish space, young artists took their mobile capital—their dreams and talent—to Paris, and extended their culture in novel ways. As they absorbed what Paris had to teach them, they combined the religious background of their childhood with newer Western currents of thought, currents already comfortable because they also tapped into Jewish preconceptions.

# Notes

1   Michel Ragon, *Mané-Katz* (Paris: Georges Fall, 1960), 14.

2   Paris and the Eiffel Tower remain international symbols of love. The online site *Huff Post/Travel*, in its feature on "The World's 5 Most Romantic Places to Share a Kiss" of July 9, 2015, describes the Eiffel Tower as the top romantic destination in the world (now that the Paris police no longer allow people to place locks on the Pont des Arts). They recommended drinking a glass of champagne there. Some enterprising merchant might consider selling prints of Chagall's *Les fiancés de la tour Eiffel* on site.

3   See *Montparnasse Déporté* (Paris: Musée de Montparnasse, 2005).

4   For a more complete listing of nineteenth-century Jewish artists, see the chapters by Alfred Werner and Ernest Nemenyi in Cecil Roth, ed., *Jewish Art: An Illustrated History* (New York: McGraw Hill, 1961).

5   Richard I. Cohen, "Introductory Essay—Viewing the Past," in Ezra Mendelsohn and R. Cohen, eds., *Art and its Uses: The Visual Image and Modern Jewish Society* (New York: Oxford University Press, 1990), 5.

6   Martin Buber, letter to Lesser Ury, 1901, in Vivian Mann, ed., *Jewish Texts on the Visual Arts* (Cambridge: Cambridge University Press, 2000), 143–6.

7   Mann, *Jewish Texts on the Visual Arts*, 5.

8   Sonia Lipsyc and Nourit Masson-Sékiné, "Abel Pann ou les Tribulations d'un Peintre de la Bible," introduction to Abel Pann, *Autobiographie* (Paris: Les Editions du Cerf, 1996), 14.

9   Nadine Nieszawer, *Les artistes juifs de l'Ecole de Paris*, 2nd edn (Paris: Somogy, 2014). The first edition, published in 2000, included brief biographies of 151 painters. The museum catalog is Pascale Samuel, ed., *Chagall, Modigliani, Soutine . . . Paris pour école, 1905–1940* (Paris: MAHJ, Musée d'Art et d'Histoire du Judaïsme, 2020), 11. Of the forty-three artists whose works were included in the exhibition, seven were women.

10  See Susan Waller and Karen Carter, eds., *Foreign Artists and Communities in Modern Paris, 1870–1914: Strangers in Paradise* (London: Aldgate, 2015). On Jewish artists, see my chapter, "Jewish Modernism: Immigrant Artists in Paris, 1905–1914," 125–40.

11  Kenneth Wayne, *Modigliani and the Artists of Montparnasse* (New York: Abrams, 2002), 23–5.

12  Wayne, *Modigliani*, 16.

13  Harold Rosenberg, "The Fall of Paris," reprinted in *The Tradition of the New* (New York: McGraw Hill, 1959), 209–10.

14  William Rothenstein, *Men and Memories: Recollections of William Rothenstein*, Vol. I: *1872–1900* (New York: Coward-McCann, 1931), 44; memories of his shared studio, 76–8.

15  See Frederick Brown, *For the Soul of France: Culture Wars in the Age of Dreyfus* (New York: Random House, 2010), for a highly readable account of these events and persons.

16  See Jess Olson, "The Dreyfus Affair in Early Zionist Culture," in Maya Balakirsky Katz, *Revising Dreyfus* (Leiden: Brill, 2013), 317–23.

17  Paula Hyman, *From Dreyfus to Vichy: The Remaking of French Jewry, 1906–1939* (New York: Columbia University Press, 1979), 34. On the Jewish immigrant response to the Dreyfus Affair, see Nancy Green, *The Pletzl of Paris: Jewish Immigrant Workers in the Belle Epoque* (New York: Holmes and Meier, 1986), 28–9.

18 Jana Braziel and Anita Mannur, "Nation, Migration, Globalization: Points of
   Contention in Diaspora Studies," in Jana Braziel and Anita Mannur, eds., *Theorizing
   Diaspora: A Reader* (Malden, MA: Blackwell, 2003), 1. Another essay in this volume,
   "Diaspora: Generation and the Ground of Jewish Identity" by Daniel and Jonathan
   Boyarin, 110, makes the bold, if startling, assertion, "Indeed, we would suggest that
   Diaspora, and not monotheism, may be the most important contribution that
   Judaism has to make to the world."

19 See Yuri Slezkine, *The Jewish Century* (Princeton, NJ: Princeton University Press,
   2004), passim.

20 Richard Krautheimer, "Comments on the Memorandum, 'General Plan for a
   Museum of Jewish Culture in New York, September 29, 1944,'" in Vivian Mann,
   ed., *Jewish Texts on the Visual Arts* (Cambridge: Cambridge University Press, 2000),
   168.

21 Harold Rosenberg, "Is There a Jewish Art," adapted from a talk at the Jewish
   Museum, published in *Commentary* 42 (July, 1966) and included in *Discovering the
   Present* (Chicago: University of Chicago Press, 1973), 223.

22 Rosenberg, "Is There a Jewish Art?, 230.

23 Jacques Biélinky, "Les artistes juifs à Paris," *L'Univers Israélite*, September 12, 1924,
   517–20.

24 Jacques Biélinky, "Les artistes juifs à Paris," *Almanach Juif 1931*, 58.

25 Joseph Milbauer, "L'art et les juifs. Y a-t-il un art juif?" *L'Univers Israélite*, August 30,
   1929, 618.

26 Milbauer, "L'art et les juifs. Y a-t-il un art juif?, 620.

27 Fritz Vanderpyl, "Existe-t-il Une Peinture Juive?," *Mercure de France*, July 15, 1925,
   394.

28 Several of the essays in the catalog that accompanied the show on the Ecole de Paris
   staged by the Museum of Modern Art of the City of Paris in 2000–1 cite these names
   and discuss what this school signified. See *L'Ecole de Paris 1904–1929: la part de
   l'Autre* (Paris: Musée d'Art moderne de la Ville de Paris, 2000), especially Gladys
   Fabre, "Qu'est-ce que l'Ecole de Paris?" Fabre discusses Warnod on 35–6. This Paris
   museum foregrounds the Ecole de Paris, as compared with its more famous Parisian
   rival in modern art, the Centre Pompidou, which ignores it.

29 Pierre Jaccard, "L'Art Grec et spiritualisme hébreu par rapport à la peinture juive,"
   *Mercure de France*, August 15, 1925, 82.

30 Jaccard, L'Art Grec," 80–93.

31 For a full discussion of alleged Jewish aniconism, see Kalman P. Bland, "Anti-
   Semitism and Aniconism: The Germanophone Requiem for Jewish Visual Art," in
   Catherine M. Soussloff, ed., *Jewish Identity in Modern Art History* (Berkeley:
   University of California Press, 1999). As the title suggests, Bland considers only
   German examples, which, he argues, derive from Kant, and included Hermann

Cohen and Martin Buber. In his 1903 volume on *Jewish Artists*, Buber showed that emancipated Jews were capable of producing art. See Bland, 55, 56.

32 Adolphe Basler, "Y a-t-il une peinture juive?," *Mercure de France*, November, 1925, reprinted in *Le Cafard Après la Fête* (Paris: Jean Budry, 1929), 136.

33 Basler, "Y a-t-il une peinture juive?," 140.

34 Arthur I. Miller, *Einstein, Picasso: Space, Time, and the Beauty that Causes Havoc* (New York: Basic, 2001), 243–4.

35 Saul J. Singer, "Pablo Picasso and the Old Jew," *The JewishPress.com*, March 11, 2015, cites John Richardson's authoritative biography of Picasso as the source for speculation that Picasso's maternal grandmother, Inés López Robles, might have been a secret Jew. He also reports on a visit that Picasso made to Poland and Auschwitz in 1948, and quotes Picasso as saying on that visit that "whenever anyone has asked me, I have always said I'm Jewish. And my painting is Jewish painting, isn't it?" This speculative source makes Picasso no more Jewish than did Adolphe Basler's assertions in the 1920s.

36 In *Reordering the Universe: Picasso and Anarchism, 1897–1914* (Princeton, NJ: Princeton University Press, 1989), and again more recently in *The Liberation of Painting: Modernism and Anarchism in Avant-Guerre Paris* (Chicago: University of Chicago Press, 2013), Patricia Leighten argues that in the years prior to World War I, Picasso had anarchist political sympathies. The period from 1880 to 1914 was the heyday of French anarchism, and many artists, including Maximilien Luce, Paul Signac, and other neoimpressionists also were anarchists. See Richard Sonn, *Anarchism and Cultural Politics in Fin de Siècle France* (Lincoln: University of Nebraska Press, 1989).

37 See Miller, *Einstein, Picasso*, for an in-depth discussion of the parallels between relativity and cubism. Linda D. Henderson, in "Cubism, Futurism and Ether Politics in the Early 20th Century," *Science in Context* 17, no. 4 (2004): 455–7, brings Miller to task for implying links between Picasso and Einstein that were not really there, even though she admits that he is careful to present his book as parallel biographies of the two men. She argues that Einstein's work was not widely known until the interwar period, and that the discovery of x-rays and the idea of the ether held sway over scientific imagination at the birth of cubism.

38 Miller, *Einstein, Picasso*, especially chapter four, "How Picasso discovered Les Demoiselles d'Avignon," 100–6.

39 Miller, *Einstein, Picasso*, 170.

40 See Julien Benda, *Belphégor* (1919) (New York: Payson and Clarke, 1929), for an impassioned condemnation of Bergson's neo-romantic intuitionism. Largely forgotten today, Bergson was hugely influential and popular at the time.

41 Adolphe Basler, *La Peinture . . . religion nouvelle* (Paris: Bibliothèque des Marges, 1926), 16.

42 Dominique Jarassé, *Existe-t-il un Art Juif?* (Paris: Biro, 2006), 139.

43 Jarassé, *Existe-t-il un Art Juif?*, 142–3.

44 Zachary Braiterman, *The Shape of Revelation: Aesthetics and Modern Jewish Thought* (Stanford, CA: Stanford University Press, 2007), makes these comparisons without ever mentioning Jewish artists. In any case, his attention is focused entirely on German-speaking Europe. Nadia Malinovich, "Le 'Reveil juif' en France et en Allemagne. Elements de comparaison en manière d'introduction," *Archives Juives: Revue d'histoire des Juifs de France* 39, no. 1 (2006): 5, says that the German Jewish renaissance of the 1920s that included great religious thinkers such as Buber and Rosenzweig had no counterpart in France.

45 Several recent books have analyzed Rothko in these terms. See Annie Cohen-Solal, *Mark Rothko: Toward the Light in the Chapel* (New Haven, CT: Yale University Press, 2015; Julia Davis, *Mark Rothko: Art of Transcendence* (Maidstone, UK: Crescent Moon, 2011); Dominique de Menil, *The Rothko Chapel: Writings on Art and the Threshold of the Divine* (New Haven, CT: Yale University Press, 2010). Lisa Saltzman, in "To Figure, or Not to Figure: The Iconoclastic Proscription and Its Theoretical Legacy," included in Catherine Soussloff, ed., *Jewish identity and Modern Art History* (Berkeley: University of California Press, 1999), connects post-World War II abstract art to Theodor Adorno's questioning of the possibility of aesthetic representation after Auschwitz.

46 Tom Sandqvist, *Ahasueras at the Easel: Jewish Art and Jewish Artists in Central and Eastern European Modernism at the Turn of the Last Century* (Frankfurt: Peter Lang, 2014), 463–7, makes a great deal out of Hasidism in terms of the influence it had on many Jewish artists. He sees a mystical pantheist spirit connecting such artists as Mela Muter, Chagall, Lipchitz, and the Polish Jewish painter Jankiel Adler. He even finds Sonia Delaunay expressing values of cosmic harmony in her painting. While this works for Chagall, I find it less convincing as an overall influence. Sandqvist also sees the Jewish time sense stamped by messianism as articulated by Martin Buber, 475.

47 See Mark Micale, "The Modernist Mind—a Map," in Mark Micale, ed., *The Mind of Modernism* (Stanford, CA: Stanford University Press, 2004), 16.

48 Gertrude Stein, "Composition as Explanation," written for lectures at Oxford and Cambridge, published by Hogarth Press in 1926. EPC, digital library.

49 Stein, "Composition as Explanation." For an extended discussion of this work, see "1926: Composition as Explanation," in Ulla Dydo, *Gertrude Stein: The Language that Rises, 1923–1934* (Evanston, IL: Northwestern University Press, 2003), 77–132.

50 Martin Jay, "Scopic Regimes of Modernity," in *Force Fields: Between Intellectual History and Cultural Critique* (New York: Routledge, 1993), 115, 116. Marshall McLuhan, *The Gutenberg Galaxy: The Making of Typographic Man* (London: Routledge and Kegal Paul, 1962), made the classic statement of this argument.

51 Svetlana Alpers, *The Art of Describing: Dutch Art in the Seventeenth Century* (Chicago: University of Chicago Press, 1983).

52 The phrases "crisis of the *ancien* scopic regime" and "denigration of vision" are taken from Martin Jay, *Downcast Eyes: The Denigration of Vision in Twentieth-Century French Thought* (Berkeley: University of California Press, 1993).

53 Jesse Matz, "T. E. Hulme, Henri Bergson and the Cultural Politics of Psychologism," in Mark Micale, ed., *The Mind of Modernism* (Stanford, CA: Stanford University Press, 2004), 348.

54 Henri Bergson, *Time and Free Will*, quoted in Matz, "T. E. Hulme, Henri Bergson," 342.

55 Glaizes and Metzinger, *Du Cubisme*, quoted in Mark Antliff, *Inventing Bergson: Cultural Politics and the Parisian Avant-Garde* (Princeton, NJ: Princeton University Press, 1993), 52. *Inventing Bergson* is invaluable in placing Bergson's thought in the cultural and artistic context of the pre-war period, and Antliff played a significant role in inspiring this chapter, along with the books by Jay and Kern.

56 Stephen Kern, *The Culture of Time and Space, 1880–1918* (Cambridge, MA: Harvard University Press, 1983), 145. On art and the fourth dimension, see Linda D. Henderson, *The Fourth Dimension and Non-Euclidean Geometry in Modern Art* (Princeton, NJ: Princeton University Press, 1983), introduction and passim.

57 Gordon Hughes, *Resisting Abstraction: Robert Delaunay and Vision in the Face of Abstraction* (Chicago: University of Chicago Press, 2014), 12, for Apollinaire's close relations with the Delaunays; 7, for resisting the anti-visual emphasis of Bergsonism.

58 Hal Foster et al., *Art since 1900: Modernism, Antimodernism, Postmodernism*, vol. 1: *1900–1944*, 2nd edn. (New York: Thames and Hudson, 2011), 122.

59 Juliet Bellow, "On time: Sonia Delaunay's sequential Simultaneism," in *Sonia Delaunay* (London: Tate, 2014), 99, 100.

60 Miller, *Einstein, Picasso,* 4 and passim. See also Kern, *Culture of Time and Space*, 19, 81, 135–6; William Everdell, *The First Moderns: Profiles in the Origins of Twentieth-Century Thought* (Chicago: University of Chicago Press, 1997), chs. 15, 16. On Poincaré and Einstein, see Peter Galison, *Einstein's Clocks, Poincaré's Maps: Empires of Time* (New York: Norton, 2003). Galison discusses two other Jews who helped redefine time in pre-war Germany: Emil Cohn and Hermann Minkowski, 263–70.

61 Henderson, *The Fourth Dimension*, 318–19. For an authoritative account of the Rutherford solar expedition, see Daniel Kennefick, *No Shadow of a Doubt: The 1919 Eclipse that Confirmed Einstein's Theory of Relativity* (Princeton, NJ: Princeton University Press, 2019).

62 Jimena Canales, *The Physicist and the Philosopher: Einstein, Bergson and the Debate that Changed our Understanding of Time* (Princeton, NJ: Princeton University Press, 2015), 5.

63 Canales, *The Physicist and the Philosopher*, 5.

64 Wyndham Lewis, *Time and Western Man* (London: Chatto and Windus, 1927), 3.

65 Lewis, *Time and Western Man*, 434.

66 Lewis, *Time and Western Man*, 106. He might better have titled the book Time and Western Woman, since he saw time as feminine, space as masculine, 444.

67 Kern, *Culture of Time and Space*, 34.

68 Eugène Minkowski, *Lived Time: Phenomenological and Psychopathological Studies*, intro. And trans. Nancy Metzel (Evanston, IL: Northwestern University Press, 1970), 17, 18.

69 Minkowski, *Lived Time*, 56.

70 Kern, *Culture of Time and Space*, x, xi.

71 Canales, *The Physicist and the Philosopher*, 7, 8.

72 Abraham J. Heschel, *Between God and Man: An Interpretation of Judaism*, Selected and Edited by Fritz Rothschild (New York: Free Press, 1959), 216, italics in original.

73 Kern, *Culture of Time and Space*, 51.

74 Yosef Hayim Yerushalmi, *Zakhor: Jewish History and Jewish Memory* (Seattle: University of Washington Press, 1982), 5.

75 Svetlana Boym, *The Future of Nostalgia* (New York: Basic Books, 2001), xv.

76 Jackie Wullschlager, *Chagall, A Biography* (New York: Knopf, 2008), 32.

77 As with a number of his works, Chagall worked on this painting over a number of years, so while it was completed by 1937, he was photographed with the canvas looking quite complete in 1933. See Meret M. Graber, "Marc Chagall, 1922–1985," in *Marc Chagall* (New York: Abrams, with the San Francisco Museum of Art, 2003), 43.

78 *Marc Chagall* (2003), 170. See also Jackie Wullschlager's comments on "Falling Angel" in *Chagall*, 426.

79 Bruno Zevi, "Hebraism and the Concept of Space-Time in Art" (1974), in Andrea Oppenheim Dean, *Bruno Zevi on Modern Architecture* (New York: Rizzoli, 1983), 158.

80 Marevna Vorobëv, *Life with the Painters of La Ruche* (New York: MacMillan, 1972), 18. Vorobëv knew the artists of this milieu personally, and reported that Modigliani considered himself to be a socialist and read Bergson, Nietzsche, and Kropotkin.

81 Horace Brodzky, *Pascin* (London: Nicholson and Watson, 1946), 39. Brodzky knew Pascin in New York during World War I.

82 Florent Fels, *L'Art Vivant de 1900 à nos jours* (Geneva: Pierre Cailler, 1956), 123. Pascin's judgment is ratified by Microsoft Word, which recognizes the name Modigliani but underlines that of Pascin to alert the writer that he may have committed a typographical error.

83 Fels, *L'Art Vivant*, 140.

84 Stephen Bann, ed., *The Tradition of Constructivism* (New York: Viking, 1974), 4, 5.

85 Ruth Olson and Abraham Chanin, *Gabo-Pevsner* (New York: Museum of Modern Art, 1948), 52.

86 Bann, *The Tradition of Constructivism*, 9, 10.

87 Olson and Chanin, *Gabo-Pevsner*, 20.

88 Olson and Chanin, *Gabo-Pevsner*, 57, quoting Pevsner from a 1947 monograph that accompanied his first one-man show at the Galerie René Drouin in Paris.

89 Heschel, *Between God and Man*, 217.

90 Man Ray, *Objets de mon affection* (Paris: Philippe Sers, 1983), 46, 47.

91 Neil Baldwin, *Man Ray, American Artist* (New York: Da Capo, 1988), 174.

# From Montmartre to Montparnasse:
# New Social and Psychological Dimensions,
# 1900–1914

*[19]12, 13, 14, what intense, explosive years for Robert and for me! ... We had found in the sky the emotive principle of all artwork: light, movement and color.*

Sonia Delaunay-Terk[1]

*"What were your first impressions of Paris?" "I seemed to be discovering light, color, freedom, the sun, the joy of living, for the first time ... In Paris, I at last saw as in a vision the kind of art that I actually wanted to create. It was an intuition of a new psychic dimension in my painting."*

Marc Chagall, responding to a question by Edouard Roditi[2]

Young Jewish immigrants to Paris in the early years of the twentieth century benefited from a fortunate coincidence. These years witnessed the enormous Jewish migration out of tsarist Russia, as Jews fled from the pogroms that began in 1881 and accelerated in the early twentieth century. Jews were also emigrating in large numbers from the Austro-Hungarian Empire. This mass migration coincided with the great breakthroughs in aesthetic modernism taking place in the French Third Republic. While the vast majority of Jewish emigrants found their refuge in the New World, 30,000 Jews made their way to France before World War I. Most Jewish immigration to France occurred in the interwar years, especially after the U.S. closed its doors to immigrants from Southern and Eastern Europe in 1924.[3] With France facing a relative lack of immigration pressure during the Belle Epoque, and the storms over the Dreyfus Affair being resolved just as most of these young artists arrived in Paris in 1905 and thereafter, they faced relatively little antisemitism. While most Jewish immigrants lived on the right bank, in the neighborhoods of the Marais and Belleville in northeastern

Paris, nearly all of the artists headed for Montparnasse, across the Seine in the southwest part of the city. Sonia Terk was one of these Russian Jews who made their way to Paris, in her case at age twenty in 1905.

Jewish artists chose to live in Montparnasse because they needed to learn their craft when they arrived in Paris, and because they needed a support network and artistic affirmation that the Jewish quarters could not provide. The bohemian and cosmopolitan atmosphere of Montparnasse made it possible for them to define themselves, hence to evade expectations of the refugee or immigrant. The availability of cheap studio space attracted these novice artists, most famously at the complex of studios known as La Ruche. They availed themselves of the art academies that catered to foreigners; the cafés along the boulevard Montparnasse that served as vital sources of communication; and the *avant-guerre* journals such as Guillaume Apollinaire's *Les Soirées de Paris* and Ricciotto Canudo's *Montjoie*. The cafés that lined the boulevard Montparnasse such as La Rotonde, which opened in 1910, evoked in every memoir and history of the era, played a vital role as places where immigrants could meet, talk, and share ideas over a cup of coffee.[4]

In the decade before World War I, most of the immigrant Jewish artists were very young, in their teens or twenties, and just beginning their artistic careers. Nor were they particularly noticed; it was only in the 1920s that their numbers and significance became apparent to French critics such as André Warnod. The 1920s marked the apogee both of Montparnasse as an international artist colony and of the Jewish artists of Paris who comprised a large portion of these foreign-born artists. Amedeo Modigliani, Jules Pascin, Marc Chagall, Chaim Soutine, Moïse Kisling, Chana Orloff, Jacques Lipchitz, Ossip Zadkine, and many others found fame and fortune in these years when they were in their prime. The 1920s witnessed a boom in the art market, fueled by new wealth created by rising stock markets. Artists began to shed their bohemian identity as poor outcasts and some bought cars and summer homes with their new incomes.

The pre-war years were particularly formative ones for the Jewish artists of Paris. All of the artists who achieved fame in the interwar era as part of the Ecole de Paris arrived in Paris in these years, though not all remained in Paris continuously. For many, the exposure to the proliferating modernist styles of fauvism, cubism, simultaneism, futurism, and expressionism played a decisive role in their artistic development. As these apprentice artists absorbed the latest styles, they also searched for that which would make their work distinctive. Most interpreted that search in individual terms without reference to religion or national origins, and found pre-war Montparnasse tolerant and nurturing. An

example of this style of complete acculturation, and the Jewish artist best known in these years, was Jules Pascin. It is difficult to identify anything particularly Jewish about Pascin's style or subject matter. At the other extreme was Marc Chagall, just gaining recognition in 1913–14. Chagall too enjoyed the creative freedom he found in Montparnasse, but he remained highly conscious of his Jewish identity. Fortuitously for Chagall, the culture of pre-war Paris also encouraged immigrant artists to accentuate difference. The dazzling presence of Sergei Diaghilev's Ballets Russes in these pre-war years reinforced Chagall's decision to emphasize his Slavic roots. While many other artists were attracted to primitivism and simplified their style in evocation of African and Oceanic sculpture, Chagall's genius was to merge modernist sophistication and primitivism in his own person, a feat that would have been difficult to perform if he had remained in Russia.[5] The worldly cosmopolitan Pascin and lyrical-nostalgic Chagall represent the alternatives available to immigrant Jewish artists.

These young artists were fortunate in their timing. One historian has called the years between 1906 and 1918 a golden age for French Jews.[6] In 1906, the army reinstated Alfred Dreyfus, who later fought in World War I. This period thus fell between the explosive Dreyfus Affair and the era of mass Jewish immigration in the interwar years that led to renewed antisemitism. The 1920s remained relatively tolerant and highly cosmopolitan, but the artistic direction of a "return to order" and the vogue for neoclassicism dampened the atmosphere of experimentation that peaked in the pre-war decade.[7] In the 1920s, Jewish artists' newly won prominence created a backlash among some hostile French critics who imagined a conspiracy between Jewish artists, dealers, and critics to advance their careers and profits at the expense of native-born artists.[8] As apprentice art students before the war, the young Jews would not have appeared threatening.

How many Jewish immigrants arrived in Paris to attend art academies between 1900 and 1914? Exact figures are hard to come by. Working from the list compiled by Nadine Nieszawer and adding some names she does not include, over sixty foreign-born Jewish painters and sculptors spent a significant amount of time in Paris, though not all of them stayed. Many of them left France during World War I and many of those returned after the war, though some as late as 1939 (as was the case with Jerzy Merkel, who left Paris in 1914 to fight in the Austrian army, remained in Vienna, then fled the Nazis after the *Anschluss*). The majority were men, but an impressive number of women, including Sonia Delaunay-Terk, Alice Halicka, Mela Muter, Chana Orloff, and Marevna Vorobëv, made careers for themselves as well.[9] Most were painters, but there were also

many sculptors, the best known of whom were Jacques Lipchitz, Oscar Miestchaninoff, Elie Nadelmann, Chana Orloff, and Ossip Zadkine. Modigliani considered himself primarily a sculptor for much of his time in pre-war Paris, but turned to painting nudes and portraits during the war. Otto Freundlich also did both, and would be immortalized by the Nazis when a sculpted head he did in 1912 adorned the cover of the catalog for the infamous *Degenerate Art* exhibition of 1937.

Nearly all the male artists arrived as young and single. The first three women cited above were married before the war, Halicka and Delaunay-Terk to other artists. Orloff married during the war but lost her husband very soon to influenza. Marevna had a child with Diego Rivera in 1919, but the relationship ended when he returned to Mexico in 1921. Marevna left two valuable memoirs of her life with the artists of Montparnasse, tinged with bitterness at the difficulty of being taken seriously as an artist. The bohemian atmosphere tolerated foreigners better than women, Marevna reported, who were perceived by the artists primarily as models who were sexually available.[10]

Why did so many young Jews come to Paris to study art in the decade before World War I? To understand why an earlier generation did not similarly create such a movement, it is instructive to compare the careers of two Polish Jewish artists who were brothers, yet brothers who did not know each other, for the elder died the year that the younger was born.

Maurycy and Leopold Gottlieb came from Galicia, the eastern-most province of the Habsburg Empire; the city of their birth is now in Ukraine. Maurycy was born in 1856, the same year as Sigmund Freud; his enlightened (Haskalah) parents sent him to art school, first in the Habsburg capital, Vienna, later in Kraków (Freud's parents, also originally from Galicia, moved to Vienna in 1860), to study with the Polish master Jan Matejko.[11] In the time remaining to him before he died of tuberculosis at age twenty-three, he produced remarkably accomplished but also very traditional paintings in an academic style. In *Jews Praying in the Synagogue on Yom Kippur* (1878), Gottlieb painted a crowded scene with the men in the foreground gathered around the rabbi holding the Torah scroll, the women above confined to their separate space, men bearded with heads covered; leaning over the rabbi was a young man with Maurycy's features. Another historical-religious painting, *Jesus Preaching at Capernaum*, left unfinished at Gottlieb's death, showed a Jewish-looking Jesus preaching in a columned classical space, a Torah in front of him, with men in the foreground and women seated separately in the gallery. Here too his self-portrait is recognizable among the male worshippers. For a Jewish artist to represent Jesus

as a Jew required a conscious decision, in Gottlieb's case "to make peace between the Poles and the Jews, for the history of both peoples is one of pain and suffering."[12] The older brother also painted portraits of prominent Jews who, like him, supported Jewish integration into the Habsburg Empire.[13] A younger contemporary of the impressionists, Maurycy showed no interest in new artistic trends. His enlightened parents permitted four of their sons to become artists (and a daughter, Jadwiga, married an artist), yet for the oldest son the horizons remained within the sphere of Eastern European Jewish culture, as well as the prevailing academic genres of historical, religious, and portrait painting.[14]

The youngest Gottlieb brother, Leopold, born in 1879 and the last of eleven children, also studied art at Kraków.[15] He moved on to Munich and then to Paris, which he first visited in 1904. His awareness of his Jewishness extended to a year spent teaching at the new art school, Bezalel, in Jerusalem. He also returned to Poland to participate and show with the formist (Polish expressionists) and rhythm movements. Leopold took up life in Montparnasse again in 1908, this time remaining until the summer of 1914, and became friends with Jules Pascin (who also had moved from Munich to Paris), Diego Rivera, Mela Muter, Elie Nadelman, and the critic André Salmon. Gottlieb painted some of their portraits, as well as that of French Jewish philosopher Henri Bergson. In 1912, he showed his art at the *Polish Parisians* exhibition in Barcelona, and then traveled to Toledo with Diego Rivera. The next year he traveled with Rivera again to Ondarroa in the Spanish Basque country, where they visited Mela Muter, who was the best-known artist in the *Polish Parisians* show of the previous year.[16] Like his older brother, Leopold Gottlieb also painted scenes evoking the New Testament, including Christ as a Beggar, the Last Supper, and a Pieta around 1909–10. For Leopold, socialist ideals informed these images of suffering. His sojourn in Paris culminated in the duel he fought with another Polish Jewish artist, Moïse Kisling, in the spring of 1914. Maurycy, the older brother, may have been more precocious, but for Leopold, mobility reinforced modernism.

After serving with the Polish Legion during the war (see Chapter 3), Leopold Gottlieb lived in Vienna and Baden, before eventually returning to Paris in the mid-1920s, where he lived for the next decade. His had his first one-man show in Paris in 1927 and André Salmon published a monograph about him that year. Gottlieb died in his studio, probably of a heart attack, in 1934; his wife was deported and died in the camps in 1943.[17] Gottlieb's later work is evocative, figurative, and somewhat symbolist. It is nothing like his elder brother's academic style, just as his peripatetic, international life contrasted starkly with Maurycy's relative rootedness. This tale of two brothers suggests that young artists studying

in Eastern Europe after 1900 came to Paris as the fount of modernism, which probably meant impressionism, pointillism, and neoimpressionism, though what they encountered there would rapidly displace those late nineteenth-century movements.

Discussing another Jewish artist who came to Paris in the 1870s may help to establish what was unique about the generation of young Jews who arrived in Paris after 1900. Max Liebermann was born in 1847 to a wealthy Prussian Jewish family, and like Leopold Gottlieb and Jules Pascin studied art in Munich. He came to Paris at age twenty-five in 1872 and returned for a prolonged stay the following year, which lasted until 1876. As with many young nineteenth-century artists, Max Liebermann did not intend to settle in France; unlike many of them, he was attracted neither to a bohemian lifestyle nor to the avant-garde of impressionism. He only discovered impressionism in private German collections in the 1890s, and eventually owned more paintings by Edouard Manet than any other German collector. Instead, Liebermann emulated the previous generation of the Barbizon school of artists, especially Jean-François Millet. Liebermann lived in Barbizon very near to Millet's residence, but Millet, who died in 1875, refused to speak to any Germans so soon after the Franco-Prussian War of 1870–1.[18] Liebermann's circle of friends in Paris included mostly German-speaking painters, such as his fellow naturalist Mihály Munkácsy (born Michael Leo Leib, 1844–1900), a Hungarian Jew whom Liebermann had first met in Düsseldorf in 1871. Munkácsy had moved to Paris in 1873, which encouraged Liebermann to move there as well.[19] In 1874, the Paris Salon accepted Liebermann's painting *Women Plucking Geese*, a naturalist work in the style of Millet, Corot, and Courbet. Liebermann would be the first German awarded an honorable mention in the Salon of 1881. The French offered him the Legion of Honor for his efforts at organizing a German art show for the Paris 1889 Exposition, but the German government did not allow him to accept it (there was no German pavilion at the fair).[20]

Max Liebermann's career was not without controversy (most notably over another "Jewish Jesus" painting he did at the same time as Maurycy Gottlieb in 1878),[21] and his Francophile cosmopolitanism led to charges of insufficient nationalism. An assimilated bourgeois German Jew, Liebermann succeeded in mainstream artistic circles but lacked a welcoming bohemian milieu populated by fellow Jewish artists. It is not as if he disdained the company of other Jewish artists; in Amsterdam, which he visited regularly for many years, he was close to his Dutch counterpart Josef Israëls, whom he first met in 1881.[22] For Liebermann in the late nineteenth century, Paris was one of several stops on his development

as an artist, and in no way suggested Jewish cultural identification. Similarly, William Rothenstein came to study art in the early 1890s and then returned to England, where he directed the Royal College of Art and received a knighthood in 1931.

Neither Gottlieb brother denied his Jewish identity, which the elder brother expressed overtly in his art, the younger by his journey to Jerusalem. Was this acceptance of Jewish identity true of the other artists who, unlike Leopold Gottlieb, settled permanently in France? One place to look for evidence would be in these artists' personal stories. The painter Alice Halicka, the sculptor Ossip Zadkine, and the painter and designer Sonia Delaunay-Terk wrote autobiographies in which one would be hard-pressed to find any references to Judaism.[23] Halicka, a doctor's daughter from Kraków, married the Polish-Jewish cubist Louis Marcoussis (born Ludvik Markus) in 1913, one year after she arrived in Paris.[24] They lived in Montmartre rather than Montparnasse and did not identify with the heavily Jewish Ecole de Paris.[25] After a brief marriage of convenience to the German art dealer Wilhelm Uhde, Sonia married the French artist Robert Delaunay in 1910.

Like Sonia Delaunay, Ossip Zadkine married a non-Jewish artist, Valentine Prax, though not until the 1920s. Halicka, Delaunay, and Zadkine all mastered French, the language of their memoirs; their privileged origins facilitated their rapid acculturation. Zadkine was born in Smolensk, Belorussia; his father taught Latin and Greek. He visited an uncle who lived in Scotland when he was fourteen, and traveled to London in 1906 before returning to Russia. There he met Chagall in Vitebsk before making his way to Paris in 1909, two years before Chagall (though he was three years his junior). Though Zadkine referred only obliquely to his Jewish heritage, when he visited London he made a point of seeking advice from two well-known Jewish artists, William Rothenstein and Jacob Epstein.[26] He reportedly told his fellow Russian immigrant artist Marevna that he wanted to revive Jewish art, a remarkable admission of Jewish ethnic if not religious identity that would be obscured in his memoirs written a half-century later.[27] Mela Muter and Alice Halicka, both from bourgeois backgrounds, converted to Catholicism in later years.

These artists' aversion to discussing their ethnicity reflects their assimilation into French culture, which displays a similar republican secular reticence about noting religious affiliation. In terms of socio-economic background, the immigrant artists varied widely, but given the later fame of Chagall and Soutine, who were poor, and the down-and-out legend of bohemia, it needs to be underscored that many immigrant Jewish art students came from bourgeois

backgrounds and many attended art schools back in Vilna and Kraków. Teachers such as Joseph Pankiewicz sent several young artists to Paris from the Fine Arts school in Kraków.[28] Halicka, Delaunay, and Zadkine were closer in class origins to Rothenstein, Liebermann, Pascin, and Mela Muter than to Chagall and Soutine. Middle- or upper-class urban Jews were less conscious of difference.

By contrast, Marc Chagall precociously wrote his autobiography before he left Russia in 1922, and then rewrote it back in France in 1924–5. Unlike the forementioned French-language autobiographies, composed much later, Chagall wrote and published his memoir in Yiddish; the French version appeared in 1931.[29] In contrast to the artists from privileged origins, Chagall's father transported barrels of herring for thirty-two years.[30] Yet one did not need to be a practicing religious Jew to identify oneself as Jewish. Amedeo Modigliani was highly conscious of his Jewish identity, proudly tracing his Sephardic heritage back to the seventeenth-century philosopher Baruch Spinoza. Presumably, he knew that Spinoza was a heterodox and controversial figure in his own time, making it easier for a bohemian artist to identify with his illustrious forebear.[31] When Jules Pascin—another Sephardic Jew—died by his own hand in 1930, he was buried in an Orthodox Jewish ceremony, with Chagall, Kisling, and Marcoussis (among others) in attendance.[32]

Given the lack of uniformity in social origins as in artistic style, the critics were hard-pressed to find an easily identifiable Jewish essence in their work. Even Chagall found the label "Jewish artist" to be limiting.[33] All were committed to modernism in the sense of experimentation, and of freedom from representational realism. Few artists of Jewish origins dwelled on explicitly Jewish subject matter. This was true of Chaim Soutine, who nonetheless evolved a distinctive style that, in its expressive force, its melancholia and negativity, expresses the pathos of the Jewish Diaspora—what one critic terms "Soutine's shudder."[34] Modigliani painted many portraits of his fellow Jewish artists, which often were not flattering but expressed the psychological presence of the model. One of his very first portraits, dating from 1908, he titled explicitly *Portrait of a Jewess*, though the unknown artist was unlikely to have received a commission from a prominent Jewish patron. These artists were coming of age as Sigmund Freud was consolidating psychoanalysis in Vienna. Psychoanalysis was as unorthodox as modern art, and Freud as much a Jewish outsider in the Viennese medical establishment as the Jewish artists vis-à-vis the official Salon.[35] Some critics identify Jewish artists in the Ecole de Paris as focusing on the human figure.[36] Not long after arriving in Paris, in 1907, Modigliani noted his psychological preoccupations in a sketchbook: "What I am searching for is

neither the real nor the unreal, but the Subconscious, the mystery of what is Instinctive in the human race."[37] For Modigliani the key to modernism was not a matter of choosing between representation and abstraction, but in penetrating beneath the surface of the subject to reveal hidden depths.

Another Jewish artistic trait was expressed by someone who was, perhaps surprisingly, part of the pre-war Montparnasse Jewish milieu—the Mexican artist Diego Rivera. Rivera spent a decade in Paris, met Picasso in 1914, and during the war entered his cubist phase. Rivera's mother was a converso—a Jew forced to convert to Catholicism. Rivera later wrote, "my Jewishness is the dominant element of my life. From this has come my sympathy with the downtrodden masses which motivates all my work."[38] Rivera was friends with many Jewish artists and voyaged to Spain with Leopold Gottlieb, visited Mela Muter there, and in 1914 was traveling with the sculptor Jacques Lipchitz when war broke out. In Paris, Rivera fathered a daughter by the Russian artist Marevna, whose mother was Jewish. He later married Frida Kahlo, whose father was a Hungarian Jew who had emigrated to Mexico. Kahlo's work also displays the intense inwardness and psychological searching of some of the Ecole de Paris Jewish artists (albeit from a slightly later period; Kahlo was born in 1907). Chagall too painted numerous self-portraits (though not as obsessively as Kahlo) and dual portraits of himself and his wife Bella, as well as psychological studies such as *The Green Jew*. Another contemporary figure, the Jewish mystic Gershom Scholem, highlights the communitarian as well as psychological aspect of Jewish culture: "Judaism . . . has always maintained a concept of redemption as an event which takes place publically, on the stage of history and within the community. It is an occurrence which takes place in the visible world and which cannot be considered apart from such a visible appearance."[39] Like Modigliani, Scholem was connecting the visible and invisible, surface and depth.

Poets who were themselves either foreign-born or fluent in Russian befriended and helped publicize the artists, and sometimes served as their dealers. Max Jacob (also Jewish, from Brittany), Blaise Cendrars (originally Swiss, who had traveled in Russia), André Salmon (who lived in Russia in the 1890s), Canudo, and Apollinaire were particularly important to Chagall. Sonia Delaunay worked with Cendrars and befriended Apollinaire; she illustrated Cendrar's poem "La Prose du Transsibérien" in 1913, which told of his travels in Russia. Modigliani befriended Cendrars and was rescued from poverty by a Polish-born poet named Leopold Zborowski, who had come to Paris to study at the Sorbonne and found a career as an art dealer. Chagall trusted poets more than painters, because they helped him acculturate and posed no threat as competitors. Suspicious and

defensive, he maintained only the most tenuous relations with other painters. In the extraordinary painting he dedicated to Apollinaire in 1913 and called *Homage to Apollinaire*, he inscribed the names Apollinaire, Walden (the German Jewish dealer who put on Chagall's first one-man show in Berlin in June 1914), Canudo, and Cendrars. A painting from 1912 called *To Russia, Asses and Others* was so-named by Blaise Cendrars, with considerable "poetic license" since no donkeys appear in the work. [40]

Sonia Delaunay was particularly adept at breaking down the barriers between fine and decorative art, compromising the integrity of neither in the process. Her painting was at the forefront of Parisian abstraction, as in her 1912 *Contrastes*

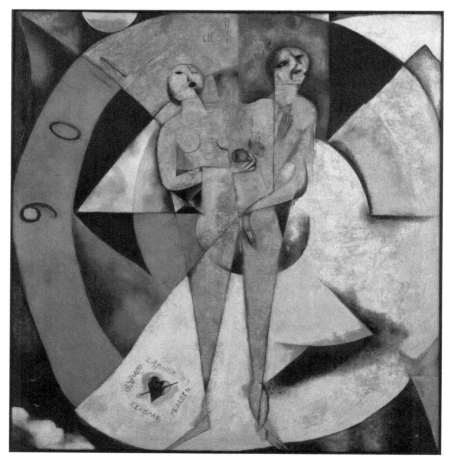

**Figure 2.1** Marc Chagall, *Homage to Apollinaire*, 1913. Stedelijk van Abbemuseum, Eindhoven, The Netherlands. Photo: Peter Cox. 2021 Artists Rights Society (ARS), New York/ADAGP, Paris.

*simultanés*. The following year she produced the extraordinary *Bal Bullier*, 1 meter high and 3⅓ meters long, that shows dancing couples at the popular Montparnasse dance hall amid broken planes of color similar to the work she did on Cendrars' *Prose du Transsibérien* that same year. The next year, *Electric Prisms* featured the circular forms that she and Robert favored to express their conception of simultaneity. She also made herself a *robe simultanée* (simultaneous dress) to wear to the ball; her work was on the cutting edge in more than one sense.[41]

Sonia Delaunay brings us back to Chagall and *Homage to Apollinaire*. In 1913, the year he painted this singular work, Chagall had (unusually for him) befriended the Delaunays. The background of *Homage* appears to be a clock complete with numbers, with the conjoined figures of Adam and Eve in the

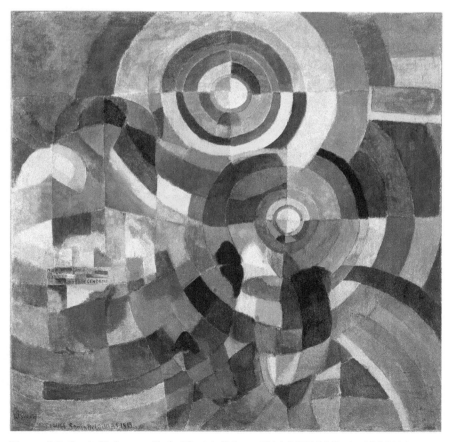

**Figure 2.2** Sonia Delaunay-Terk, *Electric Prisms*, 1914. MNAM Paris, AM 3606. Pracusa 20200824.

center. The painting spirals out from the belly of these primordial figures, as if signifying the unity of male and female as similar to space and time.[42] For once, Chagall painted a clock without representing the pendulum clock in his childhood home. Given the Delaunays' fascination with circular forms signifying simultaneity, it would appear that Chagall allowed himself to be lured into avant-garde artistic speculation, before returning to safer ground. Even so, the figures of Adam and Eve from the Old Testament distinguish Chagall's painting from anything the secular Delaunays might have attempted.

Jules Pascin was the Jewish artist best known to pre-war Parisians. Born Julius Mordecai Pincas in Bulgaria, Pascin arrived in Paris at the age of twenty in 1905 by way of Munich. He continued to frequent German and Scandinavian artists in Paris. Pascin was a "Dômier," meaning an artist who frequented the Café du Dôme on the boulevard Montparnasse. Other German Jewish artists who met their compatriots there were Walter Bondy, a cousin of the philosopher Ernst Cassirer, Georges Kars, and Rudolph Levy.

The circle formed around the charismatic Levy in Munich, who was a decade older; then many of them came to Paris to take classes from Henri Matisse, who opened an art school designed especially for foreigners in 1908. Matisse oversaw the courses until 1911, after which Rudolph Levy took over supervision for another year.[43] Jewish dealers such as Adolphe Basler and Alfred Flechtheim frequented the Dôme too; Pascin would later paint Flechtheim in the incongruous garb of a toreador. Flechtheim popularized the name Dômiers when he staged an exhibition of these artists in Dusseldorf in 1914.[44]

From 1910 on one could see many other artists, including Kisling, Max Jacob, Rivera, and Modigliani, at the Café de la Rotonde, just down the street from the Dôme. These cafés played an important role in bohemian conviviality. Artists could meet to discuss their work while keeping warm, finding refuge from unheated studios where many of them lived as well as worked.[45] A photograph shows Pascin sketching at the Dôme, his black bowler hat perched jauntily on his head, in company with the dealer and critic Wilhelm Uhde, Walter Bondy, and Rudolph Levy, all looking proper in jackets and neckties.[46] One of the few women artists they tolerated in their presence was Hermine David, who would eventually marry Pascin. Other photos show the Swedish painters Isaac Grünewald and Sigrid Hjertén at the Dôme in 1910, who were in Paris to study with Matisse and who later married and returned to Stockholm.[47] Neither David nor Hjertén were Jewish, but their presence reminds us that many women were studying art in Paris in these years, some of whom established careers in the interwar period.

The Armory Exhibition of 1913, which first exposed Americans to European modernism, exhibited several of Pascin's works.[48] Two watercolors sold, for $65 each, as well as several drawings. Other Paris-based Jewish artists who showed works there included Rudolph Levy (1875–1944) and Eugene Zak (1884–1926), and the sculptors Oscar Miestchaninoff (1884–1956) and Elie Nadelman (1882–1946).[49] Pascin never painted scenes from his Balkan childhood, as Chagall would do of Vitebsk. Like Toulouse-Lautrec, Pascin reveled in portraying the vice and depravity he saw around him; like Chagall, he arrived at a definitive version of his artistic style as well as subject matter in these pre-war years, which would not change significantly in the 1920s. His great drawing facility and his preoccupation with female subjects limited his development as an artist. Pascin never seemed to search deeply within himself and so never achieved the power of imagery that one associates with Chagall and Soutine, or the stylistic evolution that one sees in the sculpture of Lipchitz and Zadkine. In 1914, as Europe descended into war, Pascin crossed the English Channel and caught the first available boat for the United States. He became a U.S. citizen in 1920, just before returning to France. Though André Warnod called Pascin "the last incarnation of the wandering Jew,"[50] mobility characterized many Jews of his generation.

In 1914, as Pascin was heading west to explore new lands, Marc Chagall headed east, initially to Berlin for his one-man show, which Herwarth Walden organized at Der Sturm Gallery, then on to Russia to attend the wedding of his sister and to pursue his own romantic interests with his fiancée Bella. Pascin passed six relatively carefree years in America; Chagall spent eight tumultuous years in the East and experienced war, revolution, and the dissolution of the Pale of Settlement. While both artists were back in Paris in the 1920s, the trajectory of their lives could not have been more different, and perhaps led to divergent fates. The restless Pascin died by his own hand in 1930, feeling aged and used-up at forty-five; Chagall survived nearly to 100, and lived his final three decades in Provence, painting until the day he died.

Jules Pascin had been in Paris for nearly a decade by 1914, and his personality as well as his talent assured him of a considerable reputation. By contrast, Chaim Soutine had been in Paris for two years when the war broke out, was eight years younger than Pascin and six years younger than Chagall, and was completely unknown. Soutine would become the foremost exemplar of Parisian expressionism after the war, a style often linked to Jewish artists because of its dark brooding quality. One other immigrant Jewish artist, Mela Muter, had established a significant reputation in pre-war Paris, and has the additional distinction of being "the first professional Jewish woman painter in Poland."[51]

Muter was a decade older than most of the other immigrant artists and arrived in France a decade before Chagall, in 1901. By 1911, when Chagall came to Paris, she already had a studio on the boulevard Montparnasse. Critics such as Florent Fels later compared her style to that of Van Gogh, a comparison later applied to Soutine. Though less avant-garde than Sonia Delaunay, Muter's expressionist style was perhaps more typical of the artists of the Ecole de Paris.

## Mela Muter

Maria Melania Mutermilch, née Klingsland, came from a prosperous Jewish family from Warsaw. After taking private art lessons, she enrolled in the School of Drawing and Painting for Women, which had opened in Warsaw in 1892. That same year, 1899, she married the writer, critic, and socialist Michał Mutermilch, who was also Jewish. She bore her only child in 1900, and the following year they decided to move to France. She took art lessons at the Montparnasse Académie Colarossi, which was open to women, who had equal access to nude models of both sexes. Other artists who studied there somewhat later than Muter were Pascin, Modigliani, his model and wife Jeanne Hébuterne, and Lipchitz.

In the summer of 1901, Mela and her husband and child first visited Concarneau, Brittany, where she would return many times, inspired by the people, landscape, and the art school of Pont-Aven. Paul Gauguin, Paul Sérusier, and other late nineteenth-century artists made southwest Brittany famous. Yet leaving Paris in one's first year there was very unusual for immigrant Jewish artists, for most of whom reaching Paris itself was a sufficient goal. Most arrived with few funds and little French, and the great majority were single men. Muter arrived with a husband and infant son, and with the resources and interest to decamp from Paris to the countryside, though Concarneau was considerably larger than Pont-Aven. She returned to the region often, especially between 1905 and 1911. Though Muter was capable of painting landscapes, it was always portraiture that most interested her, which suggests that she had the means to pay models to pose for her. In the guidebook *Breton Folk: An Artistic Tour in Brittany*, published in London in 1880, Henry Blackburn wrote that the peasants were glad to earn a little extra income by posing for artists, except during the harvest season. In 1880, this might cost as little as one franc per day. "Once or twice a week in the summer, a beauty comes over from Concarneau in a cart, her face radiant in the sunshine, the white lappets of her cap flying in the wind," referring to the *coiffe* or traditional white Breton headgear.[52] A 1906 work by

Muter called *Sad Country* shows a group of Breton peasants waiting for the men to return from a fishing trip. She portrayed them sympathetically but realistically; her style did not become more expressionist until about 1910, when she layered her paint with distinct brushstrokes.[53] At about that time she began to visit Spain, where the old cities such as Toledo inspired cityscapes of houses on hillsides that look vaguely cubist.

Muter's pre-war nostalgia for the archaic, rural, and peasant Brittany and Spain was mixed with appreciation of avant-garde forebears such as Gauguin; both impulses separate her from slightly later Jewish immigrant artists who were attracted unambiguously by Parisian modernity. Muter's urban sophistication led her to Concarneau; artists from Vitebsk and Vilna were unlikely to seek out peasants and fishermen in preference to the Eiffel Tower.

The artist began calling herself Mela Muter in 1907, and showed in many of the major art salons, including at the Salon d'Automne from 1905 on (she was invited to sit on the salon jury in 1921). She received a solo show in Warsaw as early as 1907, only the second such show by a female artist.[54] After a one-woman show in Barcelona in 1911, she showed at the same gallery in 1912 with fellow Polish artists, including Leopold Gottlieb, Eugene Zak, and Elie Nadelman, with a catalog written by her husband. In the years before World War I, Spain replaced Brittany as her artistic preoccupation, perhaps in part because she was able to show as well as paint there. The Catalonians, for their part, identified with Poles struggling for their national independence.[55] Muter was the best known of this party of artists. Her budding expressionist sensibilities led her to appreciate the painting of Goya and El Greco, whose distorted and impassioned forms inspired several of these artists, including Gottlieb.[56] In 1913 she met Diego Rivera in Spain, and painted his portrait (as did Modigliani and Gottlieb; Rivera's considerable presence was hard to resist). She excelled in portraying children and the aged as well as mothers with children. She described one early painting, *Fruits of Pain* (1900–07), as inspired by "an old village woman, with almost sculpted features, carved out by pain. I did not know her life, but looking at this face destroyed by tears, I could not resist repeating in my soul, 'this is the mature fruit of pain.'"[57]

Muter's fascination with peasants and the poor is reminiscent of Camille Pissarro, and the two Jews expressed similar leftist politics, anarchism in Pissarro's case and socialism for Muter. Pissarro was still alive and active when Muter arrived in France; he did his last self-portrait in 1903, not long before his death at seventy-three.[58] Mela Muter added another artistic source of inspiration in Vincent Van Gogh, who never visited Brittany, though Paul Gauguin wrote to

him from there. Gauguin died the same year as Pissarro, not in Paris or Pont-Aven, but in the South Seas, still in pursuit of the primitive.

Muter admitted to being influenced by Dostoyevsky's sympathy for the downtrodden, a connection that would be repeated by a number of interwar French critics. It has been argued that Muter was stereotyped as Dostoyevskian because of her Eastern Jewish heritage; critics even expected her to look like her paintings, and were surprised to discover that she was an attractive woman.[59] At the end of her life, she admitted, "there is no doubt that feelings of certain melancholy, certain sufferings and sadness are closer to me than elegance and happiness," and cited Dostoyevsky again.[60] Her awareness of suffering came not from exposure to pogroms (interwar critics associated Ashkenazi Jews with ghettos) in her privileged Warsaw background, but instead to leftist politics. Her Jewish sensibility empathized with the suffering poor and registered the marks of time on their weathered, worn flesh. If classical and Latin art idealized a timeless stasis, Jewish art was the opposite, pursuing the expressive destructuring of forms.

After the war, Muter's personal life did expose her to suffering. Muter's lover Jules Lefebvre died in 1920 (he drowned on a return voyage from visiting the Soviet Union); her father died in 1922, her only son in 1924. The artist converted to Catholicism in 1923 and became a French citizen in 1927. Given her leftist sympathies, conversion seems like a strange choice, and may have registered her distress at the loss of so many people close to her. It was also a politically wrought period, in that her Polish homeland had become independent again after 130 years and Muter was still a Polish citizen. On the other hand, in 1916 she painted *Mother and Child with Haloes*, showing a non-idealized mother and child in contemporary dress in an urban scene, both with small yellow haloes suggesting Madonna and child. In 1924, the year she lost her tubercular son, she did another mother and baby, this one called *Maternity*, also featuring an older mother, with the mother's breasts exposed and the baby naked in her lap, with no haloes this time. *Maternity* featured a higher vantage point, the mother's worn, solemn face perfectly foreshortened.[61] In the 1930s, the Société des Femmes Artistes Modernes invited her to join, and she showed with them regularly. In 1937, she refused candidacy for the Legion of Honor.[62] Her interwar art mixed evocations of working-class women with society portraits of many well-known people, including musicians such as Honegger, Ravel, and Satie, her fellow Jewish artist Chana Orloff, the German poet Rilke, and several unsmiling self-portraits standing in front of her easel or holding her brushes. If Mela Muter is not widely known today, her career typifies modern artists who were not identified with a

particular movement and were not avant-garde. The maternal theme that characterized much of the work of Muter and the sculptor Chana Orloff was stigmatized as feminine. One feminist critic suggests that the Ecole de Paris specifically included female artists who were outside of the avant-garde movements of purism, dada, and surrealism, and whose figurative styles were more marketable. The focus on a decorative and sensual surface was associated with a feminine style, as was the alternative term to Ecole de Paris, *l'art vivant* (living art), formulated by André Salmon and Florent Fels, and whose 1920s journal by that name included regular coverage of "arts de la femme."[63]

## La Ruche: Immigrant Artists and Revolutionaries

Marc Chagall was not a café habitué like Pascin; we have seen that he preferred the company of poets to that of painters, and they visited him in his studio. This studio complex has become nearly as legendary as the cafés of Montparnasse, and functioned similarly as a primary site of sociability. La Ruche, the Beehive, was a circular building with two floors, the ground floor occupied mostly by sculptors, the upper floor by painters. One of these immigrant Jewish artists, Jacques Chapiro, has told its history. Since he only arrived in Paris in 1925, much of what he wrote was second-hand, and done in part to save the building from demolition in the 1960s. His campaign succeeded, as La Ruche was restored and still serves as an artists' complex today. It was not located in Montparnasse proper, but further southwest at the edge of the city, near the Vaugirard slaughterhouses. Much like the "zone" on the northern edge of Montmartre, this peripheral, liminal space existed beyond the old city walls. La Ruche was the creation of a sculptor named Alfred Boucher, who bought up materials left over from the 1900 Universal Exposition, including the wine pavilion that comprised the central core. Boucher was a follower of the nineteenth-century utopian socialist Charles Fourier, and offered his studio space to artists for very low rents of 100 francs a year, and even that modest sum was treated as optional. By 1910, Chapiro wrote that it included such artists as Fernand Léger, Alexander Archipenko, and Henry Laurens; by 1913, it also housed a large number of Jewish artists, including Pinchus Krémègne, Chaim Soutine, Michel Kikoïne, Isaac Pailès, Isaac Dobrinsky, Léon Indenbaum, Amedeo Modigliani, Marek Szwarc, and Oscar Miestchaninoff. Not all were there at the same time; some, like Modigliani, would come and go, while others stayed for years, well into the 1920s. The studios featured loft bedrooms, no heat, and minimal plumbing.

Chapiro wrote that in the 1920s one heard German, Italian, Spanish, Japanese, Russian, and Polish, and compared La Ruche to the Tower of Babel. Before the war one certainly heard Yiddish there as well. During World War I, many artists left and war refugees moved in. Although electricity was installed in 1925, Chapiro recalled still using oil lamps for light.[64]

Another artist memoir of La Ruche was based on personal experience of life in pre-war Paris. Marek Szwarc (1892–1958) was a Polish Jewish sculptor who lived at La Ruche from 1910 to 1914, when he returned to Poland after war broke out. His *Memoirs between Two Worlds* appeared in Polish in 1954; it was translated into French in 2010. Szwarc arrived with a letter of introduction to another Polish sculptor, Samuel Lipszyc, who Szwarc found was making commercial art paid by the piece, and who had given up on fine art. He devoted a chapter of his book to Chagall, who had become famous by the 1950s when he wrote his memoir.[65] Szwarc, five years younger than Chagall, looked up to him as a more experienced artist. He reported that Chagall painted at night, and said that "Chagall" in Russian meant "he walked." Szwarc asked rhetorically, "where do you travel, solitary man?" suggesting that Chagall was a loner who held himself aloof from his fellow immigrant artists. Szwarc, along with Joseph Tchaikov (1888–1979), created a monthly review of Jewish art they called *Makhmadim*, Precious Ones in Hebrew, which has been called the first periodical of Jewish art. Ten artists collaborated on this homemade journal, which had hectographed drawings but no text. Other artists involved in the project were Polish nationals of the Russian Empire like Szwarc, including Itsakh Likhteinstein, Leo Koenig, and Genrikh Epstein.[66] These artists sought models for artists in the treasures of Jewish antiquity. Chagall did not participate, nor did Soutine, who Szwarc called wild (*sauvage*), and who had the air of a beggar or lunatic, hanging out in cafés in hopes that someone would buy him a café-crème.[67]

A rival group of La Ruche artists to the Makhmadim circle sought different sources of inspiration for the regeneration of Jewish art. These, significantly, were young Jewish sculptors who, given the injunction against graven images, were unlikely to find much precedent in Jewish ritual objects. Ossip Zadkine was at the center of this group, which also included Chana Orloff, who arrived in Paris in 1910 from Palestine, and Léon Indenbaum. Immigrants from the East, they sought artistic inspiration in Near Eastern art, including from the art of ancient Egypt and Assyria.[68] One should add Modigliani to this list, since in these pre-war years he too was a sculptor who was directly inspired by the art of Egypt and Sub-Saharan Africa. Zadkine hosted another artist who was a friend

of his childhood in Vitebsk, Lazar Lissitsky, an exact contemporary who had started his artistic life as a student of Yuri Pen's studio in Vitebsk (along with Zadkine and Chagall). Lissitsky was an artist and graphic designer rather than a sculptor. The time he spent in this milieu awakened his interest in Jewish art and traditions.[69] He returned to Russia and as "El Lissitsky" became a prominent figure in the artistic avant-garde.

One other artist mentioned by Marek Szwarc from these years is David Shterenberg, who Szwarc remembered as quiet and shy, fond of stroking his cat, then saw him again a quarter-century later, the organizer of the Soviet Pavilion at the Paris International Exposition of 1937 and no longer timid.[70] David Shterenberg (1881–1948) studied art in Odessa, Ukraine, before living in Paris for at least six years, some of which he spent at La Ruche. The artist colony housed some writers and revolutionaries including Anatoly Lunacharsky, and the painter Kikoïne, whom the French police classified as a "non-dangerous Bolshevik."[71] Shterenberg along with many other leftists returned to Russia after the Bolshevik Revolution. Lunacharsky became head of Narkompros, the Soviet Commissariat of Enlightenment, which had charge of public education and the arts. In this capacity, Lunacharsky appointed his old La Ruche acquaintance Marc Chagall as Art Commissar for his native town of Vitebsk in 1918, though Chagall did not last long in this role. Lunacharsky made Shterenberg the head of the art section of Narkompros, both because of his distinction as a painter and his left-wing politics—he was a left Bundist, that is, a Jewish socialist. Shterenberg, with his avant-garde French background, defended modern art against the Proletkultists who favored popular propaganda. In 1922, Shterenberg showed his work at an exhibition of Jewish artists in Moscow, a show in which Chagall also participated. He was a leading figure in the Moscow Society of Artist-workers from 1925 to 1931, when the new orthodoxy of socialist realism led to an accusation of formalism.[72] Yet he adapted well enough that at the height of Stalin's purge trials in 1937, he was placed in charge of the Soviet Pavilion in Paris. He survived until his death in 1948. One wonders whether Alfred Boucher, a follower of the French utopian socialist Fourier, knew that some of his renters at La Ruche would be involved in making a real revolution. Diego Rivera lived there too for a while, and drank with Leon Trotsky at La Rotonde a quarter-century before hosting "the old man" in Mexico as Trotsky fled from Stalin's henchmen. Those like Chapiro who only experienced Montparnasse in its Roaring Twenties heyday waxed nostalgic for this less hedonistic, more bohemian, and more radical era.

# From Primitivism to Surrealism

Parisians, artists, and connoisseurs were unusually receptive to foreign influences in the years before the Great War, and readily incorporated exotic styles into their artworks, their clothing, and their home décor. One might even say, the more alien, the better. This was the high point of interest in "primitivism," when the art of Africa, Egypt, and Oceania inspired artists to simplify and abstract their works. The African sculptures viewed in the Trocadéro ethnological museum encouraged Picasso and other cubists to break with representational art. Primitive art also signified vitality and passion, as seen in the fauves' pulsating paintings. Among the Jewish artists, Jacques Lipchitz began collecting African sculptures soon after he arrived in Paris from Lithuania in 1909. Modigliani thought of himself primarily as a sculptor from 1909 to 1915, and according to the Russian poet Anna Akhmatova, his neighbor and lover in 1911, the Egyptian art that he saw at the Louvre obsessed him, as did Baule dance masks from Ivory Coast. His later paintings resemble sculptures, especially in the African-inspired elongated noses. This style did not necessarily endear him to his sitters; Jacques Lipchitz did not care for the wedding portrait Modigliani did in 1916 of him and his wife Berthe.[73]

Art historian Wilhelm Worringer explained how "primitive" art differed from European art in his doctoral dissertation, *Abstraction and Empathy*, which appeared, with perfect timing, in 1907, the year that Picasso began cubism. Much later, Worringer remembered a further Paris connection. In 1905, he was strolling through the Trocadéro ethnology museum in Paris when he encountered the German philosopher Georg Simmel, and later attributed his intellectual breakthrough to this chance encounter.[74] If he encountered Picasso there, he probably would not have recognized him, though the German theorist and Spanish artist were both born in 1881. Worringer argued that primitive art was stylized and abstract, reflecting a distinctive worldview, while post-Renaissance European realism reveled in the beauty of the organic. Primitive peoples did not possess less artistic ability than Europeans did; rather, they expressed different sensibilities based on their inner relation to the world. The British philosopher T. E. Hulme applied Worringer's distinction to the British vorticist movement of 1914, finding apposite Worringer's notion that "the urge to abstraction finds its beauty in the life-denying inorganic, in the crystalline or … in all abstract law and necessity."[75] Expressionists, including Franz Marc and Wassily Kandinsky, took Worringer's book, published in 1908, as a manifesto for their own artistic explorations.[76]

Worringer benefited from the fortuitous coincidence that his book appeared as modernist artists in France and Germany were inspired by primitive art. At the same time, several notable Jewish thinkers became preoccupied with premodern thought, particularly in France, between 1903 and 1913. In 1903, the founder of French sociology, Emile Durkheim (1858–1917), published a book called *Primitive Classification* in conjunction with his nephew, Marcel Mauss (1872–1950), who had himself recently published his *General Theory of Magic*. In 1910, Lucien Lévy-Bruhl (1857–1939) wrote *Les fonctions mentales dans les sociétés inférieures*, which was translated into the more succinct and less pejorative *How Natives Think*. Durkheim responded to this work two years later with his magnum opus, *The Elementary Forms of Religious Life*. The following year, in Vienna rather than Paris, Sigmund Freud (1856–1939) released a volume on ideas he had been toying with since 1908, which he called *Totem and Taboo*. The titles of these books suggest that these were not the work of academic anthropologists, who would not appear on the scene until a generation later.[77] The artists inspired by the African artifacts they saw for sale in dealer Paul Guillaume's gallery immediately after the war were also amateurs in terms of their knowledge of primitive art. Guillaume, whose portrait Modigliani painted during the war, helped introduce collector Albert Barnes to the work of Chaim Soutine in 1922.[78]

The eruption of interest in primitive cultures suggests firstly that in the age of imperialism, contact with and knowledge about non-Western societies was growing. Secondly, recently assimilated Jewish intellectuals of Freud's generation, followed by newly liberated artists in the next generation, found it useful to compare their own ways of thinking and perceiving with that of the peoples of Africa, Australia, and the New World. For Freud, it was to base the Oedipus complex on some primordial totemic ritual; the subtitle of his book was *Several Congruences in the Mental Life of Savages and Neurotics*. He believed he had found the origins of exogamy and totemism in the incest taboo, the origins of civilization in sons' urge to kill their father, whom they deified out of Lamarckian guilt at this act of Ur-violence.[79] A common subtext may have been to locate Jews firmly on the side of modernity. Artists such as Modigliani admired African art in a way that was out of reach of the intellectuals, as their pejorative titles indicate. Durkheim was the most capable of viewing anthropological customs relatively; he argued that each society evolved religious beliefs as needed for social cohesion. In the aftermath of the Dreyfus Affair, secular theories of social order and belief were reassuring to Jewish intellectuals.[80]

**Figure 2.3**  Amedeo Modigliani, *Léon Bakst*, 1917. National Gallery of Art. Chester Dale Collection, 1963.10.173.

The other great exotic influence on pre-war Paris came not from Africa but from Russia. From 1909 until the war, Sergei Diaghilev's Ballets Russes was the toast of Paris. The sets and costumes designed by Léon Bakst (whose real name was Lev Samoilovich Rozenberg), the music of Igor Stravinsky, the choreography of Massine and Nijinsky, all entranced Parisian audiences and sometimes, as in

the famous 1913 début of *Le Sacre du Printemps* (*The Rite of Spring*), the great *succès de scandale* and most overtly primitivist work, outraged them. After amazing Parisians in 1909 with *The Firebird* and *Cleopatra*, Bakst outdid himself in 1910 with *Schéhérazade*, employing colors described as "orgiastic, ecstatic, voluptuous and exuberant."[81] Marc Chagall had studied with Bakst in St. Petersburg. Unable to obtain a legal residence permit, which was required of Jews wishing to live in the Russian capital, he departed for Paris in 1911. When Bakst was departing for Paris in 1910, Chagall tried to sign on as assistant set decorator, but Bakst refused to take him on.[82]

The "East meets West" cultural refrain that pervaded pre-war Paris (and which echoed the military alliance between republican France and tsarist Russia) resonated with the young Jews who had so recently left behind the land of onion domes and icons, none more than Chagall. Unlike Picasso and Modigliani, who by incorporating geometric African conceptions of art into their work liberated themselves from the European artistic tradition, Chagall united the modern and archaic, the Western and Eastern, in his person.[83] Modern art provided him with an entrée back into the Pale of Settlement he had so recently escaped. He did not evolve his modernist style until he arrived in Paris, where he mythicized the site of his origin. When he returned to Russia in 1914, he retained his new style and transferred it to another brave new world with the advent of Bolshevism in 1917. When the fusion of Jewish modernism and communism failed, he returned to France, which became his homeland. He felt his artistic debt to France to such an extent that he told an interviewer in 1924 that he was from Vitebsk "but also was born in Paris."[84] Aside from a brief visit in old age, he never returned to Russia.

In his autobiography, Chagall reports that he visited Diaghilev's ballet to see Léon Bakst and Nijinsky. He even tells us what they were performing: *Le Spectre de la Rose*, sets and costumes by Bakst, choreography by Michel Fokine, which premiered in the spring of 1911.[85] After seeing Bakst at the theater, shortly after arriving in Paris, Bakst visited him at his first Montparnasse studio in June 1911 and, according to Chagall, praised his use of color.[86] In these first months in Paris (his first outside of Russia), Chagall knew few other artists and little French, and so reached out to his old teacher, even though Bakst had discouraged him from coming to Paris. Chagall criticized the ballet for being over-refined, for reaching society "in a slick, sophisticated style" that he contrasted with his own lowly origins as the "son of workers." [87] Nevertheless, in the 1920s, when he returned to Paris and settled into a bourgeois lifestyle with his wife and daughter, he often went to see the Ballets Russes.[88] The encounter with Bakst and the

Russian ballet appears as a seminal experience for the young artist seeking his own place between Russia and the West.

Apollinaire and Cendrars perceived these echoes of exotic primitive Russia in his canvases in 1912 and 1913. In a review of the 1914 Salon des Indépendants in his journal *Les Soirées de Paris*, for example, here is how Apollinaire summarized Chagall's Salon contribution: "Chagall is a very gifted colorist who lets himself go to all that his mystical and pagan imagination suggests to him. His art is very sensual."[89] It is difficult to imagine anyone referring to the overtly Jewish Chagall's "pagan imagination" without conflating his art with that of Bakst (who was also Jewish) and the Ballets Russes. Two Russians, Baroness Hélène d'Oettingen and Serge Jastrebzoff, bought Apollinaire's journal in 1913 and encouraged the Parisian elite to recognize Montparnasse as the new site of artistic fashion. They lived on the boulevard Raspail, which that same year had been extended to cross the boulevard Montparnasse, marked by a ceremony presided over by President Poincaré. They also held salons to which they invited Picasso, Modigliani, Zadkine, Kisling, Max Jacob, and Leopold Survage.[90] Both d'Oettingen and Jastrebzoff participated in the arts under a variety of pseudonyms, including the revealing Jean Cérusse (*gens ces russes*, these Russian people).

Aside from Chagall and Bakst, other Jews involved in the Ballets Russes included financiers recruited by Gabriel Astruc, Diaghilev's producer and the son of a prominent French rabbi, to underwrite the ballet. When Léon Bakst died in 1925, the novelist Paul Morand wrote that his Jewish origins stimulated "the great Israelite audiences that established the success of the Russian Ballet."[91] The French artist and critic Maurice Denis put it more simply in a 1910 diary entry: "*Saison russe: les ballets juifs*" ("Russian season: the Jewish ballet").[92] Since neither Diaghilev, Nijinsky, nor Stravinsky were Jews, Denis' comment perhaps simply registered prejudice against wealthy, culture-conscious Jewish patrons eager to associate with the new vogue from the East. One suspects that Chagall understood the marketing potential of his own origins. Scenes rendered with gritty realism back in Vitebsk now danced with surreal fantasy. Chagall got his chance at set design while working for the Yiddish Theater in Moscow in 1921, and then in American exile when the former Ballets Russes dancer and choreographer Léonide Massine invited him to design the scenery and costumes for the New York Ballet Theater production of *Aleko* in 1942.[93] The point is not that Chagall succeeded in accomplishing three decades later what he could not do in 1912, but that his artistic style was rooted in that moment before the war(s) when he painted on the left bank while the Ballets Russes danced for high society across the Seine.

The Delaunays encountered the Ballets Russes while they spent the war years in neutral Spain and Portugal. In Madrid, they met Diaghilev and Nijinsky, and received a commission for Robert to do the sets and Sonia the costumes for a new version of *Cleopatra*. Léon Bakst had designed the original sets and costumes for the 1909 production, but they had been lost on a South American tour. Diaghilev was pleased enough with the results that he offered them a regular position with the dance company, but they refused, preferring to retain their artistic independence.[94] The Delaunays were ideally positioned to appeal to Diaghilev, since Robert was prominent among the Parisian avant-garde and Sonia was a fellow Russian and had already experimented with clothing design.

Jewish artists, dealers, and collectors thus contributed something unique to the mixture of modernism. When Chagall spoke to the poet and promoter of cubism Guillaume Apollinaire in his studio in La Ruche, deriding most contemporary artistic movements and praising the technical perfection of primitive art, Apollinaire listened and, with Chagall's canvases all around him, came up with the term "supernatural" (*surnaturel*) to describe them.[95] During the war, he would coin a related term, *surréal*, to describe his own 1917 play, *The Breasts of Tiresias*. Apollinaire died in the influenza epidemic at the end of the war, but his new coinage would have a great career after the war when appropriated by André Breton. *Surréalisme* was also the title of a short-lived journal edited by Jewish poet Yvan Goll in 1924.

Yvan and Claire Goll became close friends of the Chagalls in the mid-1920s, and Chagall illustrated their collected poems. Seeing Chagall as a progenitor of surrealism in an iconic work such as *Paris through the Window* (1913) suggests one way in which the Jewish artists of Paris contributed to modernism. Chagall never joined the surrealists, or any other group, but he appreciated that the poet-critic had seen his pre-war paintings as harbingers.[96]

Apollinaire coined the term surrealism during the war; his favorite pre-war term to describe the new art was Orphism, which was synonymous with *surnaturel*. The artists who best embodied this ideal were Robert Delaunay, whose 1912 painting *La Ville de Paris* Apollinaire greatly admired, and Marc Chagall. The poet-critic similarly thought highly of *Paris through the Window*, and put Chagall in touch with Herwarth Walden. *Homage to Apollinaire*, discussed earlier, registers Apollinaire's mystical and alchemical interests, as well as the Jewish kabbalistic idea of the androgyne. Hasidism, which Chagall grew up with in Vitebsk, borrowed this imagery from the kabbala, referring to it as *jichud* or divine unification. The androgyne represented the primeval cosmogonic being, whose separation into male and female led to the creation of humankind.[97]

The circular shape behind the androgyne recalls Delaunay's disks and may emphasize Chagall's ties to Orphism, but it is also a clock, as made clear by the numbers 9, 10, and 11 correctly placed where they belonged on the clock face. The Janus-faced figure in *Paris through the Window* and the double-sexed figure in *Homage to Apollinaire* convey Chagall's experience of living in two worlds, Russia and France, as well as the dualism of external reality and the inner world he was most interested in capturing.

Sculptor Jacques Lipchitz encountered the Ballets Russes at a key moment in his life, when after four years in Paris his work was rapidly evolving toward cubism and increased abstraction. On the eve of the war, Diego Rivera introduced him to Picasso; in the artist's studio, they discussed the sculptural attributes of an African mask.[98] Lipchitz also expressed interest in futurist sculptural experiments, such as Umberto Boccioni's *Development of a Bottle in Space*, though the idea of rendering motion did not interest him as much as "the interaction of forms."[99] In 1913, Lipchitz also did *Dancer*, in which he showed a contrapposto female bronze figure, one sinuous arm placed on her hip, head bent down the other way. The piece is curvilinear rather than cubist. Lipchitz does not directly relate *Dancer* to the Ballets Russes, but the same year he made it, he reports in his memoir that he was present at the famous premiere of Stravinsky's *Rite of Spring*:

> I remember that in my enthusiasm, which was both chauvinistic and a recognition of this ballet's importance, I was applauding wildly when suddenly an old gentleman behind me hit me on the head with his umbrella. Diaghilev's ballets were exceptional, but they were still symptomatic of the tremendous richness and excitement of the artistic life in Paris even during the darkest years of the First World War. We were all going about our work in the midst of this chaos, perhaps conscious that what we were doing represented some of the few marks of sanity in an insane world.[100]

This citation makes it clear why Lipchitz did not connect his sculpture of a dancer with the ballet; he remembered the event nearly sixty years later as taking place during World War I rather than in May 1913. In the same paragraph, he refers to Diaghilev connecting the dance to new experiments in music and the visual arts, and enlisting Erik Satie and Picasso, so perhaps he was conflating *Rite of Spring* with *Parade*, which did appear during the war, in 1917. We will see that Lipchitz became obsessed with translating music into sculpture over the next two decades, so his early involvement with the music of Stravinsky and Satie influenced his career. As he admitted, his Russian chauvinism made him proud of the contributions that his compatriots were making to the culture of

modernism. Ashkenazi artists thought of themselves in terms of their homeland as well as their ethnicity.

The decade beginning in 1905, when Jules Pascin and Sonia Terk arrived in Paris, and ending in 1914, when Marc Chagall traveled to Berlin for his first solo show and continued on to Russia, was the seminal period of artistic creativity for many of these artists. Certainly, many artists did great things in later years: Modigliani's art reached its apogee during the war, Soutine's in the early 1920s.

Lipchitz, only eighteen years old in 1909 when he arrived in Paris, did not fully explore his cubist sculptural style until after 1914. On the other hand, the tension between the primitive and the modern that was so powerful before the war waned during the 1920s, and the lure of financial success tempted artists such as Kisling—who along with Man Ray became Mr. Montparnasse—to produce slick, popular works. Chagall's return to France in 1923 led to many more great works, but he never again made the stylistic leaps that had characterized his pre-war paintings. The works that had been a revelation in 1912 lost their edge, though his career lasted for sixty more years and he was still capable of greatness in works such as *White Crucifixion* of 1938. The same might be said of Robert and Sonia Delaunay, whose pathbreaking art of 1910–14 would lead to repetition and commercialization in later years. In short, as Jewish immigrants acculturated in the 1920s, they tended to lose the tension between two worlds that characterized their early work. As outsiders looking in, immigrant artists had something unique to offer. The history of artistic bohemias, from the Latin Quarter on, shows that eras of genuine creativity—edginess— may be of short duration. Montparnasse was the site of intersecting cultures and inter-penetrating influences. When multiculturalism entered the mainstream in the interwar era, its modernist edge declined.

Chagall's career revived a quarter-century after he left Paris on the eve of World War I. The decade that followed *White Crucifixion*, a painting that registered the trauma of Kristallnacht, the Nazi pogrom of November 1938, was a tumultuous one for Chagall as for Jews in general. We will explore this era in detail in Chapter 8. As Marc Chagall was confronted by the greatest crisis in the history of the Jewish people since the destruction of the second temple in Jerusalem in 70 CE and the dispersion of the Jews from the land of Zion, he rose to the occasion with a series of powerful paintings confronting the Holocaust. As Marc and Bella Chagall were forced to flee their second homeland and find refuge in the United States,[101] history provided Chagall with another period of flux and liminality comparable to the earlier decade between 1911, when he arrived in Paris, and 1922, when he left Russia and its revolution behind. The earlier period proved to be more stylistically

transformative; the later one helped him regain his voice and exploit the symbolic language he had developed to evoke the plight and anguish of his people.

# Notes

1 Sonia Delaunay, *Nous irons jusqu'au soleil* (Paris: Robert Laffont, 1978), 45.

2 Edouard Roditi, *Conversations with European Artists at Mid-Century* (San Francisco: Bedford Arts, 1990), 20 (Chagall interview conducted in 1963).

3 Paula Hyman, *From Dreyfus to Vichy: The Remaking of French Jewry, 1906–1939* (New York: Columbia University Press, 1979), 64, 68.

4 See André Salmon's *Montparnasse: mémoires* (Paris: Arcadia, 2003); Michel Georges-Michel, *Les Montparnos* (Paris: A. Fayard,1924); Ilya Ehrenburg, *People and Life: Memoirs of 1891–1917*, trans. Anna Bostock and Yvonne Kapp (London: MacGibbon and Kee, 1961); Jean-Paul Crespelle, *La vie quotidienne à Montparnasse à la Grande Epoque, 1905–1930* (Paris: Hachette, 1976); Billy Klüver and Julie Martin, *Kiki's Paris: Artists and Lovers, 1900– 1930* (New York: Abrams, 1989).

5 Natalia Goncharova and Mikhail Larionov did synthesize modernism and primitivism back in Moscow, at the same time that Chagall was doing so in Paris, but Larionov had spent time in Paris and both artists were informed of modernist currents in France and Germany. See Jane Sharp, "Natalia Goncharova," in John Bowlt and Matthew Drutt, eds., *Amazons of the Avant-Garde* (New York: Guggenheim, 2000).

6 Hyman, *From Dreyfus to Vichy*, 34.

7 The classic statement of the conservative trend during and after World War I comes from Kenneth Silver, *Esprit de Corps: The Art of the Parisian Avant-Garde and the First World War, 1914–1925* (Princeton, NJ: Princeton University Press, 1989). See also Romy Golan, *Modernity and Nostalgia: Art and Politics in France between the Wars* (New Haven, CT: Yale University Press, 1995).

8 The most notorious of these attacks were two books by Camille Mauclair titled *La Farce de L'art vivant* (Paris: La Nouvelle Revue Critique, 1928 and 1930). The second volume was subtitled *Les Métèques contre l'art français*; "métèques" was the pejorative term for "alien" coined by right-wing ideologue Charles Maurras

9 All of these female artists were long-lived, and survived long past their husbands, living into the 1960s and 1970s, except for Marevna, who died at the age of ninety-two in 1984. Muter died at ninety-one in 1967.

10 An exhibition at the Musée Bourdelle focused on her, titled *Marevna et les Montparnos* (Paris: Paris-Musées, 1985). Though she painted in a synthetic cubist style, she moved toward neoimpressionism between the wars. In her first memoir,

*Life in Two Worlds: A True Chronicle of the Origins of Montparnasse* (London: Abelard- Schumann, 1962), 184–7, Marevna Vorobëv wrote that sometimes men who bought a painting thought they had purchased the artist as well, and that being an unattached young female artist brought numerous problems.

11 Larry Silver, "Jewish Identity in Art and History: Maurycy Gottlieb as Early Jewish Artist," in Catherine Sousloff, ed., *Jewish Identity in Modern Art History* (Berkeley: University of California Press, 1999), 88–9.

12 Maurycy Gottlieb quoted in Ziva Amishai-Maisels, "Origins of the Jewish Jesus," in Matthew Baigell and Millie Heyd, eds., *Complex Identities: Jewish Consciousness and Modern Art* (New Brunswick, NJ: Rutgers, 2001), 64.

13 Samantha Baskind and Larry Silver, *Jewish Art: A Modern History* (London: Reaktion, 2011), 52–6. See also Alfred Werner, "Jewish Artists of the Age of Emancipation," in Cecil Roth, ed., *Jewish Art: An Illustrated History* (New York: McGraw Hill, 1961), 555–9.

14 Artur Tanikowski, "Toward the Philosophy of Work: The Late Paintings of Leopold Gottlieb," *Ars Judaica* 9 (2013): 76.

15 There seems to be some confusion about Leopold Gottlieb's date of birth and family life. His Polish biographer Artur Tanikowski seems confident that Leopold was born on January 3, 1879 and was the last of eleven children, while other sources mention a birth date of 1883 and a family of thirteen children.

16 Tanikowski, "Toward the Philosophy of Work," 83, 84.

17 Edouard Roditi, "The Jewish Artist in the Modern World," in Cecil Roth, ed., *Jewish Art: An Illustrated History* (New York: McGraw Hill, 1961), 807–8.

18 Angelika Wesenberg, "'For Seeing [was I] Born, for Watching Employed,' Max Liebermann's Landscapes and Gardens," in Götz Czymmek and Helg Aurisch, eds., *German Impressionist Landscape Painting: Liebermann, Corinth, Slevogt* (Stuttgart: Arnoldsche, 2010), 53.

19 Barbara Gilbert, "Max Liebermann: A Long and Fruitful Career," in Barbara Gilbert, ed., *Max Liebermann: From Realism to Impressionism* (Los Angeles: Skirball Cultural Center, 2005), 26–9.

20 Peter Paret, "Triumph and Disaster of Assimilation: The Painter Max Liebermann," *Jewish Studies Quarterly* 15, no. 2 (2008): 135.

21 See Ziva Amishai-Maisels, "Origins of the Jewish Jesus," 66, for a discussion of Liebermann's *The Twelve-year-old Jesus in the Temple*. He too was motivated by increasing German antisemitism, which culminated in the founding of the Antisemitic League in 1879.

22 Suzanne Zuber, "Chronology," in Barbara Gilbert, ed., *Max Liebermann: From Realism to Impressionism* (Los Angeles: Skirball Cultural Center, 2005), 204.

23 Paula Hyman, *Gender and Assimilation in Modern Jewish History: The Roles and Representations of Women* (Seattle: University of Washington Press, 1995), 53.

24 Hyman, *Gender and Assimilation*, 24, argues that the feminization of the synagogues in the late nineteenth century paralleled that of the Christian churches.

25 Alice Halicka, *Hier* (Paris: Pavois, 1946).

26 Ossip Zadkine, *Le Maillet et le ciseau: souvenirs de ma vie* (Paris: Albin Michel, 1968); on Delaunay-Terk, see Sherry Buckberrough, *Sonia Delaunay: A Retrospective* (Buffalo, NY: Albright-Knox Art Gallery, 1979).

27 Marevna Vorobev, *Life with the Painters of La Ruche* (London: Constable & Robinson, 1974), 36; reference found in Kenneth Silver, "Jewish Artists in Paris 1905–1945," in Kenneth Silver and Romy Golan, *The Circle of Montparnasse: Jewish Artists in Paris, 1905–1945* (New York: Jewish Museum, 1985), 58, n. 26.

28 Billy Klüver and Julie Martin, *Kiki's Paris: Artists and Lovers, 1900–1930* (New York: Abrams, 1989), 54.

29 Benjamin Harshav, *Marc Chagall and His Times: A Documentary Narrative* (Stanford, CA: Stanford University Press, 2004), 78.

30 Harshav, *Marc Chagall and His Times*, 90.

31 Mason Klein, "Modigliani Against the Grain," in Mason Klein, ed., *Modigliani: Beyond the Myth* (New York: Jewish Museum, New Haven, CT: Yale University Press, 2004), 8.

32 Hugh Ford, ed., *The Left Bank Revisited: Selections from the Paris Tribune 1917–1934* (University Park, PA: Penn State University Press, 1972), 205 (article published June 8, 1930).

33 Edouard Roditi, *Dialogues: Conversations with European Artists at Mid-Century* (San Francisco: Bedford Arts, 1990), 20 (interview with Chagall conducted 1963).

34 Donald Kuspit, "Soutine's Shudder," in Matthew Baigell and Milly Heyd, eds., *Complex Identities: Jewish Consciousness and Modern Art* (New Brunswick, NJ: Rutgers University Press, 2001), 98.

35 Donald Kuspit, "Meyer Schapiro's Jewish Unconscious," in Catherine Soussloff, ed., *Jewish Identity in Modern Art History* (Berkeley: University of California Press, 1999), passim.

36 Eliane Strosberg, *The Human Figure and Jewish Culture* (New York: Abbeville, 2008), 115.

37 Quoted by Mason Klein in "Modigliani Against the Grain," 14.

38 "Conversos: Mexico's Lost Jews," www.jewishvirtuallibrary.org. Rivera's first biographer, Bertram Wolfe, in *Diego Rivera: His Life and Times* (New York: Knopf, 1939), 5, identifies Rivera's grandmother as Ynez Acosta, of Portuguese Jewish descent, who at age seventeen married the fifty-year-old Anastasio Rivera.

39 Matthew Baigell, "Jewish American Artists: Identity and Messianism," in Matthew Baigell and Millie Heyd, eds., *Complex Identities: Jewish Consciousness and Modern Art* (New Brunswick, NJ: Rutgers University Press, 2001); Scholem passage quoted on 183.

40 Blaise Cendrars, *Planus*, ed. and trans. Nina Rootes (London: Peter Owen, 1972; originally Paris: Denöel, 1948), 109, 110.

41 David Cottington, *Cubism in the Shadow of War: The Avant-Garde and Politics in Paris, 1905–1914* (New Haven, CT: Yale University Press, 1998), 179–88.

42 Sherry Buckberrough, *Robert Delaunay: The Discovery of Simultaneity* (Ann Arbor, MI: UMI Research Press, 1982), 149, discusses Chagall in the context of his friendship with the Delaunays. This book alerted me toward this interpretation of *Homage to Apollinaire*.

43 Billy Klüver and Julie Martin, *Kiki's Paris: Artists and Lovers, 1900–1930*, 39.

44 Anette Gautherie-Kampka, *Les Allemands du Dôme: la colonie allemande de Montparnasse dans les années 1903–1914* (Bern: Peter Lang, 1995), 373, 374.

45 See Leona Rittner, W. Scott Haine and Jeffrey Jackson, eds., *The Thinking Space: The Café as a Cultural Institution in Paris, Italy and Vienna* (Farnham: Ashgate, 2013), especially the chapter by Shachar Pinsker, "Jewish modernism and Viennese cafes, 1900–1930."

46 Klüver and Martin, *Kiki's Paris*, 33.

47 Klüver and Martin, *Kiki's Paris*, 30, 31.

48 Horace Brodzky, *Pascin* (London: Nicholson and Watson, 1946), 21.

49 Milton Brown, *The Story of the Armory Show* (n.p.p.: Hirshhorn Foundation, n.d. but probably 1963), 261, 274, 301. See also Marilyn Kushner and Kimberly Orcutt, eds., *The Armory Show at 100: Modernism and Revolution* (New York: New York Historical Society, 2013), 303.

50 André Warnod, *Pascin* (Monte-Carlo: Editions du livre, 1954), 18.

51 Natasza Styrna, "Mela Muter, 1876–1967," *Jewish Women: A Comprehensive Historical Encyclopedia*, March 2009, Jewish Women's Archive, http//jwa.org/encyclopedia/article/muter-mela.

52 Henry Blackburn, *Breton Folk, An Artistic Tour of Brittany*, quoted in Judy Le Paul, *Gauguin and the Impressionists at Pont-Aven* (New York: Abbeville, 1987), 42.

53 Urszula Lazowski, "Mela Muter: A Poet of Forgotten Things," *Woman's Art Journal* 22, no. 1 (Spring/Summer 2001): 22.

54 Catherine Puget, *Mela Muter: la rage de peindre d'une femme* (Pont-Aven: Musée de Pont-Aven, 1993), n.p.; Styrna, "Mela Muter."

55 Artur Tanikowski, "Heralds of moderate modernity: Polish-Jewish artists in Catalonia," in Jerzy Malinowski et al., eds., *Jewish Artists and Central-Eastern Europe* (Warsaw: Wydawnictwo DiG, 2010), 243. A photo on this page shows Witold Gordon, Elie Nadelman, Leopold, Mela Muter, and Michal Mutermilch in Barcelona for the show.

56 Tanikowski, "Heralds of moderate modernity," 249.

57 Muter quoted in Lazowski, "Mela Muter," 22.

58 Le Paul, *Gauguin and the Impressionists of Pont-Aven*, 76–82.

59 Paula Birnbaum, *Women Artists in Interwar France: Framing Femininities* (Farnham: Ashgate, 2011), 80, 81. Birnbaum accuses many French critics of stereotyping Muter, but doesn't mention that the artist herself made the Dostoyevsky connection.

60 Quoted by Lazowski, "Mela Muter," 22.

61 Birnbaum, *Women Artists*, plate 18 for *Mother and Child with Haloes*, 17 for *Maternity*.

62 Birnbaum, *Women Artists*, 78, 80.

63 Gillian Perry, *Women Artists and the Parisian Avant-Garde: Modernism and "Feminine" Art, 1900 to the late 1920s* (Manchester: Manchester University Press, 1995), 95. Perry discusses Muter on 157.

64 Jacques Chapiro, *La Ruche* (Paris: Flammarion, 1960), 15, 25–31, 80, 134–5.

65 Marek Szwarc, *Mémoires entre deux mondes*, trans. Suzanne Brucker (Paris: Ressouvenances, 2010), 254.

66 Aleksandra Shatskikh, *Vitebsk: The Life of Art*, trans. Katherine Foshko Tsan (New Haven, CT: Yale University Press, 2007), 58.

67 Szwarc, *Mémoires*, 245.

68 Shatskikh, *Vitebsk*, 58.

69 Shatskikh, *Vitebsk*, 58.

70 Szwarc, *Mémoires*, 255.

71 Jackie Wullschlager, *Chagall: A Biography* (New York: Knopf, 2008), 150.

72 Sheila Fitzpatrick, *The Commissariat of Enlightenment* (Cambridge: Cambridge University Press, 1970), 122.

73 Klein, "Modigliani Against the Grain," 11.

74 Wilhelm Worringer, "Foreword" to 1948 edition of *Abstraction and Empathy* (New York: International Universities Press, 1948), viii-ix.

75 Worringer, *Abstraction and Empathy*, 4.

76 Neil Donahue, ed., *Invisible Cathedrals: The Expressionist Art History of Wilhelm Worringer* (University Park, PA: Penn State University Press, 1995).

77 Emile Durkheim, *Elementary Forms of the Religious Life* (New York: Oxford University Press, 2001); Marcel Mauss, *General Theory of Magic* (Boston and London: Routledge and Kegan Paul, 1972); Lucien Lévy-Bruhl, *How Natives Think* (New York: Knopf, 1926); Sigmund Freud, *Totem and Taboo* (New York: Nortion, 1950).

78 Klüver and Martin, *Kiki's Paris*, 122, 123, which includes a photo of Paul Guillaume during a visit to the Barnes Foundation in 1926. See John Warne Monroe, *Metropolitan Fetish: African Sculpture and the Imperial French Invention of Primitive Art* (Ithaca, NY: Cornell University Press, 2019), 85-130, for more on Guillaume.

79 Peter Gay, *Freud, a Life for Our Time* (New York: Norton, 1988), 332, 333; Adam Kuper, *The Invention of Primitive Society: Transformation of an Illusion* (London: Routledge, 1988), 110–12.

80 Kuper makes this point in *The Invention of Primitive Society*, 113, 114.

81  Charles Mayer, "The Impact of the Ballets Russes on Design in the West, 1909–1914," in Gail Roman and Virginia Marquardt, eds., *Avant-Garde Frontier: Russia Meets the West, 1910–1930* (Gainsville: University of Florida Press, 1992), 17.

82  Franz Meyer, *Marc Chagall: Life and Work*, trans. Robert Allen (New York: Abrams, 1964), 93.

83  Admittedly, neither Picasso nor Modigliani entirely liberated themselves from European artistic traditions nor fully understood African conceptions of art. Primitivism is rife with cultural misunderstanding.

84  Florent Fels, *Propos d'artistes* (Paris: Renaissance du livre, 1925), 32.

85  Lynn Garafola, *Diaghilev's Ballets Russes* (New York and London: Oxford University Press, 1989), 402.

86  Marc Chagall, *My Life* (New York: Oxford University Press, 1965, 1989), 104–5. Kenneth Silver discusses Chagall's ties to Bakst and the Ballets Russes, in "Jewish Artists in Paris, 1905–1945," 28, 29.

87  Chagall, *My Life*, 104.

88  Wullschlager, *Chagall,* 313.

89  Guillaume Apollinaire, "Le 30e Salon des "Indépendants," 1914, *Les Soirées de Paris*, 1912–14 (Geneva: Slatkine Reprints, 1971), 185.

90  Cottington, *Cubism in the Shadow of War*, 194. See also Frederick Brown, *An Impersonation of Angels: A Biography of Jean Cocteau* (New York: Viking, 1968), 133, 134.

91  Garafola, *Diaghilev's Ballets Russes*, 284.

92  Garafola, *Diaghilev's Ballets Russes*, 284.

93  Wullschlager, *Chagall*, 404.

94  Stanley Baron, with Jacques Damase, *Sonia Delaunay: The Life of an Artist* (New York: Abrams, 1995), 69–72.

95  James Johnson Sweeney, *Marc Chagall* (New York: Museum of Modern Art, 1946), 29.

96  Wullschlager, *Chagall*, 164.

97  Adrian Hicken, *Apollinaire, Cubism and Orphism* (Aldershot, UK: Ashgate, 2002), chapter 5, "Chagall's Homage to Apollinaire (1913–14)," 129–39.

98  Jacques Lipchitz, with H. H. Arnason, *My Life in Sculpture* (New York, Viking, 1972), 7, 8. Since other sources suggest that Rivera met Picasso in 1914, Lipchitz's claim that Rivera introduced them in 1913 might be faulty.

99  Lipchitz, *My Life in Sculpture*, 15

100 Lipchitz, *My Life in Sculpture*, 46.

101 See the essay by Matthew Affron, "Constructing a New Jewish Identity: Marc Chagall, Jacques Lipchitz," in Stephanie Barron, ed., *Exiles + Emigres: The Flight of European Artists from Hitler* (Los Angeles: Los Angeles County Museum of Art, 1997), for a selection and discussion of Chagall's canvases painted between 1938 and 1948.

# Masculinity and Patriotism: Artistic Responses to World War I, 1914–1920

The best-known images of wartime Montparnasse are the photographs taken by the writer and impresario Jean Cocteau on August 12, 1916. These pictures show Pablo Picasso with his current girlfriend, the young model Emilienne Pâcquerette Geslot, the poet and critic André Salmon, the painter and sculptor Amedeo Modigliani, the poet and sometime painter Max Jacob, the Chilean artist Manuel Ortiz de Zarate, and the painter Moïse Kisling.[1] The mood seems festive and bohemian. Salmon, Jacob and Picasso were old friends from the Bateau-Lavoir

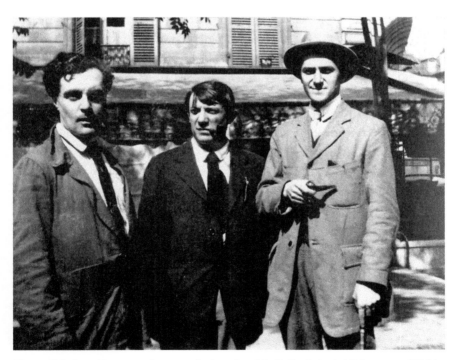

**Figure 3.1** Jean Cocteau, photograph: Amedeo Modigliani, André Salmon, and Pablo Picasso, August 12, 1916. ARS/Comité Cocteau, Paris/ADAGP, Paris 2021.

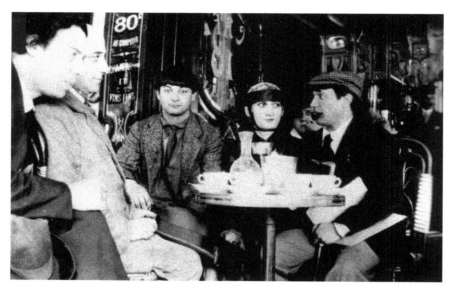

**Figure 3.2** Jean Cocteau, photograph: Moïse Kisling, Pablo Picasso, and others, August 12, 1916. ARS/Comité Cocteau, Paris/ADAGP, Paris 2021.

days in pre-war Montmartre. In 1916, Salmon bequeathed the name *Les Demoiselles d'Avignon* on Picasso's landmark cubist painting of 1907, which it has kept ever since.[2] Modigliani was establishing his reputation as a painter of portraits, soon to include nudes as well, and shared studio space with Kisling during the war. Cocteau had recently met Picasso, and by the time he took these photos Picasso, Modigliani, and Kisling had all drawn or painted his portrait.[3] Cocteau was trying to convince Picasso to design the sets and costumes for the ballet *Parade* based on his script, with music by Erik Satie. Performed in Paris in May 1917 by Sergei Diaghilev's Ballets Russes, *Parade* would be a momentous occasion for Picasso as well as for wartime avant-garde culture, not least because he met and married a Ballets Russes dancer named Olga Khokhlova. Kisling would marry Renée Gros a year after these pictures were taken, with three days of festivities following the wedding. For his part, Modigliani would meet Jeanne Hébuterne in 1917, who would be the (last) love of his life. One would scarcely know that the bloody battles of the Somme and Verdun were raging not far away on the Western Front. Nor would one know that Picasso, Modigliani, Ortiz, and Kisling were foreigners residing in Paris, or that Modigliani, Kisling, and Jacob were Jews. These photographs and *Parade* signify that the first wave of wartime enthusiasm and chauvinism was waning, and that artists were eager to resume their lives and careers.

The artists met at the Café de la Rotonde on the boulevard Montparnasse that Saturday afternoon in the summer of 1916, then crossed the street to dine at Chez Baty. They returned for coffee at La Rotonde, and then ambled down the street as Cocteau shot his pictures. Pâquerette, wearing a stylish outfit, was a model for the couturier Paul Poiret, who also supported the avant-garde art scene. The month before, Poiret had hosted the most important wartime modern art show in Paris at the Salon d'Antin, in which all of these artists had participated. Max Jacob had read a poem there, "Christ à Montparnasse" (though born a Jew, Jacob would convert to Catholicism and eventually retreat to a monastery). Salmon and Modigliani did not dine with the others and arrived late, possibly after eating at Modigliani's favorite restaurant, Chez Rosalie, run by a fellow Italian, Rosalie Tobia. Kisling and his dog Kouski left early; he may have alerted Modigliani about the gathering. By August 24, Cocteau and Satie announced that Picasso had agreed to Cocteau's entreaties and would create the sets for the ballet.[4]

Remembering these wartime years nearly forty years later, Jean Cocteau underscored the transnational nature of this milieu with the phrase "international patriotism" (see Introduction, 4).[5] Cocteau does not underline the fact that Picasso, Ortiz, and Modigliani remained in Montparnasse during the war because they did not have to enlist, as so many French artists including Léger and Braque did. It could be uncomfortable for young men of fighting age to remain in Paris, especially when their art seemed alien and hostile. Critics began spelling cubism with a "k" to make it appear Germanic. Yet Cocteau emphasized the positive aspect of allegiance to the world rather than the nation. He recalled, "this revolution took place in very strange circumstances in the middle of the 1914 war, a war so strange that while we had our posts at the Front we moved backwards and forwards between the Paris front and the fighting front."[6] Cocteau included himself and the poet-critic Guillaume Apollinaire in this category, in order to show that there was interplay rather than opposition between the front and the capital. He could have added that Kisling, Apollinaire, and Cendrars had all returned from the front after being wounded in action.

World War I disrupted the Parisian art world during one of the most intensely productive periods of modern art. No decade has witnessed more fertile artistic movements, from fauvism and cubism, analytic and synthetic, to expressionism, futurism, and orphism, than the years from 1905 to 1914. At this same time, Montparnasse replaced Montmartre as the center of modern art and bohemian culture. The great era of the Bateau Lavoir, birthplace of cubism, ceded to that of La Ruche and other left-bank studio complexes. When Picasso crossed the Seine

from the right to the left bank in 1911, moving into a studio across from the Montparnasse Cemetery, Montmartre's artistic centrality was over. If Montparnasse's ascendancy began around 1910, Cocteau is suggesting that despite appearances it did not cease with the war, but continued through the war years, which was only possible because it contained so many foreign-born and female artists who were not subject to the draft. Most of the young Jewish artists who arrived in pre-war Paris did so in the five years between 1909 and 1914, and many were neither ready to return home nor eager to fight in the Russian army, which is where they would have wound up if they had repatriated themselves. What continuity existed between the pre-war and wartime artists of Montparnasse did so largely because of expatriate or immigrant artists, of whom the young Jewish artists formed a sizeable contingent. They helped ensure that modernism continued during the war years. Since the Russian Revolution broke out during World War I and influenced the lives and careers of a number of Jewish artists, either because they were socialists or because they were from Russia, it makes sense to include the years of revolution with those of the war. The death of Modigliani, in January 1920, was the watershed dividing the early bohemian years of Montparnasse from the high life of the 1920s, and so fittingly concludes the era.

Jewish artists, along with other foreign-born artists such as Picasso and Juan Gris, continued the trajectory of avant-garde art that the war interrupted in 1914. Modigliani, Rivera, and Lipchitz, for example, would make great artistic strides between 1914 and 1920. They also remained committed to modernism and seemed relatively unaffected by the nationalist and military currents sweeping through war-torn Europe. Like dadaist Zurich, wartime Montparnasse resisted the siren song of nationalism; in both locales, Jews played prominent roles. The putative founder of dada, Tristan Tzara, né Samuel Rosenstock, was a wartime refugee from Romania, along with fellow Jewish artist Marcel Janco. Vladimir Lenin was another revolutionary figure who found refuge in neutral Zurich; before the war he too could be found in the cafes of Montparnasse, along with other Russian revolutionaries, including Trotsky and Lunacharsky. The war years were not wholly sacrificed to nationalism and bellicosity.

These names highlight the international make-up of the Parisian art world in 1914, for among the artists mentioned above, only Fernand Léger and Georges Braque were French. Modigliani and Pascin were Sephardic Jews; most of the other art students were Ashkenazi Jews from the Yiddish-speaking enclaves of Eastern Europe. The area stretching from the Baltic Sea to Ukraine known as the Pale of Settlement was part of the Russian Empire, though many of these Jewish

artists would not have called themselves Russian. Jacques Lipchitz, Pinchus Krémègne, and Michel Kikoïne were Lithuanian Jews (known as Litvaks); Marc Chagall, Chaim Soutine, and Ossip Zadkine were Belorussian (now known as Belarus); Sonia Delaunay-Terk, Chana Orloff, Mané-Katz, and Isaac Pailès were Ukrainian; Moïse Kisling, Eugene Zak, Louis Marcoussis (Ludwik Marcus), Simon Mondzain, and Henri Hayden were Poles. These immigrants experienced war differently from a purely French contingent of avant-garde artists. Nationalism had been growing in the years before World War I, yet had little impact on bohemian Montparnasse; then the war enormously magnified nationalist tensions. Immediately all of the German artists working in Montparnasse repatriated themselves. So did artists from the Austro-Hungarian Empire. The Czech artist Emil Filla (1882–1953) reported that foreign artists who frequented the Dôme Café, identified with Germans, could risk beatings. Filla and the Prague Jewish artist Georges Kars took a train to Belgium, reportedly traveling there with Adolphe Basler and Jules Pascin. Kars returned to Prague and spent the rest of the war serving with the Austrian army. Another Czech Jewish artist, Otto Gutfreund, decided to remain in France, and along with his fellow national, painter Frantisek Kupka, volunteered for the French Foreign Legion. Kars returned to France in 1919.[7] Artists who were citizens of nations that were either neutral or allied with France were in less immediate danger. Unlike French artists who faced conscription, immigrant artists had to decide how they would respond to war in a foreign land.

The young male Jewish artists could repatriate themselves, which likely meant fighting for their homeland, or join the French war effort. They could also choose to avoid the war, by either remaining in France as civilians or by finding refuge from the maelstrom elsewhere. Aside from the existential choice of participating in the war, they also had to decide whether to represent the war in their art, and if so, how? Though less immediately affected by war, the lives of female artists also changed. The responses to the challenge of being foreigners in wartime Paris varied enormously, from fleeing to neutral Spain and Portugal (the choice of Robert and Sonia Delaunay) to fighting on the Western Front. Few of the Jewish artists residing in Paris (with the exception of Marcoussis—who was exceptional in a number of ways) fought in the war without having some compelling reason to do so. Those from neutral countries, such as Diego Rivera (Mexico), stayed in Paris. So did most of those with Russian citizenship, like Jacques Lipchitz, Chaim Soutine, Pinchus Krémègne, and Michel Kikoïne. The situation was more complicated for Polish Jews who, we must remember, lacked a homeland of their own. Prussia (later Germany), Austria, and Russia

partitioned Poland at the end of the eighteenth century, and Poland disappeared from the political map of Europe until it was recreated by the Versailles Treaty in 1919.

Foreigners residing in France had an unusual option that, by 1914, was widely recognized: they could join the French Foreign Legion. King Louis-Philippe created the Legion in 1831, and during the nineteenth century it helped to expand and protect the growing French colonial empire. Enlistees were required to adopt pseudonyms, which reinforced the unit's reputation as a place where men could forget past mistakes and renew themselves. Instead of the standard motto on French military regimental flags, *honneur et patrie*, Legion flags bore the motto *honneur et fidélité* (honor and loyalty rather than honor and country). A historian of the Legion puts its reputation on the eve of World War I less kindly: the French government ghettoized foreigners "in a unit perceived to be ... a holding pen for marginal social elements."[8] Despite this reputation, the many Jews who had come to France fleeing pogroms in Eastern Europe enthusiastically volunteered. Poet Scholem Schwartzbard composed a song comparing Jewish volunteers to the Maccabees (heroes of resistance against the Hellenistic ruler of Israel, Antiochus, in 168 BCE, remembered in the holiday of Hanukkah).[9] Thirteen years later, Schwartzbard stood in the dock for killing the former hetman of the Ukraine, Simon Petliura, in a trial known as *Le Procès des pogromes* (trial of the pogroms). He was acquitted of the murder because he had acted like a courageous Frenchman, proof of which was the Croix de Guerre he had been awarded for his service in the Legion.[10] Poet Blaise Cendrars, a Swiss citizen who issued a call to his fellow foreign intellectuals to join up on August 1, 1914, wrote that most of the volunteers were small tradesmen and artisans, "plus a few intellectuals from Montparnasse who, like me, were enchanted by the obscene language of these exhilarating companions and their enchanting exuberance."[11]

Those Jewish artists who returned to Russia or Ukraine in 1914, including Chagall, Mané-Katz, and Isaac Pailès, evaded fighting for mother Russia. Nearly all the rest were either pro-French or remained neutral. Yet pro-German sentiment was strong among one large community of Jewish immigrants: those who had fled the Russian Empire and emigrated to the United States in the three decades before World War I. Russian Jews had little love for the government of the tsar, the most overtly antisemitic regime in the world. Many Jews had fled pogroms in their homeland and did not favor any country siding with the tsar. The German government recognized this fact and encouraged it, while the French Jewish Consistory sent Victor Basch, professor at the University of

Rennes, to the U.S. to win over his co-religionists to the Franco-British-Russian side.[12] As late as December 1916 the American Yiddish press remained pro-German, and with good reason.[13] Hundreds of thousands of Jews who lived in the Pale of Settlement in western Russia became refugees, forced out of the homes by the tsar's armies.[14]

A family story reinforces the sense of crisis faced by Ashkenazi Jews. My grandfather arrived in the U.S. in 1912, intending to save enough money to send for his family. The war intervened, the money he sent to Poland was stolen, and my grandmother and her four children were stuck there for the duration of the war. Though she did not have to evacuate, she told how of all the armies coming through their village in northeast Poland, the Germans treated the Jews best. The most feared were the Cossacks; when they rode through the village, the Jews hid in their cellars. My aunt, born in 1910, would tell this story ironically in the aftermath of World War II and the Holocaust, but we never really understood how bad it was for Jews suspected of being traitors by the Russian military, and whose Yiddish language sounded like German. The family reunited in Chicago in 1920, and my mother was born there three years later to parents well into their forties.

## Jews and Masculinity

The interwar journalist and novelist Joseph Roth oversimplified Jewish emigration to America when he suggested that most such emigrants had received their call-up papers and decided to leave Russia or Austria rather than serve in the military. Nevertheless, it was an oft-told story that Jewish men faced a grim fate if they served in these Eastern armies, and many did leave to avoid military service.

Roth wrote in the 1930s, "If Eastern Jews weren't quite so timorous, they could take justifiable pride in being the most antimilitaristic people in the world."[15] Roth explained further that serving the tsar or emperor meant bearing arms on the Jewish Sabbath, breaking kosher dietary laws, as well as being subjected to antisemitic hostility on all sides. Eastern Jewish tradition celebrated the scholar and rabbi as male models of behavior and rectitude, rather than the warrior image of the knight held up as an exemplar for mainstream European masculinity. Jewish men who were not cerebral were mercantile, yet neither rabbis nor merchants were deemed robust and were even seen as effeminate.

After losing disastrously to the Prussians in 1870–1, then finding their country surpassed economically and demographically by the new German

Reich, the French Third Republic formed during the Franco-Prussian War was afflicted by a pervasive fear of decadence. The sense of decline was abetted by economic depression, which lasted on and off until 1896, by political crises such as the Panama scandal which included some prominent Jewish bankers, and by a wave of anarchist bombings that culminated in the assassination of the president of France in 1894. Captain Alfred Dreyfus (1859–1935) became the most famous man in the world in this context.[16] Dreyfus pursued a military career as if to underscore that all roads were open to Jews in France, but instead of being welcomed as a patriot, he was accused of treason. Antisemites perceived Dreyfus as lacking vitality and courage, as being weak and nervous. His Jewishness undermined his manliness.[17] If serving on the French general staff did not suffice to prove a Jewish man's virility, what hope was there for less martial Jews?

Jewish male roles, whether scholarly, mercantile, or professional, rarely included physicality. None of these professions would have helped young Jewish artists express their masculinity. The nearest equivalent to an artist would have been a café intellectual or writer, though working with brush or chisel was more tactile and artisanal than creating with a pen. Art remained a largely male sphere, as artists such as Marevna Vorobëv ruefully acknowledged, and French artists such as the sculptor Auguste Rodin projected a hyper-masculine image. Mainstream artists such as Rodin who received commissions from the state were distant from bohemian artists existing in poverty on the fringe of society. Young Jews must have found their roles to be even more tenuous, given what little place was accorded to artists in Ashkenazi society. Acculturation into French society and assumptions about standards of manliness help explain the war-era behavior of two Jewish artists, Moïse Kisling and Leopold Gottlieb.

Historians of gender roles go further in showing how Jews were stigmatized, arguing that Jewish men were grouped with homosexuals in the nineteenth century as marginalized outsiders and "countertypes" who helped mainstream European society construct its own image. The antisemitic, self-hating Austrian Jew Otto Weininger was yet more extreme in connecting hatred of Jews and women in his influential 1903 book, *Sex and Character*. Weininger was unable to enjoy the notoriety of his misogynist thesis, since he killed himself, aged twenty-three, a few months after his book came out.[18] Weininger did not want to live in an age when, as he put it, "Judaism is the spirit of modern life . . . Our age is not only the most Jewish, but the most feminine."[19] Reinforcing the argument that diasporic Jews failed as men, the nascent Zionist movement in the 1890s argued that only by reclaiming the land of Israel and working the land could effete

coffeehouse Jews turn into "muscle Jews." Max Nordau, second in command to the Zionist leader Theodore Herzl, was especially eager to promote a tough new Jewish manliness. Even before he became a Zionist stalwart, he was famous for his 1892 book, *Degeneration*, which equated most modern art and literature with madness and degeneracy. His subsequent embrace of Zionism as Jewish nationalism, the political corollary of his critique of Western society, bore some similarity to right-wing nationalists who sought regeneration through politics.[20] The early Zionists sponsored Jewish sports societies to build up their muscles and overcome their alleged nervousness. Sigmund Freud would locate Jewish male uncertainty and ambivalence in a castration complex fostered by the traditional practice of circumcision, which he even identified as "the deepest unconscious root of antisemitism."[21] One does not have to accept Freudian psychology to see how pervasive Jewish concerns over masculinity were in this period.

The founder of Zionism himself advocated the "strictest traditions of chivalric honor" for his Westernized beau ideal.[22] In Dreyfus-era Paris in the 1890s, Theodor Herzl had the opportunity to see many Jews defending the honor of their "race." Particularly vulnerable, and eager to defend their honor, were the 300 Jewish members of the French officer corps. The most famous and tragic duel in this era was fought by Captain Armand Mayer and the antisemitic Marquis de Morès. Morès ran Mayer through with his sword in 1892, before the Dreyfus Affair but in response to a rising tide of antisemitism fostered by Edouard Drumont's scurrilous newspaper, *La Libre Parole*. In 1912, the future socialist political leader Léon Blum fought a duel with the playwright Pierre Veber, and only missed killing Veber because his sword struck the playwright in the sternum. In accepting to fight such duels, antisemites who denied that Jews could be true Frenchmen were conveying a de facto message of equality on the field of honor.[23]

Nearly all of the Jewish artists who arrived in Paris before World War I were young and single. Many who left behind the limitations of the Pale of Settlement also left a repressive patriarchal society in which their fathers did not encourage their artistic careers. Yet several of these artists married during the war, implicitly trading their former bohemian lives for a more settled existence. Marc Chagall married his fiancée Bella in Russia in 1915; Jacques Lipchitz and Moïse Kisling married later in the war, as did Chana Orloff. Even the arch-bohemian Modigliani had a child by Jeanne Hébuterne and might have married if death had not intervened in three lives, including that of their unborn second child. Marevna began an affair with Diego Rivera during the war and bore a child with him in

1919, but he returned to Mexico two years later and she raised their child by herself. Jules Pascin returned to Paris after the war married to another artist, Hermine David. Zadkine and Mondzain married soon after the war ended. The major figure who did not follow this pattern was Chaim Soutine, who never married and had no stable relationship until he was in his mid-forties. This assumption of masculine responsibility during wartime suggests that while many men demonstrated their virility on the battlefield, these artists did so domestically. Some, like Kisling, reaped the rewards of military valor, while others found a more traditionally Jewish way of establishing manhood.[24]

Kisling arrived in Paris aged nineteen in 1910, where he moved into the Bateau Lavoir about the time that Picasso was leaving, but soon followed Picasso to Montparnasse. Kisling was a colorful character with an exuberant personality. His most famous exploit before the war involved not art but the duel he fought on June 12, 1914 with fellow Polish Jewish artist Leopold Gottlieb for reasons that remain unclear. They began with pistols and finished with sabers. The duel ended after an hour of combat when Kisling wounded Gottlieb on the chin, and who in turn managed to slash Kisling across the nose. Kisling evidently was not injured seriously, since he was ready with an insouciant quip—he referred to his

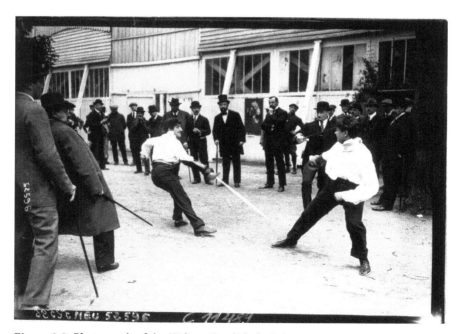

**Figure 3.3** Photograph of the Kisling–Gottlieb duel, June 12, 1914. Agence Meurisse, Bibliothèque Nationale de France.

slashed nose as the fourth partition of Poland. He and his friends went out to drink to his survival as well as his panache.[25] The duel was well documented photographically, including close-ups of Kisling's slashed nose, suggesting that the escapade may have been as much a publicity event as a serious conflict. The bohemian British expat artist Nina Hamnett reported that the duel was shown on that evening's newsreels, so even though it had nothing to do with defending the honor of Jews and was a purely private affair, the duel was deemed newsworthy.[26] This duel, fought on the eve of the war, must have been one of the last such duels of the *avant-guerre*, in an era that abounded in them. Since both duelists would soon be fighting in the war, albeit on opposite sides, their combat suggests that they took the masculine cult of honor and violence as seriously as had Léon Blum two years earlier. No stunt more than a duel fought at dawn could have made its immigrant participants appear as true Frenchmen. And since they invited reporters and photographers to record the event, they took no chances of having their escapade misinterpreted.

## Jewish Attitudes to World War I

A month after the February Revolution in 1917 toppled the tsar, 20,000 Jews marched to Madison Square Garden to celebrate the democratic revolution.[27] Civil emancipation of Russian Jews followed on April 2, 1917; four days later the U.S. declared war on Germany. Though radical Jews still opposed war, most moderate Jews were enthusiastic, as were French Jews. At the end of 1917, the Balfour Declaration announced official British support for the idea of a Jewish homeland in Palestine. In December, General Allenby led British troops into Jerusalem, making the Balfour Declaration seem more realizable.[28] The year 1917, which began with the end of tsarist autocracy and concluded with the triumph of Zionism, took on a messianic quality for many Jews.[29] The U.S. remained neutral until after the February 1917 Revolution that toppled the tsar; when the U.S. joined the war two months later, there was no question of divided allegiances. The exceptions were leftist Jews such as Emma Goldman and Alexander Berkman who opposed conscription and war, and they were acting as anarchists or communists rather than as Jews.

Native-born French Jews had no such ambivalence; most felt strong bonds toward the first country to emancipate the Jews of Europe and harbored no second thoughts about the Russian alliance. French Jews went to the front in the same numbers as other Frenchmen. Grand Rabbi Abraham Bloch stood for

French Jewish patriotism. Bloch was killed on August 29, 1914 in the Vosges, shortly after bringing a crucifix to a dying soldier who had requested one, apparently mistaking the rabbi for a priest. Maurice Barrès, in *Les Diverses Familles Spirituelles de la France*, cited this story as the perfect expression of human goodwill.[30] The war helped efface the antisemitism of the Dreyfus Affair; Alfred Dreyfus himself returned to military service, attaining the rank of lieutenant colonel. Jews along with Protestants and Freemasons had been among the strongest supporters of the Third Republic, and craved acceptance into the community of the *patrie*, and they flocked to enlist.[31] On August 3, 1914, an appeal from the Federation of Jewish Societies went out calling for immigrants to show their French patriotism, saying, "if we are not Frenchmen in law, we are so in heart and in soul." The Jewish captain who cited this call to arms in 1919 estimated that of 30,000 Jewish immigrants who resided in Paris in 1914, 4,000 signed up for the French Foreign Legion.[32] An estimated 8,500 foreign Jews fought for France, and comprised a quarter of all foreign volunteers in 1914–15.[33] The death rate was steep; 1,600 Jewish volunteers perished, among the 7,500 Jews who died in French uniform.[34]

Despite all the talk of the Union Sacrée and former anti-Dreyfusards like Barrès recognizing Jewish contributions to the war effort, antisemitism did not simply dissolve on the Western Front. Hostility toward Jewish soldiers was most evident in the only regiments that accepted foreign volunteers—the Foreign Legion. One Ukrainian-born Jew who served in the Legion wrote in his Yiddish-language memoir that "escaped criminals, liberated prisoners, thieves, drunkards, men who had lost their human feelings . . . sought to lose themselves in the Legion . . . Their only duty was to obey a terrible inhuman soldierly discipline."[35] Jewish volunteers such as Sholem Schwartzbard, author of this statement, heard repeatedly that the Jews had enlisted for the army food, not for fighting. When legionnaires heard Jews speaking Yiddish, it sounded to them as if they were speaking the language of the German enemy. After the Battle of Carency in May 1915, a rumor spread that volunteers could choose to fight in regular French army units or for Russia. Large groups of both Jewish and non-Jewish soldiers refused orders to move up to the front, and demanded transfers to the regular army. This refusal of orders resulted in courts-martial, leading to nine executions and over twenty prison terms for Jewish legionnaires. When news of the executions reached Paris, foreign-born Jews were discouraged from volunteering to fight. That summer the French government decided to investigate these foreigners, and threatened to deport to Russia those who refused to volunteer. Some Jews left for Spain or the United States.[36] In such an atmosphere,

it is scarcely surprising that those Jewish artists who had not signed up in the first rush of enthusiasm in 1914 remained in their studios or headed to the south of France to escape the privations of the war.

Most immigrant artists neither left France nor fought in the war, but stayed in Montparnasse. The outbreak of war found Jacques Lipchitz, a Russian national, traveling in Spain with Diego Rivera, the Mexican artist who identified himself as Jewish. They returned to Montparnasse before the end of 1914, though Lipchitz later admitted to feeling some guilt at avoiding fighting for either Russia or France. He was not badly off financially, since there was a moratorium on rents, while artists who had works accepted for the salon received meal tickets. Toward the end of the war, a piece of shrapnel from the huge German cannon Big Bertha fell in his studio, prompting him to leave Paris for a while.[37] Lipchitz and Rivera were both cubists at this point in their careers and shared the same dealer, Léonce Rosenberg, who had taken over the role of promoter of cubism from another Jewish art dealer, Daniel-Henry Kahnweiler, forced to leave France due to his German nationality. In his wartime letters to Rosenberg, Lipchitz sounded more incommoded by the war than he revealed in his memoirs. In his letters, he complained frequently about the cold; for a good portion of the winter of 1916, the lack of coal made it too cold for him to work in his studio. He reiterated this complaint in the winter of 1917, writing that the cold and lack of coal was Parisians' dominant obsession.[38] One presumes that it was not much warmer in the trenches, and likely much wetter. He found warmth and good food at Gertrude Stein's regular receptions, which he began to attend in the war years. Like Picasso, he did Stein's portrait, but though he hoped she would buy the bronze head he did of her, she never did.[39]

Jacques Lipchitz took full advantage of his non-combatant status to make great strides in his art. The outbreak of war found him experimenting with simplified forms, as in his *Dancer* of 1913. During the war, he turned to an abstract and geometric style that made him the foremost cubist sculptor by the interwar period. His style would remain cubist throughout the 1920s, and only evolve toward less geometric forms in the 1930s. Lipchitz's and Rivera's adoption of cubism during World War I contradicts the assertion of the foremost art historian of the wartime avant-garde, Kenneth Silver, who argues that cubism was branded as a foreign, Germanic style and that artists such as Picasso who remained in Paris turned away from it during the war.[40] Silver also cites a letter to the newspaper *Le Pays* in the summer of 1918 by artists who identified themselves as cubist sculptors and painters, who distanced themselves from Guillaume Apollinaire's play *Les Mamelles de Tirésias* and the avant-garde

wartime journal *Sic*. Of the eight artists who signed the article, six were foreigners; of them four were Jews, including Lipchitz and Kisling (though Kisling was not really a cubist).[41] Aside from signaling divisions in the avant-garde of Montparnasse, this letter suggests the disproportion of foreign vs. French-born artists in Paris, and also these cubists' desire to disavow the new style that Apollinaire (himself in uniform) was already terming surrealist. Silver also argues that "aesthetic conservatism at home" contrasted with avant-garde styles at the front. He explains that though Paris and the front were less than 75 miles apart, "they were absolutely separate worlds."[42] While there is some truth in this, Cocteau's reminiscences belie this contention. More importantly, the initial wave of patriotism that made it uncomfortable for non-combatant males of military age to be on the streets of Paris in 1914 gradually abated, so that by 1916 and after, the avant-garde regained its footing.

The hardships of wartime Paris that filled his letters did not cause Jacques Lipchitz to neglect his personal life. Like Marc Chagall, home in Vitebsk or else in Petrograd, Lipchitz married a Russian woman during the war. His friend Modigliani celebrated the union with a now-famous dual portrait of Jacques and Berthe Lipchitz. As Modigliani turned from sculpture to painting around this time, he did portraits of many of his fellow Jewish artists during the war. After Kisling returned from active service (Modigliani had been rejected for military service due to ill health and would die of tuberculosis in January 1920), he and Modigliani shared a studio and did portraits of each other. The fact that Modigliani did so many wartime portraits of fellow Jewish artists suggests either that they were available because they were not away at war, or that he associated them as part of his inner circle of Montparnasse-based Jewish artists—probably both. Modigliani turned from sculpture to painting around 1914, and thus produced virtually his entire oeuvre during and immediately after the war, since he died not long after the war ended. This work included only two genres, portraits and nudes, all painted either in Montparnasse or on sojourns to the south of France.

Modigliani moved around in these years rather than remaining at La Ruche, perhaps because the "Beehive" was located inconveniently at the southern edge of Paris. Chaim Soutine, who only arrived in Paris in 1913, did remain at La Ruche and volunteered for home front service, then worked at the Renault factory with other Jews who lived at the La Ruche artists' colony, such as Isaac Dobrinsky. The government forced the owner of La Ruche, Alfred Boucher, to take in war refugees, but some artists remained, including the Lithuanian-born Pinchus Krémègne and Michel Kikoïne.

## Women in Wartime

Female artists had fewer pressures on them in wartime, though the shrunken art market affected them equally. The Russian Marie Vasiliev set up a cheap cantina, much appreciated by her fellow artists; her compatriot Marevna Vorobëv also remained in Montparnasse. Marevna painted still-lives in the synthetic cubist style. In 1917, she painted a powerful response to the war: *Woman and Death*. Also called *Prostitute and Dead Soldier*, it showed male and female figures seated around a table with two glasses, but neither figure seems likely to be drinking. The male figure in a blue uniform and kepi has a skull for a face, while the female, stylishly dressed in a low-cut polka-dot dress is wearing a gas mask.[43] Such a jaundiced portrayal of the war represents attitudes toward the end of the cataclysm, when exhaustion and cynicism had replaced the earlier enthusiasm.

**Figure 3.4** Chana Orloff, *The Kiss, or The Family*, 1916, bronze. MAHJ98.6.2. Photo: Jean Gilles Berizzi. RMN-Grand Palais/Art Resource, New York. 2021 Artists Rights Society (ARS), New York/ADAGP, Paris.

Alice Halicka, whose husband, Louis Marcoussis, was off at the front, also explored cubism, though with no political connotations. The canvas of her *Cubist Still-life with Guitar* of 1916 is divided in half, with the lower portion shown using realistic perspective, while the upper portion is more abstract. By 1919, a similar work, *Cubist composition with Violin and Musical Score*, is fully flattened and better integrated, with the flat planes of color comprising the background hard to distinguish from the foregrounded sheet music and other objects.[44] Unfortunately, when Marcoussis returned from military service he discouraged Halicka from continuing with cubism; apparently he felt that "one cubist in the family was enough."[45] Whatever the family dynamics at play here, Halicka, Marevna, and other artists such as Marevna's friend Maria Blanchard helped keep avant-garde painting alive.[46]

Chana Orloff was a third Russian-born artist who spent the war in Paris (Vasiliev was not Jewish). Orloff's family left Ukraine for Palestine in 1905; her father was an observant Jew and ardent Zionist. She came to Paris at age twenty-two in 1910 to work as a tailor for Jeanne Pacquin, the first woman to play a role in French haute couture.[47] By 1912, Orloff had enrolled in art classes at the Ecole National Supérieure des Arts Décoratifs; she also took classes at Marie Vasiliev's Russian Academy in Montparnasse, and met Modigliani, Soutine, and Pascin there. Orloff proved to be a quick study; by 1916, she was already showing her sculptures in a group exhibition at the Bernheim-Jeune Gallery, a Jewish-owned venue whose artistic director was the anarchist and art critic Félix Fénéon.[48] Orloff much later remembered wartime Montparnasse as relatively pleasant, due to the subsidized meals and sense of community.[49] It was easier for a woman to remain in wartime Paris and not have to withstand the pressure of civilian disapproval leveled at males. In 1917, she married a Polish Jewish poet named Ary Justman and gave birth to a son the following year. She and Justman both contributed to the wartime avant-garde journal *Sic*, her woodcut portraits accompanying his poems. She also published a volume of woodcuts in 1919. Orloff's husband died in the influenza epidemic in 1919, leaving her to raise their disabled son. This tragic loss makes Orloff's hopeful work of 1916, *The Kiss, or The Family*, all the more poignant. Despite these multiple drawbacks, Orloff created a highly successful career for herself over the next decade, and unlike Halicka and Delaunay she never obscured her Jewish identity. In 1925, she became a French citizen and won a Legion of Honor commendation; by 1927, she was able to commission the well-known architect Auguste Perret to build her a home and studio in Montparnasse.[50]

The war changed Mela Muter's life. She stopped receiving funds from her father, and her husband and brother (who was a diplomat stationed in Paris)

joined the French army (since Warsaw was part of the Russian Empire in 1914, they would have had to join the Russian army if they had returned home). Muter nursed French victims of the Battle of Verdun in 1916, and did a series of anti-war drawings. In 1917, she met the young French socialist Raymond Lefebvre, who had been seriously injured earlier and by 1917 opposed the war. Muter divorced her husband after the war while living with Lefebvre, who had been born in 1891 and was fifteen years younger than she was. They planned to marry, but Lefebvre died in a shipwreck on the return voyage from Russia in 1920 while serving as a delegate to the Third International. In this period, Muter met many of the leading French socialists through Lefebvre, and painted portraits of Anatole France, Romain Rolland, Henri Barbusse, and Paul Vaillant-Couturier. These activists of the left were also famous for their antiwar stance, Rolland having written *Above the Fray* in neutral Switzerland, Barbusse the wartime novel *Fire*. Muter contributed drawings to the leftist journal *Clarté* in the 1920s. She was in good company here, as her fellow artists Picasso, Chana Orloff, and Moïse Kisling also provided illustrations for *Clarté*.[51] Male artists such as Lipchitz and Soutine who resided in France thanks to the good graces of the French government were more circumspect in their politics.

## Artists at War

Why would a young art student volunteer to fight and possibly die for a country he barely knew? One might not expect the bohemian milieu of Montparnasse to encourage strong nationalist feelings, especially among artists who lived alongside many other foreigners, were still learning the French language, and might feel more comfortable speaking Yiddish, Russian, or Polish. Aside from gratitude for the nation that had opened its doors to them, we have seen that enemy aliens had to choose between leaving France and serving in its army. Louis Marcoussis, Moïse Kisling, and Simon Mondzain fought in the Foreign Legion alongside the Swiss poet Blaise Cendrars. Ossip Zadkine served in a non-combatant capacity. Cendrars was not Jewish, but knew many of the artists of La Ruche between 1911 and 1914, in particular Chagall and Modigliani (who painted Cendrars' portrait). Despite being a foreigner, a leftist, and an arch-bohemian, Cendrars took it upon himself to issue a call for intellectuals and foreigners to support the war. The poet and promoter of cubism Guillaume Apollinaire signed this call to arms, and soon volunteered as well. Of the seventeen signatories, twelve were Russian or Romanian-born Jews.[52] Cendrars

joined the Legion on September 3 and headed for the front, where he served until he was severely wounded about a year later. Cendrars lost an arm (he wrote a book about the experience, called *La Main Coupée* (The Severed Hand), but not until the waning years of World War II), and gained naturalized French citizenship the following year. Kisling and Zadkine were also wounded in action, became French citizens, and remained in France the rest of their lives, with the exception of the next war. Mondzain too survived the war, became a French citizen, married a Jewish woman from Algiers, and settled there in the 1930s, thereafter splitting his time between Algiers and Paris until the end of French Algeria in 1962.

Did their religious or national identity as foreigners affect immigrant artists more? It is striking that the immigrant Jewish artists who volunteered to serve France—Kisling, Mondzain, Marcoussis— were Polish rather than Litvak Jews, that is, those from the old Grand Duchy of Lithuania that once included the Baltic States, Belorussia, and Ukraine. The one exception, Zadkine, from Vitebsk, joined the Russian ambulance corps operating on the Western Front and thus was not a combatant. One Ukrainian-born Jewish artist, Isaac Dobrinsky, volunteered for the Foreign Legion but was exempted on health grounds. While Poland did not exist as a sovereign state in 1914, it remained a distinct culture. Further, Gottlieb, Kisling, and Marcoussis all belonged to the secret Riflemen's Association, or *Strzelec*, which Josef Pilsudski himself visited and motivated before the war. This secret organization included Gentile as well as Jewish artists from Poland who wanted to prepare their homeland for eventual independence.[53] German Jews like Walter Bondy, Otto Freundlich, and Rudolph Levy and the dealer Alfred Flechtheim returned home to fight for Germany.[54] These examples of Jewish artists who fought in the war suggest that Polish and German Jews were more likely to volunteer than were Jews from Russia and the Baltic states.

Male artists from the Austro-Hungarian Empire had a stark choice to make in 1914: join the French Foreign Legion, find some neutral refuge, or repatriate themselves. Later that year, as Kisling and Simon Mondzain volunteered for the Foreign Legion, Gottlieb returned to his homeland to fight for the Polish Legion, led by Josef Pilsudski but within the armies of the Habsburg Empire. Kisling was from Kraków; his friend Simon Mondzain, who also attended art school in Kraków, was from Chelm, near Lublin, but part of the Russian Empire. Louis Marcoussis was from Warsaw, which would have placed him within the Russian Empire. He attended art school in Kraków in 1901, arrived in Paris in 1903, and married Alice Halicka in 1913, who was also from Kraków. A biography published in Paris in 1961 says he enlisted because he loved France, and had lived there for

over ten years, longer than most of the foreign-born artists. A photograph dated 1914 shows him in uniform, holding his sword, standing next to his wife. He served as a junior officer in an artillery regiment, and in 1916 acted as adjutant to Captain Radziwill on a Franco-Polish Mission.[55] Unlike Kisling and Gottlieb, neither Mondzain nor Marcoussis were enemy combatants and were therefore not compelled to join the Legion.

Moïse Kisling and Simon Mondzain were friends and fellow art students in Kraków, Poland. They studied under Joseph Pankiewicz, who had spent his own formative years in Paris and encouraged many of his students to do the same. Kisling fought alongside Blaise Cendrars and was wounded at the Somme in 1915, gored in the chest by a bayonet. He returned to Paris, where doctors feared he might contract tuberculosis and advised him to go south to recuperate in a warmer climate. Kisling headed for Spain, but was back in Paris in 1916, where he then collaborated with Cendrars on a small book called *La Guerre au Luxembourg*. Kisling contributed six drawings to illustrate Cendrar's book-length poem, set not on the Western Front but in the Luxembourg Gardens in Paris. Cendrars described children playing at war, with kites rising as rapidly as fighter planes. Kisling's illustrations are as charming and innocent as Cendrar's text. This book by two wounded warriors was as far from the experience of the front as it was possible to get, which Cendrars recorded later in detail in his memoir *La main coupée*. It is hard to say whether this was due to wartime censorship or simply to the fact that both veterans were recuperating back in Paris, and so recorded what they experienced as convalescents. The book was dedicated to fallen comrades, including Mieczlaw Kohn, presumably another Polish Jew, and Victor Chapman, an American who died at Verdun on June 23, 1916—the first U.S. aviator to die in the war.[56] Chapman must have been close to Kisling, for he left the still-unknown and impoverished artist the significant sum of $5,000 in his will. This sum along with his military service allowed Kisling to marry Renée Gros in 1917, daughter of the commandant of the Republican Guard. Moïse Kisling became a French citizen in 1924, by which time he was a successful artist with a large studio in Montparnasse. When Cendrars received his wound in September 1915, the Legion lost 608 men out of 1,960.[57] His lost arm did not dampen Cendrars' enthusiasm for carousing with Modigliani on his return to Montparnasse.[58]

Kisling's friend Simon Mondzain, who was also born in 1890 and arrived in Paris in 1909, was one of the rare soldiers who went through the war unscathed. On September 10, 1916, Kisling wrote to Mondzain that he was thrilled to hear that his friend was alive.[59] That same year, Mondzain did a powerful drawing

**Figure 3.5** Simon Mondzain, *Pro Patria*, 1920. MAHJ 2011, RMN-Grand Palais/Art Resource, New York. 2021 Artists Rights Society (ARS), New York/ADAGP, Paris.

that he later turned into a painting called *Pro Patria*. It shows a nude Marianne holding a bouquet of flowers toward a soldier in a casket, both in a reinforced trench.[60] This undoubtedly remained a private sketch, since the French government forbade the publication of any images that showed wounded or dead French soldiers. Mondzain received his naturalization papers as a French

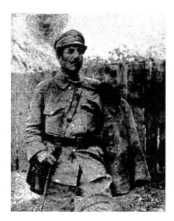

**Figure 3.6** Photograph: Léopold Gottlieb in uniform (undated).

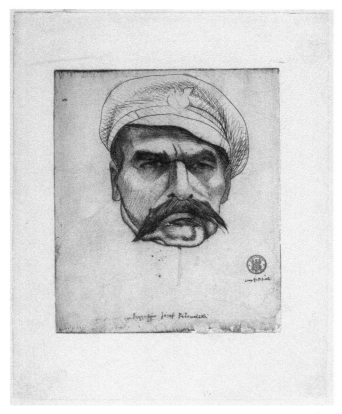

**Figure 3.7** Léopold Gottlieb, *Brigadier Josef Pilsudski*, 1914. National Museum in Kraków, IIII-ryc-774.

citizen in 1923. Jacques Lipchitz, who did not volunteer and who married a fellow Russian immigrant, received his French naturalization the same year as Kisling, in 1924. In his case, staying in Montparnasse and advancing his artistic career served him well.

Leopold Gottlieb came from Austria-Hungary, whose Jewish citizens felt much more loyalty and even gratitude to their tolerant Emperor Franz Josef than did Russian Jews to the regime of Nicholas II. In 1914, after fighting his duel with Kisling, Gottlieb returned home to fight under Jósef Pilsudski (1867–1935), a Polish nationalist who saw his Polish Legion as the nucleus of a future Polish nation.[61] This in fact worked out much as he hoped, and Pilsudski became the father of a revived Polish Republic after the war. Furthermore, Pilsudski envisioned a multi-ethnic Poland, an important issue given that Poland was 10 percent Jewish, with three million Jews still living there despite considerable emigration in the previous decades. Gottlieb drew many portraits of Pilsudski, often in action on horseback, as well as his fellow Polish combatants, and these

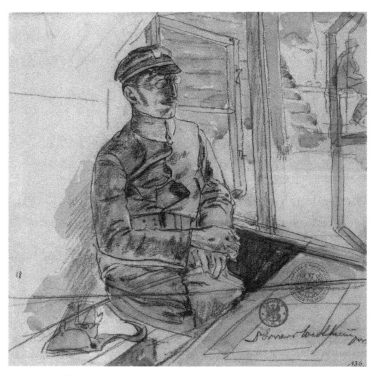

**Figure 3.8** Léopold Gottlieb, *Dr. Edward Wertheim*, 1916. National Museum in Kraków, III-r.a.8176.

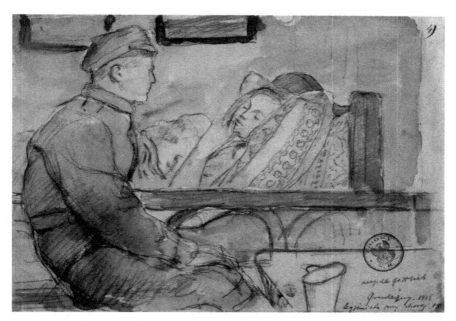

**Figure 3.9** Léopold Gottlieb, *Legionary next to sick woman*, 1915. National Museum in Kraków, III-r.a.997.

went on display in Kraków during the war. According to Gottlieb's Polish biographer Artur Tanikowski, they were published in a portfolio called *The Legions* in Zurich, Switzerland in 1916.[62] He rendered these drawings in a realist style, with none of the idealism that infused his paintings. Pilsudski is easily recognizable from his large black moustache and stern features, looking every inch the commander. Gottlieb showed his fellow soldiers at play as well as at war, some holding machine guns but others with musical instruments—mandolins and accordions. Gottlieb also contributed illustrations for another wartime volume, *From the Notes of a Legionary*, written by fellow soldier Seweryn Romin.[63]

Dr. Edward Wertheim was a fellow Jewish soldier whom Gottlieb sketched in a moment of leisure. Gottlieb also drew genre scenes not directly related to military matters; one showed a legionary comforting a sick woman at her bedside. Such drawings humanized the conflict. Twenty years after its initial publication (and after the artist's death), Gottlieb's series of twenty-two color lithographs titled *The Polish Legion* was re-released in Warsaw, with the recommendation that every cultured Polish home should have a copy.[64]

Publishing a book of wartime drawings in 1916 should have placed Gottlieb at the forefront of wartime artists, except that he was involved in a mostly unknown sector of the war. Motivated by Polish nationalism, Leopold Gottlieb became the most significant Jewish artist of World War I. As such, he was the exception that proved the rule, since most of the Jewish artists who remained in Paris did not demonstrate a similar commitment to depicting the war.

There is one further exception. Back in Paris, one Jewish artist did respond to the impact that the war had on the Jews living in the Pale of Settlement in ways that bear comparison to Leopold Gottlieb. Abba Pfeffermann was born in Belorussia in 1883. Four years older than Marc Chagall, he studied drawing for three months with Yehuda Pen in Vitebsk, who later taught Chagall and Zadkine. He continued on to art school in Odessa and made it to Paris in 1903, where he was an early lodger at La Ruche, where Chagall would alight eight years later. He supported himself as an illustrator; one of his editors suggested he shorten his name to make it sound less Germanic, and he became Abel Pann, the name he used for the rest of his life.[65] In 1913, Pann left Paris for Palestine. He returned to Paris days before the outbreak of the war, planning on packing up his belongings and returning to the Holy Land for good. He wrote, "the evening I arrived, Jean Jaurès was assassinated, and mobilization began the next day."[66] Pann's timing was even worse than Chagall's, with similar results; he did not return to Palestine for another six years. By the end of 1915, he heard reports of the terrible plight of Ashkenazi Jews on the Eastern Front, accused of collaborating with the German and Austro-Hungarian armies. Over the next year, he made fifty sketches, mostly pastels on cardboard, of Jewish evacuations and the aftermath of pogroms. He planned to publish these powerful and poignant illustrations in an album of drawings, but when the Russian ambassador got wind of the project, he put pressure on the publisher and the book was withdrawn. The enterprising artist then took his drawings to the United States, where they showed successfully around the country, and led to Pann being identified in the American press as "the greatest Jewish artist."[67] A Cincinnati shoe manufacturer purchased the entire lot, called the *Jug of Tears*, for $4,000, which Pann donated to the Bezalel Museum in Jerusalem. In 1926, at the trial of Sholem Schwartzbard in Paris, who had killed the exiled former hetman of Ukraine, Simon Petliura, for his role in the mass murders of Jews during the civil war of 1918–20, the *Jug of Tears* series was entered into evidence (this despite the fact that the pogroms pictured took place several years earlier). Schwartzbard was acquitted.[68] Pann was no modernist, came from a religious background (his father was a rabbi), and ended up in Jerusalem, all of which underscore why his artistic response to the war

differed so greatly from contemporaries such as Modigliani and Lipchitz. On one score, however, Abel Pann did resemble artists such as Pascin and Gottlieb—in his extraordinary mobility.

Leopold Gottlieb eventually returned to Paris in 1925 and spent the last nine years of his life there. Toward the end, with the rise of antisemitism in Germany and Poland, Jewish themes returned to his work, and his style became allegorical. Leopold Gottlieb's life and career, aside from the unusual military involvement that made him effectively an enemy combatant (though the Polish Legion fought the Russian rather than French army), shows an artist moving freely between East and West, Poland and Paris, and also trying on a variety of styles from realist to modernist, if not avant-garde. By contrast, his opponent and fellow Polish Jew Kisling had no interest in returning to the land of his birth and instead played a central role in interwar Montparnasse society. His marriage to a non-Jewish Frenchwoman in 1917 highlighted his bond to his new homeland.

Ossip Zadkine's war could hardly have been more different from Leopold Gottlieb's. Zadkine was a sculptor who was born in Vitebsk in 1890, the same White Russian town that produced the painter Marc Chagall. He arrived in Paris in 1909, about the same time as Kisling and Mondzain, having already spent time in London and Scotland (his father was Jewish, his mother Scottish, so he was sent to visit his relatives while in his teens). He volunteered as a stretcher-bearer with the Russian ambulance corps, attached to the French army. A letter he sent to his old art teacher Yuri Pen back in Vitebsk suggests he was less than enthusiastic about his time in the military. He wrote, "How are you feeling and what are you doing? How are our friends—Lissitzky, Libakov, Masel, Mekler, and Chagall? ... I am in fine health but tired of it all—it's utterly disgraceful, makes the soul turn cold. If only it could just end."[69] After being gassed, Zadkine was sent to recuperate near Épernay, where he did a series of watercolor drawings of hospital life, twenty of which he collected and published after the war in hopes of realizing some profit, apparently without much success.[70] The drawings were reproduced in black-and-white images of 4 × 5 inches. They show soldiers on crutches walking down a street, an ambulance with two soldiers in the foreground bearing stretchers, soldiers arm wrestling, and others standing in front of what appear to be coffins. The style is vaguely cubist in simplification but the drawings are mostly realistic. These artists mostly showed little of the bitterness that affected the much more tormented work of painters like the Germans Otto Dix, Max Beckmann, or Georg Grosz. After the war, they quickly moved on to pursue their careers in the Montparnasse of *les années folles*. Zadkine was naturalized French in 1921, married the Algerian-born artist Valentine Prax, and moved his

studio to the rue d'Assas near the Luxembourg Gardens, where it remains today as the Musée Zadkine (the only Paris museum dedicated to a single artist of the Ecole de Paris other than Picasso; there is a Chagall museum in Nice). War service benefited all these immigrant artists, especially insofar as none were killed and all recovered from their wounds.

The advent of war took Marc Chagall by surprise. After three years in Paris, from May 1911 to June 1914, Chagall tied the door of his La Ruche studio shut with rope and left for his Berlin exhibition. He planned to attend his sister Zina's wedding in Vitebsk that summer, hopefully marry his fiancée Bella, and return with her to Paris. The forty Chagall canvases at the Berlin show made Chagall's name, but when he boarded a train for Vitebsk on June 15, he had no idea that he would remain in Russia for the next eight years.[71] He wrote to his fellow Russian Jewish émigré Sonia Delaunay back in Paris, telling her, "I send you my regards from Russia, from its depths, where the Russian people rose so beautifully to defend its future. And this gives me joy. I am longing for Paris."[72] Later that summer came the war, trapping Chagall in Russia, and Vitebsk became a major railroad depot, with soldiers departing for the front and many returning wounded. Chagall made several drawings titled "Wounded Soldier" in 1914, which, in their quiet power, reveal the pathos of war on the Eastern Front.[73]

Chagall did marry Bella in 1915, and then fulfilled his military service in the war office in Petrograd, fortunately spared from the front with aid from his brother-in-law. The war quickly disappeared from his art after 1914, though many years later in the 1960s, Chagall completed a large canvas called *War*, which showed an apocalyptic scene of peasants fleeing a burning village. A large white beast towers over the disaster, with a crucified Christ posed behind the beast of war in the upper right-hand corner.[74] Nevertheless, the war years were highly productive ones for Chagall. His personal life with Bella and then with their daughter Ida, born the year after their marriage, seems to have displaced geopolitical issues. Works such as *The Birthday* (1915), *Promenade* (1917–18), and *Above the Town* (1914–18) all feature the young couple levitating over the Russian countryside, while *Bella with White Collar* (1917) shows his bride as a giant looming over a forest, looking down upon a tiny Chagall and daughter in the lower foreground. Bella's countenance is severe in this rendition; one commentator suggests, "Chagall cherished a private vision of his wife as the divine protector of his art, even beyond death."[75]

After the revolution broke out, Chagall returned to Vitebsk, and Anatoly Lunacharsky appointed him as director of the art school in his hometown. The Vitebsk People's Art School opened in November 1918, with Marc Chagall

(formerly Moisei Shagal) Arts Commissar for the Vitebsk region. Despite what one might infer from Chagall's imagery, Vitebsk was not a shtetl village but the provincial capital of the region, with a population of 80,000 in 1914. It had been one of the dozen largest cities in the Polish-Lithuanian Commonwealth until the first partition of Poland made it part of the Russian Empire in 1772. Jews comprised 60 percent of its population; most were engaged in commerce and trade.[76] The Bolsheviks ended all of the proscriptions on Jews decreed by the tsars, most importantly the laws restricting Jews to residing in the Pale of Settlement. Not surprisingly, many Jews welcomed the revolution, which also famously included a number of prominent Jewish names among the Bolshevik leadership, including Leon Trotsky, Lev Kamenev, and Gregory Zinoviev. In 1918, the first monograph on Chagall was published in Moscow, and he was certainly Vitebsk's most famous artist, as well as being well connected, having known both Anatoly Lunacharsky, head of Narcompros, the People's Commissariat of Enlightenment, and David Shterenberg, head of Narcompros' Department of Fine Arts. Chagall threw himself into his new job, recruiting artists and even house painters to decorate the city while organizing classes at the art school and working to establish a museum of contemporary art so that students could see examples of modern art. At this early stage, Chagall and other artist supporters of the revolution believed that artists would play the key role in building a new artistic culture for Russia. It would not take long for leftist artists to be disabused of this notion, and political intervention happened in Vitebsk even sooner than in other Russian cities.[77]

Already by 1919, Chagall was disenchanted enough with his administrative duties that three times that year he tried to step down; each time his own students made him reconsider. It is hard to imagine Chagall as an effective administrator; a portrait by his first art teacher, Yuri Pen (whom Chagall had recruited to teach at the school) shows a dreamy bohemian in a wide-brimmed hat holding a palette, looking not at all like a Soviet apparatchik. The trip from Vitebsk to Moscow took three days by train, and Chagall made the journey repeatedly in search of supplies for his school and paintings for his museum. Chagall's brief career as art teacher and administrator was finally terminated by suprematist artist Kazimir Malevich, who arrived at the school in November 1919. Malevich (1878–1935) was nearly a decade older than Chagall, and while not from Vitebsk was also well known in avant-garde circles.

Unlike Chagall, Malevich was a theorist as well as practitioner of art, and demanded that abstract art be the modernism taught at Vitebsk. Chagall neither in 1919 nor later accepted abstraction, and never had much use for theory.[78] By

May 1920, most of the students had gravitated to Malevich's camp. On June 5, 1920, Chagall, who had been living in two rooms that the art school had allocated to him, left Vitebsk forever. So did the family of his wife Bella. The Rosenfelds were prominent jewelers whose home was torn apart by the Soviet secret police, who also denounced and killed the husband of Bella's sister Chana.[79]

Chagall, with Bella and daughter Ida, went to Moscow to design costumes and paint set designs for the Jewish Theater. Here he fully engaged with Jewish folklore from a modernist perspective. His portrayal of *Dance* (1920) shows a woman clapping her hands as floating instruments accompany her; *Music* shows the famous green-faced violinist standing on rooftops, his long coat opened to reveal a prayer shawl. This would be the image made famous decades later and a continent away in *Fiddler on the Roof*, a musical depiction of Ashenazi shtetl life that did not please Marc Chagall. He also depicted *Literature* in the guise of a bearded man writing on a scroll; *Drama* shows a black-garbed man in a skullcap gesticulating in a fragmented space. The very large-scale *Introduction to the Jewish Theater*, also from 1920, depicts animals and people doing handstands in a fragmented cubist space.[80] Yet Chagall felt isolated, accepted neither by the practitioners of realist proletkult art nor by the partisans of abstraction, and finally left Russia with his wife and daughter after the Civil War ended in 1922. By the time he returned to Paris in 1923 after a sojourn in Berlin, he was well known. In 1912 he had refused to become a cubist, in 1919 he rejected suprematism, and on his return to France he would resist overtures from Max Ernst and Paul Eluard to join the surrealists. The art he would continue to produce in interwar France, especially his allegorical and narrative paintings of Jewish themes, expressed his own identity as a modern artist with distinct cultural roots. If they were not fashionable, by avant-garde standards, they nevertheless affirmed Chagall's position as the central interpreter of the Jewish Diaspora.[81]

The other immigrant artist who, like Chagall, portrayed Jewish life was Mané-Katz, who similarly returned to his homeland during the war. Born Emmanuel Katz in Ukraine in 1894, and a year younger than Soutine, he also arrived in Paris in 1913 knowing two French phrases: "I don't understand," and "I want to eat." His father was a shames or rabbi's assistant, and he arrived in Paris still wearing the orthodox Jew's sidelocks, which he soon cut off. Mané-Katz, as he called himself, did try to enlist in the French Foreign Legion, but they rejected him due to his small stature. He crossed the English Channel and from England made his way back to Kremenchug, the Ukrainian city that was home to 30,000 Jews. Also like Chagall, he taught art in his native land, but was engulfed in the civil war between Ukrainian nationalists, White Tsarist forces, and the Red army,

**Figure 3.10** Jules Pascin, *Landscape*, 1917. Barnes Foundation, BF413. 2021 Artists Rights Society (ARS), New York.

lost all his students, and witnessed many Jews killed in the pogroms of 1919–20. From Kharkov, he returned to Paris in 1921, via Baku, Tiflis, Moscow, Minsk, and Warsaw. During the next war, he fled to New York, and died in Israel in 1962, where a museum in his name exists in Haifa.[82] Mané-Katz became another prominent artist of the Jewish Diaspora, famous for his paintings of klezmers or musicians, frequently shown performing at Jewish weddings, though he also painted landscapes and still lives.

Jules Pascin's war years were much less stressful than were Chagall's; in the United States, he experienced neither war nor revolution. In 1914, he was probably the best-known immigrant Jewish artist. Pascin had a number of advantages that allowed him to escape the war-torn continent between 1914 and 1920. He was slightly older than most of the other Jewish artists, being nearly thirty in 1914. His native country, Bulgaria, was not a French ally, and would finally join the war on the side of the Central Powers in October 1915. By that time, Pascin was long gone from Europe. He used his American sojourn to travel around the country, including in the South and in Cuba, and painted colorful

landscapes rather than the studio nudes for which he was best known. He married fellow artist Hermine David in 1920, became an American citizen that same year, and then returned to Paris, where he lived the next decade as one of the most celebrated devotees of the high life of the crazy years of the 1920s.

# Modigliani

Chagall, Modigliani, Soutine, and Pascin are the best-known Jewish artists who found their fame and careers in Paris. Chagall and Pascin spent the war years abroad, and did not return to Paris until the 1920s. Soutine only arrived in Paris in 1913 and would not become known until the 1920s; during the war he was living at La Ruche and working at various jobs, including at Renault. That left Modigliani, who turned thirty in 1914, as the central figure among the Jewish artists of wartime Montparnasse. Nearly all the work that has made him famous he did during or immediately after the war. The case of Modigliani (who did not care for his given name Amedeo; his family called him Dédé, and his friends called him Modi) is particularly interesting in terms of the wartime context of his artistic development. There is scarcely any direct trace of the war to be seen in the many paintings he made between 1914 and his death early in 1920—just one portrait of a young man in a French Zouave uniform painted in 1918. There is also the question about how his Jewish background influenced his work. He was widely reported to be proud of his heritage, though he was not religious. In her memoir, the British artist and bohemian Nina Hamnett reported that on her first night in Paris in 1913 she was having dinner at Rosalie's Italian restaurant in Montparnasse when "suddenly the door opened and in came a man with a roll of newspaper under his arm. He wore a black hat and a corduroy suit. He had curly black hair and brown eyes and was very good looking. He came straight up to me and said, pointing to his chest, 'Je suis Modigliani, Juif, Jew,' unrolled his newspaper, and produced some drawings. He said, 'Cinq Francs.'"[83] The drawings he showed her were long heads with pupil-less eyes, which she found beautiful, and bought one in pencil; others were in red and blue chalk. She must have known that these were sculptural drawings, because she told him she knew Jacob Epstein, the sculptor who had recommended that she eat at Rosalie's restaurant. She did not comment on how strange it must have sounded to have Modigliani announce himself as "the Jew," but soon thereafter, she was strolling along the boulevard St. Michel with another Jewish sculptor, Ossip Zadkine, the Russian artist Marie Vassiliev, Modigliani, and several others. Zadkine and Modigliani

together bought her a large bouquet of roses and accompanied her back to her hotel at 7.30 am. Her popularity may have been due to her penchant for dancing nude at parties, which she reports in the same paragraph that she mentions meeting Zadkine.[84] When Nina Hamnett returned to Paris after the war, she shared Modigliani's former studio with a Polish artist. She reported that it had neither electricity nor gas, so they used an oil lamp. "We were quite certain that Modigliani was still with us and fancied at night that we could hear his footsteps walking through the studio."[85] Minimal lighting may have facilitated the haunted effect; it also reminds us that colorful bohemian poverty included real deprivation.

As these recollections suggest, Modigliani was a notorious figure whom everyone knew in wartime Montparnasse, and so many of them shared their memories of him after his premature death that it is hard to disentangle his legend from the real artist. The tendency was to portray him as the last bohemian, who was mostly high on drugs (cocaine and hashish) or inebriated, who was also given to shedding his clothes at parties and reciting Dante at all hours of the night (as his friend and fellow sculptor Jacques Lipchitz reported in a book he wrote many years later).[86] On the other hand, there has been an effort to portray him as a serious, hard-working artist who participated in many group shows in these years, and who was well read.[87] This interpretation links Modigliani to the contemporary avant-garde, and particularly to the cubists, including Picasso, Rivera, Lipchitz, and Léopold Survage.

Jacob Epstein, the sculptor to whom Nina Hamnett referred, was close to Modigliani in 1912 when Epstein spent six months in Paris working on his tomb for Oscar Wilde.[88] Epstein reinforced the bohemian legend when he wrote that when Modigliani was high on hashish he would place lighted candles on his sculpted heads and embrace them. Yet Epstein also wrote that when he knew him, Modigliani was "robust and even powerful."[89]

Jacob Epstein (1880–1959) was an American-born Jew who studied sculpture in Paris from 1902 until 1905 but lived and worked in London for most of his life, and so is peripheral to this story. His work on the tomb of Oscar Wilde, which can still be seen in Père Lachaise Cemetery, where Wilde was buried in 1900, brought Epstein to Paris and involved him in one of the artistic *causes célèbres* of the era. He endowed the sphinxlike figure he created with male genitals, which the authorities deemed unacceptable in a public place visited by families. Epstein refused to modify the statue, so a bronze plaque was cast and fitted to the monument like a fig leaf after the monument was dedicated in August 1914. Not long thereafter, a band of artists and poets made a raid and removed the plaque. For a while, the

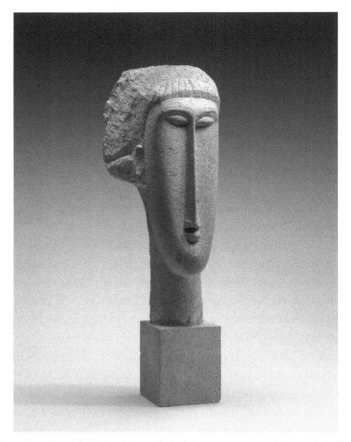

**Figure 3.11**  Amedeo Modigliani, *Head of a Woman*, 1910-11. National Gallery of Art. Chester Dale Collection. 1963.10.241.

authorities covered the sculpture with a tarpaulin, which they removed in recognition of the thousands of Englishmen fighting on French soil.[90]

As with many of his fellow artists, Modigliani was caught up in the war fever that struck France, and much of Europe, in August 1914, but though he too volunteered to serve in the Foreign Legion, he was briskly turned away due to ill health.[91] Modigliani faced his own crisis in 1914 aside from fighting Germans. His dealer, Paul Guillaume, counselled him to give up sculpture and devote himself to painting, and he reluctantly agreed. The war was making stone harder to come by and sculpture harder to sell in a contracted art market. He could not find men able to break up slabs of stone, while the powder from chipping away the stone proved deleterious to Modigliani's tubercular lungs. The paintings he did in 1914–15 show him groping for a style as he reacquainted himself with the medium. The

canvases he did between his arrival in Paris in 1906 and his move to sculpture around 1911 look nothing like the work that we know him for today, and show the influence of Gauguin, Toulouse-Lautrec, and the fauves. He had always drawn copiously, and supported himself by trading these drawings for food and drink in the cafes and restaurants of Montparnasse. Now he had to derive a style that was his own. One can see him working toward this in the early portraits he did of his friend Diego Rivera, whom he painted in 1914. They evoke the Mexican artist powerfully; then he incorporated cubism into his portraits. In fact, his faces often took on the stylized, mask-like appearance of his sculptures, which in turn were influenced by primitive art. The smooth, faceted heads and the asymmetrical eyes which often were left blank (or sometimes one eye had a pupil) bore both cubist and sculptural influences. His later portraits from 1918–19 evolved again, replacing the anti-naturalist physiognomies with a more expressive appearance. He also painted the "common people" in his last years, including young peasants, chambermaids, and apprentices, in part because he spent fourteen months in southern France away from his artist friends. Since he could not afford to pay models, he painted mostly his friends who were willing to sit for him or, like Lipchitz, pay him his modest fee of 10 francs per day for their portraits. He never painted still lives and did only one, not very successful, landscape. His focus was entirely on the human.[92]

Despite what he said in his early years in Paris about capturing the unconscious, these portraits are not psychological to the same degree as were those that expressionists across the Rhine, such as Oskar Kokoschka, were doing at the same time. They do evoke the personality of the sitter, but they are also immediately recognizable as the work of Modigliani (unless they are forgeries, which became legion after his posthumous fame), and are too stylized to convey depth.[93] What is remarkable about them is less psychology than sociology; Modigliani painted everyone he knew, and that included many of his fellow Jewish artists. Starting with Diego Rivera, he quickly did portraits, sometimes several, of Max Jacob, Jacques Lipchitz and his bride Berthe, Chaim Soutine, Pincus Krémègne, Moïse Kisling, and the sculptors Léon Indenbaum, Chana Orloff, Oscar Miestchaninoff, and Jacob Epstein. One biographer expresses surprise that he did not paint Chagall, but Chagall left Paris in June 1914 and did not return until after Modigliani's death.[94] Of course Modigliani painted many non-Jews as well, including his dealers Paul Guillaume and Leopold Zborowski, Mme. Zborowska, their friend Lunia Czechowska, his mistresses Beatrice Hastings and Jeanne Hébuterne, Picasso, Survage, Cendrars, and so on. His portraits reflect in part the Jewish presence in wartime Montparnasse, in part the

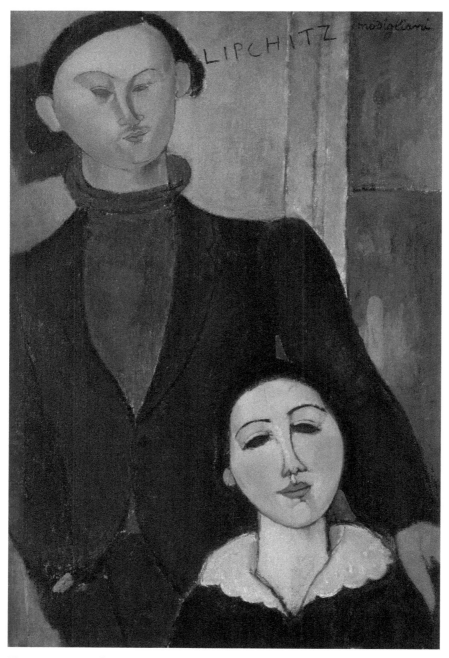

**Figure 3.12**  Amedeo Modigliani, *Jacques and Berthe Lipchitz*, 1916. Art Institute of Chicago, 1926. 221.

foreign presence, since aside from Guillaume and Hébuterne all these people were immigrants. The contrast is especially evident in the year he spent in Provence painting ordinary French people. Though there seems to be little that is overtly Jewish in these portraits, the fact that Modigliani chose to focus on the human form, rather than genres such as landscapes or still lives, conveys his fascination with the individual. Unlike Chagall, for example, he only did one self-portrait, and that was at the end of his life, as if he wanted to preserve his image for posterity.

The other genre for which Modigliani is remembered are his nudes. These were not of the women to whom he was closest, Beatrice and Jeanne, and most received their modeling fee (typically 5 francs per day) from his last dealer, Zborowski, who knew these paintings would be saleable. The nudes were explicit and scandalous enough to cause the police to intervene in the only one-man show Modigliani ever had during his lifetime, at the Galerie Berthe Weill late in 1917. She had placed them in the window and caused people to gather in front of the shop; unfortunately, she was directly across from a police station. Agents removed them because, they claimed, the display of pubic hair offended public morals. Despite the scandal, the show itself continued, and Blaise Cendrars wrote a poem "On a portrait of Modigliani" for the brochure.[95] Modigliani's nudes connect him with Jules Pascin, Moïse Kisling, and Man Ray as Jewish artists who were identified with the risqué side of Montparnasse. His reputation as a handsome womanizer who slept with his models became integral to his reputation. Since both he and Pascin were considered aristocrats who were comfortable with Latin culture, French critics did not condemn their immorality; they saw them as inspired by the Italian Renaissance and French Rococo. Depicting sensuous nudes demonstrated acculturation into French society, which was true enough for these four artists, born in Italy, Poland, Bulgaria, and the United States.

Modigliani painted his series of nudes between late in 1916 and 1919, at the end of his life as well as at the end of the Great War. He had done few such works earlier. Now he painted over thirty nudes, all of young women, all devoid of narrative or mythological content. Their pure sensuality, which shocked the French police if not gallery owner Berthe Weill, must have meant something powerful to the artist. They did not mean that he was searching for acceptance by critics or dealers (though Zborowski facilitated the work), nor did they express primarily bohemian disregard for convention. While modernist in form, they did not express any particular school of art. When he was once asked to what school or style his work belonged, he replied proudly, "Modigliani."[96]

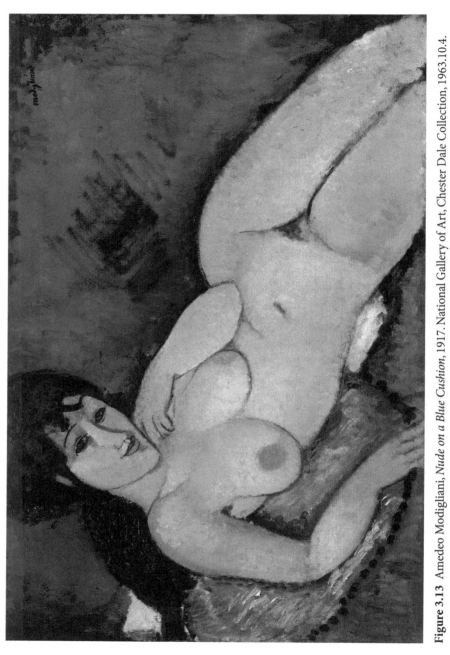

**Figure 3.13** Amedeo Modigliani, *Nude on a Blue Cushion*, 1917. National Gallery of Art, Chester Dale Collection, 1963.10.4.

The most convincing explanation for this departure is that they formed a counterpoint, if not outright protest, against his own declining health, as well as against the death that hung over the world. The increasingly haggard artist was offering the world a glimpse of eros as an alternative to death and destruction; affirming life amid pain and suffering, his own and that of the world.[97] While seemingly apolitical, these life-affirming paintings suggest a bohemian rejection of the bellicose external world, and assert the priority of eros and personality, of art and love. Many of his models, including the nudes, had their eyes closed, like his *Seated Nude* of 1916, her head inclined to increase the sense of introspection.[98] She, like the artist, was looking inward. One could protest the war noisily, as in dadaist Zurich, or quietly, by a dying artist.

Ilya Ehrenburg, the Russian writer who was friends with Modigliani as well as the many Russian immigrant artists of Montparnasse, showed no trace of disappointment when the French Foreign Legion rejected him. He was still there in 1917 when the October Revolution broke out in Russia, and reported that Modigliani came running up to him enthusiastically, and was so excited that he had trouble making out his words. After the revolution, La Rotonde became suspect to the authorities (who likely recalled that at the beginning of the war one could see Russian revolutionaries sipping coffee there), and made it off-limits to soldiers.[99] Montparnasse may have appeared chic to Jean Cocteau and the Tout Paris who enjoyed the frisson of bohemia, but the authorities perceived it as unstable and potentially seditious due to its large proportion of leftists and foreigners, one category sliding into the other. Seditious Montparnasse gave way to High Life Montparnasse in the 1920s, by which time Lunacharsky and Lenin were in Moscow, and thousands of White Russian émigrés were pouring into Paris.

Some of the Jewish artists who had come before World War I remained there throughout the interwar years. Others who had spent their student years in Paris returned after the war, and many more arrived for the first time in the 1920s. The fall of the tsarist regime increased toleration of Jews in Russia, and some artists who had lived in Paris before the war remained in Russia to further the revolution: the list includes Natan Altman, David Shterenberg, El Lissitzky, and David Burliuk. Paris was the place to make one's reputation and fortune, and artists such as Chaim Soutine, Chana Orloff, Marc Chagall, Jacques Lipchitz, and Moïse Kisling thrived. Newcomers faced increasing competition and did not fare so well. The most famous of all of them died at the beginning of 1920. Chaim Soutine, nearly a decade younger than Modigliani, was still unknown, but it was during the war that Modigliani took him under his wing.

## Routes to Success

One of the ironies of this school is that though it thrived throughout the 1920s, and artists such as Soutine and Chagall established their reputations, only those Jews who arrived in Paris in the heady era of cubism and the pre-war avant-garde achieved fame and fortune after the war. Of course, early arrival was no guarantee of success. Yet many artists born in the decade 1884–94 made it in the art market while those born a decade later did not, perhaps because few of them participated in the latest avant-garde experiments, dada and surrealism. The exceptions to the rule that only the pre-war avant- garde prospered after the war were two prominent Jewish figures, the Romanian writer Tristan Tzara and the American Man Ray, who were active in both movements. Tzara came to Paris late in 1919, Man Ray in 1921; the latter figure engaged in art as painter, sculptor, and photographer, and as a surrealist was never associated with the Ecole de Paris. Some immigrant artists who arrived in Paris between 1905 and 1913 left France in 1914 and returned after the war, like Pascin, Mané-Katz, and Chagall, thrived in postwar Paris. So did many who stayed, like Soutine, Modigliani, and Lipchitz, and so did those who served in the war and survived, like Kisling, Marcoussis, and Zadkine. Disruptive as it was, the war did not play a decisive role in these artists' fortunes. Kisling and Mondzain, who volunteered for war, returned to marry French women, and attained citizenship and artistic success in the booming interwar art market. As outsiders who became insiders, they abandoned the avant-garde for commercial success with landscapes, portraits, and nudes. Of the artists who served, only Zadkine achieved artistic greatness in the aftermath of the Great War.

Tristan Tzara and Man Ray were immigrant Jews who became insiders in French avant-garde circles and kept their distance from the Jewish artists who identified with the Ecole de Paris. Likewise, though Jewish artists experimented with a wide variety of modernist styles, few of them followed Tzara into the nihilistic pathways of dada, though this was arguably the most avant-garde artistic movement of the 1916–24 period. French dadaists such as Marcel Duchamp and Francis Picabia mocked the pretensions of art, including modern art, in a way that even the most acculturated immigrant artists, such as Jules Pascin and Louis Marcoussis, could not accept. France, Montparnasse, and modernism all represented forms of liberation that these artists were unable to reject. Pascin returned to Paris after his American sojourn; Marcoussis did too from his years on the Western Front. Newcomers who arrived after the war, Man Ray and Tzara changed their names and buried their Jewish identities. Even in

his autobiography, *Self Portrait*, published in 1963, Man Ray never divulged his Jewishness.

Another artistic path emerged from the war that also, and significantly, was a route not taken by Jewish artists. As a reaction to the chaos of the war, as well as the turbulent years immediately following the war, a number of artists followed the painter Amédée Ozenfant and the architect Le Corbusier in seeking an aesthetic of neoclassical order based on geometry. Ozenfant coined the term purism in 1916, and the two Swiss men proselytized values of clean lines and rationality in their journal *L'Esprit Nouveau*, which they founded in 1920. While both Ozenfant and "Corb" painted in the purist style, the best-known artist in their circle in the 1920s was Fernand Léger. He knew the Jewish artists well, since he lived among many of them before the war in La Ruche. His time at the front during the war led him to appreciate mechanical forms, and a machine aesthetic strongly marked his paintings over the next decade.[100] None of the immigrant Jewish artists expressed the kind of admiration for machinery that characterized purism—not even cubists such as Lipchitz and Hayden, though the critic Paul Dermée praised Lipchitz *in L'Esprit Nouveau*.[101] This may in part be because most of them did not serve long years at the front, but a machine aesthetic was also antithetical to the way most of them envisioned art. They tended toward the expressionistic and emphasized the psyche of the inner person, finding little appeal in works that required a compass and straight edge. In 1924, for example, the American painter George Biddle invited Chaim Soutine to a party at his studio. When Soutine found Léger there, he was furious, while for his part Léger left the party early. Biddle commented on the confrontation that "they disapproved of each other's painting."[102] Léger's use of color and inclusion of people in his paintings rescued them from the tedium that afflicted most purist art. Le Corbusier was a more successful architect than artist, and Ozenfant is mostly forgotten. Jewish modernism valued depth over surface, and did not conflate modern art with modernity.

Two deaths of foreign-born artistic figures beloved in Montparnasse marked the end of an era. Two days before the armistice, on November 9, 1918, the poet and critic Guillaume Apollinaire died of the influenza epidemic. He had served in the war and been wounded in action; Picasso drew him in his uniform with his head bandaged. Yet he had returned to the key position in the avant-garde he had played in the pre-war years, as shown by his 1917 play, *Les Mamelles de Tirésius* (The Breasts of Tiresius). Apollinaire was not Jewish, but because of his Polish antecedents, many people assumed he was, much like his friend Picasso. The other death was that of Modigliani on January 24, 1920. His friends Ortiz de

Zarate and Kisling found him in his freezing cold studio coughing up blood, while Jeanne sat beside him without calling for a doctor. He died soon after in the hospital of tubercular meningitis. The next day, Jeanne came to visit his body, and the following day, eight and a half months pregnant, jumped out of the fifth floor window of her parents' apartment.[103] Jacob Epstein reports in his memoir that he was at the gallery on Shaftesbury Avenue in London where modern French art was on display, including numerous works by Modigliani, when a telegram arrived from Paris saying, "Modigliani dying. Sell no more of his works. Hold them back."[104] Mercenary though this was, it was shrewd financially, as his prices rose precipitously on his death, and continued their steep rise, as did art prices in general in the 1920s. Modigliani's funeral was a grandiose affair, paid for by his brother in Italy, who cabled instructions that he should be buried like a prince. Among the artists in attendance were Picasso, Brancusi, Derain, Jacob, Kisling, Ortiz de Zarate, Soutine, and Vlaminck. Picasso remembered Modigliani as a subversive who did not get along with the police. When he noticed the police saluting the coffin as it passed by, he remarked that this was Modigliani's revenge. On his own deathbed many decades later, these two deaths still haunted the most successful artist of the twentieth century. In April 1973, Pablo Picasso reportedly mouthed the names Apollinaire and Modigliani.[105]

# Notes

1 Sylvie Buisson, "Jean, Pablo, Max, Ortiz, Marie et les autres," in *Jean Cocteau à Montparnasse* (Paris: Des Cendres and Musée de Montparnasse, 2001), 15.

2 Charles Riley II, *Free as Gods: How the Jazz Age Invented Modernism* (Lebanon, NH: ForeEdge, 2017), 174.

3 Billy Klüver, "Modigliani et Picasso à Montparnasse," in *Modigliani, L'ange au visage grave* (Milan: Skira/Seuil, 2002), 74–8.

4 John Richardson, *A Life of Picasso*, vol. II: *1907–1917* (New York: Random House, 1996), 393. Richardson includes the portraits of Cocteau by Modi, Kisling, and Picasso on 385 and 389.

5 Jean Cocteau, "Pablo Picasso," in Margaret Crosland, ed., *My Contemporaries* (London: Peter Owen, 1967), 75.

6 Cocteau, "Pablo Picasso," 78. At the outset of the war, Cocteau had expressed strong nationalistic views, editing a chauvinist arts journal called *Les Mots* with Paul Iribe. This underscores how attitudes changed and softened between 1914 and 1917.

7 Nicholas Sawicki, "Between Montparnasse and Prague: Circulating Cubism in Left Bank Paris," in Susan Waller and Karen Carter, eds., *Foreign Artists and*

*Communities in Modern Paris, 1870–1914: Strangers in Paradise* (Farnham: Ashgate, 2015), 77, 78.

8  Douglas Porch, *The French Foreign Legion: A Complete History of the Legendary Fighting Force* (New York: HarperCoillins, 1991), 335.

9  Porch, *French Foreign Legion*, 336.

10 See Chapter 7, "Facing East: Russians and Jews," in Richard Sonn, *Sex, Violence and the Avant-Garde: Anarchism in Interwar France* (University Park, PA: Penn State University Press, 2010). 140–9.

11 Blaise Cendrars, quoted in Porch, *French Foreign Legion*, 339.

12 Jean Lafranchis, *Marcoussis: sa vie, son oeuvre* (Paris: Les Edition du Temps, 1961), 75. This biography lists Marcoussis' birth date as 1878, while other sources, including the Museum of Modern Art website, cite it as 1883. Since he attended art school in 1901, either date is plausible. A major source of the biography is Marcoussis' wife Alice Halicka's memoir, *Hier*, published in 1946.

13 Lafranchis, *Marcoussis*, 40.

14 See Peter Gatrell, *A Whole Empire Walking: Refugees in Russia During World War I* (Bloomington: Indiana University Press, 1999), especially Chapter 1.

15 Joseph Roth, *The Wandering Jews*, trans. Michael Hofmann (New York: Abrams, 2001), 93.

16 See Frederick Brown, *For the Soul of France: Culture Wars in the Age of Dreyfus* (New York: Random House, 2010), for a good summary of the crises that beset France under the Third Republic.

17 In *The Dreyfus Affair and the Crisis of French Manhood* (Baltimore, MD: Johns Hopkins University Press, 2004), Christopher Forth develops these themes at great length. See, for example, Chapter 1, "Masculine Performances: Alfred Dreyfus and the Paradox of the Jewish Soldier."

18 Sander Gilman, *Jewish Self-Hatred, Anti-Semitism and the Hidden Language of the Jews* (Baltimore, MD: Johns Hopkins University Press, 1986), 244–8.

19 Otto Weininger, quoted in Paula Hyman, *Gender and Assimilation in Modern Jewish History: Roles and Representation of Women* (Seattle: University of Washington Press, 1995), 153.

20 George Mosse, *The Image of Man: The Creation of Modern Masculinity* (New York: Oxford University Press, 1996), 56–7, 82–3. Also see Paul Breines, *Tough Jews: Political Fantasies and the Moral Dilemma of American Jewry* (New York: Basic Books, 1990), and David Biale, *Eros and the Jews: From Biblical Israel to Contemporary America* (New York: Basic Books, 1992), especially Chapter 8, "Zionism as an Erotic Revolution."

21 Sigmund Freud, "Analysis of a Phobia in a Five-Year-Old-Boy," quoted by Daniel Boyarin, *Unheroic Conduct: The Rise of Heterosexuality and the Invention of the Jewish Man* (Berkeley: University of California Press, 1993), 252. Boyarin discusses

Zionism as the Jewish counterpart to "muscular Christianity" on 259. Later, on 272, Boyarin argues that Freud also coded Zionism as masculine, and discusses Herzl, Zionism, and masculinity at length on 277ff.

22 Robert Nye, *Masculinity and Male Codes of Honor in Modern France* (New York: Oxford University Press, 1993), Theodor Herzl quoted on 206.

23 Nye, *Masculinity and Male Codes of Honor in Modern France*, 206.

24 See Steafanie Schüler-Springorum, AHR Roundtable: "Gender and the Politics of Anti-Semitism," *American Historical Review* 123, no. 4 (October 2018), for a discussion of antisemitism, Jewish masculinity, and gender. She addresses masculinity and Otto Weininger on 1214–15.

25 Jacques Lambert, *Kisling, Prince de Montparnasse* (Paris: Les editions de Paris, 2011), 51.

26 Billy Klüver and Julie Martin, *Kiki's Paris: Artists and Lovers, 1900–1930* (New York: Abrams, 1989), 54. Artur Tanikowski speculates that the duel was "sparked by political differences—different opinions as to which army it would be worth fighting in for Poland. Although both duelists came from Galicia, only Gottlieb returned there after the outbreak of war." Artur Tanikowski, ed., *Jew, Pole, Legionary, 1914–1920* (Warsaw: Museum of the History of Polish Jews, 2014), 19.

27 Lambert, *Kisling*, 57–9; Claude de Voort, *Kisling, 1891–1953* (Paris: ADAGP, 1996), 65.

28 Christopher Sterba, *Good Americans: Italian and Jewish Immigrants during the First World War* (London: Oxford University Press, 2003), 170.

29 Joseph Rappaport, *Hands across the Sea: Jewish Immigrants and World War I* (Lanham, MD: Hamilton, 2005), 88–9, 97.

30 The Barrès citation is included in Captain Sylvain Halff, "The Participation of the Jews of France in the Great War," *American Jewish Year Book*, XXI (Philadelphia: Jewish Publication Society of America, 1919), 92. A painting in the Musée d'art et d'histoire du Judaïsme, Paris, also captures this iconic event.

31 Paula Hyman, *From Dreyfus to Vichy: The Remaking of French Jewry, 1906–1939* (New York: Columbia University Press, 1979), 34. On Jews serving in the French army, see Philippe-E. Landau, *Les juifs de France et la grande guerre: un patriotisme républicain* (Paris: CNRS, 1999).

32 Halff, "Participation of the Jews of France in the Great War," 80.

33 Landau, *Les juifs de France et la grande guerre*, 40.

34 Landau, *Les juifs de France et la grande guerre*, 157.

35 Zosa Szajkowski, *Jews and the French Foreign Legion* (New York: Ktav, 1975), 28. Szajkowski, born in 1911, volunteered for the French Foreign Legion in 1939. He translated this excerpt from Sholem Schwartzbard's memoir, *In krig mit zikh aleyn* (In the War with Oneself), published in 1933. Schwartzbard became famous in the interwar period for killing the former hetman of the Ukraine, Simon Petliura, in the streets of Paris.

36 Szajkowski, *Jews and the French Foreign Legion*, 31. Also see Porch, *French Foreign Legion*, 359–62, who records the dominant Legion sentiment that Jews enlisted to avoid being sent to internment camps.

37 Jacques Lipchitz, *My Life in Sculpture* (New York: Viking, 1972), 19, 20, 51.

38 Fonds Léonce Rosenberg, Musée Kandinsky, box 19, letters from Jacques Lipchitz to Rosenberg, Jan 24, 1916, undated letter from February, 1916, letter of March 2, 1916, letter of January 30, 1917.

39 Lipchitz, *My Life in Sculpture*, 23.

40 Kenneth Silver, *Esprit de Corps: The Art of the Parisian Avant-Garde and the First World War, 1914–1925* (Princeton, NJ: Princeton University Press, 1989), 79–84.

41 Silver, *Esprit de Corps*, 167. Silver says that only one of the artists named was French, Jean Metzinger, but André Lhote was another French signatory.

42 Silver, *Esprit de Corps*, 80, 1, and passim.

43 Gillian Perry, *Women Artists and the Parisian Avant-Garde* (Manchester: Manchester University Press, 1995), plate 23 following page 96. Perry includes selections from Marevna's book *Life in Two Worlds*, published in 1961, as Appendix 3, 166–74.

44 Perry, *Women Artists*, plates 17 and 18, following page 64.

45 Perry, *Women Artists*, quoting Jeanine Warnod on 66.

46 For Blanchard (1882–1932), see Perry, *Women Artists*, 67–72, 150.

47 Paula Birnbaum, "Chana Orloff: A modern Jewish woman sculptor of the School of Paris," *Journal of Modern Jewish Studies* 15, no. 1 (March 2016): 66.

48 Birnbaum, "Chana Orloff," 67.

49 Jean-Marie Drot and Dominique Polad-Hardouin, *Les heures chaudes de Montparnasse* (Paris: Hazan, 1995), 51, quotes Chana Orloff in an interview recorded in 1960: "It was marvelous during the war, shameful to say. The French government organized aid to artists, we got 25 centimes a day and meals in the cantines. It was the ideal life. I could work on my sculpture day and night without looking to earn anything."

50 Birnbaum, "Chana Orloff," 73–5.

51 Urszula Lazowski, "Mela Muter: A Poet of Forgotten Things," *Woman's Art Journal* 22, no. 1 (Spring/Summer 2001): 26, n. 17.

52 Landau, *Les juifs de France et la grande guerre*, 38.

53 Tanikowski , *Jew, Pole, Legionary*, 18, 122. For Dobrinsky, see his biographical entry in Pascale Samuel, *Chagall, Modigliani, Soutine . . . Paris pour école, 1905–1940* (Paris: MAHJ, 2020), 222.

54 Another Jewish artist who fought for the Austro-Hungarian Empire was Georges Kars (1882–1945). Born in Prague. Kars had lived in Paris since 1908. He fought on the Galician front until captured by the Russians. He returned to Paris after the war. En.wikipedia/wiki/Georges Kars. "Artists in Uniform," *1914: The Avant-Gardes at War* (Cologne: Snoeck, 2013), 316, photo shows Freundlich in the uniform of the Cologne-Deutz Cuirassiers.

55  Lafranchis, *Marcoussis: sa vie, son oeuvre*, 75. See note 12, above.

56  Blaise Cendrars, *La Guerre au Luxembourg, Six dessins de Kisling* (Paris: Dan. Niestle, 1916). See also Klüver and Martin, *Kiki's Paris*, 64.

57  Claude Leroy, ed., *Blaise Cendrars et la Guerre* (Paris: Armand Colin, 1995), 39. The Czech artist Frantisek Kupka was also invalided out of the Foreign Legion in 1915.

58  Blaise Cendrars, *Planus*, trans. Nina Rootes (London: Peter Owens, 1972), 109, 110.

59  Elzbieta Grabska, "Les Tableaux et les sculptures voyagent . . ", in *Autour de Bourdelle: Paris et les artistes polonaises* (Paris: Paris musées, 1996), 83.

60  The oil painting *Pro Patria* by Simon Mondzain is now in the Musée d'art et d'histoire du Judaïsme, Paris.

61  Artur Tanikowski, *Likenesses of Humanity, Rites of Commonness: Leopold Gottlieb and his Work*, English language summary of *Wizerunki Cztowieczenstwa, Ryticaty Powszedniosci Leopold Gottlieb I Jego Dzieło* (Cracow: Universitas, 2011), 333–5.

62  Tanikowski, *Likenesses of Humanity, Rites of Commonness*, 335.

63  Tanikowski, *Jew, Pole, Legionary*, 149.

64  Tanikowski, *Jew, Pole, Legionary*, 142.

65  Yigal Zalmona, *The Art of Abel Pann: From Montparnasse to the Land of the Bible* (Jerusalem: Israel Museum, 2003), 8–10.

66  Zalmona, *Art of Abel Pann*, 33.

67  Zalmona, *Art of Abel Pann*, 34.

68  Zalmona, *Art of Abel Pann*, 35.

69  Letter by Ossip Zadkine to Yuri Pen, quoted in Jackie Wullschlager, *Chagall: A Biography* (New York, Knopf, 2008), 196.

70  Ossip Zadkine, *Vingt eaux-fortes de la guerre de 1914–1918*, presented by Jean Cassou (St. Gallen: Erker-Verlag, 1978), 5. Original text read "en vente chez l'auteur, 35 rue Rousselet, Paris."

71  Wullschlager, *Chagall*, 179–81.

72  Benjamin Harshav, *Marc Chagall and His Times: A Documentary Narrative* (Stanford, CA: Stanford University Press, 2004), 224.

73  *Chagall entre guerre et paix*, exhibition at the Musée de Luxembourg, February 21 to July 21, 2013, displayed several of these drawings.

74  Marc Chagall, *War*, 1964–6, oil on canvas, 163 x 231 cm, Kunsthaus Zurich; description and reproduction in *Chagall* (Madrid: Museo Thyssen-Bornemisza, 2012), 212–13.

75  Didier Schulmann, "Bella with White Collar," cited in *Marc Chagall* (New York: Abrams, with San Francisco Museum of Art, 2003), 92.

76  Aleksandra Shatskikh, *Vitebsk: The Life of Art*, trans. Katherine Foshko Tsan (New Haven, CT: Yale University Press, 2007), 2.

77  Shatskikh, *Vitebsk*, 22–5.

78 Jean-Michel Foray, "The Jewish Theater in Moscow," in *Marc Chagall* (New York: Abrams, with San Francisco Museum of Art, 2003), 104. From September 14, 2018 to January 6, 2019, the Jewish Museum in New York City featured an exhibition called *Chagall, Lissitzky, Malevich: The Russian Avant-Garde in Vitebsk, 1918–1922.*

79 Wullschlager, *Chagall*, 244, 245.

80 *Marc Chagall* (New York: Abrams, with San Francisco Museum of Art, 2003), 107–13.

81 Jean-Michel Foray, "France, America, France," in *Marc Chagall* (New York: Abrams, with San Francisco Museum of Art, 2003), 130, 131.

82 Michel Ragon, *Mané-Katz* (Paris: Georges Fall, 1960), 10–27, 85.

83 Nina Hamnett, *Laughing Torso* (New York: Ray Long and Richard R. Smith, 1932), 48, 49.

84 Hamnett, *Laughing Torso*, 52.

85 Hamnett, *Laughing Torso*, 155.

86 In case one wonders why a Jew such as Modigliani would have memorized *The Divine Comedy*, it is worth noting that Primo Levi reveals in *Survival in Auschwitz* (New York: Touchstone, 1996, originally published in 1958 with the title *If This is a Man*) that he too had memorized Dante and was able to recite long passages of it in the concentration camp in 1944. See Chapter 11, "The Canto of Ulysses."

87 See, for instance, Kenneth Wayne, *Modigliani and the Artists of Montparnasse* (New York: Abrams, 2002). Wayne also reports that Nina Hamnett lived in Modigliani's studio after his death with Jean Zwadowski, called Zawodo; Hamnett herself never names him. The address was 8 rue de la Grande-Chaumière, on the top floor (22, 23). Meryle Secrest, *Modigliani: A Life* (New York: Knopf, 2011), emphasizes that the artist died of tuberculosis, not dissipation.

88 Wayne, "Modigliani and the Avant-Garde," in *Modigliani and the Artists of Montparnasse* (New York: Abrams, 2002), 32–6.

89 Jacob Epstein, *Let There Be Sculpture* (New York: Putnam, 1940), 39.

90 Epstein, *Let There Be Sculpture*, 44–7. Epstein added an appendix (254–70) in which he included in translation many of the comments pro and con about the Oscar Wilde sculpture in 1912–13. See also Mark Antliff, "Egoism, Homosexuality, and *Joie de vivre*: Jacob Epstein's *Tomb of Oscar Wilde*," in Carolin Kosuch, ed., *Anarchism and the Avant-Garde: Radical Arts and Politics in Perspective* (Leiden and Boston: Brill Rodolpi, 2020).

91 Carol Mann, *Modigliani* (New York: Oxford University Press, 1980), 126.

92 David Morris, *Eros and Illness* (Cambridge, MA: Harvard University Press, 2017), Chapter 5, "Eros Modigliani: Assenting to Life," 139.

93 Werner Schmalenbach, "Les portraits," in *Modigliani, l'ange au visage grave*, 39–42, compares Modigliani to Kokoschka.

94 Schmalenbach, "Les portraits," 33.

95 Wayne, *Modigliani and the Artists of Montparnasse*, 67.

96   Morris, *Eros and Illness*, 144.

97   I owe this insight to David Morris, *Eros and Illness*, who devotes a chapter of his book to Modigliani. Morris insightfully compares Modigliani to John Keats, who also enjoyed a creative outburst as he too was dying of tuberculosis. See Morris, *Eros and Illness*, Chapter 5, passim, and particularly 160–1.

98   Anette Kruszynski, *Amedeo Modigliani: Nudes and Portraits* (Munich: Prestel, 2005), 90–1; Morris, *Eros and Illness*, 143.

99   Mann, *Modigliani*, 130.

100  See Riley, *Free as Gods*, especially Chapter 11, "Geometry and Gods, Side by Side: Le Corbusier," 119–31, and Chapter 12, "Connoisseur of Contrasts: Fernand Léger," 132–9.

101  Christopher Green, *Cubism and its Enemies: Modern Movements and Reaction in French Art, 1916–1928* (New Haven, CT: Yale University Press, 1987), 81.

102  George Biddle, *The Yes and No of Contemporary Art*, quoted in Alfred Werner, *Chaim Soutine* (New York: Abrams, 1977), 9.

103  Mann, *Modigliani*, 204–6.

104  Epstein, *Let There Be Sculpture*, 40. Epstein gives the wrong date, saying this happened in 1921, and also calls Modigliani's dealer Zobourovsky (Zborowski).

105  Wayne, *Modigliani and the Artists of Montparnasse*, 39.

# Cosmopolitan Montparnasse in
## *Les Années Folles,* 1920–1930

In November 2015, Amedeo Modigliani's 1917–18 painting *Reclining Nude* sold for \$170.4 million, at that time the second largest sum ever paid for a work of art at auction (Picasso's *Femmes d'Alger* (1955) brought in \$9 million dollars more earlier that same year).[1] This extraordinary demand for a modernist work painted by an artist of the Ecole de Paris (two works, if one includes Picasso as a member of this school) suggests the allure that still clings to Montparnasse and to Modigliani, whose art is inextricably linked to his biography. Like the life stories of Vincent Van Gogh and Henri de Toulouse-Lautrec, both of whom also died in their thirties, Modigliani's bohemian nonconformity includes a strong admixture of pathos and anguish. It is doubtful that the Chinese buyer of this canvas knew that Modigliani was Jewish, nor would one know that from the films made of his life. Yet the artist himself insisted on his Jewish identity as a key aspect of his self-image.[2] Even Jewish filmmakers have neglected the pervasive Jewish presence in Montparnasse in those years.[3]

The music and art that saturated Montparnasse in the jazz era marked a distinct period in the history of artist colonies, which set it apart from the pre-war and wartime eras. Relatively unknown before 1919, Montparnasse sheltered impecunious artists from abroad who needed cheap studios and welcoming cafés where they could interact with fellow artists and keep warm in winter for the price of a café crème. By contrast, Montparnasse in the 1920s was internationally famous, and attracted tourists as well as expatriates from all over the world. Its renown led to a brisk trade in guidebooks that dwelled lovingly on the neighborhood's nightspots. One such book opened with the extravagant claim "Montparnasse is the center of the world,"[4] which would scarcely have registered as hyperbole at the time. Artists still worked there, and many were newly arrived from elsewhere in Europe and abroad. Interwar Montparnasse reached its apogee as a cosmopolitan artistic scene, but the prosperity of the

1920s that led to a booming art market marginalized the bohemian element. Guidebook writer Gustave Fuss-Amoré felt no hesitation in proclaiming the centrality of Montparnasse, without considering what that meant for its future as an artist colony, which would indeed be short-lived. For a few magical years, the artists, cafés, nightlife, and tourists were able to share the space.

The death of Modigliani in January 1920 marked the decline of bohemia; the suicide of Jules Pascin a decade later marked the end of the boom years. The fact that both artists were Jews indicates their ubiquitous presence in interwar Montparnasse. Montparnasse was central to artistic practice and to the hedonistic culture of the 1920s, yet immigrant Jewish artists defined as marginal were prominent in that culture. A parallel alignment of the socially marginal and the symbolically central characterized 1920s Chicago, where gangsters and speakeasies were central to American Prohibition culture. Chaim Soutine was no Al Capone, but both men were outsiders from scorned ethnic minorities who transgressed societal norms.[5] They differ in that no one could outshine the hold that organized crime figures played in the popular imagination, whereas American expatriates and American culture more broadly seized control of the Montparnasse imaginary while Jewish artists labored in relative obscurity. To extend the comparison, it would take the German invasion and mass persecution to make Jewish marginality as filmic as the celebration of gangsters from *Scarface* to *The Godfather*.

The high price paid at auction for Modigliani's *Reclining Nude* underscores another aspect of Montparnasse in its golden age between 1910 and 1930: its spirit of pervasive sensuality. Implicit in both art and bohemia, sexual freedom was not new to Montparnasse; it had marked the earlier avant-gardes of the Latin Quarter and fin-de-siècle Montmartre. In the 1920s, critics called Jules Pascin a latter-day Lautrec, though he did not immortalize any particular site as Toulouse-Lautrec did for the Montmartre dance hall the Moulin Rouge. The French critic André Warnod claimed Pascin personified the spirit of the era rather than other artists who became more famous, such as Soutine or Chagall (or for that matter Picasso). This is in part due to Pascin's death in 1930, which confined his career and image to this period, but underscores how he exemplified the hedonism of 1920s Montparnasse.

Shortly after World War II, the American art critic Clement Greenberg went so far as to define the Ecole de Paris in terms of its hedonism:

> Materialism and positivism when they become pessimistic turn into hedonism, usually. And the path-breakers of the School of Paris, Matisse and Picasso, and Miró too . . . began during the twenties to emphasize more than ever the pleasure

element in their art. The School of Paris no longer sought to *discover* pleasure but to *provide* it [emphasis in original]. [They] saw it principally in luscious color, rich surfaces, decoratively inflected design.[6]

Though Greenberg does not refer to the artists discussed here, his definition applies remarkably well to Pascin. By "materialism and positivism," Greenberg was saying that the artists of the Ecole de Paris rejected abstraction, on the one hand, and academic escapism à la Bouguereau on the other, in order to dwell on their own environment. He did not explain what he meant by pessimism, but the term fits the world-weary Pascin better than Matisse or Picasso, and echoes Gertrude Stein's famous admonition to a young Ernest Hemingway that he was part of a lost generation. Characterizing the artists of Montparnasse in terms of hedonism and pleasure helps explain why Modigliani and Pascin were central figures in the artistic imaginary.

Modigliani and Pascin's Sephardic roots integrated them in this mythic landscape. Marc Chagall might have wanted the public to think of him as an artist rather than a Jewish artist, but no one then or now can ignore his ethnic identity. Yet despite his pride in his heritage, Modigliani is not similarly equated with Jewish culture. This contrast between Sephardic and Ashkenazi culture also reflected the social class of Pascin and Modigliani, both of whom came from privileged backgrounds. They had less difficulty acculturating, in particular to French sexual norms, than did most Ashkenazi artists. Nearly all artists worked with nude models in art school, yet only these two among the hundreds of Jewish artists of Montparnasse devoted so much of their oeuvre to the nude. Medieval Sephardic Jews living in southern France and Spain had more contact with their Muslim and Christian neighbors than did Jews in Northern and Eastern Europe. That was especially true of amorous relations.[7] Modigliani and Pascin became insiders despite being foreign-born Jews. Despite his financial success in the 1920s, Chaim Soutine remained an outsider, even though his landscapes and portraits were no more Jewish-themed than were theirs. If cosmopolitanism was one vital aspect of 1920s Montparnasse, sexuality was the other.

One would exaggerate in referring to Jewish Montparnasse, but for the first time commentators noted the Jewish artistic presence. In January 1925, André Warnod coined the name L'Ecole de Paris for the cosmopolitan group of artists working in Montparnasse. While this school included Picasso, Van Dongen, Foujita, and other non-Jewish foreign-born artists, other critics were not hesitant in referring to it as L'Ecole juive (the Jewish School). As mentioned in the Introduction, of the twelve artists whom Warnod cited as belonging to this school, seven were Jews.[8] Whether

that indicated hostility or approbation, all agreed that the essence of the interwar Parisian artistic scene lay in its internationalism. Most critics were confident that the pull of Paris was a good thing, and that foreign artists would adapt to French cultural norms. Others were not so sure, and saw foreign artistic accomplishment as a threat. Chauvinist critics added in the many Jewish critics and dealers as an additional threat to native-born artists. Montparnasse's reputation as a pleasure center increased accusations of cultural decadence, where drugs and sexual libertinism flourished, and jazz music triumphed over the traditional French café-concert. Montparnasse of the 1920s embodied a standing reproach to nationalistic xenophobia. As one contemporary put it, that which diplomats debated in Geneva, where the League of Nations met, was lived on a daily basis in Montparnasse.[9]

The appearance of foreign-born artists in Paris, who had been present in large numbers throughout the period of the Third Republic, was in itself neither new nor troubling.[10] Artists from all over the world had come to Paris to study with the masters, and whether they returned home, as most did, or remained, they had never threatened the hegemony of French artists. The French could accommodate lone foreign figures such as Camille Pissarro and Vincent Van Gogh. In the 1920s, there was still no shortage of French artists, but now Fernand Léger, Henri Matisse, and other leading French modernists had to compete on equal terms not only with Picasso, Gris, Lipchitz, and Foujita, but with such newcomers as Max Ernst, Joan Miró, Salvador Dali, and Man Ray. Sympathetic critics such as André Salmon could take pride in the fact that the presence of so many foreign artists meant that Paris remained the center of the art world; others found the same internationalism disturbing, and began to construct a nativist Ecole Française to combat the Ecole de Paris. Jewish visibility in art was part of a larger "Jewish awakening" in literature and the Parisian Jewish press, which led to more publicity for the artists of Montparnasse.[11]

Interwar France was not just a sanctuary for émigré artists; in the 1920s, France took in more refugees than anywhere else in the world. The percentage of foreigners in the French population rose from 2.8 percent in 1911 to 3.9 percent in 1921, peaking at 7 percent in 1931, at which time the foreign-born population in Paris reached 9.2 percent [12] Many of these foreigners were Poles and Russians, and 150,000 of them were Jews, of whom 60 percent lived in the Paris basin.[13] By 1939, there were 200,000 Jews in the Paris basin, representing 7 percent of the total population.[14] The Jewish population of France roughly doubled in these two decades, mostly due to Ashkenazi Jews arriving from Central and Eastern Europe. Broadly speaking, France welcomed immigrants in the 1920s when the country was eager to replenish itself with workers who would rebuild the shattered infrastructure. The French liberalized naturalization laws in 1927,

making it easier to become a French citizen. Then they withdrew the welcome mat in the 1930s as the Great Depression created competition for jobs, and at a time when Jews began to arrive in even greater numbers with the rise of Nazism in Germany. As fears of war increased, many French perceived Jews as fervent anti-Nazis likely to instigate conflict with Germany. The rise of the Popular Front and the triumph of the first socialist prime minister of France, none other than the Jewish writer and intellectual Léon Blum, further exacerbated native French antisemitism. Chapter 7 will consider how Jewish artists responded to the increasingly somber international scene.

## Artists and Sexual Politics

Whether one emphasizes the apparent triumph of Jewish artists in the 1920s or the backlash against them by fellow artists and hostile critics can be a glass half-empty or half-full choice. Substantial levels of success and integration led to some inevitable hostility, which would hardly have surprised young Jews who were used to much worse. Rather than weighing degrees of acceptance and rejection, it might be more useful to determine the factors that conditioned their success in this particular milieu. One element was sexuality. As people flocked to hedonistic Montparnasse to rub shoulders with artists and literati, they indulged themselves in drink, dance, and drugs. Historians have warned us about a backlash here too, as politicians and moral reformers worried about French demographic decline connected to a "civilization without sexes," signified above all by the "new woman" or flapper who preferred independence to marriage and maternity.[15] Radical changes in sexual mores and gender norms were certain to elicit strong responses. Conservatives like Pierre Drieu la Rochelle feared the loss of gender boundaries and would have perceived Montparnasse as the epicenter of dangerous new norms. The same critics who decried the new sexual freedom also feared loss of boundaries between immigrant Jews and native-born French artists. The more those male Jewish artists demonstrated their virility, the more readily they were accepted as quasi-French and the less "Jewish" they seemed. A previous chapter has shown how Jewish men were often perceived as bookish intellectuals or "coffeehouse Jews" who would rather read or argue than ride and fight. Artists were not the tillers of the soil imagined by Theodor Herzl and Max Nordau, leaders of the Zionist movement, but in their own sphere they could normalize themselves and at the same time sell their art by painting nudes.[16]

One might call this focus on the nude the "Modigliani Effect." The whiff of scandal that adhered to Modigliani's nudes did not hurt their sales potential, as the French smiled knowingly at the unsurprising appeal of such works.[17] The art studios of Montparnasse featured nude models who posed for art students of both sexes. For Jewish artists of the 1920s like Jules Pascin, Moïse Kisling, and Man Ray, representing the nude would have been the opposite of transgressive. It would have celebrated their integration in Montparnasse and the larger French society by suggesting that they were virile, heterosexual men who recognized that the erotic and aesthetic were normative in French society and even more so in bohemian circles. Jewish artists who accepted these norms diminished the sense of otherness that clung to them.

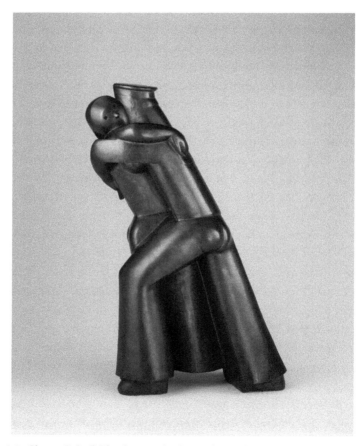

**Figure 4.1** Chana Orloff, *The dancers (sailor and sweetheart)*, 1923, cast 1929, bronze. Philadelphia Museum of Art, purchased with the Bloomfield Moore Fund, 1937-21-3. 2021 Artists Rights Society (ARS), New York/ADAGP, Paris.

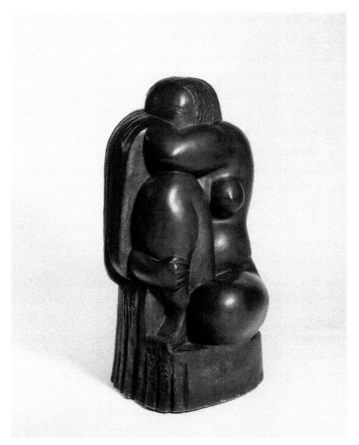

**Figure 4.2** Chana Orloff, *Crouching woman*, 1925, bronze. MNAM, JP34S. Photo: Philippe Migeat. CNAC/MNAM/Dist RMN-Grand Palais/Art Resource, New York. 2021 Artists Rights Society (ARS), New York/ADAGP, Paris.

Antisemitism and misogyny overlapped. The same people nostalgic for an earlier era of order and hierarchy would have found Jews and modern women threatening.[18] The best-known female Jewish painters and sculptors came from Eastern Europe and did not flaunt their sexuality or indulge in the modish lesbianism of interwar Paris. Alice Halicka and Sonia Delaunay were married to other artists; Mela Muter had divorced her husband and lost her French lover at sea soon after the war; Chana Orloff was a widow and single mother; Marevna raised her daughter Marika on her own when Rivera returned to Mexico in 1921. Orloff and Muter conformed to gender norms for female artists in creating works celebrating maternity and childhood. Both also did a large number of portraits, which helped pay the bills. Orloff also sculpted busts of some of the

more notorious lesbian personalities of the era, showing her level of comfort with deviant sexuality. Women artists may have been less overtly sexual than were their male peers, but in not violating sexual norms Muter, Delaunay, and Orloff achieved a high degree of acceptance and economic success. One might contrast them with the best-known Polish artist working in 1920s Paris, Tamara de Lempicka, who explicitly depicted queer female sexuality. She portrayed women who did not need men to experience pleasure, in a hard-edged art-deco style that has become emblematic of the era.

These artists born in the late nineteenth century also differ from Meret Oppenheim, a Jewish artist a full generation younger who took art classes at the Académie de la Grande Chaumière in Montparnasse when she arrived in Paris in 1932 from Berlin aged eighteen. The free-spirited Oppenheim, of Swiss-German heritage and thus one who did not come to Paris from Eastern Europe, turned to the surrealists, posed nude for Man Ray, and was involved romantically with Man Ray and Max Ernst. On the other hand, the most famous expatriate lesbian in Paris was probably Gertrude Stein (though Natalie Clifford Barney, also from the United States, led a more notorious lifestyle). A Jewish writer and art collector who conducted her salon at her home at 27 rue de Fleurus, between Montparnasse and the Luxembourg Gardens, Stein held sway over the avant-garde for most of these years. Picasso painted her portrait, Lipchitz sculpted her, and artists and writers flocked to her Saturday salons. No opprobrium attached to her lifestyle, at least in avant-garde circles. At least three Jewish women, Berthe Weill, Katia Granoff, and Jadwiga Zak, worked as art dealers and patronized female artists, both Jewish and non-Jewish, including Suzanne Valadon and Alice Halicka.[19]

## Les Peintres Maudits (The Cursed Painters)

Modigliani died in the first month of the new decade, but his memory lived on in the 1920s and beyond. The edited volume on Modigliani released by the Jewish Museum of New York in conjunction with their 2004 one-man show—*Modigliani: Beyond the Myth*—aimed to dispel the legend of the dissolute bohemian who drank incessantly, smoked hashish, and did himself in to an early death at age thirty-five. Everyone who knew him told stories about him, and it seems that everyone in Montparnasse knew him. Jacques Lipchitz wrote at length on him; so did André Salmon. His own daughter, Jeanne Modigliani, wrote a biography called *Modigliani: Man and Myth* in the 1950s. A notorious early treatment of the artist's life that encouraged the myth was the novel written by Michel Georges-

Michel, pen name of Georges Dreyfus, called *Les Montparnos: roman de la bohème cosmopolite* (The Montparnassians, novel of cosmopolitan bohemia), written in 1924, translated into English in 1931, and retitled somewhat vaguely as *Left Bank*. The novel preserves most of the artists' real names, but lightly fictionalizes Modigliani as Modrulleau, and Jeanne Hébuterne as *Haricot Rouge*, Kidney Bean (her real nickname was *Noix de Coco*, Coconut, due to her pale white skin). Dreyfus worked for the Ballets Russes as well as being a painter and writer, and given his name was likely Jewish. A second volume called *Les Autres Montparnos* was published in 1935. The fatuous plot of the novel centered on Modrulleau's (called Modru, as Modigliani was called Modi) hope of fathering a child who will be "the one who is to come." First, he thinks it will be with Haricot Rouge, then he meets a princess and couples with her so as to produce a prince-artist. When she aborts the child, he goes crazy, wrecks his studio, and destroys his possessions. He dies at the end and Haricot Rouge falls rather carelessly out of a window, killing herself and her unborn child. Modigliani's early death and the dramatic suicide of his mistress/model the next day made his story irresistible; his copious use of drugs and alcohol added further piquancy to the legend of the *peintre maudit* (that *maudit* was a homonym for Modi didn't escape French writers).

The value of the novel lies in the profuse details about life in 1920s Montparnasse. The Café de La Rotonde plays a central role in the novel as the home away from home for immigrant artists. Dreyfus called Montparnasse the most interesting place in the world:

> You are a journalist, and you will not fail to see the thousands of "stories" in these thousands of people. All of them are intellectuals, they have come here from every corner of the globe, from Siberia and South America, from Scandinavia and the Cape. All have revolutionary ideas about politics or art. All are gestating the future, in this atmosphere which you have described as poisonous … [W]ouldn't you like to get drunk with Kisling, who takes raw color in his hands and models it as a sculptor does clay, a tremendous force in spite of his sprees and eccentric rages? You might become the brother of the little Jew Bezalel who came to Paris from Jerusalem on foot to sculpt ivory wreaths.[20]

After itemizing some of the exotic sites from which artists have come, Dreyfus focuses on Moïse Kisling, and calls an artist from Jerusalem "Bezalel," after the name of the art school founded by Jews in Palestine in 1906 to further Jewish craft tradition. Kisling's prominence as the most discussed artist in the book, next to Modi/Modru, reflects his considerable reputation in the early 1920s and his penchant for throwing parties in his studio that earned him the title "king of

Montparnasse." He was also close to Modigliani during the war, after his return from the French Foreign Legion; at one point they shared a studio. *Les Montparnos* nicely conveys the Ashkenazi Jewish culture that permeated Montparnasse:

> The Russians, who had already lunched, came in about noon. There was Blumenfeld, the translator of Yiddish. He had a leonine head with a square muzzle, fiery hair which stood up and waved like flames, but, like Soutine, he had beautiful eyes, clear, candid, pure. Since Trotsky's departure he had been secretary of the cap-maker's union in the rue des Rosiers, and every week he gave them a lecture in Yiddish on political, literary and scientific happenings all the world over, for all these uncouth kinsmen of Spinoza were more famished for things intellectual than they were for bread. In La Rotonde they could have inscribed on the marble table-top the Talmudic precept: "If three men seated at a table are not speaking of the things of wisdom they are no better than dead men."[21]

This passage connects Montparnasse both to Jewish radicalism and to the Jewish neighborhood on the right bank called the Pletzl of Paris. It also indicates that Jewish poets and translators as well as visual artists inhabited Montparnasse. Lupus Blumenfeld was a real person, so despite Dreyfus' novelizing, the details may well be accurate. The passage connects the many immigrant Jews living in the fourth and eleventh arrondissements on the right bank with the Jewish artists of Montparnasse. One conjectures that young Jewish artists must have shopped in the Pletzl for familiar foods such as rye bread and pickled herring. These humble details, the real value of Dreyfus' novel, make one more passage worth quoting. He reports on snatches of conversation overhead at the Montparnasse café La Rotonde:

> They're all foreigners, the ones who have tried to simplify the French language and do away with syntax and punctuation: Apollinaire, a Pole, Cendrars, a Swiss … If the Jews were clannish, as is claimed, they would be the masters of the world, and the frightful war of 1914 would not have occurred. The Russians: all the faults attributed to the Jews. That is why they are anti-Semitic … When one leaves Montparnasse one gets a nostalgia like that of the war, one misses the incessant movement, the life, because as many things are born here—and in what cadence!—as were destroyed out there."[22]

Dreyfus jumbles a variety of perceptions, of the foreign artistic element, of Jews, and of Montparnasse as the creative antidote to the destruction wrought by the war. One can imagine the resentment felt by French nationals especially during the war at encountering artists who were still unfamiliar with French and

perhaps spoke German-sounding Yiddish. There are echoes too of Jews like the Yiddish scholar Ludwig Zamenhof who created Esperanto in hopes of encouraging universal goodwill, and perhaps memories of the large Esperantist congress held in Paris prior to the war. While Dreyfus/Georges-Michel did not avoid the Jewish presence in Montparnasse, by turning Modigliani into Modrulleau he obfuscated both Modigliani's Italian and Jewish heritage. While the real artist never hid his Jewishness, it was easy for his admirers to substitute bohemian for Jewish marginality, which was easier to romanticize and fit into French tropes of the artist. Georges-Michel's novel played on Henri Murger's 1851 stories *Scenes of Bohemian Life* in imagining Montparnasse as a latter-day Latin Quarter.[23]

Though their identification with licentious subject matter, chiefly nudes for Modigliani and nude or partially draped young women for Pascin, as well as reputedly dissolute life styles, made both artists subject to censure, both were in fact beloved figures within the artistic community of Montparnasse. Friendly critics called them "princes" for their patrician allure. Modigliani spoke excellent French and was strikingly handsome; Pascin was dapper in his black clothes, white silk scarf, and bowler hat, and came from a wealthy family, though some said that despite his adaptation to many cultures he spoke all languages equally badly.[24] Their outsider status transmuted from Jew to bohemian and dandy. They were outsiders who became emblematic Montparnasse insiders partly because their Latinized Jewishness appeared less threatening. Their opposite number was Chaim Soutine, whom Modigliani saw as his successor but who carried the mark of the shtetl and an impoverished childhood. It was a tribute to Modigliani and a testament to his Jewish identification that he perceived continuity rather than difference in his and Soutine's disparate styles. On his deathbed, Modigliani told his dealer Leopold Zborowski not to grieve, for "in Soutine I leave you a genius of an artist."[25] Yet Soutine was also a *peintre maudit*, cursed in his case by his difficult, recalcitrant personality, shaped by youthful deprivation.

## Paris Was a Woman: Wives, Mistresses, and Models in Libertine Montparnasse

Aside from their Sephardic Jewish origins and premature deaths, their contemporaries connected Pascin and Modigliani for their evocation of the sensuality of the Parisian artistic scene. Modigliani was the exuberant, handsome seducer who painted scandalous nudes and believed that to paint a woman was

to possess her. He had turbulent affairs with the Russian poet Anna Akhmatova, with the South African writer Beatrice Hastings, and with the young art student Jeanne Hébuterne, who bore him a child and killed herself out of love for him. The myth of bohemia included sexual freedom, yet Warnod was quick to point out that women did not function solely as models, mistresses or muses. Paris featured liberated women who not only drank and smoked in bars but also worked as artists. Modigliani met Jeanne at art school, and Pascin was married to the artist Hermine David, as were many other Jewish artists, including Ossip Zadkine, Sonia Terk, Louis Marcoussis, and Alice Halicka (the latter two married to each other). Sonia Terk's prior marriage to the art dealer Wilhelm Uhde in 1908, a marriage of convenience that allowed her to remain in Paris, suggests that before the war it was still difficult for unmarried women to pursue an autonomous career.

The *garçonnes* (Victor Margueritte's neologism for the androgynous women of the era, title of an infamous 1922 novel) who flaunted their libertine lifestyles in the cafés of the left bank did not fit so easily into mythic bohemia or high-life Montparnasse. In her first book of memoirs, Marevna revealed the difficulties and sexual demands that a female artist faced, from customers as well as from fellow artists.[26] She wrote that Picasso infuriated Diego Rivera by making sexual overtures to her, then a generation later similarly caressed her daughter Marika's breasts; she reassured her daughter that that was just Picasso.[27] Her memoir shows the continual interplay between art and eros, sexual license excused by genius or bohemia. Marevna's most well-known works feature the artists from her circle rather than (nude) models, and included other foreigners like the Russian writers Ilya Ehrenburg and Maxim Gorky. Women, many foreign born, are emblematic of Paris in the 1920s. They include Josephine Baker, American star of the Revue Nègre; Nancy Cunard, British heiress and devotee of jazz and Black culture; and Tamara de Lempicka. Lesbian writers, artists, and salonnières such as Gertrude Stein and Alice B. Toklas, Claude Cahun and Marcelle Meyer, Nathalie Barney and Germaine Brooks, and the bisexual Tamara de Lempicka, contributed to the atmosphere of "Paris was a woman." Stein, Toklas, Cahun, Lempicka, Meyer, and Barney were Jewish or part Jewish.[28] Of the twenty-two female expatriate writers included in Shari Benstock's *Women of the Left Bank*, thirteen were lesbians. Though she lists many entries under "lesbian" in her index, Benstock has no similar category for "Jew."[29] Much as Jews left their home countries for the freedom Paris promised in pursuing artistic careers, so women and more particularly lesbian women found greater autonomy. They also found female support networks in Paris, as Barney and Stein hosted salons and

promoted artists, and Berthe Weill and other female Jewish art dealers helped them sell their works.

"Paris was a woman" has two very different meanings. It implies the eroticization of Paris as lover and even as prostitute, as when the American expatriate poet e. e. cummings called the city of light "the *putain* [whore] with the ivory throat."[30] Since one of the attractions of Paris in the 1920s was the low cost of living for those with American dollars, Paris could be a cheap whore. The French feminized the republic itself, embodied in the allegorical figure of Marianne dating back to the French Revolution.[31] Since Marianne was allegorical, she was unreal, and therefore could not be confused with whatever powerful male was ruling the state. When applied to the 1920s, "Paris was a woman" signifies the newly prominent role that women played in its cultural life, particularly on the *rive gauche*. These women were real rather than symbolic, independent and self-motivated rather than eroticized and objectified.[32] While the phrase does not exclude French women, it emphasizes that Paris attracted many foreign women artists, writers, publishers, and art dealers in the same years that Jews also flocked there. One would imagine that Otto Weininger, the turn-of-the-century Viennese misogynist and antisemite, would have seen Montparnasse in the 1920s as proof of his thesis that these two categories of outsiders reinforced the worst tendencies in each other.[33]

Until World War I, Italians comprised most of the cohort of artists' models. In Montparnasse, they gathered in front of two art academies, Colarossi and Grande Chaumière, on the rue de la Grande Chaumière. Artists could watch them from the terrace of the Dôme café and sometimes arrange to share a model.[34] At the outset of the war, the government decreed that all foreigners had to register with the police. Most of the Italian models lacked working papers and quickly returned to Italy. After the war, as demand for models increased, French women and foreign women seeking to become artists themselves became models, following the example of Suzanne Valadon, who had modeled for Toulouse-Lautrec, Renoir, and others in Montmartre in the 1880s. Models who became artists included French star Kiki de Montparnasse, British Nina Hamnett, Americans Lee Miller and Berenice Abbott (both photographers), and Swiss-German Meret Oppenheim.[35]

The artists' models of 1920s Montparnasse became celebrities in their own right, more widely recognized than most of the female artists. Pascin discovered the black model Aïcha Goblet riding a white horse in a circus, a career that merited her assuming the title of *artiste*. Her exotic looks caught the attention of numerous artists, including Henri Matisse, though photographs show her as

striking rather than beautiful. She became the companion of a Jewish artist, Samuel Granowsky, better known as the "cowboy of Montparnasse." Alice Prin became the most celebrated model of the 1920s, painted by Kisling and Foujita and photographed by Man Ray, whose mistress she became for most of the decade. Made famous under her nickname Kiki, she personified the free sexuality of the era even more than Pascin. Her well-known memoirs (which she sold in 1929 by promising an autograph and a kiss in the bargain, in return for 30 francs)[36] reveals that as a teenager in 1918 she was already the model/mistress of another Jewish artist, Maurice Mendjizky, and that Florent Fels and Leopold Zborowski watched her posing for Kisling.[37] Kiki's friend Thérèse Maure, whom the poet Robert Desnos nicknamed Thérèse Treize, became a model and lover of Per Krogh once Lucy (also a model) had left him for Pascin. Lucie Badoul became the model and lover of the Japanese artist Foujita, who renamed her Youki, Japanese for snow. She eventually left him for Desnos. There were also the Perlmutter girls, Bronia and Tylia, who arrived from Holland in 1922. Bronia was particularly striking, modeling for Man Ray and Kisling and posing as Eve to Marcel Duchamp's Adam in a farce organized by Francis Picabia, before she married the filmmaker René Clair.[38] From serious female artists such as Chana Orloff and Sonia Delaunay to joyful models and chanteuses (Kiki performed at the Jockey and other clubs), Kiki's Montparnasse was embodied in a woman. The bohemian myth of the carefree *grisette* embodied in the character of Mimi in *La Bohème* was alive and well.

Simone de Beauvoir wrote about Montparnasse as it was when she lived there a decade later, but the scene she described sounds very similar to the café life of the 1920s:

> On the whole ... we found the women more interesting and amusing than the men. Every night tall American girls could be seen getting themselves majestically stewed. There were women artists, artists' women, models, minor actresses from the Montparnasse theaters, pretty girls and those not so pretty, but all of them, more or less, kept by someone or other ... From time to time we would go to the Sélect, among the crop-haired Lesbians, who wore ties and even monocles on occasion; but such exhibitionism struck us as affected.[39]

Like Beauvoir herself, women of the left bank were independent and sexually liberated, yet insofar as some of them were "kept" by some man, they remained dependent on the male artists and customers. The model Tylia Permutter belonged to the lesbian scene that included the photographer Berenice Abbott and the novelist Djuna Barnes.[40]

## Jules Pascin, Icon of the Crazy Years

The French critic André Warnod who dubbed the eclectic and cosmopolitan group of Montparnasse-based artists the Ecole de Paris followed it up with a book that described the "cradles of young painting" in Montmartre and now in Montparnasse. Warnod cited the names of many artists in a book of nearly 300 pages, yet stated categorically, "If we had to designate a single painter capable of representing all the living forces which animate Montparnasse, we wouldn't hesitate. We would name Pascin."[41] He called him "uniquely capable of expressing the disquieting and tormented epoch in which we live . . . He offers a curious type of perfectly international culture."[42] Pascin's studio was located on the boulevard de Clichy in Montmartre, but no matter; Warnod identified him with Montparnasse,

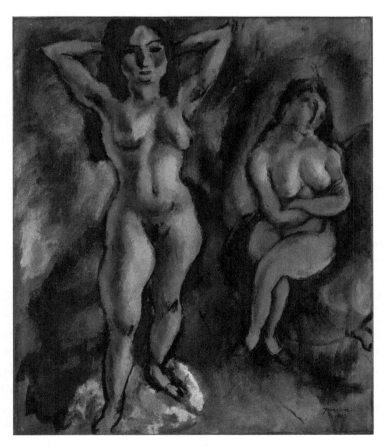

**Figure 4.3** Jules Pascin, *Two nudes, one standing, one sitting*, 1913. Barnes Foundation, BF439. 2021 Artists Rights Society (ARS), New York.

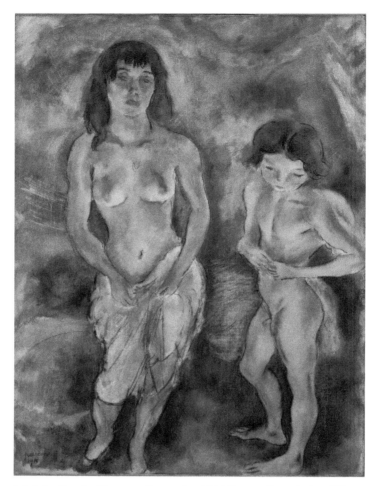

**Figure 4.4** Jules Pascin, *Two standing nudes*, 1914. Barnes Foundation, BF276. 2021 Artists Rights Society (ARS), New York.

where he had been a fixture in the Café du Dôme ever since his arrival in December 1905. He justified his choice of Pascin because of his "disquieting and clairvoyant sensibility, his cerebral quality,"[43] but perhaps above all because of Pascin's cosmopolitanism—a citizen of the United States from his wartime sojourn who was born on the Danube and inhabited artistic bohemia more than he did France.

Blessed and cursed with great artistic facility, Pascin tended toward a facile and repetitive art. The best-known Jewish artist of Paris in 1914, Pascin, as we have seen, took off for America and in his usual restless way traveled around the American South and the Caribbean during the war, producing a body of quite distinct landscapes, many of which featured Black people he viewed in Harlem,

Charleston, and Havana. He returned to Paris in the year that Modigliani died, but he was not claiming Modigliani's heritage. Being absent from Paris for six years means that Pascin missed most of the trajectory of Modigliani's career. Born a year after Modigliani in 1885, Pascin would personify Montparnasse in the 1920s, become a beloved figure in the artistic community, and immolate himself through over-indulgence.

Pascin lived the decade of the Crazy Years in emblematic style, partying, filling his studio with hangers-on, and reverting to his pre-war subject matter of melancholy women and blowsy nudes. He was a victim of his lifestyle, which required a continual infusion of money that kept him producing the trademarked risqué works he knew would sell. The critic Florent Fels, editor of the journal *L'Art Vivant* during the 1920s, quoted Pascin as telling him, "the temperament of a man counts for more than his work. I would not be disagreeably surprised to see the works treated as perishable matters and to disappear at the death of the artist."[44] This interview took place in the spring of 1930 on the outdoor terrace of La Rotonde. One suspects that Pascin realized near the end of his life that his indiscipline made this statement true. That June he slit his wrist, scrawled "adieu Lucy" in a farewell gesture to his mistress (wife of the artist Per Krogh), and when he failed to die quickly enough hung himself in his studio. Modigliani's death was at least inadvertent, though probably exacerbated by living too long on the edge. The word Fels applied to Pascin, *libertinage* (libertinism), is more accurate than bohemian, for Pascin was a dandy, and 1920s Montparnasse had replaced bohemian seediness with upward mobility and the high life. Fels encapsulated Pascin nicely by comparing him to two nineteenth-century figures: "The rhapsody of the life of this personage who lived like Henri Heine and finished as Gérard de Nerval has the perfection of a pure poem."[45] Heine was the German-Jewish poet who, like Pascin, fled his Jewish origins to live in Paris; Nerval was the Romantic suicide famous for his unconventional lifestyle.

Pascin's relations with women played a central role in his life and death. The artist Hermine David followed Pascin to America in the spring of 1915; they both sailed on the *Lusitania*. Hermine would be especially lucky to arrive safely; on the return trip from New York to Liverpool departing on May 1, a German submarine sank the *Lusitania*, killing 1,100 people. The two artists married in 1918 after traveling all over the U.S. The restive Pascin spent time in New Orleans and Charleston as well as Cuba, and ventured as far west as El Paso, Texas.[46] Back in Paris at the end of 1920, an American citizen only since September 20, when he swore the oath in the presence of Alfred Stieglitz and Maurice Sterne, whom he'd known in pre-war Montparnasse at the Dôme, his marriage to Hermine

eventually fell apart. In 1910, he had a brief affair with Cécile Marie "Lucy" Vidil. During the war, in Pascin's absence, Lucy married the Norwegian artist Per Krogh, who would become famous three decades later for the mural he painted for the United Nations Security Council chamber in New York. Pascin and Lucy would take up with each other after his return, but she was unwilling to leave her husband, by whom she had had a son, so the relationship remained difficult.

Meanwhile Pascin resumed his peripatetic ways, traveling to Algeria in 1921 and to Tunisia for a prolonged stay in 1924. He visited Italy in 1925, and the following year headed for Palestine, despite his lack of overt identification with his Jewish heritage. He made a detour to Tunisia and disembarked in Egypt before reaching the Holy Land. He returned to New York in 1927 to renew his U.S. citizenship. Lucy joined him there briefly in January but soon departed; they traveled to Spain and Portugal together in 1929. Pascin signed "Adieu, Lucy" in his own blood in June 1930; her response was finally to leave Per Krogh and to work at sustaining his memory in the Lucy Krogh Gallery that she opened in the 1930s and ran for forty years (she lived until 1977).

Pascin expressed his Jewishness in his "man without a country" persona of the wanderer. Whereas Marc Chagall never forsook his roots in Vitebsk, Pascin was the arch-internationalist. Partly this reflects Pascin's privileged, cosmopolitan background. He was an expatriate, never an immigrant. As with Hemingway, his "fellow American" with whom he drank in Montparnasse, Paris for Pascin was a moveable feast. One might not expect Ernest Hemingway to be overly chummy with Jews, given the antisemitism expressed in his 1926 novel *The Sun Also Rises* and his frequent use of the slur "kike" in his correspondence.[47] Pascin's persona evidently bore none of the stigmatized stereotypes of Jewishness. Hemingway typed Pascin in the same way everyone else did in his memoir of 1920s Paris, as lascivious and a drinker. Finding Pascin sitting at an outdoor café on the boulevard Montparnasse with two young models, he joined him, and after inquiring about Hemingway's age (twenty-five), Pascin offered him the sexual favors of one of the models. After some mixed sexual and artistic banter, during which Pascin told the girls that the next day he would do watercolor portraits of them, Hemingway begged off, saying he had to go home to his "légitime," his legitimate wife. This anecdote established his moral superiority to the temptations that the older roué Pascin had offered. Hemingway concluded that Pascin "looked more like a Broadway character of the Nineties than the lovely painter that he was, and afterwards, when he had hanged himself, I like to remember him as he was that night at the Dôme."[48] Hemingway's remarks highlight one of

Pascin's most commented traits, his vaunted generosity.[49] Pascin offered to buy him a real drink, not just a beer, as well as offering him one of "his" girls. His bon vivant persona may have hastened his untimely end. His need for money to support his festive lifestyle led him to sign a contract with the Bernheim-Jeune Gallery; toward the end he told friends he felt bought, as well as used up. He ended as dejected as the women he depicted sprawled across divans, peering out morosely from beneath their cloche hats. So ended the life of Pascin, called the prince of the three mounts: Montmartre, Montparnasse, and Mont de Vénus. His libertine reputation did nothing to diminish his popularity.

The deaths of Modigliani and Pascin are bound up inescapably with their reputations. Both died prematurely, Modigliani at age thirty-five and Pascin at forty-five. Though disease felled Modigliani, his premature death certainly hastened the untimely end of his young mistress, whose suicide enhanced the romantic aura of the bohemian artist. Pascin confessed to feeling used up. In Freudian terms, he failed to sublimate his sexuality in his art, or to renounce instinctual gratification for the higher pursuits of culture.[50] Both artists burned brightly and paid for the lack of self-restraint in their lives. The sense of suffering conveyed by their deaths may have furthered their Jewish identity.

## Kisling, Prince of Montparnasse

Moïse Kisling, the third master of revelry during the Crazy Years of the 1920s, replaced Modigliani as "prince of Montparnasse;" unlike his friends Modigliani, Soutine, and Pascin, he was neither tormented nor cursed. Kisling was an Ashkenazi Jew from Poland, son of a tailor who died in 1900, who arrived in France at the age of nineteen in 1910 with his friend Simon Mondzain and 20 francs in his pocket. That same year the pianist Arthur Rubinstein made the same voyage from Poland to Paris, and he and Kisling became friends. Kisling moved right into the Bateau Lavoir, still the home of Picasso, and did not make it down to Montparnasse until 1913, claiming to have evacuated Montmartre due to all the dust and noise from the construction going on there. Kisling's ebullient personality led to success after success.[51] His famous duel with his fellow Polish-Jewish immigrant artist Leopold Gottlieb, on the eve of the war, enhanced his reputation, as did the three-day-long wedding celebration marking his marriage to the daughter of the commandant of the Paris Guard before the war was over. The duel followed by service in the French Foreign Legion and then by marriage to a Frenchwoman reinforced Kisling's reputation.

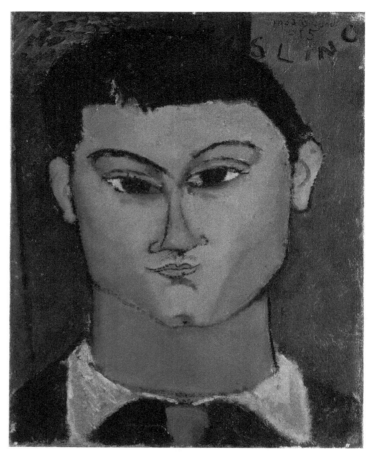

**Figure 4.5** Amedeo Modigliani, *Portrait of the painter Moïse Kisling*, 1915. Pinaciteca di Brera Gallery, Milan, HIP/Art Resource, New York

Moïse and Renée Kisling cut their hair in look-alike bangs, and Kisling proceeded to storm the art world and the postwar Montparnasse scene. He was known as Kiki even before the model made famous by Man Ray went by that name; even more confusedly he painted nude portraits of her (presumably signed as Kisling, not Kiki). The parties he held in his studio were famous and much recounted by Montparnasse memoirists. Apparently, he also lost his foreign accent. Made a French citizen in 1924, he received the Legion of Honor medal in 1933; a ceremony held at the Montparnasse nightspot La Coupole in his honor attracted 900 celebrants.[52] The androgynous hairstyle and the nickname he shared with Montparnasse's most famous model suggest that Kisling must have been comfortable enough in his masculinity to accept some of

the gender-bending styles of jazz age Paris. He may have been the most acculturated Ashkenazi Jewish artist in Montparnasse. Although photos of him include nude models inspecting his paintings by his side, his image of bonhomie did not include a dissolute lifestyle, and he remained a good family man whose success led eventually to a country home at Sanary in the south of France.

The one thing he neglected was to advance his art, which stagnated as the 1920s wore on. At the studio that Kisling shared with Modigliani at times during the war (more precisely, the improvident Modigliani shared his studio), one often found Apollinaire, the critic and poet André Salmon, and the poet Max Jacob frequenting there as well. If despair and suffering were qualities assumed to comprise part of the make-up of a Jewish artist, then Kisling fell short. His paintings were at most melancholy, tending increasingly to sentimental, large-eyed waifs, which some mistook as reflecting inner anguish. Unlike Pascin, who was known entirely for portraits and nudes during the 1920s, Kisling painted in all the standard genres— nudes, landscapes, still lives, portraits—and standard they appeared, modernist in their lack of narrative but far from avant-garde. A critic who wanted to deride the Jewish painters of the Ecole de Paris for lack of imagination and boldness might well point to Kisling. Neither cubist nor expressionist, he evolved a generic, vaguely modern style, which underscored his complete assimilation.

In March 1924, Kisling had his first one-man show of the decade at the right-bank gallery of Paul Guillaume. Critic André Salmon called him one of the leaders of the new generation of young painters. The success of this show, which featured nudes of Kiki as well as landscapes and cute children, propelled his career. The following year he told one of the editors of *L'Art vivant*, "One must read in a picture the joy felt by a painter in creating it. It's for this reason that I say: pooh to the problems of geometry, painting must sing."[53] By "problems of geometry," Kisling was referring to cubism. This succinct statement of 1920s hedonism and the rejection of organized schools of art for an aesthetics of pleasure sold paintings, but guaranteed that his figurative style would not push any boundaries.

Kisling was typical of the artists of his generation in neither denying nor emphasizing his Jewishness. In a letter he sent from New York during World War II to a sculptor then living in Brazil, he wrote, "In the U.S. they call me a Polish painter. In Poland, I am a Jew and among the French, I am a *métèque* [pejorative term for alien, foreigner]."[54] In another letter, written after World War II to Ernest Namenyi, author of *L'Esprit d'art juif* (*The spirit of Jewish art*, 1957), Kisling denied that there was either Polish or Jewish art: "I don't believe in the racial influence on art." He felt completely formed by his lifetime spent in France, and saw no similarity in the styles of Modigliani and Soutine, or between

Chagall and Pascin. The best solution is simply to group "all of them under the same flag which is called l'Ecole de Paris."[55] As with Pascin and Modigliani, one would be hard-pressed to identify Jewish traits in his work.

## Soutine and Jewish Expressionism

When Chaim Soutine painted Kisling's portrait, he revealed his mastery of expressionist technique and showed why Modigliani had such faith in him at the

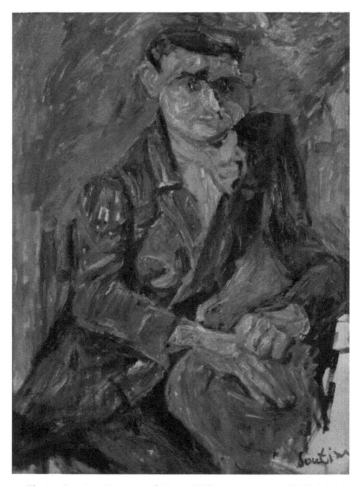

**Figure 4.6** Chaim Soutine, *Portrait of Moïse Kisling, c.* 1919–20. Philadelphia Museum of Art, gift of Arthur Wiesenberger, 194-101-1. 2021. The Renee and Chaim Gross Foundation/Artists Rights Society (ARS), New York.

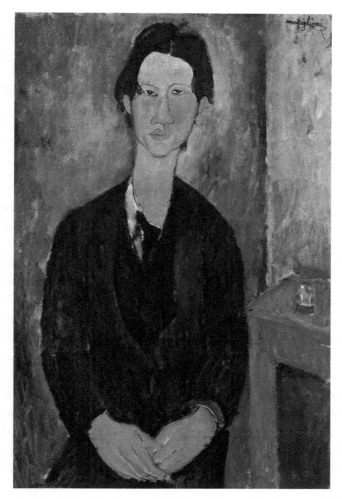

**Figure 4.7** Amedeo Modigliani, *Portrait of Chaim Soutine*, 1917. National Gallery of Art, Chester Dale Collection, 1963.10.47.

end of his life. The irony of the painting lies in the great distance between Soutine's powerful yet accurate rendering of his fellow Jewish artist and Kisling's own smooth untroubled art. One wonders whether Kisling realized that the young and still unknown Soutine had already surpassed him. Of all the Jewish artists of the Ecole de Paris, Soutine was the most original, most *sui generis*, and most difficult for French critics to accept. Listen for a moment to the nearly unhinged commentary of Maurice Raynal, esteemed French critic and author of the 1928 book *Modern French Painters*:

The art of Soutine is the expression of a kind of Jewish mysticism through appallingly violent detonations of color. His work is a pictorial cataclysm, comparable in its exasperated vision to the reckless frenzies of martyrs and heroes ... This art is the very antithesis of French tradition ... It defies all measure and control ... All those distorted, devastated ... landscapes, all of the appalling, inhuman figures, treated in a stew of unheard-of colors, must be regarded as the strange ebullition of an elementary Jewish mentality which, weary of the yoke of its rigorous Talmud, has kicked over the Tables of the Law, liberating an unbridled temperament ...[56]

Raynal mixes the strongest terms he can find with repeated allusions to Soutine's Jewishness. No one ever wrote of Pascin or Kisling this way. Despite all the references to Judaism, Soutine never painted Jewish themes, and rarely even painted his fellow Jews. Yet critics always inferred Jewish angst and one even suggested that his art "prefigured the Holocaust."[57] Soutine demonstrates that an artist can entirely eschew his past and his native heritage, at least in terms of subject, and through style alone convey his inner psyche and cultural underpinnings.

From Kisling (and Modigliani and Pascin) to Soutine, one moves from the pleasure principle to the reality principle, in Freudian language; or from extroverts to introverts, in Jungian terms. This is not to deny levels of psychological depth to the acculturated Jewish artists, especially to Modigliani, but he excelled at the decorative surface of the painting in a way that deflected attention from the psyche. Soutine was all psychic depth, hence critics read him as filled with the angst of the ghetto. That these artists could share so much in common, including friendship and studio space, and yet be so different in style and temperament, underscores the variety of artistic approaches included in the umbrella term Ecole de Paris. Modigliani the portraitist and Pascin the sardonic cosmopolite approached their artistic callings differently, but did not escape from their heritage.

If his artistic style could best be compared to contemporary Austrian artists such as Oskar Kokoschka and German artists like Ernst Ludwig Kirchner and Georg Grosz, Soutine did share one characteristic with Modigliani and Pascin (aside from their religious affiliation): the tendency for writers to romanticize and mythologize him. Soutine came packaged with a storyline: the impoverished child of the shtetl who, despite his success during the boom years of the 1920s, was never able to shake off his disadvantaged upbringing. His humble origins contrasted with those of many of the Jewish immigrant artists who left bourgeois families in Poland, Lithuania, and Russia to become artists in Paris. Recounting this litany of deprivation proved irresistible. Soutine's father was not even a tailor but rather a mender of used clothing, one at the bottom of the social hierarchy,

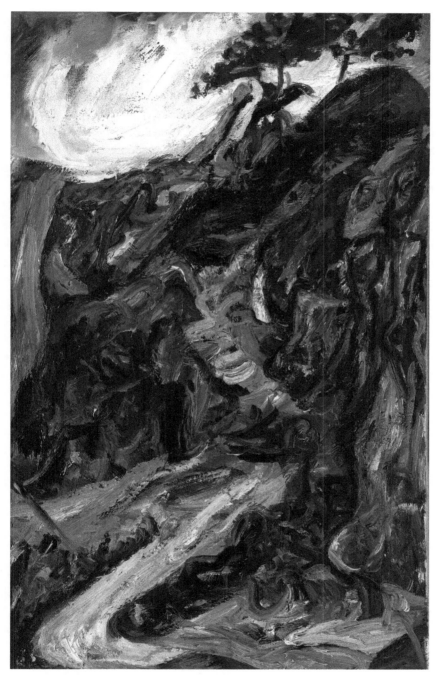

**Figure 4.8**  Chaim Soutine, *Winding Road, near Gréolières*, 1920-1. Barnes Foundation, BF2044. 2021. The Renee and Chaim Gross Foundation/Artists Rights Society (ARS), New York.

who nonetheless had to support a family that included eleven children. Chaim was able to attend art school with the 25 rubles he received as compensation for getting beaten up for sketching another boy's father, a story meant to show not only his poverty but the degree to which art was anathema in that culture. The art historian Maurice Tuchman cited a distrust of the visual in Ashkenazi culture, which led to the belief that pregnant women were not to look at anything that might harm their unborn child for fear of the evil eye.[58] Soutine himself allegedly adopted a furtive manner, and avoided looking people in the eye. In striking contrast to Modigliani, Pascin, and Kisling, Soutine's oeuvre contains only one nude, done late in his career, marking the limits of his acculturation.

Soutine's poverty lasted for his first thirty years, and he was infamous for his poor hygiene. For most of that time, he maintained a studio in La Ruche, where he had arrived in July 1913. His fortunes improved when Leopold Zborowski took him under his wing and sent him to Cagnes-sur-Mer in 1918 and then to the

**Figure 4.9** Chaim Soutine, *Pastry Chef*, 1919. Barnes Foundation, BF 442. 2021. The Renee and Chaim Gross Foundation/Artists Rights Society (ARS), New York.

French Pyrenean town of Céret, where he stayed until returning to Paris at the end of 1920. Dr. Albert Barnes arrived in Paris from Philadelphia two years later, and when Zborowski showed him the landscapes Soutine had done at Céret, Barnes exclaimed, "this is the genius I have sought for many years."[59] Barnes bought dozens of them for between $15 and $30 each (he also bought all the works of Modigliani he could find, paying considerably higher prices). Barnes was not the last to compare Soutine to the putative founder of expressionism, and believed that Soutine would surpass Van Gogh. If this judgment was mistaken, it was true that Soutine's landscapes did exceed Van Gogh's in expressionist passion and wildness. In any case, Barnes made Soutine's name, his prices increased dramatically, and he began to dress and live more modishly. Yet the Lithuanian-Jewish artist Neemya Arbit Blatas, who only arrived in Paris in 1926 during Soutine's heyday, reports in his memoir that when he visited Soutine's studio in the early 1930s it was the most chaotic of any he'd seen—and he was used to artistic disorder. Clothes and shoes filled the bathtub, making it appear that he never bathed. He carried cigarettes in his pockets, including the American brand Lucky Strikes, testament to his newfound prosperity. The two immigrant artists spoke in Russian and fractured French. Arbit Blatas said that Soutine had left Lithuania before it attained independence and so never learned that language, but in fact, Soutine went to art school in Vilna but was from Belorussia. Soutine posed for him in 1939 wearing hat and coat, hands as always jammed into his pockets. Arbit Blatas also commented that Soutine longed to visit the rue des Rosiers in the Marais and eat pickled herring, a traditional Jewish food that his ulcers made it hard for him to digest. Though it would make sense that immigrant Jewish artists would frequent right bank Parisian Jewish neighborhoods, there is little evidence of them doing so.[60] Unlike many of his peers who in France became Marc, Jacques, and Jules, Soutine remained Chaim.

Soutine's landscapes from the south of France made him famous, but like his friend Modigliani he also painted numerous portraits in the 1920s. As might be expected, Soutine's portraits are as unconventional as his landscapes, and are every bit as expressionist. Nearly all are of humble people (he did paint his benefactor Madeleine Castaing, Kisling, and the sculptor Oscar Miestchaninoff) and bear generic titles such as *The Pastry Chef* and *The Chambermaid*. Unlike the standard commissioned portrait, perhaps as rendered by John Singer Sargent, it is hard to imagine anyone being pleased with Soutine's savagely satirical works, with faces twisted and over-large, contorted hands and fingers. Yet the most grotesque portrait is one he did of himself in 1922–3, perhaps before Dr. Barnes discovered him. He exaggerated his ugliness, reddening his face (cadmium red

dominates many of his canvases, sometimes emphasizing vitality, but when applied to a face suggesting embarrassment), and his misshapen, over-sized jacket dominates. Soutine showed himself as one ill at ease with the world.

Preceded stylistically by Van Gogh, Soutine's style influenced later artists, notably abstract expressionists such as de Kooning, Pollock, Dubuffet, and Francis Bacon.[61] This positions Soutine as a forerunner of some of the most important painters of the twentieth century, for whom the process of painting was integral to their art. Soutine was an action painter *avant la lettre*, who frequently damaged his canvases by attacking them with his brushes and palette knife, and destroyed those with which he was unsatisfied (Zborowski sometimes intervened to save paintings from his wrath). He also damaged his canvases by stacking them on top of each other. His patron of the 1930s, Madeleine Castaing, wrote that "when inspired he would paint in a frenzy, using up to forty brushes that he tossed about wildly and discarded on the spot."[62] If this accurately described the practice of the mature Soutine when his painting was relatively controlled, he must have been even more frenzied a decade earlier at the height of his expressionist phase.

The myth of the angst-ridden Soutine obscures the artist's appreciation of the great masters of realist art that he saw in the Louvre. He admired Chardin, Courbet, and especially Rembrandt. Many Jewish artists saw Rembrandt as a predecessor, a quasi-Jew who portrayed sympathetically the inhabitants of the Jewish quarter of Amsterdam among whom he lived. Soutine traveled to Amsterdam to view Rembrandt's works numerous times. The year after his death during World War II, his friend Henri Sérouya paid tribute to him in an article titled "Rembrandt's Successor: Soutine," which appeared in an underground pro-Resistance newspaper.[63] Sérouya argued that it was in imitation of Rembrandt's *Slaughtered Ox* in the Louvre, and not from some atavistic desire to strip away the veneer of civilization and arrive at raw nature, that he hung a beef carcass in his studio in 1925. He reportedly made the metaphorical statement, "In the body of a woman Courbet was able to express the atmosphere of Paris—I want to show Paris in the carcass of an ox."[64] Perhaps Soutine was aware of the performance-art quality of his act, which led to the neighbors protesting vociferously and calling the police. His comment reveals another of Soutine's masters, the French realist Gustave Courbet. A third was the eighteenth-century French painter Jean-Baptiste Siméon Chardin, another master of realism in an age that did not value the style. Soutine's respect for the traditions of Western art and his penchant for realism reflects the difficulty of classifying him as an expressionist, a category he probably would have rejected. The naturalist writer

**Figure 4.10**  Chaim Soutine, *Grotesque (self portrait)*, before 1929. AM VP 1134. RMN-Grand Palais/Art Resource, New York. 2021. The Renee and Chaim Gross Foundation/Artists Rights Society (ARS), New York.

and proponent of impressionism, Emile Zola, defined art as "a bit of nature seen through a temperament,"[65] which neatly defines Soutine's approach to empirical reality.

Soutine's realism underscores how he filtered the external world through his own personality and his modernist sensibility; he enhanced reality by his use of vibrant colors and impasto rather than turning away from it. The same is true for nearly all of the Jewish artists working in Paris before 1940. Those who turned to pure abstraction did so only after 1945. This fact is worth emphasizing, since critics have argued that Jewish modernism was aniconic and abstract, reflecting the religious bias against graven images. These critics cite American Jewish artists working in postwar abstract expressionism such as Mark Rothko, Adolph Gottlieb, and Barnett Newman, "not because images are forbidden, but because the absolute cannot be rendered in an image. It is a purely abstract conception, imageless, like the Jewish God."[66] Yet if one compares their works, or those of Jackson Pollock, allegedly a disciple of Soutine (who was not Jewish, though Pollock was married to a Jewish expressionist, Lee Krasner), one sees the distance between expressionism and abstract expressionism. Soutine and his fellow artists expressed a hunger for the world that contrasted with the abstract transcendentalism of a Rothko. Stated more forcibly, modernism has been equated with a Jewish opposition to pagan idolatry. In *The Artless Jew*, Kalman Bland suggests that aniconism or the rejection of images was due more to Kant, Hegel, and German Jewish idealists who emphasized Judaism's universalistic ethical ethos, than it was to Jewish fear of idolatry.[67] Yet the first artist to banish the real world entirely from his art, Kasimir Malevich, not only was not Jewish but also evicted Marc Chagall from his post as art commissar in Vitebsk. The suprematist black square thereafter floated over Vitebsk instead of Chagall's wandering Jew.

The Jews of Chagall and Soutine's generation felt liberated by their contact with French art and its comfortable relationship to their world. This adherence to representation may have diminished their avant-gardism in the era of nihilist dada and irrationalist surrealism, but the Jewish artists of Paris were nonetheless modernists. The central figure of Parisian modernism, Pablo Picasso, remained representational as well, and for the same reason: they were attracted to the sensory, if not always sensual, world. Dazzled by the light and color of France after enduring the gray wintry skies of their northerly homelands, the Jews were eager to capture the celebrated French quality of light.

Soutine is key to considering the question of the Jewishness of the Ecole de Paris, because critics invariably referred to his ethnic background despite the fact that he never painted overtly Jewish subjects. His difficult childhood caused

him to sever himself from all contact with his family of origin. Even when he became well off in the 1920s, he refused to aid his impoverished family back in Smilovichi. Critics believed they could detect bitter rebelliousness in his paintings. When he painted carcasses, they thought that he was consciously violating Jewish proscriptions against blood. The agonistic element in Soutine's violent approach to art led him not only to reject his origins but also to destroy his own canvases when he was not satisfied with them. The paintings themselves registered a level of violence and alienation that furthered the myth of Soutine as a *peintre maudit* in the tradition of Van Gogh.

Waldemar George, the dominant French Jewish critic of the interwar era who was highly critical of Soutine at the time, later saw his art as triumphant in exorcising death, and said "Soutine, this seer, is a tragic author."[68] This is a post-Holocaust assessment; in the interwar era, George advocated accommodation to French taste. Soutine, who never became a French citizen, rejected the shtetl from which he came but never acculturated like Pascin or Kisling, though he far outshone either one.

Though *peintre maudit* was a familiar category in which the French might place Soutine, it merely romanticized suffering. In the Jewish case, it suggested that Soutine was *maudit*, accursed, because the very wish to become an artist meant he must transgress his culture of origin. Like most of his fellow Jews, critics labelled him an expressionist, which also implied a kind of naiveté, the unrepressed expression of subjectivity. Chagall cultivated this naiveté in his overt primitivism, and shared with Soutine a lack of interest in the theories that motivated other artists to pursue cubism or neoclassicism. Soutine's naiveté was more instinctual and violent than Chagall's, and reflected his sense of isolation. Unlike Chagall, he never married, never was comfortable in the world, and was never nostalgic about his origins. "Soutine's shudder" of subjectivity marked the ghetto Jew who, though freed from the limitations of his birth, could never psychologically overcome those origins.[69] Despite these differences, the French emphasized the Jewish artists' similarities. In a show in 1928, Soutine was classified alongside Chagall, Modigliani, Kisling, and such non-Jewish artists as Rouault, Vlaminck, and Grimaire, as French expressionists. In 1935, he was included along with Chagall, Modigliani, Pascin, and the French artists Utrillo and Rousseau in an exhibition pointedly called *Instinctive Painters: birth of expressionism.*[70] Labelling artists as expressionists might have served to distance them from the French mainstream, but the fact that native-born artists were included as well as immigrants suggests that French expressionism had become conceivable.[71]

# Mané-Katz, Artist of the Diaspora

Soutine was born in 1893, Emmanuel Mané-Katz a year later; both arrived in Paris in 1913, and they worked together in Cormon's studio during their first year in Paris before the outbreak of war. Both were also realists who employed an expressionist style, and both matured as artists in the years after World War I, being too young to fully experience the pre-war avant-garde (Fernand Cormon's reputation was based on his having taught Toulouse-Lautrec and Van Gogh, but he specialized in historical "costume" pictures).[72] In 1914 their paths diverged, and though both of them had brilliant careers in interwar Paris, Soutine remained the dour loner and Mané-Katz the sunny artist who embraced his origins, and the most important portrayer of Jewish traditions after Chagall.

Emmanuel Katz, who went by Mané-Katz (reminiscent of Emmanuel Radnitsky becoming Man Ray; perhaps they felt burdened by a name meaning "God is with us"), came to Paris from Ukraine, where he briefly attended art school in Kiev. His very short stature may have played a role in determining his future, as due to his height (little more than five feet tall) he was barred entry into the French Foreign Legion when he volunteered in 1914. He traveled to London, then back to Russia and his native town of Kremenchug. When he arrived in Paris, Mané-Katz was still wearing traditional Jewish sidelocks (which he soon cut off) and knowing two sentences in French: "I don't understand" and "I want to eat."[73] After the Revolution of 1917 enfranchised the Jews, Mané-Katz was named professor of art at Kharkov. In this way, his career ran parallel to that of Marc Chagall, whom the revolution made an art teacher in his home town of Vitebsk. Both also experienced the disruptions of civil war, though these were likely worse in Mané-Katz's case, as Ukraine witnessed terrible pogroms against the Jews. He lost all of his art students, and returned to Paris in 1921, two years before Chagall.[74]

It is inevitable that Mané-Katz would be compared with Chagall, since they were the two French-based artists to dwell on images drawn from the "old country" from which they came. They are the two pre-eminent painters of the Jewish Diaspora, who arrived on the artistic scene at a critical juncture, able to accurately depict as well as imagine Jewish life in the shtetl as it existed before the Russian Revolution and the end of the Pale of Settlement, and who portrayed that experience in a modernist idiom. Polish artists had been depicting Jewish life at least since the eighteenth century.[75] With Chagall and Mané-Katz, Jews participated in their own representation. Chagall was better at situating his figures in their surroundings, depicting villages, farm animals, and the accoutrements of life in the shtetl (though in fact his native Vitebsk was a city rather than the village he portrayed). Because

he was more a realist than a fantasist like Chagall, Mané-Katz was better at depicting the range of Jewish types who inhabited that world. Still, there is considerable overlap in their subject matter, if not in their styles. Mané-Katz did not solely paint scenes of Russian Jewish life; he also did nudes, still lives, landscapes, and portraits, as for example portraits of the Russian writer Ilya Ehrenburg in 1922 and the French writer Paul Valéry in 1937.[76] In Paris the Yiddish writer Lupus Blumenfeld encouraged him to become the Jewish painter of the Diaspora, perhaps because he knew Mané-Katz had a stronger religious upbringing than did Chagall, having studied Hebrew in a rabbinical school from the age of four.[77]

As early as November 1924, the artistic editor of the Jewish journal *L'Univers Israélite* reported on a Mané-Katz exhibition at the Galerie Percier. Jacques Biélinky, himself a Russian émigré from Vitebsk who had arrived in France in 1909, traced Mané-Katz's life and career, asking, "who is this young artist, so little, appearing so juvenile, and whose labor and talent have already acquired a great renown?"[78] The critic reported that he studied at a yeshiva until 1909, when at age fifteen he left for art school in Vilna. Lacking money to continue, he returned home and then spent a year in Kiev. The Parisian press referred to his "Slavic soul;" Biélinky remonstrated, and wrote:

> A specifically Jewish sentiment dominates his canvases. Very typical are his *Young Boys*, his *Old Men*, his *Hassidim*, it is Jewish and archaic Poland. His *Sabbatai Zevi* is a bold work and even a little disconcerting. His pastels are fine and tender. His portraits (*Rabbi Liber* and others) carry the personal cachet of the artist. A visit to that show will be a revelation for many of our coreligionists.[79]

Biélinky reported on many of the Jewish artists working in Paris; none besides Chagall were so unequivocally committed to Jewish art. At the Salon d'Automne of 1924, Biélinky counted fifty-eight Jewish artists showing 145 works. By 1929 at the Salon des Indépendants, the other art show that attracted many Jews, Biélinky enumerated 106 Jews out of 357 artists, of whom one-third were French Jews. Of the remaining seventy-one Jewish artists from abroad, thirty-seven were Russians, fourteen Poles, six Hungarians, three Americans probably born in Russia, two Romanians, and three from Palestine. At the Salon des Tuileries in 1930, he counted eighty-two Jewish artists contributing 193 works out of a total of 2,944 paintings and sculptures. Biélinky provided these numbers in part to reassure critics who feared a Jewish invasion of the arts.[80]

Mané-Katz first visited Palestine in 1928, and returned there in 1935 and 1937; Chagall made the trip in 1931. Mané-Katz was naturalized a French citizen in 1927, Chagall not until a decade later.

Both artists became refugees themselves in 1940, and both spent World War II in New York, returning to France after the war. Back in Paris, Mané-Katz's studio was filled with Jewish artifacts along with the instruments played by "his" musicians: double bass, violin, trombone, and so on.[81] He was also an accomplished sculptor, creating such Judaica as Moses holding the tablets of the law aloft, and David battling Goliath, so despite his Orthodox origins he had no inhibitions about creating graven images. Beginning in 1948, Mané-Katz spent part of every year in Israel, but always returned to Paris. During the Jewish War of Independence, he impressed the Israeli public by bringing many of his paintings to Israel, risking them as the Jewish state fought to survive. He died in Tel Aviv in 1962, and a Mané-Katz Museum opened in Haifa to celebrate the artist and his works that portrayed the world of the Jewish Diaspora.

## Other Expressionists

While many talented Jewish immigrant artists painted as expressionists, most of them have been overshadowed by Soutine. One of those who was once close to Soutine and resented his success was Pinchus Krémègne, who was three years older than Soutine and like him attended art school in Vilna.[82] He came to Paris in 1912 and encouraged Soutine to follow him, which he did the following year, moving into the poorly lit warren known as La Ruche. Like Modigliani, Krémègne initially considered himself a sculptor, but similarly switched to painting during the war. He also visited the Pyrenees town of Céret the year before Soutine got there, in 1918, and that year did a vibrant landscape showing strong rhythmic rooftops and sky. It is not hard to see why he resented being shunted into the shadows by Soutine's celebrity a few years later. Perhaps if Albert Barnes had "discovered" Krémègne in 1922 the story would have turned out differently, but in truth, Krémègne was more balanced between cubist formal rigor and expressionist dynamism than was Soutine, making his canvases more subtle and less radical. One of his biographers says he was at the center of the multiple tendencies of modern art, and synthesized them.[83] Some of his early works during the war have both symbolist and expressionist tendencies, much as did the pre-war paintings of Leopold Gottlieb and Modigliani. Symbolist dreaminess tended to drop away, leaving stark, raw color. Krémègne was finally able to leave La Ruche in 1927, which was a good thing since by that time he was supporting a wife and a son. His wife was Swedish and had worked as a governess for the Nobel family.[84] In 1939, he sent the two of them to Sweden but oddly chose to

remain in France. He survived the war, as did others who remained in France, by moving to the unoccupied zone, in his case to Corrèze, a rural department in southwestern France. Like most of these artists, he painted the usual range of subjects, and was particularly skilled in rendering flesh tones, as in *Nude from the Back* of 1923. Many of his paintings feature musical instruments, including violins and saxophones. In 1960, Krémègne built a small house in Céret and lived there as well as in Paris for twenty years, until his death at ninety-one. A decade later, on the centenary of his birth, the Musée d'art moderne of Céret presented sixty of his canvases. In striking contrast to Pascin the bon vivant, Krémègne told Arbit Blatas that "it is not the man which is of interest, it is the work."[85] Arbit Blatas praised the tranquility and balance of his landscapes and still lives; he described his portraits as "poignant work, pierced by profound psychological observation. Work which evokes the existence of the poor, which recalls to us the moving painting of an Israel . . . The art of Krémègne is all an intense vibration of poetry, all an explosion of humanity, and it awakens some profound resonance."[86]

The third of the "three magi" from Vilna, Lithuania, was Michel Kikoïne, a year older than Soutine and a close friend in their youth. A talented painter who spent fifteen years living in poverty at La Ruche before achieving some artistic success, he has been overshadowed by both Soutine and Krémègne. During World War I he joined the auxiliary corps and dug trenches; he became a French citizen in 1924. Originally from Belorussia, he was the son of a banker, which may explain why his disposition was sweeter and less bitter than that of Soutine. Unlike Soutine, he enjoyed life and infused his art with Jewish mysticism. He married and had a family, again unlike Soutine, and was eventually able to buy a summer home in Burgundy. Conscious of his relation to his adopted country, Kikoïne said, "because we Jews are different, we do not have traditions of painting such as the Italians, Spanish or French do, we must assimilate and appropriate them to our own characteristic outlook."[87] This suggests his equanimity in fusing his Litvak origins with French style. In 2004, a wing of an art gallery at the University in Tel Aviv was dedicated to his memory, and his daughter contributed many of his works to be shown there.

Many more artists deserve mention, but one stands out to exemplify the remarkable role that Jews played in developing European modernism. Isaac Grünewald was a Swedish Jew who arrived in Paris in 1908. He wrote that "one day at Café Versailles I told my Swedish comrades about my experience at the Salon d'Automne, where suddenly I stood in front of a wall that sang, no screamed, color and radiated light, something completely new and ruthless in its unbridled freedom."[88] This experience led him to study at Matisse's academy, which attracted

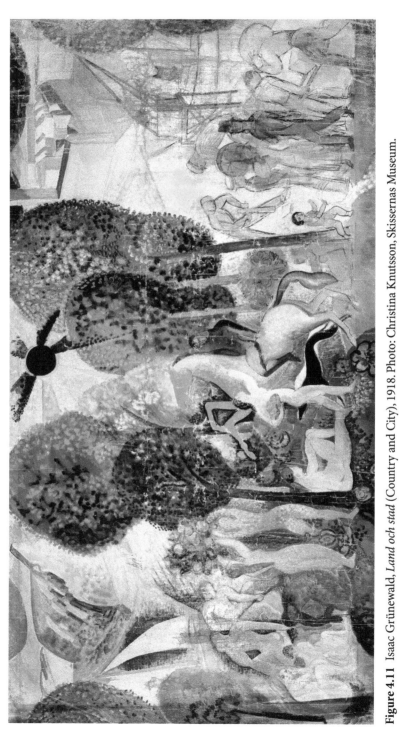

**Figure 4.11** Isaac Grünewald, *Land och stad* (Country and City), 1918. Photo: Christina Knutsson, Skissernas Museum.

mostly foreign art students. He came to know the poets Salmon, Jacob, and Apollinaire, and was part of the German-Scandinavian set who frequented the Café du Dôme in Montparnasse, along with Pascin.[89] His own brilliant palette shows fauvist influence, presumably taught by Matisse, a style which never left him. He met fellow Swedish artist Sigrid Hjertén in 1909, convinced her to join him to study painting in Paris, and married her in 1911. They returned to Stockholm before the war and Grünewald moved back and forth between France and Sweden in the interwar years. His impact on his home country was perhaps unparalleled, since he played the central role in introducing Parisian modernism to Sweden. In 1918, he painted a luminous mural called *Country and City*; in this case he toned down his expressionism for a more decorative effect. Very Jewish in appearance with dark wavy hair, he must have stood out in Sweden, where he became the principal target of antisemitism from the time he first showed his expressionist canvases in 1910 and through the 1920s. By the 1930s, he became a professor at the Royal Swedish Academy of Arts; in 1941, he opened his own art school before dying in a plane crash in 1946. His grandson Bernard Grünewald produced a book about him; the works included there reveal a first-rank modernist who remains little known outside his country of origin.[90]

## And Still They Kept Coming

One could cite many more Jews who studied in Paris for a few years and returned to their native countries, such as the American Max Weber. Yet Grünewald returned frequently to France, executing an excellent portrait of the critic Adolph Basler in 1927 and still painting landscapes at Collioure on the Mediterranean in the 1930s. That Grünewald returned home while most of the Polish and Russian-born Jewish artists stayed in France underscores the difference between willing expatriates and immigrants who felt liberated in France compared to their more hostile homelands. Grünewald did experience antisemitism in Sweden, but it was not enough to hinder his career there.

Though these immigrant artists became well known in the interwar era, they all arrived in Montparnasse before the war, with the exception of Neemya Arbit Blatas, who was born in 1908. Many more immigrant Jews arrived in Paris in the 1920s heyday of the Montparnasse scene, and many became significant artists. Yet none of those who arrived in Montparnasse for the first time after the war achieved the fame that came to Chagall, Soutine, Modigliani, Pascin, and a few others. The generation born in the 1880s and early 1890s alone attained critical

and commercial success. Those born in the first decade of the twentieth century did not. Why did Chagall and the others succeed, while Arbit Blatas, Grégoire Michonze, Philippe Hosiasson, Jacques Chapiro, and many others did not? I think one clue lies in the quotation from Isaac Grünewald cited above: the *avant-guerre* art scene was simply richer with exciting new possibilities. The only comparable era to that of cubism, futurism, and fauvism was possibly the period from 1880 to 1895 when impressionism and neoimpressionism were challenging the domination of the salons. The only Jewish immigrant artist who arrived in France in 1921 and rapidly ascended in the postwar world was Man Ray, and he joined with the surrealists rather than the artists grouped in the Ecole de Paris (he also made a living from commercial photography). Dada and surrealism were new, postwar movements in Paris, but they remained distinct from the Ecole de Paris. Other Jews who participated in French surrealism included the Romanians Victor Brauner and Jacques Hérold, but neither achieved the success of a Salvador Dali or Max Ernst. Another Romanian Jew, Marcel Janco, remained in Paris only a couple of years before returning to Romania. Man Ray had unusual access to the French art scene through his friendship with Marcel Duchamp, whom he knew in New York during World War I.

Another reason why it might have been more difficult for new names to emerge in the 1920s was increased competition in the art market. If hundreds of Jewish artists were working in Montparnasse,[91] it would likely become more difficult to establish a distinct artistic identity. That may help explain why a Jewish immigrant like Tristan Tzara would mount a publicity campaign for his movement, dada; he was hard to ignore. Yet merely appearing outrageous was not enough. Samuel Granowsky was a fixture of 1920s Montparnasse, instantly recognizable in his Stetson hat and cowboy boots, but though he appears in every memoir and guidebook of the Quarter, he did not achieve artistic success. Chapter 6 will suggest that timing was important in achieving success and recognition; those artists who arrived in Paris before World War I were able to capitalize on the artistic boom of the 1920s, while most of those who arrived in the interwar years were not.

There were far too many Jewish artists of the caliber of Grünewald working in 1920s Montparnasse to single out many of them here. Nadine Nieszawer gives short biographies of 178 of them in *Les artistes juifs à Paris, 1905–1939*; her list of painters and sculptors can be consulted online. Two of the most promising died prematurely: Eugène Zak in 1926 and Abraham Mintchine in 1931. In *L'Art vivant* dated February 1, 1926, Florent Fels reported that 300 mourners attended Zak's funeral ceremony at Montparnasse Cemetery. He called him a magician who could animate fantastic figures in the purest poetic invention. Zak had a delicate, Watteau-like sensibility,

and painted thin, sylph-like figures, usually in profile, reminiscent of Picasso's blue period but in a style distinctly his own. He died at age forty-two. Mintchine was only thirty-three and had just signed a contract with the French Jewish dealer René Gimpel when he died of an aneurysm while working in the south of France near Toulon in 1931.[92] From Kiev, he was apprenticed to a goldsmith at thirteen, and spent three years in Berlin before coming to Paris in 1925. He did some beautiful land- and seascapes around Collioure, and an excellent portrait of the critic and Yiddish translator Lupus Blumenfeld. He also painted some allegorical works; the most striking shows a sleeping man, probably the artist himself, dreaming at his desk while an angel rides an eagle equipped with reins over his easel.[93]

We have seen that Lucy Krogh responded to the death of Jules Pascin by opening a gallery, to support herself in part by selling the paintings and drawings that Pascin left to her in his will. Per Krogh divorced Lucy in 1931 and moved to Oslo. Lucy also showed the works of Pascin's wife, Hermine, to whom the artist had left a portion of his work.[94] Jadwiga Zak, the widow of Eugène (Eugeniusz) Zak, opened the Galerie Zak in 1929 in Saint Germain-des-Prés, north of Montparnasse on the left bank. She profited from her connections with Jewish artists, showing the works of Chagall, Modigliani, and Pascin, as well as other modernists such as Kandinsky. In 1930, Mme. Zak experienced some unwanted publicity when Picasso sued her for having purchased and then sold some of his juvenile drawings, which the artist claimed had been swindled from his aged mother in Barcelona.[95] The Galerie Zak survived this episode, but Mme. Zak fell into the hands of the Germans in 1943 and was deported. From Modigliani to Pascin, the Jewish presence combined art, commerce, and personal tragedy. For Eugène and Jadwiga Zak, art existed on the edge of an abyss.

# Notes

1   www.theguardian.com, November 10, 2015. *Nu couché* sold for $170.4 million at Christie's auction house in New York, November 9, 2015. Picasso's *Les Femmes d'Alger* sold for $179.4 million at Christies in May. Annette Kruszynski, *Amedeo Modigliani: Nudes and Portraits* (Munich: Prestel, 1996), 99, dates the painting as 1917 and gives the title as "Nude on a Cushion." In 2017, Leonardo da Vinci's painting *Salvator Mundi* sold for $450 million, eclipsing all previous sales records.

2   A film called *Modigliani*, starring Andy Garcia as the artist, appeared in 2004 and focused on the Picasso-Modigliani rivalry. An earlier French film called *Les Amants de Montparnasse* (The Lovers of Montparnasse), starring Gérard Philipe as

Modigliani, appeared in 1958, and was based on the 1924 Georges-Michel novel *Les Montparnos*. It featured the love affair between Modigliani and Jeanne Hébuterne.

3  The 2011 Woody Allen film *Midnight in Paris* highlighted Montparnasse in the 1920s, and despite the director's Jewish heritage featured only one Jewish artist, Man Ray, who played a minor role compared with Hemingway and other American expatriates.

4  Gustave Fuss-Amoré, *Montparnasse* (Paris: Albin Michel, 1925), 7.

5  The theory of how that which is socially marginal can become symbolically central comes from Peter Stallybrass and Allon White, *The Politics and Poetics of Transgression* (Ithaca, NY: Cornell University Press, 1986).

6  Clement Greenberg, "The School of Paris," *The Nation*, June 29, 1946, 792.

7  David Biale, *Eros and the Jews: From Bibical Israel to Contemporary America* (New York: Basic Books, 1992), 87.

8  André Warnod, "L'Ecole de Paris," *Comoedia*, January 21, 1925. The twelve artists cited were Picasso, Pascin, Foujita, Chagall, Van Dongen, Modigliani, Galanis, Marcoussis, Gris, Kisling, Lipchitz, and Zadkine.

9  Nesto Jacometti compared Geneva to Montparnasse in *Têtes de Montparnasse* (Paris: Villain, 1934), 189.

10  See Susan Waller and Karen Carter, eds., *Foreign Artists and Communities in Modern Paris, 1870–1914: Strangers in Paradise* (Farnham, UK: Ashgate, 2015).

11  See Romy Golan, *Modernity and Nostalgia: Art and Politics in France between the Wars* (New Haven, CT: Yale University Press, 1995), especially Chapter 6, "In Defense of French Art." On the Jewish awakening, see Catherine Nicault, ed., *Dossier: Le "Reveil juif" des années vingt, Archives Juives: Revue d'histoire des Juifs de France* 39, no. 1 (2006).

12  Christopher Green, *Art in France, 1900–1940* (New Haven, CT: Yale University Press, 2000), 61; Maria Delaperrière and Antoine Marès, *Paris "capitale culturelle" de l'Europe centrale? Les échanges intellectuels entre la France et les pays de l'Europe médiane, 1918–1939* (Paris: Institut d'études slaves, 1997), 21.

13  Delaperrière and Marès, *Paris "capitale culturelle,"* 23.

14  Golan, *Modernity and Nostalgia*, 141.

15  Mary Louise Roberts, *Civilization without Sexes: Reconstructing Gender in Postwar France, 1917–1927* (Chicago: University of Chicago Press, 1994). The phrase "civilization without sexes" was voiced by Pierre Drieu la Rochelle in 1927, 2.

16  See Paula Hyman, *Gender and Assimilation in Modern Jewish History: The Roles and Representations of Women* (Seattle: University of Washington Press, 1995), especially Chapter 4, "The Sexual Politics of Jewish Identity," for more on this theme. Hyman says that Max Nordau popularized the term "muscular Jewry," and that Zionists sponsored gymnastics and sports competitions to remake Jewish bodies (144, 145).

17  Fae Brauer, *Rivals and Conspirators: The Paris Salons and the Modern Art Centre* (Newcastle-Upon-Tyne: Cambridge Scholars Publishing, 2013), includes a number of cartoons from French magazines around 1910 satirizing the interest of male art lovers and museumgoers in nudes.

18  Hyman, *Gender and Assimilation*, 137. See also Sander Gilman, *Jewish Self-Hatred: Anti-Semitism and the Hidden Language of the Jews* (Baltimore: Johns Hopkins University Press, 1986), 243ff. The classic statement of misogynist antisemitism came from Otto Weininger in his 1903 book, *Sex and Character*.

19  Gillian Perry, *Women Artists and the Parisian Avant-Garde: Modernism and "Feminine" Art, 1900 to the Late 1920s* (Manchester: Manchester University Press, 1995), 89–93.

20  Michel Georges-Michel, *Left Bank*, trans. Keene Wallis (New York: Liveright, 1931), 24.

21  Georges-Michel, *Left Bank*, 218.

22  Georges-Michel, *Left Bank*, 198.

23  See Maurice Berger, "The Modigliani Myth," in Mason Klein, ed., *Modigliani: Beyond the Myth* (New York: Jewish Museum, 2004), 77. In 1964, Thaddeus Wittlin published a 530-page novel titled *Modigliani: Prince of Montparnasse* (Indianapolis: Bobbs-Merrill, 1964). Wittlin spoke with members of Modigliani's family as well as Jacques Lipchitz, Alexander Archipenko, and other artists who had known Modigliani.

24  André Warnod, *Pascin* (Monte Carlo: André Sauret, 1954), 23.

25  Antanas Andrijauskas, *Litvak Art in the Context of the Ecole de Paris*, trans. Jonas Steponaitis and Agne Narusyte (Vilnius: Art Market Agency, 2008), 103.

26  Marevna Vorobev, *Life in Two Worlds: A True Chronicle of the Origins of Montparnasse*, trans. Benet Nash (London: Abelard and Schumann, 1962), 184–7.

27  Marevna repeated this story about Picasso in her later memoir, *Life with the Painters of La Ruche*, trans. Natalie Heseltine (New York: MacMillan, 1972), 97. She reports that they fought about it when they got home and Rivera pricked her neck with a knife, though she swore she was not sleeping with Picasso.

28  Paula Birnbaum, "Chana Orloff: a modern Jewish woman sculptor of the School of Paris," *Journal of Modern Jewish Studies* 15, no. 1 (March 2016): 81, discusses the sculpted busts that Orloff made in the 1920s of many of these women, including Cahun and Barney, that emphasized their Jewish features.

29  Shari Benstock, *Women of the Left Bank: Paris, 1900–1940* (Austin: University of Texas Press, 1986), 8; "lesbianism" in the index on 514. Admittedly, fewer of the American expatriate writers were Jewish.

30  e.e.cummings, "little ladies more," Collected Poems, in Shari Benstock, "Expatriate Modernism: Writing on the Cultural Rim," in Mary Lynn Broe and Angela Ingram, eds., *Women's Writing in Exile* (Chapel Hill: University of North Carolina Press, 1989), 27.

31  See Joan B. Landes, *Visualizing the Nation: Gender, Representation, and Revolution in Eighteenth-Century France* (Ithaca, NY: Cornell University Press, 2001).

32  See Andrea Weiss, *Paris Was a Woman* (San Francisco: HarperSanFrancisco, 1995). Weiss made a documentary film with the same title also in 1995, featuring Sylvia

Beach, Janet Flanner, and other American expatriate women. Shari Benstock, author of *Women of the Left Bank*, featured prominently in the film.

33 On Weininger, see Gilman, *Jewish Self-Hatred*, 244–8.

34 Billy Klüver and Julie Martin, "A Short History of Modeling," *Art in America* 5 (May 1991): 159.

35 Klüver and Martin, "A Short History of Modeling," 160–3.

36 Wambly Bald, *On the Left Bank, 1929–1933*, ed. Benjamin Franklin V (Athens: Ohio University Press, 1987), 2.

37 Alice Prin, *Kiki's Memoirs*, trans. Samuel Putnam (Hopewell, NJ: Ecco Press, 1996), 131 and passim.

38 For a striking photo archive of all of these models, see Billy Klüver and Julie Martin, *Kiki's Paris: Artists and Lovers 1900–1930* (New York: Abrams, 1989), passim. Kiki de Montparnasse became so identified with eroticized high life that her name has been appropriated for a line of lingerie.

39 Simone de Beauvoir, *The Prime of Life*, trans. Peter Green (Cleveland and New York: World, 1962), published as *La Force de l'Age* (1960), 224.

40 Sean O'Rourke, "Who was with Pascin at the Dôme?" *Journal of Modern Literature* 26, no. 2 (Winter 2003): 160–3. O'Rourke mostly corrects Hemingway's story in *A Moveable Feast* of dining with Jules Pascin, whom Hemingway claimed was with the Perlmutter sisters. O'Rourke doubts that was the case.

41 André Warnod, *Les berceaux de la jeune peinture, Montmartre, Montparnasse* (Paris: L'Ecole de Paris, 1925), 235.

42 Warnod, *Les berceaux*, 236.

43 Warnod, *Les berceaux*, 240

44 Florent Fels, *L'Art Vivant de 1900 à Nos Jours* (Geneva: Pierre Cailler, 1956), 123.

45 Fels, *L'Art Vivant*, 121.

46 Gaston Diehl, *Pascin*, trans. Rosalie Siegel (New York: Crown, 1984, originally 1968), 46–50.

47 For a sample of these antisemitic slurs, see the review of his edited letters in Edward Mendelson, "Who was Ernest Hemingway?" *New York Review of Books*, August 14, 2014, 30–1.

48 Ernest Hemingway, *A Moveable Feast* (New York: Scribner's, 1964), 104.

49 Klüver and Martin, *Kiki's Paris*, 114, 144–7, 176–9.

50 Biale, *Eros and the Jews*, 5.

51 Jacques Lambert, *Kisling, Prince de Montparnasse* (Paris: Editions de Paris, 2011), 20–5.

52 Didier Epelbaum, *Les Enfants du papier: les juifs de Pologne immigrés en France jusqu'en 1940* (Paris: Bernard Grasset, 2002), 34, 35.

53 Moïse Kisling, quoted by Christopher Green, *Cubism and its Enemies: Modern Movements and Reaction in French Art, 1916–1928* (New Haven, CT: Yale University Press, 1987), 68.

54  Lambert, *Kisling*, 13,

55  Lambert, *Kisling*, 12.

56  Maurice Raynal, *Anthologie de la peinture en France* (1927), quoted by Esti Dunow, "Rethinking Soutine," in *Chaim Soutine, Catalogue Raisonné*, I (Cologne: Benedikt Taschen Verlag, 1993), 58. Alfred Werner quotes the same passage from Raynal in *Chaim Soutine* (New York: Abrams, 1977), 28, 32.

57  Avram Kampf, *Jewish Experience in the Art of the Twentieth Century* (1975), quoted by Alfred Werner, *Chaim Soutine* (New York: Abrams, 1977), 16.

58  Maurice Tuchman, *Chaim Soutine, Life and Work* (Los Angeles: Los Angeles County Museum of Art, 1968), 14.

59  Andrijauskas, *Litvak Art*, 106, 107.

60  Neemya Arbit Blatas, *Portraits de Montparnasse* (Paris: Ed. de l'Albaron, 1991), 39–54.

61  See Maurice Tuchman and Esti Dunow, *The Impact of Chaim Soutine (1893–1943): de Kooning, Pollock, Dubuffet, Bacon* (Cologne: Gallery Gmurzynska, 2002). In 2021, the Barnes Foundation featured a show called *Soutine/de Kooning: Conversations in Paint.*

62  Ellen Pratt, "Soutine beneath the Surface: A Technical study of His Painting," in Norman Kleeblatt and Kenneth Silver, eds., *An Expressionist in Paris: The Paintings of Chaim Soutine* (Munich and New York: Prestel, 1998), 122.

63  Romy Golan, "Blind Alley: Soutine's Reception in France after World War II," in Norman Kleeblatt and Kenneth Silver, eds., *An Expressionist in Paris: The Paintings of Chaim Soutine* (Munich and New York: Prestel, 1998), 68.

64  Werner, *Chaim Soutine*, 122.

65  Kenneth Silver, "Where Soutine Belongs: His Art and Critical Reception in Paris Between the Wars," in Norman Kleeblatt and Kenneth Silver, eds., *An Expressionist in Paris: The Paintings of Chaim Soutine* (Munich and New York: Prestel, 1998), 21.

66  Avram Kampf, *Jewish Experience in the Art of the Twentieth Century*, quoted by Anthony Julius, *Idolizing Pictures: Idolatry, Iconoclasm and Jewish Art* (London: Thames and Hudson, 2000), 42.

67  Kalman Bland, *The Artless Jew: Medieval and Modern Affirmations and Denials of the Visual* (Princeton, NJ: Princeton University Press, 2000), 15, 16, 52.

68  Waldemar George, "On Soutine," in Pierre Lévy, *Des artistes et un collectionneur* (Paris: Flammarion, 1976), 245.

69  Donald Kuspit, "Soutine's Shudder: Jewish Naiveté?" in Norman Kleeblatt and Kenneth Silver, eds., *An Expressionist in Paris: The Paintings of Chaim Soutine* (Munich and New York: Prestel, 1998), 77–86.

70  Silver, "Where Soutine Belongs," 27, 28.

71  In 2014 a major exhibition was staged with the title *Expressionism in Germany and France: From Van Gogh to Kandinsky*. See the catalog by that name, edited by Timothy Benson (Munich and New York: Prestel, 2014). This show covers art up to

1914, and thus does not include any of the artists discussed in this chapter, but underscores the internationalism of the style in the pre-war era.

72 Werner, *Chaim Soutine*, 21.

73 Michel Ragon, *Mané-Katz* (Paris: Georges Fall, 1960), 10, 14.

74 Ragon, *Mané-Katz*, 27; *Mané-Katz, 1894–1962, Exposition retrospective* (Haifa: Musée d'art moderne, municipalité de Haifa, 1985).

75 See Halina Nelken, *Images of a Lost World: Jewish Motifs in Polish Painting, 1770–1945* (Oxford: Institute for Polish-Jewish Studies, 1991).

76 Peillex, "L'Art au service de la paix," in *Mané-Katz et son temps, L'Aube du XXe Siècle, Peintres expressionistes et surréalistes de Montparnasse* (Geneva: Petlt Palais, 1969), 4, 5.

77 Peillex, "L'Art au service de la paix," 5, 6.

78 Nelken, *Images of a Lost World*, passim.

79 Jacques Biélinky, "Une Exposition Mané-Katz," *L'Univers Israelite*, November 7, 1924.

80 Annette Gliksman-Weissberg, *Les artistes immigrés juifs de l'Ecole de Paris dans la société française du début du XXième siècle à la Seconde Guerre Mondiale: du Schtetl à Paris: Intégration et mode de vie*, Mémoire du Maîtrise d'Histoire (Paris: Université Paris VII, 1994–95), 154, 155, 157.

81 Ragon, *Mané-Katz*, 32 on instruments, 86 on travels.

82 See Timothy Benson, ed., *Expressionism in Germany and France: From Van Gogh to Kandinsky* (Munich: Delmonio/Prestel, 2014).

83 Huyghe, in *Krémègne, 1890–1981* (Paris: Pavillon des Arts, 1993), 24.

84 Andrijauskas, *Litvak Art*, 174.

85 Arbit Blatas, *Mémoires de Montparnasse*, 52.

86 Arbit Blatas, *Mémoires de Montparnasse*, 56.

87 Andrijauskas, *Litvak Art*, 166.

88 Klüver and Martin, *Kiki's Paris*, 40.

89 Klüver and Martin, *Kiki's Paris*, 30, 31, show him and Hjertén at the Dôme.

90 Bernard Grünewald, *Orientalen: Bilden av Isaac Grünewald I svensk press 1909–1946* (Stockholm: CKM Forlag, 2011). Because this text is in Swedish, I also had to consult "Isaac Grünewald" in *Wikipedia* for biographical information. An earlier book dating from 1950 on Grünewald by J. P. Hodin is also in Swedish.

91 This is the contention of Nadine Nieszawer et al., in *Peintres juifs à Paris, 1905–1939* (Paris: Denöel, 2000).

92 Klüver and Martin, *Kiki's Paris*, 114; Barnes correspondence.

93 Massimo di Veroli, *Abraham Mintchine, 1898–1931* (Paris: Galerie de Veroli, 2005).

94 Klüver and Martin, *Kiki's Paris*, 206, 207.

95 Laurence Madeline, "Picasso and the Calvet Affair of 1930," *Burlington Magazine* 147, no. 1226 (May 2005): 316–23.

# Jews in Jazz Age Paris:
# The Symbiosis of Music and Art

*All art constantly aspires to the condition of music.*

Walter Pater, 1877

*A man is an instrument, and his life is the melody.*

Hasidic saying

The silence of painters (the title of a book on French artists facing the Great War)[1] before the unimaginable horrors of the Western Front was supplanted by the raucous sounds of jazz. During *les années folles*, the crazy years, as "the roaring twenties" were called in France, people lived frenetically in order to efface mass death in the trenches. The frenzy was especially evident in the pleasure districts and artists' colonies of Montmartre and Montparnasse. After the war, Russia was convulsed in revolution and civil war; Germany reeled from defeat, revolution, and hyperinflation; Austria devolved from a huge empire to a small country with an oversized capital city; Italy was embittered by a peace that brought few rewards; and Great Britain struggled with the Irish rebellion and unrest in India. Victorious France revealed two contrasting attitudes toward the recent bloodletting. As a public response to the enormous loss of life, the French erected thousands of monuments to the dead, brought in foreign workers to rebuild the shattered departments in the northeast, and outlawed most forms of birth control in the hope of repopulating the country. In terms of private life, a combination of economic boom and a desperate search for normalcy led to the rapid expansion of nightclubs, dance halls, and other pleasure centers, catering to French people and, increasingly, large numbers of foreigners.

The music was foreign too; the 1920s became known as the jazz age, so pervasive did this import from America become in interwar Paris. Montmartre's star as an artists' colony might be fading, but jazz clubs run by African Americans gave it a new lease on nightlife. Montparnasse, the most international artistic

center the world had ever seen, saw its cosmopolitan ambience heightened by the jazz clubs and Caribbean dance halls of the Quarter. Jazz-infused Montparnasse represented the antithesis of nationalism and militarism.

Young French avant-garde composers were also influenced by the new rhythms of jazz, none more so than the Provençal Jewish composer Darius Milhaud. Milhaud and the other young composers who by 1919 were known as "the Six," along with their mentor Erik Satie, would bring new sounds to Montparnasse. The new musical forms that defined the era attracted the attention of the painters and sculptors, and mediated between sensual popular music and highbrow Parisian culture. Jewish artists from privileged backgrounds such as the Pole Henri Hayden, the Lithuanian Jacques Lipchitz, and the Belorussian Ossip Zadkine were enthusiastic supporters of the music of Stravinsky, Messaien, Poulenc, and others.

The Jewish artists of the Ecole de Paris were not unique in portraying music and musicians, nor were modernists seizing new artistic ground in depicting musical scenes and instruments. The novel aspect of the attempt to capture sound in silent media was the modern desire to represent not simply the instrument or the musician but musicality itself. Modernist artists admired classical Western music as the most non-representational of the arts, which had succeeded in moving beyond program music in the nineteenth century to attain aesthetic purity. Artists also admired music for its impact on the inner person, its ability to appeal directly to the emotions. Music was non-objective both in its ability to convey moods rather than things and to form an emotional bond with the listener and between listeners; shared musical experiences formed communities. Sound conveyed immediacy and immersion that the visual sense lacked—but to which visual artists aspired.

While Jewish artists were not alone in making these visual-auditory connections, they may have been particularly attracted to musical themes. One of the commonest assertions made by French critics of the many Jewish artists who came to Paris in the first third of the twentieth century was that Jews had no tradition in the plastic arts of painting and sculpture, especially when compared with their widely acknowledged achievements in music. Composers from Felix Mendelssohn to Gustav Mahler and Arnold Schoenberg were compared invidiously to the handful of Jewish artists in order to underscore that Jews were better at music than art. The young Jews who came to Paris to study art may have felt instinctively more comfortable assimilating their art to music, either mixing the genres or representing the sonic landscape. The new sounds of jazz after the Great War were exhilarating rather than comforting, but these young foreign

artists may have seized on the markers of racial difference that defined African-American jazz. In America, the Jewish performer Al Jolson put on blackface in the tradition of minstrelsy in *The Jazz Singer* of 1927, the first film accompanied by sound recording. In France, Jewish artists could borrow the modernity and exoticism of jazz music to express their own marginality and desire to escape the shtetls of Eastern Europe to make it in the modern, cosmopolitan West. For Jewish artists, music signified both cultural familiarity and difference, in an early version of "west meets east.²" At least one American-born Jewish artist supported himself by playing jazz in the nightclubs of Montparnasse.

The "musicalization of all the arts" did not go unchallenged. The prominent French Jewish critic and essayist Julien Benda (1867–1956) was best known for his 1927 jeremiad *The Betrayal of the Intellectuals*, in which he advised intellectuals to refrain from political involvement. At the end of the Great War, Benda published another book, titled *Belphégor*, which made enough of a splash to be translated into English a decade later, with an introduction by the conservative American intellectual Irving Babbitt. Babbitt noted that "the term 'Belphegorism' has entered into current French usage."³ Benda dredged up the term from a demon whose name derives from an Assyrian deity named Baal-Peor, worshipped as a phallus and associated with orgies—in short, *les années folles*. In *Belphégor*, one Jewish intellectual confronted another, as Benda attacked the philosopher Henri Bergson (1859–1941) for advocating the use of intuition in order to penetrate the flow of time. Benda hated the "cult of the indistinct,"⁴ preferring clarity and definite outlines. He considered irrationalism to be a feminizing philosophy that appealed especially to women, who, he said, had taken charge of French culture while their husbands tended to business. Because music was the most fluid and affective art form, capable of appealing directly to the emotions and of producing a spirit of "dizzy intoxication,"⁵ people wanted music to serve as a model for all the arts, and even for ideology. Benda identified Debussy and Wagner, different though they were, as the most fluid composers, and cited Verlaine and Barrès as romantic writers expressing a subjective and musical sensibility, following Baudelaire's synesthetic example.⁶ He disapprovingly quoted the poet and modernist critic Apollinaire: "modern painting will be an entirely new art which will be to the painting of the past what music is to literature."⁷ Benda was sensitive to the charge that some blamed this trend toward intuitive emotion on the presence of Jews. He divided Jewish thinkers into two groups, one severely moralistic, the other greedy for sensation, and objected to the latter. Benda proved prophetic in predicting dominant trends that soon emerged full-blown in the 1920s. If he disapproved of Debussy

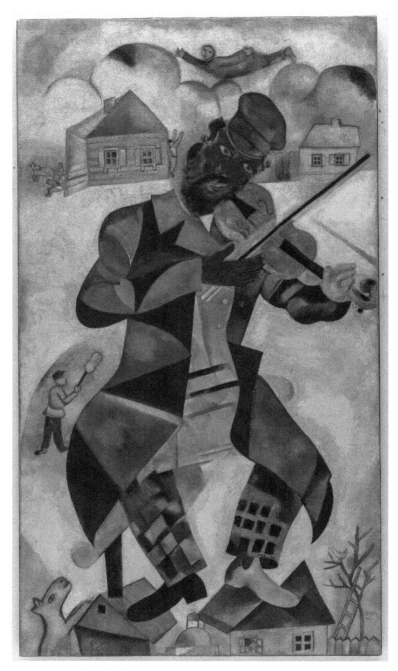

**Figure 5.1** Marc Chagall, *The Green Violinist*, 1923–4, oil on canvas. 37.446, Solomon R. Guggenheim Museum, New York, Solomon R. Guggenheim Founding Collection, by gift. 2021. Artists Rights Society (ARS), New York/ADAGP, Paris.

and Wagner, one can guess that Benda probably did not favor trendy new jazz clubs such as Le Boeuf sur le Toit, which opened in 1921 and took its name from a ballet score by Darius Milhaud, which in turn was inspired by Brazilian tango.

The popular musical idiom that would have been most familiar to many of these immigrants was klezmer, the traditional music of Ashkenazi Jews from Eastern Europe. Artists given to evoking their Russian homeland, most notably Marc Chagall and Mané-Katz, filled their canvases with bearded violinists and wedding processions serenaded by strolling musicians. The iconic image of the Jewish musician created by Marc Chagall has come to stand for the pre-Holocaust culture of the shtetl. As early as 1911, the year he arrived in Paris, Chagall portrayed a violinist standing in a Russian village. In 1913, on a tablecloth that his fiancée Bella had given him before he left Russia, he portrayed another violinist. The green-faced fiddler balancing on a roof was the largest figure he painted in Paris (the tablecloth provided a low-cost alternative to a large canvas). Chagall returned to Russia just before the outbreak of war. In 1920, he painted sets for the Yiddish Kamerny Theater in Moscow, and included a large green violinist in his evocation of music. When he left Russia for good in 1922, he made a copy of *Green Violinist* to take with him.

A young artist named Boris Aronson, son of the Grand Rabbi of Kiev, met Chagall in these years, and wrote an early book about the painter in 1923. Forty years later and on another continent, the producer Harold Prince hired Aronson to do the set design for the Broadway production of *Fiddler on the Roof*, the musical based on the Yiddish stories of the writer Sholem Aleichem, pen name of Solomon Rabinovich (1859–1916). Aronson made no secret of the fact that "it was the emotion of Chagall's paintings I tried to incorporate into *Fiddler*. Chagall ... takes Anatevka [the shtetl where *Fiddler* is set] wherever he goes. I only got to do it once."[8] Much later, Chagall would contribute a drawing of Sholem Aleichem to a book by the writer, further reinforcing the shared identity of these two master conjurers of the world of the Jews under the tsars. Chagall's grandfather was an amateur musician; his Uncle Neuch was known for playing the violin on the roof, legs crossed. The green face played on the Yiddish word *grin*, which referred to the color as well as to a novice (a greenhorn) or naïve person. Chagall showed *The Violinist* at the Salon des Indépendants in March 1914; his friend the poet Blaise Cendrars told him it was the most beautiful painting in that year's Salon.[9]

The Hasidic strain of Jewish practice that Chagall grew up with in Vitebsk differed from orthodox rabbinical Judaism in holding that communion with God could be achieved through singing and dancing.[10] Chagall often drew on the

Hasidic tradition, especially when he was portraying musicians. In 1925, a painting called simply *The Musician* featured a cellist or bassist whose body seems to have morphed into the instrument. An arm holds the bow, and the player's head is surmounted by the large scroll as if it were a hat. Chagall may have been inspired by the Hasidic saying "A man is an instrument, and his life is the melody," a phrase used by the great Yiddish writer I. L. Peretz. Chagall's favorite instrument was not the cello but the violin, which he included in many paintings made throughout his long life. The fish flying above the river in *Time is a River without Banks* plays a violin. In the 1950–2 work *The Dance*, a donkey-headed musician in red plays a blue violin as a woman proffers him a bouquet of flowers.[11] In his important work *Liberation*, completed after World War II, a number of instruments appear, including a cello and clarinet, but the central figure is the violinist rising from the ashes. Perhaps the centrality of the violin in Chagall's iconography helps explain why he loathed its appropriation by Broadway.

What made Marc Chagall repeatedly paint the Jewish violinist, both in Paris and in Russia? Nostalgia for his homeland, contained in sound, was one reason why Chagall painted violinists rather than violins as his contemporaries the cubists did, including the image that became emblematic of the uncertainty of shtetl life: the precariously balanced fiddler on the roof. Well before the era of Yehudi Menuhin, Jascha Heifetz, Isaac Stern, and Yitzhak Perlman, Jews were known for their musical abilities. Joseph Joachim (1831–1907) was one of the greatest nineteenth-century violinists and a friend of Brahms; Arthur Rubinstein, born the same year as Chagall, 1887 (he died just three years before Chagall in 1982 at the age of ninety-five) was one of the greatest pianists of the twentieth century. While other great Jewish pianists come to mind (Anton Rubinstein, Vladimir Horowitz, Vladimir Ashkenazy), the violin is closely associated with Jews, one might even say representative of Jewish culture. Unlike pianos, violins are small and portable, and played an important role along with clarinets in the klezmer music of Ashkenazi Jewish culture. Klezmer fiddlers could make their instruments "sob," approaching the sound of the human voice in eliciting a plaintive, melancholy sound. A clarinet was popular for the same reason; it too was portable, could imitate the human voice, and could evoke the inescapable pathos of life in the Pale. The violinist represented the Jewish soul; the fiddler on the roof signified the *luftmensch*, the contemplative Jew who did not have his feet on the ground and was involved with airy intellectual pursuits rather than with practical reality.

Every French critic, including sympathetic ones such as Guillaume Apollinaire and Jewish ones such as Adolphe Basler, felt compelled to point out how bemused

they were in finding so many young Jewish immigrants trying to become artists in Paris when there was little tradition of Jewish plastic art. Chagall painted a number of self-portraits showing himself easel in hand, as if to stake his claim that he was both a Jew and an artist. The most famous of these self-portraits is the one he did during his first stay in Paris, holding the palette with seven fingers: a reference to the Yiddish proverb that doing something with seven fingers is to do it well or cleverly. Part of the attraction of portraying Jewish musicians may have been an affirmation of Jewish artistry in the face of skepticism about Jewish painters' motives or talent. This new generation still had to prove itself while contending with the religious precept against graven images. It was easy to fasten onto the folk image of the fiddler and the klezmer as an artist firmly rooted in Jewish culture. Klezmer musicians were itinerant, traveling from town to town in search of audiences. Their instruments needed to be portable and so featured violins, clarinets, and tsimbls, a multi-stringed instrument like a hammered dulcimer that was more mobile than a piano. Artists who had voyaged from Russia with nothing more than paintbrushes and their talent could identify with traveling musicians.

Until the nineteenth century when woodwinds and brass instruments were introduced into klezmer music, stringed instruments—violin, cello, bass, tsimbl—along with some percussion made up most klezmer ensembles. Even as the clarinet grew in popularity, the violin remained the Jews' favorite instrument for its ability to mimic the human voice, in particular the sound of the cantor or *khazn*, including the characteristic groan or moan, called a *krekht*, which issued from the cantor's mouth. A talented klezmer fiddler could make his instrument laugh, cry, moan, and even ululate.[12] Chagall's unsteady Jewish fiddler resonated with particular force in Ashkenazi culture.

One area that inevitably overlaps in the art of Marc Chagall and Mané-Katz, and for that matter of earlier Polish artists, is their depiction of Jewish musicians. Judging from the frequency of the theme among nineteenth-century Polish artists, Jews' musical talents were widely recognized. Instruments shown include violins, tsimbls, cellos, drums, and horns, with violins predominant.[13] From the mid-1920s, Mané-Katz painted itinerant Jewish musicians; for example in 1927 he painted *Traveling Musicians* playing a violin, trombone, and bass in a flat, simplified style. Very often, he showed musicians performing for a wedding celebration, a classic use of klezmer music of the Ashkenazi Jews. These paintings would often include the bride and groom, sometimes under the *huppah* or wedding canopy. Marriages, rabbis, and musicians were among his commonest subjects. It is difficult to imagine Mané-Katz painting an abstract instrument

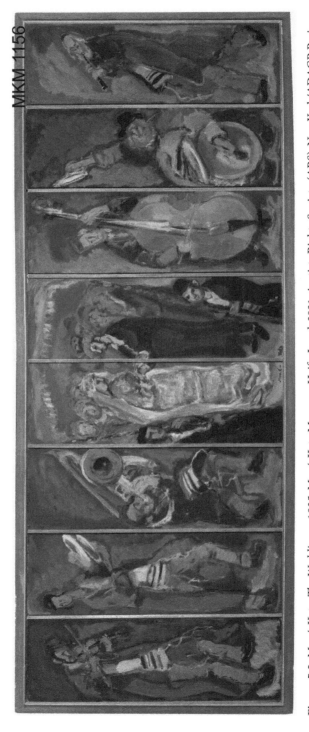

**Figure 5.2** Mané-Katz, *The Wedding*, c. 1935. Mané-Katz Museum, Haifa, Israel. 2021. Arrtists Rights Society (ARS), New York/ADAGP, Paris.

lying on a table in the manner of Braque; instead, he placed music making in a cultural context.[14] It was not the form of the instrument that intrigued him, but the auditory environment in which he was raised. By contrast, Chagall's legendary violinists exist in physical context, standing on a roof in a Russian village setting, or even transmuting the violinist into a cow-headed harlequin as in *Dance*, but they are not shown performing at a Jewish wedding. It is as unlikely for Mané-Katz to indulge in the phantasmagoria of a cow playing a violin as it is for Chagall to show a group of klezmer musicians realistically.[15]

Jacques Chapiro, who arrived at La Ruche in the 1920s and wrote a book after the next war recalling its heyday, commented repeatedly on the music that issued forth from the seedy studios on the southern edge of Montparnasse: "One might hear a piano, violin, trombone, airs played on a reed pipe (*chalumeau*), then came noise from the slaughterhouse."[16] In a complex where one could "hear German, Italian, Spanish, Japanese, Russian, Polish and God knows what else,"[17] music could function as a lingua franca. He noted that evenings were noisy with songs and music, which included the sculptor Léon Indenbaum singing Russian songs and accompanying himself on the guitar.[18] Marek Szwarc lived at La Ruche before World War I, and in his memoirs recalled that street singers had a lively success among the poor artists, as did the organ grinder with his trained monkey, who entertained the artists from the central courtyard.[19]

Another La Ruche artist, Pinchas Krémègne, remained at La Ruche from 1912 until well into the 1920s. He featured violins, often with bows, open cases, and sheet music, in numerous still lives and interior shots, as if the instrument stood for domesticity, much as had the piano in nineteenth-century parlors. In 1920, he included a cornet or trumpet along with a mandolin in *Still life with musical instruments*. For all of the artists mentioned above, the violin is not portrayed for its feminine shape, as it was for Picasso (along with the guitar and mandolin; these instruments were featured in nearly half of all the paintings Picasso did in the analytic cubist years before World War I),[20] but rather for its cultural associations. For Krémègne, the violin was a familiar object connecting his old and new worlds. For an artist to include a cultural object such as an instrument in a still life means something different from a bowl of fruit. A violin, especially when posed in an open case, invokes the music it can make, and calls attention to the cultural claims of the household. In the case of Krémègne, it suggests that the poor Jewish artist working at La Ruche can draw upon a rich cultural heritage.

# Synesthesia

Another Jewish immigrant from the Russian Empire who resided at La Ruche in the years before the war had a far more radical conception of the ways that art could capture and contain music. Daniel Vladimir Baranoff-Rossiné (born Shulim Wolf Baranov in 1888), who apparently went by Daniel Rossiné in his pre-war days, arrived in Paris in 1910, having already studied art in Odessa in his native Ukraine and then at the Imperial Fine Arts Academy in St. Petersburg. In Paris, Rossiné befriended Robert and Sonia Delaunay, and his paintings from 1913 bear some resemblance to their experiments in simultaneity.[21] He drew upon both cubism and futurism in breaking up the picture plane while trying to capture motion and dynamism with vivid use of color. *Capriccio Musicale (Circus)*, of 1913, juxtaposes the image of circus aerialists in motion with the score for the opening measure of Liszt's Hungarian Rhapsody.[22] By then, Rossiné had already come to the attention of the Russian artist and art theorist Wassily Kandinsky, then working in Germany. Kandinsky wrote of "a young Russian artist called Rossiné, who is occupied with the theory of painting and especially with color music."[23] Kandinsky was engaged in similar experiments. Inspired by the atonal music of Arnold Schoenberg, he painted *Impression III (Concert)* in 1911, which he followed with *Fragment 2 for Composition VII* in 1913 and *Fugue* in 1914. Music helped liberate Kandinsky from dependence on nature, allowing him to move toward that which he defined in his 1911 treatise, *On the Spiritual in Art*, as a higher, more spiritual reality. Rossiné was at the forefront of these new pan-European conceptions both of abstraction and especially of the fusion of music and art. In 1913, Rossiné created polychrome sculptures with names such *Symphony Number 1* and *Rhythm*, and the even more radical assemblage titled *Counter-Relief*, in which he included objects that resembled the body of a banjo, behind which stood the outline of a violin.

This phase of his career ended with the coming of World War I. Rossiné returned to Russia, then moved on to neutral Scandinavia, where he developed his optophonic piano. In Christiania, Norway, he first exhibited his color organ, which consisted of a piano keyboard which, when played, produced not sound but colored images produced by hand-painted colored disks mounted with mirrors, filters, and lenses. "The keys on Rossiné's optophonic piano were not linked to individual spotlights with colored filters. Instead, they operated a motor that drove two rotating disks made of transparent painted glass decorated with various patterns. These disks could be exchanged for other differently patterned ones depending on the character of the music being performed."[24]

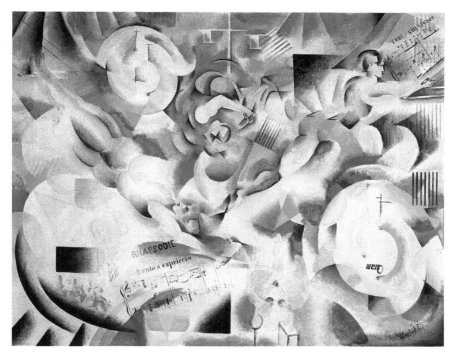

**Figure 5.3** Daniel Baranoff-Rossiné, *Capriccio Musicale*, 1913. Lee Stalsworth. Hirschhorn Museum and Sculpture Garden, gift of Mary and Leigh Block, 1986, 88.8. 2021. Artists Rights Society (ARS), New York.

When he returned to Russia in 1917, Rossiné found the revolutionary government receptive to his experiments, and performed color music concerts as late as 1923–4. He reported on one of his performances to his friends the Delaunays back in Paris:

> My apparatus gives me an unusual freedom in exploring dynamic painting that I could hardly have dreamed of before. An artist is no longer a slave to the surface … but lord of his ambitions and master of his freedom. That is where a really immense field for creation of paintings opens up … Music is, of course, a compromise with the audience. Like music, a painting should always be in motion.[25]

Despite this success, by the next year Rossiné was back in Paris, where he founded an Optophonic Academy in 1927 and continued to perform on his optical piano. Unfortunately, he remained in France too long; he was deported to Auschwitz in 1944. Rossiné like Kandinsky was moving in the direction of synesthesia, in which one faculty stimulates the sensory response of another, so that one might

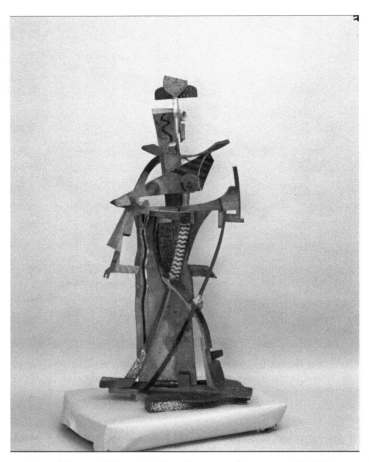

**Figure 5.4** Daniel Baranoff-Rossiné, *Symphony Number 1*, 1913. MoMA. 2021. Artists Rights Society (ARS), New York.

hear colors and see sounds. For Kandinsky, who played the violin, this could lead to a sense of mystical unity. It is not surprising that Kandinsky should have been inspired by Schoenberg's atonal compositions, as that was the nearest corollary to Kandinsky's own abstract ideal purged of all naturalistic references. Composers inclined to mysticism, such as Alexander Scriabin in Russia and, two decades later, Olivier Messaien in France, used synesthesia to achieve a higher reality. In his *Quartet for the End of Time*, composed in 1940 while he was being held in a German prisoner-of-war camp, Messaien constructed seven movements, one each for the six days of creation followed by the day of rest, all based on the Book of Revelation, one of whose verses announces that "there should be time no longer."[26]

# Apollinaire and Orpheus on Mount Parnassus

Poet, art critic and impresario of the avant-garde, Guillaume Apollinaire reigned over pre-war Montparnasse. He was the foremost avant-garde poet in Paris despite his foreign origins. He had been born in Rome to a Polish (or Belorussian) mother and an Italian-Swiss father. He was Catholic but was often assumed to be Jewish because of his Polish origins; in 1915 he wrote that antisemites who "cannot imagine a Pole not being a Jew" attacked him. Fellow poet Max Jacob delighted in spreading rumors of Apollinaire's Jewishness,[27] which perhaps underscored his cosmopolitanism. In 1913, he published his major collection of art criticism, *Les peintres cubistes,* as well as his most important collection of poems to date, *Alcools.* He also befriended Marc Chagall, and in the spring of 1914 dedicated a poem to him titled "À travers l'Europe," a prophetic title considering that Chagall would indeed be traveling by train to Germany and on to Russia that summer. The poem ends with the poet telling the painter that "tes cheveux sont le trolley / À travers l'Europe vêtue de petits/feux multicolores" (your hair is the trolley crossing Europe dressed in little multicolored lights). The poet seems to have been struck by Chagall's head of exuberant curls, and imagined that he might cross the continent by trolley as if he were traversing the city of light.

One more term that Apollinaire coined around 1912 has less art-historical resonance than "surrealism" but more relevance for the relation of art to music. He referred to the work of such artists as the Delaunays, Marc Chagall, and Francis Picabia as Orphism, based on the mythical ancient Greek musician Orpheus, son of Apollo (in some versions of Greek myths).[28] Apollinaire's first book of poetry announced his identification with the mythological Greek figure. He called *it Le bestiaire, ou le cortège d'Orphée* (The bestiary, or the procession of Orpheus). Published in 1909, *Le bestiaire* included short stanzas on a variety of animals as well as on Orpheus, and was illustrated with woodcuts by Raoul Dufy. While Chagall inhabited a land of fantasy and the cubists one of rigorous rationalism, the Orphists were engaged in what Apollinaire termed pure painting, by which he meant the non-representational use of color in swirling forms that approximated to a kind of visual music. The works of Daniel Baranoff-Rossiné would also qualify as Orphism, though the restless painter-inventor would not settle into one style as did his friend Robert Delaunay. Francis Picabia's wife Gabrielle Buffet, who was a musician, claimed she suggested the term Orphism to Apollinaire. In *Les peintres cubistes,* Apollinaire did not explicitly connect painting and music, and later that same year he distinguished the successive and temporal art of music from the simultaneous one of painting.[29] Whether or not he created the term, his

poetic soul must have recognized the magic in the name. Chagall did a painting of a nude *Orpheus* holding his lyre in the year before the war, the same time that he felt indebted to the poet for whom he painted his *Homage to Apollinaire*. This echoes Dufy's first image of Orpheus in Apollinaire's *bestiaire*, in which the singer stands frontally nude, holding his lyre, with what looks suspiciously like the Eiffel Tower behind him.[30] Isaac Grünewald in far-off Sweden showed the continuing appeal of these images in a mural he painted in 1933 called *The Birth of Drama*, where Orpheus or Apollo (the Greeks attributed drama to Dionysus, but that god did not play the lyre) is playing for the assembled Olympians.

Orphism may have failed to catch on to the same degree as cubism and surrealism, but it highlights the pre-war search for a new kind of visual music that Apollinaire was praising in Paris at the same time that Kandinsky was creating and theorizing in Munich. Born Wilhelm Albert Włodzimierz Apolinary Kostrowicki, Guillaume Apollinaire was ideally named to preside over this new artistic

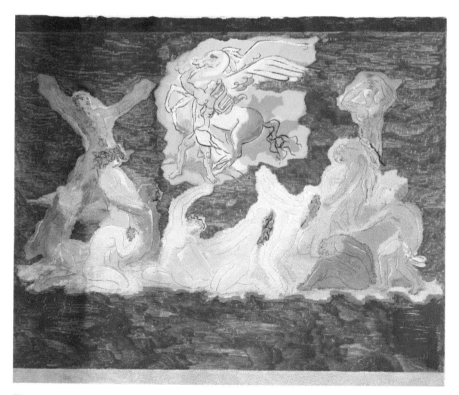

**Figure 5.5**  Isaac Grünewald, *Dramats Fodelse* (Birth of Drama), 1933. Photo: Christina Knutsson, Skissernas Museum.

pantheon. Apollo was the Greek god of music, who resided on Mount Parnassus along with the muses such as Calliope, fount of epic poetry and Orpheus's mother. The oracle of Delphi also resided there and was devoted to the cult of Apollo. "Music," from the Greek *mousikos*, echoes the muses and originally was not distinct from poetry and the other arts. The nine classical muses were female personifications of the arts and creativity. As the nature of music was sensual, music was seen as inspiring love. In a Renaissance engraving by Luca Penni titled *Parnassus* that dates from around 1550, Apollo and the nine muses are shown with instruments, with Apollo playing the Renaissance era viola da braccio.[31]

Apollo gave Orpheus his golden lyre on Mount Parnassus and taught him to play. The left-bank neighborhood that became Montparnasse was so-named by the students from the Latin Quarter who declaimed poetry there along its rustic pathways in the seventeenth century. It only slightly overstates the case to say that Apollinaire presided godlike over the burgeoning art movements of Montparnasse. He returned to Paris with his head bandaged from a war wound in 1916, then succumbed to influenza at the moment of victory in November 1918, vulnerable in his all-too-human mortality.

A decade after the poet's death, the specter of Apollo returned, this time care of Terpsichore, the muse of dance. Before the war, Igor Stravinsky had composed the celebrations of primitive Russia, *The Firebird* and *The Rite of Spring*, for the Ballets Russes. Fifteen years after Nijinsky's *Rite* scandalized Paris, Stravinsky in a very different mood composed *Apollon Musagète* to celebrate not Russia (which had replaced tsarist archaism with Soviet modernity) but rather French classicism. This new ballet was scored for strings rather than percussion and woodwinds as in the earlier pieces, and featured the Greek god Apollo and only three of the nine muses, those representing poetry, mime, and dance. This stripped-down production told the story of Apollo's birth, his tutoring the muses, and his ascent to Parnassus. *Apollon Musagète* was significant both for its assertion of the countercurrent of neoclassicism and the pursuit of order within the raucous spirit of the jazz age, and for its twenty-four-year-old choreographer, whom Sergei Diaghilev convinced to westernize his name to George Balanchine.[32] If the 1920s were poised between the Apollonian and the Dionysian (or Marsyan), this late ballet of 1928, performed just one year before Diaghilev died, shows that no one style or musical form is adequate to characterize the decade. Twenty years after premiering in Paris, the Ballets Russes left behind its Eastern origins and had fully integrated into Parisian culture.

The Greeks assigned different gods to different instruments; how did the monotheistic Jews respond to music? The Book of Psalms in the Old Testament

referred often to music, and while stringed-instrument references predominated, Psalms accepted a variety of musical forms to praise God. The final psalm, 150, is the most inclusive: "Praise Him in the firmament of His power. Praise Him for His mighty acts; Praise Him with the blast of the horn; Praise Him with the psaltery and harp. Praise Him with the timbrel [tambourine] and dance; Praise Him with stringed instruments and the pipe. Praise Him with the loud-sounding cymbals."[33] Psalm 92 refers to a ten-stringed instrument as well as mentioning the psaltery and harp. Ancient Jews welcomed a variety of devices in a religious context, though musical instruments dropped out of use in religious services, with the exception of the ram's horn or *shofar* used on the Jewish New Year, Rosh Hashonah. The Greeks with their multiplicity of gods assigned stringed instruments to Apollo and panpipes to Dionysus. Since the Jews' transcendent deity was unlikely to make music, music-making could be valued without projecting it onto a deity, and strings, horns, and percussion could all participate and harmonize in God's praise.

Meanwhile, in wartime Montparnasse another group of artists picked up the fallen lyre of Apollo and pursued the fusion of art and music. The art market was moribund during the war years, and those artists who remained in Montparnasse were disproportionately foreign born. We have seen that Modigliani became a key figure in the wartime life of the Quarter, and that Jean Cocteau inserted himself into Montparnasse when he photographed the artists in August 1916. Modigliani, Kisling, Picasso, and Cocteau together decided that works of art could be displayed in an artist's studio while patrons were attracted by a concert and poets read from their works or those of their friends. Thus was born the Lyre and Palette, multi-media events that took place in the studio of the painter Emile Lejeune at 6 rue Huyghens, just off the boulevard Montparnasse. Paintings by Kisling, Modigliani, Picasso and the Chilean artist Ortiz de Zarate, and the African sculptures of the dealer Paul Gullaume were displayed at the first show, held from November to December 1916. The first wartime concert performed music by Satie, and Cocteau invited his rich friends from the right bank. The cover of the December 16 program featured a work by Diego Rivera. The second show, held in January and February 1917, featured the works of two female artists, Marevna and Olga Sacharoff, a Spaniard who was born in Georgia, Russia. The third show included works by Kisling and Zadkine, as well as the American abstract painter Morgan Russell.[34] Cocteau wore his custom-made military uniform while the artists were garbed in overalls, sandals, and sweaters.[35] Out of this collaboration in an artist's studio, Cocteau would go on to create the premier artistic event of wartime Paris, the avant-garde ballet *Parade*, performed in May 1917 by the Ballets Russes, with scenario by Cocteau, sets and costumes

by Picasso, and ragtime-inflected music by Satie. On the curtain for *Parade*, Picasso included a golden lyre.

These impromptu wartime performances that mixed art and music had a more lasting significance for the world of avant-garde classical music. Out of the evenings at the little room in Montparnasse emerged the group of composers dubbed "Les Six," which included the Sephardic composer Darius Milhaud and their mentor, Erik Satie. In his memoir, Milhaud remembered the female Capelle Quartet playing his Fourth Quartet. Milhaud was gone from Paris during the later part of the war, accompanying the poet and ambassador Paul Claudel to Brazil. Milhaud had already written his piece called Poèmes Juifs (Jewish Poems) and would write more Jewish-themed music in the 1920s and after. Shortly after the war, in 1919, a critic named Henri Collet published "Five Russians and Six Frenchmen" in *Comoedia*. Milhaud claimed the Six had little in common except that they knew each other. Georges Auric and Francis Poulenc supported Cocteau's ideas expressed in the essay "The Cock and the Harlequin" (dedicated to Auric), which called, in wartime, for a revitalized French music free of foreign influence. For his part, Milhaud called his own music Mediterranean lyricism, while Honegger was closer in spirit to German romanticism. Milhaud also expressed a dislike for joint declarations, finding them limiting.[36] Nevertheless the appellation Les Six was trumpeted by Cocteau and stuck, and affirmed a new postwar French style of music. The six young composers, who included one woman, Germaine Tailleferre, frequently met at Milhaud's apartment, together with a variety of painters.

## The Meeting of Two Diasporas

Milhaud would furnish the music for another Cocteau production, the ballet Le *boeuf sur le toit* (The Ox on the Roof), based on Brazilian tunes Milhaud had heard during the war, which premiered in February 1920. The following year the bar-owner Louis Moysés opened a bar on the right bank with the same name, which became a 1920s institution and principal hangout for Jean Cocteau and his friends.

In 1928, the popular writer Paul Morand, who was a friend of Milhaud's,[37] published a collection of stories called Le *Magie Noir* (Black Magic), which captured the 1920s vogue for jazz music and Black culture. He prefaced the book with a page of preliminary observations that included key events in his life that led to his interest in African and African-American culture. He noted that in

September 1914, infantry from Senegal marched down the boulevard Saint Michel, headed for the Marne. His postwar entries are as follows:

> 1919.—Darius Milhaud arrives from Brazil. He describes Bahia, the black Rome, and plays me those Negro sambas, which are shortly to serve for the music of his *Boeuf sur le Toit*. 1920.—I return to France. In the post-War bars. So sublime, so heartrending, are the accents of jazz, that we all realize that a new form is needed for our mode of feeling. But the basis of it all?
>
> Sooner or later, I tell myself, we shall have to respond to this summons from the darkness, and go out to see what lies behind this overweening melancholy that calls from the saxophones.
>
> How can we stand still while the ice of time is melting between our warm hands?"[38]

Morand, a bon vivant who sometimes expressed racist and antisemitic attitudes, later collaborated actively with the Vichy government. During the 1920s, he frequented the same high-society circles as Jean Cocteau and Coco Chanel, yet he dedicated the section of *Le Magie Noir* set in the West Indies to Milhaud and was sympathetic to, or at least highly conversant with, Black culture. The section on Africa was dedicated to another composer who was one of Les Six, Georges Auric. Morand connected two crucial aspects of 1920s Parisian musical culture: the jazz-inspired avant-garde music of Milhaud, Poulenc, and company, and the enormous vogue for primitivism and other aspects of Black culture. In conflating Africa and African-American jazz as Morand and the French were wont to do— most notoriously in Josephine Baker's *"danse sauvage"* performed in La Revue nègre of 1925—interwar racial stereotypes jostled with genuine excitement and interest in this new music.[39]

Darius Milhaud explicitly connected the oppression experienced by Jews and Blacks. In 1938, when life looked much grimmer for Jews than it had in the halcyon 1920s, Milhaud wrote:

> The primitive African side has remained profoundly rooted in the blacks of the United States, and it is there that we can see the source of that formidable rhythmic power, as well as that of the melodies, which are so expressive, and which are endowed with a lyricism that only oppressed races can produce ... It is the same tenderness, the same sadness, the same faith as that which animated the slaves who, in their songs, compared their fate to that of the Jews captive in Egypt and who called, with all their souls, for a Moses who would save them.[40]

One could summarize Milhaud's insight colloquially as "you've got to suffer if you want to sing the blues."[41] In an American context, the expression of shared

suffering appeared in such works as George Gershwin's African-American opera *Porgy and Bess*, or the anti-lynching song "Strange Fruit," written by a Bronx Jewish high school teacher named Abel Meeropol and recorded by the Black singer Billie Holiday in 1939. By the 1920s, Tin Pan Alley was filled with such Jewish composers as Irving Berlin and Harold Arlen who made careers out of popularizing Black musical idioms such as ragtime and jazz. The African American blues singer Ethel Waters supposedly called Arlen (born in 1905 as Hyman Arluck, the son of a cantor) the "Negro-ist" white man she knew.[42] In France, critics of modernism and especially of Montparnasse internationalism decried both Negro music and immigrant (*métèque*) Jewish art as undermining native French traditions.[43]

Ashkenazi Jewish musical traditions coming from Eastern Europe seem distant from the jazz that derived from African-American culture in the opening decades of the twentieth century. Yet in New York, and in Paris to a lesser degree, because so many Jews wrote and performed in the jazz idiom, it was widely assumed that these two musical cultures overlapped. Listen, for instance, to the principal Jewish newspaper of New York, *The Forward*, writing about the Jewish performer Al Jolson in the early 1920s:

> Is there any incongruity in this Jewish boy with his face painted like a Southern Negro singing in Negro dialect? No, there is not. Indeed, I detected again and again the minor key of Jewish music, the wail of the Chazen [the cantor], the cry of anguish of a people who had suffered. The son of a line of rabbis well knows how to sing the songs of the most cruelly wronged people in the world's history.[44]

These parallels did not pertain only to popular music. The great Black singer Paul Robeson told another Yiddish-language paper that he wanted to sing in a Jewish opera but did not like singing in French, German, and Italian. He explained, "I do not understand the psychology of these people, their history has no parallels with the history of my forebears who were slaves. The Jewish sigh and tear are close to me ... [I] feel that these people are closer to the traditions of my race."[45] This discourse of shared suffering suggests that the legion of Jewish songwriters on Tin Pan Alley were not simply exploiting an indigenous musical style, but instead possessed a sympathetic understanding of jazz and blues—though appearing in blackface may have gone a step too far.

The best Parisian venues for listening to American jazz were in the clubs of Montmartre. American jazz musicians performed in Montparnasse too, at the Jockey and the Jungle, but Montparnasse was better known for its dance halls.

The Rotonde, which had opened in 1910, expanded in the boom years of the 1920s, while after 1927 La Coupole became the center of left-bank nightlife. The most distinctive dance hall of the interwar years in the environs of Montparnasse was the Bal Nègre on the rue Blomet, which featured music by immigrants from the French islands of Martinique, Guadeloupe, and Haiti, known in France as Antillean music.[46] Opened in 1924 as the Bal Colonial by a man from Martinique, it initially catered to the sizeable Antillean community of several thousand, many of whom lived in the fourteenth and fifteenth arrondissements. In this dance hall, Black people were not performing for a white audience, but for other Black people. The young surrealists Robert Desnos and Philippe Soupault discovered and popularized it, then were dismayed when other whites flocked there too; the model Kiki, Kisling, Pascin, and other artists were soon seen there.[47]

A 1932 photograph by the Hungarian-born photographer Brassai of a Black man dancing with a white woman, called *The Bal Nègre, rue Blomet* captures the transgressive, sensual appeal of these dance clubs. Man Ray played on the same juxtaposition in titling more than one photograph Black and White. One shows an African sculpture of a woman next to a nude sculpture of a Western woman.[48] Better known is Man Ray's photograph of Kiki, her head inclined, holding up an African mask. American and Caribbean music became integral parts of the cosmopolitan cultural openness of interwar Montparnasse. In contrast to right-bank practice, Montparnassians did not simply watch a Josephine Baker floor show; they engaged with Black music and culture.

Another Jewish expatriate strongly identified with 1920s Montparnasse high life made a career as a performer/painter. The oddly named Hilaire Hiler was born Hiler Harzberg in St. Paul, Minnesota in 1898. His family faced such antisemitic prejudice that the whole family changed their names to Hiler. That left him without a viable first name, so his sense of humor led him to choose Hilaire. He arrived in Paris in 1919 determined to become an artist. A photograph from the 1920s identifies him as "the painter Hilaire Hiler" in distinguished expat company with Tristan Tzara, Man Ray, and Ezra Pound; the only Frenchman present is the ubiquitous Jean Cocteau. To support himself, he played jazz saxophone and piano, and was part of the first jazz band to tour Germany. Hiler appears in such memoirs of 1920s Montparnasse as Charles Douglas's *Artist Quarter*, who described him as an American Jewish painter with an Irish mother, who sang in both French and English as he played.[49] Hiler was better known as a musician and nightclub owner than as an artist, moving from the Dingo to the Jockey later in the decade and prospering during the

Montparnasse boom years. He decorated the Jockey with those most iconic of American images, pictures of cowboys and Indians designed to make expat habitués feel at home.[50]

When Hiler returned to the United States in the 1930s, he resumed his identity as an artist. He is remembered for one monumental work, the 10' x 100' seascape called *The Lost Continents of Atlantis and Mu* that he painted on the wall of the Aquatic Park Bathhouse (now the lobby of the Maritime Museum) in San Francisco and completed in 1939 under the aegis of the Works Progress Administration (WPA).[51] Hiler also wrote on color theory and art; his book *Why Abstract?* included letters of appreciation from the writers William Saroyan and Henry Miller. He also reminisced about his time as an entertainer: "the days when I ran the Jockey, played piano and sang at the Dingo, or danced at the Scala Palast on Lutherstrasse are long gone."[52] By the end of World War II, Hiler was writing that easel painting was on its way out, and that artists in the future would work as color consultants alongside architects. His books on color theory advanced the idea that the modern role of the artist was as industrial designer, yet at some point in the postwar era Hiler returned to Paris, and died there in 1966. His story shows the interplay between the worlds of art and entertainment in Montparnasse. Whereas the Chat Noir in fin-de-siècle Montmartre created the cabaret artistique, where poets became singer-songwriters, Montparnasse a generation later presented music as an alternative economy for painters who were unable to profit from the art market.

An early example of a Jewish artist portraying a jazz band occurred not in Paris but in neutral Zurich, Switzerland, where the avant-garde known as dada had found a refuge from the war. Among the leaders of dada were the Romanian-born Jews Tristan Tzara and Marcel Janko. The dadaists of the Cabaret Voltaire featured regular African nights with rhythmic drumming and poets and painters wearing African-style masks created by Janco. The artist captured this spirit in his 1918 painting *Jazz 333*, an abstract cubo-futurist work in browns and blues that expresses the cacophony or *bruitisme* that the dadaists favored. For Janco and the others, jazz fitted into their cult of the primitive and irrational that propelled their rejection of Western culture and its alleged rationality.[53] Since jazz only arrived in Europe with African-American troops in 1917–18, this must have been one of the first artistic evocations of the new music. Janco came to Paris with his brother immediately after the war to practice architecture, breaking with dada at that time, but returned to his native Romania at the end of 1921 and remained in Bucharest until he fled World War II and the Holocaust in 1941 for British Palestine. He spent the second half of his life in Palestine/Israel.

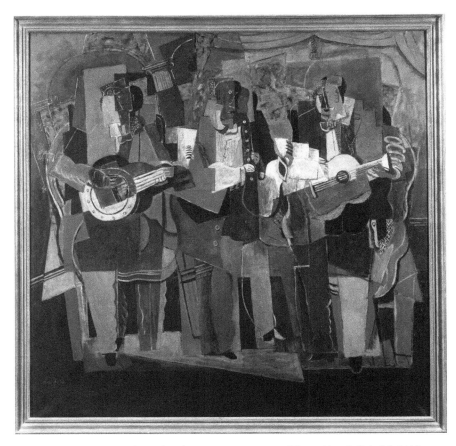

**Figure 5.6** Henri Hayden, *The Three Musicians*, 1920. Photo: René-Gabriel Ojéda, RMN-Grand Palais/Art Resource, New York. 2021. Artists Rights Society (ARS), New York/ADAGP, Paris.

Henri Hayden also produced a major painting of a jazz band shortly after the war. Born Henryk in Warsaw to a wealthy Jewish merchant family, he attended the fine arts academy in Warsaw before coming to Paris in 1907 at the age of twenty-four. He moved to a studio in Montparnasse at the beginning of the war in 1914, and met Max Jacob and Jacques Lipchitz, who introduced him to the dealer Léonce Rosenberg. Hayden's style took a marked cubist direction from then until 1923. From 1916 to 1920, the years of the Lyre and Palette concerts on the rue Huyghens, Hayden befriended the young composers performing there, as well as Erik Satie.[54] This period of musical effervescence led to Hayden's 1920 canvas *The Three Musicians*, which shows an (apparently) Black banjo player, clarinetist, and guitarist in a fractured cubist style. Hayden's colors are subdued

and the musicians appear static, in contrast to Janco's violent and more abstract work. Hayden finished the work in 1919, his biographer Jean Selz commenting that "by its shattered construction, the articulation of its planes, the rhythm of its solid colors, the canvas is powerfully evocative of the syncopated movements of jazz."[55] The date on Hayden's work is important too, in that one might assume he was copying Picasso's painting of the same name and similar theme. In fact, the two versions of Picasso's *Three Musicians* were produced a year later. Picasso may have seen Hayden's painting at the Salon des Indépendants of 1920, or else in Rosenberg's gallery; in any case the two artists' works are quite distinct. Picasso used bright colors, the musicians were rendered more abstractly, and he included images of sheet music. Picasso included a clarinetist in both pictures but no banjo player.[56] Hayden painted *Le banjo* in 1921 and *Great Still Life with Banjo* in 1922, showing his continuing fascination with jazz, before abandoning cubism in 1923. The fact that Hayden was deeply involved in the music of Poulenc and his fellow modernists and yet painted images of jazz musicians suggests the continuity between classical and popular music, since the young Parisian musicians were themselves influenced by the sounds from the New World.

Another striking example of this jazz-classical matrix is the production of *La création du monde* for the Ballet Suédois in 1923. Darius Milhaud composed the music; Fernand Léger designed the Africanist sets and costumes. Milhaud had immersed himself in the jazz clubs of Harlem in New York City the previous year, and transposed what he heard into African creation mythologies. The idea for the ballet came from Blaise Cendrars. The conflation of Cendrars' African myths, the animal costumes dreamed up by Léger, and African-American jazz did not bother the Parisians.[57] Africa stood for the primitive, jazz for elemental energy, with slippage between the two reinforced by racial stereotypes. Milhaud made this primitivist connection explicit when he wrote of his experience in a Harlem, New York nightclub: "This authentic music had its roots in the darkest corners of the Negro soul, the vestigial traces of Africa, no doubt.[58] That conflation was par for the course in the 1920s.

## Music and Sculpture

Sculptors were as inspired by the power of music as were painters. Jacques Lipchitz and Ossip Zadkine, two of the pre-eminent sculptors of the Jewish Diaspora, turned to the music all around them, and Lipchitz in particular became practically obsessed by music and musical instruments in the 1920s.

Lipchitz associated the métiers of the composer and the artist all his life. In a 1949 letter to the noted art critic and museum curator Jean Cassou, Lipchitz compared painting to sculpture by using a musical analogy: "There is no essential difference between sculpture and painting! Two instruments which play the same music. It is the music that has importance. And we don't know yet which of these instruments will find grace in the eyes of history in order to have expressed most completely our torments and our laughter (maybe), or our pains and our hopes."[59] Lipchitz was complaining about the neglect of sculpture in museums of modern art, and inquired with some asperity why sculptures were often placed at the bottom of stairways or in dark basements. Lipchitz's musical analogy is striking. Feeling unappreciated as a sculptor among painters, Lipchitz has turned himself into a musician. This off-the-cuff comment in a private letter reveals a paradox about Lipchitz. His works of the 1920s, both bas-reliefs and sculptures in the round, obsessively revolved around music and musical instruments. The evocation of music dominated his work until the crises of the 1930s led him to grapple with more politically charged themes. In the autobiography he published at the end of his life, he says how much he and his wife Berthe loved music, and regularly attended the Paris symphony. Yet he never acknowledges how central music had been in the cubist phase of his sculptural production.[60]

Lipchitz was eighty years old in 1971 when H. H. Arnason spent six weeks interviewing him on film. He then worked closely with his interviewer in preparing *My Life in Sculpture*. Along with Picasso and Chagall, he was one of the final survivors of the "first heroic age of the 20th century," meaning artists of the pre-World War I era.[61] Here is what Lipchitz had to say about the role that musical instruments played in his sculpture:

> The musical instruments that I used in this and other reliefs (*Still Life with Musical Instruments*, 1918) were part of my basic vocabulary. Like cubist painters, I collected musical instruments and decorated my studio with them. We used these objects, which were familiar parts of our everyday lives, as a kind of reaction against the role and exalted subjects of the academicians. They were, in effect, truly neutral objects that we could control and in terms of which we could study abstract relations. They also appealed to us because they were always interesting and unusual in their shapes and thus served as the basis for intricate compositions.[62]

In highlighting the spatial aspects of musical instruments, Lipchitz minimized music itself. Yet in 1919, he created, for the first time, two works that featured the clarinet, moving away from the canonical cubist instruments, the guitar, violin,

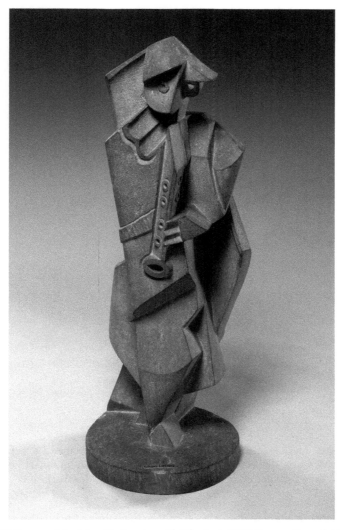

**Figure 5.7** Jacques Lipchitz, *Harlequin with Clarinet*, 1919. Barnes Foundation, A234, Estate of Jacques Lipchitz, courtesy Marlborough Gallery, New York.

and mandolin. Lipchitz placed this popular jazz instrument not in the hands of an African-American musician, but instead in figures from the European tradition of commedia dell'arte: Pierrot and Harlequin. It is likely that he procured a clarinet for his studio in that postwar year, and placed it in the relatively safe hands of figures that reinforced rather than challenged European popular culture, this despite the fact that Lipchitz was an avid collector and enthusiast of African carvings. In the aftermath of the war in which Lipchitz had

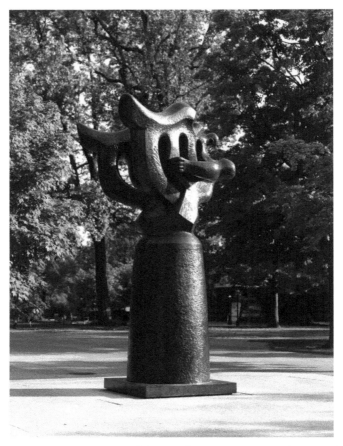

**Figure 5.8** Jacques Lipchitz, *Song of the Vowels*, 1931–32, executed 1969. John B. Putnam Jr. Memorial Collection, Princeton University Art Museum/Art Resource NY. Estate of Jacques Lipchitz, courtesy Marlborough Gallery, New York..

avoided fighting, he may have chosen not to emphasize the challenge posed by the non-European, non-white culture of jazz.

Albert Barnes saw the 1918 piece *Still Life with Musical Instruments* in Lipchitz's studio on his visit to Paris in 1922, and commissioned similar works from the sculptor for his new museum outside Philadelphia.[63] Despite the incursion of clarinets, most of the many pieces in which Lipchitz featured musicians and instruments throughout the next decade were the traditional Apollonian stringed instruments. Late in the 1920s he was very taken by a duo of female harpists; their image was eventually abstracted first into *The Harpists* of 1930 and then into one of Lipchitz's signature pieces, *Song of the Vowels* (1931). No instrument contrasted more with the horns of jazz musicians than

the harp. Lipchitz appreciated the sensuality of his female harpists. Stringed instruments were associated with Apollo and Orpheus and perceived as noble by the Greeks, in contrast to phallic wind instruments that were Dionysian. Many Renaissance and Baroque artists had featured the conflict between Apollo and the satyr Marsyas, who challenged the music of the god and was punished for his temerity by being flayed alive.[64] By the time Lipchitz sculpted *Song of the Vowels*, he had left cubism behind. In the mid-1920s he had experimented with openwork pieces in bronze he called "transparents," which included a *Harlequin with Guitar* in 1926 and *The Harp Player* in 1928. By the late 1920s and into the 1930s his work was semi-abstract, fluid, and increasingly expressionist, so that while musical themes persisted throughout the two decades from the beginning of World War I until 1932, his way of expressing the relationship of musician and instrument had changed. *Song of the Vowels* fuses the women and their harps into one continuous flowing form. In 1945, year of liberation, Lipchitz was moved to create *The Joy of Orpheus*, in which the bodies of Orpheus and Eurydice are joined, forming a lyre.

Ossip Zadkine was never a cubist, and unlike Lipchitz minimized his Jewish heritage, despite having attended the same art school taught by Yuri Pen in his native Vitebsk as Marc Chagall. His French wife and fellow artist, Valentine Prax, wrote a memoir of her time with Zadkine. She recounts how impassioned her husband was for music, in particular the music of Stravinsky and the Ballets Russes, as well as Vivaldi. He knew the composer group "Les Six" personally and tried to introduce his wife to their music, which she found difficult. She also reports on the coming of Negro dancers to Paris, as well as some late performances by Isadora Duncan, but the dreams of dancing seem more hers than Zadkine's.[65] The refined Zadkine seems never to have strayed from the Apollonian representation of music as a higher art form. His musicians tend toward the allegorical, and mostly hold lyres rather than guitars, much less clarinets and saxophones. In his own memoir, Zadkine reports that a trip to Greece in 1931 inspired his subsequent career.[66] He must have been prepared for classical allusions, since his father taught Latin and Greek. Zadkine's modernism was never fully abstract, and in the 1930s his work moved toward the allegorical and mythological. His figures are elongated and expressive, nearly always humans or gods holding their emblematic instruments. His work is readily available for view in Paris in situ, since his former studio and home on the rue d'Assas between Montparnasse and the Latin Quarter has become the Zadkine Museum. There one can experience his tall elegant figures in wood, bronze, and stone looming over the spectator; out in the garden a reclining figure holds a violin over the

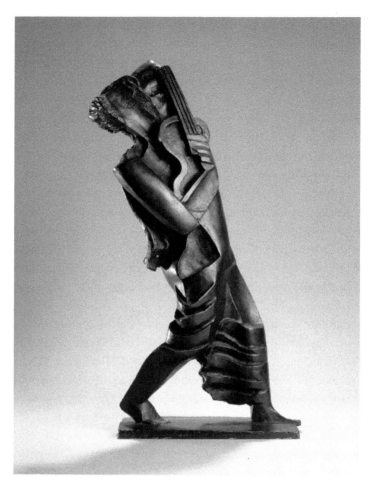

**Figure 5.9** Ossip Zadkine, *Orpheus Walking*, 1930. Paris Musées, Musée Zadkine. Dist. RMN-Grand Palais/Art Resource NY. ARS, Artist Rights Society, NY.

lawn. There is a second Zadkine museum at Arques, south of Toulouse, where the artist had a summer home. There his wife stayed during World War II while Zadkine spent three and a half years in the U.S. (he does not explain in his memoir why he left her behind, but they reconnected at war's end). Music was important for Ossip Zadkine as for many other immigrant artists, but he remained firmly on the side of the eternal and ethereal Apollo rather than the subversive satyr Marsyas and his pipes.

In 1930, Zadkine sculpted a full-length figure of Orpheus grasping his lyre. As befits this optimistic period, Orpheus appears serene and classical as he strides forward in his robe; the lyre resembles an upright violin. Two decades later, after

the war, Zadkine created another Orpheus in bronze. This Greek god is both more abstract and more expressionist. The lyre is integrated into his body, and an arm is raised as if he is gesticulating as he strides forward. Zadkine did one more Orpheus, immediately after the war, but this one, executed in plaster, he called *Project for a monument for G. Apollinaire*. The poet sits on a base that resembles books, and loose pages of an open book lie across one leg, suggesting the poet's literary vocation. Yet his arms grasp not a pen but rather a lyre, with the strings clearly expressed. Here the sculptor interpreted the great poet literally as the muse of Parnassus and the critic who imagined the art of Robert and Sonia Delaunay as Orphism.[67] The Provençal Jewish composer Darius Milhaud was similarly taken with the figure of Orpheus, and a year after *La création du monde* composed a chamber opera called *Les Malheurs d'Orphée* (The Misfortunes of Orpheus), which was set in the Camargue in southern France.[68]

Another Jewish sculptor in interwar Paris also felt the pull of musical themes. Morice Lipsi was the youngest of all the immigrant artists to have arrived in Paris before World War I, reaching Paris from his native city of Łodz, Poland, in 1912 at the tender age of fourteen. Lipsi may have been precocious, but he was also joining his older brother, Samuel Lipszyc, already ensconced in a studio in La Ruche and working in ivory. Lipsi worked in armaments factories during the war and briefly attended the Ecole des Beaux Arts in 1916. He remained at La Ruche until 1927, when he found a studio on the rue de Vanves, closer to Montparnasse. In 1933, he moved to a studio and house in a suburb south of Paris, where he remained for decades except for the years of World War II, when he fled south first to Charentes, then to Switzerland after the Nazis occupied all of France at the end of 1942. His older brother disappeared during the German occupation. Lipsi was seemingly unaffected by the ideological currents of the 1920s, working in a figurative style free of cubist influence. After 1945, his work turned abstract. A catalog of his works between 1920 and 1965 shows that nearly all the works with musical titles were done during the 1920s. The first such work, *Musiciennes* (*Female Musicians*), dates from 1925. It was followed by *Leaning Accordion Player* and *Musical Group* in 1926 and four such works in 1927, including another *Accordionist* and *Cello Player*. Then the musically themed pieces drop off precipitously. The next one listed is *Angel Musicians*, done in 1942 for a church in Vienne, France, while Lipsi was on the run from the Nazis. In 1946, he did *Mask with Violin*, and another titled *Musical Instruments* in 1948. The first musical piece, *Female Musicians* of 1925, looks art deco-inspired with two nude figures (one seems to wear a cloche hat), but the instrument in question is hard to identify. It seems more architectural than musical.[69]

The Hungarian Jewish photographer André Kertesz, who had recently arrived in Paris from Budapest, took Zadkine's picture playing the accordion in his studio in 1926. Behind the musician-sculptor sits a carving in wood of an accordionist.[70] Chana Orloff cast a sculpture of an accordionist two years earlier and subtitled the work *Portrait of Per Krogh*—the Norwegian painter whose wife Lucy carried on a long-term relationship with Jules Pascin. Pascin also did a painting of an accordionist in 1924, in his case played by the writer Pierre Mac Orlan (real name Pierre Dumarchey) with a cigarette dangling from his lips. Mac Orlan accompanied himself on the accordion as he sang his own songs at the Lapin Agile café-bar in upper Montmartre.[71] Morice Lipsi did a carved wooden piece in 1926 called *Musical Group*, which also featured an accordionist. These works made a statement about Parisian popular culture, as still survived in the Bals Musettes of the *quartiers populaires*.[72] If the violin was familiarly Jewish, the accordion was typically French; it is not surprising that artists as acculturated as Krogh and Zadkine should have played it, or that Pascin and Orloff should have depicted it.

Jewish artists explored a wide variety of options in representing music in their painting and sculpture. Those like Chagall and Mané-Katz who evoked the world of the shtetl they had left behind associated music with Jewish culture. Melancholically in Chagall's vertiginous violinists or more joyfully in Mané-Katz' wedding celebrations, music stood for Jewish traditions, especially those of the Hasidic world of ecstatic piety. At the same time, Jewish artists and composers were steeped in the Black music of the New World that shaped much of the nightlife of the Montparnasse artists' colony in the interwar era. Jewish artists and composers felt no inhibitions about engaging with African-American art forms. Darius Milhaud and his American counterpart George Gershwin (whose *Rhapsody in Blue* followed by one year *La création du monde*); jazz musicians such as Mezz Mezzrow, Artie Shaw, and Benny Goodman in addition to the local artist-musician Hilaire Hiler; and the songwriters of Tin Pan Alley forged a diasporic alliance between jazz and Jews. Those artists less comfortable with popular music still felt the need to highlight the synchrony between the auditory and visual arts, synesthetically in the case of Daniel Rossiné, formally for Jacques Lipchitz, and mythologically for Ossip Zadkine. In contrast to the original Mount Parnassus, in the cosmopolitan and hedonist culture of the modern Montparnasse, Apollo and Marsyas coexisted happily. Nor did Jewish artists find the pagan spirits of Apollo and Orpheus antithetical, as they might have in Hellenistic times when Jews were threatened by Greek culture.

# Bringing it all Back Home

The power of this interplay between Jewish art and music emerged again a half-century later, and on another continent. The connections, while indirect, are striking, and bring us back to the great Yiddish writer Sholem Aleichem, cited at the beginning of this chapter. The writer's youngest son, Norman, who changed his surname from Rabinovich to Raeben, was born in Russia in 1901 and came with his family to the United States in 1914. During the war years, young Norman studied art in New York with the so-called Ashcan school of realist painters, which included Robert Henri, John Sloan, and George Luks. Norman Raeben traveled to Paris immediately after World War I and claimed to have participated in the bohemian Montparnasse milieu that included Chagall, Modigliani, and Soutine; he even said he shared lodgings with Soutine. Since Modigliani died early in 1920, this suggests the date must have been 1919; on the other hand, Chagall was in Russia at the time, so unless his stay in Paris extended from 1919 to at least 1923, Raeben might have been exaggerating.[73]

Norman Raeben was running his own art school in Manhattan a half-century later, when he acquired his most famous student. In the spring of 1974, the singer-songwriter Bob Dylan walked into Raeben's studio, and for the next two months took art lessons from Raeben full time, from 8 am to 4.30 pm five days a week. Dylan's painting style presumably reflects Raeben's influence. More importantly, Dylan himself attributes the revival of his songwriting ability at a time when his career was at a low point to the influence of his art teacher. Dylan was injured in a motorcycle accident in 1966 and claimed that the trauma hindered his ability to create lyrics. The art lessons he took in 1974 appeared to free his psyche. It was not only the lessons but the combination of art and philosophy that Raeben imparted that affected the 1960s' icon, for the artist talked incessantly as his students painted. As Dylan put it, "he put my mind and my hand and my eye together, in a way that allowed me to do consciously what I unconsciously felt."[74] He also described Raeben as a magician "who looked into you and told you who you were."[75] We don't know if Raeben attributed his wisdom to his experience in Paris in the 1920s, but his advice focused on spontaneity and intuition, the sort of ethic he might have imbibed from Modigliani and Soutine.

The immediate result of the experience with art and Jewish metaphysics was the album *Blood on the Tracks*, which critics acclaimed as Dylan's best work since his legendary albums of the mid-1960s such as *Blonde on Blonde*. Apparently, even the title of the most famous song on the album, "Tangled Up in Blue," was a phrase that Dylan heard from Raeben, who criticized him for using too much blue in a still life. When Dylan tried to explain to interviewers in subsequent

years what he had learned from Raeben that transformed both his songwriting and his life, he said that above all his notion of time had changed. Past, present, and future now seemed all the same; as in a painting, one perceived both the various elements and the work as a whole at the same time. Though Dylan did not use the term simultaneity to describe the disruption of temporality, he meant that his goal had become in part the dissolving of time: "I mean what the songs are necessarily about is the illusion of time. It was an old man who knew about that, and I picked up what I could."[76] Bob Dylan, the Jewish boy from Hibbing, Minnesota who emerged onto the music scene in bohemian Greenwich Village in 1961, emulating the Oklahoma folksinger Woody Guthrie, had his career and sensibility resurrected by a Jewish artist whose own seminal experiences dated from an earlier bohemia. The Raeben–Dylan connection suggests the continuing interplay between Jewish identity, music, and art. Raeben died a few years later, in 1978, and if one searches for him on the internet, one would think his entire career was overshadowed by the two months he served as Bob Dylan's mentor. Historian Sean Wilentz summarizes the impact of Raeben on Dylan:

> With Raeben, he [Dylan] learned to eschew conceptualization (the bane, in Raeben's view, of the contemporary art scene), and to see things plain, as they really are, always aware of perspective, both straight on and from above, simultaneously. He also learned how to abandon the sense of linear time to which he had clung automatically, and to understand the artistic possibilities of pulling together the past, present and future, as if they were of a piece, permitting a clearer, more concentrated focus on the objects or object at hand.[77]

This Raeben–Dylan connection shows the influence of art on music rather than the impact of music on art, as has been emphasized for interwar Paris. In fact, this story indicates the reciprocal interplay between these art forms. Norman Raeben reminds us that the stories of his father, Sholem Aleichem, inspired the most important postwar evocation of traditional Ashkenazi culture, *Fiddler on the Roof*. What struck Bob Dylan about his experience with the old Jewish artist (in 1974 Raeben was seventy-three, Dylan thirty-three) was that art included not just the practice of painting but phenomenology, that is a particular way of grasping the world, which the songwriter credited with changing his life.

# Notes

1   Philippe Dagen, *Le Silence des peintres: Les artistes face à la grande guerre* (Paris: Hazen, 2012).

2 The British Jewish violinist Yehudi Menuhin famously collaborated with the Indian sitar master Ravi Shankar in several albums called *West Meets East*, the first of which appeared in 1967.

3 Irving Babbitt, introduction to Julien Benda, *Belphegor*, trans. S. J. I. Lawson (New York: Payson and Clarke, 1929), n.p., sixth page of introduction.

4 Benda, *Belphegor*, 18.

5 Benda, *Belphegor*, 30.

6 Benda, *Belphegor*, 32, 33.

7 Benda, *Belphegor*, 27.

8 Jewish-theatre.com/visitor/article-display.aspx/articleID=3438; Jackie Wullschlager, *Chagall: A Biography* (New York: Knopf, 2008), 170, 500.

9 Wullschlager, *Chagall*, 177.

10 Alberto Ausoni, *Music in Art*, trans. Stephen Sartarelli (Los Angeles: J. Paul Getty Museum, 2009), 290.

11 *The Dance* was featured as the poster advertising the 2013 exhibition at the Musée du Luxembourg called *Chagall entre guerre et paix*.

12 Yale Strom, *The Book of Klezmer: The History, the Music, the Folklore* (Chicago: A. Cappella, 2002), 113, 114.

13 Michel Ragon, *Mané-Katz* (Paris: Georges Fall, 1960), 10–14.

14 *Mané-Katz et son temps, l'aube du XXe Siècle* (Geneva: Petit Palais, 1969), frontispiece. The comment about shaving his sidelocks comes from Ragon, *Mané-Katz*, 14.

15 Ragon, *Mané-Katz*, 32.

16 Jacques Chapiro, *La Ruche* (Paris: Flammarion, 1960), 35.

17 Chapiro, *La Ruche*, 80.

18 Chapiro, *La Ruche*, 75, 77.

19 Marek Szwarc, *Mémoires entre deux mondes*, trans. Suzanne Brucker French (from Polish) (Paris: Ressouvenances, 2010), 249.

20 Simon Shaw-Miller, *Visible Deeds of Music: Art and Music from Wagner to Cage* (New Haven, CT: Yale University Press, 2002), 96.

21 Peter Vergo, *The Music of Painting: Music, Modernism and the Visual Arts from the Romantics to John Cage* (London: Phaidon, 2010), 283, suggests that Rossiné may have picked up ideas concerning the affinity of music and painting from the Delaunays.

22 *Visual Music: Synaesthesia in Art and Music since 1900* (Washington, D.C.: Hirshhorn, 2005), 41–2.

23 *Visual Music*, 49.

24 Vergo, *The Music of Painting*, 283.

25 *Visual Music*, 49; letter to Sonia and Robert Delaunay, dated December 19, 1924.

26 Shaw-Miller, *Visible Deeds of Music*, 83, 84.

27 Francis Steegmuller, *Apollinaire: Poet among the Painters* (London: Rupert Hart-Davis, 1963), 220, 229.

28 *Visual Music*, 38.

29 Shaw-Miller, *Visible Deeds of Music*, 134–6.

30 Adrian Hicken, *Apollinaire, Cubism and Orphism* (Aldershot, UK: Ashgate, 2002), painting reproduced on 33. Surprisingly, Hicken does not discuss Orphism in terms of its musical influence despite Apollinaire's identification with Orpheus. On the importance of Orpheus in modern art, see Judith Bernstock, *Under the Spell of Orpheus: The Persistence of a Myth in Twentieth-Century Art* (Carbondale: Southern Illinois University Press, 1991). Bernstock discusses Apollinaire and Orphism on 11–21, and Lipchitz and Zadkine on 37–41.

31 Michael Shapiro, "Sound in a Silent Medium: Thoughts on the Pleasures and Paradoxes of Musical Paintings," in *The Art of Music: American Paintings and Musical Instruments, 1770–1910* (Clinton, NY: Fred Emerson Gallery, Hamilton College, 1984), 12.

32 Jennifer Homans, *Apollo's Angels: A History of Ballet* (New York: Random House, 2010), 336–8, and Charles Riley II, *Free as Gods: How the Jazz Age Reinvented Modernism* (Lebanon, NH: ForeEdge, 2017), 42–4.

33 Psalm 150, 2–5, *The Holy Scriptures* (Nashville, TN: Jewish Publication Society of America, 1917, 1955), 984.

34 See the "Lyre & Palette exposition, le Tout-Paris des Arts à Montparnasse, 1916–1919" show at bookstore Sur le fil de Paris, November 13–December 14, 2014, www.surlefildeparis.fr. See also John Warne Monroe, *Metropolitan Fetish: African Sculpture and the French Imperial Invention of Primitive Art* (Ithaca, NY: Cornell University Press, 2019), 49, 96–7.

35 Silvie Buisson, "Jean, Pablo, Max, Ortiz, Marie et les autres," in *Jean Cocteau à Montparnasse* (Paris: Edition des cendres/Musée de Montparnasse, 2001), 30, 31.

36 Dariius Milhaud, *My Happy Life* (London and New York: Marion Boyars, 1995), 84.

37 James Harding, *The Ox on the Roof: Scenes from Musical Life in Paris in the Twenties* (London: Macdonald, 1972), 133.

38 Paul Morand, *Black Magic*, trans. Hamish Miles (New York: Viking, 1929), v, vi. The American translation of Morand's book was illustrated by the prominent African-American artist Aaron Douglas, a fact which underscores that Morand was not perceived as trying to belittle or patronize Black culture.

39 A good discussion of La Revue nègre can be found in Jody Blake, *Le Tumulte noir: Modernist Art and Popular Entertainment in Jazz-Age Paris, 1900–1930* (University Park, PA: Penn State University Press, 1999), 91–9. See also Phyllis Rose, *Jazz Cleopatra: Josephine Baker and her Times* (New York: Doubleday, 1989).

40 Darius Milhaud, "Notes sur la musique," quoted by Jane Fulcher, *The Composer as Intellectual: Music and Ideology in France, 1914–1940* (New York: Oxford University Press, 1995), 180.

41 The title of Jeffrey Merrick's book, *A Right to Sing the Blues: African Americans, Jews, and American Popular Song* (Cambridge, MA: Harvard University Press, 1999), makes this connection explcit.

42 Jeffrey Jackson, *Making Jazz French: Music and Modern Life in Interwar Paris* (Durham, NC: Duke University Press, 2003), 95. Jeffrey Melnick, *A Right to Sing the Blues: African Americans, Jews, and American Popular Song* (Cambridge, MA: Harvard University Press, 1999), delves deeply into connections between Black and Jewish music in an American context. The Harold Arlen reference occurs on 50.

43 Jackson, *Making Jazz French*, 97–103.

44 *The Jewish Forward*, quoted in Melnick, *A Right to Sing the Blues*, 178.

45 Paul Robeson to the Morgan Journal-Tageblatt, quoted in Melnick, *A Right to Sing the Blues*, 180.

46 Blake, *Le Tumulte noir*, 115–19.

47 Brett Berliner, *Ambivalent Desire: The Exotic Black Other in Jazz-Age France* (Amherst and Boston: University of Massachusetts Press, 2002), 207–8.

48 Blake, *Le Tumulte noir*, 87; the Brassai photo is included on 118.

49 Charles Douglas, *Artist Quarter: Reminiscences of Montmartre and Montparnasse in the First Two Decades of the Twentieth Century* (London: Faber and Faber, 1941), 189.

50 Jackson, *Making Jazz French*, 68.

51 Heather Hernandez, a librarian at the Maritime Museum, tracked down Hilaire Hiler's biographical details; see www.maritimelibrawfriends.org #13, April 2009.

52 Hilaire Hiler, *Why Abstract?* (New York: New Directions, 1945), 67.

53 Blake, *Le Tumulte noir*, 75–6.

54 Biography of Henri Hayden, 1883–1970, in Kenneth Silver and Romy Golan, eds., *The Circle of Montparnasse: Jewish Artists in Paris, 1905–1945* (New York: Universe, 1985), 101–2.

55 Jean Selz, *Hendryk Hayden* (Geneva: Cailler, 1962), 18.

56 A review of a Hayden retrospective exhibition compares the *Three Musicians* by Hayden and Picasso. See Pierre Granville, "A Glance at the Work of Henri Hayden," *Burlington Magazine* 110, no. 784 (July 1968): 421.

57 Harding, *The Ox on the Roof*, 132–3.

58 Milhaud, quoted in Glenn Watkins, *Pyramids at the Louvre: Music, Culture, and Collage from Stravinsky to the Postmodernists* (Cambridge, MA: Harvard University Press, 1994), 115. In 1927, Milhaud still believed that, "The primitive African side remains profoundly anchored in the blacks of the United States, and it is there that we must find the source of this formidable rhythmic force as well as their expressive melodies, which possess a lyricism such as only oppressed races can produce." Milhaud, quoted by Watkins, 161.

59 Fonds Lipchitz, Bibliothèque Kandinsky, Paris, Jacques Lipchitz to Jean Cassou, August 5, 1949, C2 9769.

60 Jacques Lipchitz (with H. H. Arnason), *My Life in Sculpture* (New York: Viking, 1972), 103, 104.

61 See Modris Eksteins, *Rites of Spring: The Great War and the Birth of the Modern Age* (New York: Doubleday, 1989), 14, for Carl Van Vechten's similar account of being beaten on the head.

62 Lipchitz, *My Life in Sculpture*, 57.

63 Cathy Putz, "Towards the Monumental: The Dynamics of the Barnes Commission (1922–24)," in Josef Helfenstein and Jordana Mendelson, *Lipchitz and the Avant-Garde: From Paris to New York* (Urbana-Champaign: University of Illinois Press, 2001), 41.

64 See Shaw-Miller, *Visible Deeds of Music*, Chapter 3, "Instruments of Desire," for a discussion of this theme. He contrasts Apollo and Marsyas on pp. 91–2.

65 Valentine Prax, *Avec Zadkine* (Paris: Bibliothèque des Arts, 1995), 35–8.

66 Ossip Zadkine, *Le Maillet et le ciseau: souvenirs de ma vie* (Paris: Albin Michel, 1968), 116.

67 All three sculptures described here are included in A. M. Hammacher, *Zadkine* (New York: Universe, 1959), plates 7, 22, and 24. In *Under the Spell of Orpheus*, Judith Bernstock discusses Lipchitz and Zadkine in a chapter called "The Lyre," 34–41, to emphasize that both sculptors sought to unify sculpture and music.

68 Harding, *The Ox on the Roof*, 181.

69 R. V. Gindertael, *Morice Lipsi*, trans. Haakon Chevalier (Neuchatel, Switzerland: Griffon, 1965). *Musiciennes* is reproduced on p. 7 of the text. The Catalogue of works is on pp. 109–15, with the 1920s works on p. 109. The catalogue begins with a general notation for 1916–23, "execution of numerous sculptures in ivory, wood and other materials," without specifying what these works were.

70 Pierre Borhan, ed., *André Kertesz, His Life and Work* (Boston: Little, Brown, 1994), 171.

71 Kenneth Silver, *Paris Portraits: Artists, Lovers, and Friends* (Greenwich, CT: Bruce Museum, 2008), 56.

72 Romy Golan, *Modernity and Nostalgia: Art and Politics in France between the Wars* (New Haven, CT: Yale University Press, 1995), makes this point and reproduces the sculptures of Orloff and Lipsi on 142–3.

73 Sean Wilentz, *Bob Dylan in America* (New York: Doubleday, 2010), 138.

74 Ben Cartwright, "The Mysterious Norman Raeben," in John Bauldie, ed., *Wanted Man: In Search of Bob Dylan* (London: Carol, 1990), 87.

75 Cartwright, "The Mysterious Norman Raeben," 86, 87.

76 Cartwright, "The Mysterious Norman Raeben," 90.

77 Wilentz, *Bob Dylan in America*, 139, 140.

# Marketing Art: Jewish Critics
# and Art Dealers

Numerous as Jewish artists became in interwar Paris, they never dominated the
art scene; like Jews everywhere, they remained a minority. Such was not the case
with Jewish art dealers, who preceded the large-scale appearance of Jewish
artists by a generation. They too flourished and expanded their numbers in these
same years, and like the artists, many arrived from other countries. Perhaps the
oldest Jewish-run gallery in Paris was Bernheim-Jeune, opened in 1863 by
Alexandre Bernheim and passed on to his sons Josse and Gaston. In 1906, the
neoimpressionist critic and anarchist Félix Fénéon became gallery director, and
over the next two decades, Bernheim-Jeune became a center of the avant-garde.
In the early years of the Third Republic, Alexandre Rosenberg, a Jewish
immigrant from Bratislava in the Austro-Hungarian Empire, opened an antique
store that soon began to sell the works of the impressionists. His sons, Léonce
and Paul, were born in Paris in 1879 and 1882. Both opened galleries of their
own, Léonce in 1910 and Paul in 1911. Their generation would be the first to
become widely recognized, and included the German Jewish immigrant Daniel-
Henry Kahnweiler (1884–1979), Russian immigrant Katia Granoff (1895–1989),
and Polish immigrant Jadwiga Zak (1895–1943/4). French-born Jewish dealers
included René Gimpel (1881–1945), Georges Wildenstein (1892–1963), Germain
Seligman (1893–1978), Pierre Loeb (1897–1964), and the slightly older Berthe
Weill (1865–1951), who was born in Paris (many Ashkenazi French Jews,
including the families of Berthe Weill and Alfred Dreyfus, came from Alsace).
The Jewish art dealer was such a common trope that in the trilogy called *Les Juifs
d'aujourd'hui* (Jews today), published in 1925–7, Jacob Lévy centered the three
novels on a bourgeois Parisian family whose patriarch is an important art dealer.

These dealers were not necessarily promoting the work of their fellow Jews.
Kahnweiler advanced the careers of Braque and Picasso (Weill discovered
Picasso first, but before his cubist period), and after he lost them to Paul
Rosenberg at the end of World War I, he picked up Picasso's fellow Spaniard Juan

Gris. Paul Rosenberg showed works by Picasso, Braque, Matisse, Léger, Bonnard, and Marie Laurencin. He convinced Picasso to move next door to his gallery at 21 rue la Boétie on the right bank in 1919, weaning the artist away from Montparnasse. He showed no interest in the Ecole de Paris or in Montparnasse, where nearly all of the Jewish artists worked.[1] His brother Léonce, by contrast, did sign contracts with Jacques Lipchitz and Diego Rivera during World War I, helping to keep them afloat by paying them a monthly stipend in return for a certain number of works. In the interwar era, Paul, the younger brother, more astute at business, overshadowed Léonce. Berthe Weill provided Modigliani with the only solo show given during his lifetime, at her small gallery in Montmartre, in December 1917. As early as 1910, she showed works by Jules Pascin (as did Paul Cassirer in Berlin, in 1907). On the other hand, Ambroise Vollard worked closely with Marc Chagall, commissioning him to illustrate the fables of La Fontaine and even the Hebrew Bible. The dealers most involved with Ecole de Paris artists were Paul Guillaume and Léopold Zborowski, neither of whom were Jewish (nor was Vollard). Guillaume and Zborowski were younger, less well-established dealers.

Why would it matter whether Jewish dealers represented Jewish artists? Hostile French critics were likely to assume that Jewish dealers were advancing the careers of their co-religionists. How else, they thought, could one explain the sudden appearance of so many Jewish artists when, as Fritz Vanderpyl archly put it in 1925, not a single Jewish artist was represented in the Louvre.[2] Antisemitic discourse in France had long confined Jews to the realms of commerce and criticism, while arguing that only Aryans possessed creativity.[3] The School of Paris undermined the invidious distinction between critical Semites and creative Greeks/Aryans, so antisemites in the tradition of Gustave le Bon and Edouard Drumont contended that it was all a conspiracy.

The German dealer in modern art Wilhelm Uhde estimated that Jews controlled at least three-quarters of the modern art market in the 1920s.[4] A similar preponderance existed in his native Germany, where Paul Cassirer, Herwarth Walden, Max Stern, and the Thannhauser family were influential dealers. Even if these Jewish dealers did not necessarily promote the work of Jewish artists, they all boosted modernism. Artists, however creative, needed to sell their works. Dealers and critics were integral to the modernist network. In 1931, a director of the prestigious Paul Cassirer Gallery in Berlin attributed the greater success of young Parisian artists, compared with their German counterparts, to the "game" between artists, merchants, critics, and collectors that promoted these artists.[5] That system allowed small galleries, such as those

run by Zborowski and Uhde, to discover artists, and the big right-bank galleries with ample funds to stock their works and assure them of regular incomes.

In the second volume of his classic biography of Picasso, covering the cubist years from 1907 to 1917, John Richardson included a chapter called "Collectors, Dealers and the German Connection." He argued that Picasso's dealer before World War I, Daniel-Henry Kahnweiler, encouraged his fellow German dealers to exhibit modernist paintings to build a clientele for the avant-garde there. The unfortunate side effect of this strategy was to allow the French to perceive cubism as alien, since its principal purveyors, art dealers such as Kahnweiler, Flechtheim, and Thannhauser, were German Jews.[6] Beyond noting the phenomenon of so many Jewish art dealers, Richardson tried to explain why this generation of Jews opened galleries:

> Numerous young men of his [Kahnweiler's] generation and background preferred to apply the financial acumen they had inherited from their parents to trading in art rather than in wheat or coal or garments. This enabled them to reconcile the *tachles*—the profitable ventures—of stern Jewish fathers with the *shmonzes*—the spiritual concerns—of idealistic Jewish sons.[7]

After their fathers made their fortunes in the rapidly expanding German Reich, members of the next generation applied themselves to the ideal of *Bildung* or personal cultivation. A few bourgeois Jews, such as the painter Max Liebermann, became artists, but others combined finance and culture, as Richardson suggested, marketing the art of others.[8]

Another explanation for the prevalence of Jewish art dealers comes from the memoirs of one such merchant, Germain Seligman. His father, Jacques Seligmann (the son dropped the second "n") came from Frankfurt, and aged sixteen, shortly after the Franco-Prussian War, moved to Paris. By 1900, Seligmann's business in dealing in fine and decorative arts had grown to the extent that he was able to open a gallery in the fashionable Place Vendôme. His son Germain expanded into modern art, and eventually opened a New York branch of Seligmann and Co. In his memoir, Germain Seligman described forward-thinking collectors such as Jacques Doucet and Auguste Pelerin who sold their stock of art so that they could buy works that were more modern. Doucet moved from impressionists to cubists; Pelerin sold thirty works by Manet in 1910 so that he could devote himself to Cézanne, at that time a more controversial figure. Seligman concluded, "These departures from the collecting traditions are particularly startling if one understands at all the psychology of the Frenchman, at once a conservative and a realist, an individualist and a

traditionalist. Due to his background and education, he has a far greater interest in the art of his proud past than in the art of his present."[9] One may infer that outsiders, such as Jews, were less tied to tradition and more willing to invest in contemporary artists. Seligman kept a foot in both camps: the 128 plates included in his book range from medieval statuary and Vermeer to paintings by Gauguin and Picasso (including the *Demoiselles d'Avignon*, which he sold to the Museum of Modern Art in 1937). The only Jewish artist mentioned was Modigliani; Seligman proudly declared that his New York gallery was the first to mount a major show of his works in the U.S.[10]

A corollary to this "German connection" was the presence in Paris of German dealers. Alfred Flechtheim and Wilhelm Uhde (the latter Prussian rather than Jewish) were among the "dômiers" who congregated at the Dôme café in Montparnasse along with Pascin, Kisling, and German-born artists like Walter Bondy and Rudolph Levy. Another mark of their French presence are the portraits painted by Picasso and Pascin of Kahnweiler, Uhde, and Flechtheim.[11] Being a dealer could involve sharing the artists' bohemian lives, no doubt one of its attractions. Wilhelm Uhde went further, marrying the Russian Jewish artist Sonia Terk in 1908, which was apparently a marriage of convenience for both of them, to allow her to remain in France and for him to mask his homosexuality.

In *Esprit de Corps: The Art of the Parisian Avant-Garde and the First World War, 1914–1925*, Kenneth Silver argues that the German taint attached to cubism made life difficult for Picasso and other cubists who remained in wartime France. Hostile critics spelled "cubism" with a "k" to show its enemy origins. Silver quotes a lecture given in Lyons in 1915, "On the Influence of the Judeo-German Cartel of Parisian Painting Dealers on French Art," which purported to show the malign influence that foreigners had on French art over the previous twenty years. Though lecturer Tony Tollet provided no names, Silver does, offering Wildenstein, Bernheim, Berthe Weill, Adolphe Basler (Polish Jewish critic and sometime dealer), and Kahnweiler as representative figures.[12] So intense was this criticism, Silver argues, that Picasso moved away from cubism during and after the war and toward a more representational style based on Latin and classical sources.

As for the dealers of German origin, they suffered more directly than Picasso, who as an alien from neutral Spain was allowed to remain in France as a non-combatant. Kahnweiler happened to be on vacation in Italy when the war broke out. His American business partner had pleaded with him to move the stock of paintings to New York, but Kahnweiler refused, spent the war years in Switzerland, and watched the contents of his gallery sequestered by the French

government. They would be auctioned after the war as confiscated goods.[13] Uhde's collection suffered the same fate.[14] The Kahnweiler auction at the Hôtel Drouot did not take place until June 1921, and the German dealers were incensed that Léonce Rosenberg participated in the sale, making estimates of the artworks' value and taking charge of the auction catalog. The cubist Georges Braque was so furious at Rosenberg that the bulky Norman, a war veteran like Rosenberg, began to pummel the dealer in the sales rooms.[15] The second phase of the auction in November saw Rosenberg square off against Basler, who also came to blows after some name-calling. In the aftermath of the Braque contretemps, Rosenberg had taken boxing lessons, and he defended himself vigorously.[16] Kahnweiler's biographer emphasizes the large number of foreign art buyers at this first public auction of modern art. The auctioneers mispronounced so many foreign names that some spectators thought they were doing so on purpose; others, including the stalwarts of the Ecole des Beaux-Arts, were glad these works were leaving France.[17] By the final auction in 1923, the French state earned 704,000 francs from the artworks seized from Kahnweiler.[18]

It must have been particularly galling for Kahnweiler to lose his prize artist, Pablo Picasso, to the French-born dealer Paul Rosenberg. Braque and Léger also signed with Rosenberg; apparently, Braque's rancor at the older brother Léonce did not affect his decision to sign with Paul.[19] Paul Rosenberg's granddaughter Anne Sinclair cites the following artists as included in his inventory of paintings: Géricault, Ingres, Delacroix, Courbet, Cézanne, Manet, Degas, Monet, Renoir, Gauguin, Toulouse-Lautrec, Picasso, Braque, Léger, Le Douanier Rousseau, Bonnard, Laurencin, Modigliani, and Matisse.[20] This gold-plated list of artists, nearly all French (only Picasso and Modigliani were foreign born), suggests why Rosenberg was not likely to seek out younger representatives of the Ecole de Paris. None, with the possible exception of Chagall, could have competed with most of the artists on this list, at least from an investor's point of view.

Marc Chagall's peripatetic career in the 1920s conveniently offers a glimpse of the way several of these art dealers advanced his career. In particular, his involvement with German Jewish dealers preceded contact with Paris-based galleries. As we have seen, Herwarth Walden at Der Sturm Gallery in Berlin arranged Chagall's first one-man show in June 1914. Two foreign-born poet-critics, Guillaume Apollinaire and Blaise Cendrars, put Chagall in touch with Walden.[21] When the artist left for Germany, he tied a rope around the doors of his studio in La Ruche, expecting to return in three months. He planned to visit Berlin for the exhibition, attend his sister Zina's wedding that summer, marry his fiancée Bella, then return with her via Berlin to Paris. In Berlin, Walden showed

forty of his canvases, to the delight of young expressionists such as Franz Marc.[22] He left Germany, fortunately, before war broke out, but then was stuck in war-torn and revolutionary Russia for the next eight years. On his return to Berlin in 1922, Paul Cassirer aided Chagall by promising to publish an illustrated version of the artist's memoirs, for which he commissioned twenty drypoint etchings. Cassirer eventually gave up on getting an acceptable version of the memoirs translated into German, and published the illustrations without the text. Meanwhile, the prominent French dealer Ambroise Vollard saw Chagall's works in the collection of art critic Gustave Coquiot, and got in touch with Chagall in Berlin via the artist's poet friend Blaise Cendrars.[23] These French connections encouraged Chagall to return to Paris.

Chagall signed a contract with Bernheim-Jeune in 1926, which provided him with financial security through the boom years of the 1920s, though the deal lapsed when the Great Depression hit France.[24] Chagall contracted with Vollard in the 1920s to provide illustrations for a book on the fables of La Fontaine. He produced a hundred etchings for this book, and an equal number for another large Vollard project on Nikolai Gogol's novel *Dead Souls*. In his memoirs, Vollard remarked that "people could not understand the choice of a Russian painter to interpret the most French of all our poets [La Fontaine]. But it was precisely on account of the Oriental sources of the fabulist that I pitched on an artist whose origins and culture had rendered him familiar with the magic East. My hopes were not deceived: Chagall did a hundred dazzling gouaches."[25] Vollard defended his decision to employ a foreign-born Jew at a time when many French felt their culture to be under attack.[26] A prominent dealer who had his portrait painted by Renoir, Cézanne, Rouault, and Picasso (all included in Vollard's memoirs) could afford to be generous with Chagall. The busy artist produced an equal number of illustrations for an edition of the Hebrew Bible, which presumably aroused no protests.[27] Meanwhile, Vollard never got around to publishing the books for which he contracted Chagall's work, but paid the artist well, profited by selling the gouaches for *The Fables of La Fontaine* to Bernheim-Jeune, which displayed them in 1930, and then showed them again at Alfred Flechtheim's Berlin Gallery.[28]

That Marc Chagall could count on art dealers as well established as Paul Cassirer, Ambroise Vollard, and Bernheim-Jeune was unusual for immigrant artists. Nor was his experience with dealers uniformly positive. Before leaving Berlin for Paris in 1923, he sued Herwarth Walden for increased compensation and the return of the paintings he had entrusted to him back in 1914. The affair caused him such stress that he rested at a German sanatorium that summer.

Back in Paris by the end of August 1923, the paintings he had left in his studio in La Ruche gone, he discovered that Charles Malpel, a dealer with whom he had signed a contract back in 1914, had been selling his works. His friendship with Cendrars collapsed over the incident, and he felt betrayed.[29] Picasso expressed similar disenchantment. At the end of the Great War, his response to his sometime dealer Léonce Rosenberg was to exclaim "Le marchand—voilà l'ennemi" ("The dealer, there is the enemy").[30] Yet like all artists, Chagall needed the financial backing dealers provided, particularly now that he was supporting a wife and child. The family's moves from Moscow to Berlin to Paris were to a significant degree directed by the support of these dealers. Thanks to them, his bohemian days were behind him.

The same was true of other successful artists of the Ecole de Paris who had arrived in Paris before World War I. Most still relied on the patronage and camaraderie they found in Montparnasse, and would not imitate Picasso's postwar move to elegant right-bank quarters. Chaim Soutine was able to leave La Ruche for Montparnasse proper, and eventually became a neighbor of Chana Orloff at the stylish Villa Seurat (though not until 1938); she built her home-studio in Montparnasse in the boom year of 1926.[31] Mela Muter built a home and studio for herself at about the same time. Kisling enjoyed a large, comfortable studio, as well as a summer home in Provence by the 1930s. In 1925, Jacques Lipchitz and his fellow sculptor Oscar Miestchaninoff built dual homes and studios for themselves in Boulogne-sur-Seine, a fashionable western suburb of Paris, designed for them by Le Corbusier.[32] For the younger artists who only arrived in Paris during the boom years of the 1920s, such evident signs of success remained remote. They showed their work at the large salons along with hundreds or even thousands of other artists, or in small galleries or nightspots. When the Depression hit and the art market collapsed, they had nothing to fall back on. The travails of the art market helps explain why the latecomers rarely matched the success of their predecessors, at least in the short term.

Jacques Chapiro, for example, was born the same year as Marc Chagall, 1887, in his case in Latvia, also part of the Pale of Settlement. He remained in the Soviet Union until 1925, when he came to Paris and moved into La Ruche, where he lived for the rest of the decade. The following year he began showing his work at the large shows most available to Jewish artists: the Salon d'Automne, the Salon des Indépendants, and the Salon des Tuileries.[33] Grégoire Michonze arrived in Paris age twenty in 1922, showed at the usual salons, and then in the 1930s supplemented them with group shows. He would enjoy no private shows until after World War II. Timing in this tumultuous era was critical.

# Marketing Art in 1920s Montparnasse

Shortly after Marc Chagall returned to Paris in 1923, he sold *The Old Rabbi* to the dealer Léonce Rosenberg for 3,000 francs. Ten days later Rosenberg wrote to Chagall, informing him that he had already sold the painting and that it was leaving Paris, so if he wanted to see it framed he'd better come by soon.[34] In the 1920s in a period of familial happiness in France living with his wife and daughter, paintings of flowers and images of *la belle France* mingled with the violinists and rabbis of his native land. His genius was simultaneously to evoke his roots and the Jews' diasporic routes to the West and to modernism.[35] Chagall's success was in part due to positioning himself well within a crowded art market, offering nostalgic subjects rendered in a modernist style.

Yet Chagall was atypical of immigrant Jewish artists working in interwar Paris. For one thing, he did not reside in Montparnasse; he lived a settled, bourgeois existence in the fashionable western district of Paris. Many aristocratic Russian émigrés lived nearby, which probably helped Marc, Bella, and Ida make the transition from their homeland to France while allowing them to retain an old-world ambience.[36] Few of his fellow Jewish artists emulated him in evoking nostalgic scenes of the old country. The vast majority were glad to be out of the Pale and thrilled by the opportunities and challenges posed by French art, and they were acculturating as fast as they could. Only Mané-Katz followed Chagall's lead in evoking diasporic culture. Why didn't more immigrant Jewish artists play upon their ethnicity to sell their art?

Chagall and Mané-Katz both returned to their homeland in 1914 and spent the long years of war and revolution there before returning to Paris in the early 1920s. The old country was fresh in their minds, which was also the case with the cubist Alice Halicka. She made two trips back to her native Poland after the war, and produced a number of figurative works depicting the teeming Kraków Jewish neighborhood of Kazimierz, some of which she exhibited at the Galerie Berthe Weill in 1921.[37] Unlike the works of Chagall and Mané-Katz, these gouaches neither idealize nor compliment their subjects, suggesting that the upper-class Halicka felt little identification with her fellow Jews. She and Marcoussis converted to Catholicism, were married in the Church, sent their daughter to a Catholic school, and neglected to tell her about her Jewish heritage until the eve of World War II.[38] Alice Halicka is the exception that proves the rule; she only painted Jewish genre scenes when her husband made it impossible for her to continue with cubist internationalism. Abel Pann was another exception: painting Jewish genre scenes meant he rejected modernism. He

emigrated permanently to Palestine in 1920, where he taught at the Bezalel art school and then embarked on a life project of illustrating the Hebrew Bible.[39]

Some critics defined artists of the Ecole de Paris as non-aligned.[40,41] The eminently French method of "branding" oneself was to join a movement or establish a coterie of like-minded artists, as had the impressionists of the 1870s and 1880s. They held group exhibitions and eventually found dealers willing to represent them. The Jewish artist best known for pursuing this route was Camille Pissarro. A Sephardic Jew from St. Thomas, a Danish possession in the West Indies, Pissarro arrived in Paris in 1855. He changed his name from Jacob Abraham Pizarro, yet retained a Danish passport all his life despite never returning to his Caribbean homeland.[42] Strongly identified with the impressionist and neoimpressionist movements, his Jewish identity was entirely subsumed by modernist group identification, though antisemitic colleagues like Renoir and Degas were likely to remind him of his origins. His long white beard made him resemble an Old Testament patriarch, so his fellow impressionists sometimes called him Abraham or Moses.[43] Two generations later, Chagall, Modigliani, and Soutine remained at arm's length from all groups. At most, artists might show together, as did the four Jewish immigrants from Galicia who became known as the Group of Four. Yet Léon Weissberg, Alfred Aberdam, Sigmund Menkès, and Joachim Weingart were no more than friends; they issued no manifestos and went their separate ways in the 1930s.

Cubism possessed a notable leader in Pablo Picasso, and some Jewish artists followed in his path, such as the Polish painter Henri Hayden and the sculptor Jacques Lipchitz, who enjoyed his first one-man show at Léonce Rosenberg's L'Effort Moderne Gallery in 1920. Diego Rivera spent some key Paris years as a cubist before returning to Mexico and a more populist style. Most Jewish artists were classed loosely as expressionists, not a term likely to propel sales in Paris, nor was it one that they used.[44] Their eclectic and individualist approach bears comparison with the American writers of the 1920s, who also frequented the cafés and clubs of Montparnasse and were known for expatriation rather than a common style. Like the Jewish artists, they were committed to modernism, cosmopolitanism, and freedom. Unlike the artists, they wrote for an audience back home, and the English language tied them to America.

How could the many immigrant Jewish artists working in interwar Paris achieve notice and sell their work? In particular, how could they set themselves apart? Many of them showed at the Salon des Indépendants and the Salon d'Automne, yet these shows included thousands of works, with each artist only able to exhibit a handful of pieces. Artists increasingly preferred to market their

works in galleries, and even in the restaurants and cafes of Montparnasse. Wherever they displayed their works, artists could hope that critics would write about them in the numerous venues for publicity. Some journals, such as *L'Art vivant* (Living Art), focused on contemporary artists and might be expected to view their art favorably, since the co-editor, Florent Fels, was Jewish. In 1924, Fels conducted an admiring interview with Chagall a year after his return to France. Two influential interwar critics, Adolph Basler and Waldemar George, were themselves Jewish immigrants. Other Jewish critics included Louis Vauxcelles (born Louis Meyer, who coined the term fauves in 1905 and cubism in 1908, but was no friend of the Ecole de Paris), René Schwob, and Claude Roger-Marx. Jewish art critics writing for the thriving Jewish press included Jacques Biélinky, Gustave Kahn, and Joseph Milbauer. French critics who viewed the artists of the Ecole de Paris favorably included André Warnod, Pierre Mac Orlan and André Salmon.[45] Salmon lived in Montparnasse and knew many of the artists personally, having been particularly close to Modigliani (he later wrote a biography, *La vie passionnée de Modigliani*). Warnod and Mac Orlan were close friends of Pascin.

The Parisian Jewish press of the era eagerly publicized Jewish artists. The most prolific critic to write for this Jewish audience was Jacques Biélinky, who like Chagall was born in Vitebsk, in 1881, and arrived in Paris in 1909, two years before Chagall. Biélinky reported for the mainstream *L'Univers Israélite*, commenting on how many Jews presented art at various salons. The critic Basler told him that one of the Jewish artists asked him if he thought art had become too "Jewified" (*enjuivé*). Biélinky responded that given that the Society of Independent Artists had 3,000 members, that hardly constituted an invasion, and added acidly "M. Basler exaggerates, which is entirely natural for a son of the ghetto."[46]

In 1924, the Salon des Indépendants decreed that henceforth it would classify artists by national origins, which led to considerable protests by Ecole de Paris internationalists, with many artists abstaining from showing there. That same year the first exhibition of Jewish artists took place in Paris under the direction of Gustave Kahn, a writer and editor of the Zionist review *Menorah*. The sixty artists showing there included Mané-Katz, Alice Halicka, Michel Kikoïne, and Henri Epstein. At a similar show four years later, few of the same artists were present, since works had failed to sell in 1924, and they did not want to define their works ethnically.[47] Journalists and critics appeared more conscious of the artists' ethnicity than were the artists themselves, while the absence of sales suggested that French Jews showed little interest in immigrant artists.

Artists who had succeeded in making their names known might aspire to having a volume dedicated to them and their work in the Triangle series *Les Artistes Juifs*. Critics such as George, Basler, and Salmon wrote short volumes on Chagall, Soutine, the sculptor Léon Indenbaum, and other artists from 1928 until 1932; some were translated into Yiddish.[48] Jacques Lipchitz noted that after his exhibition of cubist sculptures at Léonce Rosenberg's gallery, Maurice Raynal wrote a book about his work in 1920. This early monograph helped establish Lipchitz's reputation.[49] A year later Raynal contributed a similar book about another Jewish sculptor, Ossip Zadkine.[50]

Though salons persisted and many venues for publicity existed in interwar Paris, private dealers were the main way artists sold their paintings and sculptures. If the major dealers were out of reach for unknown artists, they might approach smaller galleries. Jewish women ran three such galleries: Berthe Weill, Katia Granoff, and Jadwiga Zak. Weill's gallery had been around since the turn of the century; Granoff and Zak opened their galleries in the 1920s, Zak after the death of her artist husband Eugène. Given her close relations with the immigrant Jewish artist community, it is not surprising that she showed many of their works at her left-bank gallery in Saint-Germain-des-Prés. Four years later, in 1932, Lucy Krogh opened a gallery, initially to show the works of Jules Pascin. Montparnasse cafés showed works of art more informally. The Café du Parnasse was the first such venue to show paintings, in 1921, when the works of forty-seven painters and sculptors were put on display. Soon many local establishments hung art for sale on its walls. The Café du Parnasse also hosted the monthly arts magazine *Montparnasse*.[51]

The classic case of an unknown Jewish artist achieving sudden success in the interwar art market was that of Chaim Soutine. We have seen that the American collector Dr. Albert Barnes, who arrived in Paris in the winter of 1922–3, employed dealer Paul Guillaume to show him around town. Guillaume in turn introduced Barnes to Leopold Zborowski, who had begun nurturing the art of Modigliani and Soutine during the war years. Barnes felt so overwhelmed by Soutine's landscapes that he bought every painting that Zborowski could find for him, over fifty in all. Since Soutine was notoriously secretive and introverted, he was fortunate to have a supporter he could trust in Zborowski. On the same trip, Barnes also visited Jacques Lipchitz's sculpture studio, and ordered several bas-reliefs for the Barnes Foundation in Merion, Pennsylvania. This was an important commission for Lipchitz, though it did not play quite the make-or-break role in his career that it did for Soutine. Soutine's story highlights the international context of the art market. Parisian dealers did not rely on French collectors; they

sold more works of art to German and American than to French buyers. The collector Albert Barnes from Philadelphia buying the works of the Russian Jew Soutine via the Polish dealer Zborowski while visiting Paris exemplifies interwar artistic internationalism.

Moïse Kisling provided another model of the successful Jewish artist in the 1920s, who, unlike Soutine, sold paintings in a pleasing *juste milieu* (middlebrow) style. In an interview published in *L'Art vivant* in 1925, Kisling called Picasso a great inventor but bad professor, because no one could follow him. Kisling argued that true painters did not belong to a school.[52] What did he recommend instead? Maybe sociability. Friendship and convergence played an important role in the early years of Montparnasse. In the same building where the Kislings lived at 3 rue Joseph Bara, there also resided the dealer Zborowski, the poet-critic Salmon, and the painter Per Krogh; Jules Pascin had lived in the same building before the war. Montparnasse in its heyday was a *fête* as well as an artists' colony, and Kisling occupied its festive center. Kisling had no regular dealer, but after a successful show at Paul Guillaume's gallery in 1924, he bought himself a new Citroën.[53] Like Pascin, Kisling sold an image of Montparnasse that matched its reputation for bohemian toleration and sexual freedom.[54]

Male artists predominated among the Jewish immigrants, just as they did on the right bank among the mass of Jewish arrivals in France. A substantial number of female painters and sculptors also came to Paris from Poland and Russia. They faced enhanced discrimination in pursuing an artistic career and selling their art, as women as well as Jews and foreigners. Chana Orloff (1888–1968) was the most successful female sculptor. She was born in Ukraine, fled from the pogroms with her family to Palestine in 1905, and came to Paris in 1910. Her work typifies Jewish modernism of the 1920s in being clean-lined and figurative—modern but not radically so. She did portraits of many of her fellow artists, including Matisse, Modigliani, Picasso, and Per Krogh. Her success enabled her to commission a studio-house from noted architect Auguste Perret.[55] She later sculpted portraits of two Israeli prime ministers, David Ben-Gurion and Levi Eshkol. She did numerous mothers and children, including the Motherhood monument in Israel.

Orloff and Mela Muter were able to live by their art; two other Jewish artists showed how women could forge alternate careers. While their status as painters declined in the 1920s, both adapted to a crowded art market in innovative ways. Alice Halicka arrived in Paris shortly before World War I and married fellow Polish immigrant artist Louis Marcoussis (born Ludwig Markus but renamed by

Apollinaire). Both Halicka and Marcoussis painted in the cubist style, and the couple lived in Montmartre rather than Montparnasse. Her career reached its apogee during the war years, when Marcoussis served at the front. Their daughter was born in 1922, and while Alice continued to paint, her husband discouraged her from continuing with cubism. In 1924, she exhibited a series of collages called *Romances capitonnées* (Padded romances), where she used feathers, bric-a-brac and other unconventional materials.[56] In the 1930s, when art was hard to sell, Halicka traveled with her friend and compatriot Helena Rubinstein to New York, where she publicized Rubinstein's beauty products. Her paintings of Paris landmarks in these years helped to glamorize cosmetics by associating them with views of the French capital.[57]

The most famous artist-couple were Robert and Sonia Delaunay. Sonia Terk arrived in Paris aged twenty in 1905; by 1910, she dissolved her brief marriage to Wilhelm Uhde and married Robert Delaunay, whose career surged along with hers over the next four years. The Delaunays spent the war years in Spain and Portugal, where Sonia became involved in designing costumes for the Ballets Russes production of *Cleopatra*, with Robert creating the sets.[58] The Russian Revolution ended remittances from her homeland, and when they returned to France after the war she helped support her husband and young son by turning her talents to textile and clothing design. Her shift from painting to fashion was not due entirely to necessity. As early as New Year's Day 1914, Apollinaire wrote in the *Mercure de France* that the Delaunays were busy reforming clothing with "simultaneous orphism." He contrasted the monotonous hues of most fancy dress with the vivid colors dreamed up by Sonia.[59]

Both Halicka and Delaunay lost their husbands in 1941 and lived long after World War II; both also wrote their memoirs.[60] Neither claimed to resent their husbands' careers and Delaunay, writing in the 1970s, explicitly disclaimed any feminist sentiments. Sonia Delaunay made a more radical marketing decision than did her male colleagues from Eastern Europe. It bears comparison to Man Ray, who was able to be a full-fledged member of the surrealist group while also making a living from fashion photography. Man Ray found it possible to balance these poles, but Sonia claimed she approached her creative life without "hierarchical prejudice."[61] By 1924, she had her own company producing fabrics printed with her designs. She designed silk and linen dresses and wool coats bought by members of the high-life set, such as Nancy Cunard, until the Depression destroyed her market and ended her firm. In her own way, Sonia Delaunay typified the "crazy years" of the 1920s as much as any of the immigrant artists of Paris. She resumed painting later in life but her style did not evolve, and

she remains best known as a decorative artist who was able to market her personal style in a remarkably entrepreneurial way. Though she placed her painting career on hiatus, she engineered a triumph in marketing that embodied the zeitgeist of the era. Though there was nothing identifiably Jewish about her simultaneous designs, there was in her choice of field, since many of her fellow Jewish immigrants in Paris made their living by clothing and textile manufacture.[62] In engaging in the "rag trade," Sonia Delaunay circuitously returned to her ethnic origins.

## La Querelle des Indépendants (Quarrel at the Salon des Indépendants)

André Warnod reassured his readers that immigrant artists had come to France to absorb the traditions of French art, which while true did not prevent a reaction against them on the part of French critics and art institutions. A series of articles in the *Bulletin de la Vie Artistique* at the beginning of 1924 reported on the controversy over whether the Salon des Indépendants should group foreign-born artists by nationality, instead of showing their works alongside those of French artists. The president of the salon, the neoimpressionist and old radical Paul Signac did not support nationalizing art,[63] but M. A. Léveillé, who proposed the change for 1924, explained that they welcomed foreign artists to show their works, and that they would benefit from not getting lost among the thousands of works shown by French artists. He referred to the adage that all artists had two countries, France and their own: "can one forget the past, the atavism, one's ancestors; can one fail to dream of the Slavic soul when one is Russian or sing in his heart under the sky of Italy when one is born in Florence?"[64] If grouped with fellow nationals they might discover a common way of seeing and feeling of which they had been unaware. His colleague Victor Dupont said the new emphasis on national identity was being done for the sake of order and clarity, and so that the public could better understand the role of French influence in the arts.

On the other side of the poll of artists' responses, Yves Alix cited Pascin and Per Krogh as having brought a new vision that had influenced French artists, and to whom they owed hospitality. The salon cubist André Lhote admitted he would not have minded if the decision had happened before the war in 1913, but "it seems to coincide dangerously with the wave of nationalism which submerges most of the consciousness of Europe."[65] He proposed instead that the promoters

should organize the artists stylistically, suggesting such categories as academicism, impressionism, cubism, and constructive naturalism. Fernand Léger, a French painter who knew many of the foreign-born artists personally, resigned from the salon board in protest.

In the next issue of the *Bulletin*, Ossip Zadkine wrote acerbically, "I oppose absolutely that decision for it is against the rules of the Society . . . If they want to indicate nationality in the catalog, fine; why enclose us in concentration camps?"[66] Zadkine had been naturalized French just as the *querelle des Indépendants* was underway, and was likely to be offended by this affront. Jacques Lipchitz, called Zadkine's compatriot, cited a long list of great French artists from Poussin to Cézanne and said if they had been sitting on the committee, the decision would have been quite different. Adolphe Féder, a third Russian Jew, claimed that national feeling was much attenuated, and cited such nineteenth-century figures as Pissarro, Sisley, and Van Gogh as foreign-born artists who showed at the Salon des Indépendants. Féder was one of the rare Jewish artists who left urban Paris behind to live and work in the Breton countryside.[67] In a third installment of the inquest, Jean Lurçat reminded the committee that Monet and Pissarro visited England in 1870 and discovered the works of Turner, which influenced impressionism. Lurçat wrote pointedly, "don't speak of nationality, speak of race. Inopportune gesture at a time when chauvinism has invaded Europe, and where one whips Jews in the streets of Berlin and Bucharest."[68] This debate referred both directly and obliquely to the presence of Jewish artists (as well as those of Spanish and other nationalities) and revealed feelings of betrayal by artists who considered art to be international. Many left the salon and showed their art at the new Salon des Tuileries, then in its second year. Of 540 artists showing there, 116 were women and 141 were foreign born (among them the Jews Henri Hayden, Lipchitz, Marcoussis, and Orloff).[69]

That this *querelle des Indépendants* occurred a year before André Warnod named the group of foreign-born artists working in Montparnasse the Ecole de Paris in 1925 suggests both the notoriety and perceived menace that the "foreign invasion" portended. This threat was not due only to antisemitism; if one thinks of the greatest artists of interwar France, one might well name Picasso, Miró, Dali, Brancusi, and Ernst before citing Léger, Matisse, and Braque. France had long welcomed foreign art students, some of whom remained in France to develop careers, but never before had the native artists felt overwhelmed by competitors. The debate that surfaced at the Salon des Indépendants in 1924 was echoed in the pages of *Montparnasse*, a monthly, sometimes bi-monthly, journal of literature and art.

## Backlash: Hostile Reactions to Jewish Artists

*Montparnasse* appeared for three issues in June and July 1914, at a time when the Quarter was just taking off as an artists' colony. Its editor-in-chief was Paul Husson, a writer who in January 1917 wrote a book about the war prematurely titled *Holocaust*. Husson died age forty-five in 1928, and the issue devoted to him included his poems and remembrances by the Alsatian Jewish poet Ivan Goll, who called him a martyr for fraternity, and Paul Dermée, who called him the *annonciateur* (harbinger) of Montparnasse who foresaw its greatness. Closed during the war, the journal reopened in July 1921, and would continue for the rest of the decade. While the pre-war issues made no mention of Jewish artists, the first postwar issue tracked artists frequenting the main Montparnasse cabarets. At the Rotonde one saw Kisling, Diego Rivera, and Max Jacob; at the Dôme the critic Adolphe Basler,[70] the dealer Flechtheim, and artists such as Pascin and Lévy; at the Petit Napolitain Gwodezki, de Chirico, and Modigliani. The text grandiloquently stated that the editors "want the review to be what it was, a reflection and synthesis. In this great intellectual crossroads where the sons of all the races rub shoulders, united in a common ideal of art— where the art of tomorrow is elaborated, where is prepared perhaps the fusion of peoples of Europe and of the world."[71] Every artist and critic mentioned was foreign and most were Jews. Husson went on to note the disappearance of Modigliani and Apollinaire, two key figures of Montparnasse cultural life; in the August issue, Husson devoted an article to Modigliani, which he titled "Le sens du tragique dans la peinture moderne;" he attributed the artist's tragic sense to his "painful Judaic heredity." The journal featured many works by Zadkine over the next few years; the cover of the December 1921 issue, for example, featured a Zadkine woodcut. In July 1922, a poem translated from Yiddish by Lupus Blumenfeld appeared under the title "Un poète Yiddisch." The poet was Moïse Carton, from Ukraine, and the preface referred to the pogroms that compelled the poet to flee his homeland. That same issue included an article by Marcel Say on "Le Fascisme Intellectuel," an early use of the term which preceded Mussolini's March on Rome. Already, Say wrote, right-wing figures such as Maurice Barrès and Léon Daudet were attacking the *métèques*, Charles Maurras' pejorative term for foreigners, and were calling the foreign artists of Montparnasse "the undesirables of art," agents of Bolshevism, who might be pan-German spies and informers. Say asked how one should respond to these "stupid defamations," and promised that they would uphold "that immortal and simple formula: art has no homeland [*patrie*]."[72] The writer concluded by praising internationalism. The cover of

*Montparnasse* the next month featured a woodcut by Kisling, in November another by Zadkine, with an appreciative article inside. By 1921–2, then, the magazine recognized that Jewish artists contributed to Montparnasse's international stature.

In February 1923, Paul Husson responded to the French invasion of the Ruhr by showing how nationalist politics were affecting literature and art. "Everything fits," Husson argued, "the old prejudices are reviving. Art, tomorrow, will no longer have the right of being international; it must bear a French stamp." The same issue announced an exposition of Russian artists including works of Soutine at the cabaret La Licorne, while at the Caméléon, Alexandre Mercereau presided with readings from foreign writers on Monday evenings. Dissension appeared the following month in "Réflexions" by Marcel Hiver. The critic expressed his horror at what he termed false primitivism, which led to works that contained nothing of modern civilization. He found Zadkine superficial and faddish, and attacked the critic Waldemar George for having compared the cubist sculptor Lipchitz to Albert Einstein. He went on to praise two non-Jewish artists, Fernand Léger and the Hungarian-born sculptor Joseph Czaky. In the next issue, Hiver praised Jewish sculptor Chana Orloff while attacking the cubists Lipchitz, Lhote, Braque, and Gleize as well as Zadkine.

Hiver continued in this vein with explicitly antisemitic comments. In "Réflexions III," he found "signs of the Talmudist" in George's writing on Juan Gris. In July 1923, he sarcastically announced, "Hallo Boys, Cheer up! Monsieur Barnes est dans nos murs" (Mr. Barnes is among us), commenting on the American connoisseur and investor who the previous winter had purchased many works by Jewish artists, and who employed Waldemar George as an in-house critic.[73] In November 1923, Hiver declared "Enough of Negro Art," claiming that Florent Fels, director of the journal *L'Art Vivant*, was nearly devoured by savages in his quest for Melanesian art. He gave a backhanded welcome to Marc Chagall, newly arrived from Russia by way of Germany, writing:

> Chagall is the very type of the false genius [who] mixes bizarreness with originality; he plays the inspired idiot—this good businessman, this good family man whose premeditated dementia gives the illusion of naiveté ... if he has known success in Germany, it's because he has exploited the frightful hysteria which tortures unhappy Germany ... I don't think Chagall will flourish in Paris.[74]

Hiver continued in this manner, to the apparent displeasure of Husson and the other writers; in November 1924, he announced his resignation from the group

running the journal. The following spring, Geo Charles, second in command, announced that Hiver was directing another journal, *Le Cap* (Cape or Headland), and said he didn't understand why Hiver had felt it necessary to reprimand Salmon, Jacob, Zadkine, and other representatives of the modern school. Hiver conflated the primitivist vogue in African art with the growing presence of Jewish artists, especially the cubists but also including expressionists like Zadkine.

The other editors found Hiver's burst of chauvinism intolerable. That spring Paul Husson defended Zadkine from Hiver's attacks, saying few sculptors possessed his sense of sculptural rhythm, and that despite appearances his work was not naïve or simple. In December 1925, Husson also praised Chagall, and placed him alongside Picasso, Man Ray, and de Chirico as surrealists before surrealism.

*Montparnasse* continued to publish poems translated from Yiddish. In 1928, the journal published extracts of André Salmon's new book on Chagall, and included Blaise Cendrar's pre-war poem about Chagall during the artist's La Ruche era. Meanwhile, *Montparnasse* had become a glossy bi-monthly journal, which now cost five francs rather than one. In November 1928, Geo Charles used the term Ecole de Paris for the first time, and said it had been "dreamed by a thousand foreign brains tested by the spiritual fever of artists from all latitudes." This special issue dedicated to Russia included a portrait of Igor Stravinsky by Flouquet. The internationalist poets Claire and Ivan Goll continued to publish in *Montparnasse* throughout the decade, underscoring a Jewish literary as well as visual arts presence.

This left-bank neighborhood closely identified with the Ecole de Paris, which in turn was associated with the large number of Jewish artists working there. Visibility inevitably led to antagonism. It was not possible simply to condemn them all as *artistes manqués*; it was easier to view them as *arrivistes* taking advantage of the booming art market and the large number of Jewish art dealers, collectors, and critics to help foster their sales. The usual line went that since Jews had no tradition in the plastic arts, the fact that suddenly, in one generation, there were hundreds of Jews making art was inherently suspicious. The many Jewish art dealers, including prestigious right-bank houses such as Bernheim-Jeune, Wildenstein, Paul Rosenberg, Léonce Rosenberg, and Kahnweiler, as well as smaller dealers like Berthe Weill and René Gimpel, and collectors like the Steins, made plausible conspiracy theories. If one added the many German Jewish dealers and collectors of modern art into the picture, it would further feed fantasies of a cabal.

Of the two best known diatribes against the sudden incursion of foreign-born Jews into the French art market, the first was penned by Fritz Vanderpyl in a trio of articles in the prestigious journal *Mercure de France* in 1925, titled "Existe-il une peinture juive?" (Is there such a thing as Jewish painting?).[75] There followed a series of articles in the conservative newspapers *Le Figaro* and *L'Ami du Peuple* written by the critic Camille Mauclair. His articles were reprinted in two books, *La Farce de l'art vivant* (The Farce of living art), published in 1929, and *Les Métèques contre l'art français* (Aliens against French art), published in 1930. The titles of these books more than Vanderpyl's more neutral-sounding query indicated the growing xenophobic response to the presence of so many Jewish artists in their midst. Not to be outdone, Vanderpyl added a further burst of xenophobic outrage in 1931 in a book with another innocuous title, *Peintres de mon époque* (Painters of my era).

Mauclair's venomous articles were particularly significant because they reached a mass audience in the newspapers that serialized them, both owned by the right-wing perfumer François Coty. *Le Figaro* was a respectable mainstream paper, *L'Ami du Peuple* a mass-market tabloid read all over France, and Mauclair was a well-known journalist and critic.[76] He called Montparnasse "the filth of Paris" that was 80 percent Jewish, and decried the idea that Jews and foreigners were being represented as the School of Paris. In referring to "living art," Mauclair attacked the journal of that name edited by Florent Fels. He savagely parodied the host of Parisian Jewish dealers as "Rosenschwein ["Red pig" in German] and Lévy-Tripp."[77] Mauclair's diatribe was a response to a critical appreciation of modern art published in 1926 by German dealer and critic Wilhelm Uhde, called *Picasso and the French Tradition: Notes on Current Painting*. Uhde (1874–1947) opened a gallery in Paris that championed the cubists in 1908, and introduced Daniel-Henry Kahnweiler to Picasso. Uhde's book announced the end of the era of art that conformed to distinct racial and national identities, as well as to particular *terroirs* (regional landscapes), and declared that modern art must be international.[78]

One further diatribe underscores how interwar xenophobia blossomed into Vichy antisemitism. In 1942, the collaborationist *Mercure de France* published Vanderpyl's final thoughts on Jewish artists in the more extravagantly titled book, *L'Art sans patrie, un mensonge. Le Pinceau d'Israël* (Art without a homeland, a lie. The brush of Israel). The book, really a long pamphlet, opened with the critic complaining that various journals refused to publish his thoughts, and even recalled receiving threats after his earlier treatment of Jewish artists. If that was true, he probably felt vindicated by the collaborationist Vichy policy of

removing Jews from French public life. In Paris, the German occupiers further stigmatized Jews by requiring them to wear the yellow star. Vanderpyl reiterated his argument that developing a national form of art took centuries; never before had a people produced a school of painting in a fifty-year period. Then he belittled the small number of Jewish artists working in Western Europe in the nineteenth century, including Camille Pissarro (he said that without doubt Pissarro was the least original of the impressionists), Joseph Israëls, Max Liebermann, and Lucien Lévy-Dhurmer. Then came World War I, and artists named Lévy became legion; in 1925, Vanderpyl had cited seven artists named Lévy. In a humorous reply to this earlier essay, Kisling had responded to the question raised by the journal *L'Art vivant* of which ten artists should be included in a prospective new museum of modern art by citing the names of nine artists surnamed Lévy plus his own.[79]

Vanderpyl's 1942 tract singled out Marc Chagall for being childish and chaotic, but the larger point the Vichyite critic wanted to make was that art was always rooted in one's native soil and could never be international. The critic bemoaned all the "isms" of modern art, and complained that if Jewish artists did not reign supreme, then Jewish critics certainly did. Jews had introduced speculation in art, making painting purely a matter of business negotiations.[80] Vanderpyl could wax blithely racist in 1942, calling Modigliani an adept at Negro art, finding Kisling to be a curious case of artificial renown, probably due to his "Asiatic" temperament, while he called fellow critic Adolphe Basler a co-religionist of Picasso. He reduced Soutine to an epigone of Van Gogh. Vanderpyl wondered whether these artists would leave for Palestine, but he doubted it. Their fundamental traits of plagiarism, utilitarianism, and endemic state of emigration (he meant the Jewish Diaspora) made it impossible to achieve racial and durable works of art.[81] He simply asserted the proposition that all art must be locally rooted. The Vichy regime's focus on the *terroir* or local soil was not likely to further artistic experimentation.

## Ambivalent Jewish Critics

Less straightforward and hence more interesting than the attacks on the mercantile roots of Jewish art by Vanderpyl, and the international communist affiliation suggested by Mauclair, were commentaries voiced by art critics who were themselves Jews. Adolphe Basler, a dealer and critic long visible in the Montparnasse milieu, had come to France from Kraków in 1898 to study chemistry, ended up

befriending the Jewish artists and selling their works, and eventually wrote books about Modigliani, Isaac Grünewald, Léon Indenbaum, and Kisling. Even more centrally placed was another Polish Jewish immigrant, Waldemar George, who arrived in Paris from Poland in 1911. George, born Jerzy Waldemar Zarocinski in 1893, was closer in age to the artists of whom he wrote; Basler was born in 1878. Born in the Pletzl of Paris, Florent Fels, born Felsenberg (1891–1977), fought in World War I and edited the journal *L'Action* in the immediate postwar years, which was anarchist in politics and modernist in aesthetics. He followed it with *L'Art vivant*, in which he supported the Ecole de Paris.

Adolphe Basler wrote two major books during the art boom of the 1920s. The first, published in 1926, was called *La Peinture ... religion nouvelle* (Painting, the new religion); the second came out three years later and was more piquantly titled *Le Cafard après la fête ou l'esthétisme d'aujourd'hui*. This one is harder to translate, since the literal meaning of *cafard* is cockroach; figuratively Basler is referring to *The Blues after the Party, or aestheticism today*. A third book that also appeared in 1929 was *L'Art chez les peuples primitifs* (Art Among Primitive Peoples), which attacked not "primitives" but primitivist modernists. Basler also published surveys of modern art and many small monographs on individual artists. Among the Jewish artists, he wrote studies of Modigliani and Léon Indenbaum (1890–1981) as part of the Triangle series on Jewish Artists. The Indenbaum volume, undated but probably issued in 1930, reveals quite a bit about Basler's biases, which by this time amounted to *idées fixes*. Indenbaum's work was mostly classical and realistic, influenced by the sculptors Bourdelle (with whom he worked) and Maillol. The strongest positive comment that Basler made about him was that there was nothing superficial in his work, and that his noble Greek-influenced forms exuded harmony and serenity.[82] Basler used Indenbaum to make invidious comparisons with other Jewish artists of the Ecole de Paris, among whom he found extravagance, primitivism, and a rejection of French good taste, all of which were epitomized by Soutine. The following passage is typical of Basler's prose:

> The wave of ugliness [*moche*] breaking on the painting and sculpture of today make the blasé Westerners accept the monstrosities of a Soutine (little Lithuanian Jew), the nightmarish assemblage of colors [*bariolages*] which satisfy the tastes of the most refined Parisian collectors. Does one believe that Soutine represents the quintessence of the Hebrew spirit in art? His success to me comes from infatuation raised to pathology. All artistic epochs have known this morbid mannerism ... the horrible grotesque, the infirmities, the pathological deformations have never banished that which we agree to call the beautiful.[83]

Basler, who had lived in France for thirty years, loved to display his acrobatic vocabulary in the service of excoriating those immigrant artists who refused to bend to French canons. He attacked Parisian art lovers who preferred primitive or backward art to the wonders of Western culture as decadent and even as self-hating. The Polish immigrant critic unleashed his full fury at those who would evoke

> ... the ghetto ... decried for its swarming vermin and its refuse ... its cunning merchants; this bad place filled with the damned of which Soutine offers us a demonic vision. It is also the refuge of mystics, of philosophers who expatiate in their synagogues ... Far from me the idea of exalting Hebrew nationalism. It repels me especially in artistic matters where Jews are novices.[84]

This extravagant denunciation by a critic who had arrived in Paris at the height of the Dreyfus Affair suggests hostility to the more recent influx of Jews coming from the East. Basler's damning by faint praise the works of Léon Indenbaum perhaps concealed the suspicion that Soutine was the more significant artist, even though his art frightened the critic (a sentiment shared by Maurice Raynal).

In his 1926 tract in which he called painting a new religion, Basler echoed Vanderpyl in decrying the search for profits, citing naive buyers such as dentists who followed the latest vogue.[85] Modigliani and Pascin got off more easily, though he called Pascin a good draftsman but a superficial painter, while Modigliani was accused of being obsessed with African sculptures, which invariably stamped all of his late works: "His art appeared confined in a most seductive mannerism, brilliant by its perverse aesthetic."[86] A third Jewish artist was Chagall, who "symbolizes with his art, if not the whole Jewish spirit, at least that which he can make of the incoherent, abracadabring and even of geniality in a Russian Jew. The nightmares of that child of the ghetto translate into a sort of imagery as expressive as it is full of extravagant madness."[87] He found Chagall to be facile and superficial, with nothing of the gravity of a true painter: "he is only a Russian image maker [*imagier*] whose delirium has something amusing about it."[88] At the end of his book he cited a member "of the tribe of Levy" who asked him whether he thinks that art has become too "enjuivé," too Jewish (the French term has a pejorative connotation, as in "too Jewed"). His response was that, like him, this other Jew found the heights of civilization in French painting. Jewish artists like Camille Pissarro who could adapt to the French genius were fine; he did not mention that Pissarro was a Sephardic Jew from the West Indies, not from the "ghetto." One is tempted to see a case of Jewish self-hatred here, and Basler seems aware of that possibility, since elsewhere in his book he cites the

notorious Jewish antisemite, Otto Weininger, and his belief that Jews were a feminine race. Yet this well-read critic concluded, "Frankly, none of the foreign painters is distinguished by a robust temperament nor by a sensitive eye, less yet by a rich pictorial culture,"[89] as if he agreed with Weininger that Jews lacked masculinity.

Basler's best-known panegyric is the prophetically named *Le Cafard Après la Fête*. The party years of Montparnasse were indeed ending in 1929, but Basler saw instead the "true mirror of European decline [*déchéance*]." He asked whether Picasso was really a painter, or rather the prophet of a new religion, a forger of mysteries, "an Iberian necromancer in possession of all the recipes of the kabbala."[90] At the end of the book, he returned to this theme, associating cubism with the Talmud and asking whether Picasso's art was due "to distant Jewish origins or an Arab atavism?"[91] Because Jews had a penchant for abstract ideas, and because Picasso was from Spain, where a Christian overlay concealed a more distant Moorish and Jewish past, he suspected Picasso of being Jewish or at least expressing some Jewish qualities in his work. Of an actual Jewish artist, such as the expressionist Pinchas Krémègne, he found hysteria and indigence on the surface, *pompierisme* (academicism) beneath.[92] The besetting sin must be the failure to acculturate, by which Basler meant that Krémègne's art was too Jewish. One suspects that Basler felt threatened in terms of his own assimilation into the dominant culture.[93]

Basler criticized his fellow Polish Jewish critic, Waldemar George, for preaching this salvation from the East, following the doctrine of Oswald Spengler. Spengler's famous tract, *The Decline of the West*, published in Germany at the end of the Great War, prophesied that the Russians would conquer the West. The Ecole de Paris and cosmopolitan Montparnasse seemed to bear out Spenglerian pessimism for Basler. On the one hand, he disliked overly intellectualized art as practiced by the cubists, on the other the tormented, ghetto-accented art of the expressionists; both were foreign to the French temperament, even though he acknowledged that Cézanne played a role in making modern painting more cerebral.[94] To this uneven diatribe, Basler appended his article from several years before asking whether there was a Jewish style of painting. This was his response to the articles by Vanderpyl and Pierre Jaccard that appeared in *Mercure de France* in 1925. Here he defended Jewish artists who assimilated, and cited especially his fellow Polish Jews such as Kisling, Mondzain, Zak, and Marcoussis. The more advanced the civilization, Basler concluded hopefully, the more the Jew is absorbed into it. The epoch, not the race, counts.[95]

Adolphe Basler was fifteen years older than Waldemar George (1893–1970). Being the same age as Soutine, perhaps his relative youth made George more sympathetic to the artistic avant-garde than Basler, who professed more middlebrow tastes. George presents another interesting case of Jewish self-hatred, or at least reversal of his earlier artistic sympathies. George was a Polish Jew who arrived in Paris shortly before the war, like many of the artists about whom he wrote. He fought in World War I and attained French citizenship, and championed artists of the Ecole de Paris in the 1920s. In particular, he supported cubists such as Gris and Lipchitz, and defended Delaunay and Léger in 1925 when they were attacked by organizers of the Art Déco Exposition of that year, which earned him the gratitude of the cubist art dealer Léonce Rosenberg.[96] George's modernism lay on an unusual intellectual foundation, which helps explain his fascist views of the 1930s. He connected cubism with the anti-rationalist tradition of Nietzsche, Bergson, and Georges Sorel, arguing that cubist idealism undercut positivist naturalism. He praised the surrealists for continuing this anti-rationalist current, and was able to support the Jewish artists of the Ecole de Paris, including Chagall, Modigliani, Lipchitz, and Soutine, as representing this "spiritual" and anti-materialist trend.[97]

In the early 1930s, however, he became enamored of Italian fascism and Mussolini in particular, and developed a theory of "Neo-Humanism" that he believed fitted an authoritarian Latin temperament. The dominant artistic styles that had attracted young Jewish artists in the previous two decades, cubism and expressionism, he viewed as appealing to the Jewish penchant for abstract thought in the first instance and for pessimism in the second. He now promoted naturalist and classicizing styles, as represented for example in the Italian modernist Giorgio de Chirico. By the time he wrote *L'Humanisme et l'idée de patrie* (Humanism and the idea of the nation) in 1936, he was reassessing Jewish contributions to art. He now wondered whether "the Jew's deficiency in the plastic arts [was] the distinctive sign of the race? Was the Jew the promoter of cubism and expressionism, or did he merely find in these movements a fertile terrain for action? Cubism complements the Jewish penchant for abstract thought. Expressionism favors the Jew's fits of pessimism."[98] George's neohumanism sounds suspiciously like racist essentialism.

One Jewish artist of whom Waldemar George did approve was Grégoire Michonze. Born Grigory Michonznic in Kishinev, Bessarabia, in 1902 (one year before the infamous pogrom that led thousands of Jews to leave Russia), his natal region was transferred from Russia to Romania after the war, and he went to art school in Bucharest, where he met Victor Brauner. In Paris, Max Ernst

introduced him to the surrealists; he also befriended Chaim Soutine and attended boxing matches with him. Michonze met American expatriates in Montparnasse and learned English from them. He became particularly close to Henry Miller in the 1930s and visited him in the U.S. after the war. Miller later wrote an appreciation of Michonze's art for an exhibition in London in 1959. That Michonze's "primitivism" was European rather than African or Oceanic in inspiration led George to support it, in the sense that it was "racially" untainted.[99] Michonze's "surreal naturalism" and his historicist evocation of earlier artists such as Breughel lent themselves to being interpreted as a style of fascist anti-modernism. That George favored returning to the human subject and saw this quality in Michonze's work does not mean that one should attribute fascist tendencies to Michonze. Most of the Jewish artists of Paris remained representational before 1940, and focusing on the human subject was at the core of their work. The disturbing aspect of Michonze's style is more likely his passéism, his search for a usable past into which he might escape the inhuman present. In any case, because his style may have corresponded to George's current critical vocabulary does not invalidate the artist's work. Michonze's work was uniquely his own; it did not attempt to fit into any particular style, and his connection to surrealism hardly makes his art either fascist or anti-modernist.

Waldemar George survived the Holocaust and abandoned his fascist sympathies.[100] In 1959, he published a volume on the Jewish artists of the Ecole de Paris, which featured an interesting provenance. The World Jewish Congress published the book in Algiers. Three years later, Algeria gained its independence and the Jewish population departed for France or Israel. One would presume that "Editions du Congrès juif mondial" left also.[101] Twenty-two years after bemoaning Jewish artistic deficiency, George now referred to their heritage decorating synagogues and Torah scrolls as key to "the secret of their plastic genius."[102] George raised the question of whether a homogeneous Jewish art existed, but found the question specious. He cited other cosmopolitan artists, such as the British-French impressionist Sisley or the Greek-Spanish El Greco. He concluded that "whether or not Jewish artists are conscious of their ethnic or religious heritage, they enrich the common patrimony of the civilized world."[103] A hint of George's pre-war values remained in his designating Camille Pissarro as the tutelary deity of Jewish artists, because Jews, the eternal nomads, can respond to the earth and produce pastoral imagery. To the myth that Jewish artists tended to abstraction, George cited the vigorous naturalism of Kisling, Krémègne, Kikoïne, Kars, Milich, and Michonze. "If the ones turn their backs on reality and construct chimeras, others observe it to love it and translate life."[104]

Waldemar George was looking back, perhaps nostalgically, to artists he now favored, as an antidote to a later generation of Jewish abstract artists such as Mark Rothko and Adolph Gottlieb.

Waldemar George accurately identified an important tendency that was clearer in retrospect, from the perspective of the postwar period. Most of these artists worked in landscapes, still lives, portraits and nudes, the classic genres of French painting. The landscapes they painted were those they found mostly in the south of France, in the Pyrenean hill town of Céret, on the Mediterranean coast at Collioure in Languedoc, and at Cagnes-sur-Mer and Sanary in Provence. Adolphe Basler did not appreciate how Soutine's dealer, Leopold Zborowski, sent him off to Céret after the war, a move that transformed his art despite being plunked down in an alien environment where most of the local people spoke Catalan and he was even more isolated than he had been in Paris. Fritz Vanderpyl attacked the immigrant Jews for lacking a *terroir*, yet these "wandering Jews" thrived in the French countryside and responded to the mountains, trees, and sea, much as would any French artist. A number of them bought country houses in the south of France: Pinchas Krémègne in Céret, Moïse Kisling in Sanary, Marc Chagall in St. Paul de Vence. Michel Kikoïne had a cottage near Dijon; Ossip Zadkine bought a farmhouse with sculpture studio in the village of Arques, south of Toulouse, though he also kept his studio on the rue d'Assas near the Luxembourg Gardens (both sites now serve as Zadkine museums). These "wandering Jews" were all too eager to establish roots in their adopted land, inspired by the *terroir* as well as the Mediterranean sun. Jews who could not own land among the Russian peasantry were happy to do so in their chosen homeland.

# Notes

1   Anne Sinclair, *My Grandfather's Gallery: A Family Memoir of Art and War*, trans. Shaun Whiteside (NY: Farrar, Straus and Giroux, 2014), makes no mention of the Ecole de Paris, Montparnasse, or Jewish artists. She does mention that among the works in his gallery in the 1930s were paintings by Modigliani, but he is cited among a long list of other artists (25). On Lévy's novel *Les Juifs d'aujourd'hui*, see Nadia Malinovich, "Littérature populaire et romans juifs dans la France des années 1920," in Catherine Nicault, ed., *Dossier: Le "Reveil juif" des années vingt. Archives Juives: revue d'histoire des Juifs de France* 39, no. 1 (2006): 48–9.

2   Fritz Vanderpyl, "Existe-t-il une peinture juive?" *Mercure de France*, July 15, 1925.

3   Eric Michaud, "Un certain antisémitisme mondain," in *Ecole de Paris 1904–1929: la part de l'Autre* (Paris: Musée d'Art Moderne, 2000), 91–2.

4 Wilhelm Uhde, *Picasso et la tradition française* (Paris: Editions des Quatre-Chemins, 1928), 81.

5 Malcolm Gee, "Le réseau économique," in *L'Ecole de Paris, 1904–1929: la part de l'Autre,* (Paris: Musée d'Art Moderne, 2000), 127.

6 John Richardson, *A Life of Picasso, Vol. II: 1907–1917* (New York: Random House, 1996), 301.

7 Richardson, *Life of Picasso, II*, 313.

8 Peter Paret, *German Encounters with Modernism, 1840–1945* (Cambridge: Cambridge University Press, 2001), discusses the privileged bourgeois background of Liebermann, who not only became a major artist but also presided over the Berlin Secession. See Chapter 3, "Modernism and the 'Alien Element in German Art.'"

9 Germain Seligman, *Merchants of Art: 1880–1960, Eighty Years of Professional Collecting* (New York: Appleton-Century-Crofts, 1959), 152. Seligman did not contrast French and Jewish collectors; in the next paragraph he described American collectors such as John Quinn who purchased Picassos, and "the irascible Dr. Albert Barnes," 153. Assimilated Jews such as Seligman did not call attention to their religious heritage

10 Seligman, *Merchants of Art*, 156, for Modigliani, 179–80 for Picasso. On 154 he does mention Camille Pissarro, but he did not handle the sale.

11 Pierre Assouline, *An Artful Life: A Biography of D. H. Kahnweiler, 1884–1979*, trans. Charles Ruas (New York: Grove Weidenfeld, 1990), 78. Billy Klüver and Julie Martin, *Kiki's Paris: Artists and Lovers 1900–1930* (New York: Abrams, 1989), 32, 33, includes photos of these artists at the pre-war Dôme, including Uhde.

12 Kenneth Silver, *Esprit de Corps: The Art of the Parisian Avant-Garde and the First World War, 1914–1925* (Princeton, NJ: Princeton University Press, 1989), 8, 9.

13 Assouline, *An Artful Life*, 117, for Kahnweiler's refusal to send his stock of paintings to New York. For the auction of his stock of paintings, see Chapter 5, "Forgetting Drouot," the name of the auction site.

14 Assouline, *An Artful Life*, 256, reported that the Nazis stripped Uhde of his German citizenship after he published a book with the provocative title *From Bismarck to Picasso*, not to mention his defense in the book of art that the Nazis deemed "degenerate."

15 Assouline, *An Artful Life*, 168.

16 Assouline, *An Artful Life*, 173.

17 Assouline, *An Artful Life*, 170, 171.

18 Assouline, *An Artful Life*, 188.

19 Assouline, *An Artful Life*, 187. Eventually Picasso and Kahnweiler renewed their friendship; in the 1930s, the two men frequently discussed painting (241).

20 Sinclair, *My Grandfather's Gallery*, 25.

21 Gee, "Le réseau économique," 130.

22 Jackie Wullschlager, *Chagall: A Biography* (New York: Knopf, 2008), 179,

23 Wullschlager, *Chagall*, 294, 295.

24 Susan Tumarkin Goodman, ed., *Chagall: Love, War and Exile* (New Haven, CT: Yale University Press, 2013), 25.

25 Ambroise Vollard, *Recollections of a Picture Dealer*, trans. Violet MacDonald (Boston: Little, Brown, 1936), 260, 261. In *Chagall: A Biography*, 324–7, Jackie Wullschlager discusses Chagall and Vollard.

26 For examples of the fear "of the barbarian hordes invading from the East in order to destroy French culture," see Romy Golan, "The 'Ecole Française' vs. the 'Ecole de Paris': The debate about the status of Jewish artists in Paris between the wars," in Romy Golan and Kenneth Silver, eds., *The Circle of Montparnasse: Jewish Artists in Paris, 1905–1945* (New York: Jewish Museum, 1985), 83.

27 Goodman, *Chagall: Love, War and Exile*, 25.

28 Wullschlager, *Chagall*, 335.

29 Wullschlager, *Chagall*, 296, 301.

30 Michael Fitzgerald, *Making Modernism: Picasso and the Creation of the Market for Twentieth-Century Art* (Berkeley: University of California Press, 1995), 3.

31 Romy Golan and Kenneth Silver, eds., *The Circle of Montparnassee: Jewish Artists in Paris, 1905–1945* (New York: Jewish Museum, 1985), 112, 114–15.

32 Henry Hope, *The Sculpture of Jacques Lipchitz* (New York: Museum of Modern Art, 1954), 12.

33 Silver and Golan, *The Circle of Montparnasse*, 97.

34 Fonds Léonce Rosenberg, Bibliothèque Kandinsky, Musée d'Art Moderne, Paris, Artistes Divers A–C, letter from Rosenberg to Chagall, December 22, 1923.

35 I borrowed the play on words between roots and routes from James Clifford, *Routes: Travel and Translation in the Late Twentieth Century* (Cambridge, MA: Harvard University Press, 1997), 36.

36 Wullschlager, *Chagall*, 312.

37 Paula Birnbaum, *Women Artists in Interwar France: Framing Femininities* (Farnham, UK: Ashgate, 2011), 146.

38 Birnbaum, *Women Artists in Interwar France*, 130.

39 Yigal Zalmona, *The Art of Abel Pann: From Montparnasse to the Land of the Bible* (Jerusalem: Israel Museum, 2003), 54 and passim.

40 Abel Pann, *Autobiographie* (Paris: Les Editions du Cerf, 1996), 80, described the pre-war Pletzl of Paris in unflattering terms, calling it crowded and dirty and comparing it to Whitechapel in London's East End. Even this rabbi's son quickly migrated to the left bank.

41 Gillian Perry, *Women Artists and the Parisian Avant-Garde* (Manchester: Manchester University Press, 1995), 94, 95.

42 Sarah Phillips Casteel, *Calypso Jews* (New York: Columbia University Press, 2016), 49.

43 Nicholas Mirzoeff, "Pissarro's Passage: The Sensation of Caribbean Jewishness in Diaspora," in Nicholas Mirzoeff, ed., *Diaspora and Visual Culture: Representing Africans and Jews* (London: Routledge, 2000), 59–68.

44 Kenneth Silver, "Where Soutine Belongs: His Art and Critical Reception between the Wars," in Norman Kleeblatt and Kenneth Silver eds., *An Expressionist in Paris: The Paintings of Chaim Soutine* (New York: Prestel, 1998), 27, 28.

45 André Warnod, "L'Ecole de Paris," *Comoedia*, January 27, 1925. On Jewish art critics, see Dominique Jarrassé, "L'eveil d'une critique d'art juive et le recours au 'principe ethnique' dans une définition de l'art juif," in Catherine Nicault, ed., *Dossier: Le "Reveil juif" des années vingt. Archives Juives: revue d'histoire des Juifs de France 39*, no. 1 (2006): 66 and passim.

46 Annette Gliksman-Weissberg, *Les artistes immigrés juifs de l'Ecole de Paris dans la société française du début du XXième siècle à la Seconde Guerre Mondiale: du Schtetl à Paris: Intégration et mode de vie*, Mémoire de maitrise d'histoire (Paris: Université de Paris VII, 1994–5), 155.

47 Dominique Jarassé, *Existe-t-il un Art Juif?* (Paris: Biro, 2006), 96.

48 Romy Golan, *Modernity and Nostalgia: Art and Politics in France between the Wars* (New Haven, CT: Yale University Press, 1995), 138.

49 Jacques Lipchitz with H. H. Arneson, *My Life in Sculpture* (New York: Viking, 1972), 57.

50 A. M. Hammacher, *Zadkine* (New York: Universe, 1959), bibliography, n.p.

51 Billy Klüver and Julie Martin, "Carrefour Vavin," in Kenneth Silver and Romy Golan, eds., *The Circle of Montparnasse: Jewish Artists in Paris, 1905–1945* (New York: Universe, 1985), 71.

52 Jacques Guenne, "Portraits d'Artistes, Kisling," *L'Art vivant*, June 15, 1925, 12.

53 Klüver and Martin, *Kiki's Paris*, 162, 163. Paul Guillaume was the dealer favored by Dr. Albert Barnes, who advised Barnes on his art purchases in Paris.

54 For example, in *Paris Montparnasse à l'heure de l'art moderne, 1910–1940* (Paris: Terrail, 1996), Valérie Bougault chose a Kisling painting, *Buste de Kiki*, 1927, for the cover of the book.

55 Silver and Golan, *The Circle of Montparnasse*, 45–7.

56 Perry, *Women Artists of the Avant-Garde*, 153.

57 The chapter on Halicka in Birnbaum, *Women Artists in Interwar France: Framing Femininities*, is titled "Self- Effacement." Other female Jewish artists included Mela Muter, Marevna Vorobëv, and Maxa Nordau. On Halicka as publicist for Helena Rubinstein, see 153.

58 See Juliet Bellow, *Modernism on Stage: The Ballets Russes and the Parisian Avant-Garde* (Burlington, VT: Ashgate, 2013), Chapter 3, "Fashioning New Women: Sonia Delaunay and Cléopâtre."

59 Apollinaire, quoted in Jacques Damase, *Sonia Delaunay: Fashion and Fabrics* (New York: Abrams, 1991), 112.

60  Alice Halicka published *Hier* immediately after the war, Sonia Delaunay did not
    publish *Nous irons jusqu'à soleil* until 1978, the year before she died.
61  Stanley Baron, with Jacques Damase, *Sonia Delaunay: The Life of an Artist* (New
    York: Abrams, 1995), 79.
62  Of the roughly 150,000 Jews living in interwar Paris, about a third or 50,000
    were employed in the garment and textile trades, and these were overwhelmingly
    Jewish immigrants from Eastern Europe. See David Weinberg, *A Community on
    Trial: The Jews of Paris in the 1930s* (Chicago: University of Chicago Press, 1977),
    11. See also Nancy Green, *The Pletzl of Paris: Jewish Immigrant Workers in the
    Belle Epoque* (New York: Holmes and Meier, 1986), who singles out tailors
    and cap-makers as the commonest occupations for immigrant Jews living in
    the Marais. See appendices C and D, 208–14, for examples. Green also points
    to the disproportionate number of Jewish males who came to France before
    1914 (104).
63  Golan, *Modernity and Nostalgia*, 139, claims that Signac as president of the salon
    made the decision to segregate artists by nationality, though in the *Bulletin de la Vie
    Artistique* he did not sound supportive. Furthermore, Golan indicates that a map of
    the exhibition published in the *Bulletin* showed that French artists would be placed
    in the center of the Grand Palais, while foreigners would be relegated to the four
    aisles. See Golan, *Modernity and Nostalgia*, 202, n. 13.
64  "La querelle des 'Indépendants,' Une Enquête," *Bulletin de la Vie Artistique*, January 1,
    1924, 6, 7.
65  "La querelle des 'Indépendants,' Une Enquête," *Bulletin de la Vie Artistique*, January 1,
    1924, 12.
66  "La querelle des 'Indépendants,'" *Bulletin de la Vie Artistique*, January 15, 1924, 31.
67  Adolphe Féder, also called Aizik, was born in Odessa in 1887, exhibited before the
    war at the Salon d'Automne, and visited Palestine in 1926. He died at Auschwitz in
    December 1943. See Miriam Novitch, ed., *Spiritual Resistance: Art from
    Concentration Camps, 1940–45* (Philadelphia: Jewish Publication Society, 1981),
    76–9, for a biographical note and examples of Féder's portraits done at Drancy
    transit camp in the winter of 1942–3.
68  "La querelle des 'Indépendants' III Chez les Exposants français," *Bulletin de la Vie
    Artistique*, February 1, 1924, 60, 61.
69  Vincent Bouvet and Gérard Durozoi, *Paris between the Wars 1919–1939: Art, Life
    and Culture* (New York: Vendome, 2010), 218.
70  The critic Adolphe Basler, himself a Polish Jew, conflated cubism and Judaism, and
    saw in Picasso evidence of the "pan-Semitic spirit." See Golan, *Modernity and
    Nostalgia*, 140–1,
71  Paul Husson, "Nous Réparaissons," *Montparnasse*, July 1, 1921, 1.
72  Marcel Say, "Le Fascisme Intellectuel," *Montparnasse*, July 1, 1922.

73 Marcel Hiver, "Hallo, Boys, Cheer Up! Monsieur Barnes est dans nos murs," *Montparnasse*, July 1923.

74 Marcel Hiver, "Réflexions VI, Assez d'Art Nègre," *Montparnasse*, October 1923.

75 See Chapter 1 for a discussion of Vanderpyl's hostile reaction to the Ecole de Paris.

76 Golan, *Modernity and Nostalgia*, 150–1.

77 Golan, *Modernity and Nostalgia*, 151.

78 See Romy Golan, "From Fin de Siècle to Vichy: The Cultural Hygienics of Camille (Faust) Mauclair," in Linda Nochlin and Tamar Gelb, *The Jew in the Text: Modernity and the Construction of Identity* (London: Thames and Hudson, 1995), 162.

79 Golan, *Modernity and Nostalgia*, 138.

80 Fritz Vanderpyl, *L'Art sans Patrie, un Mensonge. Le Pinceau d'Israël* (Paris: Mercure de France, 1942), 41 and passim.

81 Vanderpyl, *L'Art sans patrie*, 62.

82 Adolphe Basler, *Indenbaum, Artistes Juifs* (Paris: Le Triangle, n.d., c. 1930), 15.

83 Basler, *Indenbaum*, 14, 15.

84 Basler, *Indenbaum*, 15.

85 Seligman, *Merchants of Art*, 155, specifically singled out the family dentist, Dr. Georges Viau, as introducing him to modern art. On the walls of his office waiting room, Seligman first saw paintings by Manet, Degas, Renoir, and Cézanne.

86 Adolphe Basler, *La Peintre . . . nouvelle religion* (Paris: Bibliothèque des Marges, 1926), 18.

87 Basler, *La Peintre*, 19.

88 Basler, *La Peintre*, 19.

89 Basler, *La Peintre*, 73.

90 Adolphe Basler, *Le Cafard après la fête, ou l'esthétisme d'aujourd'hui* (Paris: Jean Budry, 1929), 15.

91 Basler, *Le Cafard*, 140.

92 Basler, *Le Cafard*, 30.

93 Michaud suggests this in "Un certain antisémitisme mondain," 95–8. On 98, Michaud writes, "For Adolphe Basler, become an art critic of the most conservative republican right wing, the Ecole de Paris put in danger the Republic and French culture, indissolubly."

94 Basler, *Le Cafard*, 84.

95 Basler, *Le Cafard*, 130, 136.

96 Matthew Affron, "Waldemar George: A Parisian Art Critic on Modernism and Fascism," in Matthew Affron and Mark Antliff, eds., *Fascist Visions: Art and Ideology in France and Italy* (Princeton, NJ: Princeton University Press), 174–7.

97 Affron, "Waldemar George," 180.

98 Affron, "Waldemar George," 186.

99   See Mark Antliff, *Avant-Garde Fascism* (Durham, NC: Duke University Press, 2007), 47–8, for a discussion of Fascist cultural primitivism.

100   In his defense, Waldemar George was hardly the only Jew to express support for Mussolini's authoritarian regime. The Italian dictator had a number of Jewish supporters in the interwar period. See Michele Sarfatti, *The Jews in Mussolini's Italy: From Equality to Persecution* (Madison: University of Wisconsin Press, 2006), and Meir Michaelis, *Mussolini and the Jews: German-Italian Relations and the Jewish Question in Italy, 1922–1945* (New York: Oxford University Press, 1978).

101   Waldemar George, *Les artistes juifs et l'Ecole de Paris* (Alger: Editions du Congrès juif mondial, 1959).

102   George, *Les artistes juifs et l'Ecole de Paris*, 6.

103   George, *Les artistes juifs et l'Ecole de Paris*, 7.

104   George, *Les artistes juifs et l'Ecole de Paris*, 12.

# Nationalism, Internationalism, and Zionism in the 1930s

*Art is international, but the artist must be national.*

Marc Chagall[1]

In 1932, the art critic and journalist Florent Fels asked the German Jewish art dealer Alfred Flechtheim (1878–1937) for some insight into Hitler, not yet chancellor of Germany. Flechtheim replied that he was a poor sort of artist who had spent ten years peddling his paintings in all the galleries, but the big Jewish dealers of Munich and Berlin, the Thannhausers and Cassirers, had rejected him, and he became a wild antisemite.[2] This art-centered perception of Nazi antisemitism is not entirely off base, since the Austrian Hitler had tried and failed to pursue an artistic career in Vienna before World War I. Once in power, Hitler proved to be extremely engaged with the art world in the 1930s, though that involvement was unlikely to meet with Fels's or Flechtheim's approval. Their conversation points toward the conflict between sophisticated Jewish art dealers with a bias toward modernism and artists such as the young Hitler with a conventional understanding of art. Differing visions of art as well as ethnicities were to clash in the 1930s. Despite some setbacks, modernism would eventually triumph. The Jews would fare less well, including Flechtheim, who fled Nazi Germany for Paris in 1933 after being dispossessed of his gallery and art, then moved on to London. Flechtheim died there in 1937, the same year Hitler and his minister of propaganda Joseph Goebbels viciously attacked modern art as degenerate.

A sexually provocative display involving three Jewish artists provides a transition from the high-spirited 1920s to the more sober decade that followed. A Swiss-German artist named Meret Oppenheim arrived in Paris aged eighteen in 1932, and soon thereafter she began a liaison with Man Ray. In 1933, he featured her posing nude in a series of photos involving a printing press, with black ink covering one hand and arm. Some of these photos also featured the

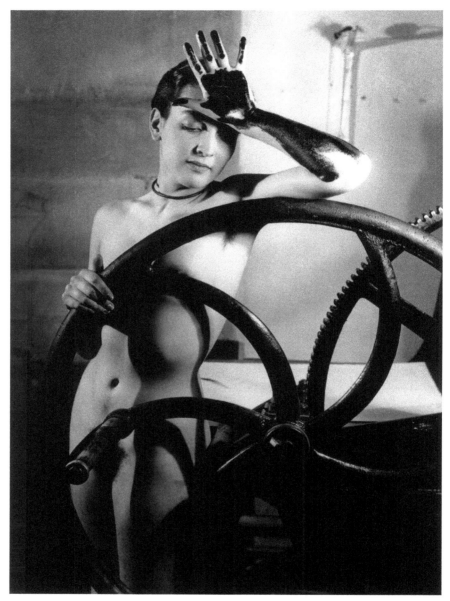

**Figure 7.1** Man Ray, *Veiled Erotic*, 1933. Man Ray 2015 Trust/Artists Rights Society (ARS), NY/ADAGP, Paris, 2021.

cubist painter Louis Marcoussis wearing a bowler hat and false beard. One photo shows Marcoussis cleaning her hand with a white cloth. Man Ray called the series *Veiled Erotic* (*Erotique voilée*); it was published in the surrealist journal *Minotaure* in 1934. The most famous photo of the series shows Oppenheim standing behind the wheel of the press, her ink-covered left hand and arm raised against her head, her body positioned so that the handle looks like a phallus, while the wheel obscures her breasts.[3] The many discussions of these photos focus on Man Ray's fascination with machines and on Oppenheim's role as surrealist *femme-enfant*, as allegorical figure and as muse. Art critics never mention that Man Ray, Oppenheim, and Marcoussis were all foreign-born Jews. Since Man Ray emphasized gender ambiguity in his portrayal of the young, slim, and short-haired Oppenheim, he could have been commenting on the ambiguous position of immigrant Jews in the Paris art world. By blackening his model's white skin, he also may have alluded to the artificiality of racial distinctions based on phenotypes such as skin color. The *Veiled Erotic* series appeared shortly after Man Ray's previous protégé and lover, Lee Miller, left him and returned to New York. In 1933, Man Ray attached a cut-out photo of Miller's eye to a metronome and called it *Object to be Destroyed*. This surrealist object, which I discussed at the end of Chapter 1, among other things displayed the artist's animosity toward the woman who left him.[4] A similar erotic tension existed in the 1933 photographic series, as Man Ray covered his new model/lover in ink and objectified her, in relation both to himself and to the machinery around her. *Object to be Destroyed* and *Veiled Erotic* contained multiple meanings, one of which was the relation of women to machines.

Oppenheim went on to become a surrealist artist in her own right (as Miller pursued her own photographic career). Her most famous creation was the 1936 *Luncheon in Fur*, in which she wrapped a cup, saucer, and spoon in fur and created the single most durable surrealist object, which critics have labeled an image of lesbian sex.[5] Oppenheim believed that gender was fluid and unstable; so were the uncertain roles of Jews in the Diaspora, never more so than in the 1930s. Looking back at these prurient images, they appear poised at the cusp of two decades, one hedonistic, and the other fraught with growing tensions. Oppenheim's German Jewish father was forced to close his Berlin medical practice and relocate to Switzerland, where Meret's mother was from. The Swiss did not allow him to practice medicine there either, and he could no longer support his daughter. In 1937, Meret returned to Basel, where she suffered intermittently from depression and produced little art for the next seventeen years.[6]

Man Ray, Marcoussis, and Oppenheim were Jews, but they were not members of the Ecole de Paris. Perhaps by coincidence, two of the best-known Jewish artists of the Ecole also painted nudes in 1933, even though neither was known for this genre. In fact, for Chaim Soutine, his *Female Nude* of 1933 is the only such work in his entire oeuvre, which consists mainly of landscapes and portraits. This one nude is not sensual; if anything, she looks awkward, her heavily worked face red and apprehensive, her hands clasped in front of her genitals. Marc Chagall's *Nude over Vitebsk* feels more assured, as the nude floats serenely over the city, a vase of flowers at her feet painted to the scale of the model rather than the town with its tiny figures. Yet here too the artist, unused to the genre, has concealed the figure by showing her only from the back. This may be because his seventeen-year-old daughter Ida posed for the painting.[7] Neither artist was as explicit as Man Ray, even though Chagall's work could fit comfortably within the surrealist mold. Soutine's embarrassed and Chagall's backward nudes ended an era begun enthusiastically, and frontally, by Modigliani and Pascin. The pleasure years were over.

## Where Do the 1930s Fit in the Art Historical Canon?

The history of French modern art, from its take-off around 1905–7 with the rise of fauvism and cubism until the finale of the Third French Republic marked by the German conquest of 1940, contains a curious disjuncture. It would seem logical to end the Ecole de Paris and in particular its Jewish presence in 1940. Artistic modernism seems to coincide with the years of the Third French Republic lasting from 1870, the dawn of impressionism, to 1940; yet for most of the books that explicate the School of Paris, 1930, not 1940, serves as the terminal date for the artistic experimentation and international participation that the artists' colony of Montparnasse represented. Some books, such as *Kiki's Paris: Artists and Lovers, 1900–1930*, simply stop at the end of *les années folles*, with the onset of the Great Depression that pulled the rug out from under the art market. The departure of most of the expatriates, including those returning to the U.S. as recorded in Malcolm Cowley's classic memoir *Exiles Return* (1934), furnishes another symbolic conclusion.

The major show on the Ecole de Paris, held in 2000–1 at the Musée d'art moderne de la Ville de Paris, covers twenty-five years, from 1904 to 1929. The first date is justified by Picasso's setting up shop in the Bateau Lavoir in Montmartre; the second date receives no clear justification. The catalog

highlights Montparnasse as "an enclave of the other,"[8] the terminal date suggesting that the quartier only shined during *les années folles*. Even a book such as Valérie Bougault's *Paris Montparnasse à l'heure de l'art moderne 1910–1940* concludes the long section on *les années folles: tous en scène* with a photo of Pascin and a 1927 painting by him of a nude, then adds a brief final section devoted not to the Ecole de Paris but rather to the surrealists. The ultimate chapter focuses on the Italian-Swiss immigrant sculptor Alberto Giacometti, born in 1901, who arrived in Paris in 1922 and maintained a studio in Montparnasse until his death in 1966. Yet Giacometti, like the surrealists, was equally part of 1920s as well as 1930s Montparnasse—Bougault, like Klüver and Martin, uses Pascin's death as a convenient way of terminating the Ecole de Paris.[9] Notwithstanding Pascin's suicide, the Ecole de Paris continued, and most artists lived and worked in Montparnasse throughout the 1930s.[10]

Unlike American expatriates, artists from Eastern Europe were unlikely to return to their countries of origin, though some left Montparnasse to live elsewhere in France. Jewish artists were immigrants rather than expatriates; in the 1930s, a growing number of refugees joined them. It is not surprising that American sources, fixated on the Anglophone expatriate community, would assume that when the Americans headed home everything ended. American writers especially tended to be insular, supporting themselves by writing for the five English-language newspapers published in Paris or sending copy back home, hanging out in clubs or bars that catered to them, such as the Dingo and the Jockey in Montparnasse, and living large on the strong American dollar.[11] As expatriates left Montparnasse in the 1930s and more Jews arrived in Paris from Central Europe, the percentage of Jewish artists must have increased.

If the Ecole de Paris did not collapse in 1930, why do most books imply as much? That Valérie Bougault turned to the surrealists for her conclusion suggests one assumption: that the apolitical high-life years of the 1920s with which the Ecole de Paris is associated gave way to the politically volatile years of the 1930s.[12] The surrealists had declared their allegiance to communism as early as 1925 and remained *engagé* during the Popular Front era. Jewish artists must also have recognized the decline of internationalism and toleration and the rise of xenophobia and antisemitism. The Stavisky scandal of 1933–4, featuring a Russian-born Jewish swindler, which ignited right-wing riots in Paris on February 6, 1934 that left fifteen dead and a hundred times that many injured, marks a distinctly different and less welcoming atmosphere. Nevertheless, France remained a relative haven for Jews and anti-fascists, as well as for modern art. Montparnasse's star had fallen, but would not be eclipsed by the Saint

Germain-des-Prés quarter until the postwar existentialist years. The term "interwar" commonly applied to this period conceals that the upbeat 1920s were *après-guerre*, postwar; the uneasy 1930s were *avant-guerre*, pre-war and after the collapse of 1940 often remembered as decadent.[13]

## Montparnasse in the 1930s

What do we know of the Montparnasse artist colony in the 1930s? One contemporary testimony comes from a relatively rare book on the scene published in 1934 (many such books appeared in the 1920s), called *Têtes de Montparnasse* (Heads of Montparnasse) by an obscure journalist named Nesto Jacometti. He expressed considerable nostalgia for the old bohemian days of Montparnasse, which he dated from 1905 to 1923, after which came the dance halls and splendid cafes of the high-life years. The economic crisis completed the destruction of the former glory of Montparnasse, leaving only a few bohemians of the old guard. Nevertheless, Jacometti reported that Samuel Granowsky (1889–1942) still swaggered into the Rotonde café wearing his cowboy boots. At La Coupole one still saw the masters, Despiau, Lhote, Friesz, Matisse, Loutchansky, Delaunay, Kisling, sometimes Picasso and the "Piccasiettes." Jacometti wrote at length about a number of Jewish artists, including Pinchas Krémègne, Michel Kikoïne, Isaak Pailès, and Lippy Lipschitz, a sculptor who signed his works Lippy so as not to be confused with the better-known Jacques Lipchitz. Though the atmosphere of the place had changed, plenty of artists evidently remained. Jacometti did not hesitate to indulge in the language of prejudice, referring to "these Teutonic Yids [*youpins tudesques*] who chatter of *Kunst* [art] and *Geschaft* [business or deals] displayed in the width of their arms *Freiheit* [freedom] written in red and Antinazis etched in black characters."[14] He also described seeing Jewish critics, including the "surly [Adolphe] Basler" who never missed his aperitif at the Dôme, and Ilya Ehrenburg, the sole Russian intellectual able to travel freely between the Soviet Union and the West throughout the 1930s. Jacometti concluded the book by comparing the *quartier* favorably with the new international center of Geneva, home of the League of Nations: "Montparnasse has nothing to envy in the tragic farce of Geneva. All countries have delegated their representatives among us. Here one works for disarmament of the spirit, which is worth more than that of the young hypocrites of international diplomacy. We are all brothers in bohemia, free and independent, disengaged from the stains of decrepit society; the hatred, prejudice, egoism,

chauvinism."[15] The cosmopolitan spirit of 1920s Montparnasse persisted, unless Jacometti's nostalgia extended to that as well.

The existentialist and feminist writer Simone de Beauvoir, who was born in Montparnasse in 1908, still frequented its cafes and nightspots thirty years later. While teaching at the Lycée Molière in the Sixteenth Arrondissement, Beauvoir lived in a hotel on the rue de la Gaîté just west of Montparnasse Cemetery, and she and Jean-Paul Sartre set up headquarters at the Dôme Café on the Boulevard Montparnasse. In the second volume of her memoirs, she described the scene there, filled with German refugees "and other foreigners, of all nationalities, conducting passionate arguments in low voices."[16] Thanks to her friends, she and Sartre "could now put a name to some of these faces. There was Rappoport, with his luxurious beard, and Zadkine the sculptor, and huge Dominguez, and tiny Mané-Katz, and the Spanish painter Florès, and Francis Gruber (with whom my sister had a fairly intimate relationship), and Kisling, and Ilya Ehrenburg . . . and a whole crowd of artists and writers, known or unknown."[17] From this list of names, only one of whom, Gruber, was born in France, one surmises that in the late 1930s Jews still predominated in Montparnasse. Charles Rappoport (1865–1941) was a Jewish immigrant from Lithuania who helped found the French Communist Party, organized Yiddish-speaking workers in Paris, and broke away from the party in 1938 over Stalin's purge trials. Zadkine, Mané-Katz, and Kisling were well-known Jewish artists. Gruber (1912–48) was a French painter from Lorraine who was a generation younger than the Jewish artists, and a friend of the Swiss artist Giacometti, cited by Beauvoir at the end of the same paragraph.

The sharp and sudden downturn in the art market and the decline of cosmopolitanism are the main rationales for ending the story in 1930. Yet modernism did not suddenly collapse along with the stock market. What did recede was the high life, which a critic such as Jacometti decried for undermining, or overwhelming, the true bohemian years of Montparnasse that preceded the bright lights and jazz clubs. If a more soulful poverty returned to the left bank in the 1930s, would that not also have meant a return to bohemian life on the edge? While poverty doubtless became the reality for many artists, bohemian destitution was much preferred in retrospect. Starving in a garret for the sake of one's ideals was better appreciated in one's youth, and the generation born between 1880 and 1894 was no longer young. Most of the Jewish artists remained, for want of an alternative, which explains why so many were caught in the Nazi dragnet in 1942 and 1943. New down-and-out bohemians did arrive in the Paris of the 1930s—one thinks of American novelist Henry Miller and British writer George Orwell. This included a younger contingent of Jewish would-be artists,

born after 1900, such as Neemya Arbit Blatas, born in Lithuania in 1908, or Grégoire Michonze, born in 1902 in Ukraine, who arrived in the 1920s but matured in the next decade. Michonze befriended Henry Miller, as did Chaim Soutine, who was a neighbor of Miller's in the Villa Seurat three kilometers south of the boulevard Montparnasse in the late 1930s (as was the sculptor Chana Orloff in this small bohemian world). For the young artists who had not "arrived," life was very hard. A salon des échanges was set up where one could exchange a painting for food or clothing. At the Cercle François Villon (commemorating the original bohemian poet of the Latin Quarter of the fifteenth century), one could find a refuge that included a library and cheap meals.[18] One could always nurse a café-crème for hours at a café and hope, as Miller did, that someone would come by who would stand you to dinner.

If the bohemia of Modigliani ceased being carefree and hard times made it hard to sell one's art, what other alternatives were available to artists? The 1930s response to the travails of capitalism was an expanding state. Paris being the capital of a highly centralized government devoted to culture and the arts, one could hope that the state would step up to protect its artistic patrimony. This proved to be particularly true of France in the 1930s, when a populist left-wing government led by a Jewish prime minister who was himself involved in the arts took power, and when a colonial exhibition and a world's fair provided employment for many artists as decorators. The Colonial Exposition of 1931 on the east edge of Paris attracted eight million visitors. The Exposition Internationale des Arts et Techniques dans la Vie Moderne of 1937 was visited by over 31 million, included two major art shows, and built new museum space on the Trocadéro that would later showcase the works of the artists of the Ecole de Paris.

Implied in the assumption that the Ecole de Paris faded in 1930 is that aesthetic modernism succumbed to a growing spirit of conservatism, which corresponded to a rising tide of nationalism, all of which culminated in the 1937 International Exposition. As the German and Russian pavilions faced off across the esplanade between the Trocadéro and the Eiffel Tower, the French turned backward to celebrate regional and artisanal folk culture in some of the 300 pavilions built for the world's fair. A prevailing art historical rhetoric argues that the years of World War I and the 1920s saw similar resistance to modernism, hearkening to a call to order and a neoclassical revival that fell back on traditional French values of order and clarity.[19] This narrative oversimplifies a more complicated story. As modernism did not fade away in the 1910s or 1920s, so it

continued into the 1930s. What happened in the 1930s was not so much a rejection of modernism as a shift from private to public forms of art. With the collapse of the art market and the move toward state intervention on both the left and the right, art became public and artists became more socially conscious. This could lead to a demand for social realism so that the public could comprehend the works they were seeing, thereby toning down the avant-garde, but could also mean involving the public in art previously aimed at an elite of dealers and collectors. The rhetoric of conservatism and xenophobia is particularly suspect when placing France in a broader international context. Compared to the Nazi praise of racially approved and academic art, on the one hand, and condemnation of modern art as degenerate, on the other, the Parisian art world of 1937 looks aesthetically progressive and a model of toleration and diversity. Modernism along with politics and economics shifted seismically in the 1930s, but it did not disappear.

The many Jewish artists who were still working, if more hungrily, in 1930s Paris were unlikely to turn away from modernism in order to seek greater acceptance. As the situation of Jews became more desperate, with refugees from Germany replacing those from the Russian Empire in the pre-war years (and those fleeing the Bolsheviks after the revolution of 1917), Jewish artists would grapple with the new vicissitudes in their work. That work became more dynamic, sometimes more socially and politically conscious, but it remained modernist. Since most of the members of the Ecole de Paris remained figurative rather than abstract artists throughout this period, the contrast between their earlier and later work was not as great as one might expect. The times lent greater emotional depth to their work as they turned from landscapes, nudes, and still lives to images of struggle in works that exposed the depths of the human soul. One theme in particular changed dramatically: the 1920s focus on musical themes as a symbol of harmony ceded to classical and biblical references that highlighted what a key writer of the era, André Malraux, would call "Man's Fate" in his 1933 novel (in French, *La Condition humaine*). If art, like life, became more serious in the "hollow years" of the 1930s, this was especially true for Jews.[20] As Jacometti suggested in his League of Nations analogy, Montparnasse represented the antithesis of narrowly nationalistic and racially defined values.

Contradicting rumors of the demise of modernism is the long campaign to provide Paris with a museum devoted to modern art, which culminated in the 1930s with the creation of the Musée National de l'Art Moderne. A national modern art museum eventually found a permanent home at the Pompidou Cultural Center in 1977, previously housed in the much smaller Jeu de Paume

near the Louvre. This museum, which replaced the Musée du Luxembourg as the modern art museum, was inescapably political as modernism signified internationalism and progressivism. A second venue for modern art, the Musée d'art moderne de la Ville de Paris, did not open its doors until 1961, although in the same space built for the World's Fair of 1937 near the Place du Trocadéro. Overshadowed by the national modern art museum, the city of Paris museum would feature the artists of the Ecole de Paris more prominently. The off-again on-again world's fair held in 1937 in Paris despite the economic crisis was encouraged as a sign of French dynamism by the leftist Popular Front government elected in May 1936. A concurrent show at the Petit Palais exhibited a large number of works by Jewish painters and sculptors, including roomfuls of sculptures by Zadkine, Lipchitz, and Orloff, and significant numbers of paintings by Chagall, Modigliani, Soutine, Pascin, and Kisling.[21] Also concurrent, across the Rhine the Nazis were lambasting similar artworks at the infamous Degenerate Art Show that opened that same summer of 1937 in Munich. Modern art did not enjoy an unalloyed triumph in Paris, but one piece of public art achieved immortality: the most iconic political art of the century, Pablo Picasso's huge mural *Guernica*, adorned the Spanish Pavilion.

That same spring of 1937, Marc Chagall became a French citizen. For foreign-born Jews, France was still a sanctuary.[22] Four years earlier, Chagall had applied for French citizenship, and despite his international reputation, the Director General of Fine Arts sniffed that the French government had acquired none of this avant-garde artist's works, so he could not offer an opinion on naturalization. Chagall's timing was not ideal; 1934 witnessed the Stavisky Affair that increased antisemitism in France. He applied again at a more propitious moment, when Léon Blum led the leftist Popular Front, and this time Chagall's citizenship request was approved.[23] Chagall was not alone in obtaining French citizenship. The Popular Front government welcomed naturalized citizens at a greatly increased rate in 1937–8.[24] The fact that France naturalized 80,000 foreigners, many of them Jews and refugees, in this two-year period stands in striking contrast to Germany, which was disgorging many of its people at an even faster rate.

While the Great Depression affected all artists engaged in what is after all a luxury trade, for Jewish artists the impact of the rise of fascism and specifically Nazism was even more profound, leading to a rapid rise in the influx of Jews entering France. The Jewish population of France tripled from 1914 to 1939, with 200,000 additional Jews arriving, most of whom had not become French

citizens by 1939.[25] While Jews still comprised less than 1 percent of the French population, numbering between 300,000 and 330,000 in 1939, they were disproportionately numerous in Paris, where three-fourths of these immigrants found a home. The 200,000 or so Parisian Jews represented the third largest concentration of Jews in the world after New York City and Warsaw. After the U.S. closed its doors to immigrants from Southern and Eastern Europe in 1924, France became a greater mecca for immigrants. This rapid rise in Jewish immigration contrasts with the earlier period from 1881 to 1914, when 2 million Jews came to the U.S. and 120,000 arrived in Great Britain, while only 30,000 settled in France.[26] On the eve of World War I, less than 3 percent of the French population was foreign born; by 1931, that number peaked at 7 percent, with 9.6 percent of the Parisian population born outside the hexagon. This number would drop to 7.7 percent by 1936, as foreign workers repatriated to Belgium, Poland, and elsewhere.[27] In August 1932, France retracted its liberal welcome to immigrants, and the Popular Front government did little to modify these laws. Nonetheless, in 1933 the Chief Rabbi of Lille in northern France commented that with more Polish than French-born Jews in his region, he was obliged to speak publicly in Yiddish.[28]

Many Jewish immigrants were also Zionists, socialists, or communists, and lived in distinct Jewish neighborhoods on the right bank, in the Marais and Belleville, and spoke Yiddish rather than French. This was not likely to endear them to the French population, who saw them as dangerous leftists and increasingly as the 1930s wore on as anti-fascists likely to involve France in another war with Germany. The fact that the Popular Front government elected in 1936 not only was led by a Jew but contained four or five other Jewish cabinet ministers (the number varied between 1936 and 1937) further alienated conservative French people, leading to the infamous slogan of the far-right Action Française, "better Hitler than Blum." The Nazi *Anschluss* with Austria in March 1938 and the nationwide German pogrom known as Kristallnacht in November of that year drove more Jewish refugees into France, though the majority passed through France on their way elsewhere.[29]

Kristallnacht had a Parisian connection. A young illegal Jewish immigrant murdered a staff member of the German Embassy in Paris on November 7, 1938, an act that served as the pretext for the pogrom of November 9 and 10. From the confidence man Serge Stavisky to socialist Prime Minister Léon Blum to the avenger/assassin Herschel Grynzspan, whose murder of diplomat Ernst vom Rath set off Kristallnacht, Jews played visible roles in the tumultuous political theater of 1930s France.

## The Popular Front and the Rise of Public Art

The Popular Front was the leftist response to the right-wing riots that seemed to threaten the stability of the Third Republic. It formed in 1935 as an electoral alliance of the parties of the left. The Communist Party belonged to the Communist International or Comintern, headquartered in Moscow and beholden to Joseph Stalin. After failing to ally with the German socialists to stop Hitler (German communists notoriously referred to the socialists as "social fascists"), and chastened by the specter of fascism spreading throughout Europe, Stalin encouraged his French followers to make a strategic alliance with the Radicals and Socialists. The labor unions and the parties of the left assembled huge demonstrations in working-class, eastern Paris, and succeeded in electing the socialist leader Léon Blum as prime minister in May 1936. Behind this election lay massive labor strikes and real class division, which gave Blum the authority to negotiate major worker-friendly laws in the Matignon Agreement of June 1936. These accords raised the minimum wage, gave all workers paid vacations, and instituted collective bargaining to adjudicate labor disputes. That summer, workers throughout France took vacations for the first time, riding subsidized trains to vacation spots that had formerly catered to the bourgeoisie. Unfortunately for Blum, in the spring of 1936 Hitler marched his army into the Rhineland, demilitarized by the Versailles Treaty; that summer the Spanish Civil War broke out when a Spanish general challenged another Popular Front government in Madrid. The force of world events would undermine progressive reform, Blum would lose power after little more than a year in office, and the enormous enthusiasm generated by the Popular Front would give way to military preparedness by 1938. An authoritative French history of the era soberly titled *La Belle Illusion*, the fine or beautiful illusion, registers this passage from high hopes to despair over another war.[30]

How did foreign-born Jewish artists, some now naturalized French citizens, respond to this activism and turmoil? Given the rise of Nazism across the Rhine and the overt Jewish presence in the Popular Front, one would expect them to side with the left. Some, like Chagall and Mané-Katz, had played active roles during the Russian Revolution, which both had experienced first-hand. On the other hand, many of the artists had fled Russia, some before and some after the revolution. Jacques Lipchitz was a French citizen, making it relatively safe for him to engage in politics, as compared to a resident alien. His is the most prominent Jewish name linked to the AEAR, the Association des Écrivains et Artistes Révolutionnaires (Association of Revolutionary Artists and Writers),

which was a communist-affiliated organization founded in 1932 by the editor of the communist newspaper *L'Humanité*. The AEAR published a monthly journal called *Commune*.[31] A generation younger than Lipchitz was Boris Taslitsky, born in Paris in 1911 to Russian Jewish emigrés who fled after the failure of the 1905 Revolution. The young Taslitsky joined the AEAR in 1933, and then unlike Lipchitz joined the French Communist Party. He was more committed to the cause of the revolution than he was to modernism, and welcomed the doctrine of socialist realism espoused by the former surrealist and now Communist Party representative Louis Aragon. Taslitsky threw himself into the leftist politics of the Popular Front era. In 1936, he painted a large (over 4 x 6 ft.), remarkably detailed work full of small figures called *The Commemoration of the Commune at Père Lachaise Cemetery in 1935*, remembering the revolutionary moment in 1871 when the people took over Paris.

Another left-oriented group of artists formed an association called L'art mural that adhered to the Maison de la Culture, and which organized at least five expositions during the Popular Front years. The AEAR created these "houses of culture" in 1935 to organize lectures and artistic events. Louis Aragon, the former surrealist poet turned communist, led the Paris Maison. Nationwide, by 1938 they boasted 90,000 members.[32] The names of Jewish artists associated with L'art mural included Lipchitz, Chagall, Max Jacob, and Ossip Zadkine. Robert Delaunay also belonged to this group, and though his wife Sonia is not mentioned in this context, if she did not belong, she shared the ideals of the members, since she was actively involved in decorating two pavilions at the International Exposition of 1937.[33] Another group that sought the union of plastic and architectural arts included Zadkine among the founders.[34] Mural art was part of the Popular Front movement to bring art to the people. It stood for public art, which did not imply that it endorsed the communist call for realism. Delaunay spoke for this sense of artistic social responsibility when he claimed that "even while the fashion was for easel painting, I already thought of large mural works."[35] Sculptors such as Lipchitz and Zadkine also favored large-scale works for public display. Fernand Léger defended the freedom of the artist in an era when individualism seemed obsolete. The art critic for *Commune* and *L'Humanité* advocated the proposition that painting was not equivalent to a propaganda poster, and offered the example of the anarchist and neoimpressionist Paul Signac, who died in 1935, as a politically committed artist who felt no need to compromise his aesthetic principles.[36] At the height of the Popular Front, leftist artists in France remained loyal to the principles of modernism.

A striking example of the idealistic humanism generated by the Popular Front spirit of 1936 is Otto Freundlich's vision of great streets lined with sculptures crossing Europe. Freundlich, a German Jewish sculptor born in 1878, conceived the peace road with his companion Hannah Kosnick-Kloss. They envisioned avenues of sculpture crossing at Auvers-sur-Oise, France, where Vincent van Gogh was buried, and where they hoped to construct a "tower of peace and the seven arts." Freundlich had first arrived in Paris thirty years earlier, in 1908, and met Picasso and friends at the Bateau-Lavoir in Montmartre. His sculpture was abstract in the cubist mold, as for example the massive work *Ascension*, completed in 1929. An Otto Freundlich Society with an ongoing project to build the Road of Peace has made a documentary called *Das geht nur langsam* (It takes time) based on Freundlich's vision.[37]

The many Jewish art dealers operating in Paris (and elsewhere) confirmed in the minds of antisemites that Jews were inveterate capitalists who could not separate *Kunst* from *Geschaft* (art from business, to use Jacometti's terms). Similarly, the many Jewish partisans of the Popular Front should not imply that all Jews were socialists and communists or dominated leftist politics. If Lipchitz played an active role in the AEAR, the other key figures included Fernand Léger, André Lhote, Frans Masereel, and Jean Lurçat, none of them Jewish. Of the eight men placed on the organizing committee of the art exhibition Maîtres de l'art indépendant, de Manet à Matisse (Masters of independent art, from Manet to Matisse), only Louis Marcoussis was Jewish. Of the 464 painters, 577 sculptors, and 336 artist-decorators hired to work on the International Exposition, relatively few were Jews. Of the Delaunay équipe composed mostly of cubists delegated by Léon Blum to decorate the aeronautical pavilion at the fair in a modernist style, only Sonia Delaunay was Jewish (Léopold Survage was also foreign born). This was also true of the different group of artists led by Delaunay to decorate the railroad pavilion.[38]

Jacques Lipchitz, who was a man of the left, visited Russia in 1935 and spent several months visiting members of his family. He returned to France disappointed by the workers' paradise, in part because the Soviet secret police persecuted his brother. He wrote in his autobiography:

> During 1935 I spent some time in Russia, which I had always wanted to visit again. As a result of my early experiences, I had been sympathetic to the Russian revolution, but I must say that my three months' sojourn there disillusioned me. I designed a project for a monument to the Russian revolution, a *maquette* [small-scale model] of dancing figures on a column decorated with reliefs. The dancing figures derived from my sculpture *Joy of Life*, and the entire monument

was intended to extoll the liberation of the Russian people through industry and agriculture. The Soviet Arts Commission was interested in the project and asked me to submit a large sketch. I sent a plaster version, which was not accepted.[39]

What Lipchitz omitted from his autobiography was that he hoped he might aid his stepson, Andrey Skimkevitch, being held in the gulag, by establishing his own communist bona fides. He was commissioned to make a sculpture of Felix Dzerzhinsky, founder of the Cheka, the precursor of the NKVD, later known as the KGB. He actually made this bust of the revolutionary police agent; a copy now sits in the Musée des Années Trente (Museum of the Thirties) in Boulogne-Billancourt. He also said he would work in the artistic section of the Soviet-French Cultural Rapprochement Society. None of this worked to secure his stepson's release, who remained incarcerated until 1957.[40] This may help explain his disillusionment despite his leftist sympathies. As with many of his fellow Jewish artists, Lipchitz emigrated to the U.S. rather than the Soviet Union in 1941, and he remained there, eventually becoming an American citizen.

Jacques Lipchitz became a central figure among the immigrant Jewish artists due to the controversy his work aroused at the International Exposition of 1937. Along with Chagall and Soutine, he was probably the most prominent Jewish artist. He wrote in his autobiography that during the 1930s there were few major sculptors working in Paris in the post-Rodin era. He cited the names of Maillol, Despiau, Laurens, and himself.[41] The prominent names he omitted were his fellow Jewish sculptors Chana Orloff and Ossip Zadkine; in fact neither are mentioned anywhere in the text. Orloff's omission is perhaps not surprising, since her work was more conventional and mostly smaller in scale. Zadkine, however, was nearly as prominent as Lipchitz and also had a room devoted to his sculpture at the Exposition, with even more pieces on display. Zadkine made a trip to Greece in 1931 that greatly inspired him, and though his work remained distinctly modernist, it did take on a classical tinge, so perhaps Lipchitz thought he was not innovative enough to deserve mention. In the famous photograph of artists in exile taken by George Platt Lynes in New York in March 1942, both Lipchitz and Zadkine are present in the picture, along with Chagall, so they certainly knew each other.

In contrasting private capitalist-oriented Paris of the 1920s with state-supported Paris of the 1930s, one could not do better than to focus on Sonia and Robert Delaunay. They achieved a significant level of prosperity with Sonia's textile design firm, which employed at least thirty people by the late 1920s, though not without help from an earlier state-supported show, the Exposition

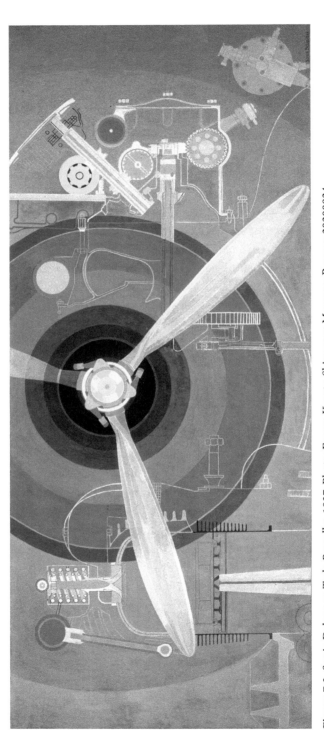

**Figure 7.2** Sonia Delaunay-Terk, *Propeller*, 1937. Photo: Emma Krantz, Skissernas Museum; Pracusa 20200824.

Internationale des Arts Décoratifs, which housed her "simultaneous boutique" and brought her considerable renown. The Depression ended her couture business, though as established artists she and Robert were not as badly off as many. They also had friends in high places. When it came time to decorate the aeronautic and railroad pavilions of the World's Fair, Robert Delaunay sent a personal note to Prime Minister Blum addressed to his "cher camarade" (dear comrade), and Blum decided in their favor over more conventional artists. Sonia had customers who knew the Blums and put in a good word for them too. Their colored geometries and abstract compositions perfectly fitted the image of French technological modernity, and aroused no opposition. They were also the first such modernist works to be presented to a large public, and as such were the most visible modernist murals in interwar France.[42] Sonia's large-scale paintings *Voyages lointains* (Distant Journeys) and *Portugal* adorned the railroad pavilion, while her large work *Propeller* decorated the Air Pavillion. While the airplane she painted was static, the movement implied by the rotating propeller recalled the circular forms of their prewar simultaneous work. The Exposition occupied most of two years in 1936–7 for the Delaunays, and in some sense represented the culmination of their dual careers. Robert would die of stomach cancer in 1941, aged only fifty-six; Sonia would live until age ninety-four and enjoy a major retrospective of her work at the Musée nationale d'art moderne in 1967, which included clothes and painted cars as well as easel paintings.[43] Her artistic career signified not only her successful integration into French culture but also the integration of public and private art, and of fine and decorative art.

The name most associated with socially-committed mural art in the 1930s is that of Diego Rivera, who championed the new public art in his native Mexico and came north to the United States with his artist wife Frida Kahlo in the 1930s to do more murals. His inclusion of a portrait of Lenin in a 1934 mural for Rockefeller Center brought him into conflict with the arch-capitalist (but also art-loving) Rockefellers.[44] Like the Popular Front, the New Deal program of President Franklin D. Roosevelt also encouraged murals on public buildings. The Works Progress Administration (WPA) employed many artists, such as Thomas Hart Benton (1889–1975) and Ben Shahn (1898–1969). The Jewish Shahn worked with Rivera and learned the art of fresco painting from him while assisting him with the Rockefeller Center project. Some of Shahn's WPA murals in the 1930s had overtly Jewish themes.[45] To extend the French parallel, the U.S. also ended the decade with a world's fair that looked forward to a confident future while still emerging from the Depression, this one in New York, and it too supported artists as decorators. As in France, artists like Benton who had studied

modern art in pre-war Paris were identified in the 1930s with the regionalist movement of Midwestern artists from the American heartland like Missourian Benton, Iowan Grant Wood, and Kansan John Steuart Curry. Their art was realist rather than abstract, and rural rather than urban. One direct link between the Ecole de Paris and the WPA was Hilaire Hiler, a Montparnasse fixture in the 1920s, who created the masterwork of his career when he decorated the lobby of the Maritime Museum in San Francisco in the late 1930s.

## 1937: Paris Exposition Universelle and the Munich Degenerate Art Show

Planning for the world's fair had been underway for a long time when Léon Blum took office in the tumultuous spring of 1936. Blum retained Edmond Labbé to organize the fair, and imagined it as commemorating the 300th anniversary of René Descartes' *Discourse on Method*, which set forth the principles of rationality and clarity that the French considered distinctly their own.[46] Blum came to politics from the literary milieu, and personally intervened to ensure that the arts would be an integral part of the ambitious undertaking. The result was two massive art shows designed to complement each other, unlike the Nazis' Degenerate Art exhibition, which they expected would contrast negatively with the Hall of German Art. Both German shows opened that same summer in Munich, 840 kilometers east of Paris. The Masterworks of French Art show occupied the exhibition grounds at the Palais de Tokyo, with 1,300 artworks spanning 2,000 years of French history. Since France did not have a national pavilion to match those of the other forty-two nations and empires that displayed objects that expressed national pride, these art shows implicitly registered French identification with art as synonymous with the nation. Nearby at the Petit Palais off the Champs Elysées, built for a previous world's fair in 1900, the Masters of Independent Art Exhibition displayed the latest trends in art, with 1,557 works spanning the years 1895 to 1937. While conservative critics praised the show trumpeting the glories of French civilization, the modern art show explicitly recognized the achievements of the Ecole de Paris, and therefore included the many foreign artists who had come to Paris over the previous forty years. The term modernism was not yet in use, but "independent" echoed the Salon des Indépendants that was created in 1884 as an alternative to the show sanctioned by the Ecole de Beaux-Arts and juried by academic artists. The show's subtitle, "from Manet to Matisse," underscored the show's avant-garde orientation.

The exhibition organizer was Raymond Escholier (1882–1971), a writer, art critic, and conservator of the Victor Hugo Museum. In addition to the modern art show at the Petit Palais, Escholier also oversaw a separate exhibition of foreign artists at the Jeu de Paume, which had shown non-French art since 1924.[47] Escholier published a book in 1937 called *Painters of the Twentieth Century*, in which he grouped Modigliani, Chagall, and Pascin not under the rubric of the Ecole de Paris but explicitly as the Ecole Juive, the Jewish school of art.[48] Escholier characterized, or stereotyped, Jewish art as "disturbed, anxious, tormented, as an echo of the pogroms which certain Semitic artists, come from Poland or Russia, have difficulty escaping."[49] He considered Chagall to be an initiator of surrealism, while Modigliani, Soutine, and Pascin were called *peintres maudits*, cursed artists. He recounted the well-known story of Soutine keeping a beef carcass in his studio for ten days.[50]

Unlike New York, Paris had no modern art museum in 1937 (the Museum of Modern Art opened in New York in 1929); this government-sanctioned show was the first official recognition of fauvism, cubism, and so on. The show included the best-known Jewish painters—Chagall, Kisling, Marcoussis, Modigliani, Pascin, and Soutine—though their works were crammed into one room. It must have been crowded considering it held seventeen paintings by Chagall, twelve by Modigliani, eleven by Soutine, seven each by Marcoussis and Pascin, and six by Kisling. By contrast, Picasso was given his own room. The sculptors fared better. Chana Orloff showed twenty-five works in room 37; Lipchitz had room 45 for his thirty-six pieces, and Zadkine showed forty-seven sculptures in room 39, the most of any Jewish artist and second only to the three rooms devoted to the works of Aristide Maillol. Chagall regretted how his works were displayed. Before the exhibition opened, Marc Chagall wrote to Escholier complaining that if they hung his large canvases in some corridor, he would prefer that they not be shown at all. He called himself a foreigner, aged fifty, who had been in Paris since 1910, a slight exaggeration since he arrived in 1911 and was absent from France between 1914 and 1923.[51] Adding to the confusion was the fact that a number of these artists were also represented at the Jeu de Paume show of foreigners, which included four works by Chagall, three by Lipchitz, and seven by Marcoussis, as well as paintings by Max Ernst, Miró, Dali, and Picasso.[52] Unlike the Jewish artists, the Masters of Independent Art show included few surrealists, who in protest mounted their own exhibition in 1938, as they had done earlier in the decade to protest the Colonial Exposition of 1931.

Given the explosive international situation and the leftist government of France, championing cosmopolitan modernism was inevitably political. Right-wing critics

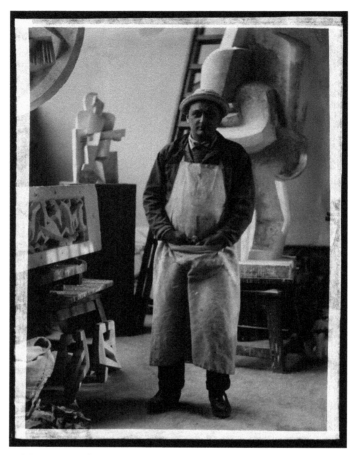

**Figure 7.3** Marc Vaux, photograph: Jacques Lipchitz in his workshop with the fireplace, mantelpiece, and firedogs, n.d. Bibliothèque Kandinsky, Photo MV2553, MNAM/Dist. RMN-Grand Palais/Art Resource, New York

of modernism and of the government attacked the most obvious target they could find: the huge sculpture commissioned by the state and decorated with a gold medal, which Jacques Lipchitz called *Prometheus Strangling the Vulture*. Lipchitz wrote in his memoirs that this work was originally designed for a scientific pavilion, such as the one the Delaunays were involved in decorating, and symbolized the victory of light over darkness. As the work evolved, he conceived it as showing struggle rather than conquest, with light, education, and science locked in combat with yet-unconquered forces of ignorance. The sculptor later wrote, "The Phrygian cap that I placed on Prometheus had a particular significance for me as a symbol of democracy; what I was trying to show was a pattern of human progress that to

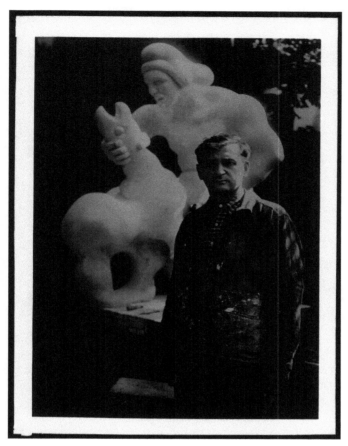

**Figure 7.4**  Marc Vaux, photograph: Jacques Lipchitz in front of his plaster model *Prometheus Strangling the Vulture*, 1936. Bibliothèque Kandinsky, Photo MV953, MNAM/Dist. RMN-Grand Palais/Art Resource, New York.

me involved the democratic ideal. So in a certain way this is a political sculpture, propaganda for democracy."[53] A photograph of Lipchitz working on the plaster sculpture shows the artist dwarfed by the 30-foot-tall piece. Placed 40 feet above the ground, it must have been impossible to ignore. Lipchitz continued to be inspired by classical myths, as in a *Rape of Europa* made in 1938, one of only two sculptures he was able to bring with him when he fled Europe for the U.S. in 1941. He reimagined it that year as an overtly political expression, with Theseus killing the Minotaur/Hitler with a dagger.[54]

Lipchitz also made different variations on the Prometheus theme over the next decade, working most concertedly on it in 1944. The revised version, cast in bronze, is less didactic and more abstract than the huge plaster model that

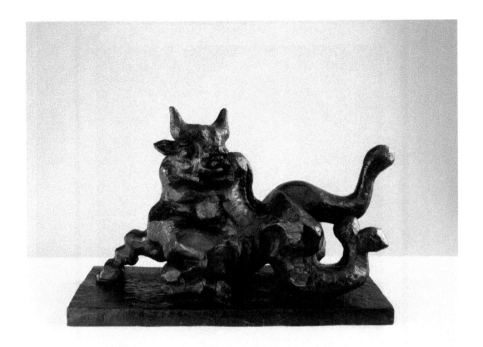

**Figure 7.5** Jacques Lipchitz, *Rape of Europa II*, 1938, bronze. Lee Stalsworth. Hirschhorn Museum and Sculpture Garden, gift of Joseph H. Hirschorn, 1966, 66.3093. Estate of Jacques Lipchitz, courtesy Marlborough Gallery, New York.

aroused such controversy in Paris in 1937.[55] All these mythological pieces retain an undulating, dynamic form that is more reminiscent of Baroque than classical sculpture. Expressionist dynamism characterizes other of his pieces from the 1930s, including *David and Goliath* made in 1933, and *Scene of Civil War* from 1936, both cast in bronze, the latter piece evoking the horrors of the Spanish Civil War. Lipchitz, unlike his rival Maillol, found no classical stasis in the unquiet years of the 1930s.

Lipchitz expressed regret that his *Prometheus Strangling the Vulture* was dismantled in 1938, but recognized that the plaster piece was intended as a temporary installation. Commentators have seen the fight over *Prometheus* as symptomatic of a backlash against Jewish art and artists. The conservative paper *Le Figaro* began the attack, Bernard Champigneulle in the journal *Mercure de France* joined in, and in the spring of 1938, the daily *Le Matin* waged a campaign against it as standing for "the level of barbarism and brutalization to which Russian 'art' has fallen."[56] Articles appeared on the front page of *Le Matin* every day for a week, identifying Lipchitz as a radical, and demanding that the statue be removed from

the Champs Elysées[57]. On April 29, they editorialized, "Alas, there is neither finesse, nor harmony, nor just proportions in the gigantic junk, so-called sculpture, placed on the Champs-Elysées in the neighborhood of the Grand Palais that it dishonors."[58] The magazine reported success in their campaign the following month, and reported mock seriously, "in order to avoid that it break en route, the workers had previously decapitated *Prometheus* and mutilated the plaster vulture."[59]

In July 1938, the Maison de la Culture, cultural arm of the French Communist Party, organized an inquest and debate on the *Prometheus* case. Behind this outcry they perceived an attack on all modern art. Artist Jean Lurçat warned against hyper-nationalism and xenophobia, and reminded his fellow Frenchmen that the Beaux-Arts professor and historical painter Fernand Cormon had attacked the impressionists during World War I as "one aspect of the activity of the German espionage system."[60] *Prometheus* was interpreted as Popular Front propaganda, which it was to some degree.[61] Lipchitz considered the sculpture to be a statement of belief rather than a work of pure art. The outcry against it has signified to historians and critics the reactionary rumblings shaking France in 1937. They point to the conspicuous celebration of regionalism and peasants at the fair.[62] The new regionalism had its artistic counterpart in realist evocations of rural life, which was diametrically opposed to modernist abstraction and internationalism.[63] Yet all political parties, including even the communists, were willing to celebrate regional and national traditions in the late 1930s. The Popular Front government was happy to launch the Musée des Arts et Traditions Populaires, while the Communist Party met in Arles in 1937 and invoked Provençal poetry and populism.[64]

One of the creative figures present at the Maison de la Culture assembly in 1938 was the architect Le Corbusier, who praised the piece. During the coming war, Le Corbusier was one of the architects charged with designing the Ministry of Education and Health building in Rio de Janeiro. Lipchitz, now living in exile in New York, was commissioned to decorate the building with his reworked design for *Prometheus Strangling the Vulture*. The resulting bronze piece was more fluid and rhythmic than the earlier plaster model. Once again, the sculpture faced problems; the Brazilian founders mistakenly reproduced the artist's 7-foot model, rather than the monumental 20-foot public sculpture envisioned by Lipchitz. A larger version was placed in front of the Philadelphia Museum of Art a decade later, though it probably lacked the explosive significance it had in Paris.[65]

These disputes signify how deeply divided France was in the 1930s, above all in the Popular Front era. Modernism and internationalism were under attack by forces that emerged triumphant in the National Revolution proclaimed by Marshal Pétain just three years later. For right-wing critics, who were numerous,

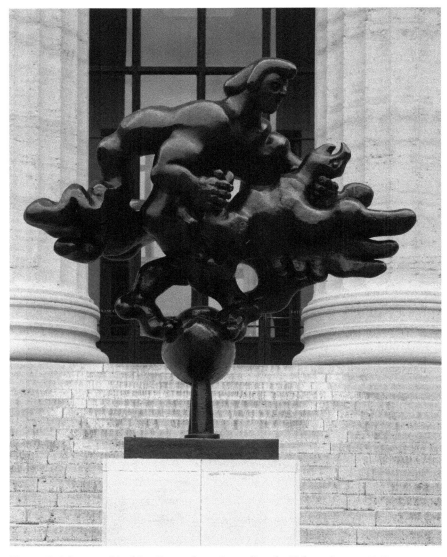

**Figure 7.6** Jacques Lipchitz, *Prometheus Strangling the Vulture*, begun 1943, cast 1952–3, bronze. Philadelphia Museum of Art, 1952-8-1, Estate of Jacques Lipchitz, courtesy Marlborough Gallery, New York.

Montparnasse stood for everything foreign and decadent they hated. Montparnasse's star had faded since its 1920s heyday, and ceased to shine entirely after 1940. The French were not immune to xenophobia and antisemitism, and yet … Maîtres de l'Art Indépendant was not *Entartete Kunst*. The work of Otto Freundlich was not ridiculed in Paris as it was in Munich; the French did not kill him in 1943, though

they may have been complicit in his murder. Since the Degenerate Art Show commenced in Munich on July 19, 1937, less than two months after the International Exhibition opened in Paris, and since the Germans had a prominent pavilion at the Paris fair, one wonders whether their attempt to denigrate modernism was a direct response to the French art shows. The celebration of German art had been in the works for years, ever since the Nazi takeover in 1933, but planning for the Degenerate Art Show was more haphazard. On June 30, 1937, Nazi Minister of Propaganda Joseph Goebbels decreed that museums all over Germany must contribute offensive examples of modern art. Seven hundred works were duly sent on to Munich and displayed promiscuously at an Archaeological Institute situated directly across from the German Art Show.[66] Eventually another 17,500 modernist works were confiscated from German museums, while the Munich show traveled throughout the Reich until 1941.[67] Marc Chagall's painting *A Pinch of Snuff (Rabbi)*, painted in 1923 after a 1912 original he feared was lost, found its place in the Munich show. It had been carried aloft through the streets of Mannheim past the home of the museum director who had acquired the work, who was fired for this aesthetic lapse soon after the Nazis took power.[68]

None of the art historians and historians writing in both *Degenerate Art* volumes reference the Paris Exhibition that attracted millions of tourists at the same time that two million people over the age of eighteen (minors were not permitted) trooped through the Degenerate Art Show in Munich. While the Nazis thought it would be apparent which art exhibition was "healthy" and which was "diseased," four times as many people viewed the disheveled modernist works as saw the sterile, literal renderings that appealed to Hitler. What remains remarkable about Hitler's personal investment in the issue of modernism was how seriously he took art. Nazis felt positively menaced by modernism, and especially by the art of their fellow Germans who called themselves expressionists. Though they focused their ire on the distortions that modernism made possible, they felt most threatened by expressionist subjectivity, the focus on the inner person. The totalitarian regimes of the 1930s, both communist and fascist, forbade interiority. Subjectivity meant individuality, not donning uniforms and marching for the *Volk* and the nation. Jews in the era of Sigmund Freud signified the inner world of thought and of the psyche. Yet most of the artists considered degenerate were not Jews, and some, such as Emil Nolde, were even followers of National Socialism.

One did not need to travel to Munich in 1937 in order to see tangible evidence of the Nazi idea of culture. The International Exposition held in Paris is remembered not for the artworks it assembled but for the national pavilions erected by the countries of Europe who would soon be going to war with one another,

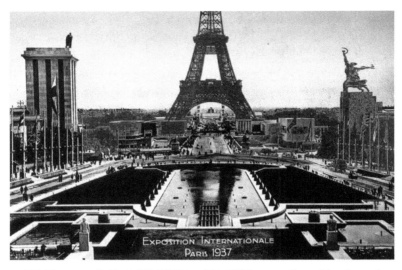

**Figure 7.7**  Photograph: Paris World Fair, 1937, Eiffel tower, Trocadéro fountain, seen from Palais de Chaillot. Photo: Séeberger frères, Centre des monuments nationaux, October 6, 1937.

notwithstanding the *Column of Peace* that the French placed optimistically at the fair's center. Hitler's favorite architect, Albert Speer, designed a tall, modernist structure surmounted by an eagle grasping a swastika in its talons. The huge, muscle-bound statue of nude men created by Josef Thorak (1889–1952) called *Comradeship* (*Kameradschaft*) conveyed exactly the masculine and racial ideal that the Nazis had in mind. Thorak used the German heavyweight-boxing champion Max Schmeling as a model for some of his literal-minded sculptures. Once inside, spectators faced an equally literal mural by Rudolph Hengstenberg called *The Construction Hut* (*Die Bauhütte*), which idealized peaceful building rather than Hitler's relentless build-up for war. This was the point: the Nazis wanted to present the illusion that cultural rapprochement might ease political tensions. Directly across the way was the yet more conspicuous Soviet Pavilion, the communist state's first such participation in an international exhibition. The enormously oversized, ultra-iconic statue by Vera Mukhina, *Worker and Kolkhoz Woman*, that stood 24.5 meters high, surmounted the dynamic, forward-thrusting structure. Instead of male musculature, the Soviets highlighted men and women working together to build the new society, while inside stood a more modest 3.5-meter-tall statue of Stalin but an equally oversized map of the Soviet Union fashioned out of minerals and semi-precious stones.[69]

Totalitarian monumentality contrasted with the more modest but also more modernist Spanish Pavilion designed by Josep Lluis Sert, a disciple of Le

Corbusier, and the Finnish Pavilion of Alvar Aalto. Though it seemed as if the German and Russian sculptures facing each other were the main rivals, Pablo Picasso's painting *Guernica* inside the pavilion of the embattled Spanish Republic formed another axis of opposition to the Nazis. *Guernica* was as political as anything in the German and Russian Pavilions without sacrificing Picasso's cubo-surrealist vision. This cynosure of modernism would not be repatriated to Spain until after General Franco's death in 1975. The building that housed *Guernica* would be reconstructed in Barcelona in 1992, the year that city hosted the summer Olympics and ran anti-nationalist ads referring to Catalonia as a country in Europe. Thus were the implications of the 1937 International Exposition of Arts and Techniques in Modern Life unfolded for the rest of the century. As well as manifesting the era's rampant nationalism, these pavilions signified the relation between politics and images. The nude Nazi figures that highlighted race, the clothed workers of both sexes that represented class, Picasso's abstract forms that pointed to human suffering in the face of the inhuman machinery of destruction: in all cases public art was recognized as possessing a power and prominence to which private art could scarcely aspire.

One little-noted aspect of the International Exposition highlights the increasingly precarious position of Jews in the late 1930s. On August 14, the Under-Secretary for Sports and Leisure, socialist Léo Lagrange, made a speech inaugurating the Pavilion of Modern Jewish Culture. He told the audience, which included many Yiddish-speaking immigrants, "on our soil, you Jews are not foreigners, because we ask you to carry to the common patrimony the magnificent riches of your heart and spirit."[70] When the politician was finished speaking, Mr. Abramavitch reminded the audience that not all Jews were bankers, as claimed by antisemites, and for proletarian Jews, France represented democracy. Jacques Biélinky reported that one wall bore the words of the Yiddish writer Sholem Aleichem, "Why must men be so mean [*méchant*] when they can be so good?" Biélinky noted the uniqueness of this pavilion, which represented neither land nor state, but rather a diasporic people. The pavilion specified that 16,300,000 Jews lived throughout the world, which if true must have represented the all-time peak of Jewish population. Of those, 11 million were Yiddish speakers, including 100,000 in Paris; 400,000 spoke Hebrew and 300,000 Judeo-Spanish (Ladino). Portraits of great Yiddish writers adorned the walls, as well as examples of the extensive worldwide Yiddish press, yet Biélinky noted that "plastic arts are frankly lacking." There were no paintings or sculptures, but only some drawings by Chagall, Chapiro, Benn, Lichtenstein, Mané-Katz, and by the deceased artists Bakst and Ryback.[71] The following week, the same Jewish

newspaper reported on the small Palestine Pavilion, whose three rooms were named for British Foreign Secretary Arthur James Balfour, Meir Dizengoff, first mayor of Tel Aviv, and the philanthropist Edmond de Rothschild. The pavilion featured a kosher restaurant, with a menu in French and Yiddish, and souvenirs made by craftspeople in the Holy Land.[72] It would have been hard to miss these signs that Jews were welcome in Popular Front Paris and that Yiddish culture still thrived. It is impossible not to see the Pavilion of Modern Jewish Culture as an elegy to a vanishing civilization, much as the Pavilion of the Spanish Republic would soon be submerged in the triumph of fascism.

The 1930s posed a number of challenges to the immigrant Jewish artists working in Paris. The Depression decreased their income; even well-known artists such as the Delaunays felt the pinch of reduced circumstances. Many who supported the Popular Front were swept up in politics from 1934 to 1937. Another ominous note: the police estimated that between 15,000 and 18,000 illegal refugees entered France in 1937 on tourist visas in order to visit the fair, and then remained in France when their visas expired (one such illegal alien was Herschel Grynzspan). At least 80 percent of these immigrants were East European Jews, many from Poland. The minister of the interior, Marx Dormoy, happened to be a socialist and a Jew, but was nonetheless furious at this incursion. He declared they would not be eligible for political asylum.[73] Jewish artists were both energized and fearful due to the rise of Nazism and the new influx of Jews fleeing the Third Reich. Given how radically the mood in the 1930s had shifted from that of the previous decade, one would expect to see significant change in these artists' subject matter and even in the style of their art. The rest of this chapter will look at how some of the most important Jewish artists reflected the immense political upheaval of these years.

## Jacques Lipchitz

Jacques Lipchitz emerged as a major cubist sculptor during World War I. In his memoirs, he claimed that he never abandoned cubism, but in fact his style developed almost continually throughout the interwar period. His geometric cubist forms evolved toward a flowing, organic style, culminating in one of the landmark works of his career, *Song of the Vowels*, completed in 1932. Such a serenely balanced sculpture of female harpists, evoking music and femininity, was soon abandoned. Instead, Lipchitz explored struggle and force through

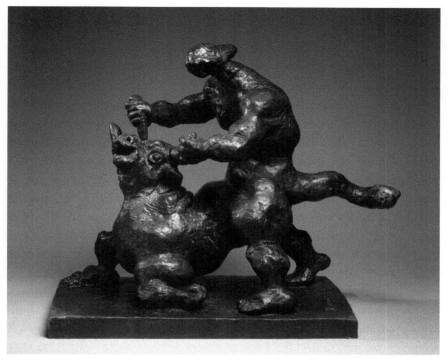

**Figure 7.8** Jacques Lipchitz, *Theseus and the Minotaur*, 1942. L.1988.62.67, the Henry and Rose Pearlman Foundation, on loan since 1976 to the Princeton University Art Museum. Estate of Jacques Lipchitz, coutesy Marlborough Gallery, New York.

dynamic forms that were more Baroque than classical, and masculine rather than feminine. In 1933, for example, he made pieces *called The Strangulation, Rescue of the Child*, and *David and Goliath*, all suggesting conflict and crisis. Later in the decade along with *Prometheus and the Vulture*, he did successive versions of *Rape of Europa* (1938–44) and *Theseus and the Minotaur* (1942), whose bull motifs might have been influenced by the example of Picasso. He described these pieces in apotropaic terms: "I was in a sense making a magical image, like a witch doctor who makes the image of an enemy whom he wishes to destroy and then pierces it with pins. Through my sculpture I was killing Hitler."[74] Lipchitz's relief at the destruction of the Nazis is also palpable in his work: he immediately produced *Joy of Orpheus* in 1945, while *Song of Songs* (1945–8) was both religious and, once again, musical in inspiration. By 1949, he had returned to flowing feminine lines in *Mother and Child I*.

# Chaim Soutine

If Lipchitz represented an artist deeply engaged with both the politics and art-politics of his time, Chaim Soutine suggests the opposite. His work showed little cognizance of any outside forces and he seemed to have no politics. Most collections of Soutine's work focus almost entirely on the work he produced from 1918 to 1929. One curator summarized why he chose only nineteen works by Soutine from the thirteen-year period from 1930–43 out of a total of ninety works selected for a show: "[I]n the thirties and until the artist's death in 1943, Soutine's production and esthetic achievement declined."[75] While the rise of antisemitism may have diminished Soutine's enthusiasm and creativity, none of his works grapples with war, racism, or revolution. His dominant subject matter remained landscapes, still lives, and portraits. Soutine was the extreme example of an artist who produced art from within his tormented psyche, rather than from contact with the outer world. Soutine did not appear engaged with his times. From 1930 to 1935, he spent most of his summers at the country house of his patrons, Marcel and Madeleine Castaing, who lived near Chartres. His best-known painting from this period is his depiction of Chartres Cathedral, seemingly an odd subject for a Jew to choose in the fraught years of 1933–4. Perhaps this was his way of escaping from the anxieties of the period.[76] He succeeded in putting his own stamp on the medieval structure, placing its towers against a dramatic sky and painting the foreground a deep red, with tiny black figures that emphasized the scale of the building. Though he did participate in the 1937 independent art show, he was not involved in painting murals or any other form of collective art.

Despite his distance from the currents swirling around him, 1937 was a sort of high point in Soutine's life. The Musée du Petit Palais accorded him a retrospective in that year, still rare for a foreign-born artist. His success in these years was probably due to his figurative style and the fact that he toned down his expressionist wildness of the early 1920s. Two other notable events in Soutine's life that year were his move to the Villa Seurat, a complex of artists' studio-residences, and the liaison he began with Gerda Groth, a young German Jewish refugee. His three-year relationship with the much younger woman, whom he called Mademoiselle Garde, which lasted until she was interned as an enemy alien in 1940, was the longest of his life.[77] He himself was unable to obtain an exit visa because of his failure to produce a single identity paper, and so was the best-known Jewish artist of the Ecole de Paris to remain and die in occupied France—as if his political naïveté had come home to roost.[78]

# Grégoire Michonze

Grégoire Michonze, born into a Jewish family of modest means named Michonzic in Kishinev in Bessarabia, a part of the Russian Empire that was absorbed by Romania after World War I and is now in Moldova, was nine years younger than Soutine and arrived in Paris nine years later. The timing of his birth was important; the year after he was born in 1902, his hometown suffered one of the most violent pogroms of any place in Russia. Romania in the interwar era was if anything more antisemitic than Russia had been, so it is not surprising that Michonze, as he called himself in France, departed for Bucharest and arrived in Paris in 1922. He soon met Max Ernst and worked with him as a decorator.[79] Ernst introduced him to the surrealists, whose work influenced him, but around 1930 he turned toward what he termed the representation of reality. By the mid-1930s, he was calling his style surreal naturalism. He insisted on linking art with life, and viewed abstract art as merely decorative, but rather than leaving the surrealists behind, his painting developed an oneiric quality inspired by de Chirico as well as Ernst. He saw his work as akin to that of his friend Soutine in that "the poetry in a painting matters more than painting itself ... Soutine is strong reality, seen by a fierce poet. It is distorted but is always according to nature and to life."[80] The critic Waldemar George compared Michonze's work to that of Flemish primitives. He painted figures in a static, breathless landscape, somewhat like his half-Jewish contemporary Balthus but on a smaller scale. Especially in his canvases from the late 1930s, he included many small figures crowded together in the foreground.

In 1937, Michonze painted the enigmatically-titled *We Play Red*, its realism undermined by a haunting presence of unseen forces lying just outside the open door. His art of stasis seemed designed to resist the tumult of the outer world. Later he would contrast his human-scaled art with the inhumanity of the atomic age; the same opposition holds for the 1930s. Also like Soutine, Michonze befriended Henry Miller, whom he met on the terrace of the Dôme café in Montparnasse in 1928, and who wrote an appreciation of his art for a postwar show. Michonze later married a Scottish artist named Una Maclean.[81] Michonze's art relates to the 1930s as a refuge from disorder, yet remains modernist in its very bizarreness, with a heightened sense of realism that is representational but not real. His work resembles Soutine's in being informed by the art of the past, in Soutine's case by Rembrandt and Chardin, in Michonze's by Breughel, another northern artist from the Low Countries. Michonze's work exemplifies the eclecticism of the Ecole de Paris.

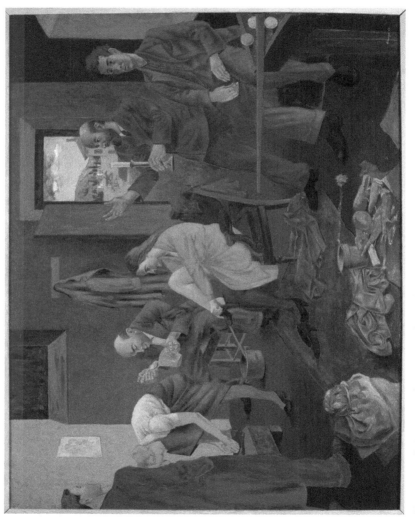

**Figure 7.9** Grégoire Michonze, *We Play Red*, 1937. MAHJ, D.2006.04.001, photo: Frank Raux

# Mané-Katz

Jacques Lipchitz acknowledged that his sense of being Jewish increased in the years of persecution, but his response in the 1930s was to make common cause with the left in order to combat fascism. He only visited Israel in 1963; at his death a decade later, he was working on a major piece to be placed on Mt. Scopus in Jerusalem. For the more recognizably Jewish artist Mané-Katz, the response to the crisis of the 1930s was not socialism or communism but Zionism. Mané-Katz arrived in Paris in 1913, returning to Ukraine during the years of war and revolution. He was back in Paris by 1921 and was naturalized French in 1927, the year that such laws were liberalized. The next year he made his first visit to the Holy Land, and returned twice more in the following decade, in 1935 and 1937, then immediately after the war in 1946. Of this postwar voyage, he said, "this was the year of struggle, of suffering, of firm resolution to defend the land at any cost."[82] He traveled to the new state of Israel in the year of statehood, 1948, despite the war of liberation raging around him, and returned from France every year after that, dying in Tel Aviv in 1962. Though he bequeathed his paintings to Haifa, which opened a museum in his name, he still felt the need to return to Montparnasse to live and work.[83]

To suggest that Mané-Katz felt allegiance to Zionism rather than communism places him closer to the mainstream of French *Israélites* who supported Jewish settlement in the Holy Land while retaining ties to France. Mané-Katz did not paint tragic scenes of struggle, at least not until he went into exile in New York during the war years. His Jewish themes included rabbis holding Torahs rendered so vividly that they may have reflected his visits to the Middle East. In 1936, he painted a rabbi and a shames, a position that his own father had held back in his native Ukraine.[84] He celebrated the humanity of Jews of the Diaspora, showing weddings, musicians, scholars, everyday life in traditional Jewish settings. His biographer Michel Ragon wrote that beneath the impression of joyous fanfare and the bright colors lay an underlying sense of sadness and resignation.[85] Mané-Katz evoked the shtetl culture of his youth as an act of homage and resistance.

# Marc Chagall

Perhaps the most complex response to the challenge of the 1930s occurs in the art of Marc Chagall. When he applied unsuccessfully for French citizenship, the stated reason for rejecting his application (in 1934) was the position he had held

as art commissar in revolutionary Russia. Though he likely soured on Bolshevism, since he lost his place as head of the Vitebsk art school to Kasimir Malevich and left Russia with his wife and daughter in 1922, his sentiments remained those of a leftist, and through the 1940s, he remained active in communist-front organizations devoted to peace. When he visited Palestine for the first time for three months in the spring of 1931, he told a Jerusalem newspaper, "in a party-line sense I am not a Zionist,"[86] but added that if those who opposed a Jewish state should visit, they would become Zionists. The founder and first mayor of Tel Aviv, Meir Dizengoff, invited Chagall to Palestine. He was planning a Jewish Museum for the new city and wanted Chagall as well as Chana Orloff and the poet and essayist Edmond Fleg to serve as consultants.[87] The Chagalls stayed with the mayor at his house. In a letter written in Russian to Dizengoff from Paris late in 1930 and received on January 14, 1931, Chagall expressed his enthusiasm for the idea of a museum of Jewish art. Though there was not yet a Jewish state, Chagall wrote, there were other "states," including Jewish spiritual culture. He cited "the renaissance of art among Jews . . . Once upon a time, when I first entered the road of art, I was almost alone—now I am surrounded by a whole army of Jewish artists."[88] Chagall was not claiming membership in a particular school of Jewish art, but believed that the greatly expanded field of Jewish artists deserved recognition. He recommended establishing societies of friends of the Jewish Museum in major population centers to support the venture. Dizengoff's response was to accept Chagall's advice that they limit the collection to modern Jewish art of the nineteenth and twentieth centuries. In subsequent correspondence, Chagall referred to his forthcoming autobiography, *Ma Vie*, from which he planned to give public readings in Palestine; he even contemplated writing another book about the voyage. On his return to Paris in June, Chagall wrote a friend, "Returned from Eretz Israel. Happy. Though not as a Zionist and not a 'nationalist,' but as a Jew."[89]

Why did Chagall insist that he returned from Palestine as a Jew but not a Zionist? He recognized the conflict between Zionists and leftist Jews over the issue of nationalism, which socialists rejected on ideological grounds. Chagall also seemed uncomfortable with some aspects of the Jewish society being established there, which was predicated on rejecting aspects of diasporic Ashkenazi culture familiar to Chagall. Previous chapters have discussed how the early Zionist leaders Max Nordau and Theodor Herzl imagined a Jewish state as the antidote to the decadent condition into which European Jewry had fallen. By the 1930s, this ideal of the "new Jew" may have seemed troubling, though in interwar France a number of leftists, both Jewish and non-Jewish, argued that

Zionism would bring Western-style progress to the Middle East and was compatible with French ideals of universalistic internationalism.[90] By the 1930s, Jewish nationalism, like the Italian and German variants, fostered a myth of regeneration of the past through land and labor, and hence regained in the present. This regenerative or palingenetic aspect of Zionism might have made Chagall uneasy.[91]

On his return to France, Chagall was interviewed (in Russian) about his trip and his ideas for the museum; his comments were published in the Paris-based Russian Zionist journal *Razsvet*. Chagall wanted halls devoted to the art of the Dutch Jew Josef Israëls, to the Berlin impressionist Max Liebermann, and to Pissarro, Modigliani, and Pascin. By then all but Liebermann were dead, and he was very old. Chagall merited a room as well, but was too modest to mention his own name. Two years later, Dizengoff wrote to him that as they enlarged their museum they were planning to add a Chagall room.[92] What Chagall did not want were portraits of famous Jews, and asked rhetorically if it was important that a Jewish museum contained a portrait of Léon Blum. More vituperatively, he condemned a museum that contained plaster casts of well-known sculptures, apparently because Mayor Dizengoff had already procured a copy of Michelangelo's sculpture of Moses. He also decried the work sent to Paris to adorn the Palestine pavilion of the Colonial Fair of 1931, which he characterized as the work of a few "women who paint Jewish ships."[93] Chagall's tenure as consultant for the Jewish Museum was brief. In a response to Dizengoff, Chagall interestingly referred to "leftist" artists and named "Cézanne, Monet, Pissaro [sic], Rodin, etc.";[94] he seemingly conflated "leftist" and avant-garde, and presumably thought of himself as fitting into this category.

Four years after the debacle of Chagall's involvement with the Tel Aviv art museum, Marc and Bella Chagall took another journey to inaugurate a Museum of Jewish Art. This one was located in Vilna, Lithuania, center of Eastern European Jewish culture. YIVO, the Yiddish Scientific Institute, which was celebrating its tenth anniversary, invited the Chagalls. Vilna was not far from Vitebsk, and reminded both Chagalls of their homeland. Half the population of Vilna was Jewish and Yiddish was spoken everywhere.[95] Like his visit to Palestine, this trip too strengthened Chagall's ties to his Jewish identity, and reinforced his nostalgia for the lost world of his youth. Antisemitism was all too palpable in 1930s Vilna, and while engaged in this forward-looking enterprise of establishing a Jewish museum, Chagall must have sensed the fragility of this world. His surreal *Time is a River without Banks* was completed the following year, and uses the fish and grandfather clock motifs to represent his nostalgia for Vitebsk and

his father, the hauler of herring. The experience of returning to Eastern Europe so affected his wife Bella that she decided to write her own memoirs in Yiddish, "my faltering mother tongue, which I've hardly used since I left my parents' house."[96] The YIVO and its archives soon relocated to New York City, where it continues today. Between the three cities of Paris, Vilna, and Jerusalem, the Chagalls felt more at home in the European cities of the Diaspora.

An admixture of ethnicity, religion, and social class influenced Chagall's sense of identity. Chagall and Soutine came from working-class backgrounds, which for Chagall came to the fore in the militant 1930s. As he wrote to the World Yiddish Cultural Alliance (YIKUF), which held its first congress in Paris in September 1937, during the International Exposition, "I am one of the people, the workers, as my father was, and I want to belong to the workers."[97] Chagall also published articles and letters in the Paris-based communist Yiddish newspaper *Naye Presse*. He viewed the Spanish Republican resistance to fascism as part of the struggle to preserve Jewish culture, and corresponded with a Jewish Loyalist fighter in Spain. The fighter hoped that artists like Chagall would portray heroic Jewish resistance to fascism; Chagall wrote an admiring letter back but was noncommittal. In a letter of 1940, Chagall mentioned to his correspondent that they had been betrayed by the Communist Party-affiliated YIKUF, referring to the Nazi-Soviet Non-Aggression pact of August 1939.[98]

In 1937, Chagall was not yet fully disillusioned with communism. The year of the International Exposition was also the twentieth anniversary of the Russian Revolution, and as the opposing Nazi and Soviet pavilions at the Paris fair suggested (and the Spanish Civil War reinforced), the Soviet Union still epitomized the alternative to the growing threat of fascism. Chagall envied Picasso and Miró for being able to be proxies for the Spanish Republic at the Exposition while he could not similarly represent his Russian homeland; he must also have recognized the greatness of Picasso's *Guernica*.[99] He created his own political statement that same year with *Revolution*, a whimsical celebration of the Russian Revolution from a distinctly Jewish point of view. He showed Lenin standing upside-down on a table, supporting himself with one hand. The French tricolor flies from his upraised legs, linking him to the French Revolution (when Lenin arrived at Finland Station in Petrograd in April 1917, the band played the Marseillaise) and connecting Chagall to his dual homelands of France and Russia. The revolutionary crowd surges forward, red flags flying, while a rabbi holding a Torah and wearing phylacteries sits next to Lenin, and a Wandering Jew peers up at him from the lower right. *Revolution* began a series of narrative paintings in which Chagall would reflect on the turmoil of his world

in the late 1930s. Enforced diasporic wandering characterized one element of Chagall's pictorial lexicon, as immigrants once again took to the roads. Marek Szwarc, who knew him in the prewar La Ruche days, wrote in his memoirs that Chagall in Russian meant to walk, so perhaps Chagall related to this peripatetic image. Szwarc reported meeting Chagall in the Soviet pavilion at the Paris Exposition.[100]

Suffering, represented modestly in *Revolution* by a weeping man sitting by an overturned chair and a Russian samovar, would be central to a painting done in

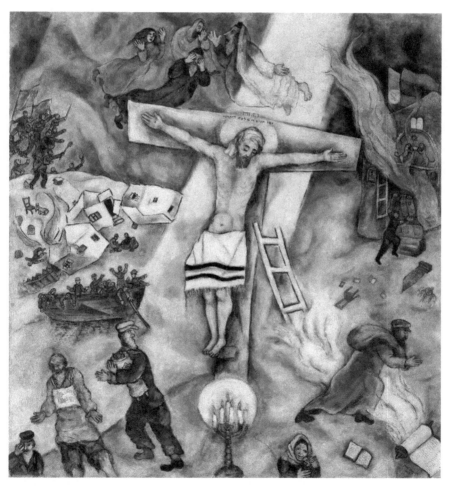

**Figure 7.10** Marc Chagall, *White Crucifixion*, 1938. Art Institute of Chicago, gift of Alfred S. Alschuler, 1946.925. Photo: Art Institute/Art Resource, New York. 2021. Artists Rights Society (ARS), New York/ADAGP, Paris.

the following year. *White Crucifixion* more than *Revolution* is Chagall's answer to the gauntlet thrown down by Picasso to respond aesthetically to the political crises of their world. The persecution of German Jews accelerated in 1938, first with the *Anschluss* that brought the 191,000 Jews of Vienna (9 percent of the city's population) disastrously under Hitler's control, culminating in November in the state-orchestrated pogrom called Kristallnacht (Night of Shattered Glass). Chagall imagined a suffering Jewish Christ, clad in a prayer shawl, surrounded by persecuted Jews and a menorah lying directly beneath his feet. To the right of Christ, a synagogue is burning, one man flees with a Torah while the Wandering Jew with his knapsack passes by a burning scroll. Chagall juxtaposed distinct scenes, such as a Jew forced to wear a sign around his neck or a boat laden with fleeing refugees, by fracturing the picture plane. He echoes *Revolution* in showing a small contingent carrying red flags entering from the left, but now the insurgents are dwarfed by the chaos that has come to dominate the Jewish world. In 2015, when *White Crucifixion* was on loan to a show in Florence, Italy, called *Divine Beauty: From Van Gogh to Chagall and Fontana*, it was taken to the Baptistery in Rome so that Pope Francis I could view it. The Pope reaffirmed that his favorite artists were Caravaggio and Chagall.[101]

Modern art moved away from narrative paintings in the nineteenth century, as well as from history paintings, which along with religious works had been the most highly valued subjects in the Beaux-Arts canon. Chagall succeeded in updating this genre while retaining the quasi-surreal style he had evolved over the previous thirty years. Similarly, the art of Rembrandt and Courbet inspired Chaim Soutine, though no one would confuse his expressionist works with theirs. Grégoire Michonze used the example of a sixteenth-century artist, Pieter Breughel, to animate his hallucinatory vision of contemporary French life. Later in life, Michonze said, "I try to continue tradition. And I'm not bothered about doing anything new at all."[102] These figurative artists of the Ecole de Paris presented their work existing in the flow of time. They resisted joining groups, thereby stamping themselves as surrealists or expressionists, because they preferred to respond individually to time and place, to their heritage and their environment. The three painters suffered divergent fates in the next war. Soutine went into hiding, emerging only when his ulcers demanded surgery, by which time it was too late. Michonze volunteered to fight for France, and spent two years in a German prisoner of war camp. When he was released in December 1942 he returned to Paris, and the following year painted *Soup of the Starved*, in which German soldiers oversaw hungry prisoners holding bowls in a crowded prison yard. One prisoner up-ended a garbage can looking for scraps. Unusually

for him, Michonze painted still lives of food during the war years, as if such pictures of plenty were themselves surreal.

In exile in America after experiencing a harrowing escape from Vichy France in the spring of 1941, Chagall would expand on the theme of suffering Jewry with the triptych *Resistance, Resurrection*, and *Liberation*. His representation of the Holocaust and exile are the subject of the next chapter. Born in the decade and country that reinvented the pogrom, Chagall witnessed war, revolution, and Holocaust and survived to envision liberation as salvation. He arrived in America on the summer solstice, at the very moment that Germany invaded Russia, his homeland.[103] Chagall never succeeded in leaving behind the Old World for the New, and did not adapt well to American life. He was one among many wanderers between the Pale of Settlement, Paris, and the New World. For him, France remained the Promised Land that made possible the paradise of art.

# Notes

1  Florent Fels, *Propos d'artistes* (Paris: La Renaissance du Livre, 1925), 33. Fels interviewed Chagall in 1924, and quoted him making this statement, which was preceded by Chagall saying that he loved Russia but loved Paris above all.

2  Florent Fels, *L'Art Vivant de 1900 à nos Jours* (Geneva: Pierre Cailler, 1956), 131. Flechtheim was referring to Heinrich Thannhauser (1859–1935) and Paul Cassirer (1871–1926).

3  Hal Foster, "Violation and Veiling in Surrealist Photography: Woman as Fetish, as Shattered Object, as Phallus," in Jennifer Mundy, ed., *Surrealism: Desire Unbound* (Princeton, NJ: Princeton University Press, 2001), 224, 225. Oppenheim's blackened hand and arm and very white skin are reminiscent of Man Ray's famous photo called "Black and White," which shows the head of his model Kiki lying horizontally on a table, while her hand holds up a black African mask. "Black and White" explicitly referred to race; the series of 1933 photos may refer to race obliquely.

4  See Janine Mileaf, "Between You and Me: Man Ray's Object to be Destroyed," *Art Journal* 63, no. 1 (Spring 2004): 4–23.

5  Robert Hughes, *The Shock of the New* (New York: Knopf, 1981), 242, 243; see especially the essays by Matthias Frenher and Kathleen Bühler, among others, in Heike Eipeldauer et al., eds., *Meret Oppenheim: Retrospective* (Vienna: Hatje Cantz Verlag, 2013).

6  Christiane Meyer-Thoss, "Biography," in Heike Eipendauer et al., eds., *Meret Oppenheim: Retrospective* (Vienna: Hatje Cantz Verlag, 2013), 290. Man Ray's series *Erotique Voileé* is included on 290, 291.

7   Jackie Wullschlager, *Chagall: A Biography* (New York: Knopf, 2008), 357.

8   Gladys Fabre, "Qu'est-ce que l'Ecole de Paris?" in *L'Ecole de Paris 1904–1929: la part de l'Autre* (Paris: Musées, 2000), 26.

9   Valérie Bougault, *Paris Montparnasse à l'heure de l'art moderne, 1910–1940* (Paris: Terrail, 1996), 168 for Pascin, 190–8 for Giacometti. See also Alain Jouffroy, *La vie réinventée à Montparnasse* (Paris: Musée Montparnasse, 2011), for a similar focus on the 1920s. In *Montparnasse vivant* (Paris: Hachette, 1962), Jean-Pierre Crespelle similarly ends his book in 1930.

10  To his credit, Kenneth Silver's essay in Kenneth Silver and Romy Golan, eds., *The Circle of Montparnasse: Jewish Artists of Paris, 1905–1945* (New York: Jewish Museum, 1985), does extend to the 1930s and the war years.

11  See, for example, Morrill Cody, with Hugh Ford, *The Women of Montparnasse* (New York: Cornwell, 1984), preface, 7–17. Morrill Cody (1901–87) lived in Montparnasse in the 1920s, editing the memoirs of Jimmy "the barman" Chambers who worked at the Dingo. Cody said that an American could get by in Paris for less than $25 a month. He earned only $15 per week working for the European edition of the *Chicago Tribune*, but that was enough (8, 9). He distinguished left-bank bohemian Americans from the larger right-bank contingent who worked for banks or the U.S. Embassy.

12  Wullschlager, *Chagall, A Biography*, 123.

13  See Eugen Weber, *The Hollow Years: France in the 1930s* (New York: Norton, 1994), 6.

14  Nesto Jacometti, *Têtes de Montparnasse* (Paris: Villain, 1934), 14. He discussed Old Montparnasse on 11, the other artists he saw at the Rotonde and the Coupole on 17. Krémègne is discussed on 51–6, Kikoine on 63–8, Pailès on 81–2, and Lippy on 177–84.

15  Jacometti, *Têtes de Montparnasse*, 189.

16  Simone de Beauvoir, *The Prime of Life*, trans. Peter Green (Cleveland and New York: World, 1962), 223; first published as *La Force de l'Age*, 1960.

17  Beauvoir, *The Prime of Life*, 224. In *The Unfree French: Life under the Occupation* (New Haven, CT: Yale University Press, 2006), 216, Richard Vinen says that the Dôme remained popular with German soldiers during the occupation, which ensured the café regular supplies of coal. This continuing German presence did not dissuade Beauvoir from working there in the winter of 1940–1.

18  Anatole Jakovsky, *Les Feux de Montparnasse: peintres et écrivains* (Paris: Bibliothèque des Arts, 1957), 110, 111.

19  Kenneth Silver, *Esprit de Corps: The Art of the Parisian Avant-Garde and the First World War, 1914–1925* (Princeton, NJ: Princeton University Press, 1989), is the outstanding text highlighting the reaction against modernism during and after World War I.

20 The term "the hollow years" refers to the military recruitment classes of the mid-1930s, when there were few twenty-year-olds to serve in the army because so few were born during the Great War twenty years earlier. See Eugen Weber, *The Hollow Years: France in the 1930s* (New York: Norton, 1994), Chapter 1, "A Wilderness Called Peace."

21 Romy Golan, *Modernity and Nostalgia: Art and Politics between the Wars* (New Haven, CT: Yale University Press, 1995), 206, n. 56.

22 Prefecture of Police, Dossier d'étranger, series étrangers, carton 6, Marc Chagall, naturalized June 4, 1937. Chagall, the best-known Jewish artist, had applied for French citizenship in 1933 but had been turned down in 1934. At that time, the Director General of Fine Arts reported on Chagall's candidacy for citizenship by writing that Chagall was an avant-garde painter, none of whose works had been acquired by the state, and who thus could not give an opinion on his request for citizenship. One wonders whether the advent of the Popular Front smoothed Chagall's application process.

23 Prefecture of Police, Paris, Direction de la Police Générale, Dossier d'Etranger, Séries Etrangers, carton 6, Marc Chagall, letter from Director General of Fine Arts dated May 9, 1934. The Minister of Justice was examining Chagall's situation on January 9, 1941, and cited the date June 4, 1937 when Chagall was naturalized as a French citizen. On January 30, 1941, a police report listed Chagall as living in Gordes, in the unoccupied zone, so the Vichy government was tracking him. The Chagalls arrived in New York on June 21, 1941. See Wullschlager, *Chagall: A Biography*, 395.

24 Vicki Caron, *Uneasy Asylum: France and the Jewish Refugee Crisis, 1933–1942* (Stanford, CA: Stanford University Press, 1999), 136, reports that over 31,000 people were naturalized in 1937, over 48,000 in 1938, increases of 8.2 percent and 55 percent respectively over the previous years.

25 Stephen Schuker, "Origins of the 'Jewish Problem' in the Third Republic," in Frances Malino and Bernard Wasserstein, eds., *The Jews in Modern France* (Hanover and London: Brandeis University Press, 1985), 166.

26 Schuker, "Origins," 168, 169.

27 Antoine Marès, "Apercu des communautés centre-Européenes à Paris dans l'entre-deux-guerres," in *Paris "Capitale Culturelle" de L'Europe Centrale* (Paris: Institut d'Etudes Slaves, 1997), 10, 11.

28 Paula Hyman, *From Dreyfus to Vichy: The Remaking of French Jewry, 1906–1939* (New York: Columbia University Press, 1979), 70.

29 Schuker, "Origins," 174, 178.

30 Pascal Ory, *La Belle Illusion: Culture et politique sous le signe du Front populaire, 1935–1938* (Paris: Plon, 1994).

31 Ory, *La Belle Illusion*, 236. See also Dudley Andrew and Steven Ungar, *Popular Front Paris and the Poetics of Culture* (Cambridge, MA: Harvard University Press, 2005), 65.

32 Julian Jackson, *The Popular Front in France Defending Democracy, 1934–38* (Cambridge: Cambridge University Press, 1988), 121.

33 Ory, *La Belle Illusion*, 244. Also see Stanley Baron, *Sonia Delaunay, The Life of an Artist* (New York, Abrams, 1995), Chapter 11, "The International Exposition of 1937."

34 Ory, *La Belle Illusion*, 235, 236.

35 Ory, *La Belle Illusion*, 244.

36 Ory, *La Belle Illusion*, 244–6.

37 www.strasse-des-friedens.net.

38 Ory, *La Belle Illusion*, 236, 281–2, 285.

39 Jacques Lipchitz, with H. H. Arnason, *My Life in Sculpture* (New York: Viking, 1972), 131.

40 Ludmila Stern, *Western Intellectuals and the Soviet Union, 1920–1940* (London: Routledge, 2006), 120.

41 Lipchitz, *My Life in Sculpture*, 135.

42 Ory, *La Belle Illusion*, 285. Baron, *Sonia Delaunay*, 102–11.

43 Baron, *Sonia Delaunay*, 196, 197.

44 For a discussion of Rivera's mural work in Depression America, albeit in Detroit rather than New York, see Anthony Lee, "Workers and Painters: Social Realism and Race in Diego Rivera's Detroit Murals," in Alejandro Anreus et al., eds., *The Social and the Real: Political Art of the 1930s in the Western Hemisphere* (University Park: Penn State University Press, 2006).

45 Diana Linden, "Ben Shahn's New Deal Murals: Jewish Identity in the American Scene," in Alejandro Anreus et al., eds., *The Social and the Real: Political Art of the 1930s in the Western Hemisphere* (University Park: Penn State University Press, 2006), 242.

46 Ihor Junyk, *Foreign Modernism: Cosmopolitanism, Identity and Style in Paris* (Toronto: University of Toronto Press, 2013), 110.

47 Golan, *Modernity and Nostalgia*, 206, n. 57.

48 Michel Hoog, "Origine et développement de l'art international indépendant," in *Paris 1937: L'art indépendant* (Paris: Paris-Musées, 1987), 32.

49 Raymond Escholier, *Peinture Française XXe Siècle* (Paris: Floury, 1937), 132.

50 Escholier, *Peinture Française*, 135, 136.

51 Bernadette Contensou, "Autour de l'Exposition des Maîtres de l'Art Indépendants en 1937," *Paris 1937: L'art indépendant* (Paris: Paris-Musées, 1987), 244 for Chagall letter, 248 for lists of artists.

52 Hoog, "Origine," 32.

53 Lipchitz, *My Life in Sculpture*, 139.

54 Lipchitz, *My Life in Sculpture*, 140, 153.

55 Lipchitz, *My Life in Sculpture*, 164–7.

56 *Le Matin*, April 24, 1938, quoted by Junyk, *Foreign Modernism*, 102.

57 "Jacques Lipchitz," in *Controversial Public Art: From Rodin to di Suvero* (Milwaukee, WI: Milwaukee Art Museum, 1983), 29.

58 Bibliothèque de France François Mitterrand, FOL-JO-1061, Peintres et sculpteurs de la Maison de Culture. No. 7, juillet 1938, Numéro special, La Liberté dans l'Art. Extrait d'un article du *Matin*, 29 avril 1938.

59 "La Liberté dans l'Art," *Matin*, May 16, 1938.

60 Jean Lurçat, *Peintres et sculpteurs de la Maison de la culture* 7 (July 1938), quoted in Laurence Bertrand Dorléac, *Art of the Defeat, France 1940–1944*, trans. Jane Marie Todd (Los Angeles: Getty Research Institute, 2008), 56.

61 Junyk, *Foreign Modernism*, 102–4.

62 Shanny Peer, *France on Display: Peasants, Provincials, and Folklore in the 1937 Paris World's Fair* (Albany: State University of New York Press, 1998).

63 See Golan, *Modernity and Nostalgia*, Chapter 5, "At the fairs."

64 Christopher Green, *Art in France, 1900–1940* (New Haven, CT: Yale University Press, 2000), 229.

65 "Jacques Lipchitz," 30.

66 Stephanie Barron, "1937: Modern Art and Politics in Prewar Germany," in Stephanie Barron, ed., *"Degenerate Art:" The Fate of the Avant-Garde in Nazi Germany* (New York: Abrams, in conjunction with the Los Angeles County Museum of Art, 1991), 19. See also the more recent catalog of the show put on by the Neue Galerie in New York, edited by Olaf Peters, ed., *Degenerate Art: The Attack on Modern Art in Nazi Germany, 1937* (Munich: Prestel, 2014). The Archaeological Institute that housed the show is discussed on 37.

67 Mario-Andres von Lüttichau, "'Crazy at any Price': the pathologizing of modernism in the run-up to the 'Entartete Kunst' exhibition in Munich in 1937," in Olaf Peters, ed., *Degenerate Art: The Attack on Modern Art in Nazi Germany, 1937* (Munich: Prestel, 2014), 48.

68 Olaf Peters, "From Nordau to Hitler," in Olaf Peters, ed., *Degenerate Art: The Attack on Modern Art in Nazi Germany, 1937* (Munich: Prestel, 2014), 29.

69 Karl Schlögel, *Moscow, 1937*, trans. Rodney Livingstone (Malden, MA: Polity, 2012), Chapter 12, "Moscow in Paris: The USSR Pavilion at the International Exposition of 1937." The argument that German participation in the Paris World's Fair was designed to allay French concerns about Hitler's military build-up is made by Karen Fiss, *Grand Illusion: The Third Reich, the Paris Exposition, and the Cultural Seduction of France* (Chicago and London: University of Chicago Press, 2009), 1–3.

70 Jacques Biélinky, "La culture Juive moderne à l'Exposition Internationale," *Nouvelle Press Juive*, Geneva, August 20, 1937.

71 Biélinky, "La culture Juive."

72 Alouna, "Terre d'Israël à Paris, une visite à l'exposition," *Nouvelle Presse Juive*, Geneva, August 27, 1937.

73 Caron, *Uneasy Asylum*, 163.

74 Lipchitz, *My Life in Sculpture*, 159.

75 Maurice Tuchman, *Chaim Soutine 1893–1943* (Los Angeles: Los Angeles County Museum of Art, 1968), n.p.

76 Esti Dunow, "The Late Works: Regression or Resolution?" in Norman Kleeblatt and Kenneth Silver, eds., *An Expressionist in Paris: The Paintings of Chaim Soutine* (Munich and New York: Prestel, 1998), 145.

77 When the Nazis invaded the Low Countries in May 1940, the French government interned refugees and aliens, including, for the first time, women. Gerda Groth was eventually released and allowed to live in Carcassonne, but she never saw Soutine again, and it appears he did not try to renew contact with her. He returned to Paris but eventually headed to the unoccupied zone. See Vicki Caron, "Unwilling Refuge: France and the Dilemma of Illegal Immigration, 1933–1939," in Frank Caestecker and Bob Moore, eds., *Refugees from Nazi Germany and the Liberal European States* (New York: Berghahn, 2010), 76.

78 Alfred Werner, *Soutine* (New York, Abrams, 1977), 40–3; see also Edward Lucie-Smith, *Art of the 1930s: The Age of Anxiety* (New York: Rizzoli, 1985), 156, and Billy Klüver and Julie Martin, "Chaim Soutine: An Illustrated Biography," in Norman Kleeblatt and Kenneth Silver eds., *An Expressionist in Paris: The Paintings of Chaim Soutine* (Munich and New York: Prestel, 1998), 110.

79 Patrick Waldberg, "The land of Grégoire Michonze," in Max Fullenbaum et al., *Grégoire Michonze, 1902–1982: Naturaliste-Surréel* (Paris: Terre des peintres, 1997), 101–2.

80 Fullenbaum et al., *Grégoire Michonze*, 90.

81 Fullenbaum et al., *Grégoire Michonze*, 65.

82 *Mané-Katz, 1984–1962, Exposition Rétrospective* (Haifa: Musée d'art modern, municipalité de Haifa, 1965), n.p.

83 Michel Ragon, *Mané-Katz*, trans. Haakon Chevalier (Paris: Georges Fall, 1960), 54.

84 *Mané-Katz et son temps, L'Aube du XXe Siècle, Peintres expressionistes et surréalistes de Montparnasse* (Geneva: Petit Palais, 1969), n.p. On French Jews' acceptance of Zionism in these years, see Catherine Nicault, "L'acculturation des israélites français au sionisme après la Grande Guerre," in *Dossier: Le "Reveil Juif" des Années Vingt, Archives Juives* 39, no. 1 (2006).

85 Ragon, *Mané-Katz*, 68.

86 Benjamin Harshav, *Marc Chagall and His Times: A Documentary Narrative* (Stanford, CA: Stanford University Press, 2004), 362. For Chagall's citizenship application, see 467. The Chagalls received their naturalization on June 4, 1937; less than four years later the Vichy government denaturalized them, by which time they had left for the U.S.

87 Harshav, *Marc Chagall and his Times*, letter to Meir Dizengoff, December 1930, 362, 363.

88  Harshav, *Marc Chagall and his Times*, letter to Meir Dizengoff, February 13, 1931, 367, 368.

89  Harshav, *Marc Chagall and his Times*, letter to Yosef Opatoshu, June 4, 1931, 374.

90  See George Mosse, "Max Nordau, Liberalism and the New Jew," *Journal of Contemporary History* 27, no. 4 (October 1992). On masculinity and the New Jew, also see Paula Hyman, *Gender and Assimilation in Modern Jewish History: The Roles and Representations of Women* (Seattle: University of Washington Press, 1995), 142–5. On the compatibility of Zionism and leftist French universalism, see Nadia Malinovich, *French and Jewish: Culture and the Politics of Identity in Early Twentieth-Century France* (Oxford and Portland, OR: Littman Library of Jewish Civilization, 2008), 202–15.

91  Palingenesis is a concept developed by Roger Griffin in *Modernism and Fascism: The Sense of a Beginning under Mussolini and Hitler* (Basingstroke: Palgrave MacMillan, 2007), and discussed extensively by Mark Antliff in *Avant-Garde Fascism* (Durham, NC: Duke University Press, 2007); see Chapter 1, "Fascism, Modernism and Modernity," 21.

92  Harshav, *Marc Chagall and his Times*, letter from Meir Dizengoff to Chagall, September 17, 1933, 393. Dizengoff wrote to express his regrets that the Nazis burned a Chagall painting in Mannheim.

93  Harshav, *Marc Chagall and his Times*, Chagall interview with Ben-Tavriya, *Razsvets*, June 14, 1931, 375–7.

94  Harshav, *Marc Chagall and his Times*, M. Chagall's response, 383.

95  Wullschlager, *Chagall: A Biography*, 363.

96  Wullschlager, quoting Bella Chagall in *Chagall: A Biography*, 364.

97  Harshav, *Marc Chagall and his Times*, Greetings to the World Yiddish Culture Congress, 472.

98  Harshav, *Marc Chagall and his Times*, on Spanish Civil War 474, 475; on betrayal by YIKUF, letter of April 18, 1940, 479.

99  Wullschlager, *Chagall: A Biography*, 372,

100 Marek Szwarc, *Mémoires entre deux mondes*, trans. Suzanne Bruker (from Polish) (Paris: Roussouvenances, 2010), 254, 255.

101 Steve Johnson, "Chicago's Chagall gets its audience with Pope Francis," *Chicago Tribune*, November 10, 2015.

102 Grégoire Michonze quoted on the website www.michonze.com.

103 Wullschlager, *Chagall: A Biography*, 396.

# The End of Time: Artists in Exile, Hiding, and Deportation

*I see them: trudging alone in rags, Barefoot on mute roads. The brothers of Israëls, Pissarro and Modigliani, our brothers—pulled with ropes by the sons of Dürer, Cranach, and Holbein—to death in the crematoria.*

Marc Chagall, "For the Slaughtered Artists," Paris, 1950[1]

The photographs taken by Jean Cocteau in Montparnasse in August 1916 captured a moment in the lives of foreign-born artists during World War I. The smiling faces of Picasso, Kisling, Modigliani, and Salmon remind the viewer of all of the artists who were absent from Paris, fighting on various fronts, as well as those who left France to avoid the war. Similarly, the photo taken by George Platt Lynes to accompany the exhibition *Artists in Exile* at the Pierre Matisse Gallery in New York in March 1942 stands for the situation of European artists a quarter-century later during World War II. Of the artists in exile from their native countries, three were Jewish artists from the Ecole de Paris: Marc Chagall, Jacques Lipchitz, and Ossip Zadkine. Standing in the back were two more Jewish artists, Eugene Berman and Kurt Seligmann; Berman had arrived in New York from Paris in 1935, Seligmann in 1939. Most of the other artists were also French and included André Breton and other surrealists, as well as Fernand Léger. Non-French artists included the German-born surrealist Max Ernst, sitting front and center in the photo, and the Dutch abstract painter Piet Mondrian, though both had also come to New York from France. The artists posed facing the camera were neat, well dressed, and male. This photo contrasts with a similar one taken later that year in New York in the apartment of Peggy Guggenheim, art collector and, for the moment, wife of Max Ernst. Here most of the artists look away from the camera, and the photo includes three women: Guggenheim, the American photographer Berenice Abbot, and the British surrealist Leonora Carrington.[2] The casual pose befitted a picture taken in Guggenheim's living room, and a couple of the men, including Marcel Duchamp, wore shirts but no jackets. Most

**Figure 8.1** George Platt Lynes, *Artists in Exile* exhibition at the Matisse Gallery, New York City, March 3–28, 1942. Chagall is second from right, Zadkine second from left in the front row. Lipchitz is directly behind Chagall. © Josh Lynes.

of the Jewish artists pictured at the Matisse Gallery were no longer present, though Guggenheim was Jewish. As in Cocteau's pictures, one is aware of the artists not pictured, including Pablo Picasso and Pierre Matisse's father Henri, who remained in occupied France, as did Jean Cocteau. These photos speak as loudly of absence as they do of the handful of fortunate souls who faced the camera.[3]

Exile was not an easy situation, yet given the alternatives one must think that these artists were lucky to have made it to the United States and able to show in a fashionable New York gallery owned by the son of the French artist Henri Matisse. Yet except for the Jews and Ernst, the artists would probably have weathered life in Vichy France. Despite his anti-fascist credentials as the creator of *Guernica*, Picasso was not harassed in France. Other French Jewish artists in exile in the U.S. included Moïse Kisling, Arbit Blatas, Oscar Miestchaninoff, Max

Band, and Mané-Katz. Man Ray and Abraham Rattner, Jewish American citizens who came to France shortly after World War I, repatriated to the U.S. The many Jewish artists who were not able to obtain visas to the United States faced a graver situation back in Nazi-occupied Europe. Most of those who survived retreated to villages in the southern part of France or made it to neutral Spain or Switzerland. While most of the Jewish artists who had established international reputations in interwar Paris survived, Vichy France and the Germans deported over a hundred others to the death camps of Poland. The only leading Ecole de Paris artist to die in France as an indirect result of the war was Chaim Soutine. The poet and painter Max Jacob also died, in his case at the Drancy transit camp outside Paris in 1944. Those artists who made it to America were the beneficiaries of their interwar reputations, which placed them on lists of artists and intellectuals to be spirited out of Europe by the American Emergency Rescue Committee led by Varian Fry. Chagall was one of those rescued; his postwar poem "On the Slaughtered Artists" registers his bitterness toward all aspects of German culture, going back to artists of the sixteenth century.

The Cocteau and Lynes photos, however peaceful, highlight the two traumatic experiences of war that engulfed the artists whom we have met in the preceding chapters. Difficult as World War I was for artists who were foreigners and citizens of other countries, World War II posed challenges they could scarcely have imagined a generation earlier. For one thing, the Jewish artists who lived in Paris in 1914 did remarkably well given the vast scale of conflict; though several were wounded, none of them died. Whereas the earlier war had treated them merely as foreign nationals, this time they were targeted as Jews. In both cases, history confronted them with violent nationalism, punctuated by periods of cosmopolitan toleration and international accord. World War I marked a pause in Parisian modernism; World War II sounded the death knell of Montparnasse, which would not revive. Though most of the Jewish artists who survived the war eventually returned to France, many left Paris, and the focus of modern art shifted perhaps permanently from Paris to New York and elsewhere. European hegemony over art as on many areas of modern life was over.

Lynes' photo of *Artists in Exile* underscores that Paris had lost its place as the center of cosmopolitanism, in the arts and in general. The French Third Republic was imperfect and unstable, but even in 1939 as storm clouds gathered over Europe, it celebrated the sesquicentennial of the French Revolution as the moment of universal liberty. French universalism lived on in the interwar years. After the United States closed its borders to most immigrants in 1924, France welcomed more of them than any other country in the world. Jews in particular

benefited from this openness. The collaborationist government based in the town of Vichy reacted against that cosmopolitanism, as it did against the very heritage of the French Revolution. After it terminated the Third Republic, it abolished the national motto. "Liberty, equality and fraternity" was replaced by a fascist-friendly trio: "work, family, and fatherland."

The term "exiles" applied to these artists suggests their unwillingness to leave their adopted homeland. The other applicable term, refugee, was more often applied to the masses of people fleeing the carnage of war, and implies nameless and homeless people, not the famous artists and writers whose names had appeared on lists compiled by scholars at the New School and the Museum of Modern Art. Given their temporary American status, they were not immigrants, and "expatriates" implied that they willingly chose their foreign destination. Émigrés is another term that is close to "exiles," but is more political, referring to people on the losing side of a civil conflict, such as the Loyalists who fled the U.S. after the American War of Independence, or the many "white" Russians who came to Paris after the Bolshevik Revolution. All of the exiles were anti-fascists, but Jews fleeing fascism had been singled out ethnically rather than politically. The exhibition of these artists' works that traveled from Los Angeles to Montreal and then to Berlin in 1997 used both terms, exiles and émigrés, and seemed to favor the latter term for anti-fascists fleeing Nazi Germany and Austria. The editors may have avoided the term "refugees" because of its negative connotations. Many Americans feared refugees flooding into neutral, isolationist America; exiles who were cultured professionals were less threatening. Artists who may have seemed peripheral to the mainstream may have been central. In "Reflections on Exile", Edward Said argued that "Modern Western culture is in large part the work of exiles, émigrés, refugees."[4] The Nazis liked to euphemize "voluntary emigration," and the French artists Yves Tanguy and André Masson opposed the term "exile" because they didn't like being considered as victims (though Masson's Jewish wife may well have been victimized if she had remained in France).[5] None of the Jewish artists of Paris would have considered themselves exiles when they lived in France, though under the tsarist regime they certainly faced discrimination. Then came the debacle of the Battle of France in 1940, and their adopted homeland no longer wanted them.

After the French army collapsed before the German onslaught in the spring of 1940, the last prime minister of the Third Republic, Paul Reynaud, resigned in favor of Marshall Philippe Pétain, hero of the Battle of Verdun in World War I. A few days after the Germans marched into Paris, Pétain called for an armistice, blaming the disaster on "too few allies, too few weapons, and too few babies," and

offering to France "the gift of my person."[6] From London, General Charles de Gaulle called for continued resistance, but most French people concluded they had lost. The Germans divided France into multiple zones; to simplify matters, one can speak of a northern occupied zone, which included Paris and the entire French coastline down to Spain, and an unoccupied free zone to the south, comprising 40 percent of French territory. Here Pétain ruled as head of the French state. In July 1940, the government set up shop in the spa town of Vichy, in part because its many hotels provided adequate office space, also because the major cities of the southern zone, Lyon and Marseilles, had large working-class populations, which this conservative authoritarian regime feared. Pétain met and shook hands with Hitler in October 1940, and pledged a policy of collaboration. What that meant for the Jewish population of France soon became apparent. The Vichy government passed anti-Jewish laws as early as October 1940, restricting Jewish participation in many walks of life, including all public service, the officer corps of the armed forces, teaching, journalism, the theater, radio, and cinema.[7] Such racially discriminatory laws violated every tenet of French republicanism dating back to the granting of equal civil and political rights to Jews in 1791. The Third Republic was condemned as a creation of Protestants, Freemasons, and Jews. The Vichy government tried former Prime Minister Léon Blum for treason in 1942. He defended himself ably, and survived the war.[8]

Most infamously, Vichy authorities cooperated with the Germans in the Holocaust. They had already agreed to hand over to the occupiers any German refugees requested by the Nazis. The policy of deporting Jews from occupied Europe to concentration and extermination camps got underway in 1942. The Vichy government insisted that French sovereignty demanded that French police should arrest Jews, intern them in the many camps already established at the beginning of the war, and then hand them over to the Germans for deportation, mostly to Auschwitz. Prime Minister Pierre Laval preferred to expel foreign-born Jews rather than native French Jews, but he also insisted that the Germans take men, women, and children, as he did not want to be saddled with caring for orphans. The most notorious roundup of Jews took place on July 16–17, 1942, when 9,000 French police fanned out over Paris and in two days rounded up 12,884 Jews. An indoor sports arena called the Vélodrome d'Hiver served as the Parisian collection center. The Vel d'Hiv roundup of July 16 now functions as Holocaust Remembrance Day in France.[9] Montparnasse provided a target rich in Jews, and the Vichy police rounded up many artists.

Issues of complicity in mass murder still haunt the Vichy years. Should the French government be held responsible for the roughly 76,000 Jews who were

deported from France to their deaths from 1942 to 1944? Assuredly, if France had not been defeated, no French Jews would have died in the Holocaust; Germans carried out the killing. Yet not only did the French round up Jews and hand them over; they were also guilty of encouraging a climate of antisemitism. On the other hand, French dislike for Jews was not murderous, as is attested by the fact that during the Dreyfus Affair of the 1890s, not a single Jew in metropolitan France was killed (two Jews in French Algeria were murdered). During the postwar trials of Philippe Pétain and Pierre Laval, the leaders of Vichy pointed out that three-fourths of the Jews living in France survived. This was a higher survival rate than any other occupied country except Italy (where only about 40,000 Jews lived) and Denmark (which spirited nearly all of its small Jewish population to neutral Sweden in 1943). Yet it is hard to give much credit to the French state for this fact; individuals stepped in to help Jews abandoned by the authorities. By singling out one ethnic/religious group for discrimination, Vichy violated deeply held values enshrined in French secular republicanism, not to mention Enlightenment-rooted standards of toleration and human rights. By collaborating with the Germans while declaring their own "national revolution," Vichy authorities indulged in an illusion of autonomy, which became entirely fictive when the Germans occupied all of France in November 1942, following the Allied landings in French North Africa.

As we have seen, Jewish art dealers played a predominant role in the interwar Parisian art market. "Aryanization" laws forced Jewish dealers to relinquish their galleries, either by entrusting them to fronts who administered the galleries for them, or by outright sale. The best-known case of the former option was that of Picasso's one-time dealer Daniel-Henry Kahnweiler, who as a German national had already faced the expropriation of his gallery during World War I. This time his sister-in-law, Louise Leiris, wife of the surrealist writer Michel Leiris, purchased the gallery and kept him updated on its business, while he managed to hide and survive in the south of France. The Bernheim-Jeune gallery was sold for a fraction of its real value to the private secretary of the extreme antisemite and head of the Commissariat on the Jewish Question Louis Darquier de Pellepoix. The Paul Rosenberg and Wildenstein galleries were similarly expropriated.[10] At the auctions conducted at the Hôtel Drouot, works by Jewish and modernist artists went for much less than works by safer French artists such as Vlaminck—one of those along with Maillol and Derain who visited Germany in the official deputation of artists of October 1941.[11]

Varian Fry, representative of the Emergency Rescue Committee, arrived in Marseilles in August 1940 with a few thousand dollars and lists of names of

artists and intellectuals endangered by the fall of France. He discovered thousands of refugees desperate to get out of Europe. Having left Nazi-occupied Paris for the unoccupied south of France, some artists were not eager to move again. Chagall, for example, had moved to the town of Gordes in Provence, not far from Marseilles, and it took several visits from Fry and Vichy's increasingly harsh anti-Jewish laws to convince him to leave. He might have been more willing if he had known that the Vichy police were watching him. On January 9, 1941, the police noted that he had been naturalized on June 4, 1937, and sought information on his family situation, profession (hardly a secret), and political attitudes since naturalization. On January 30, the police noted that he was living in Gordes, and included a note that no information regarding his true sentiments toward France was available, so he was still under surveillance.[12] Adding to the Chagalls' ambivalence about leaving was the problem that their daughter Ida and her husband Michel did not have rescue visas. In March 1941, Ida and Michel went to live with his parents in Nice. Marc and Bella took a train from Marseilles to Lisbon on May 7 (7 being Chagall's lucky number). They sailed for New York in mid-June. Ida and Michel managed to make it to the U.S. later that year after a series of harrowing adventures, and even brought a crate of Chagall's paintings with them.[13]

More politically astute and having faced the wrath of the French right over his work, Jacques Lipchitz was more willing than Chagall to leave. Yet Jacques and Berthe Lipchitz did not arrive in New York until June 1941, a full year after the German occupation of France and the same month that Marc and Bella Chagall arrived there. It was neither easy to get out of Europe nor easy to comprehend the consequences of not doing so. Non-Jews such as Picasso, Matisse, Gide, and Malraux all rejected Fry's assistance.[14] While many surrealists made it to America, lesser-known surrealists who lacked sponsors in America were not able to obtain visas. These included the Romanian-born Jews Victor Brauner and Jacques Hérold, who had arrived in Paris in the 1930s. Both survived the war in hiding. Brauner spent the war concealed as a shepherd on remote Alpine farms; Hérold tried to escape but the Swiss turned him back, and he joined the Resistance, specializing in the production of false documents.[15] German Jewish émigré Otto Freundlich, unable to obtain naturalization papers despite having lived in France for three decades, was interned at the beginning of the war but released in February 1940 due to Picasso's influence. He sent numerous pleas to the American Jewish Joint Distribution Committee, without results. He lived in a village in the Pyrenees but was unable to cross into Spain. As late as May 1941, Freundlich wrote to Picasso asking him if he could pay five months' rent on his

Paris studio so he could maintain it. Arrested in February 1943, Freundlich was deported to Majdanek death camp and killed on arrival.[16] While it would seem obvious that Jewish artists were most at risk, at the outset of the war the Holocaust had not yet begun, so the focus on rescuing artist celebrities was perhaps excusable.[17]

Foreigners in Vichy France did not only have to fear being deported to points east, a process which had not yet begun when the Vichy authorities evicted Fry and his mission in September 1941. The French themselves, even before the collapse of the Third Republic, were rounding up aliens. A law dated September 17, 1939, shortly after the outbreak of World War II, set out details for interning all "suspicious, dangerous, or undesirable" foreign refugees. After the fall of France, the armistice with Germany stipulated in article 19 that the French government had to hand over on demand all German nationals requested by the German government. This violation of the right of asylum provoked the creation of the Emergency Rescue Committee. The southern zone contained over a hundred concentration camps for interning foreigners, which included German surrealists Max Ernst, who had lived in France since 1922, and Hans Bellmer. Soutine's companion Gerda Groth was interned, though one would think that a Jew who had fled from Hitler's Germany would not pose much of a security threat. So many artists were interned at Les Milles camp, where Ernst and Bellmer were held, that forty of them got together to decorate the walls of the camp with murals.[18] These internment camps run first by the government of the Third Republic and then by Vichy became transit camps once the Holocaust got underway in 1942. From August 7 to September 5, 1942, internees held in the camps at Les Milles, Gurs, and elsewhere in the free zone went by train to Drancy, on the northern outskirts of Paris, from which they were dispatched to the death camps in Poland.

Even after Vichy forced Varian Fry to leave France, the activities of the American Rescue Committee did not end. Mané-Katz, Zadkine, and Kisling all left France after his departure.[19] The final client of the committee was Marcel Duchamp, who did not depart Marseilles until May 1942.[20] Why did they leave Chaim Soutine behind? After Gerda Groth was sent to Gurs internment camp in the Pyrenees on May 15, 1940, Soutine remained in Paris for medical reasons. He was still there in November when he met Marie-Berthe Aurenche, former wife of Max Ernst, at the Café Flore. They would live together for the rest of his life, moving to a village in Touraine in the occupied zone. He was required to wear the yellow star beginning in 1942. He also obediently registered with the police as a Jew. His friend and fellow artist Chana Orloff wrote after the war that

Soutine did realize the importance of getting out of France but when he approached the American Embassy, he made no headway because he could not produce a single identity paper.[21] Unlike Chagall, Lipchitz, and Kisling, all French citizens, Soutine was stateless, and all successful refugees required a lot of paperwork. Not only did one need to obtain an entry visa for the U.S.; one also needed an exit visa from France and transit visas for the neutral countries such as Spain and Portugal through which one passed. One also needed sponsors in the U.S. who would guarantee one's finances. Soutine lacked not money but documentation. The police kept track of his whereabouts; a report dated March 18, 1942 gave his permanent address as 18 villa Seurat in Paris but reported that he had been in a *maison de santé* (convalescent home) in the department of Seine-et-Oise since December 1941, which, if true, differs from the standard biographies. He died on a Parisian operating table in July 1943. The police also reported on the address of Madame Orloff,[22] also in danger, but she managed to get herself and her disabled son into Switzerland and so survived.

Other Jewish artists managed to live quietly, usually in out-of-the-way towns in southern France, without attracting attention. Such was the case for Sonia Delaunay, Michel Kikoïne, Léon Zack, Alice Halicka, Mela Muter, and Marevna Vorobëv. Mela Muter, the oldest of these artists at age sixty-five in 1941, spent the war years at a Catholic girls' school, the Collège St. Marie, in the southern city of Avignon, where she taught drawing and art history.[23] Since Muter had converted to Catholicism in 1924, the Church was probably more eager to employ and protect her than if she had remained a practicing Jew. Like Halicka, Sonia Delaunay had been widowed in 1941; she found a refuge in the southeast town of Grasse, center of the French perfume industry. She lived with several artists, including the married couple Hans Arp and Sophie Tauber. Tauber was Swiss but Arp was Alsatian, and since Alsace had been annexed to Germany, he was now nominally German. They eventually moved to Switzerland for safety, but Sonia remained in Grasse, living in and taking care of the Arps' house. Living with other artists helped sustain creativity in difficult circumstances. Sonia worked especially in gouache, an opaque watercolor medium, in relatively small formats.[24] Another artist who joined them in Grasse was Ferdinand Springer, born in Berlin and living in France since 1928, who had been interned as an enemy alien. He too fled to Switzerland in 1942 when the Germans occupied all of France, but remembered Grasse so fondly that he returned in later life and died there in 1998. Another member of the Grasse group was Alberto Magnelli (1888–1971), an Italian anti-fascist working in Paris, whose wife Susi was Jewish. Artists had a variety of reasons for evading Vichy and the Germans. Sonia

Delaunay was not very conscious of her Jewish heritage, but the curator of the Grenoble Museum reminded her about it in 1942, when she met with him to discuss the possibility of selling one of Robert Delaunay's paintings. The curator mentioned that the authorities had confiscated all of Ossip Zadkine's sculptures, and asked her if she had encountered any similar problems.[25]

The third group of Jewish artists includes those who failed to flee from occupied France and were unable to lie low and evade detection. Those who were deported to the death camps of Poland were less likely to have been naturalized as French citizens, less likely to be acculturated to French language and culture, and hence easier for the Vichy authorities to round up and hand over to the Germans. Three-quarters of the Jews who were deported from France between March 1942 and July 1944 were foreign born, which meant that French citizenship helped but did not guarantee safety. Vichy Prime Minister Pierre Laval knew it was unpopular to deport French citizens and preferred to hand over aliens to his German masters. Hersch Fenster was one of those foreign-born Jews interned by Vichy who managed to survive. We know as much as we do about the deported artists of the Ecole de Paris through his efforts. Fenster was born in Galicia, in the Austro-Hungarian Empire, in 1892, and by the time he arrived in Paris in the 1920s was a Yiddish scholar, anarchist, and vegetarian. He was a writer rather than a painter, who served at one point as the secretary to the noted Yiddish author Sholem Asch when Asch lived in Meudon, a suburb of Paris. Fenster knew many of the artists of Montparnasse personally. From 1937 to 1940, he ran the Foyer Amical or Friendship Center for Jewish refugees, which served meals and celebrated Jewish holidays. Fenster escaped to Switzerland, where the Swiss interned him in a camp. After the war, he researched the many artists who had not survived and published a book in 1951 titled (in Yiddish) *Undzere Farpainikte Kinstler* (Our Martyred Artists). He died in Paris in 1963.[26] Fenster's book is the main source for the list of deported artists included in the volume *Montparnasse Déporté: Artistes d'Europe* published by the Musée de Montparnasse, which also includes brief essays and examples of the work of some of these artists.

Relying on the list of deported artists as presented in *Montparnasse Déporté* is problematic. It includes some artists, such as Max Ernst, who were interned but not deported; furthermore, Ernst was not Jewish. It also includes French Resistance heroes such as Jean Moulin and Robert Desnos who were not artists, though Moulin made sketches and Desnos was a poet. Violette Rougier Le Cocq was another Resistance hero deported to the Ravensbruck women's camp, who made sketches of camp life there, which she later published. Limiting the list to Jews residing in France, nearly all of whom were deported (a few, such as Chaim

Soutine and Max Jacob, died in France but their deaths can be attributed to their plight as Jews), gives a total of 105 deported Jewish artists, of whom nine survived. Nine of these artists were women, six were French, and five more were born in France to parents who had recently immigrated. Of the rest, thirty-five were from the Russian Empire, which includes those from Lithuania and Ukraine. Forty-one were Polish, which includes Austrian, Russian, and German Poles. Among the rest, there were five Germans, seven Hungarians, three Czechs, one Slovak, and one Greek from Salonika. This breakdown by nationality suggests that foreign-born Jews were much more vulnerable to deportation than native-born French Jews, since 90 percent of the list was foreign born (artists were more likely to be foreign born than native French Jews).

There are a few other anomalies. Georges Kars was a Jewish artist from Prague who escaped to Switzerland, but committed suicide in 1945; he was a victim but was not deported. Lou Albert-Lasard, called Mabull, born in Metz in eastern France, was included because she was interned for three months at Gurs in the Pyrenees. Sigismond Kolos-Vary was Romanian, and spent two years at Gurs before escaping and making his way to Switzerland. Lili Rilik-Andrieu was a German Jew from a privileged background (her father was a friend of Albert Einstein) who was interned at Gurs, transferred to Les Milles in 1942, and hospitalized with typhus. Once cured, she joined the Resistance, survived the war, and died in San Diego in 1996. Similarly, Edith Auerbach, from Cologne, was interned in 1940, became ill, and was transferred to a prison hospital in Toulouse. She escaped and worked as a domestic for the rest of the war.[27] Polish-born Jesekiel Kirszenbaum was interned and his wife was deported, but he survived. Isis Kischka, born in Paris in 1908, spent two years in the Drancy transit camp, where he befriended several other artists, all of whom were deported. After the war in 1946 he participated in the Salon of Painters Witnesses of their Times. Ossip Lubitch, who had lived in Paris since 1923, had an equally unlikely route to survival in occupied Paris. He remained in Montparnasse during the war, in fact remained in his studio on the rue d'Odessa, where he continued to paint. He did not declare his Jewish identity to the police, and did not wear the yellow star decreed for all Jews in June 1942. Neighbors who coveted his studio denounced him; he was sent to the Drancy transit camp, and was released on August 18, 1944 upon the liberation of Paris. It is hard to understand how he evaded capture for so long. He returned to his studio and enjoyed a long life, dying in Paris at age ninety-three in 1990. Meyer-Miron Kodkine was not so lucky; he fled from Paris in the mass exodus of June 1940 and was killed on June 10 by a German bullet, having made it only 20 kilometers from the capital.

Few artist-deportees made it back to France after the war. Three who did
include Jacob Markiel and David Olère, who were deported to Auschwitz; both
survived the Nazi death march from Auschwitz in the winter of 1945. Boris
Taslitzky was born in Paris to Russian immigrant parents and survived
Buchenwald concentration camp. The commentary on Olère, who was born in
1902, suggests that he survived due to his drawing skills as well as to his
multilingual abilities—he spoke Polish, Russian, Yiddish, French, English, and
German.[28] A selection of Boris Taslitzky's drawings of the camp, titled *111
Buchenwald Drawings*, arrived in Paris before his own return and was published
in 1945. Markiel and Taslitzky were both born in 1911 and were thus younger
than many other deportees. Taslitzky was arrested for Resistance activities, so it
is possible the Germans did not know he was Jewish and so sent him to
Buchenwald in Germany, rather than to Auschwitz.[29] Both of these artists
enjoyed long lives: Markiel died in 2008 and Taslitzky in 2005. They must have
been the last witnesses of the Ecole de Paris as it had existed in interwar
Montparnasse. Grégoire Michonze spent two years in a POW camp in Germany,
but when he returned to Paris at the end of 1942 he was not harassed, nor was
his wife despite her Scottish origins.

It is more difficult dispassionately to consider the victims than it is the
survivors. This is a history of the Ecole de Paris; surveys of art of the Holocaust
already exist.[30] Artists who experienced the ghettos and concentration camps
and bore witness to life and death performed an invaluable service. My purpose
here is to record how the crisis of the Jewish people affected some of the artists
of the Ecole de Paris who experienced the Holocaust, some from a distance,
others directly. As with all victims of the Holocaust, one cannot read even brief
biographies of the artists who perished without mourning the loss of so much
talent and so much innocent humanity. Most of these artists were arrested by
French police, not by the Gestapo, which underscores their betrayal by the
country to which they had come with hopeful phrases echoing in their minds
such as "happy as God in France." France was not immune from antisemitism,
but since the French Revolution the state had defended Jews from the intolerance
of the Catholic Church and popular prejudice; now as the collaborationist Vichy
government handed them over to the Germans, many French people stepped in
to protect them (others denounced them to the police, as happened to Charlotte
Salomon in 1943). Most of the artist-victims were less well known and established
than were the artists who survived. The great majority of those deported arrived
in Paris in the interwar period, but that does not make them recent arrivals;
many had lived in France for fifteen to twenty years, long enough to become

acculturated. Some had been there longer. The most colorful character was probably Samuel Granovsky, who arrived in Paris in 1909 from Ukraine and was called the Cowboy of Montparnasse. Tall and handsome, he worked as an artist's model as well as a painter, appeared as an extra in a film, and continued to wear his cowboy clothes and even occasionally to ride a horse in his daily life. The French police arrested him on July 17 during the Vel d'Hiv roundup, and he was sent to Auschwitz five days later. Otto Freundlich first came to Paris a year earlier, in 1908, and spent a year in the Bateau Lavoir in Montmartre with Picasso. He was sixty-five years old when he was deported in 1943. His notoriety hurt him, since the Nazis had featured his 1912 sculpture *The New Man* on the catalog cover of the Degenerate Art show, yet he was not famous enough to merit an American sponsor or a place on Varian Fry's list.

In the early 1920s, four Jewish artists from Galicia made their way to Paris. Most knew each other previously, in Berlin, where they studied with Alexander Archipenko. Sigmund Menkès, Alfred Aberdam, Joachim Weingart, and Léon Weissberg exhibited together, and these close friends became known as the Group of Four. Their subsequent fates varied widely. Menkès left for New York in 1935, and lived to age ninety. While Aberdam stayed in Paris and survived, Weingart was swept up in the Vel d'Hiv roundup and sent to Auschwitz. Weissberg moved to the south of France in the 1930s and was not arrested until 1943. Léon Weissberg was not famous like Chagall or Soutine but he was not a marginal figure in Montparnasse. One critic wrote, "To speak of the painting of Léon Weissberg is to evoke interwar Montparnasse. His subtle expressionism radiates . . . A great freedom characterizes his paintings . . . marked by a profound humanism."[31]

Another skilled painter who worked in an expressionist style was Henri Epstein, who arrived in Paris in 1912 from Poland at the age of twenty and lived at La Ruche. In the 1920s, he showed regularly at all the "alternative" salons, and married the daughter of a French artist. He and his wife bought a farm near Epernon, southwest of Paris, but still in the occupied zone. He managed to escape detection until early in 1944, when three Gestapo agents found him. He was deported on March 7, by which time he had lived in France for over thirty years.

In 1940, the French Catholic composer Olivier Messaien (1908–92) was a prisoner of war in Silesia. He found other prisoners who could play the violin, cello, and clarinet, and composed a quartet for them, with himself playing piano. They first performed the piece for the assembled French prisoners in January 1941 in freezing conditions on instruments of poor quality—the piano keys did

not return, the cello only had three strings, and Messaien wore wooden clogs and a threadbare jacket at the performance. He called the composition *Quartet for the End of Time*, alluding to a phrase from the Book of Revelation as well as to the unusual rhythms of the piece, which he wrote to "banish the temporal." The relevant text from Revelation spoke of an angel who "lifted up his hand to heaven. And swore by him who lives forever and ever saying there should be time no longer."[32] The piece included eight movements, with the last called "Praise for Immortality," and concluded by invoking "immobility, fixity, abolition of time."[33] Messaien was released later that year; as a POW he had less reason to harbor apocalyptic thoughts than would a Holocaust victim, though living conditions were harsh. Much more than conventional war, the Holocaust must have appeared like the end time to many Jews and to other victims of Nazi brutality who were marked for destruction. Apocalypse is more a Christian than Jewish mode of thought, most famously invoked in the Book of Revelation in the New Testament. Jews are messianic rather than apocalyptic, though they too might expect that redemption might ensue after a period of suffering.[34]

If Jewish artists were preoccupied with time (as argued in the opening chapter), would their confrontation with the Nazi effort to exterminate the Jewish people diminish normal concerns with temporality? Would Jewish artists abandon the representation of nature and historical reality, and seek symbolic modes of representation that evoked this existential crisis in the apocalyptic terms that Messaien sought in music? Would artists who had fled persecution in tsarist Russia and elsewhere in Eastern Europe, only to encounter it again in even deadlier form, turn from the celebration of life to musings about death?

Marc Chagall adopted the Christian embodiment of suffering and martyrdom in Christ on the cross in these years of trauma, dispossession, and death. One might wonder why a Jewish artist would repeatedly paint images of crucifixion. Chagall made it clear that his Jesus on the cross was a Jew by wrapping his loins in a Jewish prayer cloth or tallis. Nazi persecution accelerated Chagall's sense of Jewish suffering, but a younger Marc Chagall had experienced prejudice in his native Russia. As early as 1912, not long after he arrived in Paris, he portrayed an innocent child on the cross in his painting *Golgotha*. This may have been in reaction to the infamous Mendel Beilis case back in Chagall's homeland. Beilis had been arrested in 1911, accused of killing a Christian child to use its blood for Jewish rituals.[35]

Nazi hatred of the Jews heightened Chagall's awareness of Jewish martyrdom. The motif of the Jewish Christ depicted before the war in *White Crucifixion* was

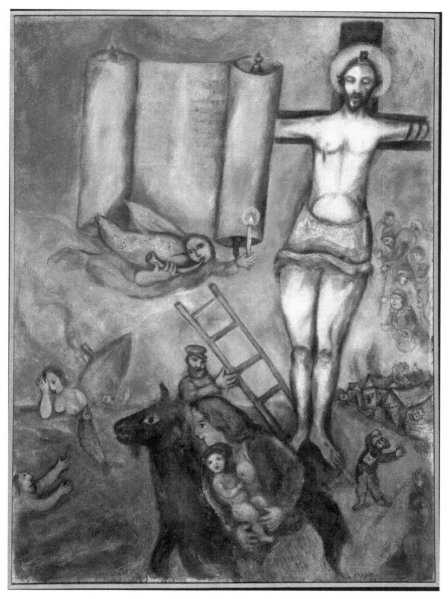

**Figure 8.2**  Marc Chagall, *Yellow Crucifixion*, 1943. CNAC/MNAM/Dist. RMN-Grand Palais/Art Resource, New York, AM 1988–74. Photo: Philippe Migeat. 2021. Artists Rights Society (ARS), New York/ADAGP, Paris.

repeated over the following decade. *White Crucifixion* dates from 1938 and is often linked with Kristallnacht, but Chagall may have been responding to synagogue burnings in Munich and Nuremberg earlier that same year.[36] Chagall's most famous response to his tortured times registered his reaction to political events that placed Jewish suffering at the center of history. Chagall was only getting started. His years in American exile correspond to those of the Holocaust and its aftermath. *Yellow Crucifixion* of 1943 showed Jesus wearing phylacteries as well as his prayer shawl-loincloth, a Torah scroll open beside him. In *Obsession* of that same year, Chagall reacted to the destruction of the Warsaw ghetto by showing a green Jesus lying helpless in the burning ghetto. In one painting called simply *The Crucified*, painted at the height of the Holocaust in 1944, he even abandoned the image of Christ and simply showed Jews hung on crosses in their own shtetl, with more bodies lying on the ground. In the background, a disproportionally outsized man sits on a house and watches over the scene. The seated figure might represent a Russian peasant, but he could also be God. This painting may have been Chagall's response to the news that Vitebsk, his hometown, had been destroyed.[37] In *Ghetto*, renamed *Resistance*, completed in 1948, souls float through the orange-red background as in Dante's Inferno. Some are refugees, others are resistance fighters come to protect them; the artist places himself at the foot of the cross.[38]

A Chagall show at the Jewish Museum in New York in 2013–14 featured no fewer than eighteen works with crucifixion themes from these years. Over the course of a decade, Chagall produced more than two dozen works depicting the Crucifixion.[39] One painting, completed after the war in 1947, shows a bright red *Flayed Ox* hanging in front of a Russian village, inescapably reminiscent of Soutine; he may also have been influenced by the fact that his uncle and grandfather were butchers.[40] More typical for Chagall, a Hasidic angel flies over the town. Chagall's dead ox suggests the end of time in the sacrifice of life, whereas Soutine's succession of painted carcasses done in the 1920s celebrated the act of painting, hence the power of expression.

While these exiled artists learned what was happening in Europe, few knew the full extent of the reality of the death camps. In terms of visual knowledge, they had not yet seen the photographs that were taken at the liberation of the camps in the spring of 1945. While Chagall presumably chose not to depict barbed wire encampments and starving prisoners, his imaginative freedom was empowered by the lack of received images. When he wrote a poem about the Holocaust five years after the war ended, he included precisely the sort of images that were by then widely available. He wrote:

I see: now they drag themselves along in tatters
Barefoot on mute roads . . .
Being led . . . to death in the crematoriums . . .
I see the fire, the smoke and the gas
Rising to the blue cloud and
Turning it black.
I see the plucked hair and teeth,
They cast my turbulent colors on me.
I stand in the desert before piles of boots,
Clothes, ash and rubbish and murmur my
*Kaddish.*[41]

The solemnity of Chagall's response to the catastrophe that had befallen the Ashkenazi Jewish community of his youth was personalized for him by the death of his wife Bella in 1944 during their American exile. For Marc Chagall, this series of visionary paintings would not in fact mark the end. The artist turned sixty in 1947, would live on for nearly forty more years in his adopted country of France, and would remarry twice in that time. His art did not remain dark; Chagall's personality was too ebullient, making these somber paintings of the Holocaust distinctive.[42] Chagall in wartime brings to mind Goya's brooding and surreal dark paintings after living through the trauma of the guerrilla war in Spain against Napoleon. Darkness descended on Chagall and his people, but perhaps he like others perceived the creation of a Jewish state in the land of Zion in 1948, the year he returned to France, as a sort of redemption or resurrection brought on by the immense suffering of the Holocaust. The cycle of crucifixion scenes culminated in *Liberation*, completed in 1952, with the Christ figure replaced now by the Chagallian violinist, with other musicians adding to the joyful sounds. Below this musical apotheosis lies Chagall with his new bride; alongside them a lit candelabra suggests that life continues.

Chagall's religious and metaphorical response to the Holocaust bears comparison with that of another Jewish artist who arrived in New York in 1940 after spending twenty years in Paris. In the case of Abraham Rattner (1893–1978), this was a homecoming, as he was American by birth. Rattner arrived in France as a soldier in World War I, which he spent designing camouflage for the artillery. He returned to France in 1920 and stayed until the next war forced his repatriation. He had a studio in Montmartre rather than Montparnasse, and married an American journalist in 1924. He befriended Henry Miller, which may have provided an entrée to the Jewish artists of Montparnasse. His Parisian art remained derivative. His best painting done in France, *Mother and Child*

(1938, now in the Museum of Modern Art, New York), shows the influence of both Picasso and Matisse. With the coming of war and Holocaust, and already in his forties, Abraham Rattner found his voice. His figurative expressionist paintings of the 1940s represent the summa of his career, and found a prestigious outlet when Paul Rosenberg gave him a one-man show in his New York gallery in May 1943, followed by subsequent shows in 1944, 1946, and 1948.

Like Chagall, Rattner identified personally with the crucified figures he depicted: "It is myself that is on the cross, though I am attempting to express a universal theme—man's inhumanity to man."[43] Chagall characteristically put it even more dramatically: "I run upstairs / To my dry brushes / And am crucified like Christ / Fixed with nails to the easel."[44] Mané-Katz, another Jewish artist in American exile, also painted an image of a Jewish Jesus in 1942 called *Now ye are brethren*. His Christ frees one arm from the cross, gesturing toward dead children lying at his feet along with a menorah and Torah scroll. Why did multiple Jewish artists suddenly include this theme in their work? Chagall in particular seems to have made a conscious choice to approach the Gentile population in a familiar visual language.

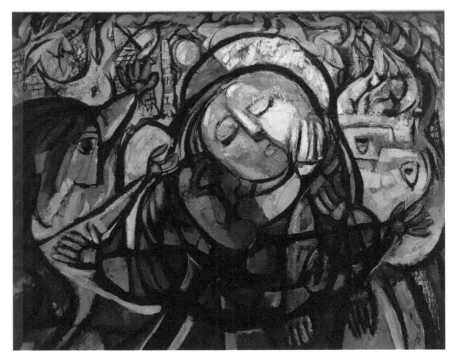

**Figure 8.3** Abraham Rattner, *The Air Raid*, 1943. Leepa-Rattner Museum of Art, St. Petersburg College, Tarpon Springs, Florida, 1997.1.1.14.

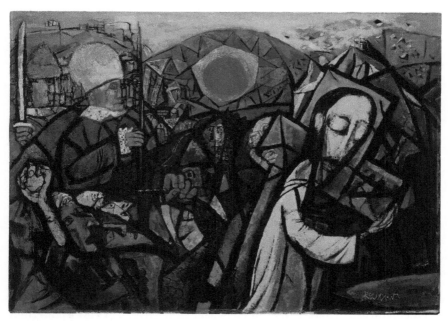

**Figure 8.4** Abraham Rattner, *Procession*, 1944. Ricardo Blanc. Hirschhorn Museum and Sculpture Garden, gift of Joseph H. Hirschhorn, 1966, 66.4184. Leepa-Rattner Museum of Art, St. Petersburg College, Tarpon Springs, Florida.

Further, by emphasizing that Christ was a Jew, these artists were trying to make their audience identify with the suffering that the Jewish people was experiencing. Later in life, Chagall explained, "For me, Christ has always symbolized the true type of the Jewish martyr. That is how I understood him in 1908 when I used this figure for the first time ... It was under the influence of the pogroms. Then I painted and drew him in pictures about ghettos, surrounded by Jewish troubles, by Jewish mothers, running terrified with little children in their arms."[45]

After absorbing cubism and surrealism, Abraham Rattner fused these styles with expressionism. All of these influences are visible in one of his most powerful works, *Darkness Fell over the Land*, painted in 1942. Mask-like faces, some holding candles in outstretched hands, parade across the bottom of the canvas, while a mostly white Christ figure dominates the center of the scene. Because he encloses the brightly colored images in black lines, the painting resembles leaded stained glass (Rattner, like Chagall, would turn to stained glass after the war, most notably for the Loop Synagogue in Chicago). In two other paintings from this period, *The Survivors* (1942) and *Apocalipsion* (1943), Rattner conveys chaos by means of fragmentation. *The Survivors* owes a debt to Picasso's *Guernica* in its anguished visages and reaching

hands. Its title is an ironic commentary on the sinking of the Jewish refugee ship *Struma* in the Black Sea, after having been refused the possibility of docking in Palestine. That same year Rattner painted *The Air Raid*, in which a female figure reminiscent of the Virgin Mary stands amid anguished eyewitnesses to man's inhumanity to man. *Apocalipsion* is somewhat less successful in juxtaposing chimneys, walls, arches, and other architectural details with a singing bird and a girl holding up a goblet in one hand and a laden plate of fruit in the other, as if to say that in all the madness there still might be hope.[46] In *The Judges*, also painted in 1943, Rattner presents a large-eyed and sorrowful Christ figure alongside more mask-like faces holding torches against a fragmented cityscape.

Expressionist paintings done later in the war, including *Lamentation, Martyr, Job, Procession*, and *Crucifixion* (all 1944) and *Christ and the Two Soldiers* and *Pietà* (1945) feature anguished figures, sometimes with hands clasped looking up to God for help. *Procession* (1944) depicts Christ carrying the cross against a backdrop of a fragmented Holy Land amid soldiers and faces, the calm Christ figure contrasting with the disjointed hands, heads, and swords of the scene.[47] Rattner returned to some of these themes later, as in *Job No. 2* (1948), a powerfully expressive figure who appears almost sculptural, and a third *Job* from 1950 whose bright colors and fragmented forms suggest stained glass. The Book of Job in the Old Testament demands to know why the righteous suffer. Job and Christ are both icons of suffering humanity; Rattner employed both figures to respond to the crises of his times. His later work turned more abstract, but still included references to Moses, Job, Esther, and other biblical figures. Several works evoked Ezekiel and the Valley of Dried Bones on a large scale, and a late work (1964) titled *Two Personages* shows the artist, palette and brushes in hand, standing before a Christ with outstretched arms, as if recognizing the degree to which he owed his career to images of pathos and suffering. Chagall did a similar painting in 1945 called *The Soul of the City*, in which he faces a canvas on which he has painted a tallis-wrapped Christ, while also looking backwards toward the wraith of his recently deceased wife. The effect of these frequent allusions to a suffering Jesus by Jewish artists was to emphasize a hyphenated Judeo-Christian civilization under threat by an ideology that elevated nation and race over all humane values.

A third Jewish artist who responded powerfully and effectively to the personal crisis of dislocation as well as the public one that led to exile was Jacques Lipchitz. Like Chagall, he continued themes present in his work from the 1930s, including the use of mythological motifs such as Prometheus and Europa. Lipchitz did not employ the crucifixion to suggest suffering, but instead sought specifically Jewish ritual practices of sacrifice. The 1938 version of the *Rape of Europa* showed how,

in the artist's words, "the conflict and terror ... is here transformed into erotic love."[48] By 1941, he saw his *Rape of Europa* "in a quite different context, the Europa as a symbol for Europe and the bull as Hitler, with Europe killing Hitler with a dagger."[49] Lipchitz also reworked the *Prometheus Strangling the Vulture* that had aroused such controversy at the 1937 Paris Exposition, with the forms becoming more fluid, dynamic, and interfused. Though geographically removed from the conflict in New York, the sculptor was no longer able to distance his aesthetic sensibility from this new world crisis.

**Figure 8.5** Jacques Lipchitz, *The Prayer*, 1943. Philadelphia Museum of Art, 1965-207-1, Estate of Jacques Lipchitz, courtesy Marlborough Gallery, New York.

The rise of Nazism in the 1930s profoundly affected Lipchitz's art; the move to America changed him again. As with Chagall and Rattner, Lipchitz responded not with disorientation or depression but with extraordinary energy. He produced some of his best and most powerful work, which influenced him personally as well as artistically. When he and his wife Berthe visited France in 1946, he decided to return to the U.S. while she remained in France. He soon remarried, and was overjoyed when his new wife presented him with a daughter when he was fifty-seven years old. Of the early war years, Lipchitz recalled being "in a state of physical excitement."[50] In 1942, he did *Benediction I*, which resembles a Henry Moore sculpture, complete with holes piercing its biomorphic form. He based it not on a prayer but on a lullaby sung by a mother rocking a cradle, which sends a message of hope. More anguished is *The Suppliant* from 1943, where a woman, her body twisted, raises her clasped arms in the air and looks to heaven for help. This piece continues Lipchitz's expressionist works of the late 1930s.

After exploring various mythological themes, the Lithuanian-born sculptor chose a uniquely Orthodox Jewish ritual to express his solidarity with the beleaguered Jews of Eastern Europe. *The Prayer* dates from 1943, and resembles neither his earlier cubist sculptures nor later pieces comprised of globular rounded forms. It resembled a sculpture he made a year earlier called *The Pilgrim*, which showed a spiky figure whose opened belly revealed his intestines. *The Prayer* shows a man, his head and shoulders covered by a prayer shawl, holding a cock overhead. Here too the man's intestines are exposed, and the rest of the figure exudes a nervous energy. The man is symbolically transferring his sins to the rooster, which he holds overhead and swings in a circle. This ritual practice, called *Kapparot*, appeared in neither the Torah nor the Talmud. Though some Jewish scholars condemned it, the practice found favor with more mystical Kabbalists.[51] Lipchitz evidently remembered it from his childhood. In his memoirs he called it "the first attempt I can recall at a specifically Jewish theme," though that discounts the biblical story of David and Goliath he had evoked a decade earlier.[52] He explained, "The figure is not a rabbi; it is Everyman, every Jew who has to do this, who is asking for forgiveness. The figure is completely disemboweled . . . The entire subject is the Jewish people, whom I thought of as the innocent victims in this horrible war . . . It had something to do with the horror I felt about Auschwitz and the other Nazi concentration camps."[53] Making it was itself a form of prayer meant to help rescue the Jews of Europe. He depicted the expiatory sacrifice as a kind of magic, art returned to its ancient ritual function.

In 1948, Lipchitz returned to the theme in a sculpture called *Sacrifice*, but unlike the terrifying earlier piece made at the height of the Holocaust, the later

work is smooth and monumental, and the man clasps the rooster in his hands rather than whirling it overhead. In *Sacrifice*, we see the man stabbing the rooster with a dagger, as if this is an Old Testament version of his Prometheus.[54] This work, so different in appearance from the wartime evocation of sacrifice and ritual slaughter, coincides with the creation of the state of Israel. This sacrifice shelters a lamb placed beneath the man and the fowl, signifying hope for rebirth. For these artists, exile (or displacement in the case of Rattner) reinforced crisis in bringing forth some of their best work. Removed from immediate personal danger, they rose to to the challenge of representing the anguish of their people.

For the artists who remained in France, the situation was markedly different. No one artist is typical, nor did they experience the fall of France and internal emigration the same way. The story of one of these lesser-known artists may stand for the plight of many of them. Léon (born Leibusz) Weissberg was typical of the artists of interwar Paris who arrived after World War I. Born in Galicia in the Austro-Hungarian Empire in 1895, he came to Paris in 1923 after studying art in Munich, Dresden, and Berlin. He was among the martyred artists recorded by Hersh Fenster and thus appears in the volume *Montparnasse Déporté*, but is not included in most books devoted to the art of the Holocaust, such as the synoptic and exhaustive book by Ziva Amishai-Maisels, *Depiction and Interpretation: The Influence of the Holocaust on the Visual Arts*. The reason he is not so included is that he was killed at Majdanek on the day he arrived, March 11, 1943; two days after Otto Freundlich met the same fate at the same extermination camp. However, he spent nearly three years as a refugee from the war in the south of France. How did the experience of hiding affect an immigrant Jewish artist?

After two years in Paris, Weissberg began showing his work with three other painters from Galicia. Though Weissberg showed his work at the gallery Au Sacre du Printemps in 1925–6 with his compatriots as well as at the various salons, life was not easy for him. He came from a relatively privileged background and his father had sent him to Vienna to study medicine or law. When he chose an artistic vocation, his father cut him off, and Weissberg supported himself with odd jobs. He married another Jewish immigrant in 1925 but she left him seven years later, at which point he left Paris for two years for St. Paul de Vence in Provence. When he returned, he took over the studio that Sigmund Menkès was vacating at 2 bis rue Perrel in Montparnasse. This was a workshop with a history; it had been the former studio of the Douanier Rousseau, and it would be reoccupied in 1944 by a third Jewish artist, the Romanian surrealist Victor Brauner.[55] In 1940, Weissberg fled south, to Rodez near the Pyrenees, and the French police sent him to live in a nearby village. During the cold winter of 1941,

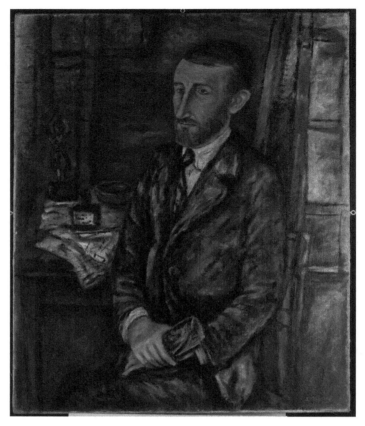

**Figure 8.6** Léon Weissberg, *Portrait of the merchant Léopold Zborowski*, 1926. MAHJ, 2002.39.005. Photo: Jean-Gilles Berizzi, RMN-Grand Palais/Art Resource, New York. 2021 Artists Rights Society (ARS), New York.

with no heat, he contracted a pulmonary abscess, which put him in the hospital for half a year. When he recovered, he moved to the small town of Entraygues, in the same southwestern region, and lived there until the French gendarmes arrived at his door on February 18, 1943. They interned him at the Gurs prison camp, sent him on to Drancy on March 2, and then made him board a train to Poland on March 6, on Convoy number 51.[56] Like so many other Jews, he was betrayed by the collaborationist French government, which by 1943 had neither autonomy nor rationale as the Germans occupied all of France.

As with so many young Eastern European Jews who came to Paris in these years, Weissberg was eager to integrate into French life. He painted still lives, landscapes, and portraits mostly in a moderate expressionist style, though two landscapes he did in 1928 are so strongly impressionist that he must have been

viewing the works of Monet and Pissarro, then displayed at the Musée du Luxembourg. His best-known painting was *The Jewish Bride*, painted in 1926 and unusual in that most of his work did not focus on explicitly Jewish themes. The Yiddish writer Shalom Asch, who saw it at the salon and was struck by its resemblance to Rembrandt's painting *The Jewish Fiancée*, allegedly bequeathed the title of this work. The pensive woman painted by Weissberg is partially nude but a veil that falls to her wrists covers her hair.[57] The bride's garments, the space around her, and the flowers in her hand are rendered in subtle, shimmering shades. Weissberg painted a portrait of the art dealer Leopold Zborowski in a conventional realist style, some time before Zborowski's premature death in 1932.

Weissberg's interwar work, including the few sculpted heads he did in the 1930s, was not distinctive. Then he worked in isolation at Entraygues-sur-Truyère in 1941–2, and his style evolved definitively. The landscapes he did there are far more abstract and evocative, not as wild as Soutine's but moving in that direction. This is true of his still lives and portraits too. Something drove him to paint a portrait of the nineteenth-century poet Arthur Rimbaud in 1942, and powerfully evoked the young bohemian. Weissberg painted with a freedom that had been lacking back in his Paris studio. In 1942, he painted repeatedly and obsessively a theme that he had hardly explored before, and a subject that one would not immediately associate with the experience of living in hiding. He painted clowns, sometimes by themselves, often with female partners called singers or riders (*écuyères*), though he included no horses. The style now is entirely his own, which might bear comparison with the impasto of Georges Rouault. These are small-scaled works painted on whatever base the artist could find, including plywood and even cardboard. They are charming and somewhat melancholy.

The *Old Clown* caps the series. In this self-portrait as clown, Weissberg portrayed himself as a bitter old jester, the face lined and the expression pensive. The circus theme now appears as a flight of escapist fancy, as if once the tent came down one was forced to face reality, and the clown costume frames that reality in a new way. These paintings reflect the isolation of this artist. Rather than painting epic or cosmological themes, he created small-scale works of great intimacy, which convey anguish in their own way.[58] In his last year of life, Léon Weissberg became a painter of genius who rose to the occasion in the way open to him. One is reminded of Jean-Paul Sartre's famous quip that was meant to evoke existentialist philosophy: "Never were we freer than under the German occupation."[59] Sartre meant that in suffering one had to choose, had to face life and death. Weissberg embodied Sartre's adage in the mastery he displayed while living in the shadows.

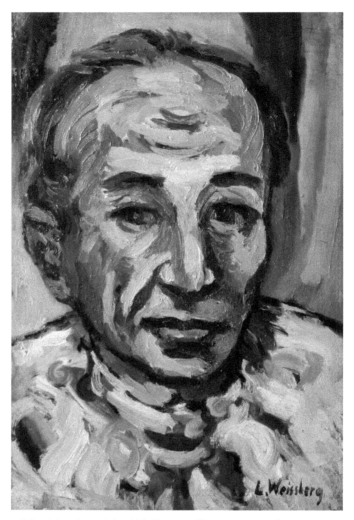

**Figure 8.7** Léon Weissberg, *The Old Clown, Self-portrait as a clown*, 1942. MAHJ 2002.39.004. 2021. Artists Rights Society (ARS), New York.

Weissberg's clowns are distinct from the people one sees in everyday life because they are made up, their faces covered in paint. These paintings, especially his self-portrait as a melancholy clown, bear comparison with those of another Jewish refugee. Felix Nussbaum was a German Jew, born in 1904, who fled Germany after the Nazi takeover and by 1935 had settled in Belgium after exploring Paris as a possible refuge. The year that he and his companion, Felka Platek, settled in Belgium, Nussbaum began painting masks, some sitting on tables as part of a still life, sometimes worn by him and others. One titled *Painter*

*with Mask* shows him with his easel in his hand, wearing a green pullover, which for him stood for the color of death. Another, called *Masks and Cat*, show three mask-wearing men, one of whom, Nussbaum, wears an artist's beret and holds a palette whose colors had dried up.

These haunting pictures signify his new life as a refugee, who needed to resort to disguises to cloak his identity as a Jew.[60] Masks are not identical to clownish greasepaint, but the comparison is suggestive. When Weissberg went into hiding in the south of France, he explored images in which the person's identity was hidden, yet under the façade the person remained. The painted disguises failed in both cases; Felix Nussbaum and Felka Platek were betrayed in their hiding place in Brussels, and were sent to their deaths in Auschwitz at the end of July 1944 on the last transport out of Belgium. His last known painting was a surrealist take on the medieval dance of death, called *The Triumph of Death*.

The contrast could hardly be greater between the wartime work of Léon Weissberg and Boris Taslitzky, one of a handful of Jews who returned from the camps. A generation younger than most of the artists discussed here, Taslitzky was also one of the very few to survive into the twenty-first century. He was a politically committed artist during the militant 1930s and the calamitous 1940s. Where Weissberg's art was personal and quiet, Taslitzky's was public and insistent.

Boris Taslitzky was born in Paris in 1911 to parents who had fled the failed Russian Revolution of 1905; he died a century after that revolution. At the age of fifteen he was already frequenting Montparnasse, taking art classes at some of the studios there before enrolling at the Ecole des Beaux-Arts in 1928. In 1933, he joined the Association of Revolutionary Artists and Writers, and two years later joined the Communist Party. He fought for France in 1940, escaped from captivity after his regiment surrendered to the Germans, and joined the Resistance. He was arrested in November 1941, at a time when very few French were actively involved in the Resistance, and sentenced to two years imprisonment. On July 31, 1944, he was deported to Buchenwald concentration camp. The late date plus his relative youth may explain why he survived, plus the fact that Buchenwald, near Weimar, Germany, was a labor camp, with most prisoners working in armaments factories. His mother, less fortunate, died at Auschwitz. That Buchenwald was not a death camp made it more feasible for Taslitzky to make a couple of hundred drawings of his fellow inmates, mostly shown in moments of leisure and individually or in small groups. Some of these pencil sketches may date from his time in the French internment camps. *Along the Barbed Wire* shows five men standing, some looking out through the multiple strands of barbed wire fence. *Sleeping in the Boxes* shows men jumbled together

**Figure 8.8** Boris Taslitzky, *The Little Camp at Buchenwald*, 1945. AM2743P. CNAC/MNAM/Dist. RMN-Grand Palais/Art Resource, New York. Photo: Adam

in the stacked bunk beds made famous in photographs taken when the camps were liberated in 1945. These undramatic naturalistic drawings document reality.

That objectivity changed in the winter of 1945 as conditions deteriorated, camp discipline broke down, and deaths from starvation and disease mounted. Now Taslitzky showed carts containing gaunt bodies and survivors mingling with corpses.[61] These later drawings became the basis for the large-scale painting, three meters in height by five meters in length that he did when he returned to Paris after soldiers in Patton's Third Army liberated Buchenwald on April 11. He finished the painting, the most memorable in his career, in six months, while the experience was still fresh in his mind. In *The Little Camp of Buchenwald*, corpses abound, with prisoners in cloaks and striped clothes accompanied by demonic looking dogs and cats. The expressionist style that Taslitzky employed in the oil painting enhances the horror. The prisoners' striped uniforms echo the gaunt corpses' rib cages.[62] A lone guard is visible at the far left; in the opposite corner in the foreground, a child contemplates an upside-down corpse. The effect is like viewing a late medieval dance of death set in the twentieth century. The *Danse Macabre* theme persisted in the Reformation, best represented perhaps by Pieter Breughel the Elder's *Triumph of Death* from 1562 (echoed also in Nussbaum's great painting of 1944). As with Taslitsky's Holocaust, so in Breughel, myriad bodies are lying on the ground along with scavenging dogs. His Flemish predecessor Hieronymus Bosch, the master of hellish landscapes in which demons manipulate tiny figures, in turn influenced Breughel. When Taslitzky made a copy of his painting for the Israeli Holocaust memorial Yad Vashem thirty-six years later, he toned down the expressionist quality of the original, making the figures less skeletal, the whole work less intense.[63] The 1945 *Totentanz*, arguably the greatest painterly evocation of the Holocaust, gains further authority due to the artist's status as a survivor. His expressionist rendering of the figures, the vivid reds and yellows, the crowds of waiting prisoners in the background, and the large scale of the whole make *Little Camp of Buchenwald* a searing indictment that uses the forms of modernism to ask how such pre-modern brutality could have happened. That Taslitzky had the fortitude to execute this major work immediately upon his release from Buchenwald exemplifies Jewish determination not to let the world forget what the Germans had done.

Taslitzky was a friend of the Resistance fighter and Communist Party leader Laurent Casanova, whose activist wife Danielle died in Auschwitz in May 1943. Five years after completing *Buchenwald*, he painted another concentration camp painting, *The Death of Danielle Casanova*.[64] Here too gaunt bodies are crowded among the living in the crude barracks. In the center of the painting, Taslitzky placed the body of Danielle dressed symbolically in the white of martyrdom.

Most of her fellow female inmates have struck positions of grief. Taslitzky explained why he eschewed any attempt at realism:

> Danielle did not die in the midst of her companions. It would have been treason, however, to paint her in solitude. The truth is the branch of lilac [that she clutches]. I did not make a historical reconstruction ... Why? Traditionally, one gives this dress to virgins, to saints ... One could say that the whole subject is religious.[65]

Didacticism makes this painting less effective than the scene of Buchenwald. The martyrdom of victims of the Holocaust seems weakened by cladding them in white or giving them halos.

The story of artist and Holocaust survivor David Olère is even more extraordinary than that of Boris Taslitzky. Born in Warsaw in 1902, he left Poland for Danzig and Berlin at the end of World War I, and then moved to Paris in 1923. In France, he worked as a commercial artist, designing sets, costumes, and publicity posters for films. Olère married in 1930 and had a son, Alexandre, who became a poet and novelist after the war, and produced an anthology of his father's drawings and paintings, to which he added his own poetry and commentary.[66] In a foreword to *Witness*, the French Nazi hunter Serge Klarsfeld wrote that "David Olère is the only artist in the world who survived working in the crematorium of Auschwitz-Birkenau with the will and the talent to deliver a visual and accurate testimony."[67] Arrested by the French police on February 20, 1943, the Germans deported Olère from Drancy internment camp to Auschwitz on March 2. There he worked as a trench digger, then as a *Sonderkommando* in Crematorium III, where he emptied the gas chambers and burned the bodies of his fellow Jews. Not only did Olère endure this experience for nearly two years, but he also survived the death march on which he embarked in the harsh winter of January 1945.

Immediately after being liberated by the U.S. army on May 6, 1945, he began sketching the horrors he had witnessed. Like Taslitsky, he returned to Paris and turned some of his drawings into paintings. One such work is a self-portrait in prisoner garb, with his concentration camp number, 106144, displayed prominently on his forearm. The artist did not avoid depicting the grim reality he lived through, but some of the most affecting pictures are unexpected, such as *Verboten* (Forbidden), which shows the last Christmas Eve at Auschwitz. One group of prisoners kneels before a cross, while Jews gather to pray around a Jewish star. Another prisoner watches for guards, making it clear that inter-denominational services were forbidden. Other drawings depict prisoners

forced to troop before bodies hung from a scaffold, with the caption "they tried to escape," and the death march, which commenced on January 19, Olère's forty-third birthday. A painting called *Fair haired girls from Poland* shows prisoners sorting and packing up long blond hair. The most painfully evocative painting in the collection shows *Asphyxiation in the gas chamber*, with men, women, and children (held in their mothers' arms) with mouths open, surrounded by blue-tinged gas. A drawing on which this painting was based is reproduced at the end of *Witness*, with the artist in his later years standing alongside it.[68] The painted version of *Asphyxiation* leaves out narrative elements included in the drawing, such as a canister labeled "Zyklon B." This may have been the only image that Olère did not actually witness himself, and therefore felt freer to imagine. Olère died in Paris at the age of eighty-three—according to his son, he died not from disease but from despair at hearing that Holocaust deniers claimed that the genocide he had witnessed was Zionist propaganda.

These few representative artists allow us to see how their responses to the Holocaust differed due to their varying life stories, depending on whether they were able to escape Nazi-occupied Europe, to seek shelter away from Paris in the south of France, or to endure in the concentration camps. Artists in America, such as Chagall, Rattner, and Lipchitz, knew what was happening but, at least while the war was underway, could not witness it directly, and so chose to represent the suffering of the Jewish people symbolically. Artists like Sonia Delaunay and Léon Weissberg living in the south of France were less likely than artists in America to know what was going on, so although they were more endangered, their response to the war was likely to be less direct. When Boris Taslitzky was incarcerated, he produced drawings of his fellow prisoners; when he returned to France and turned those drawings into paintings, he turned away from realism but still portrayed the interior of the camps and especially the victims, some as prisoners and some as corpses. David Olère's work shows the artist confronting the momentous events of his time, culminating in the triumph of art over death. The hand of death weighs on these works, with the exception of Weissberg, whom death found in person.

Marc Chagall was able to record the passage of time, both because he had the good fortune to have so much of it available to him and because he lived through anguishing times. He painted numerous works containing timepieces, and did a series of martyred Christs, a symbolic motif that seemed to transcend time. In some of his immediate postwar paintings, time and eternity met. Chagall had been working on *The Falling Angel* for decades, as if time inhered in the theme itself. He began it in 1923 just after he had left Russia for Western Europe, and he returned to

**Figure 8.9** Marc Chagall, *The Falling Angel*, 1947. Private collection/ Kunstmuseum Basel. 2021 Artists Rights Society (ARS), New York/ADAGP, Paris.

it in a series of 1934 studies, after the Nazis had taken over Germany and begun persecuting Jews. In one 1934 version, the angel holds what appears to be the tablets of the law in her hands, and she falls toward the Jewish Jesus on the cross, wearing the phylacteries of Orthodox practice.[69] A gouache done the same year is closer to the final version of the painting, and now includes the falling clock. The completed painting of 1947 darkens the background, as night falls over the shtetls of Eastern Europe. The bright red angel dominates the space, hurtling like a fiery torch down to the earth, where a much smaller Christ-figure rises on the cross. Falling with the angel is the familiar clock that hung in his childhood home four decades earlier, a home that no longer existed with the destruction of Vitebsk in World War II. In contrast to the beatific *Time is a River without Banks*, in which a fish glides over the landscape carrying the clock more or less horizontally, this one is plummeting to earth and destruction, signified by the bearded Jew saving the scrolls of the Torah. A tiny wandering Jew makes his escape from the village, just beneath the violin that always recalled the old country.[70] Another Chagall work from that same year, 1947, conjoins clock and crucifixion. *Self-portrait with Clock* (see Figure 1.4) shows a clock with outstretched hands—literally, as human hands emerge from the cabinet—overhead, as the artist—part human, part donkey—stands in front of a canvas in which a Christ figure is embraced by a woman wearing white. If *Self-portrait with Clock* is more personal, reflecting the artist's sense of loss after the death of his wife, *The Falling Angel* mixes similar imagery to historical and meta-historical purpose. In 1947, Chagall was still in exile, a stranger in a strange land; the next year he returned to France and eventually settled in Saint Paul de Vence, while conflict in the Middle East resulted in the creation of the state of Israel, a Jewish homeland signifying renewed life. Chagall remained a Jewish artist of the Diaspora, yet perhaps he hoped that the falling angel could alight on the earth, so that Jewish martyrdom could lead to a new era, next year in Jerusalem.

*      *      *

Much of this book has followed the careers and creations of a handful of the best-known artists, like Chagall and Lipchitz. Others, like Chana Orloff, Jules Pascin, and Boris Taslitzky, are less well known, and some, such as Mela Muter and Léon Weissberg, have been mostly forgotten. Beyond these artists' individual careers lay the movement called l'Ecole de Paris, which demonstrated how a commitment to art, creativity, and camaraderie could transcend the narrow tribalism of race and nation. The matrix of modernism granted immigrant artists the right to innovate freely and independently, while the artists' colony allowed its denizens to live differently, in ways that challenged prevailing

attitudes toward nationalism, racism, fascism, and militarism. For a brief period, Montparnasse was the cultural counterpart to Geneva, home of the League of Nations, which itself lasted for only twenty-six years. Montparnasse may have been viewed by many as a pleasure center, but it was much more. For a while, it was where the twentieth century happened in its Parisian guise as city of light, resisting the forces of darkness.

After the experimental pre-war years and the buoyant 1920s came the somber 1930s, when artists responded to new challenges with renewed determination. The Popular Front government aspired to defend French Revolutionary values, and put on a world's fair in 1937 to showcase its Column of Peace. This alliance of the left proved to be ephemeral, but it found an ally in modernism. These artists, along with the surrealists, posed a universalistic, cosmopolitan, and tolerant alternative to the prevailing currents that would soon engulf them. Nazis and their French sympathizers, who used "Jews" as shorthand for these alien values they feared, reinforced this identification.

Jews participated in all of the key avant-garde movements from impressionism to cubism, dada, surrealism, and expressionism. It took a leap of imagination to leave the Pale of Settlement and declare their right to create images. The symbolic forms they made played an inescapably political role in a world that sought to define and exclude them. It is not surprising that the Ecole de Paris was sometimes referred to as the Ecole Juive; in these turbulent times, the values that emerged from the studios and cafés of Montparnasse were viewed by both supporters and detractors as Jewish.

# Notes

1 Marc Chagall, "For the Slaughered Artists," in Susan Tumarkin Goodman, *Chagall: Love, War and Exile* (New Haven, CT: Yale University Press, 2013), 96. "Israels" refers to Josef Israëls (1824–1911), a Dutch Jewish artist.

2 The two photos are included in Romy Golan, "On the passage of a few persons through a rather brief period of time," in Stephanie Barron, ed., *exiles + émigrés: The Flight of European Artists from Hitler* (Los Angeles: Los Angeles Museum of Art, 1997), 135, 136. Carrington had been Max Ernst's lover before he married Guggenheim, suggesting a certain level of bohemian toleration. Ernst would soon leave his second wife and benefactor for another surrealist painter, Dorothea Tanning, to whom he would remain married until his death in 1976. Maria Delaperrière and Antoine Marès, *Paris "Capitale Culturelle" de L'Europe Centrale? Les*

*échanges intellectuels entre la France et les pays de l'Europe médiane, 1918–1939* (Paris: Institut d'Etudes Slaves, 1997), 10, 11, 23.

3   Peggy Guggenheim spent most of the interwar years in Europe and became an important collector of modern art in the late 1930s and early war years, but she was more connected with surrealists than with Ecole de Paris artists, and did not patronize Jewish artists. The only Jewish artist included in the 1942 photo was her relative, Kurt Seligmann, a Swiss surrealist exile. See Peggy Guggenheim, ed., *Art of This Century* (New York: Art Aid, 1942), and Jacqueline Weld, *Peggy: The Wayward Guggenheim* (New York, Dutton, 1986).

4   Edward Said, "Reflections on Exile," in *Reflections on Exile and Other Essays* (Cambridge, MA: Harvard Unversity Press, 2000), 173. See also Stephanie Barron, "European artists in exile: a reading between the lines," in Stephanie Barron, ed., *exiles + émigrés: The Flight of European Artists from Hitler* (Los Angeles: Los Angeles Museum of Art, 1997), 19; and Ziva Amishai-Maisels, "The Artist as Refugee," in Ezra Mendelsohn, ed., *Art and its Uses: The Visual Image and Modern Jewish Society*, vol. 6 (New York: Institute of Contemporary Jewry, Hebrew University of Jerusalem, 1990).

5   Sabine Eckman, "Considering (and reconsidering) art and exile," in Stephanie Barron, ed., *exiles + émigrés: The Flight of European Artists from Hitler* (Los Angeles: Los Angeles Museum of Art, 1997), 31.

6   Pétain's summary explanation of why an allegedly decadent and feminized France lost to the Germans can be found in Robert Paxton, *Vichy France: Old Guard and New Order* (New York: Columbia University Press, 1972), 21.

7   Susan Zucotti, *The Holocaust, the French, and the Jews* (Lincoln: University of Nebraska Press, 1993), 56. The other standard English-language text is Michael Marrus and Robert Paxton, *Vichy France and the Jews* (Stanford, CA: Stanford University Press, 1981).

8   Among the many excellent books on Vichy France, the most complete and synoptic English text is Julian Jackson, *France: The Dark Years, 1940–1944* (New York: Oxford University Press, 2001).

9   Marrus and Paxton, *Vichy France and the Jews*, 250–2.

10  Laurence Bertrand Dorléac, *Art of the Defeat, France, 1940–1944*, trans. Jane Marie Todd (Los Angeles: Getty Research Institute, 2008), 152–4.

11  Bertrand Dorléac, *Art of the Defeat*, 156.

12  Paris Prefecture of Police, Dossier d'Etranger, Séries Etrangers, Carton 6, Marc Chagall. The January 30, 1941 report is the final one in the dossier.

13  Jackie Wullschlager, *Chagall: A Biography* (New York: Abrams, 2008), 393, 398–9.

14  Elizabeth Berman, "Moral triage or cultural salvage? The agendas of Varian Fry and the emergency rescue committee," in Stephanie Barron, ed., *exiles + émigrés: The Flight of European Artists from Hitler* (Los Angeles: Los Angeles Museum of Art, 1997), 103.

15 Michèle C. Cone, *Artists under Vichy: A Case of Prejudice and Persecution* (Princeton, NJ: Princeton University Press, 1992), 124, 125.

16 Johanna Linsler, "Les Refugiés juifs en provenance du Reich allemande en France dans les années 1930," in Colette Zynicki, ed., *Terre d'exil, terre d'asile* (Paris: Edition de l'éclat, 2009), 40–1. See also Cone, *Artists under Vichy*, 127, for the letter to Picasso.

17 Linsler, "Les Refugiés juifs," 108, 109. Fry published his own memoir, *Surrender on Demand* (New York: Random House, 1945).

18 Bertrand Dorléac, *Art of the Defeat*, 62, 63.

19 Cone, *Artists under Vichy*, 122.

20 Cone, *Artists under Vichy*, 228, n. 40.

21 Chana Orloff published "My friend Soutine" in 1963; cited in Alfred Werner, *Chaim Soutine* (New York: Abrams, 1977), 41–3.

22 Prefecture of Police, Carton 6, Soutine, report of March 18, 1942.

23 Natasza Styrna, "Mela Muter, 1876–1967," *Jewish Women's Historical Encyclopedia*, March 1, 2009, Jewish Women's Archive, online.

24 Cone, *Artists under Vichy*, 90–7, 125.

25 Stanley Baron, with Jacques Damase, *Sonia Delaunay* (New York: Abrams, 1995), 122–5. Sonia's son Charles Delaunay, a major critic and promoter of jazz music, remained in Paris during the war, was involved in the Resistance, and was arrested and interrogated by the Gestapo in October, 1943. Yet he was released, suggesting that the Germans did not know of his partly Jewish origins. See Jeremy Lane, *Jazz Perspective: Jazz and Machine-Age Imperialism: Music, "Race," and Intellectuals in France* (Ann Arbor: University of Michigan Press, 2013), Chapter 4, 128 and 142–53.

26 Nadine Nieszawer, "Hersch Fenster, Inventeur d'un Ouvrage de Référence: 'Nos Artistes Martyrs,'" in Sylvie Buisson, ed., *Montparnasse Déporté: artistes d'Europe* (Paris: Musée de Montparnasse, 2005), 30. Fenster's original Yiddish text appeared in a French translation published by the Musée d'art et d'histoire du Judaïsme in 2021.

27 "Edith Auerbach," in Sylvie Buisson, ed., *Montparnasse Déporté: artistes d'Europe* (Paris: Musée de Montparnasse, 2005), 40. The text in her biography says she was deported to a concentration camp in 1940, but it seems unlikely that she would have been sent back to France upon becoming ill; more likely she was being interned as an enemy alien.

28 "David Olère," in Sylvie Buisson, ed., *Montparnasse Déporté: artistes d'Europe* (Paris: Musée de Montparnasse, 2005), 85.

29 Sylvie Buisson, ed., *Montparnasse Déporté: artistes d'Europe* (Paris: Musée de Montparnasse, 2005). Albert-Lasard's biography is on 38, Kolos-Vary's on 70, Rilik-Andrieu's on 88, Olère's on 85, Taslitzky's on 102.

30 See Mary Constanza, *The Living Witness: Art in the Concentration Camps and Ghettos* (New York: Free Press, 1982); Janet Blatter and Sybil Milton, *Art of the*

*Holocaust* (London: Book Club, 1982); Ziva Amishai-Maisels, *Depiction and Interpretation: The Influence of the Holocaust on the Visual Arts* (New York: Pergamon Press, 1993); Matthew Baigell, *Jewish-American Artists and the Holocaust* (New Brunswick, NJ: Rutgers University Press, 1997); Nelly Toll, *When Memory Speaks: The Holocaust in Art* (Westport, CT: Praeger, 1998); Monica Bohm-Duchen, *Art of the Second World War* (Princeton, NJ: Princeton University Press, 2013), Chapter 9, "Art of the Holocaust."

31 Buisson, *Montparnasse Déporté*, 107. The critic quoted is Lydia Harambourg. The surrealist Philippe Soupault is quoted on the same page praising Weissberg's work.

32 Elizabeth Bourgogne, Liner notes to Olivier Messaien, *Quator pour la fin du temps*, performed by Ensemble Walter Boeykens (France: Harmonia mundi, 1990), 7.

33 Bourgogne, Liner notes to Olivier Messaien, *Quator pour la fin du temps*, 9.

34 Jonathan Boyarin, "At Last, All the Goyim: Notes on a Greek Word Applied to Jews," in Richard Dellamora, ed., *Postmodern Apocalypse: Theory and Cultural Practice at the End* (Philadelphia: University of Pennsylvania Press, 1995), 53.

35 Marc Chagall, quoted in Ziva Amishai-Maisels, "Christological Symbolism of the Holocaust," *Holocaust and Genocide Studies* 4 (1988): 464.

36 Ziva Amishai-Maisels, "Chagall's 'White Crucifixion,'" *Art Institute of Chicago Museum Studies* 17, no. 2 (1991): 142, 146–7.

37 Amishai-Maisels, "Christological Symbolism of the Holocaust," 463–4.

38 See Matthew Affron, "Marc Chagall in New York, 1941–45," in Stephanie Barron, ed., *exiles + émigrés: The Flight of European Artists from Hitler* (Los Angeles: Los Angeles Museum of Art, 1997), 114–19.

39 Kenneth Silver, "Fluid Chaos Felt by the Soul: Chagall, Jews, and Jesus," in Susan Tumarkin Goodman, ed., *Chagall: Love, War and Exile* (New Haven, CT: Yale University Press, 2013), 103.

40 Greta Berman, "A Darker Side of Marc Chagall," *Juillard Journal*, December 2013, January, 2014, online.

41 Chagall poem quoted in Amishai-Maisels, *Depiction and Interpretation*, 74. This poem was written in Yiddish for Hersch Fenster's book about the martyred Jewish artists of Paris.

42 This is the dominant tone of Greta Berman, "A Darker Side of Marc Chagall," *Juillard Journal*, December 2013.

43 Amishai-Maisels, *Depiction and Interpretation*, Rattner quoted on 186.

44 Amishai-Maisels, *Depiction and Interpretation*, Chagall quoted on 184.

45 Amishai-Maisels, *Depiction and Interpretation*, Chagall quoted on 185. For Mané-Katz, see 185.

46 Allen Leepa, *Abraham Rattner* (New York: Abrams, 1969), 45 for Leepa's commentary on *Apocalipsion*, plates 50, 51, and 52 for the three paintings. See also Amishai-Maisels, "The Artist as Refugee," 123–4.

47 Leepa, *Abraham Rattner*, plates 72–8. For Rattner's show at Paul Rosenberg's gallery, see Piri Halasz, "Figuration in the 40s: The Other Expressionism," *Art in America*, November 1982, 70, 117.

48 Jonathan Fineberg, "Lipchitz in America," in Josef Helfenstein and Jordan Mendelson, eds., *Lipchitz and the Avant-Garde: From Paris to New York* (Urbana-Champaign: University of Illinois Press, 2001), Lipchitz quoted on p. 59.

49 Fineberg, "Lipchitz in America," 59.

50 Henry Hope, *The Sculpture of Jacques Lipchitz* (New York: Museum of Modern Art, 1954), 18.

51 Richard Schwartz, "Jewish Practices and Rituals: The Custom of Kapparot in the Jewish Tradition," *Jewish Virtual Library*, online.

52 Fineberg, "Lipchitz in America," Lipchitz is quoted on 60.

53 Lipchitz quotation in Amishai-Maisels, *Depiction and Interpretation*, 295.

54 Hope, *The Sculpture of Jacques Lipchitz*, 18. *Sacrifice* is featured as the frontispiece of the book. See also Amishai-Maisels, *Depiction and Interpretation*, 296.

55 Lydia Harambourg, "The Painting of Léon Weissberg," in Lydia Harambourg and Lydie Marie Lachenal, *L. Weissberg: Catalogue raisonné de l'oeuvre peint, dessiné, sculpté* (Paris: Somogy, 2009), 27.

56 Harambourg, "The Painting of Léon Weissberg," 28, 29.

57 Harambourg, "The Painting of Léon Weissberg," 64, 65.

58 In Joseph Roth's interwar book of essays, *The Wandering Jews*, trans. Michael Hofmann (New York: Norton, 2001), 86, in the chapter on France, he mentions a musical clown who came from a long line of klezmer musicians back in Eastern Europe. In France he played the concertina, harmonica, and saxophone and made people laugh. Perhaps Léon Weissberg was also translating traditions remembered from his childhood in Eastern Europe into modern French equivalents.

59 Jean-Paul Sartre, "Paris Alive: The Republic of Silence," *The Atlantic*, December 1944. This was the opening sentence of the article.

60 Karl Georg Kaster, ed., *Felix Nussbaum: Art Defamed, Art in Exile, Art in Resistance: A Biography* (Woodstock, NY: Overlook Press, 1995), 175–80.

61 Amishai-Maisels, *Depiction and Interpretation*, contrasts the earlier mild drawings with these later ones from 1945; see drawings 2, 3, 7, and 9 in contrast to 167 and 168.

62 Amishai-Maisels, *Depiction and Interpretation*, 56.

63 Amishai-Maisels, *Depiction and Interpretation*, 56, 57.

64 Amishai-Maisels titles this painting *The Death of Danielle Casanova at Buchenwald*, but the text on 8 says she died at Auschwitz, so it is unclear why she locates the scene at Buchenwald. Black-and-white reproduction, 11.

65 Amishai-Maisels, *Depiction and Interpretation*, Taslitzky quoted on 9.

66 David Olère and Alexandre Oler, *Witness: Images of Auschwitz* (N. Richard Hills, Texas: WestWind Press, 1998). A brief biography of the artist appears on 108.

67  Olère and Oler, *Witness*, 8.

68  Olère and Oler, *Witness*, 109.

69  Wullschlager, *Chagall: A Biography*, 367.

70  The various versions of *Falling Angel* can be seen in Jean-Paul Prat, *Chagall* (Madrid: Museo Thyssen-Bornemisza, 2012), 178–83. Federico Zeri chose this work to stand for Chagall's art as a whole, in *Chagall: The Falling Angel* (Richmond Hill, Ontario: NDE, 1999), which also provides detailed images of the final painting, though not the sketches.

# Bibliography

Ades, Dawn, ed. *Art and Power: Europe under the Dictators 1930–45*. London: Thames and Hudson, 1995.

Affron, Matthew and Mark Antliff, eds. *Fascist Visions: Art and Ideology in France and Italy*. Princeton, NJ: Princeton University Press, 1997.

Agnew, Vanessa. *Enlightenment Orpheus: The Power of Music in Other Worlds*. New York: Oxford University Press, 2008.

Albright, Daniel. *Untwisting the Serpent: Modernism in Music, Literature and Other Arts*. Chicago: University of Chicago Press, 2000.

Alouna. "Terre d'Israël à Paris, Une Visite à l'exposition." *Nouvelle Presse Juive*, August 27, 1937.

Alpers, Svetlana. *The Art of Describing: Dutch Art in the 17th Century*. Chicago: University of Chicago Press, 1983.

Amishai-Maisels, Ziva. "The Artist as Refugee." In *Art and its Uses: The Visual Image and Modern Jewish Society*, edited by Ezra Mendelsohn. New York: Oxford University Press, 1990.

Amishai-Maisels, Ziva. "Chagall's 'White Crucifixion.'" *Art Institute of Chicago Museum Studies* 17, no. 2 (1991): 142-7.

Amishai-Maisels, Ziva. *Depiction and Interpretation: The Influence of the Holocaust on the Visual Arts*. New York: Pergamon Press, 1993.

Amishai-Maisels, Ziva. "Origins of the Jewish Jesus." In *Complex Identities: Jewish Consciousness and Modern Art*, edited by Matthew Baigell and Milly Heyd. New Brunswick, NJ: Rutgers University Press, 2001.

Andrew, Dudley and Steven Ungar. *Popular Front Paris and the Poetics of Culture*. Cambridge, MA: Harvard University Press, 2005.

Andrijauskas, Antanas. *Litvak Art in the Context of the Ecole de Paris*. Translated by Jonas Steponaitis and Agne Narusyte. Vilnius: Art Market Agency, 2008.

Antliff, Mark. *Inventing Bergson: Cultural Politics and the Parisian Avant-Garde*. Princeton, NJ: Princeton University Press, 1993.

Antliff, Mark. *Avant-Garde Fascism*. Durham, NC: Duke University Press, 2008.

Apollinaire, Guillaume. "À travers l'Europe, un poème de Guillaume Apollinaire." poetica.fr (n.d.).

Apollinaire, Guillaume. *Le bestiaire, ou le cortège d'Orphée*. Paris: M. Eschwig, 1920.

Apollinaire, Guillaume. *Le 30e Salon Des "Indépendants," 1914, Les Soirées de Paris, 1912-14*. Geneva: Slatkine Reprints, 1971.

Apollinaire, Guillaume. *Calligrammes, Poems of War and Peace, 1913-1916*. Berkeley: University of California Press, 2004.

Aragon, Louis. *Ecrits sur l'art moderne*. Paris: Flammarion, 1981.

Aronson, Chil. *Scènes et visages de Montparnasse*. Paris: n.p., 1963.

Assouline, Pierre. *An Artful Life: A Biography of D.H. Kahnweiler, 1884–1979*. New York: Grove Weidenfeld, 1990.

Ausoni, Alberto. *Music in Art*. Translated by Stephen Sartarelli. Los Angeles: J. Paul Getty Museum, 2009.

Baigell, Matthew. *Jewish-American Artists and the Holocaust*. New Brunswick, NJ: Rutgers University Press, 1997.

Baigell, Matthew. "Jewish American Artists: Identity and Messianism." In *Complex Identities: Jewish Consciousness and Modern Art*, edited by Matthew Baigell and Milly Heyd, 183. New Brunswick, NJ: Rutgers University Press, 2001.

Baigell, Matthew and Milly Heyd, eds. *Complex Identities: Jewish Consciousness and Modern Art*. New Brunswick, NJ: Rutgers University Press, 2001.

Bald, Wambly. *On the Left Bank, 1929–1933*. Edited by Benjamin Franklin. Athens: Ohio University Press, 1987.

Baron, Stanley and Jacques Damase. *Sonia Delaunay: The Life of an Artist*. New York: Harry N. Abrams, 1995.

Barron, Stephanie. *exiles + emigres: The Flight of European Artists from Hitler*. Los Angeles: Los Angeles County Museum of Art, 1997.

Baskind, Samantha and Larry Silver. *Jewish Art: A Modern History*. London: Reaktion Books, 2011.

Basler, Adolphe. "Y a-t-Il une peinture juive?" *Mercure de France*, November 1925.

Basler, Adolphe. *La Peinture . . . religion nouvelle*. Paris: Bibliothèque des Marges, 1926.

Basler, Adolphe. *Le cafard après la fête: ou l'esthétisme d'aujourd'hui*. Paris: Jean Budry, 1929.

Basler, Adolphe. *Indenbaum (Artistes Juifs)*. Paris: Le Triangle, 1930.

Bauldie, John. *Wanted Man: In Search of Bob Dylan*. London: Carol Publishing Group, 1990.

Beauvoir, Simone de. *The Prime of Life*. Translated by Peter Green. Cleveland and New York: World, 1962.

Bellow, Juliet. *Modernism on Stage: The Ballets Russes and the Parisian Avant-Garde*. Burlington, VT: Ashgate Publishing, Ltd., 2013.

Benda, Julien. *Belphégor*. Translated by S. Lawson. New York: Payson and Clarke, 1929.

Benhabib, Seyla. *Another Cosmopolitanism*. Edited by Robert Post. New York: Oxford University Press, 2006.

Benson, Timothy O., ed. *Expressionism in Germany and France: From van Gogh to Kandinsky*. Munich and New York: Prestel, 2014.

Benstock, Shari. *Women of the Left Bank, Paris, 1900–1940*. Austin: University of Texas Press, 1986.

Berliner, Brett. *Ambivalent Desire: The Exotic Black Other in Jazz-Age France*. Amherst: University of Massachusetts Press, 2002.

Berman, Greta. "A Darker Side of Marc Chagall." *Juilliard Journal*, December 2013.

Berman, Jessica Schiff. *Modernist Fiction, Cosmopolitanism, and the Politics of Community*. Cambridge: Cambridge University Press, 2001.

Bertrand Dorléac, Laurence. *Art of the Defeat: France, 1940-1944*. Translated by Jane Marie Todd. Los Angeles: Getty Research Institute, 2008.

Biale, David. *Eros and the Jews: From Biblical Israel to Contemporary America*. New York: Basic Books, 1992.

Biale, David. *Not in the Heavens: The Tradition of Jewish Secular Thought*. Princeton, NJ: Princeton University Press, 2011.

Biélinky, Jacques. "Les Artistes Juifs à Paris." *L'Univers Israélite*, September 12, 1924, 517–20.

Biélinky, Jacques. "Une Exposition Mané-Katz." *L'Univers Israélite*, November 7, 1924.

Biélinky, Jacques. "La Culture Juive Moderne à l'Exposition Internationale, Discours Du Ministre Léo Lagrange." *Nouvelle Presse Juive*, August 20, 1937.

Bilski, Emily D. *Berlin Metropolis: Jews and the New Culture, 1890-1918*. Berkeley: University of California Press, 1999.

Birnbaum, Paula. *Women Artists in Interwar France: Framing Femininities*. Farnham: Ashgate, 2011.

Birnbaum, Paula. "Chana Orloff: A Modern Jewish Woman Sculptor of the School of Paris." *Journal of Modern Jewish Studies* 15, no. 1 (March 2016): 65–87.

Blake, Jody. *Le Tumulte Noir: Modernist Art and Popular Entertainment in Jazz-Age Paris, 1900-1930*. University Park, PA: Pennsylvania State University Press, 1999.

Bland, Kalman P. "Anti-Semitism and Aniconism: The Germanophone Requiem for Jewish Visual Art." In *Jewish Identity in Modern Art History*, edited by Catherine M. Soussloff. Berkeley: University of California Press, 1999.

Bland, Kalman P. *The Artless Jew: Medieval and Modern Affirmations and Denials of the Visual*. Princeton, NJ: Princeton University Press, 2000.

Blatas, Arbit. *Portraits de Montparnasse*. Paris: Ed. de l'Albaron, 1991.

Blatter, Janet and Sybil Milton. *Art of the Holocaust*. London: Book Club, 1982.

Bloch-Morhange, Lise and David Alper. *Artiste et Métèque à Paris*. Paris: Éditions Buchet/Chastel, 1980.

Bohm-Duchen, Monica. *Art and the Second World War*. Princeton, NJ: Princeton University Press, 2013.

Borhan, Pierre, ed. *André Kertész, His Life and Work*. Boston: Little, Brown, 1994.

Borvine-Frenkel, Boris. *Mit Yidishe Kinstler*. Paris: Yiddisher Kultur-Kongres in Frankrayck, 1963.

Bosschère, Jean de. *Les Artistes à Paris 1937*. Paris: Arts, Sciences, Lettres, 1937.

Bougault, Valérie. *Paris Montparnasse à l'heure de l'art moderne, 1910-1940*. Paris: Terrail, 1996.

Bouvet, Vincent and Gérard Durozoi. *Paris between the Wars 1919-1939: Art, Life and Culture*. New York: Vendome Press, 2010.

Boyarin, Daniel. *Unheroic Conduct: The Rise of Heterosexuality and the Invention of the Jewish Man*. Berkeley: University of California Press, 1993.

Braiterman, Zachary. *The Shape of Revelation: Aesthetics and Modern Jewish Thought.* Stanford, CA: Stanford University Press, 2007.

Brauer, Fae. *Rivals and Conspirators: The Paris Salons and the Modern Art Centre.* Newcastle upon Tyne: Cambridge Scholars Publishing, 2013.

Braziel, Jana and Anita Mannur, eds. *Theorizing Diaspora: A Reader.* Malden, MA: Blackwell, 2003.

Breines, Paul. *Tough Jews: Political Fantasies and the Moral Dilemma of American Jewry.* New York: Basic Books, 1990.

Brennan, Timothy. *At Home in the World: Cosmopolitanism Now.* Cambridge, MA: Harvard University Press, 1997.

Brenner, Michael. *The Renaissance of Jewish Culture in Weimar Germany.* New Haven, CT: Yale University Press, 1996.

Broe, Mary Lynn and Angela Ingram. *Women's Writing in Exile.* Chapel Hill: University of North Carolina Press, 1989.

Brougher, Kerry and Olivia Mattis. *Visual Music: Synaesthesia in Art and Music since 1900.* Washington, DC: Hirshhorn, 2005.

Brown, Frederick. *For the Soul of France: Culture Wars in the Age of Dreyfus.* New York: Random House, 2010.

Buber, Martin. "Letter to Lesser Ury, 1901." In *Jewish Texts on the Visual Arts*, edited by Vivian B. Mann, 143–6. Cambridge: Cambridge University Press, 2000.

Buckberrough, Sherry A. *Sonia Delaunay: A Retrospective.* Buffalo, NY: Albright-Knox Art Gallery, 1979.

Buckberrough, Sherry A. *Robert Delaunay: The Discovery of Simultaneity.* Ann Arbor: UMI Research Press, 1982.

Buisson, Sylvie. *"Jean, Pablo, Max, Ortiz, Marie et Les Autres," Jean Cocteau à Montparnasse.* Paris: Des Cendres and Musée de Montparnasse, 2001.

Buisson, Sylvie. *Montparnasse déporté: artistes d'Europe.* Paris: Musée du Montparnasse, 2005.

Calhoun, Craig. "Cosmopolitanism in the Modern Social Imaginary." *Daedalus* 137, no. 3 (Summer 2008): 105–14.

Caron, Vicki. *Uneasy Asylum: France and the Jewish Refugee Crisis, 1933–1942.* Stanford, CA: Stanford University Press, 1999.

Caron, Vicki. "Unwilling Refuge: France and the Dilemma of Illegal Immigration, 1933–1939." In *Refugees from Nazi Germany and the Liberal European States*, edited by Frank Caestecker and Bob Moore. New York: Berghahn, 2010.

Carter, Karen and Susan Waller, eds. *Foreign Artists and Communities in Modern Paris, 1870–1914: Strangers in Paradise.* London: Ashgate, 2015.

Cartwright, Ben. "Wanted Man: In Search of Bob Dylan." In *Wanted Man: In Search of Bob Dylan*, edited by John Bauldie. London: Carol Publishing Group, 1990.

Casteel, Sarah Phillips. *Calypso Jews: Jewishness in the Caribbean Literary Imagination.* New York: Columbia University Press, 2016.

Cendrars, Blaise. *La Guerre au Luxembourg, Six dessins de Kisling.* Paris: D. Niestlé, 1916.

Cendrars, Blaise. *La main coupée*. Paris: Gallimard, 1975 (orig. 1946).

Cendrars, Blaise. *Planus*. Translated by Nina Rootes. London: Peter Owen, 1972.

Chagall, Marc. *My Life*. New York: Oxford University Press, 1965.

Chapiro, Jacques. *La Ruche*. Paris: Flammarion, 1960.

Charters, Jimmie. *This Must Be the Place: Memoirs of Montparnasse by Jimmie "The Barman" Charters*. London: Herbert Joseph, 1934 (reprint: New York: Collier, 1989).

Clifford, James. *Routes: Travel and Translation in the Late Twentieth Century*. Cambridge, MA: Harvard University Press, 1997.

Cocteau, Jean. "Pablo Picasso." In *My Contemporaries*, edited by Margaret Crosland. London: Peter Owen, 1967.

Cohen, Richard I. "Introductory Essay—Viewing the Past." In *Art and Its Uses: The Visual Image and Modern Jewish Society*, edited by Ezra Mendelsohn. New York: Oxford University Press, 1990.

Cohen, Richard I. *Jewish Icons: Art and Society in Modern Europe*. Berkeley: University of California Press, 1998.

Cohen-Solal, Annie. *Mark Rothko: Toward the Light in the Chapel*. New Haven, CT: Yale University Press, 2015.

Cone, Michèle C. *French Modernisms*. Cambridge: Cambridge University Press, 2001.

Contensou, Bernadette. "Autour de l'Expo Des Maîtres de l'Art Indépendants en 1937." In *Paris 1937, L'art Indépendant*. Paris: Paris-Musées, 1987.

Contensou, Bernadette. *Paris 1937: l' art indépendant*. Paris: Musée d'Art Moderne (Paris), 1987.

*Controversial Public Art: From Rodin to di Suvero*. Milwaukee, WI: Milwaukee Art Museum, 1983.

Costanza, Mary S. *The Living Witness: Art in the Concentration Camps and Ghettos*. New York: Free Press, 1982.

Cottington, David. *Cubism in the Shadow of War: The Avant-Garde and Politics in Paris, 1905–1914*. New Haven, CT: Yale University Press, 1998.

Crespelle, Jean-Paul. *La vie quotidienne à Montparnasse à la grande époque: 1905–1930*. Paris: Hachette Littératures, 1976.

Cuddy-Keane, Melba. "Modernism, Geopolitics, Globalization." *Modernism/Modernity* 10, no. 3 (September 2003): 539–58.

Czymmek, Götz and Helga Aurisch, eds. *German Impressionist Landscape Painting: Liebermann, Corinth, Slevogt*. Stuttgart: Arnoldsche Art Publications, 2010.

Dagen, Philippe. *Le silence des peintres: les artistes face à la grande guerre*. Paris: Hazan, 2012.

Damase, Jacques. *Sonia Delaunay: Fashion and Fabrics*. New York: Harry N. Abrams, 1991.

Davis, Julia. *Mark Rothko: The Art of Transcendence*. Maidstone, UK: Crescent Moon, 2011.

Delaperrière, Maria and Antoine Marès. *Paris "capitale culturelle" de l'Europe centrale?: les échanges intellectuels entre la France et les pays de l'Europe médiane, 1918–1939*. Paris: Institut d'études slaves, 1997.

Delaunay, Sonia. *Nous irons jusqu'au soleil*. Paris: Robert Laffont, 1978.

De Menil, Dominique. *The Rothko Chapel: Writings on Art and the Threshold of the Divine*. New Haven, CT: Yale University Press, 2010.

Desbiolles, Yves Chevrefils. *Les revues d'art à Paris 1905–1940*. Paris: Ent'revues, 1993.

Desbiolles, Yves Chevrefils. "Le critique d'art Waldemar-George. Les paradoxes d'un non-conformiste." *Archives Juives* 41, no. 2 (2008): 101–17.

De Voort, Claude. *Kisling, 1891–1953*. Paris: A.D.A.G.P., 1996.

Diehl, Gaston. *Pascin*. Translated by Rosalie Siegel. New York: Crown, 1984.

Donahue, Neil H. *Invisible Cathedrals: The Expressionist Art History of Wilhelm Worringer*. University Park, PA: Pennsylvania State University Press, 1995.

Dorival, Bernard. *The School of Paris in the Musée d'art moderne*. London: Thames and Hudson, 1962.

Douglas, Charles. *Artist Quarter: Reminiscences of Montmartre and Montparnasse in the First Two Decades of the Twentieth Century*. London: Faber and Faber, 1941.

Drot, Jean-Marie and Dominique Polad-Hardouin. *Les heures chaudes de Montparnasse*. Paris: Hazan, 1995.

Durkheim, Emile. *The Elementary Forms of the Religious Life*. New York: Oxford University Press, 2001.

*Ecole de Paris*. London: Tate, 1962.

*Ecole de Paris 1900–1950*. London: Royal Academy of Arts, 1951.

*L'Ecole de Paris: la Part de l'Autre*. Paris: Musée d'art moderne de la Ville de Paris, 2001.

Eipeldauer, Heike, Ingried Brugger, Gereon Sievernich, Kunstforum Wien, and Allemagne Martin-Gropius-Bau (Berlin), eds. *Meret Oppenheim: Retrospective*. Ostfildern: Hatje Cantz, 2013.

Eksteins, Modris. *Rites of Spring: The Great War and the Birth of the Modern Age*. New York: Doubleday, 1989.

Epelbaum, Didier. *Les Enfants du papier: les juifs de Pologne immigrés en France jusqu'en 1940*. Paris: Bernard Grasset, 2002.

Epstein, Jacob. *Let There Be Sculpture*. New York: Putman, 1940.

Èrenburg, Il'ïa. *People and Life: Memoirs of 1891–1917*. Translated by Anna Bostock and Yvonne Kapp. London: McGibbon & Kee, 1961.

Escholier, Raymond. *Peinture Française XXe Siècle*. Paris: Floury, 1937.

Exter, Alexandra, John E. Bowlt, and Matthew Drutt. *Amazons of the Avant-Garde: Alexandra Exter and Others*. New York: Solomon R. Guggenheim Foundation, 2000.

Fabre, Gladys. "Qu'est-ce que l'Ecole de Paris?" In *L'Ecole de Paris 1904–1929: la Part de l'Autre*. Parijs: Musées, 2000.

Fels, Florent. *Propos d'artistes*. Paris: Renaissance du livre, 1925.

Fels, Florent. *L'Art Vivant de 1900 à nos jours*. Geneva: Pierre Cailler, 1956.

Fiss, Karen. *Grand Illusion: The Third Reich, the Paris Exposition, and the Cultural Seduction of France*. Chicago and London: University of Chicago Press, 2009.

FitzGerald, Michael C. *Making Modernism: Picasso and the Creation of the Market for Twentieth-Century Art*. Berkeley: University of California Press, 1996.

Fitzpatrick, Sheila. *The Commissariat of Enlightenment*. Cambridge: Cambridge University Press, 1970.

*Fonds Jacques Biélinky*. Alliance Israélite Universelle. Materials from 1920s–1930s.

Ford, Hugh D., ed. *The Left Bank Revisited: Selections from the Paris Tribune 1917–1934*. University Park, PA: Pennsylvania State University Press, 1972.

Forth, Christopher E. *The Dreyfus Affair and the Crisis of French Manhood*. Baltimore, MD: Johns Hopkins University Press, 2004.

Foster, Hal. "Violation and Veiling in Surrealist Photography: Woman as Fetish, as Shattered Object, as Phallus." In *Surrealism: Desire Unbound*, edited by Jennifer Mundy. Princeton, NJ: Princeton University Press, 2001.

Fraquelli, Simonetta and Nancy Ireson. *Modigliani*. New York: Skira Rizzoli Publications, 2017.

Freud, Sigmund. *Totem and Taboo: Resemblances between the Psychic Lives of Savages and Neurotics*. New York: Norton, 1950.

Fry, Varian. *Surrender on Demand*. New York: Random House, 1945.

Fulcher, Jane F. *The Composer as Intellectual: Music and Ideology in France, 1914–1940*. New York: Oxford University Press, 1995.

Fuss-Amoré, Gustave. *Montparnasse*. Paris: Albin Michel, 1925.

Galison, Peter. *Einstein's Clocks, Poincaré's Maps: Empires of Time*. New York: Norton, 2003.

Garafola, Lynn. *Diaghilev's Ballets Russes*. New York: Da Capo Press, 1998.

Gatrell, Peter. *A Whole Empire Walking: Refugees in Russia During World War I*. Bloomington: Indiana University Press, 1999.

Gautherie-Kampka, Annette. *Les Allemands du Dôme: la colonie allemande de Montparnasse dans les années 1903–1914*. Bern: Peter Lang, 1995.

Gauthier, Ambre. *Chagall: Colour and Music*. Translated by Lisa Davidson. Paris: Gallimard, 2015.

Gay, Peter. *Freud, Jews, and Other Germans: Masters and Victims in Modernist Culture*. New York: Oxford University Press, 1978.

Gay, Peter. *Freud: A Life for Our Time*. New York: W. W. Norton & Company, 1998.

Gee, Malcolm. *Dealers, Critics and Collectors of Modern Painting: Aspects of the Parisian Art Market between 1910 and 1930*. New York: Garland, 1981.

George, Waldemar. *Krémègne (Artistes Juifs)*. Paris: Le Triangle, 1930.

George, Waldemar. "Art in Paris," *Formes: An International Review of Plastic Art*. 1930–1.

George, Waldemar. *L'Humanisme et l'idée de patrie*. Paris: Bibliothèque Charpentier, 1936.

George, Waldemar. *Les artistes juifs et l'École de Paris: suivi de six coryphées juifs de l'École de Paris et deux jeunes animateurs de l'art contemporain*. Alger: Éditions du Congrès juif mondial, 1959.

Georges-Michel, Michel. *Les Montparnos: Roman*. Paris: Fayard, 1924.

Georges-Michel, Michel. *Left Bank*. Translated by Keene Wallis. New York: H. Liveright, 1931.

Georges-Michel, Michel. *From Renoir to Picasso: Artists in Action*. Translated by Dorothy Weaver and Randolph Weaver. Boston: Houghton Mifflin, 1954.

Gilbert, Barbara C. "Max Liebermann: A Long and Fruitful Career." In *Max Liebermann: From Realism to Impressionism*, edited by Barbara C. Gilbert, 26–9. Los Angeles: Skirball Cultural Center, 2005.

Gilbert, Barbara C., ed. *Max Liebermann: From Realism to Impressionism*. Los Angeles: Skirball Cultural Center, 2005.

Gilman, Sander L. *Jewish Self-Hatred, Anti-Semitism and the Hidden Language of the Jews*. Baltimore, MD: Johns Hopkins University Press, 1986.

Gimpel, René. *Diary of an Art Dealer*. Translated by John Rosenberg. New York: Hodder & Stoughton, 1966.

Gindertael, R. V. *Morice Lipsi*. Neuchâtel: Editions du Griffon, 1965.

Golan, Romy. "The 'Ecole Française' vs. the 'Ecole de Paris.'" In *The Circle of Montparnasse: Jewish Artists in Paris, 1905–1945*, edited by Romy Golan and Kenneth E. Silver, 81–7. New York: Jewish Museum, 1985.

Golan, Romy. *Modernity and Nostalgia: Art and Politics in France Between the Wars*. New Haven, CT: Yale University Press, 1995.

Goldberg, Sylvie Anne. *Clepsydra: Essay on the Plurality of Time in Judaism*. Translated by Benjamin Ivry. Palo Alto, CA: Stanford University Press, 2016.

Goldstein, Rosalie. *Controversial Public Art: From Rodin to Di Suvero*. Milwaukee: Milwaukee Art Museum, 1983.

Goodman, Susan Tumarkin. *Chagall: Love, War, and Exile*. New Haven, CT: Yale University Press, 2013.

Goodman, Susan Tumarkin, ed. *The Emergence of Jewish Artists in Nineteenth-Century Europe*. New York: Merrell and Jewish Museum, New York, 2001.

Grabska, Elzbieta. *"Les Tableaux et Les Sculptures Voyagent . . .", Autour de Bourdelle: Paris et Les Artistes Polonaises*. Paris: Paris musées, 1996.

Granville, Pierre. "A Glance at the Work of Henri Hayden." *Burlington Magazine* 110, no. 784 (1968): 421–3.

Green, Christopher. *Cubism and Its Enemies: Modern Movements and Reaction in French Art, 1916–1928*. New Haven, CT: Yale University Press, 1987.

Green, Christopher. *Art in France, 1900–1940*. New Haven, CT: Yale University Press, 2000.

Green, Nancy. *The Pletzl of Paris: Jewish Immigrant Workers in the Belle Epoque*. New York and London: Holmes and Meier, 1986.

Griffin, Roger. *Modernism and Fascism: The Sense of a Beginning under Mussolini and Hitler*. Basingstoke: Palgrave Macmillan, 2007.

Grossman, Grace Cohen. *Jewish Art*. n.p.: Hugh Lauter Levin Assoc., Incorporated, 1995.

Halff, Captain Sylvain. "The Participation of the Jews of France in the Great War." In *American Jewish Year Book, XXI*. Philadelphia: Jewish Publication Society of America, 1919.

Halicka, Alice. *Hier*. Paris: Éditions du Pavois, 1946.

Hammacher, Abraham Marie. *Zadkine*. New York: Universe Books, 1959.

Hamnett, Nina. *Laughing Torso*. New York: Ray Long and Richard R. Smith, 1932.

Harambourg, Lydia, Kenneth Mesdag Ritter, and Lydie Lachenal, eds. *L. Weissberg: catalogue raisonné de l'oeuvre peint, dessiné, sculpté*. Paris: Somogy, 2009.

Harding, James. *The Ox on the Roof: Scenes from Musical Life in Paris in the Twenties*. London: Macdonald, 1972.

Harshav, Benjamin. *Marc Chagall and His Times: A Documentary Narrative*. Stanford, CA: Stanford University Press, 2004.

Helfenstein, Josef and Jordana Mendelson, eds. *Lipchitz and the Avant-Garde: From Paris to New York*. Urbana-Champaign: University of Illinois, 2001.

Hemingway, Ernest. *A Moveable Feast*. New York: Scribner's, 1964.

Henderson, Linda Dalrymple. "Editor's Introduction: I. Writing Modern Art and Science—An Overview; II. Cubism, Futurism, and Ether Physics in the Early Twentieth Century." *Science in Context* 17, no. 4 (December 2004): 423–66.

Herbert, James D. *Paris 1937: Worlds on Exhibition*. Ithaca, NY: Cornell University Press, 1998.

Hewitt, Nicholas. "La Bohême Réactionnaire." *French Cultural Studies* 11 (1993): 129–44.

Hicken, Aan. *Apollinaire, Cubism and Orphism*. Aldershot, UK: Ashgate, 2002.

Hiler, Hilaire. *Why Abstract?* New York: New Directions, 1945.

Hiver, Marcel. "Hallo, Boys, Cheer Up! Monsieur Barnes Est Dans Nos Murs." *Montparnasse*, July 1923.

Hiver, Marcel. "Réflexions VI, Assez d'Art Nègre." *Montparnasse*, October 1923.

*The Holy Scriptures*. Nashville, TN: Jewish Publication Society of America, 1917.

Homans, Jennifer. *Apollo's Angels: A History of Ballet*. New York: Random House, 2010.

Hoog, Michel. "Origine et développement de l'art international indépendant." In *Paris 1937: l'art indépendant*. Paris: Paris musées., 1987.

Hook, Philip. *Rogues' Gallery: The Rise (and Occasional Fall) of Art Dealers, the Hidden Players in the History of Art*. New York: The Experiment, 2017.

Hope, Henry R. *The Sculpture of Jacques Lipchitz*. New York: Museum of Modern Art, 1954.

Hughes, Robert. *The Shock of the New*. New York: Knopf, 1981.

Husson, Paul. "Nous Réparaissons." *Montparnasse*, July 1, 1921, 1.

Hutchinson, George. *Facing the Abyss: American Literature and Culture in the 1940s*. New York: Columbia University Press, 2018.

Hyman, Paula E. *From Dreyfus to Vichy: The Remaking of French Jewry, 1906–1939*. New York: Columbia University Press, 1979.

Hyman, Paula E. *Gender and Assimilation in Modern Jewish History: The Roles and Representation of Women*. Seattle: University of Washington Press, 1995.

Hyman, Paula E. *The Jews of Modern France*. Berkeley: University of California Press, 1998.

Hyman, Paula and Alice Shalvi. *Jewish Women: A Comprehensive Historical Encyclopedia*. Philadelphia: Jewish Publication Society, 2007.

Jaccard, Pierre. "L'Art Grec et Spiritualisme Hébreu Par Rapport à La Peinture Juive." *Mercure de France*, August 15, 1925.

Jackson, Jeffrey H. *Making Jazz French: Music and Modern Life in Interwar Paris*. Durham, NC: Duke University Press, 2003.

Jackson, Julian. *The Popular Front in France Defending Democracy, 1934–38*. Cambridge: Cambridge University Press, 1988.

Jackson, Julian. *France: The Dark Years, 1940–1944*. New York: Oxford University Press, 2001.

Jacometti, Nesto. *Têtes de Montparnasse*. Paris: Villain, 1934.

Jakovsky, Anatole. *Les Feux de Montparnasse: Peintres et Écrivains*. Paris: Bibliothèque des Arts, 1957.

Jarrassé, Dominique. *Guide de patrimoine juif parisien*. Paris: Parigramme, 2003.

Jarrassé, Dominique. *Existe-t-il un art juif?* Paris: Biro, 2006.

Jay, Martin. *Downcast Eyes: The Denigration of Vision in Twentieth-Century French Thought*. Berkeley: University of California Press, 1993.

Jay, Martin. *Force Fields: Between Intellectual History and Cultural Critique*. New York: Routledge, 1993.

Jensen, Robert. *Marketing Modernism in Fin-de-Siècle Europe*. Princeton, NJ: Princeton University Press, 1994.

Jouffroy, Alain. *La vie réinventée à Montparnasse*. Paris: Musée du Montparnasse, 2011.

Julius, Anthony. *Idolizing Pictures: Idolatry, Iconoclasm and Jewish Art*. London: Thames & Hudson, 2000.

Jullian, Philippe. *Montmartre*. New York: Dutton, 1977.

Junyk, Ihor. *Foreign Modernism: Cosmopolitanism, Identity, and Style in Paris*. Toronto: University of Toronto Press, 2013.

Kahn, Gustave. *Feder*. Paris: Amitié Française, 1932.

Kahnweiler, Daniel-Henry and Frances Crémieux. *My Galleries and Painters*. Translated by Helen Weaver. New York: Viking Press, 1961.

Kalliney, Peter J. *Modernism in a Global Context*. New York: Bloomsbury, 2016.

Kampf, Avram. *Jewish Experience in the Art of the Twentieth Century*. S. Hadley, MA: Bergin & Garvey, 1984.

Kangaslahti, Kate. "The Ecole de Paris, Inside and Out: Reconsidering the Experience of the Foreign Artist in Interwar France." In *Crossing Cultures: Conflict, Migration and Convergence*, edited by Jayne Anderson, 602–6. Melbourne, Australia: Miegunyah Press, 2009.

Kaspi, André and Antoine Marès. *Le Paris des étrangers: depuis un siècle*. Paris: Imprimerie nationale, 1989.

Kaster, Karl Georg, ed. *Felix Nussbaum: Art Defamed, Art in Exile, Art in Resistance: A Biography*. Woodstock, NY: Overlook Press, 1997.

Katz, Maya Balakirsky. *Revising Dreyfus*. Leiden: Brill, 2013.

Kern, Stephen. *The Culture of Time and Space, 1880–1918*. Cambridge, MA: Harvard University Press, 1983, 2003.

*Kikoïne*. Paris: Albaron, 1992.

Kisling, Moïse, Joseph Kessel, Jean Kisling, Henri Troyat, and Jean Dutourd. *Kisling*. New York: Harry N. Abrams, 1971.

Kleeblatt, Norman L. and Kenneth Silver, eds. *An Expressionist in Paris: The Paintings of Chaim Soutine*. Munich and New York: Prestel, 1998.

Klein, Mason, ed. *Modigliani: Beyond the Myth*. New York and New Haven, CT: Jewish Museum and Yale University Press, 2004.

Klüver, Billy. *"Modigliani et Picasso à Montparnasse," Modigliani, L'ange au visage grave*. Marc Restellini. Milan: Skira/Seuil, 2002.

Klüver, Billy, and Julie Martin. *Kiki's Paris: Artists and Lovers, 1900–1930*. New York: Harry N. Abrams, 1989.

*Krémègne, 1890–1981: Pavillon des Arts*. Paris: Paris-Musées, 1993.

Kruszynski, Anette. *Amedeo Modigliani: Nudes and Portraits*. Munich: Prestel, 2005.

Kuper, Adam. *The Invention of Primitive Society: Transformations of an Illusion*. London: Routledge, 1988.

Kusch, Celena E. "Disorienting Modernism: National Boundaries and the Cosmopolis." *Journal of Modern Literature* 30, no. 4 (Summer 2007): 39–60.

Kuspit, Donald. *The Cult of the Avant-Garde Artist*. Cambridge: Cambridge University Press, 1993.

Kuspit, Donald. "Meyer Schapiro's Jewish Unconscious." In *Jewish Identity in Modern Art History*, edited by Catherine M. Soussloff. Berkeley: University of California Press, 1999.

Kuspit, Donald. *Psychostrategies of Avant-Garde Art*. Cambridge: Cambridge University Press, 2000.

Kuspit, Donald. "Soutine's Shudder." In *Complex Identities: Jewish Consciousness and Modern Art*, edited by Matthew Baigell and Milly Heyd, 98. New Brunswick, NJ: Rutgers University Press, 2001.

Lafranchis, Jean. *Louis Marcoussis: Sa vie, son oeuvre*. Paris: Les Edition du Temps, 1961.

Lambert, Jacques. *Kisling, Prince de Montparnasse*. Paris: Les Éditions de Paris, 2011.

Landes, Joan B. *Visualizing the Nation: Gender, Representation, and Revolution in Eighteenth-Century France*. Ithaca, NY: Cornell University Press, 2001.

Lane, Jeremy F. *Jazz and Machine-Age Imperialism: Music, "Race" and Intellectuals in France, 1918–1945*. Ann Arbor: University of Michigan Press, 2013.

Lazowski, Urszula. "Mela Muter: A Poet of Forgotten Things." *Woman's Art Journal* (2001): 21–6.

Lebovics, Herman. *True France: The Wars over Cultural Identity, 1900–1945*. Ithaca, NY: Cornell University Press, 1992.

Leepa, Allen. *Abraham Rattner*. New York: Harry N. Abrams, 1974.

Leighten, Patricia Dee. *Reordering the Universe: Picasso and Anarchism, 1897–1914*. Princeton, NJ: Princeton University Press, 1989.

Leighten, Patricia Dee. *The Liberation of Painting: Modernism and Anarchism in Avant-Guerre Paris*. Chicago: University of Chicago Press, 2013.

Le Paul, Judy. *Gauguin and the Impressionists at Pont-Aven*. New York: Abbeville Press, 1987.

Leroy, Claude, ed. *Blaise Cendrars et la guerre*. Paris: Armand Colin, 1995.

Levi, Primo. *Survival in Auschwitz*. New York: Touchstone, 1996.

Lévy, Pierre. *Des artistes et un collectionneur*. Paris: Flammarion, 1976.

Lévy, Sophie. "Sympathetic Order." In *A Transatlantic Avant-Garde: American Artists in Paris, 1918–1939*, edited by Christian Derouet and Sophie Lévy. Berkeley: University of California Press, 2003.

Lévy-Bruhl, Lucien. *How Natives Think*. New York: Knopf, 1926.

Lewis, Wyndham. *Time and Western Man*. London: Chatto and Windus, 1927.

Linden, Diana. "Ben Shahn's New Deal Murals: Jewish Identity in the American Scene." In *The Social and the Real: Political Art of the 1930s in the Western Hemisphere*, edited by Alejandro Anreus, Diana Linden, and Jonathan Weinberg. University Park, PA: Pennsylvania State University Press, 2006.

Lipchitz, Jacques and H. Harvard Arnason. *My Life in Sculpture*. New York: Viking Press, 1972.

Livak, Leonid. *How It Was Done in Paris: Russian Émigré Literature and French Modernism*. Madison: University of Wisconsin Press, 2003.

Livak, Leonid. *The Jewish Persona in the European Imagination: A Case of Russian Literature*. Stanford, CA: Stanford University Press, 2010.

Livak, Leonid. *Russian Emigrés in the Intellectual and Literary Life of Interwar France: A Bibliographical Essay*. Montreal and Kingston: McGill-Queen's University Press, 2010.

Long, Rose-Carol Washton, Matthew Baigell, and Milly Heyd, eds. *Jewish Dimensions in Modern Visual Culture: Antisemitism, Assimilation, Affirmation*. Hanover, NH, and London: Brandeis University Press, 2010.

Lucie-Smith, Edward. *Art of the 1930s: The Age of Anxiety*. New York: Rizzoli, 1985.

Lyon, Janet. "Cosmopolitanism and Modernism." In *The Oxford Handbook of Global Modernisms*, edited by Mark A. Wollaeger and Matt Eatough. New York: Oxford University Press, 2012.

Malinovich, Nadia. *French and Jewish: Culture and the Politics of Identity in Early Twentieth-Century France*. Oxford and Portland, OR: Littman Library of Jewish Civilization, 2008.

Malinowski, Jerzy, ed. *Jewish Artists and Central-Eastern Europe: Art Centers, Identity, Heritage: From the 19th Century to the Second World War.* Warsaw: Wydawnictwo "DiG," 2010.

*Mané-Katz et Son Temps, L'Aube Du XXe Siècle, Peintres Expressionistes et Surréalistes de Montparnasse.* Geneva: Petit Palais, 1969.

Mann, Carol. *Modigliani.* New York: Oxford University Press, 1980.

Mann, Vivian B., ed. *Jewish Texts on the Visual Arts.* Cambridge: Cambridge University Press, 2000.

Marcilhac, Félix. *Chana Orloff: 1888–1968.* Paris: Les Editions de l'Amateur, 1991.

Markham, Patrick. *Dreaming with His Eyes Open: A Life of Diego Rivera.* New York: Alfred A. Knopf, 1998.

Martin, Julie, and Billy Klüver. "A Short History of Modeling." *Art in America* 5 (May 1991): 159.

Matz, Jesse. "T. E. Hulme, Henri Bergson and the Cultural Politics of Psychologism." In *The Mind of Modernism: Medicine, Psychology, and the Cultural Arts in Europe and America, 1880–1940*, edited by Mark S. Micale. Stanford, CA: Stanford University Press, 2004.

Mauclair, Camille. *La Farce de L'art vivant.* Paris: La Nouvelle Revue Critique, 1929.

Mauclair, Camille. *La farce de l'art vivant. 2 Les Métèques contre l'art français.* Paris: La Nouvelle Revue Critique, 1930.

Mauss, Marcel. *A General Theory of Magic.* Boston and London: Routledge and Kegan Paul, 1972.

Mayer, Charles. "The Impact of the Ballets Russes on Design in the West, 1909–1914." In *The Avant-Garde Frontier: Russia Meets the West, 1910–1930*, edited by Gail Harrison Roman and Virginia Carol Hagelstein Marquardt. Gainesville: University of Florida Press, 1992.

McLuhan, Marshall. *The Gutenberg Galaxy: The Making of Typographic Man.* London: Routledge and Kegal Paul, 1962.

McWilliam, Neil. *Nationalism and French Visual Culture, 1871–1914.* New Haven, CT: Yale University Press, 2005.

"Mela Muter, 1876–1967." In *Jewish Women: A Comprehensive Historical Encyclopedia.* n.p: Jewish Women's Archive, March 2009.

Melnick, Jeffrey. *A Right to Sing the Blues: African Americans, Jews, and American Popular Song.* Cambridge, MA: Harvard University Press, 1999.

Mendelsohn, Ezra and Richard I. Cohen, eds. *Art and Its Uses: The Visual Image and Modern Jewish Society.* New York: Oxford University Press, 1990.

Meyer, Franz. *Marc Chagall: Life and Work.* Translated by Robert Allen. New York: Harry N. Abrams, 1964.

Micale, Mark S. "The Modernist Mind—a Map." In *The Mind of Modernism: Medicine, Psychology, and the Cultural Arts in Europe and America, 1880–1940*, edited by Mark S. Micale. Stanford, CA: Stanford University Press, 2004.

Micale, Mark S., ed. *The Mind of Modernism: Medicine, Psychology, and the Cultural Arts in Europe and America, 1880–1940*. Stanford: Stanford University Press, 2004.

Michaelis, Meir. *Mussolini and the Jews: German-Italian Relations and the Jewish Question in Italy, 1922–1945*. New York: Oxford University Press, 1978.

Milbauer, Joseph. "L'art et Les Juifs. Y a-t-Il Un Art Juif?" *L'Univers Israélite*, August 30, 1929, 618.

Mileaf, Janine. "Between You and Me: Man Ray's Object to Be Destroyed." *Art Journal* 63, no. 1 (Spring 2004): 4–23.

Milhaud, Darius. *My Happy Life*. London and New York: Marion Boyars, 1995.

Miller, Arthur I. *Einstein, Picasso: Space, Time, and the Beauty That Causes Havoc*. New York: Basic Books, 2001.

Minkowski, Eugène. *Lived Time: Phenomenological and Psychopathological Studies*. Translated by Nancy Metzel. Evanston, IL: Northwestern University Press, 1970.

Mirzoeff, Nicholas. *Diaspora and Visual Culture: Representing Africans and Jews*. London: Routledge, 2000.

Mirzoeff, Nicholas. "Pissarro's Passage: The Sensation of Caribbean Jewishness in Diaspora." In *Diaspora and Visual Culture: Representing Africans and Jews*, edited by Nicholas Mirzoeff. London: Routledge, 2000.

Morand, Paul. *Black Magic*. Translated by Hamish Miles. New York: Viking Press, 1929.

Morris, David B. *Eros and Illness*. Cambridge, MA: Harvard University Press, 2017.

Mosse, George L. "Max Nordau, Liberalism and the New Jew." *Journal of Contemporary History* 27, no. 4 (October 1992): 565–81.

Mosse, George L. *The Image of Man: The Creation of Modern Masculinity*. New York: Oxford University Press, 1996.

Nelken, Halina. *Images of a Lost World: Jewish Motifs in Polish Painting, 1770–1945*. Oxford: Institute for Polish Studies, 1991.

Nicault, Catherine, ed. *Dossier: Le "Reveil juif" des années vingt. Archives Juives: Revue d'histoire des Juifs de France* 39, no. 1 (2006).

Nieszawer, Nadine, Marie Boyé, and Paul Fogel, eds. *Peintres juifs à Paris, 1905–1939*. Paris: Denoël, 2000.

Nieszawer, Nadine, Deborah Princ, Oleg Semenov, and Claude Lanzmann. *Artistes juifs et l'École de Paris, 1905–1939*. Paris: Somogy, 2015.

Nochlin, Linda and Tamar Garb. *The Jew in the Text: Modernity and the Construction of Identity*. London: Thames and Hudson, 1995.

Nye, Robert A. *Masculinity and Male Codes of Honor in Modern France*. New York: Oxford University Press, 1993.

O'Hagan, John and Christiane Hellmanzik. "Clustering and Migration of Important Visual Artists: Broad Historical Evidence." *Historical Methods: A Journal of Quantitative and Interdisciplinary History* 41, no. 3 (2008): 121–36.

Olère, David, and Alexandre Oler. *Witness: Images of Auschwitz*. North Richland Hills, TX: WestWind Press, 1998.

Olin, Margaret Rose. *The Nation without Art: Examining Modern Discourses on Jewish Art.* Lincoln: University of Nebraska Press, 2007.

O'Rourke, Sean. "Who Was with Pascin at the Dôme?" *Journal of Modern Literature* 26, no. 2 (Winter 2003): 160–3.

Ory, Pascal. *La Belle Illusion: Culture et politique sous le signe du Front populaire, 1935–1938.* Paris: Plon, 1994.

Oslon, Jess. "The Dreyfus Affair in Early Zionist Culture." In *Revising Dreyfus*, edited by Maya Balakirsky Katz, 317–23. Leiden: Brill, 2013.

Pann, Abel, *Autobiographie: Odyssée d'un peintre israélien né en Russie tsariste et français d'adoption.* Paris: Les Éditions du Cerf, 1996.

Paret, Peter. *German Encounters with Modernism, 1840–1945.* Cambridge: Cambridge University Press, 2001.

Paret, Peter. "Triumph and Disaster of Assimilation: The Painter Max Liebermann." *Jewish Studies Quarterly* 15, no. 2 (2008): 135.

*Paris "Capitale Culturelle" de L'Europe Centrale? Les échanges intellectuels entre la France et les pays de l'Europe médiane, 1918–1939.* Paris: Institut d'Études Slaves, 1997.

Paxton, Robert O. *Vichy France: Old Guard and New Order 1940–1944.* New York: Columbia University Press, 2001.

Peer, Shanny. *France on Display: Peasants, Provincials, and Folklore in the 1937 Paris World's Fair.* Albany: State University of New York Press, 1998.

Peillex. *"L'Art Au Service de La Paix," Mané-Katz et Son Temps, L'Aube Du XXe Siècle, Peintres Expessionistes et Surréalistes de Montparnasse.* Geneva: Petlt Palais, 1969.

Perry, Gillian. *Women Artists and the Parisian Avant-Garde: Modernism and "Feminine" Art, 1900 to the Late 1920s.* Manchester: Manchester University Press, 1995.

Peters, Olaf. "From Nordau to Hitler: 'Degeneration' and Anti-Modernism between the Fin-de-Siècle and the National Socialist Takeover of Power." In *Degenerate Art: The Attack on Modern Art in Nazi Germany, 1937*, edited by Bernhard Fulda and Olaf Peters, 16–18. Munich and New York: Prestel, 2014.

Peters, Olaf and Bernhard Fulda, eds. *Degenerate Art: The Attack on Modern Art in Nazi Germany, 1937.* Munich and New York: Prestel, 2014.

Porch, Douglas. *The French Foreign Legion: A Complete History of the Legendary Fighting Force.* New York: HarperCollins, 1991.

Prat, Jean-Louis. *Marc Chagall.* Madrid: Museo Thyssen-Bornemisza, 2012.

Prax, Valentine. *Avec Zadkine.* Paris: Bibliothèque des arts, 1995.

Prin, Alice. *Kiki's Memoirs.* Translated by Samuel Putman. Hopewell, NJ: Echo Press, 1996.

Puget, Catherine. *Mela Muter: La Rage de Peindre d'une Femme.* Pont-Aven: Musée de Pont-Aven, 1993.

Putz, Cathy. "Towards the Monumental: The Dynamics of the Barnes Commission (1922–24)." In *Lipchitz and the Avant-Garde: From Paris to New York*, edited by Josef Helfenstein and Jordana Mendelson. Urbana-Champaign: University of Illinois Press, 2001.

*La Querelle des indépendants: une enquête*. Paris: Bulletin de la vie artistique, 1924.

Raeff, Marc. *Russia Abroad: A Cultural History of the Russian Emigration 1919–1939*. New York: Oxford University Press, 1990.

Ragon, Michel. *Mané-Katz*. Translated by Haakon Chevalier. Paris: Georges Fall, 1960.

Rappaport, Joseph. *Hands across the Sea: Jewish Immigrants and World War I*. Lanham, MD: Hamilton Books, 2005.

Raynal, Maurice. *Anthologie de la peinture en France*. Paris: Montaigne, 1927.

Richardson, John. *A Life of Picasso*, Volume II: *1907–1917*. New York: Random House, 1996.

Riley II, Charles A. *Free as Gods: How the Jazz Age Reinvented Modernism*. Hanover, NH: ForeEdge, 2017.

Rittner, Leona, W. Scott Haine, and Jeffrey H Jackson, eds. *The Thinking Space: The Café as a Cultural Institution in Paris, Italy and Vienna*. Farnham: Ashgate, 2013.

Roberts, Mary Louise. *Civilization without Sexes: Reconstructing Gender in Postwar France, 1917–1927*. Chicago: University of Chicago Press, 1994.

Roditi, Edouard. "The Jewish Artist in the Modern World." In *Jewish Art: An Illustrated History*, edited by Cecil Roth and Bezalel Narkiss. New York: McGraw Hill, 1961.

Roditi, Edouard. *Dialogues: Conversations with European Artists at Mid-Century*. San Francisco: Bedfort Arts, 1990.

Roland, Charlotte. *Du ghetto à l'occident: deux générations yiddiches en france*. Paris: Minuit, 1962.

Roman, Gail Harrison and Virginia Carol Hagelstein Marquardt, eds. *The Avant-Garde Frontier: Russia Meets the West, 1910–1930*. Gainesville: University of Florida Press, 1992.

Rosenberg, Harold. "The Fall of Paris." In *The Tradition of the New*, edited by Harold Rosenberg, 209–10. New York: McGraw Hill, 1959.

Rosenberg, Harold. *The Tradition of the New*. New York: McGraw Hill, 1959.

Rosenberg, Harold. *Discovering the Present: Three Decades in Art, Culture and Politics*. Chicago: University of Chicago Press, 1973.

Roth, Cecil. *Jewish Art: An Illustrated History*. New York: McGraw Hill, 1961.

Roth, Joseph. *The Wandering Jews*. Translated by Michael Hofmann. New York: Harry N. Abrams, 2001.

Rothenstein, William. *Men and Memories: Recollections of William Rothenstein, 1872–1900*. New York: Coward-McCann, 1931.

Salmon, André. *Montparnasse: mémoires*. Paris: Arcadia, 2003.

Salmon, André. *André Salmon on French Modern Art*. Translated by Beth S. Gersh-Nešić. New York: Cambridge University Press, 2005.

Saltzman, Lisa. "To Figure, or Not to Figure: The Iconoclastic Proscription and Its Theoretical Legacy." In *Jewish Identity in Modern Art History*, edited by Catherine M. Soussloff. Berkeley: University of California Press, 1999.

Samuel, Pascale, ed. *Chagall, Modigliani, Soutine . . . Paris pour école, 1905–1940*. Paris: Musée d'Art et d'Histoire du Judaïsme (MAHJ), 2020.

Samuels, Maurice. *The Right to Difference: French Universalism and the Jews*. Chicago: University of Chicago Press, 2016.

Sandqvist, Tom. *Ahasuerus at the Easel: Jewish Art and Jewish Artists in Central and Eastern European Modernism at the Turn of the Last Century*. Frankfurt: Peter Lang, 2014.

Šatskih, Aleksandra Semënovna. *Vitebsk: The Life of Art*. Translated by Katherine Foshko Tsan. New Haven, CT: Yale University Press, 2007.

Say, Marcel. "Le Fascisme Intellectuel." *Montparnasse*, July 1, 1922.

Schlögel, Karl and Polity Press. *Moscow, 1937*. Translated by Rodney Livingstone. Malden, MA: Polity, 2012.

Schuker, Stephen. "Origins of the 'Jewish Problem' in the Third Republic." In *The Jews in Modern France*, edited by Frances Malino and Bernard Wasserstein. Hanover, NH: Published for Brandeis University Press by University Press of New England, 1985.

Schüler-Springorum, Stefanie. "AHR Roundtable: 'Gender and the Politics of Anti-Semitism.'" *American Historical Review* 123, no. 4 (October 2018): 1210–22.

Schvalberg, Claude. *La critique d'art à Paris, 1890–1969*. Paris: Porte étroite, 2007.

Schwartz, Richard. "Jewish Practices and Rituals: The Custom of Kapparot in the Jewish Tradition." *Jewish Virtual Library* (online).

Secrest, Meryle. *Modigliani: A Life*. New York: Alfred A. Knopf, 2011.

Seligman, Germain. *Merchants of Art: 1880–1960*. New York: Appleton-Century-Crofts, 1962.

Selz, Jean. *Hendryk Hayden*. Geneva: Pierre Cailler, 1962.

Sérouya, Henri. *L'Art plastique chez les juifs*. Paris: Gazette des Beaux Arts, n.d. (1930s).

Shapiro, Michael. "Sound in a Silent Medium: Thoughts on the Pleasures and Paradoxes of Musical Paintings." In *The Art of Music: American Paintings & Musical Instruments 1770–1910*, edited by Celia Betsky. Clinton, NY: Fred Emerson Gallery, Hamilton College, 1984.

Sharp, Jane. "Natalia Goncharova." In *Amazons of the Avant-Garde: Alexandra Exter and Others*, edited by John E. Bowlt, Alexandra Exter, and Matthew Drutt. New York: Solomon R. Guggenheim Foundation, 2000.

Shaw-Miller, Simon. *Visible Deeds of Music: Art and Music from Wagner to Cage*. New Haven, CT: Yale University Press, 2002.

Silver, Kenneth E. *Esprit de Corps: The Art of the Parisian Avant-Garde and the First World War, 1914–1925*. Princeton, NJ: Princeton University Press, 1989.

Silver, Kenneth E. "Where Soutine Belongs: His Art and Critical Reception between the Wars." In *An Expressionist in Paris: The Paintings of Chaim Soutine*, edited by Norman L. Kleeblatt and Kenneth Silver. Munich and New York: Prestel, 1998.

Silver, Kenneth E. *Making Paradise: Art, Modernity, and the Myth of the French Riviera*. Cambridge, MA: MIT Press, 2001.

Silver, Kenneth E. *Paris Portraits: Artists, Friends, and Lovers*. Greenwich, CT: Bruce Museum, 2008.

Silver, Kenneth E. and Romy Golan, eds. *The Circle of Montparnasse: Jewish Artists in Paris, 1905–1945*. New York: Universe Books, 1985.

Silver, Larry. "Jewish Identity in Art and History: Maurycy Gottlieb as Early Jewish Artist." In *Jewish Identity in Modern Art History*, edited by Catherine M. Soussloff. Berkeley: University of California Press, 1999.

Sinclair, Anne. *My Grandfather's Gallery: A Family Memoir of Art and War*. Translated by Shaun Whiteside. New York: Farrar, Straus and Giroux, 2014.

Singer, Saul J. "Pablo Picasso and the Old Jew." *The JewishPress.Com*, March 11, 2015.

Slezkine, Yuri. *The Jewish Century*. Princeton, NJ: Princeton University Press, 2004.

Soltes, Ori Z. *Fixing the World: Jewish American Painters in the Twentieth Century*. Hanover, NH, and London: Brandeis University Press, 2003.

Sonn, Richard D. *Anarchism and Cultural Politics in Fin de Siècle France*. Lincoln: University of Nebraska Press, 1989.

Sonn, Richard D. *Sex, Violence, and the Avant-Garde: Anarchism in Interwar France*. University Park, PA: Pennsylvania State University Press, 2010.

Sonn, Richard D. "Jewish Modernism: Immigrant Artists in Paris, 1905–1914." In *Foreign Artists and Communities in Modern Paris, 1870–1914: Strangers in Paradise*, edited by Karen Carter and Susan Waller, 125–40. London: Ashgate, 2015.

Sonn, Richard D. "Jewish Expressionism in France." In *The Routledge Companion to Expressionism in a Transnational Context*, edited by Isabel Wünsche. London: Routledge, 2019.

Sonn, Richard D. "Jewish Artists and Masculinity in France during the Great War." In *Artistic Expression and the Great War: A Hundred Years On*, edited by Sally Charnow. Bern: Peter Lang, 2020.

Soussloff, Catherine M. *Jewish Identity in Modern Art History*. Berkeley: University of California Press, 1999.

Spencer, Charles. *The Immigrant Generations: Jewish Artists in Britain, 1900–1945: The Jewish Museum, New York, May 24–September 25, 1983*. New York: Jewish Museum, 1982.

*Spiritual Resistance: Art from the Concentration Camps, 1940–1945*. Philadelphia: Jewish Publication Society of America, 1981.

Stallybrass, Peter and Allon White. *The Politics and Poetics of Transgression*. Ithaca, NY: Cornell University Press, 1986.

Steegmüller, Francis. *Apollinaire: Poet among the Painters*. London: Rupert Hart-Davis, 1963.

Stein, Gertrude. *Composition as Explanation*. London: Hogarth Press, 1926.

Stein, Gertrude. *Paris, France*. New York: Liveright, 1940.

Sterba, Christopher M. *Good Americans: Italian and Jewish Immigrants during the First World War*. London: Oxford University Press, 2003.

Stern, Ludmila. *Western Intellectuals and the Soviet Union, 1920–40: From Red Square to the Left Bank*. London: Routledge, 2006.

Strom, Yale. *The Book of Klezmer: The History, the Music, the Folklore*. Chicago: A. Cappella, 2002.

Strosberg, Eliane. *The Human Figure and Jewish Culture*. New York: Abbeville Press, 2008.

Styrna, Natasza. "Mela Muter, 1876–1967." In *Jewish Women's Historical Encyclopedia*. Jewish Women's Archive, March 1, 2009, https://jwa.org/encyclopedia/author/styrna-natasza.

Sweeney, James Johnson. *Marc Chagall*. New York: Museum of Modern Art, 1946.

Szajkowski, Zosa. *Jews and the French Foreign Legion*. New York: Ktav Publishing House, 1975.

Szwarc, Marek. *Mémoires entre deux mondes*. Translated from Polish by Suzanne Brucker. Paris: Ressouvenances, 2010.

Tanikowski, Artur. "Heralds of Moderate Modernity: Polish-Jewish Artists in Catalonia." In *Jewish Artists and Central-Eastern Europe: Art Centers, Identity, Heritage: From the 19th Century to the Second World War*, edited by Jerzy Malinowski. Warsaw: Wydawnictwo "DiG," 2010.

Tanikowski, Artur. *Wizerunki Cztowieczenstwa, Ryticaty Powszedniosci Leopold Gottlieb I Jego Dzieło*. Cracow: Universitas, 2011.

Tanikowski, Artur. "Toward the Philosophy of Work: The Late Paintings of Leopold Gottlieb." *Ars Judaica* 9 (2013): 75–100.

Tanikowski, Artur. *Likenesses of Humanity, Rites of Commonness: Leopold Gottlieb and His Work*. No publishing information.

Tanikowski, Artur, ed. *Jew, Pole, Legionary, 1914–1920*. Warsaw: Museum of the History of Polish Jews, 2014.

Toll, Nelly S. *When Memory Speaks: The Holocaust in Art*. Westport, CT: Praeger, 1998.

Tuchman, Maurice. *Chaim Soutine 1893–1943, Life and Work*. Los Angeles: Los Angeles County Museum of Art, 1968.

Tuchman, Maurice and Esti Dunow. *The Impact of Chaim Soutine (1893–1943): De Kooning, Pollock, Dubuffet, Bacon*. Cologne: Gallery Gmurzynska, 2002.

Tuchman, Maurice, Esti Dunow, Klaus G. Perls, Michèle Schreyer, and Chaim Soutine, eds. *Chaim Soutine, Catalogue Raisonné*. New York: Harry N. Abrams, 1977.

Vanderpyl, Fritz. "Existe-t-Il Une Peinture Juive?" *Mercure de France*, July 15, 1925, 386–96.

Vanderpyl, Fritz. *L'Art sans Patrie, un Mensonge. Le Pinceau d'Israël*. Paris: Mercure de France, 1942.

Veblen, Thorstein. "The Intellectual Pre-Eminence of Jews in Modern Europe." *Political Science Quarterly* 34, no. 1 (March 1919): 33–42. Reprinted in Rick Tilman, ed. *A Veblen Treasury*. Armonk, NY: Sharpe, 1993.

Vergo, Peter. *The Music of Painting: Music, Modernism and the Visual Arts from the Romantics to John Cage*. London: Phaidon Press, 2010.

Vollard, Ambroise. *Recollections of a Picture Dealer*. Translated by Violet Macdonald. New York: Dover, 1978.

Vorobëv, Marevna. *Life in Two Worlds: A True Chronicle of the Origins of Montparnasse*. London: Abelard-Schuman, 1962.

Vorobëv, Marevna. *Life with the Painters of La Ruche*. Translated by Natalie Heseltine. New York: Macmillan, 1972.

Vorobëv, Marevna. *Marevna et les Montparnos*. Paris: Musées de la ville de Paris, 1985.

Waldberg, Patrick. "The land of Grégoire Michonze." In *Grégoire Michonze, 1902–1982: Naturaliste-Surréel*, edited by Max Fullenbaum, Francis Barlier, Dominique Daguet, and Pierre Descargues. Paris: Terre des peintres, 1997.

Warnod, André. *Les berceaux de la jeune peinture; Montmartre, Montparnasse*. Paris: l'Ecole de Paris, 1925.

Warnod, André. "L'Ecole de Paris." *Comoedia*, January 21, 1925.

Warnod, André. *Pascin*. Monte-Carlo: Editions du livre, 1954.

Warnod, Jeanine. *L'Ecole de Paris*. Paris: Arcadia editions, 2004.

Watkins, Glenn. *Pyramids at the Louvre: Music, Culture, and Collage from Stravinsky to the Postmodernists*. Cambridge, MA: Harvard University Press, 1994.

Wayne, Kenneth. *Modigliani and the Artists of Montparnasse*. New York: Harry N. Abrams, 2002.

Weber, Eugen. *The Hollow Years: France in the 1930s*. New York: Norton, 1994.

Weil, Patrick. *La France et ses étrangers: l'aventure d'une politique d'immigration: 1938–1991*. Paris: Calmann-Lévy, 1991.

Weiss, Andrea. *Paris Was a Woman: Portraits from the Left Bank*. San Francisco: HarperSanFrancisco, 1995.

Werner, Alfred. "Jewish Artists of the Age of Emancipation." In *Jewish Art: An Illustrated History*, edited by Cecil Roth and Bezalel Narkiss, 555–9. New York: McGraw Hill, 1961.

Werner, Alfred. *Chaim Soutine*. New York: Harry N. Abrams, 1977.

Wierzbicka, Anna. "Polish Artists in France 1918–39: The Discussion Concerning National Art." In *Crossing Cultures: Conflict, Migration and Convergence*, 607–12. Melbourne, Australia: Miegunyah Press, 2009.

Wilentz, Sean. *Bob Dylan in America*. New York: Doubleday, 2010.

Wilson, Sarah, ed. *Paris: Capital of the Arts, 1900–1968*. London: Royal Academy of Arts, 2002.

Worringer, Wilhelm. *Abstraction and Empathy*. New York: International Universities Press, 1948.

Wullschläger, Jackie. *Chagall: A Biography*. New York: Knopf, 2008.

Wünsche, Isabel, ed. *The Routledge Companion to Expressionism in a Transnational Context*. New York: Routledge, 2019.

Zadkine, Ossip. *Le Maillet et le ciseau: souvenirs de ma vie*. Paris: Albin Michel, 1968.

Zalmona, Yigal. *The Art of Abel Pann: From Montparnasse to the Land of the Bible*. Jerusalem: Israel Museum, 2003.

Zeri, Federico, Marco Dolcetta, Elena Mazour, and Tonino Sofia. *Chagall, The Falling Angel*. Richmond Hill, Ontario: NDE, 1999.

Zuccotti, Susan. *The Holocaust, the French, and the Jews*. Lincoln: University of Nebraska Press, 1999.

Zynicki, Colette, ed. *Terre d'exil, terre d'asile*. Paris: Éditions de l'Éclat, 2009.

# Index

*A Pinch of Snuff (Rabbi)* (Chagall), 279
Aalto, Alvar, 281
Abbott, Berenice, 155
Aberdam, Alfred, 313
abstract expressionism, 170, 172
abstraction, 72–3, 123–4, 145, 172, 277
academicism, 29–30
Académie Colarossi, 76
Académie de la Grande Chaumière, 150
Académie Française, 38
Académie Julian, 21, 23
Académie Russe, 21
Action Française, 265
aesthetic conservatism, 110
African art, 8, 88
African sculpture, 82
African-American culture, 203–9, **208**
African-Americans, 7, 9
*Air Raid, The* (Rattner), **318**, 320
Akhmatova, Anna, 87, 154
Albert-Lasard, Lou, 311
Aleichem, Sholem, 191, 217, 218, 281
Alexander II, Tsar, assassination of, 4, 25–6
Alix, Yves, 236–7
Alliance Israélite Universelle, 28
Altman, Natan, 133
American Art Association, 21
Amishai-Maisels, Ziva, 323
anarchism, 58n36
aniconism, 33, 172
*Anschluss*, the, 265, 292
anti-Jewish laws, 305
anti-modernists, 34
antirationalist tradition, 246
antisemitism, 9, 10, 10–1, 23–4, 63, 104,
        105, 108–9, 149, 179, 224, 237, 239,
        241–2, 255, 259, 264, 278–9, 289,
        306, 312
Antokolsky, Mark, 18
*Apocalipsion* (Rattner), 319, 320

Apollinaire, Guillaume, 7, 16, 39, 64, 71, 86,
        87, 163, 192–3, 199–201, 227, 235,
        238
    background, 199
    and Chagall, 199
    death, 135
    *Les Mamelles de Tirésias*, 109–10
    World War I service, 99, 113
Apollo, 200–1, 213, 216
*Apollon Musagète* (Stravinsky), 201
Aragon, Louis, 267
Arbit Blatas, Neemya, 169, 179, 262
Archipenko, Alexander, 51, 313
Arlen, Harold, 205
Armory Exhibition, 1913, 75
Arnason, H. H., 210
Aronson, Boris, 191
Arp, Hans, 309–10
art academies, 2, 20, 21, 64, 65
art critics, 5–6, 10, 232
    importance, 224
    and Jewish art, 26–31
art dealers, 5–6, 10, 240
    1930s decline, 263
    German connection, 225–9
    importance, 224–5
    Jewish, 242–8
    prevalence of Jewish, 223–6
    role of, 228–9
    and WWII, 306
Art Déco Exposition,1925, 246
art historical canon, place in, 258–60
art market, 6, 230–6
    1930s decline, 261
    branding, 231–2
    and ethnicity, 230–1
    female artists, 234–6
    Great Depression collapse, 229
    international, 233–4
    Jewish control, 224
    publicity, 232–3
    and sociability, 234

art students, 19, 20, 25
artist numbers, 65–6
artist-deportees, WWII, 310–4
artistic assimilation, 5
artistic community, 21
artistic heritage, 50
artistic mobility, 2
artists' colonies, 2
*Artists in Exile* exhibition, 301–2, **302**, 303
arts de la femme, 79
Ashcan school, 217
Ashkenazi Jews, 3, 35, 44, 100–1, 103, 152, 191, 205
*Asphyxiation in the gas chamber* (Olère), 331
assimilation, 12, 21, 24, 69
Association des Artistes Scandinaves, 21
Association des Écrivains et Artistes Révolutionnaires, 266–7, 268, 327
Astruc, Gabriel, 86
Au Sacre du Printemps, 323
Auerbach, Edith, 311
Aurenche, Marie-Berthe, 308–9
Auric, Georges, 203
Auschwitz, 305, 312, 322, 327, 330–1
Austria, the *Anschluss*, 265, 292
authority, rejection of, 2

backlash, 238–42, 276–7
    Jewish critics, 242–8
Badoul, Lucie, 156
Baker, Josephine, 154, 204
Bakst, Léon, 84, **84**, 85, 86
*Bal Bullier* (S. Delaunay), 39, **40**, 41, 73
Bal Nègre, 206
Balanchine, George, 201
Balfour Declaration, the, 107
Ballet Suédois, 209
Ballets Russes, 8, 65, 84–7, 88–9, 98, 201, 202–3, 235
Baranoff-Rossiné, Daniel Vladimir, 196–8, 199, 216
    *Capriccio Musicale*, 196, **197**
    color organ, 196
    *Counter-Relief*, 196
    *Symphony Number 1*, 196, **198**
Barbusse, Henri, 113
Barcelona, 77

Barnes, Albert, 6, 48, 88, 169, 212, 233–4, 234
Barnes, Djuna, 9
Barney, Natalie Clifford, 150
Barrès, Maurice, 108, 238
Basch, Victor, 102–3
Basel, fifth Zionist Congress, 18
Basler, Adolphe, 13n10, 31, 33, 74, 101, 179, 192–3, 232, 242–3, 243–6, 260
Battle of France, 304
Bazin, Germain, 31
Beach, Sylvia, 9
Beauvoir, Simone de, 156, 261
Beckmann, Max, 121
Belleville, 63
Bellmer, Hans, 308
Benda, Julien, 32, 38, 189, 191
*Benediction I* (Lipchitz), 322
Benstock, Shari, 154
Benton, Thomas Hart, 271, 272
Bergson, Henri, 32, 35–8, 48–51, 67
    and time, 38–9, 41–4
Berkman, Alexander, 107
Berlin, 7, 18, 75, 122, 227–8, 228
Berlin, Irving, 205
Berman, Eugene, 301
Bernheim-Jeune Gallery, 112, 161, 223, 228, 306
Bezalel Academy of Arts and Design, Jerusalem, 18–9
Biddle, George, 135
Biélinky, Jacques, 28–9, 175, 232
*Birth of Drama, The* (Grünewald), **200**
*Black Glove, The* (Chagall), 46–7
Blanchard, Maria, 112
Bland, Kalman, 172
Bloch, Abraham, 107–8
blood libel, 24
Blum, Léon, 10, 105, 107, 147, 264, 265, 266, 268, 271, 272
Blumenfeld, Lupus, 175
Boccioni, Umberto, 52, 88
bohemian acculturation, 22–3
bohemian myth, 150–3
bohemian subcultures, rise of, 2
Bolshevism, 85
Bondy, Walter, 74
Bosch, Hieronymus, 329
Boucher, Alfred, 79, 81, 110
Bougault, Valérie, 259

boulevard Raspail, 86
branding, 231–2
Braque, Georges, 99, 100, 227
Brauner, Victor, 32, 180, 307
Breton, André, 6, 87, 301
Breughel, Pieter, 49
*Bridal Couple of the Eiffel Tower* (Chagall),
    16–7
*Brigadier Josef Pilsudski* (Gottlieb), **117**
Brittany, 76
Buber, Martin, 18, 33
Buchenwald, 312, 327, 329
Buffet, Gabrielle, 199
*Bulletin de la Vie Artistique*, 236, 237
Burliuk, David, 133

Café de la Rotonde, 50, 64, 74, 97–9, **98**,
    133, 151, 152
Café du Dôme, 74, **157**, 179, 226, 261,
    294n17
Café du Parnasse, 233
cafés, 21, 64
Cahun, Claude, 9, 154
Calliope, 201
Canudo, Ricciotto, 7, 64, 71, 72
*Capriccio Musicale* (Baranoff-Rossiné),
    196, **197**
*Carcass of Beef* (Soutine), 48, **49**
Cartesian perspectivalism, 37
Carton, Moïse, 238
Casanova, Laurent, 329–30
Cassatt, Mary, 3
Cassirer, Paul, 228
Cassou, Jean, 210
Castaing, Madeleine, 170
Cendrars, Blaise, 71, 72, 86, 99, 102, 113–4,
    115, 131, 191, 227, 228
Chagall, Bella, 16, 17, 46, 105, 122, 124, 230
Chagall, Marc, 5, 19, 70, 80, 87, 101, 133,
    173
    and abstraction, 123–4
    Apollinaire and, 86, 199
    art dealers, 224, 227–9
    autobiography, 70
    and the Ballets Russes, 85–6, 86
    Basler on, 244
    Berlin show, 1914, 75, 122, 227–8,
        228–9
    *The Black Glove*, 46–7

*Bridal Couple of the Eiffel Tower*, 16–7
*Christ as a Clock*, 46
citizenship application, 284–5, 295n212
clock motif, 45–7, **47**, 73–4, 289–90,
    **332**, 333
comparison with Mané-Katz, 174–6
*The Crucified*, 316
crucifixion motif, 12, 122, **291**, 292,
    314, **315**, 316, 318–9
death, 75
director of Vitebsk People's Art School,
    122–4, 288
Eiffel Tower symbolism, **15**, 16, 16–7, 45
Escholier on, 273
exile, 301, **302**, 307, 317, 333
expressionism, 33
*The Falling Angel*, 46, 331, **332**, 333
*Flayed Ox*, 316
genius, 65
*Golgotha*, 314
*The Green Jew*, 71
*The Green Violinist*, 10, **190**, 191–2, 193
Hasidic influence, 34
*Homage to Apollinaire*, 7, 72, **72**, 73–4,
    87–8
*I and the Village*, 45
Jewish identity, 65, 145, 290
knowledge of cubism, 16
La Fontaine illustrations, 228
marketing potential of origins, 86
marriage, 46, 105, 122
memoirs, 228
*Music*, 124
*The Musician*, 192
naturalization, 264, 295n23, 298n86
nostalgia, 45–8, **47**, 192, 289–90
*Nude over Vitebsk*, 258
"On the Slaughtered Artists", 303
*Orpheus*, 200
*Paris through the Window*, 15–6, **15**, 45,
    52, 87, 88
*A Pinch of Snuff (Rabbi)*, 279
and poets, 71–2
relations with other painters, 72
response to crisis of the 1930s, 284–93,
    **291**
response to the Holocaust, 89–90, 314,
    **315**, 316–7
return to France, 1948, 317

return to Paris, 1923, 1, 124, 228
*Revolution*, 290–1
and Russia, 85
*Self-portrait with Clock*, 46, **47**, 333
self-portraits, 71, 193
status, 6
studio, 79
success, 230
supporters, 7
and Tel Aviv art museum, 288–9
and time, 8, 45–8, **47**, 52, 331, 333
*Time is a River without Banks*, 8, 46,
    289–90, 333
Vanderpyl attacks, 242
violin motif, 46, 192, 216
visits Palestine, 288–9
*War*, 122
*White Crucifixion*, 52, 89, **291**, 314, 316
and WWI, 102, 122–3
and WWII, 293, 307, 314, **315**, 316–7,
    331, **332**, 333
*Yellow Crucifixion*, **315**
and Zionism, 288–9
Champigneulle, Bernard, 276
Chapiro, Jacques, 79–80, 195, 229
Chapman, Victor, 115
Chardin, Pierre, 48
Charles, Geo, 240
Chez Rosalie, 99
Chicago, 144
*Christ as a Clock* (Chagall), 46
Christianity, 25
circumcision, 105
Cité Falguière, 22
citizenship, 3
civil rights, 3
*Clarté*, 113
clock motif, 45–7, **47**, 52, 73–4, 289–90,
    **332**, 333
Cocteau, Jean, 33
    Café de la Rotonde photograph, 4,
        97–9, **98**, 301
    The Cock and the Harlequin, 203
    *Le boeuf sur le toit*, 203
    on Montparnasse, 100
    on transnational ambience, 4–5
    wartime performances, 202–3
    World War I service, 4, 99
    on WWI, 99

Cody, Morrill, 294n11
Colonial Exposition, 1931, 262, 273
commercialization, 89
*Commune*, 267
communism, 85
Communist International, 266
*Comoedia*, 5
Concarneau, Brittany, 76
conservatism, 263
conspiracy theories, 6, 28, 65, 146, 240
*Contrastes simultané* (Delaunay), 72–3
Cormon, Fernand, 174, 277
cosmopolitanism, 6–7, 34, 44, 145, 158, 261
Coty, François, 241
*Counter-Relief* (Baranoff-Rossiné), 196
*Country and City* (Grünewald), **178**, 179
Courbet, Gustave, 1, 48, 170
Cowley, Malcolm, 258
*Crouching woman* (Orloff), **149**
*Crucified, The* (Chagall), 316
crucifixion motif, 12, 122, **291**, 292, 314,
    **315**, 316, 318–9, **319**, 320
cubism, 3, 8, 16, 20, 32–3, 33, 35, 39, 51, 64,
    109, 112, 180, 196, 226, 231, 246, 258
cultural distinctiveness, 26
cultural inheritance, 55
cultural traits, 26
Cunard, Nancy, 154, 235
Curry, John Steuart, 272

dada, 6, 79, 134, 172, 180, 207
Dali, Salvador, 180
    *The Persistence of Memory*, 52, 53
dance clubs, 206
*Dancer* (Lipchitz), 109
*dancers (sailor and sweetheart), The*
    (Orloff), **148**
*Darkness Fell over the Land* (Rattner), 319
Daudet, Léon, 238
David, Hermine, 74, 106, 125–6, 154,
    159–60
de Chirico, Giorgio, 52
de Gaulle, Charles, 305
*Death of Danielle Casanova, The* (Taslitzy),
    329–30
decadence, 146
    fear of, 104
*Degenerate Art* exhibition, 11, 66, 264, 272,
    279, 313

Delaunay, Charles, 336n25
Delaunay, Robert, 16, 32, 35, 39, 199, 235, 269
  and the Ballets Russes, 87
  commercialization, 89
  *La Ville de Paris*, 87
  and public art, 267
Delaunay, Sonia, 16, 19, 35, 39, 65, 66, 149, 156, 235–6, 268, 269, 271, 309–10
  abstraction, 72–3
  *Bal Bullier*, 39, **40**, 41, 73
  and the Ballets Russes, 87
  commercialization, 89
  *Contrastes simultané*, 72–3
  *Electric Prisms*, 73, **73**
  marriage, 154
  Musée nationale d'art moderne retrospective, 271
  and poets, 71
  *Propeller*, **270**, 271
  *Prose du Transsibérien*, 73
  *robe simultanée*, **73**
Denis, Maurice, 86
Dermée, Paul, 135
Descartes, René, 37
Desnos, Robert, 156, 206, 310
Diaghilev, Sergei, 65, 84, 87, 201
Diaspora, the, 25–6
displacement, sense of, 44–5
Dix, Otto, 121
Dizengoff, Meir, 288, 289
Dobrinsky, Isaac, 110, 114
d'Oettingen, Hélène, 86
Dorival, Bernard, 33
Dormoy, Marx, 282
Doucet, Jacques, 225
*Dr. Edward Wertheim* (Gottlieb), **118**
Dreyfus, Captain Alfred, 24, 65, 104
Dreyfus, Georges, *Les Montparnos: roman de la bohème cosmopolite*, 151–3
Dreyfus Affair, the, 3, 5, 10, 11–2, 24, 63, 104, 108, 306
Drieu la Rochelle, Pierre, 147
drugs, 146
Drumont, Edouard, 23–4, 105
Duchamp, Marcel, 9–10, 134, 180, 308
  *Nude Descending a Staircase*, 9
duels, 8, 67, 105, 106–7, **106**, 161
Duncan, Isadora, 213

Durkheim, Emile, 35, 88
Dutch art, 37
Dylan, Bob, 217–8

East meets West, 84–7
Ecole de Paris, 5, 6, 19, 28, 29–30, 33, 34, 50, 79, 143, 144–5, 145–6, 231, 237, 240, 258–9, 262–3, 292, 333–4
Ecole des Beaux-Arts, 20
Ecole Juive, 145, 334
Ecole Nationale des Beaux Arts, 21
Ecole National Supérieure des Arts Décoratifs, 112
Ehrenburg, Ilya, 133
Eiffel Tower, **15**, 16, 16–7, **17**, 45, 55n2
Einstein, Albert, 32, 33, 34, 35, 41–2, 50–1
*Electric Prisms* (Delaunay), 73, **73**
Eluard, Paul, 124
Emergency Rescue Committee, 306–7, 308
Epstein, Genrikh, 80
Epstein, Henri, 313
Epstein, Jacob, 126, 127–8, 135–6
Ernst, Max, 124, 150, 180, 246–7, 285, 301, 308, 310, 334n2
eroticization, 155
Escholier, Raymond, 273
exile, 301–4, **302**, 307, 308–9, 323, 333
experimentation, 70
Exposition Internationale des Arts et Techniques dans la Vie Moderne, 1937, 10–1, 81, 262, 264, 269, 271, 272–7, **275**, **280**, 334
  national pavilions, 279–82, 290
  Pavilion of Modern Jewish Culture, 281
expressionism, 3, 33, 64, 75, 246
  Grünewald, 177, **178**, 179
  Kikoïne, 176
  Krémègne, 176–7
  Soutine, 164–6, **164**, **165**, **167**, 168–70, **168**, **171**, 172–4
Express-Sionistes, 33

*Falling Angel, The* (Chagall), 46, 331, **332**, 333
false primitivism, 239
fascism, 10–1, 246, 266
Faubourg St. Denis, 23
fauvism, 3, 20, 64, 179, 180, 258

Féder, Adolphe, 236–7
Federation of Jewish Societies, 108
Fels, Florent, 50, 76, 79, 159, 180, 232, 239, 241, 243, 255
*Female Nude* (Soutine), 258
feminine romanticism, 38
Fénéon, Félix, 112, 223
Fenster, Hersch, 310
*Fiddler on the Roof* (musical), 191
Filla, Emil, 101
Fitzgerald, F. Scott, 9
*Flayed Ox* (Chagall), 316
Flechtheim, Alfred, 74, 226, 228, 255
Fleg, Edmond, 288
Florence, 2
Foire aux Croûtes, 28
foreign invasion, threat of, 237
foreign-born population, 146, 265
formalism, 81
formism, 67
Foujita, Tsuguharu, 5
Fourier, Charles, 79, 81
Foyer Amical or Friendship Center, 310
France, Anatole, 113
Franco-Prussian War, 1, 103–4
freedom, 12
French Algeria, 24
French artists, no shortage of, 146
French Communist Party, 261, 266, 267, 277, 327
French Foreign Legion, 4, 8, 101, 102, 108–9, 114, 115, 124–5, 133, 161, 174
French Revolution, 12, 16
Freud, Sigmund, 32, 33, 34, 35, 35–6, 43–4, 50–1, 66, 70–1, 88, 105, 279
Freundlich, Otto, 19, 66, 268, 278–9, 307–8, 313
*Fruits of Pain* (Muter), 77
Fry, Varian, 303, 306–7, 308, 313
Fuss-Amoré, Gustave, 144
futurism, 3, 39, 51, 52–3, 64, 180, 196

Gabo, Naum, 51–2
Galanis, Demetrios, 5
Galerie Berthe Weill, 131
Galerie Percier, 51, 175
Galerie Zak, 181
*garçonnes*, 154–5
Gauguin, Paul, 77–8

gender ambiguity, 257
gender boundaries, 147
gender norms, 9, 149–50
gender roles, 104–5
George, Waldemar, 31, 173, 232, 239, 243, 245–8, 285
Germany, rise of Nazism, 147
Gershwin, George, 205, 216
Geslot, Emilienne Pâcquerette, 97–9
Giacometti, Alberto, 259
Gimpel, René, 223
Gleizes, Albert, 39
Goblet, Aïcha, 155–6
Goebbels, Joseph, 255, 279
golden age, 18
Goldman, Emma, 107
*Golgotha* (Chagall), 314
Goncharova, Natalia, 90n5
Gottlieb, Adolph, 248
Gottlieb, Leopold, 19, 66, 71, 77
    background, 67
    *Brigadier Josef Pilsudski*, **117**
    career, 67
    death, 67
    *Dr. Edward Wertheim*, **118**
    duel with Kisling, 8, 67, 104, 106–7, **106**, 161
    first one-man show, 67
    Jewishness and Jewish identity, 67, 69
    *Legionary next to sick woman*, **119**
    in Montparnasse, 67
    Polish nationalism, 120
    post-WWI, 121
    return to Paris, 1925, 121
    style, 121
    World War I service, 8, 67, 114, **117**, 118–20, **118**, **119**
Gottlieb, Maurycy, 66–7, 69
Granoff, Katia, 150, 223, 233
Granowsky, Samuel, 156, 260, 313
Grasse, 309–10
graven images, biblical commandment against, 27–8, 30, 33, 172
Great Britain, Jewish immigration, 265
Great Depression, the, 10, 147, 228, 258, 282
*Green Jew, The* (Chagall), 71
*Green Violinist, The* (Chagall), 10, **190**, 191–2, 193

Greenberg, Clement, 144–5
Gris, Juan, 3, 5, 100, 224
Gros, Renée, 98, 115
Grosz, Georg, 121, 166
*Grotesque (self portrait)* (Soutine), **171**
Groth, Gerda, 284, 298n77, 308
Group of Four, the, 313
Gruber, Francis, 261
Grünewald, Isaac, 74, 177, 180
    *The Birth of Drama*, 200, **200**
    *Land och stad*, **178**
Grynzspan, Herschel, 265, 282
*Guernica* (Picasso), 264, 281
Guggenheim, Peggy, 301–2, 335n3
Guillaume, Paul, 88, 128, 224
Gutfreund, Otto, 101

Habsburg Empire, 66–7
Halicka, Alice, 8, 65, 66, 69, 112, 114, 149,
    230, 234–5
Hamnett, Nina, 107, 126–7, 155
*Harlequin with Clarinet* (Lipchitz), **211**,
    213
Hasidism, 34, 59n46, 87, 191–2
Hastings, Beatrice, 154
Hayden, Henri, 231
    *The Three Musicians*, 208–9, **208**
*Head of a Woman* (Modigliani), **128**
Hébuterne, Jeanne, 76, 98, 105, 135–6, 154
hedonism, 144–5
Heine, Henri, 159
Hemingway, Ernest, 9, 145, 160–1
Hengstenberg, Rudolph, 280
Hérold, Jacques, 180, 307
Herzl, Theodore, 11, 24, 105, 288
Heschel, Abraham J., 44
Hiler, Hilaire, 206–7, 272
historical memory, 44–5
history, 44
Hitler, Adolf, 11, 255, 266, 279, 305
Hiver, Marcel, 239–40
Hjertén, Sigrid, 74, 179
Holiday, Billie, 205
Holocaust, the, 12, 89–90, 247, 293, 303,
    305–6, 310–4
    Chagall's response to, 314, **315**, 316–7
    Lipschitz's response to, 320–3, **321**
    Rattner's response to, 317–20, **318**, **319**
    survivor's responses, 327, **328**, 329–31

Holocaust deniers, 331
Holocaust Remembrance Day, 305
*Homage to Apollinaire* (Chagall), 7, 72, **72**,
    73–4, 87–8
*Homage to Paris* (Mané-Katz), 16, **17**
houses of culture, 267
Hulme, T. E., 38, 87
human subjectivity, 50
Husserl, Edmund, 35, 43
Husson, Paul, 238, 239

*I and the Village* (Chagall), 45
identity
    mobile, 45
    search for, 28
    *see also* Jewishness and Jewish identity
identity politics, 11–2
idolatry, 172
immigration, 3, 3–4
impressionism, 3, 5, 20, 68, 180
Indenbaum, Léon, 21, 80, 243, 244
influenza epidemic, 1919, 112, 135
*Instinctive Painters: birth of expressionism*
    exhibition, 173
International Exposition, 1889, 23
international patriotism, 4–5, 99
International Time Bureau, 55
internationalism, 21, 29–30, 277
intuitive state, 39
irrationalism, 189
Islam, 25
Israel, 175
Israëls, Josef, 18, 289

Jaccard, Pierre, 5–6, 13n10, 30–1, 245
Jacob, Max, 4, 71, 97–9, 163, 199, 303
Jacometti, Nesto, 260–1, 261, 263
*Jacques and Berthe Lipchitz* (Modigliani),
    **130**
Janco, Marcel, 32, 100, 207
Jastrebzoff, Serge, 86
jazz, 7, 10, 146, 187–9, 203–9, **208**, 216
Jazz Age, the, 10, 187–218
    and African-American culture, 203–9,
    **208**
    Raeben.Dylan connection, 217–8
    and sculpture, 209–16, **211**, **212**, **214**
    synesthesia, 196–8, **197**, **198**, 199–203,
    216

jazz bands, 207–9, **208**
jazz clubs, 187–8, 191, 205–6
Jerusalem, Bezalel Academy of Arts and Design, 18–9
Jesus Christ, 66–7, 67, 122, **291**, 292, 314, **315**, 316, 318–9, **319**, 320, 333
Jeu de Paume, 263
Jewish art, 7–8, 15–20
    characteristics, 29–30
    and the critics, 26–31
Jewish artists, arrival in Paris, 19–20
Jewish awakening, 146
*Jewish Bride, The* (Weissberg), 325
Jewish culture, 71, 152
Jewish Diaspora, 7, 70
Jewish emancipation, 18
Jewish Enlightenment, 12
Jewish immigration, 1, 3, 23–6, 63–76, 179–81, 264–5, 303–4
Jewish incursion, criticism of, 5–6
Jewish martyrdom, 314, **315**, 316, 333
Jewish mysticism, 177
Jewish nationalism, 289
Jewish population, 4, 10, 24, 146, 252n62, 264–5, 281
Jewish radicalism, 152
Jewish temperament, 29, 35
Jewish thought, 31–6
Jewish War of Independence, 175
Jewishness and Jewish identity, 26, 30, 65, 67, 69, 70, 143, 145, 153, 160, 163–4, 172–3, 231, 290
Joachim, Joseph, 192
Jockey, the, 206–7
Jolson, Al, 189, 205
*Joy of Orpheus* (Lipchitz), 283
Joyce, James, 9, 41–2
Judaism, 25–6, 71
    holidays, 8, 44
    and time, 44
    universalistic ethical ethos, 172
Justman, Ary, 112

kabbala, the, 87
Kahlo, Frida, 71, 271
Kahnweiler, Daniel-Henry, 109, 223, 223–4, 226, 226–7, 306
Kahnweiler auction, 227
Kandinsky, Wassily, 33, 87, 196, 197–8, 200

Kant, Immanuel, 6–7
Kars, Georges, 101, 139n54, 311
Kertesz, André, 216
Khokhlova, Olga, 98
Kiki de Montparnasse, 155, 156, 162, 163, 206
Kikoïne, Michel, 33, 101, 110, 177
kinetic sculptures, 52–3, **53**
Kirchner, Ernst Ludwig, 166
Kirszenbaum, Jesekiel, 311
Kischka, Isis, 311
Kisling, Moïse, 5, 6, 19, 30, 89, 133, 134, 151–2, 229, 234, 239, 261
    background, 161
    Café de la Rotonde photograph, 4, 97–9, **98**, 301
    duel with Gottlieb, 8, 67, 104, 106–7, **106**, 161
    exile, 308
    French Foreign Legion service, 4, 8, 161
    French naturalization, 118, 162
    Jewishness, 163–4
    Legion of Honor, 162
    *les années folles*, 161–4
    marriage, 105, 115, 161
    Modigliani portrait, **162**
    post-WWI, 121
    reply to Vanderpyl, 242
    Soutine portrait, 164–5, **164**
    World War I service, 99, 113, 114, 115
*Kiss, or The Family, The* (Orloff), **111**, 112
Klarsfeld, Serge, 330
Klee, Paul, 33
klezmer music, 191, 192, 193
Kodkine, Meyer-Miron, 311
Koenig, Leo, 80
Kokoschka, Oskar, 129, 166
Kolos-Vary, Sigismond, 311
Kook, Abraham, 18–9
Kosnick-Kloss, Hannah, 268
Krasner, Lee, 172
Krautheimer, Richard, 26–7
Krémègne, Pincus, 33, 101, 110, 176–7, 195, 245
Kristallnacht, 265, 292, **315**
Krogh, Lucy, 233
Krogh, Per, 160, 181
Ku Klux Klan, 9
Kupka, Frantisek, 101

*La Belle Illusion*, 266
La Coupole, 206
*La Libre Parole*, 105
La Ruche, 15, 22, 35, 64, 79–81, 99, 110, 168, 176, 177, 195, 229
*La Ville de Paris*, (R. Delaunay), 87
Labbé, Edmond, 272
Lagrange, Leo, 10–1, 281
*L'Ami du Peuple*, 241
*Land och stad* (Grünewald), **178**, 179
*Landscape* (Pascin), **125**
Langevin, Paul, 41–2
Larionov, Mikhail, 90n5
*L'art mural*, 267
*L'Art Vivant*, 79, 159, 232, 242, 243
Latin Quarter, 2, 22
Laval, Pierre, 305, 306, 310
Le Boeuf sur le Toit, 191, 203
*Le boeuf sur le toit* (Cocteau), 203
Le Corbusier, 135, 277
*Le Figaro*, 241, 276
*Le Matin*, 11, 276
Le Monocle, 9
Lefebvre, Raymond, 113
L'Effort Moderne Gallery, 231
Léger, Fernand, 99, 100, 135, 146, 227, 237, 239, 267, 268, 301
Legion of Honor, 68, 78, 162
*Legionary next to sick woman*, Gottlieb, Leopold, **119**
Leighten, Patricia, 58n36
Leiris, Louise, 306
Lempicka, Tamara de, 150, 154
Lenin, Vladimir, 100
*Léon Bakst* (Modigliani), **84**
*les années folles*, 8–9, 143–81, 187, 258
    bohemian myth, 150–3
    Kisling, 161–4
    Mané-Katz, 174–6
    Pascin, 144, 145, 157–61
    Soutine, 164–6, **164, 165, 167**, 168–70, **168, 171**, 172–4
    women and, 153–6
*Les Artistes Juifs.*, 233
*Les Demoiselles d'Avignon* (Picasso), 41, 98, 226
*Les Soirées de Paris*, 86
lesbianism, 9, 149, 150, 154–5
Levitan, Isaac, 18

Levy, Emmanuel, 12
Lévy, Jacob, 223
Lévy, Léopold, 29
Levy, Rudolph, 74, 75
Lévy-Bruhl, Lucien, 88
Lewis, Wyndham, 38, 41–2
Lhote, André, 236–7, 268
*L'Humanité*, 267
*liberté*, 12
Liebermann, Max, 5, 18, 289
    background, 68
    career, 68–9
    Legion of Honor, 68
Likhteinstein, Itsakh, 80
Lipchitz, Berthe, 210, 307
Lipchitz, Jacques, 5, 8, 19, 21, 36, 48, 66, 71, 76, 88, 89, 101, 127, 133, 135, 150, 224, 229, 231, 233, **274, 302**
    1930s, 260
    AEAR links, 266–7
    African sculptures, 87
    *Benediction I*, 322
    bull motifs, 283
    *Dancer*, 109
    exile, 301, 307
    exploration of struggle, 282–3, **283**
    French naturalization, 118
    *Harlequin with Clarinet*, **211**, 213
    *Joy of Orpheus*, 283
    marriage, 105, 110
    Modigliani portrait, **130**
    *Mother and Child I*, 283
    and music, 209–13, **211, 212**, 216
    musical instrument motifs, 210–3, **211, 212**
    paradox, 210
    *The Prayer*, **321**, 322
    *Prometheus Strangling the Vulture*, 11, 274–7, **275, 278**, 283, 321
    and public art, 267
    *Rape of Europa*, 275, 283, 320–1
    *Rape of Europa II*, **276**
    response to crisis of the 1930s, 282–3
    response to the Holocaust, 320–3, **321**
    *Sacrifice*, 322–3
    *Song of Songs*, 283
    *Song of the Vowels*, 212–3, **212**, 282
    *Still Life with Musical Instruments*, 212

*The Suppliant*, 322
*Theseus and the Minotaur*, 283, **283**
visit to Russia, 1935, 268–9
and WWI, 100, 109–10
Lipsi, Morice, 215, 216
Lipszyc, Samuel, 80, 215
Lissitzky, El, 81, 133
literacy, 26
*Little Camp at Buchenwald, The* (Taslitzy),
    **328**, 329
Loeb, Pierre, 223
Louvre, the, 36
Lucy Krogh Gallery, 160
Lunacharsky, Anatoly, 81
*Luncheon in Fur* (Oppenheim), 257
*L'Univers Israélite*, 28–9, 175, 232
Lurçat, Jean, 236–7, 268, 277
*Lusitania* (ship), 159
Lyre and Palette evenings, 5, 202

Mac Orlan, Pierre, 232
Maclean, Una, 285
Magnelli, Alberto, 309
Magritte, René, *Time Transformed*, 52
Mahler, Gustav, 188
Maison de la Culture, 267, 277
Maîtres de l'art indépendant, de Manet à
    Matisse exhibition, 268
*Makhmadim*, 80
male roles, 104
Malevich, Kazimir, 123–4, 288
Malpel, Charles, 229
Malraux, André, 263
Man Ray, 9, 32, 36, 89, 134, 134–5, 150,
    180, 206, 235, 258
    Black and White, 293n3
    *Object to be Destroyed*, 53, **53**, 55, 257
    *Observatory Time—The Lovers*, **54**, 55
    and time, 8, 53, **53**, 55
    *Veiled Erotic*, 255, **256**, 257
Mané-Katz, 1, 12, 19, 102, 124–5, 174–6,
    216, 230, 261, 308, 318
    *Homage to Paris*, 16, **17**
    response to crisis of the 1930s, 287
    *Traveling Musicians*, 193
    *The Wedding*, **194**
manifestos, 3, 51
Marais district, 3, 19, 21, 63, 265
Marc, Franz, 33, 87, 228

Marcoussis, Louis, 5, 19, 112, 113, 134,
    234–5, 257–8, 268
Margueritte, Victor, 154
Markiel, Jacob, 312
Marseilles, 306–7
Marx, Karl, 32
masculinity, 103–7, **106**
Masereel, Frans, 268
masks, 327
Massine, Léonide, 86
Masson, André, 304
Masters of Independent Art Exhibition,
    272–7
Masterworks of French Art exhibition, 272
materialism, 38
*Maternity,* (Muter), 78
Matignon Agreement, 1936, 266
Matisse, Henri, 20, 74, 146, 179
Mauclair, Camille, 29, 241
Maure, Thérèse, 156
Maurras, Charles, 38, 238
Mauss, Marcel, 35, 88
Mayer, Captain Armand, 105
Meeropol, Abel, 205
Mendelssohn, Felix, 188
Menkès, Sigmund, 313
*Menorah*, 232
*Mercure de France*, 5–6, 13n10, 30–1, 241,
    245, 276
Merkel, Jerzy, 65
Messaien, Olivier, 198, 313–4
Metzinger, Jean, 39
Michonze, Grégoire, 49, 229, 246–7, 262,
    285, 292–3
    *We Play Red*, 285, **286**
Miestchaninoff, Oscar, 66, 75, 229
migration, 3–4
Milbauer, Joseph, 29
Milhaud, Darius, 7, 188, 191, 203, 204, 209,
    216
Miller, Henry, 247, 257, 261, 262, 285
Miller, Lee, **54**, 55, 155
Millet, Jean-François, 68
Minkowski, Eugène, 35, 42–3, 50–1
*Minotaure*, 257
Mintchine, Abraham, 180–1
misogyny, 149
models, 155–6
modern art, 3

modernism, 3
modernist literature, 41–2
Modigliani, Amedeo, 5, 6, 19, 21, 32, 50, 51,
    76, 97–9, **97**, 105, 126–33, 224, 238
  affairs, 154
  and African art, 88
  apogee, 89
  appearance, 126, 153
  Basler on, 244
  bohemian nonconformity, 143
  Café de la Rotonde photograph, 4, 301
  career peak, 8
  death, 127, 135–6, 144, 161
  funeral, 136
  *Head of a Woman*, **128**
  health, 110, 128, 133
  *Jacques and Berthe Lipchitz*, **130**
  Jewish background, 126
  Jewish identity, 70, 143, 145, 153
  *Léon Bakst*, **84**
  myth, 150–3
  *Nude on a Blue Cushion*, **132**
  nudes, 66, 110, 131, **132**, 133, 147–8,
    153, 153–4
  and poets, 71
  *Portrait of a Jewess*, 70
  *Portrait of Chaim Soutine*, **165**
  *Portrait of the painter Moïse Kisling*,
    **162**
  portraits, 70, **84**, 88, 110, 129, **130**, 131,
    **162**
  psychological depth, 166
  psychological preoccupations, 70–1
  *Reclining Nude*, 143, 144
  sculptural drawings, 126
  sculpture, 80, **128**
  *Seated Nude*, 133
  status, 127
  style, 87, 129, 131
  and time, 48–9
  turns to painting, 110, 128–9
  and WWI, 99, 100, 110, 126
Modigliani, Jeanne, 150
*Modigliani: Beyond the Myth* exhibition,
    150
Moholy-Nagy, László, 51–2
Mondzain, Simon, 106, 113, 114, 115, 134,
    161
  *Pro Patria*, 116, **116**

Montmartre, 2
  jazz clubs, 205
  shift from, 3, 8, 99–100
*Montparnasse*, 237, 238–40
Montparnasse, 1, 9–10, 20–3, 64, 334
  1930s, 260–5
  American population, 9
  apogee, 143–4
  authorities attitude towards, 133
  Cocteau on, 100
  comparison to a ghetto, 29–30
  cultural connections, 5
  importance, 12
  international artist colony apogee, 64
  internationalism, 21
  Jewish immigration, 64–76
  Jewish population, 4
  settlement in, 19–20
  shift to, 3, 8, 19, 99–100
  status, 143–4
  transnational ambience, 4–5
Morand, Paul, 86, 203–4
Morès, Marquis de, 105
Moscow Society of Artist-workers, 81
*Mother and Child I* (Lipchitz), 283
*Mother and Child with Haloes* (Muter), 78
Moulin, Jean, 310
Moulin Rouge, 23
Mount Parnassus, 201, 216
Mukhina, Vera, 280
Munkácsy, Mihály, 68
mural art, 267, 271–2
Murger, Henri, 22, 153
Musée d'art moderne de la Ville de Paris,
    258–9, 264
Musée des Arts et Traditions Populaires,
    277
Musée du Petit Palais, 284
Musée National de l'Art Moderne, 263–4,
    271
Musée Zadkine, 122
muses, the, 201
Museum of Jewish Art., Vilna, 289
music, 187–95, 199–203
  and African-American culture, 203–9,
    **208**
  jazz, 7, 10, 146, 187–9, 203–9, **208**, 216
  Raeben.Dylan connection, 217–8
  and sculpture, 209–16, **211**, **212**, **214**

*Music* (Chagall), 124
musical themes, 188–9
musicality, 10
musicalization, 189
*Musician, The* (Chagall), 192
Muter, Mela, 19, 33, 65, 67, 71, 149, 229,
    234
    background, 76
    career, 76–9
    *Fruits of Pain*, 77
    Legion of Honor, 78
    *Maternity,*, 78
    *Mother and Child with Haloes*, 78
    nostalgia, 77
    reputation, 75
    *Sad Country*, 77
    style, 76, 77
    suffering, 78
    and WWI, 112–3
    and WWII, 309
mysticism, 198

Nadelmann, Elie, 66, 67, 75
national identity debate, 236–7
nationalism, 100, 101, 262–3, 264, 289
nationalist politics, 239
naturalization, 22, 118, 146–7, 162, 295n23,
    295n24, 298n86
*Naye Presse*, 290
Nazi Germany, 3
    the *Anschluss*, 265, 292
    cultural rapprochement, 280
    *Degenerate Art* exhibition, 11, 66, 264,
        272, 279, 313
    Exposition Internationale des Arts et
        Techniques dans la Vie Moderne
        pavilion, 279–80, 281
    fear of degeneration, 11
    Kristallnacht, 265, 292
    occupation of the Rhineland, 266
    persecution of Jews, 292
Nazism, rise of, 147
Nazi-Soviet Non-Aggression pact, 290
Near Eastern art, 80–1
neoclassicism, 65
Neo-Humanism, 246
neoimpressionism, 20, 68, 180
networking, 21
new Jew, the, 288–9

new woman, the, 147
New York, Pierre Matisse Gallery, 301–2,
    **302**
Newman, Barnett, 27
Nieszawer, Nadine, 65, 180
Nijinsky, 84, 87
Nordau, Max, 11, 104–5, 288
Nordau, Maxa, 29
nostalgia, 45–8, **47**, 51
*Nude Descending a Staircase* (Duchamp), 9
*Nude on a Blue Cushion* (Modigliani), **132**
*Nude over Vitebsk* (Chagall), 258
nudes, 66, 110, 131, **132**, 133, 145, 147–8,
    153, 153–4, 157, 163, 255, **256**,
    257–8
Nussbaum, Felix, 326–7

*Object to be Destroyed* (Man Ray), 53, **53**,
    55, 257
*Observatory Time—The Lovers* (Man Ray),
    **54**, 55
ocularcentrism,, 36–8
Odessa, pogrom, 1905, 3
Oedipus complex, 88
*Old Clown, Self-portrait as a clown, The*
    (Weissberg), 325, **326**
Olère, David, 312, 330–1
    *Asphyxiation in the gas chamber*, 331
Oppenheim, Meret, 32, 150, 155, 255, **256**,
    257–8
    *Luncheon in Fur*, 257
oppression, 204
Optophonic Academy, 197
Orloff, Chana, 19, 21, 65, 66, 79, 80, 105,
    133, 149–50, 156, 229, 234, 262, 269,
    288, 308–9
    *Crouching woman*, **149**
    *The dancers (sailor and sweetheart)*,
        **148**
    *The Kiss, or The Family*, **111**, 112
    *Portrait of Per Krogh*, 216
    and WWI, 112
Orpheus, 199–201, 214–5, **214**, 216
*Orpheus* (Chagall), 200
*Orpheus Walking* (Zadkine), **214**
Orphism, 16, 39, 87–8, 199–201, **200**
Ortiz de Zarate, Manuel, 4, 97–9, 99, 135–6
Orwell, George, 261
Otto Freundlich Society, 268

outsider status, 153
Ozenfant, Amédée, 135

pagan imagination, 86
Pailès, Isaac, 102
Palais de Tokyo, 272
Palestine, 175, 288–9
Panama scandal, the, 104
Pankiewicz, Joseph, 70, 115
Pann, Abel, 120–1, 230–1
*Parade*, 98, 202–3
Paris Commune, 1, 9
*Paris through the Window* (Chagall), 15–6,
    **15**, 45, 52, 87, 88
Paris was a woman, 154–5
*Partisan Review*, 21
Pascin, Jules, 5, 19, 30, 32, 49–50, 61n82,
    67, 76, 101, 134, 179, 216, 224
  in America, 75, 158–9, 159–60
  American paintings, 158–9
  appearance, 153
  background, 74
  Basler on, 244
  career, 74–5
  cosmopolitanism, 158
  Jewishness and Jewish identity, 145
  *Landscape*, **125**
  *les années folles*, 144, 145, 157–61
  *libertinage*, 159
  marriage, 106, 126, 154, 160
  relations with women, 159–60
  studio, 157
  style, 65, 75
  suicide, 70, 75, 144, 159, 160, 161, 259
  travels, 160
  *Two nudes, one standing, one sitting*,
    **157**
  *Two standing nudes*, **158**
  and WWI, 125–6, **125**
passéism, 247
Passover, 44, 44–5
*Pastry Chef* (Soutine), **168**, 169
patriotism, 108
Péguy, Charles, 39
Pelerin, Auguste, 225
Pen, Yuri, 123
Peretz, I. L., 192, 193
performance-art, 170
Perlmutter, Bronia, 156

Perlmutter, Tylia, 156
Pétain, Marshall Philippe, 277, 304–5, 306
Petit Palais, 264, 272
Pevsner, Antoine, 51–2
Pfeffermann, Abba, *see* Abel Pan
Picasso, Pablo, 3, 5, 87, **97**, 172, 203, 231
  anarchist sympathies, 58n36
  art dealers, 223, 225, 226–7, 229
  Basler on, 245
  bull motifs, 283
  Café de la Rotonde photograph, 4,
    97–9, **98**, 301
  death, 136
  *Guernica*, 264, 281
  Jewish traits, 31, 31–2, 58n35
  *Les Demoiselles d'Avignon*, 41, 98, 226
  move away from cubism, 226
  shift to Montparnasse, 19, 99–100
  status, 31–2
  Stein portrait, 36
  *Three Musicians*, 209
  violin motif, 195
  and WWI, 99, 100
  WWII, 302
Pierre Matisse Gallery, New York, 301–2,
    **302**
Pilsudski, Josef, 114, **117**, 118–9
Pissarro, Camille, 3, 5, 18, 31–2, 77–8, 231,
    242, 244, 247
place, lack of, 44–5
Platek, Felka, 326–7
pleasure principle, the, 166
Pletzl of Paris, the, 152
poets, 71–2
Poincaré, Henri, 41
pointillism, 68
Poiret, Paul, 99
Poland, 25, 67
Polish Legion, 67
*Polish Parisians* exhibition, 67
Pollock, Jackson, 172
Pompidou Cultural Center, 263
Pont-Aven, 76
Popular Front, 10, 11, 147, 259, 264, 265,
    266–9, 271–2, 277, 282, 334
*Portrait of a Jewess* (Modigliani), 70
*Portrait of Chaim Soutine* (Modigliani),
    **165**
*Portrait of Moïse Kisling* (Soutine), **164**

*Portrait of Per Krogh* (Orloff), 216
*Portrait of the merchant Léopold Zborowski*
    (Weissberg), **324**, 325
*Portrait of the painter Moïse Kisling*
    (Modigliani), **162**
positivism, 38
Poulenc, Francis, 203
Pound, Ezra, 36
poverty, 22–3, 127, 261
Prax, Valentine, 213
*Prayer, The* (Lipchitz), **321**, 322
primitive art, 48, 87, 87–8
primitivism, 8, 65, 82–7, 89, 173
Prin, Alice. *see* Kiki de Montparnasse
Princet, Maurice, 32, 41
printing, 37
*Pro Patria* (Mondzain), 116, **116**
*Procession* (Rattner), **319**, 320
*Prometheus Strangling the Vulture* (Lipchitz),
    11, 274–7, **275**, **278**, 283, 321
*Propeller* (S. Delaunay), **270**, 271
*Prose du Transsibérien* (Delaunay), 73
Proust, Marcel, 37–8, 44
psychoanalysis, 70–1
psychological depth, 166
public art, 263, 267–9, 271–2
publicity, 232–3
pure painting, 52
purism, 79, 135

*querelle des Indépendants*, 236–7

racial distinctions, 257
racial stereotypes, 204, 209
racism, 9
racist essentialism, 246
Raeben, Norman, 217–8
*Rape of Europa* (Lipchitz), 275, 283, 320–1
*Rape of Europa II* (Lipchitz), **276**
Rath, Ernst vom, 265
Rattner, Abraham, 12
    *The Air Raid*, **318**, 320
    *Apocalipsion*, 319, 320
    background, 317–8
    *Darkness Fell over the Land*, 319
    *Mother and Child*, 317–8
    *Procession*, **319**, 320
    response to the Holocaust, 318–20
    *The Survivors*, 319–20

Ravensbruck, 310
Raynal, Maurice, 165–6, 233
*Razsvet*, 289
realism, 3, 51, 70
reality principle, the, 166
*Reclining Nude* (Modigliani), 143, 144
redemption, 71
refugees, 259, 265, 282, 298n77, 304
regionalism, 277
Reicheit, Franz, 16
relativity theory, 41–2
religiosity, 26
Renaissance Italy, 2
representational art, 50
republican tradition, 12
Resistance, the, 307, 311, 312, 327
*Revolution*, (Chagall), 290–1
Reynaud, Paul, 304
Richardson, John, 225
Rilik-Andrieu, Lili, 311
Rio de Janeiro, 277
Rivera, Diego, 32, 66, 67, 71, 77, 81, 88, 100,
    101, 105–6, 109, 202, 224, 231, 271
Road of Peace, 268
Robeson, Paul, 205
Rodin, Auguste, 104
Roger-Marx, Claude, 232
Rolland, Romain, 113
Romin, Seweryn, 119
Roosevelt, Franklin D., 271–2
Rosenberg, Alexandre, 223
Rosenberg, Harold, 21, 27–8
Rosenberg, Léonce, 109, 224, 227, 229, 230,
    231, 246
Rosenberg, Paul, 10, 224, 227, 318
Rosenzweig, Franz, 33
Roth, Joseph, 103
Rothenstein, William, 23, 69
Rothko, Mark, 12, 27, 33, 248
Rougier Le Cocq, Violette, 310
Rubinstein, Arthur, 161
Rubinstein, Helena, 234–5
rue Dragon, 23
rue Ravignan, 23
Russian Academy, 112
*Russian Constructivists* exhibition, 51
Russian culture, 8
Russian Empire, 24, 25–6, 102
    1905 Revolution, 3

Jewish emigration, 24, 63–4
   primitivism, 84–7
   repression, 3
   Russian Revolution, 100, 107, 122–4, 133, 174, 235, 290

Sacharoff, Olga, 202
*Sacrifice* (Lipchitz), 322–3
*Sad Country* (Muter), 77
Said, Edward, 304
Salmon, André, 4, 67, 71, 79, 97–9, **97**, 146, 163, 232, 301
Salon d'Antin, 99
Salon d'Automne, 77, 175, 229, 231
Salon des Indépendants, 20, 86, 175, 191, 209, 229, 231, 232, 236–7
Salon des Tuileries, 175, 229
Salon of Painters Witnesses of their Times, 311
salons, 2, 233
Sartre, Jean-Paul, 261, 325
Satie, Erik, 98, 188, 203, 208
Say, Marcel, 238
Schatz, Boris, 18
Schoenberg, Arnold, 188, 196
Scholem, Gershom, 71
School of Paris. *see* Ecole de Paris
Schwartzbard, Scholem, 102, 108–9, 120, 198
Schwob, René, 232
Scriabin, Alexander, 198
sculpture, and music, 209–16, **211, 212, 214**
*Seated Nude* (Modigliani), 133
self-identity, 21–2
*Self-portrait with Clock* (Chagall), 46, **47**, 333
Seligman, Germain, 223, 225–6
Seligmann, Jacques, 225
Seligmann; Kurt, 301
Selz, Jean, 209
sensory hierarchy, 36–8
Sephardic Jews, 32, 145
Sert, Josep Lluis, 280
sexual libertinism, 146, 154–5
sexual politics, 144, 147–50, **148, 149**
Shahn, Ben, 271–2
Shterenberg, David, 81, 133
Signac, Paul, 236, 267

Silver, Kenneth, 109–10, 226
Simmel, Georg, 87
simultaneism, 35, 39, **40**, 41, 64
Six, the, 188, 203, 213
Skimkevitch, Andrey, 269
skin color, 257
Social Darwinism, 26
social realism, 263
social transformation, 26
socialist realism, 81, 267
socialization, 21
Société des Femmes Artistes Modernes, 78
socio-economic background, 69–70
solidarity, 21
*Song of Songs* (Lipchitz), 283
*Song of the Vowels* (Lipchitz), 212–3, **212**, 282
Soupault, Philippe, 206
Soutine, Chaim, 19, 21, 33, 36, 80, 88, 101, 106, 133, 135, 144, 174, 229, 233–4, 247
   1930s, 262
   apogee, 89
   Basler on, 243
   *Carcass of Beef*, 48, **49**
   death, 284, 303, 309
   expressionism, 164–6, **164, 165, 167**, 168–70, **168, 171**, 172–4
   *Female Nude*, 258
   financial success, 145
   *Grotesque (self portrait)*, **171**
   Jewishness, 172–3
   *les années folles*, 164–6, **164, 165, 167**, 168–70, **168, 171**, 172–4
   Modigliani portrait, **165**
   myth, 166, 168, 170
   *Pastry Chef*, **168**, 169
   political naïveté, 284
   *Portrait of Moïse Kisling*, 164–5, **164**
   poverty, 168
   psychological depth, 166
   Raynal on, 165–6
   realism, 172
   refusal to conform, 6
   response to crisis of the 1930s, 284
   retrospective, 1937, 284
   status, 6
   studio, 168
   style, 75, 166, 169–70

and temporality, 8
and time, 48, **49**
*Winding Road, near Gréolières*, **167**
and WWI, 110, 126
and WWII, 292, 308–9
Soviet Union, 268–9, 280
space-time, 41–2
Spain, 77
Spanish Civil War, 266, 290
Speer, Albert, 280
Spengler, Oswald, 245
Spinoza, Baruch, 70
spirituality, 33–4
Springer, Ferdinand, 309
Stavisky Affair, 9, 259, 264, 265
Stein, Gertrude, 2, 9, 36, 109, 145, 150, 154
*Still Life with Musical Instruments*
        (Lipchitz), 212
Stravinsky, Igor, 84
        *Apollon Musagète*, 201
stream of consciousness literature, 44
subconscious, the, 71
subjective self, the, 35–6
*Suppliant, The* (Lipchitz), 322
support networks, 64
suprematism, 123–4
surreal naturalism, 247
surrealism, 632,, 36, 52, 79, 87, 172, 180,
        199, 246–7
*Survivors, The* (Rattner), 319–20
*Symphony Number 1* (Baranoff-Rossiné),
        196, **198**
synesthesia, 196–8, **197**, **198**, 199–203, 216
Szwarc, Marek, 80, 81, 195

Talmud, the, 44
Tanguy, Yves, 304
Tanikowski, Artur, 119
Taslitzy, Boris, 267, 312, 327, 329–30
        *The Death of Danielle Casanova*,
        329–30
        *The Little Camp at Buchenwald*, **328**,
        329
Tatlin, Vladimir, 51
Tauber, Sophie, 309
Tel Aviv art museum, 288–9
Terpsichore, 201
*Theseus and the Minotaur* (Lipchitz), 283,
        **283**

Third French Republic, 1, 3, 24, 104, 108,
        258, 303, 305
Thorak, Josef, 280
*Three Musicians* (Picasso), 209
*Three Musicians, The* (Hayden), 208–9, **208**
time and temporality, 8
        art of, 44–53, **47**, **49**, **53**, **54**, 55
        Bergson and, 38–9, 41–4
        Chagall and, 45–8, **47**, 52, 331, 333
        Judaism and, 44
        Man Ray and, 53, **53**, 55
        Modigliani and, 48–9
        sanctification of, 44
        Soutine and, 48, **49**
*Time is a River without Banks* (Chagall), 8,
        46, 289–90, 333
Tobia, Rosalie, 99
toleration, 3, 7, 9, 24
Tollet, Tony, 226
Toulouse-Lautrec, Henri de, 23, 143,
        144, 155
tradition, 20, 27–8
transcendence, 33
*Traveling Musicians* (Mané-Katz), 193
Tuchman, Maurice, 168
*Two nudes, one standing, one sitting*
        (Pascin), **157**
*Two standing nudes* (Pascin), **158**
Tzara, Tristan, 9, 36, 100, 134, 180

Uhde, Wilhelm, 74, 224, 225, 226, 227, 241,
        249n14
unconscious, the, 36, 43–4, 129
Union des Artistes Polonaise en France, 21
Union des Artistes Russes, 21
United States of America
        and African-American culture, 205
        Armory Exhibition, 1931, 75
        assimilation, 12
        exile in, 301–4, **302**, 307, 308-9, 317,
        333
        Jewish immigration, 25, 63, 103, 265
        mural art, 271–2
        New Deal program, 271–2
        Pascin in, 75, 158–9, 159–60
        Prohibition, 9
        Prohibition culture, 144
        Works Progress Administration, 271–2
        and WWI, 107

universalism, 11–2, 303–4
Ury, Lesser, 18

Vaillant-Couturier, Paul, 113
Van Dongen, Kees, 5
Van Gogh, Vincent, 143, 169, 170
Vanderpyl, Fritz, 5–6, 13n10, 30, 224, 241, 241–2, 244, 245, 248
Vasiliev, Marie, 111, 112, 126
Vauxcelles, Louis, 232
Veber, Pierre, 105
*Veiled Erotic* (Man Ray), 255, **256**, 257
Vel d'Hiv roundup, 305, 313
Verdun, Battle of, 113
Verlaine, Paul, 189
Vichy government, 22, 241–2, 302, 304, 304–10, 312
Vidil, Cécile Marie, 160
Vilna, Museum of Jewish Art., 289
visibility, 1, 5, 146, 240
visual sense, the, 36–8
visual-auditory connections, 188–9
Vitebsk People's Art School, 122–3, 288
Vollard, Ambroise, 224, 228
Vorobëv, Marevna, 65, 66, 71, 90–1n10, 104, 105–6, 149., 154, 202
    *Woman and Death*, 111

Walden, Herwarth, 7, 75, 87, 227–8, 228–9
wandering Jew motif, 7, 50, 248, 333
*War* (Chagall), 122
Warnod, André, 5, 19, 29–30, 64, 145–6, 154, 157–8, 232, 236, 237
Waters, Ethel, 205
*We Play Red* (Michonze), 285, **286**
*Wedding, The* (Mané-Katz), **194**
Weill, Berthe, 131, 150, 155, 223, 224, 233
Weininger, Otto, 104, 155, 245
Weissberg, Léon, 313, 323–7
    *The Jewish Bride*, 325
    *The Old Clown, Self-portrait as a clown*, 325, **326**
    *Portrait of the merchant Léopold Zborowski*, **324**, 325
Wertheim, Edward, **118**, 119
*White Crucifixion* (Chagall), 52, 89, **291**, 292, 314, 316
Wildenstein, Georges, 223

Wilentz, Sean, 218
*Winding Road, near Gréolières* (Soutine), **167**
Wittlin, Thaddeus, 183n23
women, roles, 153–6
Wood, Grant, 272
Works Progress Administration (USA), 271–2
World War I, 1, 8, 97–136, 177, 226–7, 242, 246, 303
    antisemitism, 108–9
    artists at, 113–6, **116**, **117**, 118–26, **118**, **119**, **125**
    Battle of Verdun, 113
    Café de la Rotonde photograph, 4, 97–9, **99**
    Cocteau serves in, 4
    Coctesu on, 99
    Eastern Front, 120
    executions, 108
    Gotleib serves in, 67
    immigrant artist responses to, 101–3
    Jewish attitudes to, 107–10
    Jewish death rate, 108
    Jewish volunteer numbers, 108
    Kisling serves in, 4
    and masculinity, 103–7, **106**
    pro-German sentiment, 102–3
    women and, 111–3, **111**
World War II, 12, 17–8, 215, 292–3
    anti-Jewish laws, 305
    artist-deportees, 310–4
    artists who remained in France, 323–7
    Aryanization laws, 306
    Battle of France, 304
    Chagall's response to, 314, **315**, 316–7
    death march, 312
    deportations, 305–6, 308, 312–3, 330
    escapes, 307–9, 308–9
    exile, 301–4, **302**, 307, 308–9, 323
    the Grasse group, 309–10
    Holocaust survivors, 327, **328**, 329–31
    internment, 308, 324
    Jewish survival rates, 306
    Kristallnacht, **315**
    Lipschitz's response to, 320–3, **321**
    Rattner's response to, 317–20, **318**, **319**
    refugees, 306–7

the Resistance, 307, 311, 312, 327
Vel d'Hiv roundup, 305, 313
Vichy collaboration, 304–10, 312
World Yiddish Cultural Alliance, 290
Worringer, Wilhelm, 87–8

xenophobia, 146, 259, 263, 278–9

*Yellow Crucifixion* (Chagall), **315**, 316
Yiddish, 26

Zadkine, Ossip, 5, 19, 21, 66, 69, 80–1, 101,
   106, 113, 114, 121–2, 126–7, 134,
   238, 239, 269
   1930s, 261
   exile, 301, **302**, 308

modernism, 213
and music, 209, 213–5, **214**, 216
*Orpheus Walking*, **214**
and public art, 267
*querelle des Indépendants*, 237
Zak, Eugène, 30, 75, 150, 180–1
Zak, Jadwiga, 223, 233
Zamenhof, Ludwig, 153
Zborowski, Leopold, 71, 168–9, 224, 225,
   233–4, 248
Zevi, Bruno, 47
Ziegler, Adolph, 11
Zionism, 11, 18–9, 24, 26, 104–5, 107, 265,
   287, 288–9
Zola, Emile, 172
Zurich, 100